China Academic Library

This book series collects, organizes and presents the master pieces in contemporary China studies. Titles in this series include those by Chinese authors who studied and worked abroad during early times whose works were originally in English and had already made great impacts in the Western world, such as Hu Shih, Fei Xiaotong and others; as well as works by more recent authors, Chinese and non-Chinese, that are of critical intellectual importance in introducing and understanding the transformation of the modern Chinese society. A wide variety of topics are covered by the series, from philosophy, economics, and history to law, cultural geography and regional politics. This series is a key English language resource for researchers and students in China studies and related subjects, as well as for general interest readers. The book series is a cooperation project between Springer and Foreign Language Teaching and Research Publishing Co., Ltd.

Academic Advisory Board:

Researcher Geng, Yunzhi, Institute of Modern History, Chinese Academy of Social Sciences, China
Professor Han, Zhen, Beijing Normal University, China
Researcher Hao, Shiyuan, Institute of Ethnology and Anthropology, Chinese Academy of Social Sciences, China
Professor Li, Xueqin, Department of History, Tsinghua University, China
Professor Li, Yining, Guanghua School of Management, Peking University, China
Researcher Lu, Xueyi, Institute of Sociology, Chinese Academy of Social Sciences, China
Professor Tang, Yijie, Department of Philosophy, Peking University, China
Professor Wong, Young-tsu, Department of History, Virginia Polytechnic Institute and State University, USA
Professor Yu, Keping, School of Government, Peking University, China
Professor Yue, Daiyun, Department of Chinese Language and Literature, Peking University, China
Zhu, Yinghuang, China Daily Press, China

Series Coordinators:

Zitong Wu, Editorial Board of Foreign Language Teaching and Research Press
Leana Li, Springer

Lili Fang

The History of Chinese Ceramics

Volume 2

 外语教学与研究出版社
FOREIGN LANGUAGE TEACHING AND RESEARCH PRESS

 Springer

Lili Fang
Chinese National Academy of Arts
Beijing, China

Translated by
Lin Ma
Beijing Foreign Studies University
Beijing, China

Sponsored by Chinese Fund for the Humanities and Social Sciences (本书获中华社会科学基金资助).

ISSN 2195-1853 ISSN 2195-1861 (electronic)
China Academic Library
ISBN 978-981-19-9096-0 ISBN 978-981-19-9094-6 (eBook)
https://doi.org/10.1007/978-981-19-9094-6

Jointly published with Foreign Language Teaching and Research Publishing Co., Ltd
The print edition is not for sale in Chinese mainland. Customers from Chinese mainland please order the print book from: Foreign Language Teaching and Research Publishing Co., Ltd.

Translation from the Chinese language edition: "中国陶瓷史" by Lili Fang, © Qilu Press 2013. Published by Qilu Press. All Rights Reserved.

This Springer imprint is published by the registered company Springer Nature Singapore Pte Ltd.
The registered company address is: 152 Beach Road, #21-01/04 Gateway East, Singapore 189721, Singapore

Preface

From the perspective of the anthropology of art, and embedded in a global academic context, this work allows one to recognize that "history is, in large measure, the record of human activity which spreads from the local to the regional, from the regional to the global, and from the global to the universal." From reading *The History of Chinese Ceramics*, you will find it evident that China was not only the first country to create porcelain but also the first to export it to the world—both the product and its technology. *The History of Chinese Ceramics* thus relives the history of China's foreign trade while at the same time depicting the expansion of Chinese ceramic technology and culture. This expansion was a learning process in which different nations were able to grow by absorbing and disseminating each other's civilization and culture. It demonstrates that China was not a closed and isolated country but rather interacted with many other nations. Moreover, China's multiple ethnicities contributed to the various cultures that made Chinese ceramics what they are today. In China, ceramics were not simply tableware but played an active role in ritual, religion, the scholar's studio, and many other cultural institutions. Hence, they are utensils as well as symbols of culture. Understanding the use, production, and international export of Chinese ceramics is invaluable for the comprehension of the history of China's society, art, aesthetic ideology, technical expertise, lifestyle, foreign trade, and civilization itself. As a result, a knowledge of the history of Chinese ceramics is of great importance to grasping the essence of Chinese culture and aesthetics.

Translated by
Andrew Maske

Beijing, China

Introduction—Viewing Ceramics History Through the Lens of the Anthropology of Art: A New Approach

Overview

To view arts and crafts history and theories from the perspective of the anthropology of art has long been my aspiration. This aspiration was the reason why, after gaining my Ph.D. in history at the Central Academy of Craft Art (now the Academy of Arts and Design at Tsinghua University) in 1996, I applied for a postdoctoral position at the Institute of Sociology and Anthropology at Peking University, where I received basic training in anthropology. The postdoctoral program ended in 1998, and since, then I have been engaged in research on the anthropology of art. I undertook an extended period of field research in Jingdezhen, where, with the ceramics-making history and production practice of craftsmen as case studies, I examined the transformation and restructuring of traditional crafts in modern society. Later, I took on a national key research project on folk culture resources in Western China. I studied the folk arts of Shaanxi Province on-site, including the folk ceramics of Chenluzhen, and visited Guizhou Province to study how the hmongb rongt people's cultural life and arts heritage were appropriated as resources.[1] Long periods of field research gave me new understandings of and new theoretical approaches to the relation between arts and socio-cultural development, the interaction between arts and people's modes of production and lifestyles, the relationship between arts and the social and aesthetic values of different eras, and the mutual promotion between the Great Tradition and the Little Tradition in art.

That was when the idea of rewriting arts and crafts history using the perspective of the anthropology of art occurred to me. Naturally, I would not be so ambitious as to take on the task of rewriting the entire history of arts and crafts. My intention was to focus on the history of one particular art and craft form, and the one I was most familiar with was the history of ceramics. I studied at the Arts Department of

[1] Fang Lili (ed.), *From Heritage to Resources—A Research Report on West Cultural Resources*, Academy Press, 2010; Fang Lili, *Travel Log to the West—Field Notes on Shaanxi Folk Arts*, Academy Press, 2010; Fang Lili et al., *Changes of Longjia Villagers' Lives—Study of Suojia Ecological Museum*, Academy Press, 2010.

the Jingdezhen Ceramic Institute, gained my Ph.D. in the history of arts and crafts in the History Department of the Central Academy of Craft Art, and then did post-doctoral studies at the Institute of Sociology and Anthropology at Peking University, where I chose Jingdezhen folk kilns as the subject of my research and produced the report *Traditions and Changes—Field Research on the Old and New Folk Kilns of Jingdezhen* as my graduation thesis. Later, I wrote *Jingdezhen Folk Kilns* and *Old Town Gone—Past Stories of the Ceramics Capital*. These three works totaled nearly one million words. Since the Yuan, Ming, and Qing dynasties, the development of China's ceramics industry has been centered on Jingdezhen; especially since the Ming and Qing dynasties, since after that Jingdezhen has basically been the sole leading kiln center while all other kilns remained secondary. The research I conducted on the history and status of Jingdezhen ceramics laid the foundation for my compilation of *The History of Chinese Ceramics*. Professor Tian Zibing, my Ph.D. supervisor, decided to compile *The Complete History of Chinese Craft Arts* in 1997 and assigned me to document ceramics history as part of that work. It took me three years to finish the first draft. But for a number of reasons, *The Complete History of Chinese Craft Arts* was never published. Then in 2007, Qilu Publishing House invited me to submit a manuscript on ceramics history. At that time, I had just completed the research project on folk culture in Western China, so I spent years revising and modifying the first draft which I wrote during my doctoral studies before submitting this final version.

I relate the above story to make two points: that this history of Chinese ceramics is written from the perspective of the anthropology of art, and that the work was initially intended to be part of *The Complete History of Chinese Craft Arts*. The latter is also why the book, viewing ceramics primarily as one major craft art in Chinese history, examines the artistic characteristics of ceramics in different historical periods and the contributing factors to those characteristics, notably, how emperors, literati, and craftsmen in different dynasties expressed their spiritual pursuits and aesthetic preferences through colorful ceramic ware.

In writing this work, much of my attention and effort was concentrated on how to observe and understand ceramics as a craft art using the approach of the anthropology of art. In art anthropological studies, "one needs to know where the art was made, who made it, what its use was, what its functions were, and what it meant to the people who made use of it. This is the study of art in its cultural context."[2] Many anthropologists conducted research into specific art works and artistic behaviors in their cultural context. As pointed out by Evelyn Payne Hatcher, "However, the majority of the art forms that we see in museums and art books that have come from Native America, or Africa, or Oceania, are objects that were once part of a larger artistic whole from which they have been extracted. The most obvious example of this is a mask that was part of the artistic whole that included the costume, the movements of the wearer, the music, and indeed, the whole performance. Such a performance may last for days and involve a great deal of artwork; it may even, as

[2] Evelyn Payne Hatcher, *Art as Culture: An Introduction to the Anthropology of Art* (second edition), London: Bergin & Garvey, 1999, p. 1.

among the Pueblos, be part of a year-long ceremonial cycle. In a sense, just to look at a mask as a work of art by itself inevitably imposes our own cultural standards. So, it is necessary to recognize that we need to try to piece together and imagine the artistic context as well as the cultural one if we are to attain a deeper sense of the import than the piece available to us provides."[3] Here, Hatcher is talking about a holistic approach, an approach that opposes the practice of isolating art works from culture and society. Alfred Gell, viewing art as a type of social agency with its own autonomy, also believes that art anthropological research should focus on the social context surrounding the production, circulation, and reception of art and defines the anthropology of art as the theoretical research of social relations related to art.[4] It can be seen from the above theoretical narrative that the study of ceramic history should not be limited to the examination of the wares themselves or the ceramic craft art alone. Rather, we should extend our horizon to wider realms including the related cultural context and the social structure and its development.

Hence, in this book, while I, like any other author writing about the history of Chinese ceramics, will describe the varieties, shapes, decorations, materials, production techniques, etc., of the ceramics in each historical period, will focus my attention not on the descriptions themselves but on the motives behind them. The reader's attention is enthusiastically drawn to the introduction and conclusion of each chapter, where I will look into the fundamental reasons for the different characteristics of Chinese ceramics in different periods by examining how natural environment, political background, cultural factors, market demands, foreign trade, and the Chinese people's philosophical thinking and aesthetic experiences in different periods were reflected in the art form and its transformation over time. Also examined is the interaction between the Great Tradition and the Little Tradition, between official (*guan*) kilns and folk kilns, between the Han people and minority ethnic groups, between refined culture and popular culture, etc. Such an approach is to examine the myriads of phenomena that make up ceramics' history in a holistic manner so as to understand how various social factors, comprised of the artistic and cultural contexts of the time, influenced ceramics, and contributed to the artistic style and characteristics of the ceramic ware of the period.

There is a grammatical architecture behind culture, and the job of anthropologists is to look for that grammar, which to most humans is unknown: just as how everyone can speak, even though they do not necessarily understand the grammar behind the language they are using. Therefore, research into the history of Chinese ceramics should not only describe the ceramic art and cultural landscape of different periods but also delve into the patterns and motives of the development of that ceramic art and, based on this, seek to offer further understandings of the features and connotations of Chinese culture and society. To this end, I share with you my thinking from an anthropological perspective in the following respects.

[3] Evelyn Payne Hatcher, *Art as Culture: An Introduction to the Anthropology of Art* (second edition), London: Bergin & Garvey, 1999, p. 13.

[4] Alfred Gell, *Art and Agency: An Anthropological Theory*, Oxford: Oxford University Press, 1998, p. 7.

Cultural Diffusion and Global Interaction

I intend to site the history of Chinese ceramics in a broad and global cultural context from the beginning, because this approach will allow us to venture beyond understanding the plethora of issues regarding the history of Chinese ceramics itself and investigate broader anthropological theoretical problems based on this context.

Classical anthropology comprises two major schools, the evolutionist school and the diffusionist school. Classical evolutionist thought all belongs to linear evolutionism, believing humanity's cultural development progresses along a single line and emphasizing the uniformity in all human potential and the decisive role such uniform potential plays in the cultural evolution of all communities. Since the mental and intellectual powers of all humans are identical, as classical evolutionism believes, the course of cultural development of all nationalities is bound to be the same,[5] i.e., from simplicity to complexity, from barbarism to civilization, and from backwardness to advancement. It is hence believed that most technologies are a natural outcome of the progress of history and are capable of being independently created or invented by individual nationalities in different historical periods.

While the evolutionist school sees culture as evolving along a temporal dimension, the diffusionist school suggests that culture is predominantly being transported via the spatial dimension, e.g., from one place to another, from one nationality to another, or from one culture to another. While concentrating comprehensively on how human culture evolves over time, the evolutionist school overlooks the geographical distribution of culture, when in reality the evolution of culture is primarily represented by its constant changes across geographical locations. "It sounds very simple: since all historical events occur in space, we must be able to measure the time they needed to spread by the distances that were covered: a reading of time on the clock of the globe."[6] That is to say, cultures of different types often develop concurrently in interaction with one another, which is made possible by large-scale population migrations or national conquests, and the similarity between different cultures is to a large degree the result of cultural contacts.[7]

The diffusionist school believes humanity's independent creative or inventive capacity is limited, and that the regularities that apply to all cultures are the result of culture dissemination rather than the "uniformity of all human beings' mental and intellectual powers" as termed by the evolutionists. Places where inventions first occurred usually became cultural centers and from these centers various cultural traits were disseminated and spread to surrounding areas. It is in this process that cultural contact and cultural change take place.

A closer look at the history of Chinese ceramics reveals that the development and spatial trajectory of Chinese ceramics is a perfect demonstration of the abovementioned theoretical anthropological proposition. Porcelain was independently invented

[5] Lewis Henry Morgan, *Ancient Society*, translated (into Chinese) by Yang Dongchun et al., The Commercial Press, 1981, p. 8.

[6] Johannes Fabian, *Time and the Other*, New York: Columbia University Press, 1983, p. 19.

[7] Fang Lili & Li Xiujian, *Art Anthropology*, SDX Joint Publishing Company, 2013.

by the Chinese. No other country has ever invented porcelain on its own. The fact that porcelain is now made around the globe resulted from the constant diffusion of China's porcelain-making techniques.

Primitive pottery appeared in China back in the Shang and Zhou dynasties and matured during the Eastern Han Dynasty. China's porcelain technology started influencing surrounding regions in the Tang and Song dynasties and spread to what is now the Middle East during the Yuan and Ming dynasties. By the end of the Ming Dynasty, the Japanese mastered China's porcelain-making methods and started selling porcelain to Europe which they made by imitating the Chinese products. In the eighteenth century, the Europeans mastered porcelain-making technology through their missionaries in China, marking the beginning of the worldwide dispersal of China's porcelain technology. Therefore, the history of Chinese ceramics is also the history of Chinese ceramic technologies being spread to other parts of the world. This is also an indication of the limitations of the evolutionist views—cultures do not develop linearly in isolation; rather, they interact with and influence each other.

Perhaps influenced by traditional evolutionist views, when observing Chinese history, we tend to look at it as an isolated entity developing on its own, and when writing on the subject, we tend to devote all our attention to the development of Chinese society only and neglect its interaction with other countries. If we adopt the diffusionist view in looking at Chinese history, we will give due weight to both the temporal and spatial dimensions. This is like looking at China and the earth from space. Unlike being solely situated within China, from this angle, you will find China to be part of the globe and closely connected to other countries and regions. You will also find that the whole world is a dynamic place with all its parts communicating with each other and evolving together.

Globalization is not something new. It has existed for ever. It is just that intercultural communication and exchange were rather slow in times past and only accelerated to a global scale in the sixteenth century when great geographical discoveries were made possible by the advancement of European navigation technologies. This whole process of globalization and its acceleration can be found to be reflected in each stage of the development of Chinese ceramics. Hence, the history of Chinese ceramics has always been part of global ceramic history, global trade history, global economic history, global political history, global cultural history, and global arts history.

I try my best to consider and accommodate intercultural communication when describing each stage of China's ceramic history. Ceramics export is touched on in each chapter and makes up increasingly large and rich portions in chapters on the Ming and Qing dynasties as well as in later periods, because after that, time global communication became ever more convenient and rapid and ceramics trade between China and other countries, especially with European countries, became ever more frequent.

The story of Chinese ceramics, told as an integral part of the globalization process, shows that while transporting ceramic products and technologies to other countries, China has also been transmitting Chinese culture to every place that its ceramic trade has reached. Meanwhile, foreign customers providing design samples and placing

orders also brought foreign culture, art, and lifestyles to China. It is clear that cultural export and communication is never a one-way process. It is mutual and interactive. The anthropological point of view shows that history moves forward amid dynamic interaction and diffusion. When looking at history, we should pay attention to both the longitudinal dimension, namely development of the subject over time, and the latitudinal dimension, namely mobility across space, for it is through such mobility that the multiplex cultural patchwork is sewn, with cultural elements from different places constituting the small patches of cloth which are tightly intertwined.

Migration, Assimilation and Cultural Communication

Anthropologists generally have a sharper eye for difference than for sameness and give more attention to the marginal than the central.[8] Cultural diversity and cultural coexistence has always been a universal phenomenon, one that embodies the unity of opposites.[9] The formation of each culture is the result of biological, geographical, historical, and economic factors. The cultures of all nationalities are equal in value and shall not be ranked into higher or lower statuses. All cultures are equal, and there should be no Euro-centrism in world cultural development. Similarly, the study of Chinese culture should give due weight to the interactions between multiple cultures and avoid allowing the Han culture to overshadow the cultural contributions made by minority ethnicities.

 To apply this view to the study of Chinese ceramic history, we should first acknowledge that with China, being an ethnically plural society, the brilliant landscape of Chinese ceramic history is the result of the development and fusion of the ceramic cultures of different ethnic groups over the centuries. As early as the primitive times, different types of pottery appeared in a number of cultures that emerged in middle and late Neolithic China. These primitive cultures include the Yangshao Culture in the middle and lower Yellow River, the Dawenkou Culture along the Huaihe River and the lower reaches of the Yellow River, the Daxi, Shanbei, Majiayao, and Hemudu cultures that emerged in the middle and lower reaches of the Yangtze River, the Shixia Culture centered on the Pearl River basin, and the Hongshan Culture along the Liaohe River. This shows that China's ceramic culture was from its very beginning heterogeneous, multi-regional and multi-ethnic. In later historical periods—from the separatist era of rivaling dukes and princes in the Spring and Autumn and Warring States periods, to the great unification in the Qin and Han dynasties, and from the coexistence of different ethnic regimes in the Wei, Jin and Southern and Northern dynasties, to the national unification of the Tang Dynasty—the ceramic arts of different ethnic groups sometimes merged with and at times separated from

[8] *Trends in Anthropology* by Social Sciences in China Press, Social Sciences Academic Press (China), 2000, p. 19.

[9] Naribilige et al., *New Patterns of Anthropological Theories*, Social Sciences Academic Press (China), 2001, p. 13.

each other with the historical tides of fragmentation or unification. Sometimes, they developed independently from each other, and sometimes, they blended with and influenced each other. By the Tang Dynasty, the integration of the different ethnic groups' ceramic cultures and technologies led to the overall pattern of celadon dominating the south and white porcelain dominating the north. Meanwhile, under the influence of diverse cultures, there emerged ceramic types that could serve ethnic minorities in northwest China, represented by the tricolor glazed earthenware of the Tang Dynasty, the blue and white porcelain of the Tang Dynasty and the Changsha kiln underglaze decorated porcelain.

The Song Dynasty, with famous kilns in almost every part of the country, marked a peak in China's ceramic development and is thus the subject of a major chapter in this *History of Chinese Ceramics*. Influenced by Han-centrism, people tend to focus on the ceramic history of the Han people when examining the ceramics of the Song Dynasty and fail to give due attention to ceramics in areas ruled by ethnic minority regimes. In this period, apart from the Northern and Southern Song, there were in fact also the Liao, Xixia, and Jin, with Liao and Jin each ruling over territories larger than those of the two Song dynasties. Previous literature only describes the ceramics of the Liao Dynasty cursorily, when in fact Liao ceramics are far more important in the history of Chinese ceramics. The Jin Dynasty was as important as the Liao in China's history because they both reaffirmed the position of ethnic minority regimes as an integral part of Chinese history. Yet the Jin is different from the Liao in that after it replaced the Liao, its territory covered all areas east of the Liaohe River along with part of the Southern Gobi desert, with its center in the central plains which were traditionally ruled by the Han. If the Jin Dynasty is not accommodated in the history of China, neither would the Liao Dynasty be regarded as part of "orthodox" Chinese history. In fact, if Jin is not taken into consideration, China as a country would not be complete, because at that time, the Southern Song Dynasty—the regime of the Han, the "orthodox" Chinese government—had in effect forsaken the central plains and merely occupied areas south of the Qinling Mountains and Huaihe River. Therefore, the Jin Dynasty is an important link in China's long history. Without this period, Chinese history would not be completed, and Chinese civilization would not be as great. In addition, the Jin Dynasty brought northeast China into the mainstream of Chinese history, an area which has since occupied a significant position on the grand stage of China's development. This has had a major impact on modern Chinese and global geopolitics. (See Figs. 8.1 and 8.2 of this work).

The territory of Jin extended to the central plains, covering what is now Hebei, Henan, Shandong, Shanxi, Shaanxi, and Gansu. These are where some of the most famous kilns of the Northern Song Dynasty were sited, such as the Ru, Ding, Yaozhou, Cizhou, and Jun kilns. The Ding and Cizhou kilns in the Jin Dynasty represented the forefront of Chinese ceramics. The black and white porcelain of the Cizhou kilns laid the foundation for many of the techniques of the blue and white porcelain of the Yuan Dynasty. The red and green porcelain that emerged in the Jin Dynasty was the first known polychrome (multicolored) porcelain in China, its decoration techniques becoming the basis for later porcelains such as the red and green porcelain of the Yuan Dynasty, the *wucai* (five-color) porcelain of the Ming Dynasty

and the Kangxi *wucai* (five-color) porcelain of the Qing Dynasty. The appearance of the white porcelain body that was indispensable to the polychrome porcelain of later periods was closely related to the Ding kilns of the Jin Dynasty. All these show that ceramic production in the Jin Dynasty laid the foundation for the blue and white porcelain and polychrome porcelains of the Yuan, Ming, and Qing dynasties and should be seen as an important part of the history of Chinese ceramics. Despite this, the Jin Dynasty has never been given the status it deserves in previous studies of the history of ceramics, sometimes being omitted altogether in some scholars' narration of ceramic history. To make up for this, this book devotes a well-researched and elaborately written section to ceramics during the Jin Dynasty.

The Yuan Dynasty is also an important period in the history of Chinese ceramics. But although ceramic wares of the Yuan Dynasty have been regularly unearthed, for a long time, there existed in the studies of ceramic history a bias favoring the Song and Ming over the Yuan because the Yuan Dynasty lasted for a relatively short time and thus left few historical records, but more importantly because the Yuan was a regime established by ethnic minority aristocrats. Some exquisite porcelain from the Yuan Dynasty was mistakenly identified as being manufactured during the Song Dynasty, and some beautiful blue and white porcelain from the Yuan was wrongly deemed to be from the Ming. Some researchers even sweepingly described Yuan ceramics as heavy, thick, and clumsy.

The chapter "Ceramics of the Yuan Dynasty" in the *History of Chinese Ceramics* published in 1982 only mentions "major kilns in the Yuan Dynasty such as the Jun, Cizhou, Huo, Longquan, and Dehua kilns continued to produce traditional varieties on the foundation of the previous dynasty,"[10] and does not mention other ceramics of the period when in fact, in recent years, occasionally during construction of industrial and agricultural infrastructure projects, a large number of fine Yuan ceramics have been unearthed, notably the blue and white porcelain and underglaze red porcelain samples discovered in Gaoan, Le'an, Yichun, Yongxin, Pingxiang, and other areas in Jiangxi, along with the finest porcelain made in major kilns across China including the Jingdezhen, Ding, Jun, Longquan, Yaozhou, and Cizhou kilns. The items were unearthed from storage pits in several spots in the ancient Yuan Dynasty town on the Jining Road in Inner Mongolia, of which the blue and white porcelain, underglaze red porcelain, and "shufu" inscription egg-white porcelain are the most eye-catching, drawing enthusiastic attention from experts at home and abroad with their sheer volume and exquisite craftsmanship.[11] These ceramics of the Yuan Dynasty, unearthed mostly from pit storages, and other materials found in recent years show that a number of kilns other than those mentioned in previous literature were also producing porcelain during the Yuan Dynasty, such as the Jizhou, Yaozhou, and Ding kilns. Recently, many scholars are using their studies to rectify

[10] Chinese Ceramic Society (ed.), *History of Chinese Ceramics*, Cultural Relics Press, 1982, p. 332.

[11] Yu Jiadong & Jiang An, "An Examination of the Historical Background of the Prosperity of Jingdezhen Porcelain from Pit Storages in an Ancient Yuan Town on Jining Road, Inner Mongolia," Chinese Society for Ancient Ceramics (ed.), *Studies on Ancient Chinese Ceramics* (Vol. 11), The Forbidden City Publishing House, 2005, p. 135.

the lack of research on the ceramic development of the Yuan Dynasty, an inadequacy probably resulting from Han-centrism, a task which this book seeks to complete. By placing an emphasis on Yuan ceramics which is worthy of their significance, we are not only painting a more objective picture of the history of Chinese ceramics but also better understanding different ethic groups' contributions to Chinese civilization and reestablishing the Chinese nation's historical landscape with all its diversity and multiplicity.

An important view of *World Civilizations* is "invasions into civilized society by barbarians often turned out to be critical historical junctures, for such invasions would expedite the breakdown of old orders and the formation of a new order."[12] Indeed, an examination of world history shows that relatively advanced civilizations, having developed to a certain historical stage, are often attacked by civilizations relatively barbarian, and the attack, while breaking old traditions of the advanced civilization, brings new vitality. The ancient civilizations of Greece, Rome, Babylon, and India were all replaced by foreign civilizations, removing their old traditions with them—the Chinese civilization being the only exception. So, what made the Chinese civilization the only one that survived?

A study of the history of Chinese ceramics might help explain this phenomenon. Attacks and power seizure by Northern nomadic peoples has occurred many times throughout China's history, from the Wei, Jin, and Southern and Northern dynasties to the Five dynasties and Ten Kingdoms Period, and from the Song Dynasty to the Xia, Liao, Jin, Yuan, and Qing. The nomadic peoples were militarily strong but not as advanced as the Han people in terms of culture, institutions, and craftsmanship. They overthrew the political power of the Han people but did not destroy their culture. Instead, they humbly learnt from the Han culture, including their ceramic art. For instance, during the Jin, Yuan, and Qing dynasties, under the rule of ethnic minority aristocrats, China's ceramic art not only continued but also gained new vigor. The Ding and Cizhou kilns of the Jin Dynasty prepared the groundwork for the white, as well as the blue and white porcelain of the Yuan Dynasty; the blue and white porcelain, underglaze red porcelain and high-temperature color glaze of the Yuan Dynasty laid the foundation for the emergence of the polychrome porcelains and the rich high-temperature color glazes of the Ming and Qing dynasties; and the reigns of Kangxi, Yongzheng, and Qianlong of the Qing Dynasty constituted a peak in the development of Chinese ceramics. All these show that the Chinese culture is immensely inclusive. It can accommodate new and different cultures, digest the novel elements of these various cultures, and assimilate them as part of its tradition. The other side of the coin is the significant contribution ethnic minorities, and their political regimes made to China's historical progress and cultural formation, a contribution that should be given credit for the continuity of Chinese history over thousands of years. Indeed, if primitive pottery is included, this history should be said to have extended over 10,000 years.

[12] Dennis Sherman, A. Tom Grunfeld, Gerald Markowitz et al., *World Civilizations*, China Renmin University Press, 2007, p. 38.

Therefore, the progress of history is the very process of ethnic migration, assimilation, and mutual influence, of the betterment of the ethnic character, and of cultural change and development. A history that fails to accommodate ethnic elements is no complete history nor would this *History of Chinese Ceramics.*

Iconographic Representations in Utensils

Clifford Geertz says in *The Interpretation of Cultures: Selected Essays*: "Human thought is consummately social: social in its origins, social in its functions, social in its forms, social in its applications. At base, thinking is a public activity—its natural habitat is the house yard, the marketplace, and the town square."[13] Taking the house yard, the marketplace and the town square as habitat is not thinking per se, but it is the vehicle for thinking, for thinking is intangible and takes concrete objects as its media. Bronislaw Malinowski echoes this observation in saying: "The problems set by man's nutritive, reproductive, and hygienic needs must be solved. They are solved by the construction of a new, secondary, or artificial environment. This environment, which is neither more nor less than culture itself, has to be permanently reproduced, maintained, and managed."[14] These anthropologists are saying that human thought and human culture reside in various objects. The material devices of humanity—utensils, houses, boats, tools, weapons, etc.—are the one aspect of culture that is the easiest to perceive and understand. Therefore, instead of going on about culture itself as an abstract concept, it would facilitate comprehension to talk about culture through the medium of utensils.

The ancient Chinese maintained that the "instrument is the carrier of the Way" and that "the metaphysical is called the Way, the physical is called the instrument." Here, instrument refers to devices and the Way means culture, namely the thought embodied in those devices. Ceramics are such devices because for the people they are not only daily utensils but also a vessel and a symbol of Chinese culture. Research into the history of Chinese ceramics, if focusing only on the instrument, i.e., the devices themselves, and overlooking the Way, i.e., the culture and thought embodied in them, would be lacking in depth and comprehensiveness. It should go beyond plain descriptions which only show ceramic wares separated from each other with no connection whatsoever, to depicting what is behind the ceramics, i.e., an entire set of culture and values and the entire course of the transformation of Chinese society.

Malinowski defines culture as "the iconography and norms collectively owned by a group of people."[15] How the collective iconography and norms of the Chinese people

[13] Clifford Geertz, *The Interpretation of Cultures: Selected Essays*, New York: Basic Books, Inc., Publishers, 1973, p. 360.

[14] Bronislaw Malinowski, *A Scientific Theory of Culture and Other Essays*, British Library Cataloguing-in-Publication Data.

[15] Wang Mingming, *Cultural Patterns and Expressions of Human Beings: A Review of Contemporary Western Anthropological Thought*, Tianjin Renmin Publishing House, 1997.

are represented in ceramics, the vessel of Chinese culture, is a question constantly on my mind when I attempt to narrate the history of Chinese ceramics.

Leslie Alvin White differentiated three components of culture: the technological, the sociological, and the ideological, with each level resting on the previous one in that order. It is the technological component which is the primary determining factor responsible for cultural evolution,[16] while the ideological component gives expression to the technological component and reflects the sociological component.[17] White's argument on the three culture components is well reflected in the development of ceramics over time.

Ceramic production requires technology for its realization. Though on the surface new varieties, new decorative patterns, new forms of expression, etc., in different dynasties were made possible by technological innovations and the adoption of new materials, my research seems to show that the technological reforms were driven by changing values and aesthetic preferences, meaning that the ideological component of culture often played a determining role. For instance, the first porcelain type Chinese people succeeded in creating was celadon rather than white or black. Technically, this could be attributed to the fact that the ancient Chinese first mastered the technique of firing celadon with reducing flame rather than firing white porcelain with oxidizing flame, when in fact it was more the result of craftsmen's pursuit of a ceramic texture that resembled greenish jade, a pursuit driven by the Chinese people's preference for jade and the greenish-blue color. Another example is the emergence of polychrome porcelain in the Ming and Qing dynasties. On the surface, it was because craftsmen mastered new decorative techniques and invented new materials, when in fact it was a natural result of new aesthetics, values, and spiritual pursuits brought on by the rise of urban life. Another contributor to the advance of ceramic production is the evolution of the sociological component, for it takes evolved social configuration and division of labor, apart from new technologies and thought, to realize real transformation. The sociological component involved the official kiln system, the government's management of folk kilns, state policies on trade ports, and the emphasis placed on the urban division of labor, which are all worthy of attention in our research.

Aside from the three components of culture, yet another influencing factor is the natural environment. Julian Haynes Steward defines culture as an integration of technologies, social organizations and values and beliefs, which constantly adjusts itself to adapt to its natural habitat and other rival cultures surrounding it.[18] The development of the ceramics industry has been closely related to the natural environment. For instance, the decline of the Yue kilns in the mid-Northern Song Dynasty should be partially attributed to the shrinking of forestry and the decrease in fuels in the area. An overview of the entire history of Chinese ceramics reveals that the

[16] Xia Jianzhong, *Theoretical Schools of Cultural Anthropology—The History of Cultural Studies*, China Renmin University Press, 1997, p. 223.

[17] See Footnote 16.

[18] Xia Jianzhong, *Theoretical Schools of Cultural Anthropology—The History of Cultural Studies*, China Renmin University Press, 1997, p. 238.

development of the industry generally underwent a north-to-south spread, and in Southern China in particular, experienced dissemination from the east to the west. Palaeoclimatological studies have found that the warm temperature zone in China moved from the north to the south over time. From the Yangshao Culture period to the Shang Dynasty, the Yellow River basin enjoyed a warm and humid climate and wide forest coverage, which was beneficial to the development of the ceramics industry. In addition, apart from a short cold period during the Western Zhou Dynasty, Northern China enjoyed a long-lasting warm climate until the Western Han Dynasty, providing favorable climatic and ecological conditions for the flourishing of the Yellow River basin civilization. A natural result of this was that over this period, the center of the ceramics industry lay along the middle reaches of the Yellow River, extending from the Weihe River to Zhengzhou. Then during the Eastern Han, and the Wei, Jin, and Southern and Northern dynasties, the freezing line moved southward, and the later years of the Eastern Han suffered lengthy natural disasters and famine also resulting from a deterioration in the natural conditions. These led to political turbulence and economic downturn in the north, which contrasted sharply with the relatively stable and warm environment of the south. Large population migrations from the north to the south occurred. It was at this very juncture that the Kuaiji kilns succeeded in firing celadon. Then during the Wei, Jin, and Southern and Northern dynasties, the Kuaiji kilns grew into the largest celadon production site in China, selling products almost everywhere south of the Yangtze River and even reaching beyond the Yangtze River to the Yellow River areas. During the Sui, Tang, and Five dynasties, Northern China warmed up again, a vital contributor to the Yellow River reaches becoming the political and economic center of China. When it came to the Southern Song and Yuan dynasties, the north entered another cold period. Forest coverage shrank, leading to a lack of fuel so kilns used charcoal instead. During the final years of the Northern Song Dynasty, the Han regime could no longer resist the Northern ethnic minority's southward advance and large populations migrated to the south.[19] By the Southern Song Dynasty, official kilns were set up in Lin'an (present-day Hangzhou), and after that, the center of Chinese ceramics remained in the south and never crossed the Yangtze River again.

In addition to vegetation and climate, the change in rivers might also affect the decline or boom of the nearby ceramics industry. Previous researchers attributed the decline of the Yaozhou kilns after the Yuan Dynasty to wars, but my investigation and analysis reveal another possible contributing factor, namely the change in the natural environment. It is recorded that the Yaozhou kilns, with the Huangbao town of Tongchuan at their center, were densely strewn along the two banks of the Qihe River, giving rise to the historical phrase the "ten-mile potteries." But when I visited the site of the Yaozhou kilns in 2004, the Qihe River had dwindled to a small ditch. Almost all ceramic production sites in history were adjacent to mountains and rivers. Mountains provide raw materials and fuel, while water is used to wash porcelain clay, to smash porcelain stone, and to serve as an important means of transport. Rivers are

[19] Xiong Haitang, *Research on the Technical Development and Exchange History of the Ceramics Industry in East Asia,* Nanjing University Press, 1995, p. 115.

essential for a flourishing ceramic production regime. Thus, in ancient times, it was often that kilns were set up along rivers and then cities took shape around them. It is therefore plausible that the decline of the Yaozhou kilns was related to the drying up of the Qihe River.

Thomas Harding et al. believe: "Adaptation to nature will shape a culture's technology and derivatively its social and ideological components. Yet adaptation to other culture may shape society and ideology which in turn act upon technology and determine its further course. The total result of the adaptive process is the production of an organized cultural whole, an integrated technology, society, and ideology, which copes with the dual selective influences of nature on the one hand and the impact of outside cultures on the other."[20] Thus, when examining the history of ceramics, in addition to the interaction and interrelation between the technological, sociological, and ideological components of culture in different periods, the role the natural environment played should also be taken into consideration as yet another variable. Previous ceramic history studies attached little importance to these factors and therefore produced few academic reports on them. I believe that in future archaeological excavations and historical studies, more emphasis will be placed on these aspects.

Intrinsic Elements from Sacred to Secular

The fact that the ancient Chinese started making pottery over 10,000 years ago makes the origin of art a natural part of the discussion of China's ceramics history. Among the many theories on the origin of art, the two predominant theories respectively relate it to religion and labor, the former holding that art originated from humanity's spiritual needs and the latter deeming that art came into being amid humanity's productive labor carried out to fulfill material needs. A close look at the history of Chinese ceramics reveals that the material and spiritual needs of the human race coexisted from the very beginning. Ceramics, both as utensils for daily use as well as a type of craft art, originated from both the material and spiritual needs of humanity. Humans are spiritual animals. All human creations, apart from their practical purposes, are bound to embody some sort of spiritual pursuit. This is especially true of the earliest years of the human race, when all creative activities were about religion and about humanity's perception of the external world. Émile Durkheim says that "almost all great social constructs (science, technology, morality, law, etc.) have their origins in religion." He believes that production technologies came from witchcraft and then gave rise to all economic activities; and that religion is not only a form of society's self-consciousness, but also a source of social solidarity and an inspiration for the collective creativity of humankind.[21] Following this line of thought, some scholars

[20] Thomas G. Harding, David Kaplan, Marshall D. Sahlins & Elman R. Service, *Evolution and Culture*, The University of Michigan Press, 1988, p. 48.

[21] Wang Hailong & He Yong, *Introduction to the History of Cultural Anthropology*, Xue Lin Publishing House, 1992, p. 142.

believe witchcraft and primitive religion preceded labor or at least coexisted with labor and that it is in the earliest witchcraft that the seeds of art were sown. Evidence shows that all forms of primitive art, such as murals, tattoos, totem symbols, and decorations, were related to witchcraft. Nevertheless, such arts, created for pragmatic purposes and inseparable from other practical human activities, were in a sense only "pre-art."[22]

This is a view that I share. For instance, the colored pottery made by the Chinese ancestors 6000 years ago were not merely for everyday use, and their decorative patterns were not randomly painted by potters for mere aesthetic purposes. They related to the religion and totem worship of the day. The Banpo type human face and fish patterns and the Miaodigou type bird pattern of the early Yangshao Culture, the Machang type frog pattern and the human figure pattern of Majiayao Culture, the Zhangjiazui type canine pattern of Xindian Culture, the Huoshaogou type lizard pattern of Siba Culture, etc., were all possibly totems and symbols of primitive tribes. Thus, the decorative arts of the pottery were not only for practical use; they probably also carried religious symbolic meaning.

Franz Boas states that it is worth noting that the artwork of many nationalities in the world, though on the surface only decoration, is in reality associated with certain meanings.[23] That is to say, the patterns are more than decoration. They are also cultural symbols with rich meaning. The mission of art in primitive society was in no way the same as that in today's civilized society. It was the fruit of primitive people's labor, a vessel for their belief, and even a sort of divine object, eventually becoming an essential part of primitive humanity's life system. In primitive cultures, art not only represented pleasure and luxury but also symbolized spiritual forces such as mystery and awe. What primitive people felt for art were not only aesthetic feelings but also a kind of worship bordering on religion. At that time, the function of art resided more in witchcraft than in aesthetics.[24]

Pottery decorations were one origin of pragmatic arts. The painted patterns were diverse. Realistic, freehand, or abstract, they were primarily closely related to the life and labor of their creators and revealed profound cultural information. For anthropological studies, these primitive pottery decorations not only carried artistic meaning, but they also contained culturally symbolic features such as inscriptions, property marks, tribal totems, family signs, and religious symbols.

This is true not only of pottery but also of porcelain. Most of the earliest primitive porcelain in China was not for daily use. The ampules and *ding* (food vessel) were ritual objects imitating bronze or lacquer wares and most of them were burial objects for funerary use.

It was not until the Eastern Han Dynasty that China's porcelain, with the maturity of its manufacturing technology, began to gradually take on more functions

[22] Wang Hailong & He Yong, *Introduction to History of Cultural Anthropology*, Xue Lin Publishing House, 1992, p. 207.

[23] Franz Boas, *Primitive Art*, translated (into Chinese) by Jin Hui, Guizhou Renmin Publishing House, 2004, p. 59.

[24] See Footnote 22.

besides the religious ones which had virtually been its sole mission for the preceding millennia. Many porcelains lost their function as ritual ware, the number of practical wares represented by pots, jars and *lei* (liquor barrels) increased dramatically, and there came into being new wares for daily use such as five-linked jars, incense burners, tiger-shaped chamber pots, water pots, and mortars. On ceramic burial objects after the Eastern Han Dynasty, paintings depicting celestial scenes decreased, replaced by those describing secular life.

In the Wei, Jin, and Southern and Northern dynasties, celadon matured and began to be used in everyday life. But most celadon wares still carried elements of primitive religion. For instance, the feet and ornamentations of the flowery washer, blue-glazed six-legged washer, blue-glazed tripod inkstone, etc., of the Western Jin Dynasty were mostly religious animal patterns or god figures. The ornamentations on the shoulders and spouts of jars and pots and on the lid knobs of tanks were all animal shaped with religious connotations. Sometimes, the entire ware was shaped like an animal, such as the blue-glazed toad water pot, the blue-glazed tortoise inkstone, the frog inkstone dropper, and the blue-glazed sparrow cup. There were numerous other animal-shaped wares, including goat-shaped wares, tiger-shaped wares, lion-shaped wares, goat-head pots, and rooster-head pots. During this period, the themes of ceramic wares were dominated by animals and gods, while plant patterns were rare. New themes such as the Buddha, flying goddesses, honeysuckle patterns, and lotus petals appeared in the Northern Qi and Southern dynasties, still resulting from religious influence.

Giambattista Vico, a philosopher and historian holding classical evolutionist views, believes each nation develops independently, resulting in a unique culture and history. Nevertheless, though the histories of different nations are isolated from each other, they all pass through the same distinct stages: the ages of gods, heroes, and men. All nations develop in parallel in conformity to this periodization of the three stages, because the motivating force of progress is human nature and human need, which is basically identical in every nation.[25] Vico's view that "each nation develops independently" is erroneous, but the division of human social development into three stages, namely the ages of gods, heroes, and men, is noteworthy, for it well echoes the history of Chinese ceramics. Before, the Shang and Zhou dynasties gods ruled over everything and almost all pottery was religious. After the Shang and Zhou, imperial power was strengthened and naturally many ceramic wares were made as ritual or burial objects. Then, by the time of the Sui and Tang dynasties, mankind's life started gaining attention. People's focus moved from the strictly hierarchal imperial court to the simple yet vivid countryside, seeking to spot the beauty and pleasure of life among the mountains, rivers, and plants. Accordingly, religious and aristocratic art styles faded away, giving way to the secular and everyday style. The subject matter of paintings moved from gods, Buddhism and human figures to landscape, flowers and birds, and the format was transferred from mural and stone carving to paper and silk, making it possible for paintings to be hung in the living rooms and studies of

[25] Xia Jianzhong, *Theoretical Schools of Cultural Anthropology—The History of Cultural Studies*, China Renmin University Press, 1997, p. 3.

the common people. Porcelain also entered the homes of ordinary people as daily utensils. Religious decorations that previously dominated ceramic wares decreased and animal patterns were gradually replaced by plant patterns. By the Tang and Five dynasties, porcelain wares were mostly shaped following plants, giving birth to a series of new models such as the melon ridge flagon, the water caltrop flower plate, the lotus flower saucer, the lotus petal *zun* (wine container), the lotus petal candleholder, and the crabapple flower bowl. Different from the unearthed animal-shaped wares of the Three Kingdoms and the two Jin dynasties which were mostly burial objects meant to repel evil forces and demons and thus appeared ferocious, the animal-shaped wares of the Tang and Five dynasties, apart from tomb-guarding animals used as burial objects, were all artistically and aesthetically appealing. The Sui, Tang, and Five dynasties were an important phase where ceramic art migrated from the sacred realm to secular life.

The appearance of new urban lifestyles in the Song and Yuan dynasties further pushed ceramics in the direction of practicality and secularity. Townsmen—craftsmen and small shop owners, and laboring masses including waiters, home servants and shop assistants that resided in cities—formed a new social class whose interests and pursuits differed sharply from those of the upper class. In contrast to rural areas where entertainment and recreational activities were carried out only when there were temple fairs, country fairs or bazaars, urban life tended to eliminate the periodicity of entertainment and so the connection between entertainment and festivals, celebrations, and religious activities gradually vanished. A number of recreation centers that provided entertainment on a regular basis, called *wazi* or *wasi*, came into being. These public places of entertainment, different from the Musical Houses (courts for imperial musicians) of the Tang Dynasty, which were set up by and affiliated with the imperial court, were venues where professional performers gathered to entertain the common folk. There were storytellers telling stories on a variety of themes (history, romance, swordsmanship, religion, etc.), mime performers with musical accompaniment, instrument players and singers, puppet show performers, circus performers, vocal imitation performers, etc. Cities became the birthplace of new art forms. Since the Song Dynasty new art forms have been developing in parallel with fine culture. The urban literature and arts all retained the folk flavor and taste of their origin places. The language was simple, popular, and rich in local style and flavor, and not devoid of dialect terms. By the Yuan Dynasty *wazi* or *wasi* developed new forms and was called *washe*, where independent performing zones were set up with railings in between separating them from each other to stage the performances of different artists. Hence, the performances were called "railing arts." It was in between these *washe* railings that the Yuan drama came into being. These operas with colorful subject matter including society at large (folklore), romance, history, etc., were not only performed on stage but also depicted on the black and white porcelain of the Cizhou kilns and the blue and white porcelain of the Jingdezhen kilns at the time. From then on, in addition to religious and imperial elements, ceramic decorations also featured pleasant birds and flowers and fascinating dramatic characters and stories.

To summarize, along with urbanization, arts gradually became detached from the religious and divine and moved toward secularization and independent development. By the Ming and Qing dynasties, as urbanization and commercialization deepened, the secularity of ceramics as a commodity and folk art became ever more prominent. Examining the history of the ceramic art has also deepened our understanding of the overall history of Chinese culture and arts and expanded our knowledge of the evolution of China's social structure over time, which is also an important subject which this book seeks to explore.

Interactions Between Official Kilns and Folk Kilns

It seems that of all the places in the world, it has been in China that official kilns have had the longest and largest presence. And why is that? As discussed above, from their very birth, Chinese ceramics were associated with primitive religion. Later, as rites and music became the de facto religion in China, ceramics were used as altar wares and ritual objects for sacrificial rites. Traditional Chinese ritualistic activities featured a great variety. Court sacrificial rites came in three types in terms of scale, namely grand sacrifices, moderate sacrifices, and inferior sacrifices. The grand sacrifices included ceremonies that sacrificed to Heaven and Earth, to the supreme god, to the imperial ancestral temple, and to the gods of land and grain (together called *She Ji* and often used to refer to the country itself). Moderate sacrifices included ceremonies that offered sacrifices to the sun, the moon, the agricultural ancestor (*Xian Nong*), the silkworm goddess (*Xian Can*), previous emperors, and the Grand Duke Jupiter (*Tai Sui*). Meanwhile, inferior sacrifices were ceremonies that sacrificed to all temples and ancestral shrines. Court rites also included weddings and funerals in the imperial palace. At such sacrificial rites and ceremonies commemorating major life events, many ritual objects were used. Before the Song Dynasty, metal wares, mainly gold, silver, and bronze dominated these ritual objects, and during the Yuanfeng era of the Song Dynasty, ceramic wares started to be used for royal sacrifices to Heaven and Earth. So, institutionalized kilns, in other words official kilns in the real sense, appeared in the Song Dynasty.

Unlike what some may believe, the establishment of official kilns was not only to satisfy the emperor's needs for an extravagant and luxurious life; rather, official kilns were more for the sacrificial ceremonies of the nation, which were a means of reinforcing "the traditional social ties between individuals; they stressed the way in which the social structure of a group is strengthened and perpetuated through ritualistic or mythic symbolization of the underlying social values upon which it rests."[26] For an imperial regime, this is a serious matter going to the very survival of its rule. Religious beliefs symbolize social relations and embody human anxieties and hopes. For the ancient Chinese, it was of paramount importance to worship

[26] Clifford Geertz, *The Interpretation of Cultures: Selected Essays*, New York: Basic Books, Inc., Publishers, 1973, p. 142.

Heaven and Earth, to sacrifice to deities, and to pay tribute to ancestors, for without their blessing the state's rule would not be secure and the people's lives would not be stable. Thus, in a sense, the official kilns made ceramics not for the emperor or the people, but for Heaven and Earth, for deities, and for ancestors. Such ceramics were therefore not commodities, but sacred objects, sacred objects that needed to be made to the highest quality regardless of cost, material, or energy. The best craftsmen and the most generous funding in the country were granted to the official kilns in order to enable them to fashion and produce porcelain. And the highest input naturally led to the best products. Led by the official kilns, the quality of porcelain produced across the country all improved. It is not surprising, therefore, that in the Ming and Qing dynasties, Chinese porcelain became the most luxurious and expensive commodity in Europe.

Official kilns represented the mainstream thought, ideology, and aesthetic preferences of an era, while folk kilns, being closest to common people's lives, often promoted the market. The progress of China's ceramic history was not entirely driven by official kilns. The important role of folk kilns and their interaction with official kilns should also be given due attention. A general rule is that official kilns dominated during certain periods but in the longer historical timeframe official and folk kilns always interacted with and influenced each other. In fact, leading official kilns often grew out of folk kilns; that is to say, creations by folk kilns in one period were often the predecessors of dominant official kiln features in the next period.

One example is the official kilns' pursuit of celadon ware resembling the color of jade in the Song Dynasty. The preference for celadon resulted from the Chinese tradition of jade appreciation. Ancient Chinese believed jade was the essence of nature and could communicate with deities. As early as the Liangzhu Culture, Chinese people used jade to make ritual objects. So, official kilns, when firing porcelain, tried to reproduce the texture of jade. In the emperor's sacrificial ceremonies, the worship of Heaven was the most important and "celadon is the celestial color," another reason why Song porcelain pursued a jade-like color. At that time, to make bluish green porcelain that looked like jade was not only the pursuit of official kilns but also the trend of the whole society. Of the five famous kilns in the Song Dynasty—Guan (official), Ru, Ge, Jun, and Ding—four made celadon wares almost exclusively, with the exception of the Ding kilns. Other renowned kilns not listed in the famous five, including the Longquan, Jingdezhen, and Yaozhou kilns, also made celadon.

The five famous kilns of the Song Dynasty all made porcelain as a tribute to the imperial court. The only exception was the Ding kilns which stopped paying tribute later. Ye Zhi explains why in his *Notes in Tan Study*: "The imperial court deemed Dingzhou white porcelain improper for use because of its unglazed rim, and so ordered Ruzhou to make celadon wares." There is a similar record in Lu You's *Notes in Old Scholar Hut*: "In the time of the former capital (Northern Song), Ding ware was not allowed into the imperial palace due to its unglazed rim, and only Ru ware was used." Nevertheless, in fact, though porcelain made by the Ding kilns featured unglazed rims which exposed the body, usually the rim was delicately edged with gold, silver, or copper. So, some researchers believe that the unglazed rim was not the only reason the royal palace stopped accepting Ding porcelain. Another possible

factor related to the aesthetics at the time. The Han Chinese regarded white as a sort of taboo color due to its exclusive use in funerals. Thus, the pure white porcelain produced by the Ding kilns might have lost its favor due to its color.

Still, when it came to the Yuan Dynasty, a regime established by Mongols who favored the color white, white porcelain naturally became the favorite of the emperor. In the Yuan Dynasty, the Jingdezhen kilns adopted a dual formula which raised the firing temperature and added aluminum oxide to enhance whiteness. Kilns that previously made celadon such as Ruzhou and Yaozhou declined and virtually disappeared in the Yuan Dynasty. Jingdezhen, once renowned for firing *qingbai* (bluish white) porcelain in the Song Dynasty, transferred to firing egg-white porcelain and blue and white porcelain in the Yuan Dynasty.

Official kilns in the Ming Dynasty were set up in Jingdezhen, and, like the Song and Yuan dynasties, produced sacrificial wares for the imperial court. Porcelain wares for sacrificial ceremonies from the Song to the Yuan were all plain. Celadon was used in the Song Dynasty while egg-white porcelain was used in the Yuan. But what about the Ming Dynasty? Records show that in the Ming Dynasty, in addition to monochrome porcelain, wares in four colors, namely celadon, yellow, red, and white, along with blue and white porcelain were also used in various sacrificial activities. This was a major development in the history of ceramics. Though polychrome porcelains existed before the Song and Yuan, they were mostly fired by folk kilns to meet occasional market needs. Not advocated by the imperial court, they never became the mainstream until the Ming Dynasty, when they not only started to be made by official kilns but were also used by the royal family in sacrificial rituals, and thus became a mainstream porcelain style. This led to the continuous development of polychrome porcelains after the Ming and Qing dynasties and replaced once-glazed plain porcelain to become the mainstream in China's ceramic aesthetics.

It can be seen that the Yuan and Ming blue and white porcelain and the Ming polychrome porcelain all originated in folk kilns. The black and white porcelain of the Cizhou folk kilns of the Song and Yuan laid the foundation for the decorative technique of the blue and white porcelain of the Yuan Dynasty, and the red and green porcelain produced by folk kilns in the Song and Jin periods blazed the trail for the blue and white *doucai* porcelain in the mid-Ming, and for the Ming *wucai* (five-color) porcelain in the late Ming. The roots and origin of the official kilns were often hidden in the fertile soil of the folk kilns. If not for the constant innovation of folk kilns which supplied nutrients to the official kilns, they would not have grown into the deeply rooted tree that ultimately represented the mainstream ceramic aesthetics of the era. Therefore, the historical value of folk kilns, like that of official kilns, should be given due emphasis in the study of Chinese ceramic history. What also requires attention is the sacred value of official kiln wares in expressing rituals and imperial power, their value as symbols of social ties, and their role in the constant restructuring of the social system and social order through the sacred structure of the universe. This aspect has not been given enough attention in previous studies of ceramic history and could well be a new research direction.

Scholar Culture and Aesthetic Values of Ceramics

According to Leslie Alvin White, there are three components of culture, the technological, the sociological, and the ideological, with the technological being the primary determining factor responsible for cultural evolution. Through an examination of the history of Chinese ceramics, I find that technological innovation is indeed important for cultural development, yet it is often driven by the ideological component. All technological development or advancement can be attributed, at least in part, to some sort of ideological change. The ideological factor determines the developmental direction of the technological component.

The innovations and changes of Chinese ceramics in terms of variety, shape, and decoration are more determined by the aesthetic preferences of the time than by technological innovations. Before the Song Dynasty, the leading force dominating China's ceramic aesthetics was the imperial power represented by the official kilns and literati ideology. Values embodied in such imperial power and literati ideology were the core values of Chinese society at the time. These values originated from the two preeminent Chinese philosophical schools, Confucianism and Taoism. The two philosophical schools found distinctly different reflections in aesthetics. Confucius, originator of the Confucian school, believed the nature of human beings lay in sociality. Thus, he advocated the conformity of appearance with nature and the combination of external decoration or artificial beauty and internal beauty or the beauty of nature. The result was a kind of beauty that was rich, intense and masculine. The representative of Taoism, Zhuangzi, believed human nature lay in nature; that any appearance added to nature was superfluous and harmful, and that all sociological embellishment confined human nature. It was believed that what is natural is intrinsically beautiful and does not need modification to fit into a certain form. Taoism stresses nature. The Taoist concept of beauty stresses "authenticity" and "plainness," meaning that the nature and original flavor of things should be preserved, and no artificial polishing is required. This is the pursuit of authenticity, of simple and natural beauty, of plain and unassuming beauty. The appearance advocated by Confucius and the nature championed by Zhuangzi, one masculine and hard, the other feminine and soft, led to two realms of beauty. The two schools of philosophical thought have long influenced the evolution of Chinese aesthetics and ceramic styles over time, with Confucianism assuming the dominant position in some dynasties and Taoism gaining the upper hand in others.

From the Qin and Han dynasties to the beginning of the Tang Dynasty, the decorative techniques of Chinese ceramics were mostly confined to carving, drawing, printing, sticking, mold printing and openwork on the surface of the item. These techniques resulted in the masculine, bold and intense beauty of the Confucian school. The most breathtaking ceramic work during the Qin and Han dynasties was the terracotta warriors unearthed in Qin Shi Huang's Mausoleum. The magnificently imposing manner, spectacularly grand scale and meticulously realistic style of these objects was not to be seen again in the Chinese ceramics which followed.

Chinese ceramic works were created by craftsmen, but what dominated the ceramic aesthetic preferences were official kilns, the market economy, and literati ideology. The preferences of the men of letters had an impact not only on the market but also on the imperial court. Deeply influenced by Confucianism and Taoism, ancient Chinese scholar-bureaucrats regulated themselves with the two philosophical systems. Often, they preferred Confucianism when young and ambitious, and leaned toward Taoism when they had experienced difficulties or gained a deeper understanding of society. Some of them "cultivated behaviors in line with Confucianism while obtaining inner tranquility through Buddhism." In some sense, ancient Chinese scholar-bureaucrats represented the unity of an ethical personality with a natural personality. In ethics, they fulfilled their filial obligations to parents, were loyal to the emperor, and discharged their duties to the patriarchal society by contributing to their families and to the country. In terms of natural personality, they enjoyed the beauty of nature and expressed their feelings through forests, mountains, and rivers to obtain spiritual rest or relief. One corresponded to their employment and the other to their free lives. The unity of these two opposing personalities was key to the balance between their lives and their minds. Such unity was particularly prominent among literati in the late Tang to the Song. During this period, men of letters on the one hand advocated Confucianism and on the other hand followed Taoism and Zen Buddhism in aesthetics and in their personal pursuits.

Such literati tastes began to be reflected in ceramic works after the Tang Dynasty. Decorations focused more on the possibilities of glaze color itself rather than on additional ornament. After the mid-Tang, Yue porcelain turned toward a simple but elegant style. Beautiful shapes combined with a bright green coloration elevated the work to a high aesthetic standard. The white porcelain of the Xing kilns in Neiqiu gained sudden fame, winning people's admiration with the charm of its snow or silver-like glaze color alone. Its thick and fine body texture and clear white glaze gave it a plain but dignified character. Besides celadon and white porcelain, kilns in the Tang Dynasty also produced colorful glaze porcelain, brown glaze porcelain, multi-clay glaze porcelain, black glaze porcelain, yellow glaze porcelain, etc., all celebrated for their naturally formed glaze color without any artificial modification. The glaze color was prone to natural and thus somewhat random change and progressed in varying degrees from single color to complex polychromatic glaze, laying a foundation for the flambé glaze of the Jun kilns, the oil-spot and hare-fur porcelain of the Jian kilns, and the tortoiseshell glaze of the Jizhou kilns that were to appear in the Song Dynasty.

While the intense, bold, and masculine aesthetic style advocated by Confucianism that emphasized a combination of nature and appearance coexisted with the simple, authentic, and elegant aesthetic style advocated by Taoism that emphasized nature over appearance, they complemented and added radiance to each other from Wei and Jin to the mid-Tang. However, when it came to the Song Dynasty, the artistic inclinations of the literati almost entirely leaned toward Taoism and Buddhism.[27] In painting, such change was reflected in the decline of religious paintings and the relegation of human figure paintings to a secondary status, giving way to the rise of

[27] Li Zehou, *The History of Beauty*, Cultural Relics Press, 1981.

themes which stressed spiritual comfort and enjoyment. People's feelings and senti-
ments became the subject of the arts and of aesthetics. Such attention to feelings and
sentiments was in line with the aesthetic aspiration of Taoism and Buddhism, the most
prominent feature of which was to understand and experience the beauty of nature.
This was an experience that was elevated above tangible activities and that focused
on an invisible realm of life. Taoist philosophy holds that purely spiritual experience
in nature is the highest and most perfect status in life. Influenced by such Taoist
views, arts in the Song Dynasty transcended sensual pleasure and artificial decora-
tion to pursue simplicity, archaism, and plainness, which in turn were believed to
embody the most intense beauty and the strongest flavor. Thus, the aesthetic pursuit
during the period could be summarized into returning to the world of natural expres-
sion and experiencing the mysterious unfolding of the inner rhythms of nature amid
silence and aloneness. This led to the artistic standard eschewing artificial ornament
and favoring natural interest, which found particularly prominent expression in the
porcelain of the Song Dynasty.

The most famous kilns in the Song Dynasty were the Ge, Ru, Guan (official),
Jun, and Ding kilns, whose products clearly displayed the aesthetic preference of the
palace nobility and scholar-bureaucrats of the time. Apart from the white porcelain
of the Ding kilns, which featured carved and printed patterns, the porcelain made
by all the other famous kilns were solid color wares with no decoration. Here, the
absence of decoration does not mean crude craftsmanship. Rather, it represented a
more conscientious aesthetic idea pursuing natural beauty. The Ge, Guan, and Ru
kilns all produced celadon decorated with natural crackle glaze. The crackle pattern
came from the cracking of the glaze surface during firing due to different contraction
coefficients of different parts of the glaze. The cracks were probably flaws that
occurred during firing, but craftsmen ingeniously made use of the defect and turned
it into a type of natural, haphazard, and fascinating decoration.

The crackle pattern of the porcelain made by the Ge kilns was the densest and
deepest. The cracks were of different depths, the deeper ones appearing black and
the shallower ones pale yellow. Where the cracks in the two colors intertwined, they
were called "golden threads and iron lines." The cracks of Guan kiln porcelain were
sparser and shallower, and thus were mostly gold in color and hence called golden
lines. The cracks of Ru kiln porcelain were even shallower and thinner. Barely visible,
they looked like transparent cracks in ice.

One famous variety of Guan ware in the Northern Song Dynasty featured "purple
rim and iron feet." The wares, produced through high-temperature reduction firing
of a body made of iron-rich clay, resulted in a blackish purple body color. The glaze
applied to the wares did not completely cover the rim area and exposed some of the
body, producing the "purple rim" feature. Unglazed surfaces at the bottom of wares'
feet turned blackish red resembling iron after firing due to the reduced atmosphere
and were therefore called "iron feet."

Porcelain produced by the Guan, Ru, and Ge kilns was all celadon, but of different
hues. That from the Ru kilns was mostly azure or of incense ash color. That from
the Guan and Ge kilns was of similar glaze colors, including light greenish blue,
pale blue, putty and bluish yellow. The different celadon hues resulted from a mix of

different body materials. Body materials of different colors, such as blackish gray, dark gray, light gray and earthy yellow, resulted in different shades of celadon. This aesthetic of achieving different colors by different characteristics of the material itself was exactly what the literati at that time pursued.

The ceramic arts of the Jun kilns also followed this aesthetic. The Jun kilns belonged to Northern celadon producers, but they introduced iron oxide and a small amount of copper oxide to the glaze as chromogenic reagents, resulting in an extremely varied glaze color during firing. Some became rose red, some the red of the crabapple flower, some pale blue, some sky blue, and some sky blue strewn with purplish red, like the glow of a sunset. There is a saying in China's ceramic world: "there are no identical Jun kiln wares." No two porcelain wares from the Jun kilns, even if fired in the same kiln, were completely the same, because their glaze color was naturally formed and could not be artificially controlled. This conformed to the highest aesthetic ideal pursued at the time.

All Taoist ideas can be traced back to the worship of nature. Taoist philosophy stresses following the natural course of things, praises the natural and authentic form of things, and advocates the display of things in their original state. It opposes forceful intervention, artificial disturbance, affectation, and hypocrisy. Laozi described the *Tao* with the descriptor "*Pu*," which refers to a natural state without decoration, and took keeping to nature and adhering to *Pu* as his ideal. The natural state then became the highest standard of beauty as deemed by literati of later generations and gave rise to the saying "the most glorious returns to simplicity." Zhu Xi states: "Heaven is devoid of sound, color, smell, or taste, yet it is the pivot of creation and root of wisdom." (*Commentaries on Zhou Dunyi's Taiji Tushuo*). This is similar to what Laozi says, namely "great music has the faintest notes." "Great music" is music without sound, and this is the essence of the porcelain art of the Song Dynasty. The Song porcelain described above embodies simplicity, plainness, natural form, expression without word, and music without sound. Even the naturally formed defects and flaws became beauty; such is the great beauty, the ultimate beauty. This aesthetic pursuit seeks to free people's thinking from all shackles so that they may move freely in the broad and boundless natural realm, to experience the innumerable languages in the wordless realm. This is an infinite realm, and such infinity dissolves rules, structures, and all other forms of existence that the human mind might possibly perceive, so as to get a sense of a more profound way of being.

Zhuangzi states: "One that appreciates ultimate beauty and enjoys ultimate happiness is the ultimate man." Here ultimate beauty refers to the profound implications of numerous natural forms in the universe, ultimate happiness is to immerse oneself in such beauty, and the ultimate man is one who is able to appreciate such happiness. I believe that of all art forms in the Song Dynasty, porcelain gave the best expression to such spirituality. It could be said that it was porcelain art that pushed the Chinese literati's aesthetic pursuit to the highest level, a level which was reached not only through technological advancement, but with ideological forces that drove the exploration and maturity of this technology.

The distinction between refined culture and popular culture is a constant feature of China's history. Refined culture came into being through the confluence of Confucian,

Buddhist, and Taoist philosophies. In ideology, Confucianism dominated, while in terms of aesthetics, Taoist and Buddhist pursuits led the way. But after the Yuan Dynasty, especially when it came to the Ming and Qing dynasties, the ideological dominance of refined culture gave way to the market economy and civilian culture.

Ceramics of the Yuan, Ming, and Qing Dynasties are Popularized

In the Yuan Dynasty the dominance of the refined culture came to an end and popular culture gradually rose to become mainstream, a change that signaled Chinese culture's transition into the modern era.[28] In ceramic art, this change was reflected in the transformation of dominant themes from the philosophical ideology embodied in the haphazard glaze colors of the Song Dynasty to the secular subjects directly depicted on the blue and white porcelain of the Yuan Dynasty and the *wucai* (five-color) porcelain and famille-rose porcelain of the Ming and Qing dynasties. This was a major turning point in the history of Chinese ceramics.

Porcelain made by Northern and Southern kilns in the Yuan, Ming, and Qing dynasties, when compared with that of the Song Dynasty, bore a common characteristic where all wares placed more emphasis on surface decoration patterns and effects rather than on the expressiveness of the glaze itself. In addition, decorative means and techniques were much richer than any previous dynasty. Decorative techniques from previous dynasties including engraving, drawing, printing, sticking, stacking, openwork, and painting were inherited, and innovations and new developments were made on their basis.

In the Yuan Dynasty, almost all Northern kilns declined, except the Cizhou kilns. This can be attributed to the style of their products. Of the Cizhou kiln products in the Yuan Dynasty, black and white porcelain was the most voluminous and influential. Black and white porcelain was already quite well known in the Northern Song and many kilns in the Yellow River reaches made it, following the Cizhou kiln model. After the Song regime moved south of the Yangtze River, the Jizhou kilns started making black and white porcelain, and even Jingdezhen's blue and white porcelain was deeply influenced. After the Yuan Dynasty, black and white wares further developed in great leaps.

Decorative themes in the Yuan Dynasty included dramatic plots and characters, literary works, calligraphy and painting. The flourishing of operatic literature in the Yuan was bound to influence porcelain decoration. The use of dramatic literature as decorative themes was a feature of Cizhou ware, as well as being observed in Jingdezhen's blue and white porcelain.

The concept of painting scenes from dramas on porcelain ware as decoration was enabled by the development of a commodity economy and of popular culture at the

[28] Wang Xiaoshu, *History of Chinese Aesthetic Culture*, Shandong Pictorial Publishing House, 2000, p. 6.

time. Most of the characters and stories drawn on Yuan blue and white porcelain were from historical dramas, such as the *Legend of Meng Tian*, or that of Xiao He and Han Xin, the *Oath in the Peach Garden*, *Three Visits to the Hut*, the *Story of Zhou Yafu*, or the story of Emperor Taizong of Tang and Yuchi Gong. Most of the blue and white wares painted with such stories were ones for display and appreciation purposes such as jars, *meiping* (plum vases), and *yuhuchun* (pear-shaped vases). Meanwhile, the Cizhou black and white wares painted with Yuan dramatic characters and stories were mostly porcelain pillows, which were both practical and ornamental.

The appearance of large numbers of historical figures and dramatic characters on the black and white porcelain of the Cizhou kilns and the blue and white porcelain of the Jingdezhen kilns in the Yuan Dynasty was a major turning point in China's ceramic decorative art. Before the Tang Dynasty, porcelain decorated with human figures was rare. After the Tang and Song dynasties, human figures started to appear on porcelain wares, especially on those produced by the Cizhou kilns after the Song Dynasty, but they were mostly children at play or occasionally beautiful women, while there were almost no valiant men like those in the Yuan Dynasty. Therefore, the appearance of characters and story scenes in the Yuan Dynasty is highly significant in the history of Chinese ceramic decorative art. This was the first time that story scenes from legends and dramas were inscribed on porcelain wares in such entirety and detail, and this laid the groundwork for the appearance of even more colorful characters on porcelain wares in the Ming and Qing dynasties, including emperors, princes, military officers, gifted scholars, beautiful women, gods and immortals, and men tilling the land or women weaving. This marked the beginning of the transformation of China's mainstream ceramic art from "refined" to "popular."

By the Ming Dynasty, popular culture decoration represented by color painting was used not only by folk kilns, but also by official kilns. Blue and white porcelain made by the Ming official kilns was used as sacrificial objects and bequeathed to foreign countries as gifts. They were completely different from the solid color porcelain pursued by official kilns in previous dynasties. Before the Ming Dynasty, Chinese porcelain was dominated by single color plain wares. While back in the Song Dynasty, the Cizhou kilns began making polychrome porcelains such as "iron rust" wares and black background sgraffito wares, and in the Yuan Dynasty blue and white wares pushed polychrome porcelain up a grade, these polychrome wares were still monotonous in color with the former being black and white only and the latter blue and white only. In addition, though these polychrome wares were widely acknowledged throughout folk society, they were not appreciated by the imperial court, scholar-bureaucrats, or the aristocratic upper class, and thus were not mainstream ceramic art at the time. The Ming Dynasty marked Chinese ceramic art's transition from an era dominated by plain ware production to an era dominated by polychrome ware. The Jingdezhen kilns were especially dazzling with a great variety of polychrome wares developed on the basis of blue and white porcelain, such as *sancai* (three-color) porcelain, red and green porcelain, *jincai* (golden polychrome) porcelain, *doucai* porcelain, and *wucai* (five-color) porcelain. The decorative patterns, subject matter, painting techniques, tools, and materials used were unprecedentedly enriched, boosting blue and white porcelain production in many places at home and

abroad and making China the epicenter of the world's porcelain. All these made the Ming Dynasty an extremely important period in the history of Chinese ceramics.

Polychrome porcelains grew from traditional Chinese ceramic art, yet they carried an ornate, flowery, and somewhat flamboyant beauty, a secular beauty, in sharp contrast with the quaint and refined beauty embodied in preceding Chinese ceramics. This was a vivid expression of popular culture in ceramic art.

Anthropologist Robert Redfield in his series of works introduced the concepts of "Great Tradition" and "Little Tradition." Great Tradition refers to the tradition of the introspective minority in a civilization, and Little Tradition refers to the tradition of the non-introspective majority. Great Tradition is nurtured in the school or the church, while Little Tradition grows and exists in the life of village communities. This pair of concepts is similar to the concepts of "elite culture and mass culture," "refined culture and popular culture," and "sacred culture and secular culture." Using these concepts, we can see that over time, Chinese ceramics basically progressed from elite culture to mass culture, from refined culture to popular culture, and from sacred culture to secular culture. I believe there are two reasons for this.

Firstly, urbanization and commercialization promoted the development of a market economy and the rising urban popular culture, and the arts were liberated from divine ceremonies and rituals enabling them to enter people's everyday lives as objects of appreciation. Redfield stresses the impact of Great Tradition on Little Tradition. He believes that in modern civilizations urban, areas represent Great Tradition while rural areas represent Little Tradition, and that with the progress of civilization, the countryside is inevitably "eaten away" and "assimilated" by cities.[29] Following such views, it could be said that Chinese society began moving toward modernity after the Yuan Dynasty, and the secularization of ceramic art was one of the signs of this migration.

Secondly, the inflow of Western culture also contributed to the secularization of ceramic art. European porcelain traders started placing orders with Jingdezhen folk kilns in the mid to late Ming Dynasty. In addition to purchasing varieties, Jingdezhen was already making, these traders requested the craftsmen to design a large number of new models and patterns suited to the culture, customs, and aesthetic tastes of Western customers to better cater to foreign market needs. Craftsmen in Jingdezhen had to create, based on the required shapes and decorative patterns, which in turn gave rise to new styles and varieties of Jingdezhen ceramics.

European culture also influenced the aesthetic preference of China's imperial court. For instance, Emperor Qianlong of the Qing Dynasty not only invited European artists to serve the royal family in the palace and to participate in the architectural design of the Yuanmingyuan imperial garden but also gave orders to set up an "Enamel Workshop" in the "Zaobanchu" (Office of Manufacture) where European artists created porcelain-body enamel together with Chinese painters and craftsmen. Additionally, many of the porcelain wares fired by the Jingdezhen imperial kilns were made following the drawings and designs provided by painters of the "Zaobanchu,"

[29] Xia Jianzhong, *Theoretical Schools of Cultural Anthropology—The History of Cultural Studies*, China Renmin University Press, 1997, p. 156.

the "Ruyiguan" (Institute of Indulgence, an agency tasked with investigating Western scientific achievements) and the "Qintianjian" (the Imperial Board of Astronomy) in the palace. European artists in the imperial palace worked with Chinese painters and craftsmen daily, influencing and inspiring each other. It was partly due to the impact of European art that Chinese ceramics, with Jingdezhen at its center, assumed a flowery, ornate, and overly elaborate style, which after the mid-Qing Dynasty replaced simple and natural beauty to become the main pursuit of Chinese ceramic art and remained the mainstream trend until the end of the Qing and even into the Republican era.

Anthropological research has traditionally aimed most of its attention at remote Indigenous tribes. In such isolated communities with little contact with the outside world, cultural evolution probably only involves the ideological component, the sociological component, and the technological component. But for an open and civilized society, there is yet another component, namely, external information, and influences. The earlier we go back in history, the more closed human society has been and the less intercultural communication has occurred. Back then, the effect of the information component was weak and social mobility was low. As mankind approached modernity or the modern era, communication between countries or regions became more frequent and social mobility speeded up. From the Ming and Qing dynasties, with the development of foreign exchange and trade, the development of China's ceramic art inevitably accelerated and moved toward commercialization and secularization, a transition in which the role of the information component could not be ignored.

Understanding Chinese Society Through Ceramic History

Ancient China as a Plebeian Society

Influenced by Western evolutionary theory, previous researchers, especially those around the founding of New China, mostly believed that all societies progressed along the same line from primitive society to slave society, feudal society, capitalist society, socialist society, and ultimately communist society. When looking at Chinese society, however, people found that such an historical progression did not always apply. The traditional view is that from the Qin and Han dynasties to the end of the Qing Dynasty China was a feudal society. Yet scholars represented by Qian Mu believe that in the Qin and Han dynasties China began a transformation from ancient aristocratic society to a plebeian society rather than a feudal society, a view that is evidenced in the study of the history of Chinese ceramics.

One example is the maturity of Chinese porcelain in the Eastern Han Dynasty, which I believe was not the arbitrary result of technological advances but was more closely related to the cultural trends at the time, and specifically, the social emphasis on the literati and the general social disdain for luxurious lifestyles. Before the Han Dynasty Chinese society was centered around the aristocratic class who led extremely extravagant lives and used bronze, gold, silver, and lacquerwares as daily

utensils, while ceramics, used only by common people as daily necessities or ritual objects, did not occupy a significant position in aristocratic life and was therefore not taken seriously by the court. But when it came to the Han Dynasty, especially the Eastern Han, the life of the rich was constrained, and the use of luxury objects as daily utensils was no longer encouraged. This is where porcelain wares came in. Simple, mild, but noble, with a jade-like texture, porcelain accorded perfectly with the aesthetic of the Chinese literati. The earliest porcelain wares were mainly used as burial objects, but as firing techniques matured, porcelain products grew to be more pleasing to the eye and more practical. Thus, they became more common in the everyday lives of the royal family, aristocrats, dignitaries, officials, and common people. They entered every corner of the Chinese people's lives and became the most important daily utensil in Chinese history.

A more important factor influencing the development of ceramics was the Imperial Examination System created during the Tang Dynasty. The examination system offered grassroots men an opportunity to enter the supreme political realm through study and examination. Most of these men were from the countryside. Qian Mu states: "That is because the rural environment was the best breeding ground for ideal talent, one that had genius, knowledge, aspiration, and good ethics. Urban society, bustling with industry and commerce, was not an ideal place for the nurturing of such people. They entered the government from the countryside and then returned to the countryside from government. Many famous figures across different dynasties, having accomplished outstanding achievements in politics, retreated to the rural quiet to enjoy the rest of their lives surrounded by beautiful landscapes and fertile lands. Such choices resulted from the literary and artistic edification they received during their early years in the countryside. Even those who remained in cities after retirement somehow turned their surrounding environments rustic and country-like. It was almost mandatory that retired scholar-bureaucrats would incorporate in their residences some small garden architectural feature with vivid rural overtones and a strong interest in nature."[30] In this way, the seeds of traditional culture remained in rural areas across the country, with its roots growing deeper and deeper and its branches reaching higher and higher. With the Imperial Examination System as the motivation, all villages in the country produced aspiring men who studied hard, and as a result now almost every place in China boasts famous historical figures and historic sites. The countryside became the incubation chamber of Chinese culture.

The significance of the Imperial Examination System to ceramics was amplified by the fact that before the Ming Dynasty, when ceramic production became a specialized urban profession, potters were also farmers and their lives involved both ceramic production and farming. Thus, the abovementioned rural-incubated culture was bound to influence the artistic creation of potters at the time, which was beneficial to the development of the ceramics industry because ceramics were not only practical commodities but also handicraft works that embodied the thought, interests, and philosophies of the Chinese literati. Progress of the handicraft industry

[30] Qian Mu, *An Introduction to the Cultural History of China*, The Commercial Press, 1994, p. 161.

and commerce promoted the production and circulation of ceramic products while progress in literature and the arts elevated their artistic taste.

Inscriptions first appeared on the porcelain wares of the Changsha kilns in the Tang Dynasty. The inscriptions included ware names as well as words and poems promoting the ware, with poems being the most prevalent. For products of the Changsha kilns, poems were mostly inscribed below the spout of bell mouth pots, and some on amphora bellies, saucer centers, or pillow surfaces. The poems or sentences, mostly originating from folk poetry and proverbs, and rarely containing allusions, were easy to understand. The inscriptions, engraved by craftsmen for the use of the common people, also led to the plebeian trajectory of the written language and calligraphy, the mastering of which were no longer the privilege of imperial aristocrats or the cultural elite. This makes the following statement by Qian Mu much easier to understand: "Ancient literature was more used by the aristocratic society, followed by religion; ancient arts were more used in religion, followed by the aristocratic society. This all changed in the Tang Dynasty, when literature and arts started serving the everyday lives of common people. This was a major leap forward in the history of Chinese culture."[31] This statement is fully reflected in the porcelain art of the Tang Dynasty.

Porcelain had always been favored by the literati, aristocrats and common people for its simplicity and jade-like texture, and in the Song Dynasty, it replaced metal wares in the royal family's sacrificial ceremonies to Heaven and Earth as it was deemed to represent "quality and sincerity." This shows that the Chinese people chose to use ceramic wares not by chance but based on certain values. In fact, an artificial creation is never solely technological; there are always cultural reasons behind it.

After the Qin and Han dynasties, China was transformed from an aristocratic society featuring a hereditary system to a plebeian society. Then, the inception of the Imperial Examination System gave common people a chance to become government officials through study and examination, a system which was quite advanced for the time. From its inception, a dedication to study became the focus of Chinese parental instruction for succeeding generations. The ancient Chinese aspiration for and stress on study was well expressed in porcelain decorations, such as the typical images of "Reading while grazing the cattle with one's book hung on the bull's horn" and "Fishing, woodcutting, plowing, and reading." These images also depicted the basic lifestyle of the early Chinese. They chose to do farm work while studying because on the one hand they yearned for the simple and free pastoral life, while on the other they aspired to enter the government and fulfill their political ambitions. From a sociological point of view, although the social structure of ancient China was strictly stratified, the examination system served as a mechanism for common people to ascend the social ladder and to change their fortunes through study. While studying, they appreciated artistic performances, craft arts and decorative images, which were also edifying experiences.

[31] Qian Mu, *An Introduction to the Cultural History of China*, The Commercial Press, 1994, p. 170.

Through the above examination of ancient Chinese ceramic art, it can be seen that ancient China was a society of civic-minded individuals, a society which held simplicity, morality, and knowledge in high regard. This makes it a much more advanced culture compared to the aristocratic culture of Europe of the same period.

The Early Maturing Chinese Culture

Liang Shuming believed Chinese culture was an early maturing culture, and Qian Mu was of the same opinion. He argued that Chinese society had been an early maturing society from as early as the Qin and Han dynasties when China had built comprehensive institutional systems. Then in the Sui and Tang dynasties, China completed the basic systems for all humanistic creativity in literature and arts.

This is true of the development of Chinese ceramics. Porcelain production matured in the Han Dynasty. In the Tang Dynasty, while celadon kilns were not as widespread as they would later become, Southern kilns represented by the Yue kilns and Northern ones represented by the Yaozhou kilns laid the groundwork for the emergence of the many celadon kilns, each with their own characteristics, in the Song Dynasty. In addition, the white porcelain firing technique of the Xing kilns laid the foundation for the appearance of the Ding kilns' white porcelain and Jingdezhen's *qingbai* porcelain, egg-white porcelain, and white porcelain after the Song Dynasty. If not for the emergence of the white porcelain, the polychrome porcelains of the Yuan, Ming, and Qing would not have flourished. The colorful glaze ware and black glaze porcelain of the Tang Dynasty laid the foundation for the flambé glaze wares of the Song Dynasty such as Jun ware, hare-fur porcelain, oil-spot porcelain, and tortoiseshell glaze ware. Then there is the tricolor glazed earthenware of the Tang Dynasty, which, though not suitable as tableware since it was low-fired lead-glazed pottery, but it still aided the development of glazed tiles which were used in later generations for building temples and palaces. Products of the Changsha kilns deserve special attention because their underglaze color painting, inscriptions, and decoration combining calligraphy and painting, sowed the seed for the black and white porcelain of the Cizhou kilns in the Song Dynasty, for the blue and white porcelain of Jingdezhen in the Yuan Dynasty, and for the blue and white *doucai* porcelain, *wucai* porcelain, and famille-rose porcelain of Jingdezhen in the Ming and Qing dynasties. From all this, it can be seen that the decorative means and expressive techniques of various porcelain varieties in later dynasties found their beginnings in the Tang Dynasty. These beginnings not only refer to technology; it also involved the formation of cultural ideas and artistic aesthetics. Chinese culture before the Sui and Tang dynasties, featuring bold and heroic values, lauded the bravery of soldiers, while after Sui and Tang it moved toward elegance and gentleness and featured more of a literatus temperament. It could be said that though ceramics during the Tang Dynasty were not as prosperous as they were in the Song, the Tang Dynasty, marking the beginning of a new style, was an important turning point in the history of Chinese ceramic art.

Liang Shuming believed that the standard of a culture achieving maturity is the inner rationality of its individuals and in this regard Chinese culture matured much earlier than Western culture. Western culture has its roots in religion while Chinese culture, taking a different path, focuses on morality rather than religion and maintains customs, discipline, and order through morality.[32] Westerners generally believe that religion is the inevitable experience of a society, yet China has never had a religion in the real sense apart from primitive religious activities. What happened is that early in Chinese history Confucianism transfigured primitive religions into rites and music, from which art was born to edify people's sentiments and improve people's self-cultivation. Ceramic wares, as a part of this process, were both ritual objects and works of art.

The two major philosophical schools in China, Confucianism and Taoism, both non-religious, regarded life as their foundation and emphasized nature rather than artifice. This philosophy is reflected in Chinese ceramic art's preference for bringing out the natural beauty of the material itself, which is considered to be real ingenuity. Chinese pursue the "union of Heaven and man," which in artistic practice became the "union of the object and the soul." Chinese craftsmen avoid impairing the inner quality of the object. Rather, they endeavor to bring out the beauty of the object itself and add radiance to it. Such is the ideal of Chinese craft arts. It is also why Chinese people often praise craft work as the "secret workings of nature" or "Heaven's workings through man's hand." These sayings show that the Chinese refuse to tamper with natural objects through artificial work. This does not mean that Chinese people are unwilling to apply human effort. It is just that they do not wish to damage, conquer, or replace nature with human effort. The goal is always to improve nature through human effort. Such philosophical thinking started to manifest itself in the ceramic art of the Tang Dynasty and reached its peak in the Song Dynasty. During this time, the craftsmen ingeniously took advantage of material properties themselves to achieve natural beauty effects. These effects included the glaze colors of azure, light greenish blue and plum green, the ice crackle pattern, "golden threads and iron lines," the crab claw pattern, "purple rim and iron feet," the flambé glaze of the Jun kilns, and the earthworm trail pattern.

The Ancient Chinese liked surrounding themselves with calligraphy, paintings and poetry and used every opportunity to edify people's sentiments through art. Thus, close attention was paid to the decorative images even on daily utensils made of porcelain, which were often flowers, birds, fish, and insects, which created a serene and peaceful atmosphere. Even wares of a single color without decoration were not entirely blank. They often featured more intricate pursuits in terms of texture. Different art forms permeate each other, and different philosophies have been expressed in literature and the arts throughout history. Ceramic art has always been a critical vessel for philosophical ideas. From Chinese ceramic works we can observe the cultural pursuits of the Chinese people. It can also be seen that Chinese culture is one that integrates everyday arts with moral concepts and uses art instead

[32] Liang Suming, *The Fate of Chinese Culture*, CITIC Press, 2010, p. 49.

of religion to express a moral orientation. It was an early maturing culture that was once admired by European society.

At a certain stage this, early maturing of Chinese society hampered the country's pace toward industrialization and as a result, the once strongest nation in the agricultural era lagged behind when the Western world entered the industrial era. But today, as mankind enters post-industrial civilization, material production has reached a certain degree of saturation and the ecological environment has been seriously damaged. Under these circumstances, it is being realized increasingly that the artistic ideal of ancient China, one that advocated nature, worshiped life, and pursued truth, may offer valuable inspiration for the future development of humankind, a quest that invites further examination.

Ancient China as a Manufacturing Power

The early maturing of Chinese society contributed to China's highly developed handicrafts in the ancient past. Yet China's industrial backwardness in the last century has led to many people's fallacious perception that ancient China was merely an agriculturally advanced country. They fail to realize that China was once also a major manufacturing power. China started exporting handicraft products to surrounding countries in the Han Dynasty and expanded the market to East Asia, Southeast Asia, West Asia, Africa, and Europe in the Song and Yuan dynasties. From the sixteenth to the nineteenth centuries, the geographical discoveries of the Europeans accelerated globalization and at the same time pushed Chinese handicraft exports to its zenith. Of China's exported handicrafts across different dynasties, porcelain has always been one of the most important.

The scale and volume of the porcelain trade alone shows that China was once a manufacturing power similar to what it is now. What is different is that now China manufactures and exports low-cost daily goods while previously the porcelain, silk, furniture, gold and silver wares, lacquerwares, etc. China made and exported were the most expensive luxuries in the world. From 1700 to 1820, the average annual growth rate of China's economy was three times higher than that of Europe and China's GDP accounted for one third of the world's total. One contributing factor of this economic success was that at the time porcelain and other handicraft products from China were luxurious and trendy commodities, heavily demanded by many countries. As the products were exported, silver flowed into China, especially from European countries. Behind the popularity of Chinese handicrafts at the time was not only the strength of China's manufacturing, but more importantly, foreign countries' admiration for Chinese values, aesthetic tastes, and the Chinese culture in general. In European countries at that time, the most sought-after household decorations were Chinese style ornamental objects, including porcelain, lacquerware, furniture, gold, and silver ware, with porcelain being the most popular. These porcelain wares, embellished with various scenes of Chinese life, with dramatic and fictional stories, with flowers, birds, fish, and insects, and with Chinese landscapes, filled Europeans

with curiosity and fascination for Chinese culture. China became the exotic ideal land of the European imagination. The sweeping popularity of Chinese culture influenced European aesthetics and arts and had a considerable impact on the Enlightenment which was taking place at the time. What China exported, then, was more than commodities—it also exported ideas, philosophy, and values embodied in those commodities.

The year 1820 was the 25th year of the Jiaqing era in China's Qing Dynasty. In that year, China was still the largest exporter and the leading economic power in the world, exporting large volumes of porcelain to Europe and America. Then, only 20 years later, the Opium War broke out, in an instant driving the Chinese empire to the verge of collapse. Subsequently, China lost its status as a manufacturing and exporting power, and even domestic manufactured products began to be imported from the West. Handicraft products such as ceramics and textiles, once China's strong suit, started to be replaced by Western machine-made items. It is still a vivid memory for many that until the 1960s the Chinese market was pervaded by imported industrial products whose names all started with the character *yang*, meaning foreign. Kerosene was called "foreign oil," cotton cloth "foreign cloth," and matches "foreign kindling."

This change fits well A. R. Radcliffe-Brown's description: the unity of a culture will be in serious turmoil because of a collision with a very different culture and may even be destroyed and replaced; such cultural disintegration is very common in today's world—from the Americas or the South Pacific to China and India.[33] The impact of the new industrial civilization turned China from a major exporter into an importer, from a strong country into a weak one, and from a culturally advanced country into a backward one. It was against this background that we forgot our history. Many major museums in Europe and America display various refined porcelain wares, furniture, gold and silver wares, lacquerwares and silk shipped from China that represent the highest manufacturing standards of ancient China, while in Chinese museums we mostly see luxury objects of the imperial palace and aristocracy but not such exquisite works. This has led many current young Chinese to overlook the fact that China was once a manufacturing powerhouse. They only regard her as once a backward agricultural civilization. Now China has again become a major exporter, but what we export is mostly cheap goods rather than fashion or luxury products. We lack design capacity and our own brands. In most cases we only manufacture based on foreign designs. The fundamental reason for the difference is that in ancient times China was a culturally developed country. Its cultural system and values were a model that the rest of the world admired and learned from. Thus, at that time China was exporting culture and values as well as goods, and this culture and these values are the most important thing a country can offer to the outside world. All commodities are essentially carriers of culture and ideology. This, in another way, shows that the determining factor of social transformation is the ideological component rather than the technological. Currently, China will achieve breakthroughs in technological and cultural innovation only if she produces thought and ideas that represent the new era.

[33] A. R. Radcliffe-Brown, *Method in Social Anthropology*, translated (into Chinese) by Xia Jianzhong, Huaxia Publishing House, 2002, p. 67.

The Contemporary Value of Chinese Ceramic History Research

Historical studies are more than explorations of the past. They are to benefit the present and the future. As an anthropologist, I have examined and written about the history of Chinese ceramics to gain and share with readers a deeper understanding of the origin and development of Chinese society and culture, namely, the yesterday of our country, which hopefully will benefit its today and tomorrow.

As Benedetto Croce argued, while history is not contemporary, if it is not regarded as a mere hollow echo and is given true meaning, all history is contemporary history. "Like contemporary history, the precondition of its existence is that the stories it tells must reverberate in the mind of historians."[34] Past history reverberates in our minds because of its close relation to present-day life. "Contemporary history no doubt comes directly from life, and history which is not called contemporary history must also come from life because it goes without saying that the only thing that would motivate people to study the facts of the past is an interest in the present life. Hence, past facts are looked at by historians with a mind to not a past interest but a current interest."[35] It is also for this that while I am writing about ancient history far removed from the present day, every step along the way I cannot resist comparing the past with today, for I know that present-day China grew out of the past and that we will understand the root of many current phenomena only if we know their past. This is exactly how Lucien Febvre put it: "It is a need every human group recognizes at some point of its evolution: people look for value in or attach value to "past" behaviors, events, and trends. These behaviors, events, and trends indicate reality, make people understand reality and help people live in reality."[36]

Karl Popper believes the usefulness of history lies in its close relationship with present reality. Some of the questions that arise from contemporary life require the historians' input of a past perspective. "We need to know how our difficulties are related to the past so as to know which path we shall take to go forward and solve the main tasks we face and choose."[37] Therefore, in a sense, all history is "contemporary history," for all history researchers rethink and rewrite history from the standpoint of life today.

The writing of this book is in a sense influenced by the concept of Cultural Self-consciousness championed by Fei Xiaotong. Cultural Self-consciousness means that people living in a certain culture should have adequate knowledge of that culture, of is origin, formation, characteristics, and development trends. Such knowledge is

[34] Benedetto Croce, *History: Its Theory and Practice*, translated (into Chinese) by Fu Rengan, The Commercial Press, 1982, p. 2.

[35] See Footnote 34.

[36] Xu Hao & Hou Jianxin, *Schools of Contemporary Western Historiography*, China Renmin University Press, 1996, p. 91.

[37] Xu Hao & Hou Jianxin, *Schools of Contemporary Western Historiography*, China Renmin University Press, 1996, p. 69.

necessary if a culture is to be more strongly independent in its cultural transformation and to achieve autonomy in the task of making cultural choices that are suited to the new environment and new era.[38] My purpose in writing this book is similar, that is, to understand Chinese culture and Chinese society through a study of China's ceramic history and to explore the future path of Chinese culture.

Fei Xiaotong's Cultural Self-consciousness requires us not to think about Chinese culture and history in isolation, but to perceive Chinese culture and history from a global perspective and from the standpoint of the interests of all human beings. Fei Xiaotong argues: "The cultural contacts following economic globalization will inevitably bring huge changes, and we should be prepared for this worldwide cultural contention. On the one hand, we should recognize the goodness in traditional Chinese culture and study our own history from a modern scientific approach in the mission of achieving Cultural Self-consciousness and creating a splendid modern Chinese culture, and on the other hand we should learn about and understand other cultures in the world, learn to handle and resolve problems arising from cultural contacts, and contribute to the common future of all humanity."[39] It is with such a mission in mind that I adopt a global vision when studying the history of Chinese ceramics, always accommodating its interaction with Western culture, thought, economy, and trade.

This book is also intended to contribute answers, albeit incomplete, to broader questions raised by Fei Xiaotong, namely, "Why are we living this way? What is the meaning of living this way? What results will such living bring us? That is to say, having developed to this stage, the human race needs to know where our cultures came from, how they took their present form, what is their essence, and where will they take human beings."[40] Examining the history of ceramics with these questions in mind, my research yields some new understandings about traditional Chinese culture. Naturally, arising from my personal research, these understandings are not automatically validated or comprehensive.

As mentioned above, all history is contemporary history. History is not the dead past. It is alive. What it has to offer is not some sealed treasure inviting us to take it as it is. It requires us to search for and assemble numerous fragments in order to truly embrace it. It takes constant re-visiting and re-understanding. People in different eras have different ways of understanding and obtain different nutrients from history, according to the needs of their respective times. That is why people in different eras interpret and write history in different ways and from different standpoints.

[38] Fei Xiaotong, "Words on 'Cultural Self-consciousness,'" *Academic Research*, Issue 7, 2003.

[39] See Footnote 38.

[40] Fei Xiaotong, "'Cultural Self-consciousness' and the Historical Task of Chinese Scholars," *Inheriting, Learning, Research*, SDX Joint Publishing Company, 2002, p. 360.

Writing Ideas

The knowledge and insights the history of Chinese ceramics is able to offer is far beyond what has been mentioned above. Since the birth of pottery, the production of ceramics has been in existence for about 10,000 years. Throughout this long history, ceramic wares have accompanied the entire course of the development of the Chinese nation, including its culture, politics, economy, and science and technology. It would be a daunting task for anyone to attempt a comprehensive discussion of this huge and complex subject through individual effort.

Therefore, in this book, I restrict myself to my own field and examine the history of Chinese ceramics purely from the perspective of the anthropology of art. My focus is on the contributing factors to the aesthetic and artistic styles of ceramics in different dynasties and on the interaction between the ideological, sociological, technological, natural, and informational components of Chinese culture as reflected in the process of ceramic production development. And the study seems to point to the following conclusions: art is born of a range of factors including material and spirit, religion and labor; the ideological component acts on the technological component to bring changes to the sociological component; Chinese history should not be divided along mechanical evolutionist lines into primitive, slave, feudal, capitalist, and socialist periods but should be reexamined from an anthropological viewpoint, and the history of ceramics shows that after the Qin and Han dynasties China was a plebeian society rather than a feudal society; attention should be given to spatial diffusion in addition to temporal evolution in the study of the history of Chinese ceramics. Another research result is the realization that not only do the ideological, sociological, and technological components as suggested by White contribute to the historical changes of a civilization, but so also do nature and information, and that in modern times, the information component, which represents diffusion and communication, is playing an ever more significant role. As the dissemination of information speeds up, so does the tempo of social change.

This work gives more weight to the information component, i.e., to the global ceramic trade and cultural exchange. Previous work on the history of Chinese ceramics has often spent more time on the Song Dynasty as that period boasted more kilns than any other period in Chinese history. This work, however, devotes its most comprehensive and richest chapter to the Qing Dynasty, because that was when Chinese ceramics enjoyed their widest distribution and the broadest contact with other countries. Selling not only in China, but also to Asian, African, and European countries as well as the emerging American market, the ceramics trade at that time was an early model of trade globalization. By then, countries around the world were no longer isolated from each other. They all joined a collective historical tide in a complex and changing era, and the development of China's ceramics industry was one wave in that tide. With the rise of the Western world, the acceleration of information, communication, and exchange around the globe altered the political, economic, cultural, and social development modes in every country.

"The other culture" and "the other" are among the most important concepts of anthropology. The general idea is to use the exotic culture of "the other" as a mirror to look at one's own culture and to reflect upon it to facilitate improvement. While "the other culture" in traditional anthropology is defined in terms of geographic distance, I believe temporal distance may also cause cultural estrangement and "otherness." To us, the ancient world and culture are also "the other" and "the other culture."

Another important anthropological concept is the idea of the "field." Fieldwork is how anthropologists obtain first-hand research materials and the field is where they meet cultural groups face to face. When our research object is history, the "field" in this sense, namely, living groups with whom we may interact and talk, is no longer present. But the "field" of ancient culture is not entirely absent. It remains in the silent wares, ruins and relics that have survived. To explore such a "field" is like talking to the ancients. In this manner, we can use ancient culture as a mirror to look at our present culture and reflect on it, which may help us find a correct path to the future.

Anthropology as a discipline originated in the West. I have long pondered how best to apply it to the study Chinese culture and history and how to develop anthropological theories with Chinese characteristics. As a venerable civilization, China has immense volumes of historical literature, rich tangible archaeological resources, and historical relics, which, if fully explored, well utilized, and carefully studied in combination with the present reality would certainly open a new door for anthropological studies in general and for branch studies including art anthropology and historical anthropology. This would remove many of the limitations on previous anthropological research, draw worldwide attention to Chinese anthropological studies, and promote the reconstruction of specialized historical studies in China such as cultural history, art history, and economic history. These are some of my objectives while writing this *History of Chinese Ceramics*.

The above are some of my ideas about the writing of this book. They are mostly about underrepresented aspects of previous ceramic history studies and problems I have been exploring. As this is perhaps the first attempt to look at the issues from an anthropological perspective, immaturity and limitations are bound to exist and further studies will be required to address the questions in more depth.

Contents

Chapter 9
Ceramics of the Yuan Dynasty

9.1 Introduction

9.1.1 Establishment of the Mongol Empire

The Mongolic people can be traced back to the *Donghu*, a nomadic confederation occupying eastern Mongolia and Manchuria, in northeastern China. Sharing the same origin and language with the *Xianbei* and *Khitan* peoples, Mongols were first recorded in Chinese history in around the sixth century and known as the "*Shiwei*." During the Northern and Southern Dynasties (420–589) and Tang Dynasty (618–907), there were few records of the Mongols. The world began to notice them in 1206 when Temujin consolidated the various Mongol tribes, founded the Mongol empire and was proclaimed "Genghis Khan." After coming to power, he first conquered his weakest neighbor, the Western Xia Empire, and in 1234 conquered the Jin and Korea. Based on his father' success, Ögedei, the third son of Genghis Khan and the second Great Khan of the Mongol empire, continued his expansion westwards to Central Asia, Russia, Persia and Eastern Europe from 1210 to 1240, reaching the Aegean Sea and rocking both Europe and Asia. Later, Yesü Möngke acceded to the throne and ordered his brother Kublai to subdue the Southern Song and Dali Kingdom. In 1260, Kublai was named successor and was known as the "Great Khan"[1] of the Mongol empire. In 1271, Kublai Khan proclaimed the creation of the name "Great Yuan" and formally established the Yuan Dynasty (1271–1368). By 1279, the Mongol conquest of the Song was complete, marking the end of the coexistence of multiple political powers since the Five Dynasties and Ten Kingdoms period (907–960). The Yuan Dynasty enjoyed not only vast territories under its rule, but also a rich cultural diversity and vigorous commercial exchange.

The expansion of the Mongol empire endowed the ancient nomadic path in the northwest with a new significance in the thirteenth and fourteenth centuries. This

[1] Xue Fengxuan, *Evolution of Chinese Cities and Civilization*, Joint Publishing HK, 2009, p. 205.

© Foreign Language Teaching and Research Publishing Co., Ltd 2023
L. Fang, *The History of Chinese Ceramics*, China Academic Library,
https://doi.org/10.1007/978-981-19-9094-6_9

path stretched through Dzungaria and Kazakhstan, and linked Mongolia with the lower reaches of the Volga River from Neolithic times. Offering direct access to the plains of Eastern Europe, this path had been planned and renovated by the Mongols in their efforts to promote the Chinese postal system, which was adopted in 1229, and improved and unified in 1237. With government granaries, pastures, stud farms and garrisons dotted across the prairie, post houses formed an excellent mechanism to facilitate exchanges between people from the Mongol Empire and northern China, to Arabic peoples, including Muslims from the Western Regions and the Middle East, native Russians originating from the Chagatai Khanate, Ilkhanate and Qipchaq ulisi, people of the defeated Liao and Jin regions of northern China, as well as merchants from Genoa and Venice who set foot on the land of the Mongols and even Beijing due to trade relations with the Russians and businesses in the Near East. As the political system of the Mongols associated business with politics, some foreign individuals even sought positions in the Yuan imperial government, including some individuals from Europe.

As the ties with western Asia and Europe were strengthened and communication via both land and sea became smooth, the Mongol rulers attached great importance to commerce and trade both at home and abroad. Even rulers and aristocrats of different ethnic groups were engaged in business. After unification of the empire, the Yuan Dynasty vigorously promoted mercantile policies to recover the economy and maintain the extravagant lifestyle of the aristocrats, through regulations like officials and armies providing security services for traveling businessmen, strictly prohibiting the detention of commercial carriages, offering imperial guarantees and military protection to businessmen, and the right to ride post horses, as well as sparing businessmen arriving from the Western Regions from miscellaneous chores and errands required by the state.[2] In the early Yuan Dynasty, many measures were adopted to protect exports. For example, in 1277, a taxation regulation provided that tariffs on foreign goods should be levied twice and that on domestic goods only once. Such approaches, along with the fact that the ship building industry was already quite advanced since the Northern Song Dynasty (960–1127) and production of porcelain and silks had been boosted, created favorable conditions for the country to develop foreign trade.[3]

On the basis of continuing the regulations of the Tang (618–907) and Song dynasties (960–1279), the Yuan Dynasty continued to improve its maritime management system. From the 22nd year of the Yuan Dynasty (1285), the government implemented the "official ship" system on a major scale. As a result of this economic reform, the state greatly strengthened its monopoly over overseas trade.

The most important port in the Yuan Dynasty was Quanzhou. In 1277, the government issued a command to set up an initial superintendency of maritime trade in Quanzhou and a Mongol official called Manggu was nominated to be head of the administration. During the reign of Kublai Khan, apart from the existing Grand

[2] Peng Yuxin (ed.), *Economic History of China's Feudal Society*, Wuhan University Press, 1994, p. 488.

[3] Ye Zhemin, *History of Chinese Ceramics*, SDX Joint Publishing Company, 2006, p. 399.

Canal, built and renovated over thousands of years, a new channel was constructed to strengthen the links between the Port of Quanzhou and the capital city, Beijing. Through this channel, it only took a dozen or so days to reach destinations when the wind was favorable and ten days from Zhihu (the current Tianjin city) to Quanzhou with a tailwind. The unprecedentedly smooth and direct traffic lines on both land and sea enabled a quick and convenient delivery of incoming goods from the Port of Quanzhou to the capital city. This ushered in a golden era in the history of the Port of Quanzhou.

Quanzhou was not only the first city to be equipped with a superintendency, it also attracted the government's attention due to its long-term ties with countries in the south sea region and the solid trade foundation established by Pu Shougeng in the area, a figure who dominated the maritime trade in Quanzhou. The Port of Quanzhou became a center for attracting foreign businessmen and conducting foreign trade. On several occasions, the central government sent envoys to countries in the south sea region to deliver imperial orders and these envoys were often from Quanzhou. Besides, delegations sent by the government were also dominated by people from Quanzhou, proving the importance of the Port of Quanzhou at the time. Quanzhou was also significant in terms of human exchange. Most envoys departed from the port to their destinations and most foreign envoys entered the empire via the port. For example, in 1292, when an Italian merchant called Marco Polo was entrusted to escort a Mongol princess Kökechin to Persia to get married, they departed from Quanzhou. From 1324 to 1328, Friar Odoric, an Italian missionary explorer, arrived in the empire at the Port of Quanzhou via the maritime route and then headed northward to the capital. In 1342, Giovanni dei Marignolli was appointed by Pope Benedict XII as an envoy to the oriental Yuan Dynasty. He stayed in Beijing for four years before traveling back to India from the Port of Quanzhou. As an envoy of the then Indian sultan, Muhammad Ibn Battuta embarked on a sea voyage to China and visited Guangzhou (Canton), Quanzhou, Hangzhou and Beijing in 1346 to get a grasp of the local landscape and customs. These four medieval travelers all recorded the prosperity of the Port of Quanzhou in their notes or works.[4] The prosperity of the Port propelled the development of ceramics in the coastal Fujian region.

9.1.2 The Shift in Ceramic Production from North to South

It is worth noting that the Yuan Dynasty attached great importance to trade and that ceramics production and exports did not decline in the Yuan as compared to the Song. The major kilns in both the north and the south continued their production, but it is clear that ceramic production began to move towards the south, and congregated especially in the south-east. While recent ample new archaeological discoveries have shown that the ceramics production during the Yuan Dynasty is not necessarily as scholars had previously held, namely that "At the time, the Yaozhou, Ding and

[4] Quanzhou Customs (ed.), *Quanzhou Customs Gazette*, Xiamen University Press, 2005.

Fig. 9.1 Black on white
figure pot, produced in the
Yuan Dynasty, height:
30.5 cm, mouth rim diameter
18.4 cm, in the Yangzhou
Museum

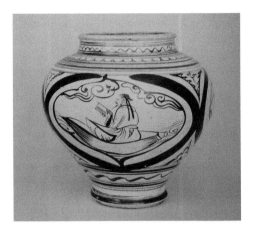

Fig. 9.2 Black on white
plate with fish and algae
pattern, produced in the
Yuan Dynasty, height: 9 cm,
mouth rim diameter: 38 cm,
in the Capital Museum

Ru kilns had declining production and, while still boasting major production, the Cizhou and Jun kilns were producing ceramics of much less quality than in the Song Dynasty".[5] Nevertheless, beginning in the Yuan Dynasty, the kilns in the south did experience greater progress than those in the north.

Some scholars believe this was the result of wars. Pursued by wars, the Song court escaped to the south, and so did many first-class craftsmen from the north. These craftsmen also brought their skills with them. For instance, before the Yuan Dynasty, the Jingdezhen kilns produced very few ceramics with color drawing. It was craftsmen from the Cizhou kilns who brought these techniques to Jingdezhen. A number of kilns in the south, such as the Jizhou kilns in Jiangxi, Xicun and Fukang kilns in Guangdong, Hepu kilns in Guangxi, Guangyuan kilns in Sichuan and Cizao kilns in Fujian, all produced similar products to those of the Cizhou kilns.[6] Was this also a result of the influence of the Cizhou kiln craftsmen? (Figs. 9.1 and 9.2).

Naturally, some experts argue that apart from wars, declining availability of raw materials was also responsible for the downturn in the ceramics industry. Mr. Xiong

[5] Chinese Ceramic Society (ed.), *History of Chinese Ceramics*, Cultural Relics Press, 1982.

[6] Ye Zhemin, History of Chinese Ceramics, SDX Joint Publishing Company, 2006, p. 447.

Haitang, an archaeologist, believes that other than raw materials, deforestation also led to a reduction in fuels. He argues that when we spoke of the decline of the Xing, Ding, Yaozhou, and Yuezhou kilns, and others, we regarded depletion of raw materials (like soil and stones) as the main reason, and forgot that fuels also played an equally crucial role in the production process [2]. Recently Li Gang, a scholar from Zhejiang Province, expressed a view on the reasons for the decline of the Yuezhou kilns. He argued that since the region around Ningbo and Shaoxing witnessed a population boom in the Northern Song, the natural vegetation in the mountainous areas was widely exploited and used as farms and tea gardens, thus hindering the development of the ceramics industry. If raw materials become hard to get, production costs undoubtedly rise, weakening one's competitiveness. For these reasons the Yuezhou kilns declined in the middle of the Northern Song Dynasty and met their demise in the later period. Following the mid Northern Song Dynasty, some craftsmen left their hometowns to seek a living. In this context, the Yaozhou kilns applied the unique M-shaped saggers of the Yuezhou kilns to produce celadon ware after the Yuezhou style and achieved success. At the same time, the proportion of celadon ware produced by the Yuezhou kilns and unearthed overseas, reached an unprecedently low level compared with that in the early Northern Song Dynasty.[7] Potters could only choose to engage in agriculture or leave to seek a job elsewhere. This led to a shift in production of celadon ware from Hangzhou Bay to mountainous regions in Longquan and Wenzhou which, while lacking quality clay, boasted vast swathes of natural vegetation. The prosperity of the Longquan kilns was achieved under such circumstances.[8] The Yuezhou and Longquan kilns serve as cases in point to illustrate the significance of fuels to the ceramics industry. As in the past, fuels mainly came from forests; where there were large plantations, the ceramics industry had a chance to boom.

Throughout the history of Chinese ceramics we can see there is a trend of shifting from the north to the south, and in the south it seems to transit from east to west. Based on palaeoclimatological research, China's warm zone shifted from the north to the south. From the *Yangshao* culture period (c. 5000–3000 BCE) to the Shang Dynasty (c. 1600–1046 BCE), many animals which lived in warm and wet areas, like bamboo rats, river deer, sika deer and buffaloes, were found in the Yellow River basin, which indicates the area had similar temperatures to that in the current Yangtze River basin. Additionally, this area had a broad forest coverage which was conducive to growth of the ceramics industry. Prior to the Western Han Dynasty (202 BCE–8 CE), and with the exception of the Western Zhou Dynasty (1046–771 BCE), the northern region remained quite warm, providing a favorable climate and ecological conditions for the prosperity of the Yellow River civilization. During this time, the center of the ceramics industry was along the midstream of the Yellow river, around the area from Weishui to Zhengzhou. In the Northern and Southern Dynasties (420–589 CE), the

[7] Arakawa Masaaki, "Trade Ceramics from the Ancient to the Medieval Age Unearthed in Japan," *Archäologisches Korrespondenzblatt*, Issue 340, 1991, p. 11.

[8] Xiong Haitang, *Research on the Technical Development and Exchange History of the Ceramics industry in East Asia*, Nanjing University Press, 1995, p. 105.

cold line moved southward. In addition, like the late Eastern Han Dynasty (25–220 CE) period, years of famine (caused by a deterioration in the natural environment), led to political chaos and economic meltdown in the north while the south enjoyed a relatively peaceful and warm climate. This resulted in a large migration from north to south. It was at this time that the Kuaiji kilns in Zhejiang successfully produced celadon ware and by the time of the Northern and Southern Dynasties it had become the largest producer of celadon ware in China and sold its products to regions along the Yangtze River and even beyond to the Yellow River. In the Sui, Tang and Five Dynasties period (581–960 CE), the north was warm again, which played a significant role in making the Yellow River basin the political and cultural center at the time. In the Southern Song and Yuan dynasties, the cold returned to the north and much vegetation was lost. As a result, fuels were insufficient and the ceramics industry had to turn to coal as a fuel. In the late Northern Song Dynasty, some ethnic groups launched attacks against the north and the government was defeated, so many people were forced to migrate to the south.[9] In the Southern Song Dynasty, the official kilns were set up in the capital city Lin'an (now Hangzhou), which strengthened the central role of the south in the ceramics industry. In the Yuan Dynasty, while the kilns in northern China were still in operation, their scale and production had dropped significantly, except for the Jun, Cizhou, Huozhou and Gangwa kilns which still maintained their past glory. In contrast, the kilns in the south not only continued their production, but also achieved much progress.

In the opinion of the author, there is another reason why the kilns in the north declined after the Yuan Dynasty. It is about market needs. For example, the Cizhou kilns, also in the north, maintained its production in the Yuan Dynasty. Why? Because of market needs! In the ruins of the Jining ancient city in Inner Mongolia, a large volume of porcelain from the Yuan Dynasty was unearthed, including over 4800 pieces of repairable samples and over 200 complete articles. Through this discovery, we can get a grasp of the porcelain production in the Yuan Dynasty since most products of the well-known kilns can be found here. Products from the Cizhou kilns account for the largest proportion, followed by the Longquan, Jingdezhen, Jun, Huo, Ding and Yaozhou kilns. These unearthed products to some extent represent the achievements and quality of ceramics in the Yuan Dynasty.[10]

This author once visited the Chenlu kilns, which is close to the old Yaozhou kilns. Situated about 20 km southeast of Tongchuan, Shaanxi Province, in the so-called "Stove mountain" of Chenlu town, the Chenlu kilns were famous for their stove fires. Due to the prosperity of its ceramics industry, Chenlu town was known as "the No.1 Town in Chang'an," the current Xi'an and the then capital city of several dynasties. Founded in the late Jin and early Yuan Dynasty, the Chenlu kilns embraced their heyday in the Ming and Qing dynasties and continued operation until the Republic

[9] Xiong Haitang, *Research on the Technical Development and Exchange History of the Ceramics industry in East Asia*, Nanjing University Press, 1995, p. 115.

[10] Li Jianmao, "Analysis of Ceramics Unearthed in Jining," Chinese Society for Ancient Ceramics (ed.), *Studies on Ancient Chinese Ceramics* (Vol. 11), The Forbidden City Publishing House, 2005, p. 71.

of China (1912–1949) period. As an old town boasting over 800 years of history in producing porcelain, Chenlu town was home to the largest kilns in Shaanxi and even in all the northwestern provinces. Many products from Chenlu have inscriptions on them, like "*Lushan*" (Lu Mountain), marking the place where they were produced. Since the late Yuan Dynasty, the Chenlu kilns assumed the central role once held by the Yaozhou kilns in Huangbao Town and became the most important kilns after the Yaozhou kilns.[11] This author learned that even though the Chenlu kilns are viewed as the central kilns after the Yaozhou kilns, the Chenlu kilns did not produce traditional celadon ware as the Yaozhou kilns had in the Song Dynasty. Instead, Chenlu set out on a path of imitation, first of some Cizhou varieties and later of the Qing Jingdezhen blue and white porcelain.

This shows that market needs represent an important factor in kiln prosperity. So, is it possible that under the overall downturn of the industry, the reason why the Cizhou and Jun kilns maintained their glory during the Yuan Dynasty was because of the popularity of their products? And besides, was the prosperity of the Longquan and Jingdezhen kilns made possible by their meeting the market demand?

Generally speaking, after the Yuan Dynasty, the prosperity of the ceramics industry never crossed further north than the Yangtze River. As the most important kilns in the Yuan Dynasty, the Longquan and Jingdezhen kilns were both situated near mountains and by rivers, providing easy access to raw materials and convenient transportation. While different from their counterparts in the Song Dynasty, the Yuan Dynasty celadon ware produced by the Longquan kilns was not as exquisite or tender. Instead, they were thick in body and light in glaze. Yet, they were enthusiastically welcomed at home and abroad as users thought they were durable and attractive. For the Jingdezhen kilns, while they had already created for themselves a degree of reputation in the Song Dynasty, they were yet to make their way into the top five famous kilns and were far from as famous as the Longquan kilns. However, they rose as a new force after the Yuan Dynasty. Was that because their new products like blue and white porcelain, underglazed blue and red porcelain and *Shufu* porcelain were popular in the market? These questions will be discussed in the ensuing pages (Fig. 9.3).

What is more, smooth transportation promoted the development of the southern kilns, especially the Longquan and Jingdezhen kilns. Compared with that in the Song Dynasty, more porcelain produced in the south was sold and used in the north in the Yuan Dynasty. One of the reasons for this was the unity achieved in the Yuan Dynasty, which provided a powerful political guarantee for economic exchange between the south and north. Another reason was because of an improved transportation system, with the water transport routes of the Beijing-Hangzhou Grand Canal and maritime routes as the backbone, linking regions south of the Yangtze River with Beijing and supporting transportation from south to north.

[11] Du Wen, "Overview of Blue and White Porcelain Produced by Private Kilns in Weibei, Shaanxi Province," Chinese Society for Ancient Ceramics (ed.), *Studies on Ancient Chinese Ceramics* (Vol. 13), The Forbidden City Publishing House, 2007, p. 349.

Fig. 9.3 Blue and white
meiping (plum vase) with
twining peony pattern,
produced in the Yuan
Dynasty, height: 42.1 cm,
mouth rim diameter: 5.5 cm,
in the Shanghai Museum

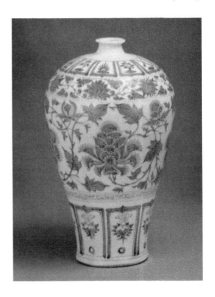

The Grand Canal was the main artery for south-north transportation during the Yuan Dynasty. Construction of the Canal began with Emperor Yang of the Sui Dynasty (581–618), and before the Tang Dynasty it was known as a furrow, a channel and a transportation channel. The Canal linked the Tongji, Shanyang, Mengdu and Yongji canals and was built across dynasties and completed in the Yuan period.[12]

In the cargo ships found in Nankaihe Village, Cixian County, Hebei Province, which were specifically for porcelain transportation of Cizhou kiln products, porcelain from the Jingdezhen and Longquan kilns were found, but they were shoddy products.[13] At the end of 1998, a lot of porcelain samples were discovered in the previous riverway of the Yuan Dynasty, in Tangyu Village, Qingpu District, Shanghai.[14] Over 90% of these were celadon ware from the Longquan kilns, followed by *Shufu* porcelain from the Jingdezhen kilns. This shows that these two waterways were Yuan Dynasty routes for transporting porcelain. Both routes terminated at Beijing, so these two places were transfer hubs for porcelain transportation from south to north.

More porcelain from the Longquan kilns was found in the north than that of the Jingdezhen kilns. This is because apart from considerations of the scale of production, the Longquan kilns had easy access to transportation. Through both maritime routes and inland canals, products of the Longquan kilns faced a shorter trip than those of the Jingdezhen kilns. Convenient water transport helped cut not only transportation

[12] Li Jianmao, "Analysis of Ceramics Unearthed in Jining," Chinese Society for Ancient Ceramics (ed.), *Studies on Ancient Chinese Ceramics* (Vol. 11), The Forbidden City Publishing House, 2005, p. 74.

[13] Zhu Jinsheng, "A Brief Report on Unearthed Wooden Ships from the Yuan Dynasty in Nankaihe Village, Cixian County, Hebei Province," *Archaeology*, 1978, Issue 6.

[14] He Jiying, "Great Discoveries of Unearthed Relics in Tangyu Village, Qingpu District, Shanghai," *China Cultural Relics News*, Feb. 3, 1999.

costs, but also time. Thus, it only took a couple of months to transport porcelain from places of origin to Beijing and then to the present Jining in Inner Mongolia.[15]

9.1.3 A Reappraisal of Ceramic Research on the Yuan Dynasty

The Yuan Dynasty is an important historical era in the development of ceramics. However, since this dynasty was short-lived, the historical record is slim. While an increasing number of porcelain articles have been unearthed, few are valuable and the variety and quantity is limited. Therefore, not much attention has been paid to the significance of Yuan porcelain and its technological progress. For a very long time, people preferred porcelain from the Song and Ming dynasties to that of the Yuan. Some even misjudged delicate Yuan porcelain as products of the Song or mistakenly took beautiful blue and white porcelain as a product of the Ming. Others generally regarded Yuan porcelain as thick, bulky and clumsy. In *The History of China's Ceramics* published in 1982, the chapter which describes the Yuan states: "The major kilns in the Yuan Dynasty like the Jun, Cizhou, Huo, Longquan and Dehua kilns, continued to manufacture traditional products based on the previous generations",[16] while failing to expand on the state of other porcelain. In recent years, with the launching of some industrial and agricultural projects, the ruins of some Yuan kilns and ceramic articles have revealed themselves. In Gaoan, Le'an, Yichun, Yongxin and Pingxiang in Jiangxi Province, a batch of blue and white porcelain and copper red porcelain was found. In the ancient Jining city in Inner Mongolia, masterpieces of the Jingdezhen, Ding, Jun, Longquan, Yaozhou, and Cizhou kilns were unearthed from a number of pits, including some amazing and exquisite blue and white porcelain, copper red porcelain and *Shufu* porcelain, which immediately attracted the attention of academia.[17] Certain information recently discovered (most from the excavation of Yuan pits) indicates that in the Yuan Dynasty quite a lot of kilns continued operation, such as the Jian, Yaozhou, and Ding kilns. Some scholars argue that as more new archaeological discoveries emerge, it is imperative that a new research campaign on Yuan porcelain is launched, especially regarding pit porcelain.[18]

[15] Li Jianmao, "Analysis of Ceramics Unearthed in Jining," Chinese Society for Ancient Ceramics (ed.), *Studies on Ancient Chinese Ceramics* (Vol. 11), The Forbidden City Publishing House, 2005, p. 75.

[16] Chinese Ceramic Society (ed.), *History of Chinese Ceramics*, Cultural Relics Press, 1982, p. 332.

[17] Yu Jiadong & Jiang An, "An Examination of the Historical Background of the Prosperity of Jingdezhen Porcelain from Pit Storages in the Ancient Yuan Town on the Jining Road, Inner Mongolia," Chinese Society for Ancient Ceramics (ed.), *Studies on Ancient Chinese Ceramics* (Vol. 11), The Forbidden City Publishing House, 2005, p. 135.

[18] Lv Jun, "Research on Yuan Porcelain Collections Unearthed from Pits in Inner Mongolia," Chinese Society for Ancient Ceramics (ed.), *Studies on Ancient Chinese Ceramics* (Vol. 11), The Forbidden City Publishing House, 2005, p. 44.

The largest trove of Yuan Dynasty pit porcelain was found in Jining, Inner Mongolia. The cache consisted of many varieties, which was unexpected. This was a major discovery in border archaeology and one of the greatest discoveries in the archaeological history of Chinese ceramics. But the discovery in Jining was not the first to uncover Yuan porcelain. Rather, it was in the mid-twentieth century that Yuan porcelain was unearthed for the first time. In May 2002, a large-scale archaeological excavation campaign was launched in Jining, resulting in many products of kilns all over central China being unearthed. This played a significant role in rediscovering the porcelain production of the Yuan Dynasty.

The establishment of the Yuan Dynasty under the rule of the Mongols brought unprecedented unity to the northern region and drove economic development in the north. It also made possible the expansion of the handicraft industries, including the porcelain industry, along the grassland Silk Road. The formerly distant Inner Mongolia was no longer distant because further north, cities like Yingchang, Jining, Quanning, Dening and Shajing City emerged. Following the Liao Dynasty (916–1125), this was an unprecedented northward movement. In regions around Inner Mongolia, there were many archaeological sites from the Jin and Yuan dynasties and most sites revealed more than one variety of porcelain.[19] Porcelain unearthed from sites like Shangdu, the former capital of Kublai Khan's Yuan Dynasty, and Jining, represented the epitome of the prosperity of the porcelain industry in northern China during the Yuan Dynasty, and reflected a truth of the industry that: "If created successfully, an item of porcelain will spread to all corners of the globe."[20]

In the south of Inner Mongolia, Jining straddled an important route and acted as an important gateway at the eastern end of the grassland Silk Road. As some have noted, "Jining combined agrarian culture with nomadic culture." "The fact that a lot of quality porcelain from various kilns was found in Jining hints at a special cultural phenomenon, and also indicates a sweeping historical background."[21]

From the porcelain unearthed at Jining, we can see that porcelain culture originating in Central China had clearly penetrated the city, a region where Mongol culture and Han culture coexisted. At the time, Jining was a place dominated by Mongols as relics unearthed indicate life habits and cultural customs of peoples from the northern

[19] *Maps of Chinese Cultural Relics—Inner Mongolia Volume*, State Administration of Cultural Heritage (ed.), Xi'an Map Press, 2003.

[20] Peng Shanguo, "An Analysis of Yuan Porcelain Unearthed in Inner Mongolia," Chinese Society for Ancient Ceramics (ed.), *Studies on Ancient Chinese Ceramics* (Vol. 14), The Forbidden City Publishing House, 2005, p. 40.

[21] Yu Jiadong & Jiang An, "An Examination of the Historical Background of the Prosperity of Jingdezhen Porcelain from Pit Storages in an Ancient Yuan Town on Jining Road, Inner Mongolia," Chinese Society for Ancient Ceramics (ed.), *Studies on Ancient Chinese Ceramics* (Vol. 11), The Forbidden City Publishing House, 2005, p. 141.

nomadic regions. However, items unearthed seem to have also been strongly influenced by Han culture as they bore much resemblance to what Han people were used to.[22]

In other words, in the Yuan Dynasty, Han soldiers, government officials, craftsmen, businessmen and farmers were able to go to the northern part of the Gobi Desert in large numbers and engage in farming, business, handicraft industries, administration and cultural and educational pursuits. In this way, Han culture was brought to the prairie. As an important life necessity and practical artistic artefact, porcelain came to regions where the Mongols lived and was accepted by the local people.

From pits, tombs and ancient city ruins where Yuan porcelain have been unearthed in recent years, we can encounter products from the Cizhou kilns which account for the largest portion, followed by the Longquan, Jingdezhen, Gangwa, Jun, Huo, Ding and Cizhou kilns. Unearthed porcelain articles in Inner Mongolia include vases, pots with lids, stoves, bowls, plates, basins, pillows and toys. Among these articles, products from the Longquan kilns usually included bowls, plates, goblets, sugarcane-like pen washers, stoves, pots with lotus-leaf-shaped lids, vases with double rings of lugs, pots with outward-opening mouths and *zun* with three feet, etc.[23]

What is worth noting is that Jun porcelain has been discovered in Baita Village in Hohhot, pits in Hajingou in Chifeng, and the ancient city of Jinning (also from pits). Unearthed items include incense burners, vases, bowls, plates, saucers, pots, etc. The bowls have three types of mouth: tight, straight and thick. Their clay usually looks light yellow and gray, while some are white, gray, gray black and light red. The glazing colors usually include bluish white, azure and sky blue, with the combination of bluish white and azure as the most common. The glaze is usually opaque and thick with embossed decorations and copper-red glaze, also as decoration. Embossed decorations can only be found on bowls and stoves, usually leaf-shaped decorations on the interior walls of bowls and rings, and flowers and lined dots on the surface of incense burners. Some articles have copper-red decorations. For example, unearthed from pits at Baita Village, incense burners and openwork high pots with double dragon-shaped lugs from the Jun kilns have a thick azure-color glaze, and after firing, the glaze spreads over the surface, rendering the image vivid. Especially beautiful is the stove, constituting a special treasure among the Jun porcelain from the Yuan Dynasty.[24]

Huo porcelain was only found in Jining and the majority of it was roughly-made articles for daily use, including bowls, plates and goblets.

[22] Lu Minghua, "A Preliminary Study of Porcelain Unearthed in Jining," Chinese Society for Ancient Ceramics (ed.), *Studies on Ancient Chinese Ceramics* (Vol. 11), The Forbidden City Publishing House, 2005, p. 56.

[23] Lv Jun, "Research on Yuan Porcelain Collections Unearthed from Pits in Inner Mongolia," Chinese Society for Ancient Ceramics (ed.), *Studies on Ancient Chinese Ceramics* (Vol. 11), The Forbidden City Publishing House, 2005, p. 47.

[24] Lv Jun, "Research on Yuan Porcelain Collections Unearthed from Pits in Inner Mongolia," Chinese Society for Ancient Ceramics (ed.), *Studies on Ancient Chinese Ceramics* (Vol. 11), The Forbidden City Publishing House, 2005, p. 48.

Porcelain from the Ding kilns was delicate and smooth, white in body and blue in glaze. Bowls and plates usually had an unglazed mouth. Printing and engraving techniques were used for decoration. Inside, there were lotus, fish, and birds, and outside they were round- or petal-shaped.

Not many products of the Yaozhou kilns have been unearthed in Inner Mongolia, but a blue-glazed plate with flower printings has been found in a pit in Linxi County. This plate is gray in body but smooth, thickly glazed inside and out with a twining peony pattern on the bottom. Thus, it seems that in the Yuan Dynasty, the Yaozhou kilns had basically ceased operation.

Jian-style porcelain, produced by private kilns in imitation of products from the Jian kilns, was the principal artefact found in Jining, including bowls, plates, bottles and cups. These articles were mainly gray, white gray, and light yellow with some reddish brown and ash black, decorated with hare's fur glaze, oil spot glaze, partridge feather and leaf patterns.[25]

From the Yuan porcelain unearthed in Inner Mongolia, we can see that the Yuan Dynasty played an important role in the history of Chinese ceramics. Li Jianmao argues: "The discovery of this batch of porcelain raised doubts about some traditionally held opinions. For instance, while they were the most vigorous kilns with the greatest potential, the Jingdezhen kilns were not the largest at the time; it was Cizhou products that accounted for the largest proportion of the unearthed porcelain in Jining. If you say the discovery of Cizhou porcelain in Jining was just coincidence, then how do you explain the fact that of the products made by the distant southern kilns, the Longquan kiln products far outnumbered those of the Jingdezhen kilns? After several wars, the northern ceramics industry was not able to develop as well as that in the southern region. But it was not as we used to believe that the industry had permanently collapsed."[26] The author partly agrees with what Li argues. If more Longquan kiln products were found in Jining than Jingdezhen products, then one possible explanation is that it was more convenient to transport Longquan porcelain to Jining than from Jingdezhen. If that is true, then Jingdezhen porcelain should have formed the largest part of the ceramics unearthed in Jiangxi Province. But this was not the case.

Apart from Yuan porcelain found in pits and tombs in Inner Mongolia, after the founding of the PRC, batches of blue and white porcelain have also been discovered in tombs and pits in Jiangxi, and some of these have been very valuable. These discoveries have been crucial to the study of blue and white porcelain. Especially precious is the porcelain found in pits. Large in size and number, and from a wide range of

[25] Lv Jun, "Research on Yuan Porcelain Collections Unearthed from Pits in Inner Mongolia," Chinese Society for Ancient Ceramics (ed.), *Studies on Ancient Chinese Ceramics* (Vol. 11), The Forbidden City Publishing House, 2005, p. 49.

[26] Li Jianmao, "Analysis of Ceramics Unearthed in Jining," Chinese Society for Ancient Ceramics (ed.), *Studies on Ancient Chinese Ceramics* (Vol. 11), The Forbidden City Publishing House, 2005, pp. 71–72.

sources, they are very rare national treasures indeed. The relevant archaeological discoveries are listed below in chronological order.[27]

1. In April 1980, piles of porcelain were found in a round pit with a depth of 50 cm and a diameter of one meter, under the wall of the east gate of the ancient city of Yongxin County.
2. In November 1980, a batch of Yuan porcelain was found in a pit during an expansion project for Jiangxi No. 2 Electrical Machinery Plant in Gaoan County, Jiangxi Province.
3. In January 1984, a batch of Yuan porcelain was found at a construction site of the Material Bureau in Zhaishang County, Jiangxi Province.
4. In April 1985, a batch of porcelain was found in a pit in Xiashi Village, Jiangxi Province.
5. In October 1990, a batch of porcelain was found at a construction site for the Yichun Courthouse, Jiangxi Province.

Among these five batches of porcelain unearthed, it was products of the Gaoan kilns that were the most renowned both at home and abroad. A significant volume of porcelain made by the Gaoan kilns was unearthed, and among them worthy of special note was the blue and white porcelain and copper red glazed porcelain. These items are not only large, but also very diverse, constituting very rare treasures among porcelain unearthed from pits.[28] According to some estimations, there were more products from the Longquan kilns than from the Jingdezhen kilns. For example, among the porcelain unearthed in Gaoan County, there were a total of 239 pieces, including 23 underglazed blue and red pieces, 10 blue and white pieces, 34 *Shufu* pieces, 168 items of celadon ware from the Longquan kilns, three pieces of Jun porcelain, and one from another kiln.[29]

Li Jianmao also offers some examples. From the shipwrecks of Sinan, South Korea, a total of 12,539 pieces of porcelain were salvaged, including 6435 celadon wares from the Longquan kilns. Additionally, in a Yuan tomb in Jianyang, Sichuan Province, a total of 612 burial objects were found, including 525 pieces of porcelain, among which 231 pieces of celadon ware hailed from the Longquan kilns, 198 blue and white porcelain items from the Jingdezhen kilns, 82 white porcelain pieces from the Ding kilns (some with silver or copper edges), nine brown-glazed bowls, and five

[27] Wu Shuicun & Wu Fang, "Study of Yuan Porcelain Found in Pits in Jiangxi Province and Relevant Issues," Chinese Society for Ancient Ceramics (ed.), *Studies on Ancient Chinese Ceramics* (Vol. 14), The Forbidden City Publishing House, 2005, p. 145.

[28] Wu Shuicun & Wu Fang, "Study of Yuan Porcelain Found in Pits in Jiangxi Province and Relevant Issues," Chinese Society for Ancient Ceramics (ed.), *Studies on Ancient Chinese Ceramics* (Vol. 14), The Forbidden City Publishing House, 2005, pp. 145–146.

[29] "Blue and White Porcelain and Copper Red Porcelain found in Pits in Gaoan County, Jiangxi Province," *Cultural Relics*, Issue 4, 1982. Quoted from a secondary source: Wu Shuicun & Wu Fang, "Study of Yuan Porcelain Found in Pits in Jiangxi Province and Relevant Issues," Chinese Society for Ancient Ceramics (ed.), *Studies on Ancient Chinese Ceramics* (Vol. 11), The Forbidden City Publishing House, 2005, p. 145.

black-glazed bowls. Therefore, Li believes that the Longquan kilns still dominated the ceramics industry in the Yuan Dynasty.[30]

However, in the *History of Chinese Ceramics* edited by the Chinese Ceramic Society, there is only one page discussing the Longquan kilns, much less than that of the Jingdezhen kilns. In addition, what is worth mentioning about ceramic production in the Yuan Dynasty includes production of blue and white porcelain in Yunnan. Thanks to the tea-horse trade, many kilns in the northern nomadic regions also produced porcelain similar to that of the Jian kilns since this was quite popular, and exports of porcelain drove forward ceramic production in the coastal regions of Fujian Province. These issues failed to attract much attention in previous research on the history of Chinese ceramics, so in this chapter, this author attempts to bring them to the attention of readers.

Porcelain unearthed in Jining and other sites plays an important role in today's research on sales of porcelain in the hinterland and overseas. In the past, we always focused on the role of the ancient Silk Road and the maritime silk road in linking up with the outside world and engaging in trade, while we lacked enough understanding of the role of the grassland Silk Road. The reason for this is because we did not know much about the routes and there was a lack of excavated porcelain and relevant historical documents to facilitate further study.[31]

Discovery of a large volume of porcelain in Jining testified to the prosperity of the city in the Yuan Dynasty. It also showed that it enjoyed a combination of agricultural and nomadic culture, as well as being a possible traffic hub, leading to the northern regions of the Gobi Desert and beyond. In terms of its geographic location, Jining was indeed one of the key regions linking Han culture and Mongol culture. Products from the Central Plains were transported to Karakorum through Jining, Jingzhou or Dening, and then to Western countries and regions via Chenghai and Qianqianzhou. From this perspective, Jining was obviously a transfer station in the Yuan Dynasty.

The commercial routes mapped out by foreign researchers tracked westward, not northward, starting from Chang'an (the current Xi'an), entering Gansu and turning north, then westwards towards Central Asia, or from Central Asia, skirting around towards West Asia. The route of the "Grassland Ceramic Road" that they traced also took a western course and not a northern one.[32]

According to previous studies, the Yuan rulers integrated transportation from the Central Plains to the southern and northern regions of the Gobi Desert in order to strengthen administration over, and ties with, the northern region. This was the

[30] Li Jianmao, "Analysis of Ceramics Unearthed in Jining," Chinese Society for Ancient Ceramics (ed.), *Studies on Ancient Chinese Ceramics* (Vol. 11), The Forbidden City Publishing House, 2005, p. 73.

[31] Lu Minghua, "A Preliminary Study of Porcelain Unearthed in Jining," Chinese Society for Ancient Ceramics (ed.), *Studies on Ancient Chinese Ceramics* (Vol. 11), The Forbidden City Publishing House, 2005, pp. 54–55.

[32] *Ceramic Treasure*, Idemitsu Museum of Arts (ed.), Tokyo, 2001. Quoted from a secondary source: Lu Minghua, "A Preliminary Study of Porcelain Unearthed in Jining," Chinese Society for Ancient Ceramics (ed.), *Studies on Ancient Chinese Ceramics* (Vol. 11), The Forbidden City Publishing House, 2005, p. 55.

Chinese post system of the Yuan Dynasty and posts were dotted along this "Post Route". The old Jining Road was located in the Ulanqab League area and there was no post route in the area at the time. The post system not only enhanced government administration over distant and border areas, but also played a very significant role in transportation. It was highly possible that Yuan porcelain was transferred through post routes to Jining, the northern regions of the Gobi Desert and onwards to Central Asia.[33]

9.2 The Jingdezhen Kilns

9.2.1 *Important Factors Contributing to the Development of the Jingdezhen Kilns*

In the Song Dynasty, since the Jingdezhen kilns produced blue and white porcelain of a quality comparable to jade, the kilns gained the favor of the imperial family and often sent tributes to the court. But at the time, the Jingdehzen kilns were not among the five largest kilns, so were far less significant than the Longquan, Yaozhou and other kilns. In the Yuan Dynasty, the Jingdezhen kilns began to attract the attention of the world and ranked as one of the most important kilns of the day. From 1271 to 1295 when Marco Polo, an Italian merchant, visited Asia, he recorded his journey. According to him, "There was a city called Jingdezhen where the best porcelain cups of the world were produced. Other than that city, no other place in the world can produce such good cups."[34] From this description, we can see how influential Jingdezhen was. But why was that? Several factors contributed to Jingdezhen's reputation.

9.2.1.1 Reform of Clay Making

Before the Yuan Dynasty, the major raw material of Jingdezhen porcelain was porcelain stone. In the Southern Song Dynasty, the depletion of porcelain stone led to the downfall of the Jingdezhen kilns. After the Yuan Dynasty, potters discovered a new material to make porcelain, a quality clay later known as kaolin. The introduction of kaolin into clay making not only expanded the range of raw materials, but also opened up a new era when the transition from soft porcelain made with a low-temperature fire to hard porcelain made with a high-temperature fire was underway.[35] Kaolin was a quality and pure porcelain-making clay. Porcelain stone alone can only bear

[33] Lu Minghua, "A Preliminary Study of Porcelain Unearthed in Jining," Chinese Society for Ancient Ceramics (ed.), *Studies on Ancient Chinese Ceramics* (Vol. 11), The Forbidden City Publishing House, 2005, p. 55.

[34] Marco Polo, *The Travels of Marco Polo*, Hugh Murray (ed.), New York, 1852, pp. 179–180.

[35] Liu Xinyuan & Bai Kun, "A Historical Examination of Kaolin," *China Ceramics*, supplementary issue in 1982.

a low sintering temperature and collapses or warps at high temperature. In contrast, containing an abundance of Aluminum oxide, kaolin is very fire-resistant. When porcelain stone and kaolin are mixed together, the sintering temperature will be high, and the density of the clay will also be enhanced. Besides, the color will also be whiter than if using porcelain stone alone. So, after the addition of transparent vitreous glaze, porcelain will appear as pure as jade and as clean as ice. It is fair to say that the use of kaolin signified an advanced development level of the Jingdezhen kilns.

9.2.1.2 White Porcelain Gains the Favor of Rulers

As early as the Sui and Tang dynasties, China's white porcelain production was already very mature. Xing kiln white porcelain from the Tang Dynasty was as "white as snow and shiny as silver", while the celadon ware from the Yue kilns was as "pure as ice and smooth as jade", winning both wide acclaim. In the Song Dynasty, the Ding kilns were among the top 5 famous kilns because of its white porcelain. But in the Song Dynasty, white porcelain was only famous for its surface print and painting decorations and little progress was made in the quality of the clay. For celadon ware and black porcelain which were made with a hot fire and color glaze, the clay was not the most important element. However, for white porcelain with a transparent vitreous glaze, clay is vital. Raw materials for Jingdezhen white porcelain contained more Aluminum oxide with the introduction of kaolin and along with the improvement in technique, much progress was made in the clay making of white porcelain. White porcelain produced in Jingdezhen was not pure white. Rather, it was slightly bluish, the color of duck eggs, so it was also known as egg-white porcelain. Besides, the glaze viscosity used on white porcelain was quite opalescent, lacking the glass-like brilliance of previous periods, resulting in a warm lanolin-like feel. This white porcelain won favor with the Yuan rulers and was nominated as a tribute item for the imperial family. The reason that Yuan rulers liked white porcelain was because, in the author's opinion, it had something to do with the Mongols' preference for white as they believed that it represented good luck.[36] As a matter of fact, when exploring the ceramic history of the Jin Dynasty, it was discovered that most of the northern nomadic peoples liked white, or black and white, hence the boom of the Ding and Cizhou kilns in the Jin Dynasty. It therefore seemed quite natural in the Yuan Dynasty that white porcelain would gain favor with the Mongol rulers, and since Mongols liked printing decorations, egg-white porcelain with flower printings produced by Jingdezhen was also the preferred choice for imperial use. While at the time, the Jingdezhen kilns were not as advanced and productive as the Longquan kilns, the Yuan government decided to set up the only administrative organ for porcelain, namely the Fuliang Ceramic Bureau, in Jingdezhen, which not only strengthened Jingdezhen's role in the ceramics industry, but it also helped promote the technical

[36] Tao Zongyi, *Record of Ceasing Farm Labors*, Vol. 1.

progress of Jingdezhen due to the high standards that the rulers demanded of their tributes.

9.2.1.3 Export Demands

According to *Jingdezhen Taolu* (*An Account of Ceramic Production in Jingdezhen*), the government appointed officials to take charge of porcelain production, and this production had to cease if no order was issued.[37] But the Yuan rulers allowed production by private kilns in Jingdezhen due to the export demand and taxation profits, thus private kilns became extremely prosperous. However, the quality of the products from private kilns fell far short of the imperial tributes which were selected by a factor of one-in-one-hundred.[38] Because of the huge overseas demand, blue and white porcelain was especially produced for export to Islamic regions. Meanwhile, after successfully producing bluish white porcelain, Jingdezhen also succeeded in manufacturing new varieties like white porcelain, copper red glazed porcelain and altar blue porcelain, inaugurating a new chapter in the history of Chinese ceramic arts and also laying a solid foundation for Jingdezhen to become the national ceramic center during the Ming Dynasty.

9.2.2 Jingdezhen Blue and White Porcelain

9.2.2.1 Emergence of Jingdezhen Blue and White Porcelain

Traditional views held that blue and white porcelain originated from the Jingdezhen kilns in the Yuan Dynasty. But now, academia generally believes that blue and white porcelain can be traced back to the Tang and Song dynasties (though there is some dispute about dating it back to the Tang).

In the Song Dynasty, very little blue and white porcelain was produced. To date the relevant archaeological discoveries include: in 1957, a complete blue and white bowl was found when excavating the footing of Jinsha Tower in Longquan, Zhejiang Province, which can be dated back to 977, in the Northern Song Dynasty, along with 13 pieces of mouth shard and the bellies of three broken blue and white bowls; in 1970, when dismantling the Huancui Tower built in 1265, in Shaoxing, Zhejiang Province, another shard of a blue and white bowl was discovered. All the pieces found were products of less advanced techniques as they were quite gray and dark in color and their clay and glaze were inferior to the bluish white porcelain produced by the Jingdezhen kilns. Thus, it seems that the producer of these pieces was the Jiangshan kiln in Zhejiang Province. Built in the Song Dynasty, the Jiangshan kiln operated until the Qing Dynasty. Jiangshan was also a supplier of asbolite.

[37] Lan Pu, *Jingdezhen Taolu*, Vol. 5.

[38] See Footnote 37.

Fig. 9.4 Blue and white
lidded plum vase with
twining peony pattern,
height: 48.7 cm, mouth rim
diameter: 3.5 cm, found in a
pit in Gaoan, Jiangxi
Province, in the Gaoan
Museum

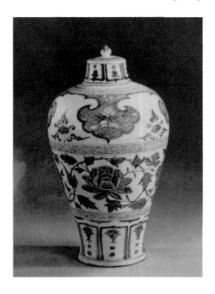

According to the Shanghai Institute of Ceramics, the reason why porcelain produced
in Zhejiang was not as colorful as that from Jingdezhen was because its raw material
was mainly asbolite; its percentage of cobalt was quite low at only 0.1–0.2%, while
its manganese content was ten times as high as cobalt, so the porcelain appeared
dark. In contrast, Jingdezhen porcelain had twice or even five times as much cobalt,
while its manganese content was only one tenth that of Zhejiang. This showed that
the unearthed pieces in Zhejiang were produced locally. Thus, some experts believe
that this kind of porcelain was originally made in small private kilns and were exper-
imental products. The quantity was small and of unstable quality and mostly dusty
blue. It is possible that when they were made, the raw materials were obtained from
local sources and their production was restricted by the then natural conditions and
production levels.[39]

From the above information we can see that blue and white porcelain can be dated
in China back to the northern kilns of the Tang Dynasty, and that with twists and
turns, it once again emerged in the southern region during the Song Dynasty. But
its production at this time was at an initial exploratory stage and that commercial
scale production was yet to appear. It was in the Yuan Dynasty that blue and white
porcelain production really began in the Jingdezhen kilns. This was a very important
event in the history of Chinese ceramics, and a turning point in the transition from
single color decoration to colorful drawing decoration (Fig. 9.4). This explains one
of the reasons why the Jingdezhen kilns emerged as the most important porcelain
producer following the Yuan Dynasty. This author believes there are three factors
which contributed to Jingdezhen's production of blue and white porcelain during the
Yuan Dynasty.

[39] Zhao Guanglin, "On the Origin and Development of Blue and White Porcelain," *Porcelain of
Jingdezhen*, Issue 26, 1984, p. 217.

a. As Jingdezhen used both porcelain stone and kaolin as raw materials, the firing temperature was high and the quality of the clay was improved. Then, there seemed to be a natural urge to find a new way of decoration on the smooth, white surface of the porcelain, thus propelling the development of the industry. In the Tang and Song dynasties, Jingdezhen did not produce color porcelain, and the bluish white porcelain produced in the Song Dynasty was simply decorated based on its original color. In the Yuan Dynasty, white porcelain made by Jingdezhen used quality clay, which paved the way for the emergence of blue and white porcelain.

b. Many scholars believe that the rise of Jingdezhen porcelain had much to do with the fall of the Jizhou kilns in Jiangxi Province and the migration of craftsmen from the Cizhou kilns to the southern regions. After the Mongol Empire defeated the Song and established the Yuan regime, the national population dropped sharply while Fuliang (a county in Jingdezhen) saw its population increase. According to records, Fuliang had 30,832 households and a population of 137,053 in 1269. In 1290, the households in Fuliang increased to 50,786 and the population to 192,148. The abrupt net increase of 55,000 people was clearly a result of the migration of people from the northern areas, and especially craftsmen. Some archaeologists believe that among these craftsmen, some were from the Cizhou kilns and that they brought the underglaze technique of the Cizhou kilns to Jingdezhen. Some of the reason for this belief, other than the sharp increase in population, is that Jingdezhen's blue and white porcelain had much in common with Cizhou underglazed black porcelain, like firing techniques, modeling, decorations, and glazing styles. Additionally, some shards of Cizhou underglazed black porcelain and underglazed red and green porcelain have been found in the ruins of Yuan period Jingdezhen kilns.[40] Another argument holds that the rise of Jingdezhen blue and white porcelain was due to the Jizhou kilns. A former prefecture chief of Jizhou once wrote: "In the Song Dynasty, the major producer of porcelain in Jiangxi Province was in Yonghe, a town in Ji'an… It was said that when craftsmen were making porcelain, after firing, there was a furnace transmutation, and the products became jade. The craftsmen were afraid the news might become known to those above, so they closed their kiln and ran away to make a living. So nowadays, most craftsmen in Jingdezhen were actually originally from Yonghe."[41] (Fig. 9.5).

In "A Preliminary Study on the Production History of the Jizhou kilns," Chen Baiquan proposed that the cessation of operations at the Jizhou kilns was due to Wen Tianxiang, a scholar-general in the final years of the Southern Song Dynasty. Wen was born in Jizhou and his family had lived in Yonghe for generations, but later moved to nearby Futianwei. A major highlight in Wen's life was to call for people to join the army to fight against the Mongol troops. After several rounds of failure, he

[40] Research Institute of the Ceramics Industry, Ministry of Light Industry (ed.), *Chinese Porcelain*, China Light Industry Press, 1983, p. 197.

[41] *Notes of Shi Runzhang*. Quoted from a secondary source: Chen Baiquan, "A Preliminary Study on the Production History of the Jizhou kilns," *Chinese Ceramics*, Issue 7, 1982.

Fig. 9.5 Black and white
furnace with pine, bamboo
and plum blossom pattern,
produced in the Yuan
Dynasty, height: 31.4 cm,
mouth rim diameter:
20.1 cm, in the Palace
Museum

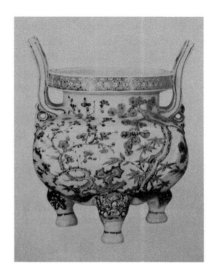

attempted to gather people to enroll in his hometown, Jizhou, and the thousands of workers at the Jizhou kilns were his main target. After failing again, these craftsmen were either killed or pursued. Those who survived were too afraid to return and work in Jizhou and so they left to work in emerging kilns in the nearby Jingdezhen in order to making a living. Their arrival invigorated the ceramics industry of Jingdezhen with new technology.[42]

The Jizhou kilns had produced a large amount of underglazed polychrome porcelain in the Southern Song Dynasty and had had a far-reaching effect. Underglazed polychrome porcelain was initiated by the Changsha kilns in the Tang Dynasty and matured in the Jizhou kilns in the Southern Song. When the Jizhou potters left for Jingdezhen, they brought underglaze techniques with them, paving the way for the production of blue and white porcelain in the Jingdezhen kilns in the future. One of the successful features that Jingdezhen drew upon from the Jizhou kilns was its mature underglaze porcelain production technology and its application of sets of major and supplementary motifs of color paintings as decoration, including creeping weed, fret patterns, brocade patterns, banana leaves, lotuses, water waves, twining flowers, etc., which bear a close resemblance to the blue and white porcelain we see today. What is more, in the Southern Song, products of the Jingdezhen kilns were not underglazed color-painted porcelain and Jingdezhen mainly applied modeling and engraving techniques for decoration. However, after the Yuan Dynasty, it seems products of the Jingdezhen kilns shared more similarities with Jizhou porcelain than their predecessors from previous generations (Fig. 9.6).

Feng Xianming believes that "Under the influence of the Cizhou kilns, Jizhou's underglaze color-painted porcelain shared a similar style. It was highly possible that after the Jingkang incident in 1127 when the forces of the Jurchen-led Jin Dynasty

[42] See Footnote 41.

Fig. 9.6 Blue and white
vase with twining peony
pattern, produced in the
Yuan Dynasty, height:
27.5 cm, mouth rim
diameter: 20.4 cm, in the
Shanghai Museum

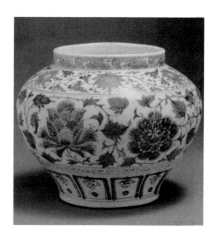

besieged and sacked Bianjing (present-day Kaifeng), the capital of the Han Chinese-led Song dynasty, some workers of the Cizhou kilns moved to Jiangxi and brought underglaze color painting techniques to Yonghe, which was very close to Jingdezhen and easily reached via the Ganjiang River. So, Jingdezhen was much more influenced by the Jizhou kilns than the Cizhou kilns, and the blue and white porcelain produced by Jingdezhen was closely related to the underglaze color painting techniques of the Cizhou kilns."[43] What is more, some hold that "Color painted porcelain in the south was inaugurated in the Jizhou kilns, making blue and white color painting possible. In this regard, color painting techniques of the Jizhou kilns played an important role in ceramic history." "Blue and white color-painted porcelain was very much associated with the Jizhou kilns."[44] Many scholars argue that it was not a coincidence that the Jizhou kilns collapsed during the early Yuan Dynasty and that the blue and white porcelain of Jingdezhen boomed in the mid-Yuan. This author thinks whether directly affected by the Cizhou kilns, inheriting the decoration techniques of the Cizhou kilns via the Jizhou kilns, or being directly influenced by the underglaze color techniques of Jizhou kilns, the traditional underglaze color painting skills passed on from the Changsha kilns in the Tang Dynasty to the Cizhou and Jizhou kilns made blue and white porcelain possible in terms of decoration.

c. The emergence and growth of Jingdezhen's blue and white porcelain was rapid. Not long previously, Jingdezhen could only make bluish white porcelain, with knife carving as the main decorative technique, while in the Yuan Dynasty, its color drawing with brushes in blue and white porcelain had already become extremely delicate and exquisite. It seemed that something was missing in this transformation. What forces could possibly have driven its rapid development?

[43] Feng Xianming, "Several Issues in the Development of Chinese Ceramics—A Discussion based on an Exhibition of Unearthed Chinese Ceramics," *Cultural Relics*, Issue 7, 1973.

[44] Chen Baiquan, "A Preliminary Study on the Production History of the Jizhou kilns," *Chinese Ceramics*, Issue 7, 1982, p. 117.

Fundamentally, the reason lay in economic profit, overseas demand, and commercial need. China's trade with Central and West Asia began in Guangdong, mainly through Persian and Arabic merchants. After 1200, exports migrated to the north. From the thirteenth century to the mid-fifteenth century, the most important port in China was Quanzhou. Maritime trade led to exchange between Muslim businessmen living in China and Chinese craftsmen. Through Persian and Syrian merchants, cobalt blue was introduced into Jingdezhen pottery from the Muslim world, and Muslim countries, which were interested in ancient Chinese ceramics, placed large orders for blue and white porcelain. These Muslim merchants not only supplied cobalt blue for decoration in the blue and white porcelain, but also provided a wide market for the delicately made porcelain articles.

These three factors made possible the production of blue and white porcelain in Jingdezhen in terms of clay, color painting techniques, decoration materials and markets, thus leading to a far-reaching revolution in the Chinese ceramics industry along with the boom of the Jingdezhen kilns in the Yuan Dynasty.

9.2.2.2 Different Development Phases of Jingdezhen Blue and White Porcelain

a. Disputes in the Yanyou Period

In the past, academics have held that blue and white porcelain made in Jingdezhen primarily falls into three periods: the Yanyou period, the Zhizheng period and the late Yuan period. The Yanyou period spanned the decades from 1271 to 1335–1340, a preparatory phase in the maturation of blue and white porcelain. However, not many products marked with their years of production have been found; only a limited number have been discovered. For example, a blue and white tower-shaped pot with a lid, made in 1319, was unearthed in a tomb in Huangmei County, Hubei Province in 1975; a set of underglaze blue and red porcelain composed of two figures, a tower-shaped pot with a lid and a porcelain granary in the shape of a pavilion, were unearthed in Jiangxi in 1977 (according to the epitaph, the tomb owner, Ling, was born in 1293 and died in 1338, and the porcelain buried with him was made in 1338) (Figs. 9.7 and 9.8). Such products were not only rarely found, but none have been discovered in kilns. Additionally, of the porcelain salvaged from shipwrecks in Sinan, South Korea, which were believed to be products of the mid-Yuan Dynasty, there was no white and blue porcelain. This indicates that at the time, Jingdezhen's production of blue and white porcelain was not fully mature, not to mention exports. This means that there was little production of blue and white porcelain at the time, and the technology was not very advanced.

There has been much debate over porcelain production in Jingdezhen in recent years, and the major dispute has been whether the blue and white tower-shaped pot made in 1319 was a blue and white porcelain article.

In Issue 9, 2009 of *Collections*, an article named "The 1319 Tower-shaped Pot Revealed as a Product of Iron Painting" states that from May 19 to 22, 2009, the

Fig. 9.7 Black and white emboss-glazed tower-shaped pot with lid, height: 22.5 cm, mouth rim diameter: 7.7 cm, unearthed in Fengcheng, Jiangxi Province, in the Jiangxi Provincial Museum

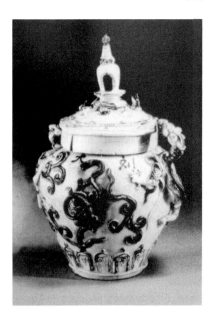

Fig. 9.8 Blue and white copper red glazed granary in the shape of a pavilion, height: 29.5 cm, width: 24.5 cm, unearthed in Fengcheng, Jiangxi Province, in the Jiangxi Provincial Museum

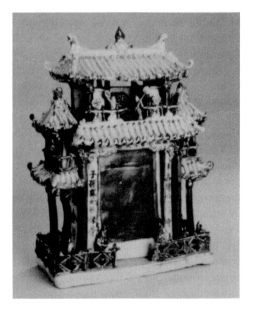

Chinese Society of Ancient Ceramics hosted a seminar in Beijing on Yuan blue and white porcelain with over 50 participants from the Palace Museum, Shanghai Museum, Capital Museum, and some provincial museums and archaeological agencies, as well as some auction houses. The participants took part in a blue and white porcelain exhibition held in the Capital Museum and a special exhibition of ceramics

in the Palace Museum. Some 24 experts engaged in discussions on authentication, division of historical periods, cobalt blue materials, decorations and unearthed documents. Academia formerly divided blue and white porcelain into two types, the Yanyou type (made with domestic cobalt blue) and the Zhizheng type (made with imported cobalt blue). The Yanyou porcelain was represented by two tower-shaped vases unearthed from the Xichi kiln in Huangmei County in Hubei Province in 1972 which were produced in 1319 and had virtually become standards by which to judge whether a porcelain article fell into this category. One piece used to be held in the Huangmei Museum but now is in the Hubei Provincial Museum. Another piece is housed in the Jiujiang Museum in Jiangxi Province. This conference revealed the scientific test results on the Yanyou vase in the Hubei Provincial Museum. It showed that this ware was made with iron, not cobalt blue material, which corrected the past erroneous idea that the piece was a Yanyou porcelain. Participants in the seminar all agreed that Yuan blue and white porcelain had been made in the late Yuan Dynasty, for no more than 50 years.[45] "After conducting studies and tests on Yuan blue and white porcelain and relevant materials, some new ideas have emerged in recent years. For instance, a blue and white female seated figurine unearthed in Hangzhou was once regarded as a product of Yanyou. After study, however, it was found that it was made in the later period of Yanyou. In that seminar, some also revealed the test results of the vase in the Jiujiang Museum, denoting it as a product of iron painting. A piece of Buddha head polychrome porcelain unearthed in the Bijiashan kiln in Chaozhou, Guangdong Province also appeared to be an article of blue and white porcelain. But according to tests at the Palace Museum, it was in fact found to be iron painting."[46]

Thus, it seems blue and white porcelain and black and white porcelain, also called iron porcelain, have much in common. Except for raw materials, they share similarities in decorative style and production technique. Thus, is it possible that the Cizhou and Jizhou kilns, apart from skills, also passed on iron materials to Jingdezhen?

The scholar Ouyang Xijun even suspected that there was a stage when Jingdezhen produced brown and black underglazed porcelain before it made blue and white porcelain. He wrote: "Among the wrecks of the sunken ship in Sinan, South Korea, there were over a dozen pieces of black porcelain plates with human figures, flowers or animals. The late ceramic expert, Mr. Feng Xianming pointed out that 'From these, we can see that before Jingdezhen started to produce blue and white porcelain and underglazed red porcelain, it once made black porcelain. When discussing the relations between the Jingdezhen kilns and the Jizhou and Cizhou kilns, the relations between underglazed black and red porcelain with blue and white porcelain are indispensable.' So it seems that before blue and white porcelain was made in the late Yuan Dynasty, Jingdezhen had made underglazed brown and black porcelain, and the two pieces of tower-shaped porcelain made in 1319 were two of these. But they have

[45] Geng Sheng, "The 1319 Tower-shaped Pot Revealed to be a Product of Iron Painting," *Collections*, Issue 9, 2009.

[46] See Footnote 45.

nothing to do with cobalt blue materials, because this was blue, not black or brown."[47] Despite the scientific proof, some still doubted the 1319 porcelain contained iron. In "Views on the 1319 Tower-shaped Pots," Zhou Fangqing expressed the following view: "In the early stages, Yuan blue and white porcelain was glazed bluish white with cobalt blue paintings. This cobalt blue was a domestically produced substance with a high content of iron, which made it gray-blue and shiny under sunlight. So, this author thinks that it is not really appropriate to say that the 1319 porcelain contains iron, because cobalt blue contains other elements. A blue and white animal head tower-shaped pot in the Jiujiang Museum was once suspected to be a product of iron painting. But this author believes that its color was so because of the color of the soil where it was unearthed. As cobalt blue contains an element of iron, after burial underground for a long time, and with oxidation, unearthed porcelain might appear to be iron painted."[48] He also argues that, while the relevant departments have tested the 1319 porcelain, even including the cobalt blue material and glaze, we need to be critical. The color might be so because of the long period of oxidation underground, thus affecting its color. Besides, in early times, blue and white porcelain was bluish white, which made it easily affected by oxidation. Thus, he believes that the 1319 pot in the Jiujiang Museum was made of domestic cobalt blue material and not a product of iron painting.[49]

Let us suppose that the porcelain in the Jiujiang Museum was iron painted and not made with cobalt blue. Can we deny the long-held view in academia that Jingdezhen once produced Yanyou porcelain, and is it possible Jingdezhen once produced underglaze black and brown porcelain? Even if it were true, the problem is: are the so-called scientific tests really accurate? Can the test results really prove that the pot in the Jiujiang Museum was iron painted? If not, it is hard to deny that Jingdezhen once made Yanyou porcelain. In the view of this author, blue and white porcelain can have originated as early as the Tang Dynasty. If it was not mature at that time, the Song Dynasty at least also produced some. If we deny this, then we can only say that Chinese blue and white porcelain was first made in the Zhizheng period (1341–1370) of the Yuan Dynasty.

With a result like this, there is no doubt we require further studies and archaeological discoveries to sort out the truth.

b. Discussions on the Zhizheng Period

The traditional view of academia is that the Zhizheng period followed the Yanyou period and that Jingdezhen blue and white porcelain reached maturity when a large amount of porcelain was made to meet export demands. However, history recorded very little of this fact. So, for a long time, there was a lack of knowledge of Yuan blue and white porcelain and for some time, its very existence was unknown to the world. Studies on this period, including discovery and time periods of Zhizheng

[47] Ouyang Xijun, "Doubts on Yanyou Blue and White Porcelain," *The Collection of Reference*, Nov. 2010, pp. 14–17.

[48] Zhou Fangqing, "Views on the 1319 Tower-shaped Pots," *Collections*, Issue 4, 2010.

[49] See Footnote 48.

porcelain, began with the British scholar Robert Lockhart Hobson. In 1929, when he visited the Oriental Art Pavilion of the Percival David Foundation of Chinese Art, he found a pair of blue and white dragon vases with a round mouth and elephant-shaped lugs marked with the 11th year of Zhizheng, namely 1351 (Fig. 9.9), with the inscription "Zhang Wenjin, from Jingtang Community, Dejiao Village, Shuncheng Town, Yushan County, Xinzhou Circuit, a disciple of the Holy Gods, is pleased to offer a set comprising one incense burner and a pair of flower vases to General Hu Jingyi at the Original Palace in Xingyuan as a prayer for the protection and blessing of the whole family and for the peace of his sons and daughters. Carefully offered on an auspicious day in the Fourth Month, 11th Year of the Zhizheng reign."[50] This pair of vases has a glittering glaze, bright color and eight layers of decorations including twining chrysanthemums, banana leaves, phoenixes, twining lotuses, flying dragons, waves, peonies and lotus petals. The two vases are not only valuable artistically but have also become benchmarks in dividing the historical periods according to when a piece of porcelain was made. After the 1950s, Dr. John Alexander Pope from the USA compared this pair of vases with similar porcelain from the Ardebil Shrine and the Istanbul Museum in Turkey as well as other porcelain made by Jingdezhen. He used the 1351 vases as a standard and identified 74 pieces as "Zhizheng" porcelain and also published identification and classification methods of blue and white porcelain in his article. This subsequently served as a benchmark on the matter. Later, Yuan blue and white porcelain was also found in China, Japan, Democratic People's Republic of Korea, Indonesia, the Philippines, Malaysia, Thailand, Singapore, India, Egypt, Yemen, Lebanon, Italy, and elsewhere. Seven Yuan kilns were found to contain pieces of blue and white porcelain. Thus, we can see that in the second half of the fourteenth century, production of blue and white porcelain boomed and exports prospered.

Zhizheng porcelain falls into two categories. The first are large articles as represented by the 1351 vases. Since porcelain of this type used porcelain stone and kaolin in the clay making, it has more aluminum oxide when compared with the bluish white porcelain of the Song Dynasty. In addition, it has less calcium oxide and more potassium and sodium in its glaze than bluish white porcelain, so it looks slightly bluish, smooth and bright. Its cobalt blue has little manganese, but much iron along with some arsenic, quite contrary to domestic cobalt blue. It therefore must have used imported cobalt blue which appears rich and bright once applied, and the glaze also exhibits black spots.

The majority of this type of porcelain includes large vases, pots, plates and bowls. They usually have many layers of decoration, with major and auxiliary decorations placed together as a whole. The major decorations fall into three categories: the first is whole pictures, like fish and algae pictures (usually on pots and plates, Fig. 9.10), human figure pictures (usually on pots, plum vases and *yuhuchunping*, namely pear-shaped vases, Fig. 9.11); the second is images of animals, mostly dragons, including dragons flying in clouds and dragons swimming in seawater (usually on pots, plates, vases and bottles), and also phoenixes, peacocks (usually on plates, vases, bottles, and jars), lions (diamond-shaped bottles), horses (plates and pots), kylins (plates, vases

[50] Chinese Ceramic Society (ed.), *History of Chinese Ceramics*, Cultural Relics Press, 1982, p. 339.

Fig. 9.9 Blue and white dragon vase with round mouth and elephant-shaped lugs, height: 63.4 cm, mouth rim diameter: 14.8 cm, in the Percival David Foundation of Chinese Art

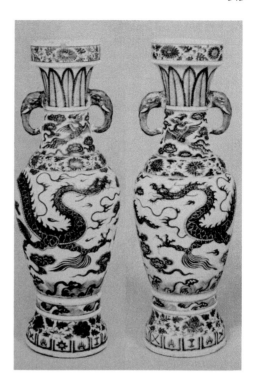

and kettles), grass and insects (plum vases); the third is flowers and twigs, mostly twining peony and lotus (usually on pots, plates, vases and goblet grain holders). In addition, there are also strings of flowers (on goblets, bottles and kettles, Fig. 9.12), and other decorations.

Auxiliary decorations were usually put on the mouths and feet of artifacts, and several sets of motifs were used to separate different parts of a piece of porcelain, mostly twining flowers (peony, lotus and chrysanthemum), lotus petals, and water

Fig. 9.10 Blue and white plate with double fish and algae pattern, produced in the Yuan Dynasty, height: 8 cm, mouth rim diameter: 45.3 cm, unearthed in Changde, Hunan Province, in the Hunan Museum

Fig. 9.11 Blue and white
figure and peony pot with lid
from the Yuxi kiln, produced
in the Yuan Dynasty, height:
28.4 cm, mouth rim
diameter: 18.5 cm, in the
Yunnan Provincial Museum

Fig. 9.12 Blue and white
vase with twigs of
chrysanthemum and two
rings of elephant lugs,
produced in the Yuan
Dynasty, height: 26.8 cm,
mouth rim diameter: 8.1 cm,
bottom diameter: 10 cm,
unearthed in Santai county,
Sichuan Province, in the
Cultural Relics
Administration Bureau of
Santai County, Sichuan
Province

waves (moving or motionless). Buddhism's Eight Auspicious Symbols were not yet
fixed by the Yuan Dynasty, but motifs often seen included flaming pearls, coral, conch
shells, rhinoceros horns, lucid ganoderma, double fish, bananas, wheels, umbrellas,
vases and endless knots. Besides these, fret patterns, banana leaves, the wheel of
Dharma, moire, lotus, twining pomegranates, and Chinese flowering crabapples

Fig. 9.13 Jingdezhen blue
and white octagonal pot,
produced in the Yuan
Dynasty, in the Victoria and
Albert Museum

are often used as auxiliary decorations. In addition, *ruyi*-head-shaped and lozenge-shaped panels were also often seen.[51] This type of porcelain is very traditional in theme and content while its style is a little exotic. Their shapes are especially Islamic and rarely seen at home, therefore porcelain of this type was apparently earmarked for export.

The octagonal pot illustrated in Fig. 9.13 is the bottom part of a *huluping* (a double-gourd vase), which might have been split into two at a later time. Its mouth was used as a brass buckle in the Iranian Qajar Dynasty (1796–1925), and the detailed images on the buckle might have come from earlier Iranian works, for example, an illustrated work describing the cosmology of bizarre creatures. Recently, it has been verified that the upper part of the gourd bottle is in the State Museum of Oriental Art in Moscow. A piece like the bottom section is now in the Ardebil Shrine, which was built by Abbas I the Great of the Safavid Empire. In the Topkapi Sarayi Museum in Istanbul, Turkey, a complete example of this type of gourd bottle can be found.

The plates in Figs. 9.14 and 9.15 carry a lot of decorations, which is quite typical of large plates made in the mid-fourteenth century. These kinds of plates are made by molding and were earmarked for export to India, the Middle East, and North Africa for Muslim banquets. In the Palace of Tughluqs in Delhi, India, built in 1354, two shards of porcelain with similar decorations were found, with the inscriptions "Imperial Kitchen" and "sād," indicating that they were especially used by the royal family. The Topkapi Sarayi Museum also has two similar plates among its collections (Figs. 9.16 and 9.17).

The Blue and white wine jar with fish playing with lotus in Fig. 9.18 is an exquisite specimen from the Berkeley Art Museum. It is an excellent example of Yuan blue and white porcelain with its shining blue glaze, vigorous, firm shape, neat decoration, meticulous, full body with four vivid fish as well as lotus and other plants. The picture

[51] Feng Xianming (ed.), *Chinese Ceramics*, Shanghai Chinese Classics Publishing House, 1993, p. 460.

Fig. 9.14 Jingdezhen blue
and white peony plate,
produced in the Yuan
Dynasty, in the Victoria and
Albert Museum

Fig. 9.15 Jingdezhen blue
and white fish and algae
plate, produced in the Yuan
Dynasty, in the British
Museum

Fig. 9.16 Jingdezhen blue
and white plum vase,
produced in the Yuan
Dynasty, in the Topkapi
Sarayi Museum

Fig. 9.17 Blue and white melon, bamboo and grape plate with uneven rim, produced in the Yuan Dynasty, height: 7 cm, mouth rim diameter: 45 cm, in the Shanghai Museum

conveys a spirit of fairness and justice, reminding its owners to be righteous and, as a wine jar, alerting owners to be cautious when faced with temptation. From its painting style, color, and shape, it resembles the Zhizheng porcelain style. However, since its pictorial decoration is so simple and explicit and there is only one auxiliary decoration on its neck, it also looks like porcelain from the late period of the Yuan Dynasty. Thus, it has been designated as having a wide production range, from 1279 to 1368.

Another type is the medium- or small-sized porcelain made with domestic cobalt blue, which distinguishes it from the bright color of imported cobalt blue. It also has no black dots, and features simple and casual decorations. It was mainly aimed at the domestic market, but some were also exported to Asian countries like Japan, the Philippines, and Indonesia. Apart from large specimens, blue and white porcelain unearthed in these regions also included small articles like water jets, water drops, small jars, and small bowls, of which some are very rare. This shows that, in order

Fig. 9.18 Blue and white wine jar with fish playing with lotus, produced in the Yuan Dynasty, in the Berkeley Art Museum

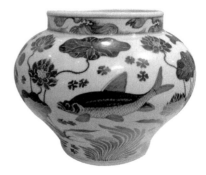

to meet the demands of different people in different places with different lifestyles, the Jingdezhen kilns made products for export.[52]

c. The Late Yuan Dynasty

Some scholars believe that the Zhizheng period lasted until around the 1350s, when wars swept Jingdezhen, and by 1360 the Ming regime had already taken over Jingdezhen. Waves of wars not only affected Jingdezhen's exports, but also cut off its sources of imported cobalt blue. From this time, Jingdezhen entered its third phase of production, namely the late Yuan Dynasty, which began in the 1350s and lasted with the end of the Yuan Dynasty in 1368. During this period, trade with the Middle East was cut off and imported cobalt blue was no longer available after all stocks had been used up. During this stage, production of blue and white porcelain in Jingdezhen became diversified.

There were domestic and imported sources of cobalt blue materials, and glaze color varied from transparent white and egg-white to bluish white. Generally, imported cobalt blue was used on transparent white porcelain, mostly to make large articles or exquisite medium- and small-sized porcelain. They had a similar decorative style to the Zhizheng period, but more explicit. This kind of product was custom-made for aristocrats and might also be exported. Domestic cobalt blue was usually applied on egg-white and bluish white porcelain. Egg-white porcelain was generally decorated with simple paintings of flowers while bluish white porcelain had various means of decoration, like simple paintings or "heavy and light paintings in a single stroke." Small porcelain with simple paintings can be found in Southeast Asian countries, but at home in China, no examples have been identified to date. It therefore seems that this style of porcelain was mainly made for export to Southeast Asia. Meanwhile, porcelain made using the "heavy and light paintings in a single stroke" technique were mainly made for domestic use.

Most blue and white porcelain made in the late Yuan Dynasty had no markings of production date on them and many used domestic cobalt blue. So, after 1368, under the rule of the Ming Dynasty (1368–1644), such porcelain continued to be made, despite dynastic change. At the same time, the decorative style changed little, especially porcelain for private use. Therefore, it is very difficult to distinguish between blue and white porcelain made in the late Yuan Dynasty and that made in the early Ming or even later, especially items for private use. It was once thought that the technique of "heavy and light paintings in a single stroke" was invented in the early Ming Dynasty, but it seems that it must have been applied from the late Yuan Dynasty. This technique was always a major decorative technique for inexpensive porcelain for private use in Jingdezhen until the Qing Dynasty (1636–1912), or even the Republican period (1912–1949).

[52] Feng Xianming (ed.), *Chinese Ceramics*, Shanghai Chinese Classics Publishing House, 1993, pp. 459–460.

9.2.2.3 The Nature of Yuan Blue and White Porcelain Production

There have been many arguments regarding the nature of the production of Yuan blue and white porcelain. Some hold that typical Jingdezhen blue and white porcelain was made by private kilns to meet market demands at home and overseas. The reason for this is that according to a work entitled *Records of Zhizheng*, written by Kong Qi in the late Yuan Dynasty, government officials and scholars tended to use porcelain from the Ding kilns, official kilns, Ge kilns, and Yutu kilns from Jingdezhen (*Shufu* porcelain), but there was no mention of blue and white porcelain. *Shufu* porcelain produced by official kilns rarely used the decorations that can be found on blue and white porcelain. Among various blue and white porcelain decorations, the most noticeable was the number of fingers on dragons. According to the *History of the Yuan Dynasty—On Emperor Shun*, in April 1336 an order was issued prohibiting the use of "any kylin, phoenix, white rabbit, lucid ganoderma, dragon with two horns and five fingers, eight dragons, nine dragons, the characters *Fu* and *Shou* and the yellow color used by emperors." Thus, Mr. Feng Xianming believes: "From this, we can see that private kilns were not permitted to make porcelain with dragons that have five fingers and we indeed have found no extant blue and white porcelain with dragons with five fingers on them."[53] Mr. Wang Qingzheng points out that among all extant Yuan porcelain, we can only find *Shufu* porcelain produced by official kilns carrying dragons with five fingers. On typical Yuan blue and white porcelain, we can only find dragons with three or four fingers. "*Chunshou*" plum vases housed in the Shanghai Museum and in Japan and the UK have dragons with five fingers. We once regarded these as products of the Yuan Dynasty, although with some doubt. But actually, they have turned out to be products of the Ming Dynasty under the rule of Zhu Yuanzhang (1368–1398), founder of the Ming regime. Since classical Yuan blue and white porcelain has no dragons with five fingers, it can be concluded that they were not made by official kilns.[54] (Fig. 9.19).

In "Overview of Blue and White Porcelain Across the Ages," Lu Minghua points out that "The Fuliang Ceramic Bureau operated in Jingdezhen for 74 years, yet none of its products has been found marked with its official insignia. In contrast, much of the egg-white porcelain from the official kilns bears marks such as '*Shufu*' and '*Taixi*', etc., which were marked especially for use by the Privy Council (for practical use) and the Taixi Sacrifice Bureau (for offering sacrifice to the ancestors). Meanwhile, at the time, blue and white porcelain appears to have been mainly used for export rather than widely used by the government, thus was rarely marked."[55]

In 1987, five pieces of blue and white porcelain were unearthed from the site of the official Zhushan kiln in Jingdezhen, including bowls, plates and goblets marked

[53] Feng Xianming (ed.), *Chinese Ceramics*, Shanghai Chinese Classics Publishing House, 1993, p. 461.

[54] Zhu Yuping, *Blue and White Porcelain in the Yuan Dynasty*, Wenhui Publishing House, 2000, p. 102.

[55] Wang Qingzheng (ed.), *Underglaze blue and red porcelain*, Shanghai Museum & Liangmu Publishing house (Hong Kong), 1987, p. 197.

Fig. 9.19 Blue and white
dragon bowl, produced in the
Yuan Dynasty, height: 9 cm,
mouth rim diameter: 18 cm,
unearthed from a pit in old
Gulou Street, Beijing, in the
Capital Museum

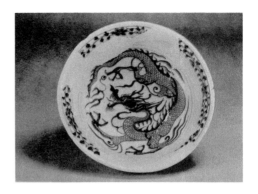

with dragons with five fingers and bearing characters in the Phags-pa script indicating that they were made in the "Zhizheng" period. In comparison with *"Chunshou"* plum vases, some scholars think that their decorative style was classic Yuan style and that their feet were also different from those of the Ming Dynasty. Thus, these articles are assumed to be products of the Yuan official kilns.[56]

Scholars represented by Mr. Liu Xinyuan believe that Zhizheng blue and white porcelain was made by official kilns under the administration of the Fuliang Ceramic Bureau. In order to make his point, Liu begins his analysis with the decorations. In "Singular Blue and White Designs of the Yuan and the Porcelain and Painting Services of Fuliang," he points out that after years of study, he has found that decorations of Yuan blue and white porcelain were affected by the following four factors: "First, it absorbs black painting techniques of the Cizhou or Jizhou kilns; second, it inherits engraving techniques developed and used by Jingdezhen from the Southern Song Dynasty to the early Yuan Dynasty; third, it exhibits influences from woodcut paintings; fourth, it takes paintings of the time as reference."[57] Liu Xinyuan proposes that, although some decorations may exhibit traces of these four origins, many others, like bead decorations, cloud shoulder decorations, horses, reeds and wild geese, lotus and water birds, have nothing to do with the four factors.[58] So where did these singular decorations originate?

In Liu's opinion, these decorations were from costumes and silk articles of aristocrats in the Yuan Dynasty. For instance, bead decorations came from a kind of garment called "quality sun dresses" which aristocrats wore to royal banquets; the horses with fire came from a flag carried by the guards of emperors; cloud shoulder decorations came from clothes of guards in the army; reeds and wild geese, though once popular in the Song Dynasty, was quite different in the Yuan as it was a goose biting reeds, which came from the clothes of level-five officials. Mandarin ducks swimming in a lotus pond, a common decoration, can be found in ladies' quilts

[56] See Footnote 54.

[57] Liu Xinyuan, "Singular Blue and White Designs of the Yuan and the Porcelain and Painting Services of Fuliang," *Journal of the Jingdezhen Ceramics Institute*, Issue 1, 1982, p. 9.

[58] See Footnote 57.

as well as in silk costumes.[59] Liu wrote that according to the *History of the Yuan Dynasty—On Emperor Shun*, in April 1336, an order was issued prohibiting the use of "any kylin, phoenix, white rabbit, lucid ganoderma, dragon with two horns and five fingers, eight dragons, nine dragons, the characters *Fu* and *Shou* and the yellow color used by emperors. Apart from white rabbits, all decorations banned in this order can be found in Yuan blue and white porcelain."[60]

We know that in ancient China, costumes that you wear represent your identity and social status, and decorations and colors on costumes have rules to follow. In Vol. 29 of *Etiquette on Costumes, Colors from Statutes of the Yuan Dynasty* and Vol. 28 of *History of the Yuan Dynasty: On Ceremonial Dress*, there were records of the costumes and colors people of different social levels wore. Especially detailed descriptions were made of what emperors and officials should wear. For example, in December 1314, different levels of officials wore different costumes in terms of color, texture, and decoration. A level-nine official, for instance, was allowed to wear a garment with four embroidered flowers, and officials above level five could wear clothes not only with embroidery, but their tents and carts could also be decorated with embroidery. However, for the common public, "They may only wear dark colored coarse cloth, silk or animal fur. Their hats cannot be decorated with gold or jade and they cannot make their shoes with special designs." If this was disobeyed, officials could be dismissed or demoted by one grade in the following year, while the common people could receive 57 lashes. The prohibited articles were to be confiscated as prizes for whistle-blowers. If the relevant government organs neglected their duties in this regard, the supervisory authorities would hold them responsible.

Different clothes, images and decorations represented different classes, even among government officials. So, were workers in Jingdezhen at liberty to place decorations with specific government provisions on porcelain at will? Liu points out that many of the decorations used on blue and white porcelain cannot be found on products from other kilns at the time. Thus, it seems that the use of these images might be especially approved by the Fuliang Ceramic Bureau, the sole authority on ceramics in the Yuan Dynasty, in service of the royal family. According to Vol. 88 of the *History of the Yuan Dynasty: Imperial Manufactories Commission*, "The Fuliang Ceramic Bureau, a level-nine bureau, founded in 1278, was in charge of the production of ceramics and equipped with a chairman and a vice chairman." Hence, Liu believes that Yuan blue and white porcelain that carried decorations associated with government officials and the royal family was all made with the approval of the Fuliang Ceramic Bureau.

According to Liu, such porcelain was not only a product of official kilns, but all their decoration designs can be traced back to government agencies. From the descriptions of the duties of the Imperial Manufactories Commission in Vol. 38 of the *History of the Yuan Dynasty: On Government Officials*, we can see that there were

[59] Liu Xinyuan, "Singular Blue and White Designs of the Yuan and the Porcelain and Painting Services of Fuliang," *Journal of the Jingdezhen Ceramics Institute*, Issue 1, 1982, pp. 10–13.

[60] Liu Xinyuan, "Singular Blue and White Designs of the Yuan and the Porcelain and Painting Services of Fuliang," *Jingdezhen Ceramics Institute Journal*, Issue 1, 1982, p. 15.

special agencies under its administration with specific divisions of labor. Among these agencies there was a painting bureau, a level-eight agency founded in 1278, which took charge of paintings and designs, under the leadership of a chairman. Thus, Liu argues that the Fuliang Ceramic Bureau functioned just like Jingdezhen as the imperial kiln in the Ming and Qing dynasties. All samples were designed by relevant agencies in the capital and no other kilns could copy them, not even private kilns which existed at the same time as Jingdezhen.

Such arguments answered two questions. First, this kind of porcelain with special decorations must have been made by official kilns; second, the large, meticulous and neatly designed Zhizheng style porcelain was actually painted by the Painting Bureau, not workers at the Jingdezhen kilns. That is also why this porcelain was so different from products of Jingdezhen from the Southern Song Dynasty.

For a long time, people thought that Jingdezhen blue and white porcelain was influenced by the Cizhou or Jizhou kilns. If Liu is correct, we now have another perspective to consider.

In Liu's opinion, extant blue and white porcelain wares at home and abroad can be placed into two categories. The first is large-sized objects with unique decorations and meticulous, neat designs, represented by collections in Iran and Turkey. Another type features simple structures and relatively casual strokes, represented by small articles unearthed in the Philippines and Indonesia.[61]

Liu thinks that the first type was made by official kilns, under the administration of the Fuliang Ceramic Bureau, no earlier than 1325 and no later than 1352, since in 1352 Fuliang was occupied by a rebel force. The second type was made no earlier than 1334 when the Fuliang Ceramic Bureau ceased operation and workers began earning their own living, and no later than 1368 when the Ming Dynasty was founded by Zhu Yuanzhang. As the former was made for imperial use, they were not numerous, but very exquisite, while the latter was produced to profit the workers themselves, so they were made in large quantities, but inferior in quality.[62]

So, was blue and white porcelain made for domestic markets or overseas markets? If for export, who were the exporters, private kilns or official kilns? Liu holds that some quality, large-sized porcelain with singular decorations were exported for profit. The evidence can be found in Vol. 25 of *History of the Yuan Dynasty: Treacherous Officials: On Temüder*. In 1314, Temüder proposed to the emperor that "…In the past, rich people conducted trade with foreign regions and gained huge profits. As more and more people were engaged in this business, there were too many exports for the foreign markets to absorb. Thus, our exports have become worth less and our imports more expensive. To turn this trend around, I suggest we put a limit on it. We should appoint Cao Li (an official in the Jiangsu and Zhejiang region) to lead only ten ships with pass permits to export. When they return, taxes shall be levied accordingly. If smugglers are found, all goods shall be confiscated." The emperor

[61] Liu Xinyuan, "Singular Blue and White Designs of the Yuan and the Porcelain and Painting Services of Fuliang," *Journal of the Jingdezhen Ceramics Institute*, Issue 1, 1982.

[62] See Footnote 61.

agreed.[63] Liu suggests that as early as 1293, porcelain was an important part of Yuan exports. From 1293 to 1314, the government allowed private kilns to sell products overseas, so those engaged in this business made a huge fortune. But after 1314, as more and more flooded into the business, the prices of Chinese exports were driven down while imports were up. To change this, the government appointed an official to direct ships to foreign markets and to squeeze others out of the business.

In his view, quality, large-sized porcelain with singular decorations were earmarked by the Fuliang Ceramic Bureau for export.[64] But one question remains: if these products were made for export, there would have been no need to place decorations based on the clothes of government officials on them, as there were apparently restrictions on how these decorations were to be used.

Jiang Jianxin holds the same view. In "On the Fuliang Ceramic Bureau, its Kilns and Products," he wrote that the establishment of the Fuliang Ceramic Bureau was probably because the government required "pure" articles to offer sacrifices to the ancestors. Porcelain made in the Hutian kilns with inscriptions of "*yu*" (jade in Chinese characters), was perhaps the first batch of products of the Fuliang Ceramic Bureau. Products of the bureau also included articles unearthed at the same time as the *yu* porcelain, including blue and white porcelain found in Iran and Turkey as well as those with singular decorations unearthed in Zhushan, including a blue and white dragon vase with a round mouth and elephant-shaped lugs. These were all products made to order by private kilns under the relaxed control of the government.[65]

Mr. Gao Ashen also agrees that Yuan blue and white porcelain was made under the administration of the Fuliang Ceramic Bureau. But he does not think that the bureau functioned like the official kilns of the Song, Ming and Qing dynasties. Instead, he writes that the Fuliang Ceramic Bureau was different from previous official kilns in that it not only produced porcelain for the government, but it also sold porcelain at home and abroad and made huge profits which it used for the military. Beautiful as they were, porcelain products not only brought trade surpluses to the country, but also gained popularity among certain influential people. Nevertheless, he believes that the government did not have much affection for blue and white porcelain and they just valued the profits porcelain could make for them. In a way, the demands of the domestic and overseas markets accelerated the growth of blue and white porcelain.[66]

Since blue and white porcelain could also be found on the domestic market at the time, why has hardly any been passed down to the present day (the extant blue and white wares have been mostly unearthed)? They are even unavailable in the Palace Museum, a place which houses the largest collections of Chinese treasures,

[63] Liu Xinyuan, "Singular Blue and White Designs of the Yuan and the Porcelain and Painting Services of Fuliang," *Journal of the Jingdezhen Ceramics Institute*, Issue 1, 1982.

[64] See Footnote 63.

[65] Jing Jianxin, "On the Fuliang Ceramic Bureau, its Kilns and Products," *Studies on Yuan Blue and White Porcelain*, Shanghai Lexicographical Publishing House, 2006.

[66] Gao Ashen, "Exploration on the Mature and Once Lost Yuan Blue and White Porcelain," *Collectors*, Issue 1, 2005, p. 49.

including products of the five most famous kilns of the Song Dynasty and arti-
cles used by the royal family in the Ming and Qing dynasties. Mr. Gao assumes
that after the Yuan Dynasty was overturned by Zhu Yuanzhang, founder of the
Ming Dynasty, he launched a cleansing campaign such that Zhizheng porcelain
was virtually obliterated.[67]

Another view holds that Zhizheng porcelain was produced by both official kilns
and private kilns. In an article published in *Cultural Relics in Southern China*, Issue
3 in 1994, Li Minju analyzed historical records and inscriptions found in tombs
and verified the time of establishment, scale and product features of the Fuliang
Ceramics Bureau. According to Li, the bureau was founded in 1278. Initially, it was
under the administration of the then Ministry of Works, and was subsumed by the
Imperial Manufactories Commission. Its products, made in Liujiawu in Jingdezhen
and mainly consisting of articles for daily use or for sacrifices, were offered to the
royal family and some were awarded to officials by various emperors. Li proposes that
not all blue and white porcelain was made under the auspices of the Fuliang Ceramic
Bureau. Most extant blue and white porcelain, including the most representative
piece, the Zhizheng blue and white dragon vase with round mouth and elephant-
shaped lugs, was made by private kilns. Thus, in order to truly figure out the truth
concerning Yuan blue and white porcelain, the key is to find out which item was
made by the Fuliang Ceramic Bureau and which was made by private kilns.[68]

Another view argues that such attractive porcelain articles were not destined for
sale. Instead, they were granted as awards to those who successfully conquered
western regions. One consideration was that the articles were very expensive since
very few could be produced due to the high technological standards required. So,
they could not possibly be sold on the market. The second reason is that decorations
on large articles of Yuan blue and white porcelain were from Tibetan Buddhism,
Taoism and traditional Chinese stories. How could Central Asia, an Islamic region
at the time, order products from China with decorations displaying other religions?
So, it seems the only explanation is that such porcelain articles were not made for
sale, but were instead made for aristocratic use.[69]

The fact that porcelain found overseas consisted mostly of articles for civilian use
and no large Yuan blue and white porcelain article has been discovered, might well
justify this view. Thus, it seems exports of blue and white porcelain began in the
Ming Dynasty or later and that exported products were for civilian use.[70]

These are the various arguments by academic colleagues. In the opinion of the
author, there are some good reasons for what Mr. Liu Xinyuan is proposing. It is
true that blue and white porcelain found in Jingdezhen had quite different decoration
styles to that of the bluish white porcelain produced by Jingdezhen in the Song
Dynasty. It also differed greatly from the painting styles of the Cizhou and Jizhou

[67] See Footnote 66.

[68] Yuan Shengwen, "Yuan Blue and White Porcelain from the Perspective of Archeology," *Cultural Relics World*, Issue 4, 2007.

[69] See Footnote 68.

[70] See Footnote 68.

kilns. The black on white porcelain of the Cizhou kilns boomed during the Jin Dynasty, which boasted a casual and simple painting style. In contrast, Zhizheng porcelain had unique and complex layers of decorations, some twelve at most, and realistic paintings, which was almost unprecedented. Thus, Liu estimates that it was designed by the Painting Bureau. Additionally, the decorations were very similar to the embroidery on the garments of aristocrats. So, it is highly possible that the same batch of designers were responsible for both.

Is it possible, then, that some porcelain products were made and decorated with paintings specified by Persian customers themselves when they made orders? When we observe the decorations on walls, blankets and clothing in Islamic countries where blue and white porcelain has been found, we can see that they feature a complex decorative style with motifs fully covering an object (Fig. 9.20). Additionally, rims in geometric shapes used to decorate exported porcelain also display a tradition of Islamic nations. So, maybe some products exported to Islamic countries had Chinese motifs as decorations, but that their decorative style was Islamic. Therefore, the author doubts that blue and white porcelain was exclusively used by the imperial family or awarded to aristocrats. Extant porcelain articles do have some decorations associated with Tibetan Buddhism, but that is not the only decoration used. For instance, articles in Figs. 9.21, 9.22 and 9.23[71] are decorated with non-Buddhist images. Also, they are fully colored. This is not a feature of the traditional Chinese style which is usually quite casual and simple. It is actually an Islamic tradition to employ full decoration. Figure 9.24 shows two ancient Ottomans who were in charge of weapons. Their clothes are fully decorated with floral scrolls, quite similar to the twining lotus in Yuan blue and white porcelain. In Fig. 9.25, the frames of the tiles are in geometric shapes while inside are relatively freely decorated flowers, also similar to Yuan blue and white porcelain. Some blue and white ceramics produced in Islamic countries also share some features with Yuan porcelain, for example the blue and white hexagonal tiles of the Muradiye Mosque in Edirne in Fig. 9.26. In Fig. 9.27, the bluish green bowl with black weeds, made in Iran in the early thirteenth century, in the Berkeley Art Museum, was also fully decorated. Figure 9.28 shows an article of the same age and the same origin. It is a bluish green and black bowl. Its compact decoration reflects the metal gloss features of ceramics made in Kazan. Its exterior is circled by two snakes with Arabic decorations and inscriptions filling in the blank. Between the heads of the two snakes, there is an animal with spots. At the bottom of the bowl, there is a deer eating grass with the sky above and a pond below. Such rings of decorations are also used by Yuan blue and white porcelain.

To sum up, it is only fair to say that it is possible that Yuan blue and white porcelain was made for the use of the imperial family and aristocrats, as well as gifts to neighboring countries. As Liu Xinyuan argues, most of the blue and white porcelain in Iran and Turkey was made in around 1328–1335 and sent as gifts from the Yuan government. But Mr. Ma Wenkuan disagrees. He holds that according to the *Daoyi Zhilüe*, an account of the travels of its author Wang Dayuan dated 1349,

[71] Figures 9.20, 9.21, 9.22, 9.23, 9.24, 9.25 and 9.26 from *Chinese Treasures in Istanbul*, Topkap Saray Muzesi, Ministry of Foreign Affairs of the Republic of Turkey, 2001.

Fig. 9.20 The Harem
hanging flower garden at the
Topkapi Palace

Fig. 9.21 Blue and white
plate, produced in the Yuan
Dynasty, in the Topkapi
Sarayi Museum in Istanbul,
Turkey

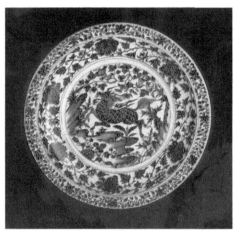

Fig. 9.22 Blue and white
plate with uneven rim,
produced in the Yuan
Dynasty, in the Topkapi
Sarayi Museum in Istanbul,
Turkey

Fig. 9.23 Blue and white bowl, produced in the Yuan Dynasty, Topkapi Sarayi Museum in Istanbul, Turkey

Fig. 9.24 Ancient Ottomans in charge of weapons

among the 99 places recorded in the Pacific and Indian oceans, porcelain was traded as a good in 46 places, among which 17 places, mostly in the Indian Ocean region, clearly indicated that this was blue and white porcelain. It can therefore be inferred that before the reign of Emperor Wen (1328–1332), production of porcelain had already grown to a considerable scale and porcelain had been exported before the first visit of Wang Dayuan in around 1327. Besides, in the Ardebil Shrine in Iran, there is an exquisitely decorated blue and white plate with a diameter of 57.5 cm. Under its rim are inscriptions in Persian, indicating that this article was perhaps ordered by the Persians and made in Jingdezhen, then shipped to Iran and put into their collections. In the William Hayes Fogg Art Museum, there is also a large blue and white plate which was purchased from India, with Persian inscriptions inside,

Fig. 9.25 Tiles on the exterior wall of the Topkapi Palace

Fig. 9.26 Blue and white hexagonal tiles of Muradiye Mosque in Edirne

Fig. 9.27 Bluish green bowl
with black weeds, produced
in Iran in the early thirteenth
century, Berkeley Art
Museum

Fig. 9.28 Bluish green and black bowl, produced in Kazan, Iran in the early thirteenth century, Berkeley Art Museum

just like that on the plate in the Ardebil Shrine.[72] So we can see that some Yuan blue and white porcelain articles in both Iran and Turkey were gifts from the Yuan Dynasty while some were goods that were custom-made for the Islamic market.

Many scholars agree with this view because at the time the Yuan Dynasty attached great importance to foreign trade as a boost to military budgets and wealth. According to the *History of Chinese Ceramics* edited by the Chinese Ceramic Society, even before the founding of the Yuan Dynasty, Mongols had already been engaged widely in trade with the Western and Arabic regions. Under the reign of the Yuan Dynasty, Maritime Trade Bureaus (*Shibosi*) were set up in places like Quanzhou. Vol. 26 of *Xuwenxiantongkao* written by Wang Qi in the Ming Dynasty states, "The government stipulated that when dealing in foreign trade, one tenth of normal goods or one fifteenth of substantive goods should be taken as taxes and a maritime official was nominated to take charge of this... In 1277, the first Maritime Trade Bureau was established in Quanzhou, headed by Meng Gudai. Later three other Maritime Trade Bureaus were set up in Qingyuan, Shanghai and Ganfu, led by Yang Fa. Every year, traded goods must be levied under the administration of these bureaus." After 1284, the government tried to monopolize foreign trade by making ships, providing funds and recruiting people for day-to-day management. Of the profits gained, the government took 70% and the managers the rest. Smuggling was prohibited, but it was never totally eliminated. Thus, throughout the Yuan Dynasty, foreign trade, both official and private, was boosted. The large demand from foreign trade propelled the growth of the handicraft industries. Against such backdrop, blue and white porcelain burgeoned.[73]

Some scholars make the point that hardly any Yuan blue and white porcelain has been found in maritime sites. The author believes that perhaps the reason for this

[72] Ma Wenkuan, "A Few Issues in Yuan Porcelain Research that Cannot be Ignored," *Art Market*, Issue 4, 2005, p. 73.

[73] Chinese Ceramic Society (ed.), *History of Chinese Ceramics*, Cultural Relics Press, 1982, p. 331.

is that exported porcelain was targeted at Islamic countries and delivered mainly overland, not by sea.

Can we then say for sure that a large part of the large-sized and fully decorated Yuan blue and white porcelain objects were especially made for Islamic nations? Margaret Medley holds that the ceramics industry in the Middle East region has not ceased operation since the tenth century, especially in making blue and white porcelain. The Freer Gallery of Art in Washington DC still houses many collections from Iran, including blue and white plates, and underglazed blue, as well as green and white bowls made in the fourteenth century. But as the raw materials in the Middle East are not of the same quality, and firing temperatures were not high enough, the products from the region cannot match the quality of the Chinese ceramics. Since the Yuan Dynasty paid much attention to foreign exchange and foreign trade and also catered to the demands of the Middle East regions for blue and white porcelain, it seems quite natural that Jingdezhen, the imperial porcelain producer, based on its advanced techniques, undertook porcelain production on a large scale and that some of this product was earmarked for export.[74]

Mr. Feng Xianming also thinks the main target of the exported blue and white porcelain is the Islamic countries in the Middle East region. In *Chinese Ceramics*, he wrote that during this period, the large articles that could be often seen are plates, vases and pots. The plates usually have round or water chestnut-shaped folding rims, and formed one of the major export products. Quite a few porcelain plates have now been found in Iran, Turkey and India. Among the collections in Turkey, Iran and India, plates account for a major part of the large pieces of porcelain, with both round and water chestnut-shaped rims. The mouth rim diameter of water chestnut-shaped edged plates is generally approximately 45 cm, but some are as large as 57 cm and a few as small as less than 40 cm. Round-edged plates usually have a mouth rim diameter of 40 cm while a few exceed 45 cm. Such plates represent a typical variety passed down through history. But most are found abroad, mainly in the Middle East region, which might be due to the local custom of sitting on the ground and eating together (Fig. 9.29), while very few have been found at home. In fact, only the Palace Museum and Shanghai Museum house a few such items. Another typical category is large bowls, with either open or tight mouths. Their mouth rim diameters are generally 35–40 cm, with some as large as 58.2 cm and some as small as 25–30 cm. These bowls are also mainly found abroad, except one which was unearthed in Nanjing, a product from 1418. Large pots also form a major part and are mostly found in Japan. As for plum vases, six pieces have been unearthed in Jiangxi, which shows that it had markets both at home and abroad. Goblets were usually targeted at the domestic market as they are rarely found outside China. In contrast, flasks were mainly found in the Middle East and only one has been found in Beijing, and this was apparently made for the foreign market (Fig. 9.30). Both the Cizhou and Longquan kilns made similar flasks in imitation. Hardly any blue and white bowls and plates for daily use have been identified. So, it seems that apart from exports and special articles made

[74] Margaret Medley & Yu Jiwang, "On the Influence of Islam over Chinese Ancient Ceramics," *Porcelain of Jingdezhen*, Issue 3, 1987.

Fig. 9.29 Blue and white plate with mandarin duck patterns, produced in the Yuan Dynasty, height: 6.7 cm, mouth rim diameter: 46.5 cm, in the Palace Museum

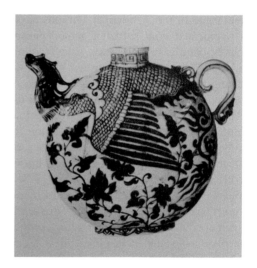

Fig. 9.30 Blue and white flask with phoenix pattern, produced in the Yuan Dynasty, height: 18.7, mouth rim diameter: 4 cm, unearthed from a pit in Old Gulou street in Beijing, in the Capital Museum

for imperial use, like goblets, no blue and white porcelain was made for the daily use of the common public. Thus, not many have been handed down.[75] (Fig. 9.31). The reason, apart from its limited production and export orientation, might also include what Mr. Gao Ashen has suggested: The Ming Dynasty embarked on a cleansing campaign and destroyed most of the specimens.

The Ardebil Shrine in Iran houses Longquan celadon from the Southern Song and Yuan dynasties, white porcelain from Southern China, *Shufu* porcelain and blue underglazed porcelain as well as 37 pieces of precious blue and white porcelain from

[75] Feng Xianming (ed.), *Chinese Ceramics*, Shanghai Chinese Classics Publishing House, 1993, pp. 456–457.

Fig. 9.31 Blue and white
octagonal pot, produced in
the Yuan Dynasty, height:
26.6 cm, discovered in a pit
in Baoding, Hebei Province,
in the Hebei Museum

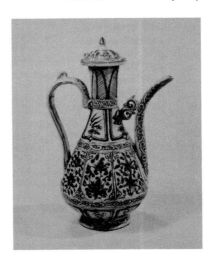

the Yuan. In the Azerbaijan Museum in Tabriz, a northwest Iranian city, there is
also blue and white porcelain and copper red porcelain, including high-quality large
plates, plum vases and bowls. The Topkapi Sarayi Museum in Istanbul also houses
a lot of Chinese porcelain, from different varieties of delicate and colorful porcelain
dating from the Southern Song to the Yuan and Ming dynasties, to exquisite white
porcelain and blue and white porcelain dating from the Yuan to the early Ming.
According to statistics, there are only around 200 complete pieces of extant Yuan
blue and white porcelain worldwide, more than 80 of which are collected here. "Large
collections have been housed here in several rooms of the Topkapi Sarayi Museum
since the Middle Ages. Though many museums have Chinese ceramics among their
collections, this museum ranks high in terms of variety, quality and quantity."[76]
Illustrated in Fig. 9.32 is a Yuan blue and white plate with water chestnut-shaped
rim. The center of its blue base is divided into six parts and decorated with flames,
ancient coins and a coral reef, along with clouds and water waves. Figure 9.33 also
displays a blue and white plate with water chestnut-shaped rim in the Topkapi Sarayi
Museum with a dragon at the center and twining lotus surrounding it. From these
collections, we can see that the decorations fully cover the bodies, which is quite
contrary to the Chinese style of decoration. Figure 9.34 shows a blue and white bowl
with water chestnut-shaped rim in the Topkapi Sarayi Museum in Istanbul, with a
lotus at the center surrounded by three circles of flowers. The innermost circle is
separated into many parts and decorated with lucid ganoderma and sea snails. The
middle circle has water waves and the outside circle peonies. The outside of the bowl
is also decorated with flowers.[77]

[76] Mikami Tsugio, *Ceramic Road—An exploration of the Connections between East and West*,
translated by Hu Defen, Tianjin Renmin Press, 1983, p. 91.

[77] Figures 9.32, 9.33 and 9.34 from *Chinese Treasures in Istanbul*, Topkap Saray Muzesi, Ministry
of Foreign Affairs of the Republic of Turkey, 2001.

Fig. 9.32 Blue and white plate with water chestnut-shaped rim, produced in the Yuan Dynasty, in the Topkapi Sarayi Museum in Istanbul, Turkey

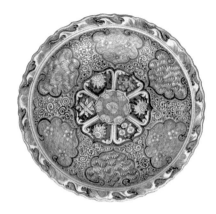

Fig. 9.33 Blue and white plate with water chestnut-shaped rim, produced in the Yuan Dynasty, in the Topkapi Sarayi Museum in Istanbul, Turkey

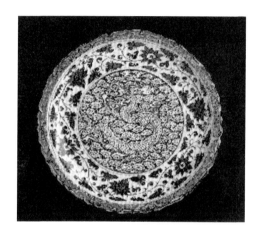

Fig. 9.34 Blue and white bowl with water chestnut-shaped rim, produced in the Yuan Dynasty, in the Topkapi Sarayi Museum in Istanbul, Turkey

In addition to the above, both complete and incomplete pieces of Yuan blue and white porcelain have been unearthed in many other regions, including Fostat in Egypt, coastal regions of the Red Sea, and within the borders of Sudan, Somalia, Kenya and Tanzania. In recent years, Asian countries like Japan, Thailand, and the Philippines have also discovered Yuan blue and white porcelain. In the Philippines

especially, many large-sized pots and bowls, including a blue and white pot with two dragons and four lugs, have been identified. These articles are generally decorated with animals, flowers and twigs, twining flowers and geometric patterns, quite different from those found earlier in Japan. The articles illustrated in Figs. 9.35, 9.36 and 9.37 are collections of the Museum of East Asian Art in Bath in the UK. They were exports of Jingdezhen to Southeast Asian countries, featuring simple paintings, light colors and relatively small sizes.

The varieties of porcelain unearthed in the Philippines are also found in the Hutian kilns of Jingdezhen. In particular, a small chrysanthemum pot is exactly the same as a piece of porcelain unearthed in the Hutian kilns. This indicates that this variety was made by the Hutian kilns in the late Yuan Dynasty when techniques in clay making

Fig. 9.35 Jingdezhen blue and white twining chrysanthemum vase with a pedestal and a garlic-shaped head, produced in the Yuan Dynasty, total height: 23.2 cm, mouth rim diameter: 2 cm, in the Museum of East Asian Art in Bath, UK

Fig. 9.36 Jingdezhen blue and white chrysanthemum pot, produced in the Yuan Dynasty, in the Museum of East Asian Art in Bath, UK

Fig. 9.37 Jingdezhen blue
and white twining lotus pot
with a lid, produced in the
Yuan Dynasty, in the
Museum of East Asian Art in
Bath, UK

and painting had matured and products were being exported. Because the Fuliang Ceramic Bureau was removed in the last dozen or so years of the Yuan Dynasty, the producers of the exports were mainly private kilns.

In fact, whether the Fuliang Ceramic Bureau was the official kiln in the Yuan Dynasty continues to be disputed. Chen Lizi reports that many scholars have confirmed through various archaeological discoveries and documents that no Yuan official kiln existed in Jingdezhen. In his view, the true official kiln must be the "Yutu kiln," which was under the administration of the Fuliang Ceramic Bureau. However, some also argue that the "Yutu kiln" was not actually a kiln and that the correct terminology should be "Yutu porcelain." Some have also doubted the very existence of official kilns in Jingdezhen as they hold that the kilns in Jingdezhen which were under the administration of the Fuliang Ceramic Bureau were private kilns, not official ones. As for the Fuliang Ceramic Bureau, its function was to levy taxes on kilns and supervise the production of quality and exquisite porcelain made by private kilns for imperial use. Many scholars do not mention the specific official kilns in Jingdezhen and argue that there was more than one kiln in Jingdezhen that was administered by the Fuliang Ceramic Bureau. Some even conclude that, in contrast to the Ming and Qing dynasties when craftsmen were gathered together in the Zhushan kilns to work, the Fuliang Ceramic Bureau put official craftsmen into the advanced Zhen kilns and the Hutian kilns.

It is still far from settled as to whether it was official or private kilns that were administered by the Fuliang Ceramic Bureau. It is also difficult to distinguish what type of Yuan porcelain, including Zhizheng porcelain, was made by official kilns and what was produced by private kilns.

Another opinion holds that since the Yuan rulers ascended the throne through blood relations, the concept of the supremacy of emperors was not as strong as emperors at other times, therefore there was probably not an official kiln in the Yuan Dynasty. Rather, some so-called "official" government organs, endorsed by the government, were actually taken charge of by the privileged. Besides, since the

Fuliang Ceramic Bureau was an agency in charge of a handicraft industry and of craftsmen, it did not produce. Therefore, Yuan blue and white porcelain might also have been a product which was produced on the initiative of aristocrats to gain profit, with some used to pay military costs and most to support their extravagant lifestyle.

To conclude, some Yuan blue and white porcelain articles might have been made for imperial use while most were made for sale and many for export.

As for exactly where blue and white porcelain was produced in Jingdezhen, this is also an issue on which opinions differ. Most believe that typical Zhizheng porcelain was made in the Hutian kilns as egg-white *Shufu* porcelain, blue and white plates, pots and bottles decorated with dragons with five fingers were also discovered there in the 1980s.[78] Other types of porcelain might have been made in different kilns. This author once collected some incomplete pieces of Zhizheng porcelain from the Hutian kilns and a blue and white cup made by the Guanyinge kilns in the Yuan Dynasty.

In recent years, a new argument has been proposed that another kiln under the Fuliang Ceramic Bureau was located in the old royal sports field of the Ming Dynasty, in Zhushan in Jingdezhen. In 1988, a batch of Yuan official porcelain was found in a ditch 1.5 m deep in the north of the old sports field, including blue and white pots and boxes with dragons with five fingers, and golden and peacock-green underglazed porcelain, etc.[79] In 1994, a batch of large blue and white plates, pots, and bowls were unearthed from the east side of the old field, which were quite similar in shape and color to official Yuan porcelain. This indicates that producers of such porcelain might be the same workers as those in the Fuliang Ceramic Bureau. So far, only the Hutian and Zhushan kilns have been found with official Yuan porcelain.[80] From 2003 to 2004, shards of Yuan blue and white porcelain, bluish white porcelain and egg-white porcelain were found in the north of the old sports field, all bearing features of official porcelain. Among them, one piece is marked with the inscription "*Juyong*," meaning "For use by the bureau", which shows that craftsmen might have continued to use the name "Fuliang Ceramic Bureau" in the early Ming Dynasty.[81] Thus, the typical Zhizheng porcelain might also be produced by the Zhushan kilns, which proves that official kilns were also part of the production of this type of porcelain.

[78] Liu Xinyuan & Bai Kun, "Reconnaissance of Ancient Kiln Sites in Hutian in Jingdezhen," *Cultural Relics*, Issue 11, 1980.

[79] "A Batch of Yuan Official Porcelain Found in Jingdezhen," *Guangming Daily*, on Sept 14, 1990.

[80] Jiang Jianxin & Jiang Jianmin, "On the Fuliang Ceramic Bureau, its Kilns and Products," *Cultural Relics in Southern China*, Issue 1, 2008.

[81] Liu Xinyuan, Quan Kuishan & Fan Changsheng, "On Discovering Jingdezhen Official Kilns," *Cultural Relics World*, Issue 4, 2004.

9.2.3 The Fuliang Ceramic Bureau and Egg-White Porcelain

9.2.3.1 The Nature of the Fuliang Ceramic Bureau and Its Production Locations

Apart from blue and white porcelain, Jingdezhen also made egg-white porcelain in the Yuan Dynasty. Why did Jingdezhen make egg-white porcelain and why was the Fuliang Ceramic Bureau especially established?

To figure this out, we first need to understand the mission of the Fuliang Ceramic Bureau, its nature and under what context it was founded.

Fuliang was a county in Jingdezhen, but the bureau was under the direct administration of the central government or the Imperial Manufactories Commission. Was the purpose of the Fuliang Ceramic Bureau the same as its counterparts in charge of ceramic administration in the Song, Ming and Qing dynasties? Many scholars have advanced different views. Mr. Gao Ashen proposed that since the Yuan rulers ascended to the throne through blood relations, the concept of the supremacy of emperors was not as strong as in other times. There were probably therefore no official kilns in the Yuan Dynasty.

The relevant historical records are listed as follows:

1. According to the *Great Gazetteer of Jiangxi Province: On Ceramics* completed in 1597, "In the Song Dynasty, porcelain was made under supervision upon imperial orders and in the Ming Dynasty, from 1324 to 1328, an official was appointed to overlook production of ceramics. Porcelain products were supplied to the government on imperial orders and there was no production when there were no orders."
2. According to the *Gazetteer of Fuliang County: On Ceramics*, dated 1783, "In the Yuan Dynasty, an official in the tax bureau of Jingdezhen was named head and in charge of ceramic production and an official was appointed to overlook production of ceramics. Porcelain products were supplied to the government on imperial orders and no production when there were no orders."
3. Kong Qi, from the Yuan Dynasty, wrote in the *Record of Zhizheng*, "The *Yutu* (referring to kaolin) in Raozhou is as white as flour and chalk. Every year, it is used to make porcelain for the emperors, and it later become known as a 'Yutu kiln' product. Once the production is finished, the *yutu* would be sealed up for safekeeping, preventing its use for any other purpose. If there was any *yutu* to spare, it was used to make articles like plates, bowls, saucers, pots and cups. They look white and lustrous. Wherever it is unglazed, it looks as white as flour, which is quite beautiful."

In "On the Fuliang Ceramic Bureau, its Kilns and Products," Jiang Jianxin and Jiang Jianmin propose that since "Porcelain products were supplied to the government on imperial orders and there was no production when there were no orders" "Every year, it was used to make porcelain for the emperors, and it later became known as 'Yutu kiln'. Once the production is finished, the *yutu* would be sealed up for

safekeeping, preventing its use for any other purpose." So, we can see that production of porcelain was not a routine, but only on the orders of the court. The fact that the *yutu* was sealed up once production was complete indicates that the kilns of the Fuliang Ceramic Bureau did not have specific locations in the way that independent official kilns in the Ming and Qing dynasties did. Because if they did, there was no need to seal up the *yutu* and thus prevent its use for private purposes.[82]

They therefore concluded that it is probable that the Fuliang Ceramic Bureau did not have specific independent kilns because the conditions to establish official kilns in the early Yuan Dynasty were not fully met. Consequently, some well-performing private kilns in Jingdezhen were selected as producers of porcelain for imperial use, which basically matched what we suggested about blue and white porcelain earlier.

9.2.3.2 The Purpose and Significance of Egg-White Porcelain Production

From 1274, Kublai started his massive campaign against the Song Dynasty and in 1279, the Southern Song Dynasty was overthrown and he eventually accomplished his great quest of uniting the whole country. In 1278, before his final victory, Kublai issued instructions regarding the setting up of the Fuliang Ceramic Bureau at very short notice in Jingdezhen, southern China, as a specific organ to produce porcelain for the royal family.

And why?

This author holds that, like rulers of other dynasties, the Yuan rulers needed to hold various national ceremonies and events where porcelain had to be supplied as offerings to ancestors. At this time especially, when the leadership of the Mongols had just been confirmed and they required a grand founding ceremony and other solemn activities, this was important. This led to the hurried establishment of the Fuliang Ceramic Bureau in Jingdezhen.

In 1999, the Jiangxi Provincial Archaeology Institute discovered three egg-white glazed goblets with the inscription "*yu*" (jade in Chinese) inside, along with a batch of egg-white porcelain articles in the Liujiawu, Hutian kilns. According to their description, under the goblets, there were decorations of gardenia and eight signs of blessings in the vernacular of Tibetan Buddhism, including chakra, Shankha, Chattra, Chuang, Padma, Kalasha, Survana Matsya and Shrivatsa, while inside, there were pictures of dragons with five or four fingers. Based on the stratum where they were found, and their features, the discoverers deduced that they were relics from the early Yuan Dynasty. With the help of relevant historical documents, researchers believe they were articles used as offerings and made in Jingdezhen on the orders of the Yuchen Institute, an agency in charge of musical affairs.[83] In addition, egg-white porcelain articles inscribed with "*Taixi*" were also found in the Hutian kilns. "*Taixi*"

[82] Jiang Jianxin & Jiang Jianmin, "On the Fuliang Ceramic Bureau, its Kilns and Products," *Cultural Relics in Southern China*, Issue 1, 2008, p. 59.

[83] See Footnote 82.

refers to the "Taixi Zen Institute," which was in charge of affairs of worship. This serves as hard evidence for the idea that egg-white porcelain was made as offerings.

Mr. Gao Ashen pointed out that the feature of being large at the top and small at the bottom, which occurs in egg-white porcelain, can be traced back to the religious outlook of the Mongols concerning the sky and earth, as the sky is at the top and the earth at the bottom. In *Essential Criteria of Antiquities*, Cao Zhao from the early Ming Dynasty made it clear: "In the Yuan Dynasty, porcelain with small feet and decorations and inscriptions of '*Shufu*' inside were tall while for newly made products, articles with large feet looked plain." Articles with different sized feet also differ in shape and purpose. Those with large feet emphasize utility while those with small feet signify the Mongols' religious outlook on the sky and earth. Additionally, decorations were usually placed inside egg-white porcelain, not outside. This indicates that these decorations were aimed at the heavens since Gods from high above could look into the inside while the outside was visible to people of flesh and blood, so there was no decoration on the outside. It also implies the concept of connecting with the Gods from the inside. Such artistic designs highlight the religious characteristics of egg-white porcelain.[84]

We thus now understand why only egg-white porcelain has inscriptions of "*Yu*" and "*Taixi*," and not blue and white porcelain. The reason, generally speaking, is that porcelain which is used as offerings must be of a single color, and only a plain color.

Of the egg-white porcelain, *Shufu* porcelain accounts for the largest proportion and also ranks as the most influential variety. We will elaborate on this further.

9.2.4 *Yuan* Shufu *Porcelain*

9.2.4.1 The Nature Nature of Yuan *Shufu* Porcelain Production

Shufu porcelain, a variety of egg-white porcelain, appears bluish white with a transparent glaze just like a duck egg, hence the name. They were custom-made articles of the Yuan's "Privy Council" (*Shumiyuan*), the then military organ, in Jingdezhen. The characters "*Shu Fu*" were systematically and invariably placed centrally on the bodies, hence the variety was generally called "*Shufu* porcelain." As *Shufu* porcelain accounted for the greatest volume and reached the widest markets of the egg-white porcelain, we will mention it specifically.

The "Privy Council" was first set up in the Five Dynasties period and it was in charge of military intelligence, border defense and army horses, etc. Under the Yuan's "military-oriented" rule, the Privy Council played a significant role. But why did a military organization make egg-white porcelain in Jingdezhen?

Mr. Gao Ashen offers his opinion. In the early Yuan Dynasty, battles between the Song and the Yuan were at a critical stage while the Yuan was also engaged in

[84] Jiang Jianxin & Jiang Jianmin, "On the Fuliang Ceramic Bureau, its Kilns and Products," *Cultural Relics in Southern China*, Issue 1, 2008, p. 37.

military expansion towards neighboring countries and regions, like Japan, Annam, Myanmar, the Champa Kingdom and Java, thus leading to a lot of casualties. To keep the battles going, it seemed necessary and urgent to expiate the sins of the dead and hold memorial ceremonies for those who sacrificed their lives for their country. So the Privy Council began making egg-white porcelain, even before the establishment of the Fuliang Ceramic Bureau.[85]

Despite being custom-made products, *Shufu* porcelain was not entirely made by official kilns. Instead, many were commercial products. How was this so? Some scholars argue that at the time, the Privy Council commanded many subsidiaries nationwide. When they needed egg-white porcelain, it was not the headquarters that placed one large order. On the contrary, each subsidiary made their own individual orders. The result was that, due to insufficient funds, some subsidiaries were stuck with shoddy porcelain, while at the same time, some porcelain with inscriptions of "*Shufu*" made their way onto the market and became merchandise.[86]

Mr. Feng Xianming points out: "From batches of egg-white porcelain abroad, we can see that they were not all made by official kilns. So, it seems a little inexact to call egg-white porcelain in the Yuan Dynasty '*Shufu* porcelain'."[87] Studies on the Hutian kilns also show that "Outwardly folding bowls and small-footed plates on the southern bank of Liujiawu usually have outwardly pointing feet and '*Shufu*' inscriptions inside. For goblets, some have dragons with five fingers inside, indicating official use. On the northern bank, meanwhile, despite being similar in shape, porcelain articles feature straight feet, no inscriptions and dragons with three or four fingers. These were products for civilian use."[88] (Fig. 9.38). As merchandise, egg-white porcelain was not only used domestically, but also sold abroad. For example, among a large batch of Chinese porcelain discovered in shipwrecks in Sinan, South Korea, there were a lot of bluish white porcelain and *Shufu* porcelain from Jingdezhen, which also revealed that egg-white porcelain came into being earlier than blue and white porcelain in the Yuan Dynasty. This indicates that blue and white porcelain emerged on the basis of *Shufu* porcelain. In addition, plenty of *Shufu* porcelain has also been unearthed in Iran, Turkey and the Philippines.

Of the porcelain unearthed from ruins in Jining, egg-white porcelain from Jingdezhen accounted for a large proportion, in fact the largest batch ever unearthed. The discovery verified the civilian use of egg-white porcelain marked with "*Shufu*." "*Shufu*" egg-white plates were also found in Jining with a "*Yao*" (medicine in Chinese) character on the bottom. Apparently, these were articles used in herbal medicine shops. Some without the "*Shufu*," were marked with a "*Yao*" and a

[85] Jiang Jianxin & Jiang Jianmin, "On the Fuliang Ceramic Bureau, its Kilns and Products," *Cultural Relics in Southern China*, Issue 1, 2008, p. 38.

[86] Wu Zhiguang & Wang Xuening, "Some Thoughts on *Shufu* Porcelain," *Collection World*, Issue 7, 2005, p. 95.

[87] Feng Xianming (ed.), *Chinese Ceramics*, Shanghai Chinese Classics Publishing House, 1993, p. 449.

[88] Liu Xinyuan & Bai Kun, "Reconnaissance of Ancient Kiln Sites at Hutian in Jingdezhen," *Cultural Relics*, Issue 11, 1980.

Fig. 9.38 Egg-white goblet with double dragon pattern, produced in the Yuan Dynasty, height: 13.3 cm, mouth rim diameter: 13.8 cm, in the Shanghai Museum

"*Wangjiayaopu*" (Wang Family Herbal Medicine Shop). There might be several explanations for this:

Shufu porcelain was not uniquely subject to official use and was not entirely custom-made by the Privy Council.

Porcelain articles marked with "*Shufu*" were available on the market and subject to civilian use.

There might be some imitation *Shufu* porcelain products among the civilian use Jingdezhen egg-white porcelain.[89]

9.2.4.2 Sites and Periods of *Shufu* Porcelain Production

According to the available archaeological materials, as early as around 1305, egg-white porcelain was already in production.[90] A lot of egg-white porcelain was salvaged from the shipwrecks of South Korea's Sinan which could date back to 1331,[91] showing that it had already begun substantial production and was being sold abroad. Two pieces of egg-white porcelain with "*Shufu*" inscriptions were unearthed from the tomb of the Rens in Qingpu County, Shanghai. According to investigations,

[89] Lu Minghua, "A Preliminary Study of Porcelain Unearthed in Jining," Chinese Society for Ancient Ceramics (ed.), *Studies on Ancient Chinese Ceramics* (Vol. 11), The Forbidden City Publishing House, 2005, p. 61.

[90] Yu Zhen & Huang Xiuchun, "On the Tombs of Tieke, Father and Son, and Zhang Honggang," *Acta Archaeologia Sinica*, Issue 1, 1986.

[91] (Korean) Zheng Liangmo, "Chronological Research on Porcelain Discovered in the Sinan Sea," *Research Materials on Export Porcelain in Ancient China*, Research Office of the Palace Museum (ed.), Issue 1.

Fig. 9.39 Egg-white bowl,
produced in the Yuan
Dynasty, height: 4.5 cm,
mouth rim diameter:
11.5 cm, in the Chongqing
Museum

the pieces were buried underground with their owner no later than 1338,[92] which indicates that production of *Shufu* porcelain began at least before 1338. Among the many egg-white porcelain articles found among the ruins of the Hutian kilns in Jingdezhen, some bear "*Shufu*" inscriptions while some do not. As the ruins were from the late Yuan period, it shows that official porcelain with "*Shufu*" would appear to be products of the middle and late Yuan Dynasty. After the Yuan, production of such official porcelain ceased while egg-white porcelain for civilian use continued to be produced from the early Yuan to the early Ming Dynasty.[93] (Fig. 9.39).

As Kong Qi from the late Yuan Dynasty wrote: "The *Yutu* (referring to kaolin) in Raozhou is as white as flour and chalk. Every year, it is used to make porcelain for the emperors, and it later became known as a 'Yutu kiln' product. Once the production was finished, the *yutu* would be sealed up for safekeeping, preventing its use for any other purpose. If there was any *yutu* to spare, it is used to make articles like plates, bowls, saucers, pots and cups. They look white and lustrous. Wherever it is unglazed, it looks as white as flour, which is quite beautiful."

The *Jingdezhen Taolu* records: "*Shufu* porcelain serves as royal porcelain and it is only made upon government orders. Its clay is fine, white and smooth and its body is thin with small feet, and it is decorated with printings. For those with large feet, they are usually plain and lustrous. Other articles like goblets, saucers, plates and jars all have inscriptions of '*Shufu*' inside. Private kilns copied such models to produce for civilian use. For official porcelain, there is a strict selection process and only one in a hundred is chosen, so they boast a far better quality than their civilian counterparts."[94] From the above descriptions, we can see that the "Yutu kilns" and "Shufu kilns" were official kilns making *Shufu* porcelain. But at different times, they had different names. So who were the specific producers of *Shufu* porcelain in the Yuan Dynasty?

[92] Shen Lingxin & Xu Yongxiang, "Research on Findings in the Tomb of the Rens in Huangpu County of Shanghai," *Cultural Relics*, Issue 7, 1982.

[93] Chen Wenping, "Chronological Research on Egg-white Porcelain," *Porcelain of Jingdezhen*, Issue 1, 1990.

[94] Lan Pu, *Jingdezhen Taolu*, Vol. 5.

Some scholars suggest that Liujiawu in the southern section of the Hutian kilns might be a production site. In "Reconnaissance of Ancient Kiln Sites at Hutian in Jingdezhen," it states: "Outwardly folding bowls and small-footed plates on the southern bank of Liujiawu usually have outwardly pointing feet and '*Shufu*' inscriptions inside. For goblets, some have dragons with five fingers inside, indicating official use."[95] After the 1990s, samples with dragons having five fingers, underglazed red phoenix, dragons and water drops and tiles with inscriptions of "*Yu*," "*Shufu*" and "*Taixi*" continued to be found. Also, from 2003 to 2004, the excavation of the northern side of the imperial sports field of the Ming Dynasty revealed shards of Yuan blue and white porcelain, bluish white porcelain and egg-white porcelain, all of which featured official marks. This shows that it might also have been one of the producers of egg-white porcelain, including *Shufu* porcelain, as one of the kilns under the Fuliang Ceramic Bureau.[96]

The general consensus in academia is that, even if the Liujiawu and Zhushan kilns were both official kilns at the time, they were different from their counterparts in the Ming and Qing dynasties. As Kong Qi writes: "Once the production is finished, the *yutu* would be sealed up for safekeeping, preventing its use for any other purpose. If there was any *yutu* to spare, it was used to make articles like plates, bowls, saucers, pots and cups. They look white and lustrous. Wherever it is unglazed, it looks as white as flour, which is quite beautiful…" Also, according to the *Jingdezhen Taolu*, "*Shufu* porcelain serves as royal porcelain and it is only made on government orders." Thus, it seems that once government orders were issued, materials would be transported for making porcelain, and when there was no official mission, the raw material would be sealed up and potters would return to their normal work of making civilian products. Thus, this author argues that the official kilns of the time were actually private kilns.

9.2.4.3 Varieties and Features of *Shufu* Porcelain

The body of *Shufu* porcelain is thick, with an opaque glaze, and appears bluish white. Egg-white glaze has a low Calcium content (about 5%) and a high potassium and sodium content, rendering it sticky and able to endure a wide range of temperatures. Products in the early stages were a little bluish since their iron content was high while in the later stages, products were becoming purer with increasingly less iron. White and glossy, egg-white porcelain was actually the forerunner to the sweet white glaze of the early Ming Dynasty. The decorations on *Shufu* porcelain were usually printings, including mold printings for *yuanqi* (open forms) like plates and bowls. The motifs included double dragons and twining flowers with "*Shu Fu*" marked symmetrically. Among extant pieces of *Shufu* porcelain, some are also inscribed with "*Taixi*" and "*Fulu*" (blessings), etc. (Fig. 9.40).

[95] Liu Xinyuan & Bai Kun, "Reconnaissance of Ancient Kiln Sites at Hutian in Jingdezhen," *Cultural Relics*, Issue 11, 1980.

[96] Xu Changqin & Yu Jiangan, "New Archaeological Findings in the Hutian Kilns," *Palace Museum Journal*, Issue 2, 2004.

Fig. 9.40 Egg-white
shallow plate with *Shufu*
inscriptions, produced in the
Yuan Dynasty, in the
Berkeley Art Museum

Those with "*Shufu*" and "*Taixi*" were generally more exquisite in terms of clay, glaze and production. Usually, "*Shufu*" products were small articles like plates, bowls and goblets. A typical type was the "*Zheyao*," an outward-folding plate, which featured small feet, flat bottom, open mouth and deep belly. This is a representative product of Jingdezhen in the Yuan Dynasty. Blue and white porcelain and bluish white porcelain of the same period also had similar designs.

Shufu porcelain was characterized by small ring feet, thick feet walls, square section feet, unglazed feet, and dotted bases, and were fired above a mixture of kaolin and chaff. Where the feet were unglazed, there were dots in iron red color, with sand stuck to its edge.

9.2.5 Yuan Underglazed Red, Copper Red and Cobalt Blue Porcelain

Apart from egg-white and blue and white porcelain, Jingdezhen's prowess was also exemplified by its underglazed red porcelain, an important invention of potters in the Yuan Dynasty. Like blue and white porcelain, underglazed red porcelain is achieved by firstly hand painting a copper oxide-based pigment on a white biscuit which is then overglazed with a transparent glaze and then fired at high temperatures under an inner flame, also known as reduction firing. But blue and white porcelain and underglazed red porcelain differ in terms of color, drawing technique, raw material, and firing temperature. Underglazed red has strict requirements for the atmosphere in a furnace because copper can only turn red under reduction firing while blue and white has relatively relaxed demands as the atmosphere in a kiln furnace has little effect on the color of cobalt. It is thus easy to make blue and white porcelain, hence many have survived to this day. But underglazed red porcelain is difficult to produce and so results in a low production volume. Very few examples therefore remain today, not to mention excavated articles suitable for scientific research (Fig. 9.41). In the Yuan Dynasty, the underglazed red technique was still in its infancy, so the products lacked the finesse of blue and white porcelain. Nonetheless, the making of underglazed blue and red porcelain represented a new direction which featured blue

and red decoration in one piece of work. This also served as a pioneer in *doucai* making after the Ming Dynasty (Fig. 9.42).

Another new variety produced by Jingdezhen was underglazed copper red porcelain. In its making, a certain amount of materials with copper content would be mixed with the glaze as a coloring agent. Underglazed red and underglazed copper red both use copper to create the color. Since copper is green in an oxidizing flame and red in a reduction firing, both of which are limited to a strict range of firing temperatures, it is very difficult to master the techniques, resulting in a very low production volume and a limited number of varieties. Extant or unearthed underglazed red porcelain from the Yuan Dynasty is very rare, except for a few from sites in Beijing, the then capital city. Since it was still in its formative stage, it was easy to lose control over the firing temperature and so the red color was not always pure. Bright red porcelain,

Fig. 9.41 Underglaze red spinning chrysanthemum goblet, produced in the Yuan Dynasty, height: 9.5 cm, mouth rim diameter: 7.8 cm, in the Gaoan Museum, Jiangxi Province

Fig. 9.42 Underglaze blue and red porcelain with flower engraving, produced in the Yuan Dynasty, height: 41.2 cm, mouth rim diameter: 15.5 cm, in the Hebei Museum

known as "Yongle Red," did not appear until the Yongle period (1403–1424) of the Ming Dynasty.

Cobalt blue porcelain was already successfully fired in the Tang Dynasty, but at the time the cobalt was blended in a low lead glaze, giving it a rather bright appearance and lacking depth. By the Yuan Dynasty, Jingdezhen invented new varieties by firing blue glaze with cobalt at high temperatures (Fig. 9.43). The resulting porcelain usually had two means of decoration. One was to create blue porcelain and decorate it with golden glaze before re-firing to prevent the golden glaze from wearing off (Fig. 9.44). The other method was to apply a white decoration on the blue glazed bodies in order to create a contrast. Firing techniques are more easily grasped than underglaze red skills, so today there is more cobalt blue porcelain from the Yuan Dynasty than underglazed red porcelain, both in terms of quantity and variety.

Fig. 9.43 Cobalt blue plum vase with a white dragon, produced in the Yuan Dynasty, height: 43.5 cm, in the Yangzhou Museum in Jiangsu

Fig. 9.44 Sapphire *jincai* liquor glass, produced in the Yuan Dynasty, height: 4 cm, mouth rim diameter: 8.1 cm, in the Hebei Museum

9.3 The Yuan Longquan Kilns

9.3.1 Development

The boom of the Longquan kilns was made possible by the retreat of the Song court to south of the Yangtze, followed by the establishment of its capital at Lin'an (now Hangzhou). With the migration, production techniques of celadon were also brought to the southern regions. "After all the ups and downs from the Five Dynasties to the Song Dynasty (960–1279), Chinese society finally enjoyed some peace and stability, thus came the times when porcelain production boomed both in quantity and quality, which led to the very existence of the best and most attractive pieces of porcelain. To be specific, during this time, the center of celadon production shifted to Longquan, Zhejiang Province. Its blue color was as clear as an autumn sky or a vast and tranquil sea. This is the famous Longquan celadon, a popular variety for export, along with celadon produced by the Fujian and Guangdong kilns."[97] Before the Southern Song Dynasty, the celadon of the Longquan kilns was light blue or transparent yellow blue. Under the influence of the relocated official kilns, the Longquan kilns began to acquire the making and firing techniques of the northern regions, and subsequently produced smooth, and opaque celadon and launched it into markets both at home and abroad.

In the Yuan Dynasty, many kilns in the north had shown signs of decline, and the focus of porcelain production had shifted to the south. At the time, the Longquan kilns were as important and famous as the Jingdezhen kilns. In Chinese history, the Yuan Dynasty was a very prosperous age, with the largest territory and the broadest markets. Despite the large market demand, many once famous kilns in the north found themselves doomed in the Yuan Dynasty. The Longquan kilns, in contrast, were endowed with great development opportunities and with increasing kilns, doubled and even redoubled production as they expanded their production scale. Around 200–300 kiln sites have been found in Longquan County with two thirds spanning the two sides of the Oujiang and Songxi rivers, over 50 in Dayao, and around a dozen in Zhukou and Fengtang. In the eastern area of Longquan, kilns were spread over Wutongkou, Xiaobaian, Dabaian, Yangmeiling, Shanshikeng, Dawangyu, Daotai, Putaoyang, Qianlai, Anfukou, Wanghu, Anfu, Ma'ao, Lingjiao, Daqi, Dingcun, Yuankou and Neiwangzhuang. Kilns were also found in Chishibu in Yunhe County, Guixi, Baoding and Anxi in Lishui County, and Jiangao and Zhutu in Yongjia County. Wuyi County was also found to host Longquan kilns. This shows that the Longquan kilns had expanded on an unprecedented scale in the Yuan Dynasty, far more than in the Song Dynasty. Concentrated on the two sides of the Oujiang and Songxi rivers, delivery of products to the important ports of Wenzhou and Quanzhou was convenient, from whence products could enter the domestic and foreign markets.

[97] Mikami Tsugio, *Ceramic Road: An exploration of the Connections between East and West*, translated by Hu Defen, Tianjin Renmin Press, 1983, pp. 20–21.

In the Yuan Dynasty, foreign trade was even more developed than in the Song Dynasty, with an expanded scale and increased export volumes. Most exports were produced by kilns situated in the southeast coastal regions, among which the Longquan kilns played an extremely important role. In *Daoyi Zhilüe*, Wang Dayuan mentions on several occasions that the "*Chuzhou* porcelain," "*Chu* porcelain" or "celadon porcelain" sold abroad was actually a product of the Longquan kilns, since Longquan County belonged to Chuzhou at the time. As mentioned above, from shipwrecks in Sinan, South Korea, over 10,000 pieces of Yuan porcelain were salvaged, including over 6000 pieces of Longquan celadon, comprising more than half the total. Among the batch of porcelain unearthed from the pits in Gaoan, Jiangxi Province, Longquan porcelain also took up over half of them. In a tomb in Jianyang, Sichuan Province, a batch of Yuan porcelain was discovered, with Longquan porcelain forming the majority. From the extant Yuan porcelain, including those passed down through history, unearthed or scattered abroad, Longquan porcelain accounts for a very large part of the overall picture.[98]

According to Li Jianmao, the Yuan court relied on Jingdezhen for a considerable amount of its tax profits, confirming the prosperity of the private kilns of Jingdezhen. In the Song and Yuan dynasties, the Jingdezhen kilns were mainly situated in the river basins of the Nanhe and Xiaonanhe rivers. The Tangxia site alone covered an area as large as $650,000$ km^2.[99] However, there are indications that the Longquan kilns overtook the Jingdezhen kilns in terms of both production quantity and scale. At the same time, Li also points out that, because of the huge market demands to be met, the quality of the Longquan porcelain generally declined, despite a large volume of excellent work.[100] This could explain why it declined after the Ming Dynasty.

9.3.2 Designs and Glaze

After the establishment of the Yuan Dynasty, a series of new policies engendered a new landscape in China. With the integration of the nomadic culture with the Central Plains culture, the course of development and evolution of the Longquan kilns was changed. Since the wiry Mongols did not necessarily appreciate the fine and gentle style of the Song Dynasty, Longquan products, which featured thin bodies, exquisite

[98] Li Jianmao, "Analysis of Ceramics Unearthed in Jining," Chinese Society for Ancient Ceramics (ed.), *Studies on Ancient Chinese Ceramics* (Vol. 11), The Forbidden City Publishing House, 2005, p. 73.

[99] Zhou Ronglin & He Shende, "On the Development of the Ancient Ceramics industry on the Southern Bank of Jingdezhen," *Cultural Relics in Southern China*, Issue 3, p. 194. Quoted from a secondary source: Li Jianmao, "Analysis of Ceramics Unearthed in Jining," Chinese Society for Ancient Ceramics (ed.), *Studies on Ancient Chinese Ceramics* (Vol. 11), The Forbidden City Publishing House, 2005, pp. 72–73.

[100] Li Jianmao, "Analysis of Ceramics Unearthed in Jining," Chinese Society for Ancient Ceramics (ed.), *Studies on Ancient Chinese Ceramics* (Vol. 11), The Forbidden City Publishing House, 2005, p. 73.

Fig. 9.45 Longquan celadon brush pen washer with double fish, produced in the Yuan Dynasty, height: 4.7 cm, mouth rim diameter: 15.6 cm, in the Shanghai Museum

and delicate styles and artistic and functional designs, gradually lost their status for imperial use. To cater to the appetite of the rulers, the Longquan kilns shifted to thick bodies and large sizes.

At the time, the Longquan kilns produced copiously, but the quality of their products declined markedly. It is not certain, however, whether this decline was because of their feverish pursuit of increased production or an attempt to meet the aesthetic tastes of the rulers. Firstly, the raw clay materials were not sufficiently pure and maturation of the clay was hastily executed such that the bodies were cruder and thicker than their counterparts in the Song Dynasty. Secondly, the Longquan kilns continued to use alkali lime glaze but glazing time was insufficient, leading to a thin glaze and a loss of the former richness (Fig. 9.45). As the firing temperatures were even higher than those in the Southern Song Dynasty, and the air was not strictly controlled, while smooth on the surface, most products were olive green, moss green or dark moss green, instead of the former bright green, grass green and pea green. The rich, smooth glaze of the lavender gray glaze, popular in the Song Dynasty, was gone. The bright, smooth, shining and richly glazed plum green, which resembled emerald in beauty, was also a distant dream. Most of the daily use porcelain articles were only glazed once or twice, hence Longquan celadon lost its jade-like quality. In order to meet foreign demand, many large articles were made, like vases exceeding 100 cm tall, plates with a diameter of over 60 cm, and bowls with a mouth rim diameter of 42 cm. Such successes demonstrated the Longquan kilns' capability in shaping. The author holds that the declining quality of the Longquan kilns was not caused by their incompetence, but rather a result of mass production or change in tastes.

Products of the Longquan kilns in the Yuan Dynasty featured thick, fine bodies in bluish white, with some in dark gray, clear or transparent glaze, just like glass, which was quite different from the devitrified style of lavender gray glaze and plum green glaze. While not so gentle and mild, it makes one feel cheerful, which presents another kind of beauty and pleasure. Illustrated in Fig. 9.46[101] is a deep bowl exported

[101] Figure 9.46 from *Chinese Treasures in Istanbul*, Topkap Saray Muzesi, Ministry of Foreign Affairs of the Republic of Turkey, 2001, p. 46.

Fig. 9.46 Longquan celadon
deep bowl, produced in the
Yuan Dynasty, in the
Topkapi Sarayi Museum,
Istanbul, Turkey

to an Islamic country. It is decorated with lotus petal patterns outside with clear and transparent glaze, quite a different style from the opaque glaze of the Song Dynasty.

Evidence of the coarse shaping of Yuan Dynasty Longquan celadon can also be found in its thick edges and roughly made feet. To meet the demands of mass production, pad firing used a randomly made pad underneath, unlike the neatly made pads used in the Southern Song Dynasty. Hence products were usually unglazed under ringed feet, which was different to the Southern Song Dynasty when they were fully glazed under feet with only a thin line left unglazed. Sometimes, grommets were placed under the feet for firing and glazing, so glaze in the center would remain there, appearing like a navel. In the Song Dynasty, the Longquan kilns were very careful in applying glaze over porcelain bodies for protection, with everywhere but under the feet glazed, revealing only a line of red color. This was a very unique style. However, in the Yuan Dynasty, to improve the appearance of the color, the Longquan kilns also applied a protective glaze. Large parts under the feet were, however, usually left undone, indicating just how roughly made such products were. Thus, naturally, no "navels" were to be found.

9.3.3 Styles and Varieties

Longquan porcelain was mainly made for daily use, including the exported products, and only a small part was made for decoration. Most of the varieties in the Southern Song Dynasty have survived to today, including bowls, plates, cups, saucers, washers, basins, pots, furnaces, vases, water pots, ink stone water holders, ewers, lamps, goblet cups, goblet bowls, boxes and wine vessels. There are many stylish designs, such as goblet cups, plates with water chestnut edges, small necked bottles, pots with double rings of lugs, phoenix-tail-shaped vases, sugarcane-shaped brush pen washers, pots with lotus-leaf-shaped lids, animal-shaped ink stone water holders, or pots with small mouths and two symmetrical holders. Such designs were not invented in the Yuan Dynasty, but during this period they were popular and thus became representatives of Longquan porcelain. Brush pen washers were the most representative and varied

varieties of all, and as a kind of stationery, it is one of the collectors' favorites. Usually, washers have open mouths, wide rims, curving bodies, flat bottoms and small ring feet. In the Yuan Dynasty, washers featured wide rims while in the Song Dynasty, they usually had thin rims, with wide rims being a rarity, which was also a result of a change in predilection.

The patterns on Longquan bowls in the Yuan Dynasty were similar to those produced in the late Song Dynasty, with the major differences being in the mouths, including open mouth, tight mouth, spreading mouth, straight mouth, outward curling mouth, water chestnut edges, chrysanthemum petal edges, lotus petal edges or geometric figure edges. Some bowls have lotus petal engravings on their outside edges: shallow and flat, not as deep and vivid as those in the Song Dynasty. Inside, flowers are printed at the center of the bottom, including lotus, chrysanthemum and peony, with water waves, twining lotus, flowers or birds decorating the interior walls. Such patterns were quite different from the style of the Song Dynasty, which was mainly plain and lacking decoration, except for some that were decorated with deeply engraved lotus petals. The Yuan Dynasty produced a variety of bowls which had spreading mouths with six notches linking to six lotus stems, other branches spreading over the walls, and a pair of small turtles lying in the center of the bottom. Such designs were exquisite, meticulous, vivid and cute. A typical type of small article produced in the Yuan Dynasty was small wine cups, whose manufacture was quite exquisite.

Goblet cups and goblet bowls had emerged following the Tang and Song dynasties but only by the Yuan Dynasty were they able to gain wide popularity and be mass produced in the Longquan kilns. The goblet cups at the time were hemispherical in shape, with flat, deep bottoms and slightly spreading mouths. They looked narrow at the top and wide at the bottom, making them stable and handy to hold. The bowls of Yuan goblet cups were almost as high as their stems.

Vases also represented an important genre among the Longquan products. The most representative vases were phoenix-tail-shaped, along with others that were "gall bladder" shaped, flasks, *cong* vases (*cong*-shaped vases), plum vases, cabbage vases, garlic-head-shaped vases, vases with double rings (Fig. 9.47), double fish vases, small necked vases, vases with pierced lugs, gourd-shaped vases, *yuhuchunping*, flat vases with two lugs, octagonal vases, base vases, and *gu* vases. Among them, gourd-shaped vases, vases with double rings, flat vases with twin lugs and base vases were representative. Assembling a vase and its base for firing also demonstrated the artistic style of the Longquan kilns, which not only made the whole article seem even more dignified, but it also indicated a diversification in porcelain shaping during the Yuan Dynasty.

The celadon pot with lotus-leaf-shaped lid was also a representative Longquan product of the Yuan period. It had a lid in a whole lotus leaf shape and some even used a small twig as a knob. Glazed in bright green, the pots were as refreshing as real lotus. The body shaping was steady and elegant, with decorations like printings, lotus petals and bow string patterns. Their sizes varied from large, medium to small. From the Sinan shipwrecks many lotus petal pots were discovered. This shows that

Fig. 9.47 Longquan celadon
vase with double rings,
produced in the Yuan
Dynasty, height: 26 cm,
mouth rim diameter: 9.6 cm,
in the Zhejiang Provincial
Museum

similar pots might have been exported in large quantities. Topkapi Palace in Istanbul also houses such pots (Fig. 9.48).

Furnaces in the form of a *ding* (a cooking vessel in ancient China) or a *li* (a round-mouthed food vessel with two or four loop handles) which had been commonly seen in the Song Dynasty were rarely produced in the Yuan Dynasty. But those in the form of a *gui* (a type of bowl-shaped ancient Chinese ritual bronze vessel used to hold offerings of food) or a *zun* (a type of Chinese ritual bronze or ceramic wine vessel with a round or square vase-like form) were to be found. The most commonly found furnace types were barrel-shaped tripod furnaces, which were already quite popular in the Southern Song Dynasty and their patterns mainly fell into two categories. The diameters of the top and bottom of the bowls of one type were almost equal, and sported a flat bottom, while the other featured a slightly outward-protruding bottom, the bottom diameters being smaller than the mouth rim diameters, and the bottoms and three feet touching the ground almost equally or almost touching the ground. In the latter half of the Yuan Dynasty, furnace mouth rim diameters became even larger and bottom diameters became smaller, sometimes only half of the mouth rim

Fig. 9.48 Celadon pot with
a lotus-leaf-shaped lid,
produced in the Yuan
Dynasty, in the Topkapi
Sarayi Museum in Istanbul,
Turkey

diameters, and the bottoms stretched down to the ground with three feet dangling in the air, basically abandoning their function. However, the furnaces of this period were characterized by rough workmanship and a large section at the bottom was left unglazed.

Apart from inheriting certain products from the Song Dynasty, the Longquan kilns also made innovations in terms of shape and decoration in the Yuan Dynasty. One of the features often remarked on from this period was the large sizes and thick bodies of the products. Many large articles, including plates, vases, pots, bowls and ewers, were almost unprecedented in terms of size. In fact, this was a common characteristic of Yuan porcelain and it saw vivid expression in the Longquan kilns. In the Dayao and Zhukou kilns of Longquan County, a huge number of large pieces of porcelain were found, with some vases as high as almost one meter and some plates with a mouth rim diameter of 60 cm. In the Lingjiao kiln, some bowls even had a mouth rim diameter as large as 42 cm. Mass production of large porcelain signified an improvement in production techniques and revealed the grand and bold character of Yuan porcelain under its Mongol rulers.

Among the products of the Yuan Longquan kilns there were not only magnificent large pieces of work, but also small exquisite articles, like pots, bottles, vases, ink stone water holders, and cups as high as 10 cm. Such small articles were often exported to Southeast Asia and were usually used as burial objects.

9.3.4 Decorations

After the Yuan Dynasty, with the boom in commerce, civilian culture began to prosper in forms like Yuan poetry and fiction, which gradually replaced the elite-centered cultural traditions prevailing in the Tang and Song dynasties. Such changes were also reflected in Longquan porcelain as potters worked to pursue complex decorations and variety in technique and raw materials, rather than holding fast to the old style of beautiful glazes and exquisite designs. The country under the Yuan Mongol rule occupied an unprecedented swathe of territory and had enhanced its ties with neighboring regions and countries, especially those in the Western Regions. A closer exchange with the outside world helped promote the integration of multiple cultures and was also conducive to doing away with many traditional shackles, hence making the Yuan Dynasty the most open period and its people the most rebellious in Chinese history. Its manifestation in Longquan porcelain was the wider range of decoration and more flexible control over the content of decorations than in other periods.

In the Song Dynasty, the Longquan kilns took pride in their jade-like products with few decorations while in the Yuan Dynasty, the glaze became noticeably thinner and transparent and engraving, drawing and printing decorations became popular. The Longquan kilns not only inherited all the best practices of the Yuan period, but also made many innovations, such as scarping, engraving, and molding as well as printing, decal and brown stippling. Engravings fell into two categories, namely, characters cut in relief and characters cut in intaglio, with the latter forming the majority.

Brown stippling was usually used on small daily ware and decorative porcelain. The Longquan kilns also excelled at the combined use of several techniques, like decal and engraving, printing, stippling, printing and engraving, or molding and engraving. Such combinations of skill greatly varied porcelain decorations and gave a special character to the Yuan Longquan kilns. Now, let us examine several of these techniques in detail.

1. Clay decal. This can be divided into glazed decal and clay decal. Glazed decal appeared early in many kilns while clay decal was a unique invention of the Longquan kilns in which a pattern or substrate was transferred onto the center of vases or plates, usually unglazed, so that after firing it turned reddish brown, forming a beautiful contrast with the blue glazed body (Fig. 9.49). This skill was used on plates, bowls, and vases, as well as on figure statues. A clay decal saucer was unearthed from the ruins of the Lingjiao kiln in Anren, Longquan County, stuck to the round feet of another piece of porcelain, which revealed a secret of clay decal: another piece of small porcelain was put on its decal, which was higher than the surface, functioning as a piece of kiln furniture, in an effort to cut costs. So, after a second firing, the decal experienced a reoxidation and became brick-red, contrasting with the blue glazed body. Pictured in Fig. 9.50 is a flat-mouthed celadon plate exported to an Islamic country in the Yuan Dynasty. Inside, it was engraved with a double fish with water waves and lotus surrounds. Clay decal was put on its edge. The author once viewed a Yuan Longquan celadon pot with unglazed human figurines in the Berkeley Art Museum in the USA (Fig. 9.51). The figures were in fact the Eight Immortals of Chinese Taoist legend, considered to be signs of prosperity and longevity. Under the pot there was a note saying that "Initially, this pot was believed to have been made in the late Ming Dynasty, however, recent academic discoveries have shown that it was actually an important Eight Immortals product of the fourteenth century. The wine pot illustrated that religious figures were also used as decorations in daily life." Despite its novelty, clay decal porcelain prevented surface smoothness and was not convenient for daily use. Thus, the novel technique was not accepted by society and soon died out.

2. Mold engraving. Along with clay decal, mold engraving was also frequently used by the Longquan kilns. Engraving was often used by the Longquan kilns in the Northern Song Dynasty, while from the Yuan Dynasty, engraving was combined with printing, making its products more multi-dimensional and distinctive. The engraving technique can be traced back to the Yaozhou kilns while printing was from the Ding kilns. When combined, they formed a unique style of the Longquan kilns. Motifs of this decorative style included banana leaves, sea water, chrysanthemum, water chestnuts, folding fans, transformed clouds, dragons and phoenix, fish, lotus petals, cranes, lucid ganoderma, orchids, pines, bamboo, plum blossoms, peaches, melons, sunflowers, litchi, morning glory, the Eight Immortals, the Eight Trigrams, *ruyi* scepter head, drum nails, checks, ancient coins, saw teeth, cloud and thunder patterns, and human figures. This type of porcelain was made in large quantities and much was exported. Illustrated in

Fig. 9.49 Longquan celadon plate with an unglazed red dragon, produced in the Yuan Dynasty, in the Topkapi Sarayi Museum in Istanbul, Turkey

Fig. 9.50 Longquan flat-mouthed celadon plate with double fish, produced in the Yuan Dynasty, in the Topkapi Sarayi Museum in Istanbul, Turkey

Fig. 9.51 Longquan celadon pot with unglazed human figures, produced in the Yuan Dynasty, in the Berkeley Art Museum in the USA

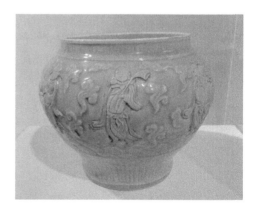

Fig. 9.52 is a bowl sold to an Islamic country, with a decal decorated five-petal flower at the center surrounded by lotus. Similar to it, Fig. 9.53 is also a bowl with a flower at the center encircled by engraved flowers. Figure 9.54 is a Longquan celadon plate with dragon printings. The printing technique was once a tradition of the Ding kilns and was initiated in the mid-Northern Song Dynasty. A mold was used to make printings, usually in relief, on the clay before the clay had dried. Some engravings, usually peony, lotus or pomegranate, were thick, such that on the celadon surface it produced slight changes in light.

Fig. 9.52 Longquan celadon decal bowl, produced in the Yuan Dynasty, in the Topkapi Sarayi Museum in Istanbul, Turkey

Fig. 9.53 Longquan celadon decal bowl, produced in the Yuan Dynasty, in the Topkapi Sarayi Museum in Istanbul, Turkey

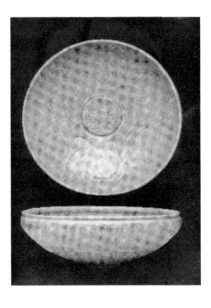

Fig. 9.54 Longquan celadon plate with dragon printings, produced in the Yuan Dynasty, in the Topkapi Sarayi Museum in Istanbul, Turkey

3. Brown stippling. Longquan porcelain was stippled with brown spots on the glaze. The technique of brown stippling on celadon ware can be dated back to the Jin Dynasty (221–265). Originally, the stippling process used a type of soil with a high iron content which was found in Zhejiang, on glazed clay. After firing it turned reddish brown or brown. While the glaze color was a far cry from that in the Southern Song Dynasty, Longquan porcelain featured a pure, rich glaze with brown spots dotted on it, making the design quite refreshing.

4. Characters. Much of the Longquan porcelain was inscribed with characters, like blessings which after translation might mean "May you live long and be successful," "Wish you every happiness," "May you live a long and happy life," "Wish you abundant wealth," etc. as well as inscriptions indicating the time and place a porcelain ware was made and even the names of its producers, kilns or potters. Apart from Chinese characters, Phags-pa script, an alphabet designed by Phags-pa as a unified script which could transcribe both Mongolian and Chinese, can also be found. The script was developed in 1269, but failed to receive wide acceptance, except among the Mongol elite as a formal language. Phags-pa script was used as relief printing on Longquan porcelain, suggesting Longquan's position as a producer of official porcelain.[102]

9.4 Kilns in Other Southern China Regions

9.4.1 The Qingbai Kilns

As the most significant kilns in the Yuan Dynasty, the Jingdezhen and Longquan kilns have been introduced in this Chapter. But apart from these two major kilns, there were also other kilns contributing to porcelain production in Southern China during

[102] Ye Zhemin, *History of Chinese Ceramics*, SDX Joint Publishing Company, 2006, pp. 443–446.

the Yuan period. *Qingbai* porcelain kilns were among these. The scale of production of the *Qingbai* kilns expanded when compared to that of the Song Dynasty. Representative *Qingbai* kilns include the Zhenghe, Minqing, Dehua, Quanzhou and Tongan kilns in Fujian Province, the Huiyang and Zhongshan kilns in Guangdong Province, the Jiangshan and Taishun kilns in Zhejiang Province, and the Fanchang kilns in Anhui Province. The Qudougong kiln, one of the principal Dehua kilns, mainly produced *Qingbai* porcelain for export to the Philippines, Indonesia and other Southeast Asian countries.

The Jingdezhen kilns were still the production center for *Qingbai* porcelain in the Yuan Dynasty, but it had deviated from the Song Dynasty in terms of clay, glaze, shape and decoration and created a style unique to this time. Due to its influence, *Qingbai* porcelain produced by other kilns also adopted a similar style. The *Qingbai* porcelain clay was made up of porcelain stone and kaolin, with a high aluminum oxide content, thus resulting in higher firing temperatures, a solid body and low warping rate. Compared to the Song Dynasty, *Qingbai* products in the Yuan Dynasty were a little more bluish and glaze-rich, but less clear and transparent.

In terms of decoration, the Yuan Dynasty inherited the engraving and printing skills of the Song Dynasty, and also made some innovations. Characters cut in intaglio in thin lines were created through printing, which was quite different from the traditional block printing technique (Fig. 9.55). Brown stippling, decal and embossed decorations of strings of beads were also popular, with the first usually used on Longquan porcelain and the last often found on *Qingbai* porcelain from the Jingdezhen kilns.

In terms of design, *Qingbai* porcelain turned from the Song thin and light style to a thick and rich style. Its clay was thicker and there were more decorations, like S-shaped double lugs, a base underneath, animal head applique with a ring-handle in

Fig. 9.55 *Qingbai* pot with dragon decorations and a lion-shaped cap, produced in the Yuan Dynasty (1324), height: 32.8 cm, mouth rim diameter: 5.8 cm, in the Jiangxi Provincial Museum

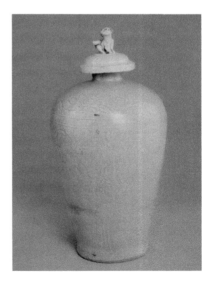

Fig. 9.56 *Qingbai*
Avalokitesvara seated
statute, produced in the Yuan
Dynasty, height: 65 cm, in
the Capital Museum

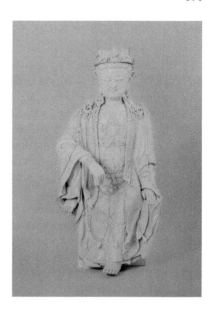

the mouth, as well as rings in shoulders and necks. More and more products assumed a prismatic shape. Apart from traditional bowls, plates, vases, pots, furnaces, and pillows, new varieties like flat ewers, gourd-shaped ewers, *yi* (a washing vessel used to contain water for washing hands before rituals like sacrifices in ancient China), mountain-shaped pen holders, *duomuhu* (a Tibetan prototype used for storing milk tea in Lamaist monasteries) and animal-shaped ink stone water holders. In addition, exquisite Buddhist statues, like that of Avalokitesvara and other Buddhist deities, which were produced in the Yuan Dynasty, might also have had some influence over the Ming Dynasty Dehua porcelain (Fig. 9.56).

After the emergence of blue and white porcelain in the Yuan Dynasty, it soon saw rapid growth, and by the mid-Ming Dynasty it had become the most prevalent variety in the ceramics industry, during which trend *Qingbai* porcelain began a downward trajectory. But what is worth noting is that in the early stages of blue and white porcelain, blue decorations were put on the clay of *Qingbai* porcelain, so there actually was a time when the two had "happily" coexisted. But *Qingbai* porcelain produced in the Yuan Dynasty was a little too blue and opaque, which made it unfit for painting blue decorations, so it seemed a "breakup" was inevitable.[103]

[103] Wu Zhanlei, *Chinese Ceramic History in Illustrations*, Zhejiang Education Publishing House, 2001, pp. 162–164.

9.4.2 The Wuzhou Kilns

The Wuzhou kilns have a long history. Their major product was celadon. While in the Yuan Dynasty, the Wuzhou kilns were not as prosperous as in the Song Dynasty, they maintained their production, but on a smaller scale. In the Yuan Dynasty, the Wuzhou kilns were famous for making bluish gray opaque glazed porcelain. Similar to the Longquan products, its wares were also exported in a large quantities.

The clay of the Wuzhou kilns lacked fineness, so its resulting products were deep gray or brown, and when unglazed they became light reddish brown. Their products varied from flowerpots, *li*-like furnaces, drum-nail brush pen washers, vases, grain holders, ewers, bowls, goblets, plates, pots, oil lamps, and more, and were mainly used as exports. Apart from small articles like bowls and plates that had a thin body, the porcelain used for decoration, such as flowerpots, vases, drum-nail brush pen washers and furnaces had a very thick body. Their opaque glaze was mainly sky blue, but some were also azure or bluish white with a dusty blue luster. For those with a thick glaze, they were usually glazed twice. The first layer was a brown glaze, which basically functioned as engobe and the second layer was opaque glaze which people could see, often sky blue or azure. Richly glazed, they appeared very bright, but the glaze was not pure enough with streaks of white color. This was a major feature of the Wuzhou kilns.

9.4.3 The Jizhou Kilns

Thriving in the Song Dynasty, the Jizhou kilns, according to the archaeological findings of the Jiangxi Province Cultural Relics Working Team and the Ji'an Cultural Relics Bureau in 1980, continued operation until the end of the Yuan Dynasty. Their black glazed papercut decal porcelain and black glaze fambe flower porcelain, very prestigious products in the Song Dynasty, basically vanished in the Yuan Dynasty. Instead, in this period the Jizhou kilns invented a unique decorative style which applied black brown underglazed decorations on beige bodies. This was apparently a result of the influence of the Cizhou kilns' black decorations on white bodies.

Apart from their black decorations, the Jizhou kilns also occasionally produced fambe porcelain like it did in the Song Dynasty. In 1984, a large basin was unearthed from the remains of the Jizhou kilns. At the center, brown bamboo, stones and flowers were painted on the yellow-white glaze while the interior and exterior walls were black glazed and dotted with yellow spots. This style could be called "tortoiseshell glaze." However, it was quite different to the style in the Song Dynasty. White glazed and green glazed porcelain were also discovered among the remains of the Jizhou kilns, as well as shards of white porcelain with flower decorations belonging to bowls, plates, vases, basins, goblets, and more. This demonstrated the wide variety of Jizhou porcelain, but also its inferior quality.[104]

[104] Ye Zhemin, *History of Chinese Ceramics*, SDX Joint Publishing Company, 2006, p. 464.

9.4.4 The Jian Kilns and the "Tea Horse Trade"

The Jian kilns were famous in Chinese history for their small teacups. In the Northern Song Dynasty, the Jian kilns produced black glazed porcelain and peaked in the Southern Song Dynasty. They continued production in the Yuan Dynasty, and ceased at the beginning of the Ming. Since the colorant of its black glaze porcelain was ferric oxide and manganese oxide, after high temperature firing its glaze became crystallized into special effects such as "hare's fur," "partridge feather" and "oil-spot" patterns, which were very rarely seen and hence, extremely precious. They even won the favor of emperors, so some articles were inscribed with characters indicating their royal usage. In *Treatise on Tea*, Zhao Ji or Emperor Huizong of Song (1082–1135) praised the Jian kiln hare's fur cups saying that "What is precious about the cups is that they are black and feature vivid 'hare fur' patterns." Black as the cups are, it is easy to distinguish tea leaves. Thick and fine, but with a few air holes, the body helps maintain the temperature, thus making it the first choice in teacups for the Song emperors.[105] Due to their high quality, and thanks to the endorsement of the emperors, the whole nation was swept up in a frenzy to use black glazed teacups. Driven by the huge market demand, the Cizhou and Ding kilns in Hebei Province, the Hebi kilns in Henan Province, the Linfen kilns in Shanxi Province, and the Yaozhou kilns in Shaanxi Province all plunged themselves into imitating the black glazed cups of the Jian kilns. Since it resulted in massive production and gradually led to a system, it became known as Jian style porcelain and only ceased production in the Yuan Dynasty.

In the past, academic circles have paid scant attention to the Jian kilns and to Jian style porcelain. For example, *History of Chinese Ceramics*, edited by the Chinese Ceramic Society and published by Cultural Relics Press in 1982, and Ye Zhemin's *History of Chinese Ceramics* published by SDX Joint Publishing Company in 2006 virtually overlooked the Jian kilns and Jian style porcelain. But from ruins in Jining in Inner Mongolia, about 100 pieces of black glazed teacups were unearthed. Due to the large quantity, wide varieties, clear stratum relations, and confirmed dates of the rise and fall of the ancient city, this discovery not only proved that production of Jian porcelain and Jian style porcelain continued in the Yuan Dynasty, but also offered precious research materials.

Among this batch of black glazed porcelain, very few were identified as products of southern kilns. Instead most of them were Jian style porcelain products made by northern kilns. While substantial in quantity, their quality was less than ideal.[106] Despite this, as articles for daily use, they still commanded a large market, reflecting the boom in Jian style porcelain in the northern region and its influence

[105] Zhang Zhongchun, "Some Ideas on Questions relating to the Jian Kiln Ceramics Unearthed in Jining," Chinese Society for Ancient Ceramics (ed.), *Studies on Ancient Chinese Ceramics* (Vol. 11), The Forbidden City Publishing House, 2005, p. 109.

[106] Zhang Zhongchun, "Some Ideas on Questions relating to the Jian Kiln Ceramics Unearthed in Jining," Chinese Society for Ancient Ceramics (ed.), *Studies on Ancient Chinese Ceramics* (Vol. 11), The Forbidden City Publishing House, 2005, p. 112.

over people's daily lives. Meanwhile, there were signs that black glazed porcelain was not only exported to Southeast Asian countries, Japan and South Korea, but the Inner Mongolian steppe was also an important market, a fact commonly overlooked by scholars.

The discovery of black glazed porcelain in Jining leads us to a discussion of the Tea Horse Trade in Chinese history. The Tea Horse Trade was a special means of exchange among different ethnic groups, initiated in the Tang and Song dynasties, prospering in the Yuan and Ming dynasties and declining in the Qing Dynasty. Through the Tea Horse Road, mainly through Yunnan, Sichuan, and Tibet, people in northwest China, like Sichuan and Yunnan provinces, traveled by foot and horseback to exchange tea, cloth, and ironware for horses with ethnic minority peoples in Tibet. As a special trade exchange activity between nomadic and agricultural people, the Tea Horse Trade developed to quite a scale, lasted a long time, covered a wide range of areas, and exchanged various kinds of goods. It thus played a very important role in China's history of trade and ethnic exchange.[107]

But how did tea and horses become trade partners? This was made possible by the then geographical environment and production conditions. Nomads saw beef, mutton and dairy products as daily necessities, and these required beverages to help in digestion which water alone could not satisfy. Tea, with its special properties that aided in dissolving fat and digesting meat and dairy thus gained popularity among the nomadic peoples.

The burgeoning development of tea plantations in Jianzhou, Fujian Province in the Song and Yuan dynasties made the Tea Horse Trade possible.[108] As tea became indispensable to nomads, in the Song and Yuan dynasties tea, represented by that produced in Jianzhou, along with black glazed teacups, was a hit in the nomadic regions.

In the past, Jian style porcelain was mainly found in southern regions while in the northern regions, especially on the Inner Mongolian steppe, it was very rare. This was possibly because the rule of the Yuan Dynasty did not last long, and there was a paucity of historical records. Additionally, Mongols conducted secret burials, so there was a lack of knowledge about their lifestyle and customs. In recent years, as more and more documents and tombs with murals of the Yuan Dynasty have been discovered, this knowledge gap has been filled somewhat. Through the information available we can see that, due to the special geographic environment and dietary structure of the Mongols, drinking tea became quite popular. So, the Tea and Horse Trade continued in the Yuan Dynasty.[109] Despite the fact that the traditional Jian kilns declined in the Yuan Dynasty, the findings in Jining reveal that kilns in the

[107] Wei Mingkong, "Review of Trade among Ethnic Groups in Northwestern China—Based on the Tea Horse Trade," *Studies in Chinese Economic History*, Issue 4, 2001.

[108] Zhang Zhongchun, "Some Ideas on Questions relating to the Jian Kiln Ceramics Unearthed in Jining," Chinese Society for Ancient Ceramics (ed.), *Studies on Ancient Chinese Ceramics* (Vol. 11), The Forbidden City Publishing House, 2005, pp. 109–110.

[109] Zhang Zhongchun, "Some Ideas on Questions relating to the Jian Kiln Ceramics Unearthed in Jining," Chinese Society for Ancient Ceramics (ed.), *Studies on Ancient Chinese Ceramics* (Vol. 11), The Forbidden City Publishing House, 2005, p. 113.

northern regions continued Jian style porcelain production to meet the demands of nomadic groups.

9.4.5 The Dehua Kilns

The Port of Quanzhou was a busy port for foreign trade in the Yuan Dynasty. Many exports to Southeast and West Asia and Africa departed from here. Close to the port, the Dehua kilns enjoyed natural advantages. *Qingbai* ware from the Dehua kilns not only made improvement in their clays and techniques, but was even whiter than that in the Song Dynasty and basically reached the standard of white porcelain by the end of the Ming, which paved the way for it to become known as "China white" in the Ming Dynasty. The Qudougong, Biangulong and Wanyangkeng kilns in Dehua were all producers of white porcelain.

One of the intact Dehua kiln sites is Qudougong, situated one kilometer west of Dehua city.[110] The deposit is around one meter thick and 1015 square meters in area. A dragon-shaped furnace was discovered here, with over 6000 pieces of sample product. Apart from the head and bottom, the kiln is 57.1 m long with 17 chambers, each separated by a small wall. This is an almost unprecedented discovery. The major porcelain samples excavated from the Qudougong site are white porcelain and *Qingbai* porcelain.

Bowls, plates, saucers, pots, handle-less cups, goblets, bottles, vases, pen washers, and powder boxes were unearthed from the site. Each article differed from the other in shape. Bowls accounted for the largest quantity. With various sizes and shapes, they can be divided into six categories and over a dozen groups (Figs. 9.57 and 9.58).

The articles have elegant designs with printings like pointed lotus petals and long, thin petals or twigs of peony or twining lotus. All handle-less cups were printed with various twigs or curling flowers, appearing very delicate and cute. Pen washers with unglazed edges were printed with busts of Mongols on the bottom and the saggers were inscribed with Phags-pa scripts, exhibiting features unique to the period. Many surface molds were engraved with characters expressing auspicious sentiments such as "Blessings," "Longevity," "Happiness," "Wealth," etc. Their decorative techniques included printing, engraving, and embossing of strings, stems of flowers, floral scrolls, basket strips, clouds, combs, coins, or lotus petals, as well as flower patterns like lotus, plum blossom, sunflowers, chrysanthemum and peony, with some inscribed with auspicious characters and some with the names of their owners and date of production.[111] Thus, obviously, the decorations of Qudougong porcelain became even more complex. Compared with previous periods, boxes were more diversified in terms of quantity, variety and shape with all articles becoming

[110] Fujian Museum (ed.), *The Dehua Kilns*, Cultural Relics Press, 1990.

[111] Huang Zhangquan, "A Brief Discussion on the Character Decoration of Dehua Porcelain," *China Ceramics industry*, Issue 5, 2009.

Fig. 9.57 Dehua white
porcelain vases with
printings (incomplete),
produced in the Yuan
Dynasty, in the Dehua
Ceramics Museum, Fujian
Province

Fig. 9.58 Dehua white
porcelain powder box with
printings, produced in the
Yuan Dynasty, in the Dehua
Ceramics Museum, Fujian
Province

generally thinner. This was a unique design feature of the Yuan Dynasty.[112] However, compared with the Song Dynasty, articles in the Yuan period featured decorations with dull, loose designs. Many products turned yellow after firing and there were clear signs that some were made in a rush, which reflected the volatile society at the time and people's desperate yearning for peace.[113] The Dehua kilns were a producer of *Qingbai* porcelain in the Song Dynasty, while in the Yuan Dynasty, white porcelain was developed which replaced the *Qingbai* by the end of the Yuan Dynasty.

[112] Zheng Xiaojun & Su Weizhen, "Discussion on the Qingbai Porcelain of the Dehua Kilns in the Song and Yuan Dynasties," *Dehua Ancient Ceramics Academic Essay Compilation*, 2002.

[113] Lin Zhonggan, "Period-specific Study on Dehua Ware," *Dehua Ancient Ceramics Academic Essay Compilation*, 2002.

9.4.6 *Yunnan Blue and White Porcelain*

According to current studies, apart from the Jingdezhen kilns, those in Yuxi and Jianshui in Yunnan Province, Jiangshang in Zhejiang Province and Jizhou in Jiangxi Province also produced blue and white porcelain. For blue and white porcelain of the Jiangshan kilns, most scholars tend to quote Feng Xianming and the Japanese scholar Sasaki Tatsuo, but no specific research reports are available. For products of the Jizhou kilns, there was in fact no official archaeological excavation; only a couple of fragmented pieces have been found at this site and they lacked evidence to identify the period of production. Pieces of blue and white porcelain have been discovered in Yiyang, Hunan Province and Yanjialiang in Baotou, Inner Mongolia respectively. But research materials have been very limited and there has been nothing to compare them with, so their stories are yet to be revealed. Among all the above-mentioned regions, Jingdezhen alone was able to offer enough evidence and statistics to prove itself a producer of blue and white porcelain in the Yuan Dynasty. However, there have been quite a number of archaeological findings in Yunnan Province, so many scholars hold that it also produced blue and white porcelain during the Yuan Dynasty.[114] Regarding the time Yunnan began to make blue and white porcelain, academia generally believe that it was during the Yuan Dynasty as some blue and white items have been unearthed in Yunnan with features of Yuan porcelain and decorations no less complicated than that of Jingdezhen porcelain. In addition, some articles with the inscriptions "*Taiding*," "*Zhizheng*" and "*Xuanguang*" and many other reign titles of Yuan rulers, were found in a tomb complex in Lufeng County. Thus, many scholars share the idea that Yunnan also produced blue and white porcelain. For example, since the blue and white pots unearthed from the Lufeng tomb complex shared a similar decorative style to that of Jingdezhen porcelain and their shapes resembled that of products from the Longquan and Jingdezhen kilns, Feng Xianming proposed that the pots were made in the Yuan Dynasty.[115] In discussing Yuan blue and white porcelain, Wu Shuicun identified a *yuhuchunping* that was unearthed in Yunnan as a product of the Yuan Dynasty. The Yuan Dynasty.[116] In their article "Zheng He's Expeditions and Blue and White Porcelain made in Yongle Period (1403–1424) and Xuande Period (1426–1435) in the Ming Dynasty," Zhang Pusheng and Cheng Xiaozhong also view blue and white porcelain made by the Yuxi and Jianshui kilns as well as those unearthed from the Lufeng tombs as products of the Yuan Dynasty.[117] In an exhibition called "Exhibition of Chinese Ceramics from Newly Discovered Kiln Sites," held in the

[114] Shi Jingfei, "Production and Development of Blue and White Porcelain in Yunnan," Chinese Society for Ancient Ceramics (ed.), *Studies on Ancient Chinese Ceramics* (Vol. 13), The Forbidden City Publishing House, 2007, p. 59.

[115] Feng Xianming, "Several Issues on the Origins of Blue and White Porcelain," *World Ceramics*, Tokyo, Shogakukan, 1981, pp. 268–269.

[116] Wu Shuicun, "A Chronological Study of Yuan Blue and White Porcelain," *Jiangxi Cultural Relics*, Issue 2, 1990, pp. 40–48.

[117] Zhang Pusheng & Cheng Xiaozhong, "Zheng He's Expeditions and Blue and White Porcelain made in Yongle Period (1403–1424) and Xuande Period (1426–1435) in the Ming Dynasty," *Compilation of Essays on Zheng He's Expeditions*, Nanjing University Press, 1985, pp. 295–304.

Idemitsu Museum of Arts in Japan, the *yuhuchunping* found in the tomb complex and blue and white porcelain samples discovered in the Yuxi kilns were also regarded as products of the Yuan Dynasty.[118] Sasaki Tatsuo, in discussing the origins of blue and white porcelain, states that Yunnan began blue and white porcelain production from the Yuan Dynasty. Some Western scholars also hold the same opinion. For example, S. G. Valenstein indicates that blue and white porcelain made in Yunnan were products of the Yuan Dynasty when talking about the Yuan blue and white porcelain of the Jingdezhen kilns.[119] In "Production and Development of Blue and White Porcelain in Yunnan," Shi Jingfei cites these examples and points out that as kilns in Yunnan were not in the mainstream, they have been scarcely mentioned in any thesis on ceramic history. Besides, the technological levels of porcelain production in this region were not advanced, so apart from a few studies on Yunnan blue and white porcelain, it has received little attention from academia.[120]

Yunnan Province is located on the border of southwestern China. With numerous mountains and steep slopes, it was isolated historically and mainly relied on horses for goods exchange. The poor geographic conditions also restricted ceramic development in the region in ancient times. Yunnan was thus not advanced in porcelain making throughout history. Therefore, after Jingdezhen, it seemed inconceivable that Yunnan could become a pioneer in blue and white porcelain production. In fact it became possible because hinterland techniques were spread to this remote area.

In 1253, Kublai took forces and captured Yunnan, ending the chaotic rule over this region which had lasted for over five centuries. The then Yuan ruler made Yunnan a province and nominated Ajall Shams al-Din Omar its governor, so that the central government took direct control over the province and ensured political stability in the border region. Economically, the government encouraged garrison troops or peasants from the hinterland to relocate here, open wasteland and grow food grain. At the same time, post stations were set up, a traffic system established, and commerce and trade were boosted which greatly promoted economic and cultural exchange between Yunnan and its counterparts in the hinterland. Garrison troops and peasants from the hinterland brought advanced technologies, including handicraft techniques. Thanks to a friendly social and economic environment, convenient traffic and increased economic and cultural ties with the hinterland, the development of blue and white porcelain in Yunnan enjoyed a favorable social environment.[121]

Yunnan was also a favorite choice of people from the Western Regions to come and settle. Their religion, Islam, favored blue and white pottery. However, by that

[118] *Exhibition of Chinese Ceramics from Newly Discovered Kiln Sites*, Idemitsu Museum of Arts, 1982.

[119] Valenstein, S. G., *A Handbook of Chinese Ceramics*. New York: The Metropolitan Museum of Art, 1989, p. 137.

[120] Shi Jingfei, "Production and Development of Blue and White Porcelain in Yunnan," Chinese Society for Ancient Ceramics (ed.), *Studies on Ancient Chinese Ceramics* (Vol. 13), The Forbidden City Publishing House, 2007, pp. 59–60.

[121] Wang Kun, "On the Rise and Fall of Blue and White Porcelain in Yunnan," Chinese Society for Ancient Ceramics (ed.), *Studies on Ancient Chinese Ceramics* (Vol. 13), The Forbidden City Publishing House, 2007, p. 2.

time, the Central Plains region had already turned to porcelain for daily use. The move to transfer the blue and white style to porcelain piqued people's interest in Islamic culture. As Yunnan was abundant in cobalt and the area also served as one of the main channels for imports of Mohammedan blue and smalt cobalt from Southeast Asia, the ceramics industry in Yunnan developed rapidly. People from the Western Regions and the hinterland exploited and refined cobalt materials and applied their production skills to local production, boosting the development and maturity of blue and white porcelain in Yunnan and enabling it to produce quality and unique products with features of the region and the era.[122]

Historically, porcelain production in Yunnan was far less advanced than that of the Central Plains region and the southern regions of the lower Yangtze reaches in terms of technology. But in the Yuan Dynasty, Yunnan made remarkable progress in clay making, glazing and firing of blue glazed products. From celadon articles unearthed from tombs of the Dali Kingdom and kiln ruins, it is obvious that Yunnan was quite adept at firing and painting, which paved the way for the emergence of blue and white porcelain. One view held that the clay making techniques of this region had come from the local pottery industry while the glazing and firing techniques were brought in from the hinterland, possibly from the Luguang kiln in Huili County in Sichuan Province.[123] Be it true or not, it was clear that Yunnan mastered the firing technologies of blue and white porcelain in the Yuan Dynasty.[124] Major kilns in Yunnan included the Jianshui, Yuxi and Lufeng kilns.[125] We will now examine these kilns in more detail.

a. The Jianshui Kilns

The Jianshui kilns were a group of kilns in Zhangjiagou, Wanyao Village, Jianshui County. These kilns covered a wide area with different stack layers and were established at different times.[126]

According to archaeological studies, the Jiu kiln, Gu kiln and the Hongs' kiln were among the first group to make blue and white porcelain in around the mid to late Yuan Dynasty. The Jiu kiln, situated in the western section of the Jianshui kilns, concentrated on blue glazed porcelain production. Celadon outwardly-folding

[122] Zhang Zengwu & Zhang Zhenhai, "Discovery of and Research on Blue and White Porcelain in Yunnan," Chinese Society for Ancient Ceramics (ed.), *Studies on Ancient Chinese Ceramics* (Vol. 13), The Forbidden City Publishing House, 2007, p. 56.

[123] Li Kunsheng, "A Brief Artistic History of Porcelain in Yunnan." Quoted from a secondary source: Wang Kun, "On the Rise and Fall of Blue and White Porcelain in Yunnan," Chinese Society for Ancient Ceramics (ed.), *Studies on Ancient Chinese Ceramics* (Vol. 13), The Forbidden City Publishing House, 2007, p. 2.

[124] Wang Kun, "On the Rise and Fall of Blue and White Porcelain in Yunnan," Chinese Society for Ancient Ceramics (ed.), *Studies on Ancient Chinese Ceramics* (Vol. 13), The Forbidden City Publishing House, 2007, p. 2.

[125] See Footnote 124.

[126] Wang Kun, "On the Rise and Fall of Blue and White Porcelain in Yunnan," Chinese Society for Ancient Ceramics (ed.), *Studies on Ancient Chinese Ceramics* (Vol. 13), The Forbidden City Publishing House, 2007, p. 3.

plates discovered here were either painted with cobalt or inscribed with the character "*Yuan*" at the center of the bottom. Fragmented articles found to date are not very refined, featuring a dark blue color and barely any decorations. Even so, they were the predecessors of Yunnan blue and white porcelain. The Hongs' kiln, located to the east of the Jiu kiln, was discovered with clear stacks of porcelain fragments. The upper layer was blue and white porcelain, and the lower layer was blue and white porcelain plus celadon ware with printings or engravings, showing a transitional process. Blue and white fragmented plates with printings found in the remains of the Hongs' kiln were painted with cobalt on the rims with large leaves and lotuses in the center, demonstrating a clear sign of transition from celadon ware to blue and white porcelain.[127]

Many other kilns were dotted around the Jianshui kiln area, like the Zhangs' kiln, the Yuans' kiln, the Huguang kiln, the Hongs' kiln, the Pans' kiln, and more. In *Overview of Yunnanese Blue and White Porcelain in the Yuan Dynasty*, Ge Jifang holds that "These kilns were mainly producing blue and white porcelain, so they were later than the Jiu and Hongs' kilns, in around the late Yuan Dynasty." By this period, production techniques were greatly improved, with light and heavy colors, different layers, complicated decorations and skillful paintings, which were later inherited and further developed by their successors in the early Ming Dynasty.[128] Blue and white porcelain produced in Yunnan in the Yuan Dynasty boasted exquisite quality, fine grayish white clay, bluish white glaze and a bright blue color. In 1986, when the author's husband was a postgraduate student, he went on a field trip with his tutor to Yunnan and found an ancient blue and white pot, with the unique decoration and design of the Yuan Dynasty. He eventually bought it (Fig. 9.59). Similar to Jingdezhen porcelain of the same period, it also used skills like one-stroke drawing and decorations like fish and algae. But compared with that of Jingdezhen, its clay seemed loose, so the glaze easily wore off.

b. The Yuxi Kilns

The Yuxi kilns, situated in the east of Wayao Village, Hongta District, Yuxi City, consisted of a set of ancient kilns including the Ping, Shang and Gu kilns. In their stack layers, the first was a soil layer, the second a blue glazed porcelain layer with a few pieces of blue and white porcelain, and the third and fourth layers were mainly blue and white porcelain. Thus, we can also see a transition from blue glazed porcelain to blue and white porcelain in the Yuxi kilns. Blue glazed porcelain produced by the Yuxi kilns was influenced by the Longquan kilns with the main feature of blue glaze and dark engravings. From its products like the outwardly folding plates with water chestnut rims discovered in the Gu kiln, we can see they were painted with blue decorations based on printings and then glazed with a light blue glaze. These were products of the transitional period from blue glazed porcelain to blue and white porcelain, which probably occurred in the late Yuan Dynasty. In this period, blue

[127] See Footnote 126.
[128] See Footnote 126.

Fig. 9.59 Jianshui blue and white pot with fish and algae, produced in the Yuan Dynasty, in the Jingdezhen Academy of Private Kiln Art

Fig. 9.60 Yuxi blue and white *yuhuchunping*, produced in the Yuan Dynasty, photo credited to Ms. Feng Xiaoqi

and white porcelain featured a clear design, various themes, and a mature production and painting technology.[129] (Fig. 9.60).

c. The Luochuan Kilns in Lufeng

The Luochuan kilns were located in Wuyao Village, Luochuan Town, Lufeng County, and started to produce blue and white porcelain from the late Yuan and early Ming period. This production took place alongside their blue glazed and copper red glazed porcelain. The major products of the Luochuan kilns were blue and white bowls and plates with small feet and folding edges, but its craftsmanship could not compare

[129] See Footnote 126.

Fig. 9.61 Sample of a
Jianshui blue and white
fishbowl, produced in the late
Yuan and early Ming period

with that of the Jianshui and Yuxi kilns. Excavations reveal that blue and white Yuan porcelain in Yunnan first experienced a transitional period from blue glazed porcelain to blue and white porcelain in around the mid to late Yuan Dynasty, and after this preliminary stage, the production technology gradually matured.

In the late Yuan Dynasty, the major production variety of the Jianshui, Yuxi and Lufeng kilns was blue and white porcelain and the production techniques of all these kilns made remarkable headway during the period.[130]

While the Yunnan kilns each had their own character, they shared many features in common. They did not use saggers. Large pieces of porcelain were half glazed while small pieces were laid on top of each other with clay beads in between separating them, leaving five marks both on the inside and the outside. The ground coat tended to be blue or yellow, and apart from a few of the better products, the blue and white porcelain was a little dark or gray.[131]

Blue and white porcelain produced in Yunnan included pots, vases, jars, furnaces, bowls and plates, with pots forming the majority. Its decorations were varied and complex, and many were the same as those from the Central Plains areas, like twining flowers, phoenix flying among flowers, paintings of eminent scholars, paintings of children at play, and lions playing with a ball. But many were also typical images of Yunnan, such as fish and algae. This was the most vivid and representative image among the decorations of Yunnan blue and white porcelain and the fish that was depicted was the local "*chonglang*" fish (Fig. 9.61).

Sunflower decoration was often used on the lids of large pots or at the center of bowls. Some say that sunflower decoration originated from the sun arms that were

[130] Wang Kun, "On the Rise and Fall of Blue and White Porcelain in Yunnan," Chinese Society for Ancient Ceramics (ed.), *Studies on Ancient Chinese Ceramics* (Vol. 13), The Forbidden City Publishing House, 2007, pp. 3–4.

[131] Li Weimin, "An Exploratory Study on Yunnan Blue and White Porcelain," *Collection World*, Issue 2, 2010, p. 61.

usually used on bronze drums in Yunnan. Some say it resembled decorations used on Mongolian yurts while still others say that it was borrowed from the Cizhou kilns.

Kilns in Yunnan all used character inscriptions on their products, but were limited in number and varied in their writing styles. For example, "*Meijiuqingxiang*" (meaning good wine) was put on *yuhuchunping*, "*Gongyang*" on large pots to offer sacrifices to the ancestors, and "*Fu*" (blessings) on bowls.

Many freehand brush paintings were applied to Yunnan blue and white porcelain, together with flowers, human figures, animals and characters. For its decorations, some were taken from the Cizhou kilns which were casual, open, natural and clear while some were apparently from Jingdezhen, especially certain flowers and leaves.

In its heyday, Yunnan blue and white porcelain boasted high technical and artistic values. The most representative of its works were blue and white pots with lids, which have been unearthed from the Lufeng and Jianshui kilns, and elsewhere. The lids are in the shape of lions or lotuses with rims resembling lotus leaves. From the lid to the bottom, the whole article is fully and clearly painted. The lids feature three layers of decoration. The inside layer is usually lotus petals, curling twigs, twining chrysanthemum and peonies; the middle carries lotus and peonies, and the outside layer has banana leaves and *ruyi* scepter heads. On the neck, there are curling twigs, fret patterns, waves, sun's rays, and *ruyi* scepter heads. The main decorations are placed on the shoulder and belly of a pot. There are two layers of decorations on the shoulder. The first is lotus petals and the second is four sets of human characters, playing chess, playing musical instruments, appreciating flowers, and dancing respectively. Some are also painted with buildings, flowers, and people fishing, lions playing with balls, phoenixes flying among peony, and cranes flying. Under the belly, there are double curling lotus petals with drops of water. Generally speaking, the whole article is orderly, made with thick clay and glazed except for the bottom. The color is a little dark or dark purple, with the strokes of paintings forming a clear but complex design. Such products display high artistic value.

It is obvious that in the late Yuan Dynasty, blue and white porcelain production in Yunnan had reached an unprecedented level, and it laid a solid foundation for its further progress and prosperity in the early Ming Dynasty.[132]

Academic circles continue to differ over when Yunnan began blue and white porcelain production since nothing solid has yet been found in kiln sites to identify the time of production. The only thing we can be sure of is that according to reports on the Yuxi and Jianshui kilns, the stratum relations indicate that blue glazed porcelain was produced before the emergence of blue and white porcelain. But the reports still provide no specific time of production or how their production style evolved.[133]

Regarding the production timeframe of blue and white porcelain in Yunnan, there are basically three opinions. The first is that Yunnan began making blue and white

[132] Wang Kun, "On the Rise and Fall of Blue and White Porcelain in Yunnan," Chinese Society for Ancient Ceramics (ed.), *Studies on Ancient Chinese Ceramics* (Vol. 13), The Forbidden City Publishing House, 2007, p. 5.

[133] Shi Jingfei, "Production and Development of Blue and White Porcelain in Yunnan," Chinese Society for Ancient Ceramics (ed.), *Studies on Ancient Chinese Ceramics* (Vol. 13), The Forbidden City Publishing House, 2007, p. 61.

porcelain in the Yuan Dynasty and its production also matured in that period. The second is that it started from the late Yuan and matured in the early Ming Dynasty. The final theory is that it was in the Ming Dynasty that blue and white porcelain production was initiated in Yunnan. Currently, the general view agrees with the second thesis.[134] Some unearthed blue and white porcelain articles with markings have also proven this point. For example, in investigating the Yuxi kilns, it is recorded that "In a tomb dated to 1366, two pieces of blue glazed fragmented plates were unearthed. They were dark in color, thick in clay, uneven in shape and marked with spots left from firing, very similar to plates of the Yuxi kilns." This record shows that at least in the late Yuan Dynasty, Yunnan had already begun blue and white porcelain production. In a tomb dating to 1379 in Lufeng, a blue and white vase with a lion and twining peony pattern was discovered. In Heijing Township, Lufeng, a large batch of Yuan pottery and blue and white porcelain were excavated with markings of "*Zhizheng*" and "*Xuanguang*" (1371–1378/1379), reign titles of Yuan emperors. Among them, over 100 pieces of large blue and white pots were unearthed which was almost unprecedented in China's Yuan-Ming-Qing archaeological history.[135]

According to studies conducted on unearthed articles, some Yunnan blue and white porcelain was directly influenced by Jingdezhen porcelain as their design and decorations were very close to that of the Jingdezhen kilns. The largest difference lay in the raw materials. Since Yunnan used local materials, its paste appeared rough and yellow and its glaze was blue or earthy yellow. To some extent, clay color affected the color of the glaze. But apart from this, glaze color was also influenced by its own content and atmospheric conditions in the firing process. Thus, Yunnan was not able to produce porcelain with as smooth, fine and minimal bluish glaze as Jingdezhen. In addition, its firing technique was also quite rough. Despite all of these considerations, many of Yunnan's products still fitted the basic character of Jingdezhen blue and white porcelain.[136]

9.5 Kilns in Northern China

In the Song Dynasty, the four major kilns in the northern region were the Ding, Jun, Yaozhou and Cizhou kilns. After the Yuan Dynasty, the Ding and Yaozhou kilns began producing porcelain for civilian use instead of high-quality fine products. The

[134] Zhang Zengwu & Zhang Zhenhai, "Discovery of and Research into Blue and White Porcelain in Yunnan," Chinese Society for Ancient Ceramics (ed.), *Studies on Ancient Chinese Ceramics* (Vol. 13), The Forbidden City Publishing House, 2007, p. 56.

[135] Chen Liqiong & Dong Xiaochen, "Survey and Discussion of the Jianshui Kilns," Chinese Society for Ancient Ceramics (ed.), *Studies on Ancient Chinese Ceramics* (Vol. 13), The Forbidden City Publishing House, 2007, p. 95.

[136] Lu Minghua, "A Preliminary Study on the Firing of Blue and White Porcelain in Yunnan Province," Chinese Society for Ancient Ceramics (ed.), *Studies on Ancient Chinese Ceramics* (Vol. 14), The Forbidden City Publishing House, 2007, p. 31.

Fig. 9.62 Blue and white
Ding-style pen washer with
dragon, produced in the
Yuan Dynasty, height: 4 cm,
mouth rim diameter:
14.2 cm, in the Palace
Museum

Jun and Cizhou kilns continued to operate and made some progress, but the quality of their products was not as good as it had been.

In recent years, a new view has been proposed that "Due to the limitation of archaeological work, many scholars believed that it was in the Yuan Dynasty that the northern kilns declined. However, according to research on the Inner Mongolia region, this view has been shown to be not entirely true. In the Yuan Dynasty, there were more northern kilns and more varieties of products than in the Song, Jin and Western Xia dynasties (1038–1227). Even the Yaozhou kilns, a traditional producer of celadon, began to make black on white porcelain at this time."[137] The author holds that in the Yuan Dynasty, though the Ding and Yaozhou kilns were declining, the Jun and Cizhou kilns enjoyed vigorous growth momentum.

9.5.1 The Ding and Huo Kilns

In the Yuan Dynasty, the Ding kilns ceased producing the exquisite products that had been seen in the Song and Jin dynasties. Instead, they mainly made daily use articles like bowls, plates, pots and jars. But its products featured rough clay, yellowish white glaze, lack of luster, and shoddy workmanship. In the Song and Jin dynasties, major Ding kilns in Jianci Village had already ceased operation, along with kilns producing imitation Ding kiln wares in the surrounding areas. But the Huo kilns in Shanxi continued to produce Ding-style porcelain, carrying forward this line of porcelain (Fig. 9.62).

The Huo kilns, situated in Chen Village on the west bank of the Fenhe River, belonged to Huozhou, hence they were named the Huo kilns. According to records, the founder of the Huo kilns was Peng Junbao, so they were also called the "Peng kilns." The Huo kilns mainly produced Ding-style white porcelain and a little black

[137] Peng Shanguo, "An Analysis of Yuan Porcelain Unearthed in Inner Mongolia," Chinese Society for Ancient Ceramics (ed.), *Studies on Ancient Chinese Ceramics* (Vol. 14), The Forbidden City Publishing House, 2005, p. 40.

on white porcelain. Since the Huo kiln white porcelain was very fine and exquisite, people at the time regarded it as an equal to the Ding kilns.

As the Huo products were very similar to Ding porcelain in terms of clay color, glaze color, design and decoration, Huo porcelain was usually regarded as Ding porcelain. The difference between them was that Ding used support rings and fired porcelain upside-down, resulting in unglazed edges while Huo used stacked firing and nail support, leaving an unglazed circle in the center and spurs at the bottom. Additionally, the clay used by the Huo kilns had a high aluminum content, but its firing temperature was insufficiently high, so the products were very fragile and subject to breaking with bare hands. This was the biggest flaw of the Huo products. But the Huo style was unique in the northern region during the Yuan Dynasty, featuring quality craftsmanship, fine clay, white glaze and neat design, a very rare phenomenon in the north. Its clay was underfired, so there was little warping and it could be very thin. As a result, its products were not durable and few complete articles have survived intact. As a major private kiln, the Huo products were unearthed in the ruins of the then capital city, Beijing, like bowls, plates, small cups, small cup holders, pen washers, goblets and pots with lids. Its outwardly folding plates were the most representative. A scholar called Gu Yingtai in the late Ming Dynasty wrote: "In the Yuan Dynasty, Peng Junbao founded kilns in Huozhou, in imitation of the Ding products, so the kilns are known as the Peng or Huo kilns. Its outwardly folding plates are quite exquisite with fine clay and smooth walls. But they are fragile and lack luster." The Shanghai Museum housed some Huo products like outwardly folding plates and pen washers with printings. The Huo kilns used nails as support during firing, at most five to four at a time over the same varieties of porcelain so marks were left on the inside walls of *yuanqi*. It had been a feature of Huo porcelain to have nail marks both inside and outside. Its white porcelain had few decorations, usually just printings of flowers. Since very little Huo white porcelain remains today and few people know of it, sometimes it is even mistakenly regarded as Song white porcelain from the Ding kilns.

9.5.2 The Jun Kilns

In the Yuan Dynasty, Jun-style porcelain was made not only in Henan, but all over the nation. Even in Inner Mongolia, Guangdong and Shanxi, Jun-style kilns could be found. Thus, at the time, the Jun kilns must have been quite influential nationwide.[138]

According to archaeological studies, ruins of kilns in northern China have been found in 27 counties and cities in four provinces or autonomous regions. They include the current Yuzhou, Ruzhou, Jiaxian County, Xuchang, Hebi, Anyang, Dengfeng, Baofeng County, Lushan County, Neixiang County, Yiyang County, Jiaozuo, Qixian

[138] Yang Ailing, "A Re-examination of Porcelain Collections Unearthed in Cellars in Yancheng," Chinese Society for Ancient Ceramics (ed.), *Studies on Ancient Chinese Ceramics* (Vol. 14), The Forbidden City Publishing House, 2005, p. 131.

County, Huixian County and Linzhou in Henan Province, Cixian County in Hebei Province, Hunyuan County in Shanxi Province and Hohhot in the Inner Mongolia Autonomous region. Among them, the Juntai kilns from Yuzhou were official kilns, providing quality and exquisite porcelain as decoration for the royal court. In the Shenhou area of Yuzhou, there were many Jun-style kilns in the Northern Song Dynasty, as the region was endowed with rich natural resources like clay, glaze and fuel. The nearby mountains abounded in malachite. When malachite is smashed into powder, mixed with plant ash and placed under a reducing flame, an ideal copper red color is achieved. Once successful, this new technique became an immediate hit and was circulated to other areas.[139]

Cixian County in Hebei was an important base of the Cizhou kilns. However, under the influence of the Jun kilns from Yuzhou and increasing consumer demand in the then competitive market, Cixian continued operation but only on a small scale and only produced small articles like various bowls, plates, saucers, etc. Apart from Cixian, Guantai, Neiqiu and Longhua in Hebei were also found to be producing porcelain in imitation of the Jun style.[140]

In Shanxi Province, Hunyuan, Linfen and Changzhi were also found to be producing Jun-style porcelain. Among them, the Hunyuan kiln mainly produced bowls, featuring a thick azure glaze. Wherever it was unglazed, it appeared dark brown, which was quite unique to the Hunyuan kiln.

In Inner Mongolia, a fragment of a Yuan-style incense burner and a Jun-style hollowed-out high vase with two dragon-shaped lugs were unearthed from the Qing-shuihe site and Baita Village in Hohhot. These articles featured neat designs and clear glaze. The incense burner bore the inscription, "Made on Sept 15, 1309." This furnace is a real gem of Jun porcelain from the Yuan Dynasty and has also served as invaluable research material for chronological studies of Jun products.[141]

According to archaeological work nationwide, more areas were found containing Jun products from tombs, relic sites and pits from the Jin and Yuan dynasties. In recent decades, Jun porcelain made in the Yuan Dynasty was excavated from tombs and pits in Henan, Hebei, Shanxi, Shaanxi, Shandong, Inner Mongolia, Liaoning and Jiangxi, the then Yuan capital, Beijing, as well as wooden boats found in Nankaihe Village in Cixian County, Hebei Province, indicating continued production during the Yuan Dynasty. The expansion of the area of Jun porcelain production also signified that at the time, the advanced technology of the Jun kilns was promoted and consumer demand for Jun porcelain increased.

Though production expanded with more kilns established, Jun porcelain declined markedly in quality to become far inferior to that of the Song and Jin dynasties. Its clay became rough, loose and thick. Its glaze, mainly azure and bluish white, failed to cover the ring feet and gave rise to bubbles and dots. As Jun porcelain in the Yuan

[139] Zhao Qingyun, "On the Rise of Jun Porcelain and the Formation of the Jun Kilns," Chinese Society for Ancient Ceramics (ed.), *Studies on Ancient Chinese Ceramics* (Vol. 11), The Forbidden City Publishing House, 2005, p. 175.

[140] See Footnote 139.

[141] See Footnote 139.

Dynasty failed to create as attractive a color as in the Song Dynasty, much attention was paid to decoration. The kilns often put glarizonae with a high copper content on articles unevenly, and after reacting in a reduction flame, it was transformed into red marks. The red marks were stiff and unnatural, a far cry from the beautifully and evenly mixed blue, purple and red color of Jun porcelain in the Song Dynasty.

One Jun blue and red pot with two small lugs produced in the Yuan Dynasty and currently housed in the Berkeley Art Museum has a different color from the Jun porcelain from the Song Dynasty, and the red marks are underwhelming (Fig. 9.63). As a matter of fact, this was not entirely caused by a decline in quality. Instead, in the Yuan Dynasty, people's tastes changed, and the color of glaze was not the only criterion for judging a fine article (Fig. 9.64). In this period, new decorative techniques like embossed decoration and hollow engraving were applied. Lotus, wild animal heads, and dragon heads were put on the shoulders or bellies of articles. Large sized articles were very popular, and many had a base. These are all unique features of Jun porcelain in the Yuan Dynasty.

Jun porcelain made in the Yuan Dynasty was usually heavy and large, a feature shared by many other kilns. The Jun kilns mainly produced articles for daily use, like bowls, plates, cups, saucers, pots, furnaces, vases, basins, pillows, goblets and

Fig. 9.63 Jun blue and red pot with two small lugs, produced in the Yuan Dynasty, in the Berkeley Art Museum

Fig. 9.64 Purple glazed bowl, produced in the Yuan Dynasty, height: 10.9 cm, mouth rim diameter: 45.5 cm, in the Hebei Museum

Fig. 9.65 Jun decal furnace with three feet and two lugs, produced in the Yuan Dynasty, height: 23.6 cm, mouth rim diameter: 16.7 cm, in the Palace Museum

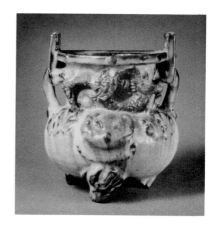

ewers. Drum-nail brush pen washers, flowerpots, *zun* and many other articles used for decoration often seen in the Song Dynasty, were all gone. In the Yuan Dynasty, *yuanqi* articles like bowls and cups paid great attention to designs on rims, while for articles used for decoration, such as incense burners and vases, there were various designs, with the application of embossment and hollow engraving (Fig. 9.65).

9.5.3 The Yaozhou Kilns

IT was in the Yuan Dynasty that the Yaozhou kilns declined. In this period, Yaozhou celadon was roughly made with loose clay, ginger-colored glaze and the area under the bottom was left unglazed. Yaozhou wares of this period also carried simple printings and engraving, losing its traditional elegant beauty. Apart from celadon, the Yaozhou kilns also produced a few white porcelain and black porcelain pieces as well as black on white porcelain and these were usually articles for daily use and produced in a rough style. All these changes showed that the once top producer of celadon in the northern region, the Yaozhou kilns, headed towards decline in the Yuan Dynasty. The once prosperous and expansive Yaozhou kilns were scarcely represented in Huangbao Town by the end of the Yuan and early Ming period.

In the Yuan Dynasty, most Yaozhou kilns moved to Lidipo, Shangdian and Chenlu from their original Song Dynasty center of Huangbao Town. Pure celadon like those made in the Song Dynasty was rare. Most articles unearthed from this period were black glazed celadon, tea-flake glazed celadon, and ginger glazed celadon, and made for daily use, such as bowls, which were numerous, along with vases, pots, plates, jars and lamps. From kiln ruins we can see that the Yaozhou kilns attained a large production capacity at the time with the assistance of stacked firing with basin-shaped or barrel-like saggers. This differed from the single-firing technique of the Northern Song Dynasty. When celadon lost popularity, a new variety of black on white porcelain in the Yaozhou style gradually distinguished itself (Fig. 9.66). This

Fig. 9.66 Black and white
plate with fish and algae,
produced in the Yuan
Dynasty, height: 9 cm,
mouth rim diameter: 38 cm,
in the Capital Museum

new variety also put engobe on clay before being glazed in black and then fired. How it differed from its Yaozhou kiln counterparts is that its decorations illustrated a vivid and natural picture with a few strokes forming a round-shaped image. Such abstract artistic expression made even common decorative motifs appear special.

9.5.4 The Cizhou Kilns

The Cizhou kilns were one of the largest private kiln networks in the Song Dynasty. While not the favorite of the Song rulers, its simple and plain decorations were popular in civil society. So, even though the northern kilns in general declined in the Yuan Dynasty, the Cizhou kilns remained a prolific producer and an active market player. Its black drawing on white body was not only unique among the private kilns of the north, but it was also copied by kilns in the south, like the Jizhou kilns from Jiangxi, the Xicun and Haikang kilns from Guangdong, the Hepu kilns from Guangxi, the Guangyuan kilns from Sichuan and the Quanzhou kilns from Fujian. With the expansion of Yuan territory and the boom in foreign trade, black on white and graffito techniques spread widely, even to Northeast Asian regions like Japan and Korea. Combined with their local styles, such techniques were adopted to create many successful works of porcelain.

Kilns producing Yaozhou-style products in the Yuan Dynasty extended through the Central Plains region and both banks of the Yellow River, including the Guantai, Linshui and West and East Aikou kilns in Cixian County, Hebei Province, the Dangyangyu kilns in Xiuwu County and the Bacun kilns in Yuzhou County, the Hebiji kilns in Tangyin, and the Shanyingzhen kilns in Anyang, Henan Province. Fragmented pieces of black on white porcelain and other Cizhou style porcelain have also been discovered in the Cicun kilns in Zibo, Shandong, the Hongshanzhen kilns in Xiujie, the Chencun kilns in Huozhou, the Longzici kilns in Linfen, the Guci kilns in Hunyuan, and the Xiaoyu kilns in Huairen, Shanxi. What is more, the Emaokou kilns in Huairen, the Qingci kilns in Datong and the Jiancaoping kilns in

Linfen, Shanxi Province have also surrendered shards of white glazed graffito porcelain. The Lingwu kilns in Ningxia were also discovered to have incomplete pieces of black glazed graffito porcelain. From these discoveries, we can see how widely Cizhou style porcelain was produced and how influential the Cizhou kilns were.

Like in the Song Dynasty, due to wars and natural disasters the official kilns abandoned production in quick succession, as did the private kilns. Thus, products of the Cizhou kilns came to meet the market demand and seized the opportunity afforded them to grow. In the Yuan Dynasty, six more kilns were built, including the Qingwan, Baitu, Shenjiazhuang, Futian, Erligou and Hequan kilns, bringing the total number of Yaozhou kilns to 16. With the increasing consumer demand, not only did the number of kilns grow, but the size of the furnaces also expanded.[142] Affected by the recession in the whole industry in the northern region, the varieties of Cizhou products were reduced. While very sturdy, due to their high firing temperature, the Cizhou products were roughly made, featuring loose clay, some even with grit, grayish brown or brown clay, a heavy body, yellowish white glaze and iron brown spots where the object was unglazed. Apart from a few exceptions, most items were unglazed at the bottom.

In terms of design, Cizhou products demonstrated characteristics of the times: they were predominantly large, and round in shape, such as large pots, basins, plum vases and pillows. In the Song and Jin dynasties, pillows were usually around 30 cm long while in the Yuan Dynasty, they were above 40 cm. And basins were even larger. A fish bowl was unearthed from the ruins of the Yuan capital, Beijing, in 1972, with the widest length measuring 49 cm. Major varieties produced by the Cizhou kilns in the Yuan Dynasty included bowls, plates, vases, pots, jars, pillows, incense burners and lamps. The most representative were ewers with four small lugs, *yuhuchunping*, and pillows in rectangular shapes, with the latter accounting for the greatest quantity. In addition, flasks with a small mouth and two small lugs, vases with a small mouth and large belly, furnaces with three feet and straight lugs, and basins with a small bottom and a handle on their edge were also typical products bearing features of the times. Pillows were already being produced in large quantities since the Song Dynasty. They took various shapes but the majority were like waists or *ruyi* scepter heads. In the Jin Dynasty, pillows were mainly in the shape of tigers and human figures. By the Yuan Dynasty, pillows in rectangular shapes were commonly seen, with flat surfaces and curved edges. Extant articles of Cizhou porcelain show that, when compared with the Song and Jin dynasties, Yuan pillows not only had an extended length, but were also painted with scenery, human figures and genre paintings. Ewers with four small lugs, a representative product of the Cizhou kilns in the Yuan Dynasty, were already popular from the Song and Jin period. In the Yuan Dynasty, ewers were longer than those of the Song and Jin, with a larger belly and four larger lugs and decorated with engravings (Figs. 9.67 and 9.68). On their bottoms, the ewers were glazed black, which visually enlarged the size of the articles and made them seem

[142] Ye Zhemin & Ma Zhongli, *The Cizhou Kilns in China*, Hebei Fine Arts Publishing House, 2009, p. 72.

calm and stable, and also formed a sharp contrast with the white glaze on top. This is a very unique decorative style of the Cizhou kilns in the Yuan Dynasty.

In this period, the varieties of Cizhou kiln products were greatly reduced and decorations simplified as compared with the Song and Jin dynasties when there were over two dozen decorative techniques. Extant products from the Yuan Dynasty are only white porcelain, black porcelain, black on white porcelain and white porcelain with engravings. The glaze and gloss of the Yuan products, meanwhile, basically remained the same as that in the Song Dynasty, though varieties in the Yuan Dynasty

Fig. 9.67 Cizhou black on white ewers with four small lugs and inscriptions of Yuan poetry, produced in the Yuan Dynasty, mouth rim diameter: 7 cm, bottom diameter: 8.2 cm, height: 36.1 cm, unearthed from Pengcheng Township, Fengfeng Mining District, Handan, Hebei Province, in the Handan Cultural Relics Protection and Research Institute

Fig. 9.68 Cizhou black on white ewers with four lugs and dragon engravings, produced in the Yuan Dynasty, height: 49 cm, in the Fukuoka Art Museum, Tokyo, Japan

were reduced to only a few types, such as black on white porcelain or black on blue porcelain, a far cry from the booming Northern Song Dynasty era.

In terms of decoration, the traditional scraping, engraving, scratching, printing, carving and molding techniques retreated, and instead, drawings with brush pens formed the majority. The most commonly seen was black drawings on a white body, some with scratching, thin black drawings on black glaze or brown red (Fig. 9.69). Motifs used were usually dragons, phoenixes, fish and algae, wild geese, flowers, plot scenes (Fig. 9.70), children at play, swirling clouds, brocade patterns, lotus, and various geometric figures. Flowers were the most popular while Chinese characters and story drawings were also frequently seen.

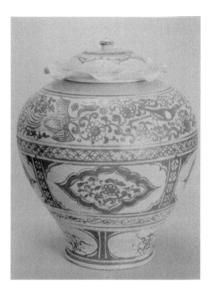

Fig. 9.69 Haikang brown red painted pot with a lid, produced in the Yuan Dynasty, height: 31 cm, mouth rim diameter: 8 cm, in the Guangdong Museum

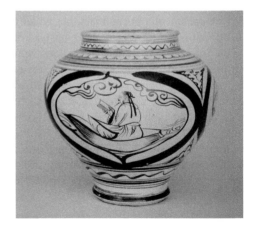

Fig. 9.70 Cizhou black on white figure pot, produced in the Yuan Dynasty, height: 30.5 cm, mouth rim diameter: 18.4 cm, in the Yangzhou Museum

Fig. 9.71 Cizhou green and
red *yuhuchunping*, produced
in the Yuan Dynasty, in the
Museum of East Asian Art
(MEAA) in Bath, UK

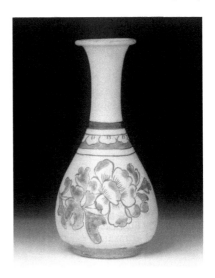

It is worth mentioning the green and red painted porcelain of the Cizhou kilns which emerged in the Jin Dynasty and became a hit on the domestic market. From the Yuan Dynasty, this ware began selling to the Southeast Asian regions and under its influence, in the Ming Dynasty, the Jingdezhen kilns, and especially the Zhangzhou kilns, produced a large volume of green and red ware and exported it to Southeast Asia. Illustrated in Fig. 9.71 is a green and red *yuhuchunping* featuring casual and simple decorations, which set the tone for the extensive production and export of green and red ware in the Ming Dynasty.

Chinese characters were popularly used as decorations on Cizhou kiln ware from the Song Dynasty and made further headway in the Yuan Dynasty with writings of poetry and *sanqu*, as well as long scripts of poems around the belly of porcelain ware, a unique feature of the Cizhou kilns in the Yuan period (Fig. 9.72). In the Song Dynasty, the Cizhou kilns only placed script on pillows and simple inscriptions of a few characters on pots and jars, but no lengthy calligraphic statements. It was quite a different story in the Yuan Dynasty. Poetry of the Tang Dynasty, Song poems, Yuan prose, idioms, slang, auspicious words, names of wines and medicines were all used for decoration. These characters are invaluable for our current research on the then Yuan social, economic and cultural development. From the perspective of calligraphy, there were regular script, cursive script, clerical script, and seal script. One can find both masterworks over generations as well as simple, plain works of ordinary potters, illustrating a real-life picture of calligraphy in society.[143] For example, on white plates, there were lines describing scenery in spring and on wine bottles, there were poems depicting life after spring rain. Thanks to their wide, flat surfaces, pillows could carry more characters, so long poems were often found

[143] Mu Qing, "Artistic Features of Black on white Porcelain from the Pengcheng Kilns in the Yuan Dynasty," Chinese Society for Ancient Ceramics (ed.), *Studies on Ancient Chinese Ceramics* (Vol. 11), The Forbidden City Publishing House, 2005, p. 248.

inscribed on their surfaces, like a long verse expressing frustrated feelings on a failed relationship. Figure 9.73 is a black on white pillow with the script of *Shanpoliyang*, a piece of Yuan prose. It has decorations on five sides, but not on the bottom. On the sleeping surface, it is a rectangular frame and four upwardly-curving edges suitable for sleeping, with water-chestnut-shaped panels and morning glory, lotus and other small flowers inside the four corners. On the sleeping surface, there are regular scripts of *Shanpoliyang* by Chen Caoan, a Yuan prose writer, warning people not to judge. On the front of the pillow, there is a poem in six-word verse and cursive script, describing a peaceful scene in the countryside. On the rear side, there is a piece of prose in semi-cursive script, expressing feelings of homesickness. The bottom bears printed lotus and an inscription indicating that it was made by the Wangs. Illustrated in Fig. 9.74 is a black on white pillow with scripts of *Chaotianzi*, also a piece of Yuan prose. On the sleeping surface is a rectangular frame and four upwardly-curving edges suitable for sleeping, with water-chestnut-shaped panels and morning glory and other flowers inside the four corners. The *Chaotianzi* is arranged at the center, urging people to refrain from greed.

Apart from the calligraphy, the Cizhou kilns' black on white decoration technique was also very special. Compared with the Song Dynasty, the Cizhou kilns emphasized

Fig. 9.72 Cizhou black on white pillow with scripts of *Xilaichun*, produced in the Yuan Dynasty, width: 27 cm, in the Hebei Museum

Fig. 9.73 Cizhou black on white pillow with scripts of *Shanpoliyang*, produced in the Yuan Dynasty, height: 28.5 cm, width: 16 cm, height: 14 cm, unearthed from a construction site south of the Cixian railway station, in the China Cizhou Kilns Museum

Fig. 9.74 Cizhou black on white pillow with scripts of *Chaotianzi*, produced in the Yuan Dynasty, height: 46.7 cm, width: 17.7 cm, height: 15.5 cm, unearthed from Shichang Village, Dudang Town, Cixian, in the China Cizhou Kilns Museum

line drawing more in the Yuan Dynasty. In the Yuan period, the Cizhou kilns still painted flowers and life scenes in a simple, plain manner, just as in the Song Dynasty. However, in this period, due to the influence of Yuan poetry, prose and novels, the Cizhou pillows were often decorated with stories, a major feature of the kilns in this period and also a highlight in the history of Chinese ceramics. Though the Song also saw figure paintings, mainly children at play, as decorations, it was in the Yuan Dynasty that painting human figures to illustrate a story prevailed for the first time in the ceramics industry. Apart from the influence of the Yuan cultural metamorphosis, this was made possible because of woodcut paintings which featured complicated scenes, fine descriptions and line drawing in traditional ink and brush style. This style not only affected the painting of the blue and white porcelain of the Jingdezhen kilns at the time, but also laid the foundation for the emergence of the blue and white figure paintings after the Ming and Qing. Figure 9.75 is a black on white pillow with a picture of Yurang, an assassin. A framework of five lines is drawn on the edge of the sleeping surface, with curving lines between the second and third lines. Inside the frame are water chestnut decorations and pomegranate flowers and other small flowers on the edge. The center features a picture of Yurang trying to kill his enemy Zhaoxiangzi. The whole picture is well structured with neat lines and vivid character depiction. With such skill, it would have been perfectly capable of producing products as beautiful as the blue and white porcelain of Jingdezhen. So, it is possible that the workers at Jingdezhen learned from the Cizhou kilns and applied the figure painting to porcelain making which can be found in products from Jingdezhen. Figures 9.76 and 9.77 feature a Cizhou black on white pillow with scripts of the love story of Liu Yi and a Cizhou black on white pillow with scripts of a Yuan poetic drama.

Dragons and phoenixes were often seen on Cizhou ware, mainly on pots and jars. A dragon was usually coupled with a phoenix, or two phoenixes were painted together. A locally produced iron ore called "*banhuashi*" was used as a pigment and through different formulas, light and heavy shades of color could be controlled. Dark colors (approaching black) were usually used on thick frame lines and light colors (approaching isabelline) for thin lines. The mixed use of heavy and light colors gave the pictures a lively appearance (Figs. 9.78 and 9.79).

Floral decorations were also casually placed on pots and jars (Fig. 9.80), quite similar to the blue and white porcelain made by private Jingdezhen kilns in the late

Fig. 9.75 Cizhou black on white pillow with picture of Yurang, an assassin, produced in the Yuan Dynasty, height: 38.5 cm, width: 17.7 cm, height: 14.5 cm, in the China Cizhou Kilns Museum

Fig. 9.76 Cizhou black on white pillow with scripts of the love story of Liu Yi, produced in the Yuan Dynasty, height: 31.5 cm, width: 16.1 cm, height: 12 cm, rear wall: 13.9 cm, unearthed from a construction site in the Fengfeng Mining District, Handan, Hebei Province, in the Institute of Cultural Relics of the Fengfeng Mining District, Handan

Fig. 9.77 Cizhou black on white pillow with scripts of a Yuan poetic drama, produced in the Yuan Dynasty, height: 30.5 cm, width: 15.3 cm, height: 12 cm, unearthed from Pengcheng Town, Fengfeng Mining District, Handan, Hebei Province, in the Institute of Cultural Relics of the Fengfeng Mining District, Handan

Fig. 9.78 Cizhou brown on
white pot with a straight
mouth, large shoulder and
dragon and phoenix
decoration, produced in the
Yuan Dynasty, mouth rim
diameter: 21.5 cm, bottom
diameter: 14.5 cm, height:
36.3 cm, unearthed from
Pengcheng Town, Fengfeng
Mining District, Handan, in
the Handan Museum

Fig. 9.79 Cizhou black on
white pot with double
phoenixes, produced in the
Yuan Dynasty, mouth rim
diameter: 24 cm, bottom
diameter: 15.8 cm, height:
43 cm, unearthed from a pit
in Zhangmeng Village,
Guangping County, Hebei
Province, in the Institute of
Cultural Relics of the
Fengfeng Mining District,
Handan

Fig. 9.80 Cizhou black on white pot with twigs of sunflower, produced in the Yuan Dynasty, mouth rim diameter: 18.3 cm, bottom diameter: 13.8 cm, height: 32.3 cm, in the China Cizhou Kilns Museum

Fig. 9.81 Cizhou black on white basin with fish and algae, produced in the Yuan Dynasty, diameter: 36 cm, height: 15 cm, unearthed from a pit in Zhangmeng Village, Guangping County, Hebei Province, in the China Cizhou Kilns Museum

Yuan and early Ming periods. Some were painted with fish and algae (Fig. 9.81) and some with lotus (Fig. 9.82). These decorations can remind one of the blue and white porcelain made in Jingdezhen or in Yunnan, both sharing some similarities with products of the Cizhou kilns. Thus, we can see that the black on white decorative technique of the Cizhou kilns indeed affected other contemporary kilns.

9.6 Pottery of the Yuan Dynasty

In the Yuan Dynasty, the Ding and Yaozhou kilns cut their production, but the Jun and Cizhou kilns remained productive and the southern kilns like Jingdezhen and Longquan emerged as important producers nationwide. This was especially true of

Fig. 9.82 Cizhou black on white basin with lotus, produced in the Yuan Dynasty, diameter: 44 cm, height: 12 cm, in a private collection in the Fengfeng Mining District, Handan

the Jingdezhen kilns which expanded rapidly and expanded its production at an unprecedented pace. Thus, as the use of pottery narrowed, so did its production. The pottery industry thus was forced to increasingly turn to the production of *liuli*, a form of archaic Chinese glasswork used by the architectural industry and gradually *liuli* production boomed and became the backbone of the pottery industry in the Yuan Dynasty. Pottery for storage and sacrificial offerings was also produced due to its simple manufacture and low costs. Terracotta figurines made in the Yuan Dynasty inherited the features of the Song Dynasty as well as developing its own style. What is worth noting are some terracotta figures in a realistic style which have been unearthed from tombs in the northern regions. For example, a set of colorful terracotta attendants was discovered from a tomb dating back to the Yuan period in Jiaozuo, Henan Province. They are delicately made with unique features. Some of the attendants are serving, with a basin or a towel in their hands, some are putting on makeup for their master, with a respectful and cautious facial expression. In the tombs of the He family in Hu County, Shaanxi, over a hundred terracotta figures were excavated, the largest batch of Yuan terracotta figures ever found. Most of the figures are in Mongolian costume and demonstrate distinctive ethnic features. The most representative among the Yuan terracotta figures are gray figurines leading a horse and figures beating a drum on camel back, which vividly show their shapes and spirits.

Liuli was originally a kind of colored glass imported from overseas in the Wei and Jin dynasties (220–420). Later it became known as "*liaoqi*" (glassware), or "*shaoliao*." After it was mixed with lead dioxide and used in construction bricks, it became known as "*liuli*," which served as a general term for pottery with a lead glaze.

In Northern China, it was generally believed that *liuli* originated from Shanxi and that it was mainly produced there, later spreading to Shandong, Henan, Beijing, and elsewhere. While the royal palace in which the Ming rulers resided, upon the founding of the dynasty, used *liuli* which was produced on Jubao Mountain

in Nanjing, following a rebuilding during the Yongle period (1403–1424), locally-produced *liuli* from the capital city, Beijing, was applied to the new palace. It is said that workers at the *liuli* factory in Mentougou in Beijing, were migrants from Shanxi in the Yuan Dynasty.

The Yongle Palace in Ruicheng County, Shanxi Province, a Taoist temple complex built in the Yuan Dynasty, preserved many *liuli* building components, mainly in the roof of the Sanqing, Chunyang, Longhu and Qizhen halls. The *liuli* ware in Sanqing Hall was the most glamorous, with five pieces placed together. Glazed in smooth, shiny and transparent peacock blue color, its *longwen*, a decoration on the roof ridge, displayed a large upwardly curling dragon as high as five meters, coupled with the dragon king or god of rain in ancient Chinese fairy tales or floating clouds, appearing quite magnificent.

The palace built on the orders of Kublai Khan in Beijing also used a lot of *liuli* ware, giving it a splendid appearance. After rebuilding in the Ming and Qing dynasties, the old palace of the Yuan Dynasty was long gone. But many pieces of *liuli* ware were found underneath the current Palace Museum, including *chiwen* (an ornament on the roof ridge in the shape of a legendary animal), plate tiles, imbrex and white eave tiles. These objects were also fine and delicate with a bright glaze. Some were very large, demonstrating the magnificent air of the royal building. For example, a fragmented *chiwen* was found and its leg and claw was as long as 23 cm, so one can imagine just how large the whole piece would have been.

Apart from building components, other *liuli* ware produced in the Yuan Dynasty included articles used for sacrifice and Buddha statues, along with some beautiful ornamental items. The Palace Museum houses a *liuli* furnace with three feet featuring a dignified design and delicate engraving, and glazed in yellow, green and white. On its two lugs, it is inscribed with characters indicating that it was made in 1308 by a man named Ren Tangcheng on imperial orders in Fenyang, Shanxi.

Varieties of *liuli* ware include furnaces, pavilions, memorial archways, lamps, jars, booths, pagodas, pots, vessel bases, and shrines. Most of them are large, glazed in yellow, green, blue or white and use pierced engravings as decoration. Many years ago, a *liuli* furnace with decal and pierced engravings was unearthed from the ruins of the Yuan capital. It reached a height of 37 cm, glazed in yellow, green and blue and was decorated with decal and pierced engravings, creating an extraordinary appearance. Its lid was in the shape of a mountain with a dragon climbing on it, forming a perfect combination with the straight lugs of the furnace. The dragon and phoenix motif on the body is also magnificent. This article displays the advanced production technique of *liuli* ware in the Yuan Dynasty (Fig. 9.83).

In the Yuan Dynasty, *liuli* ware was usually inscribed with the names of its producers, along with the place and time of production. For example, the furnace mentioned above has inscribed in its lugs that it was made in early April, 1308 by a man named Ren Tangcheng in Liuyang, Shanxi. By 1308, it had been 48 years since the founding of the Yuan Dynasty and both society and the economy were still in recovery. Liuyang is a city in Shanxi Province and ranked as an important place for producing *liuli*. This work, with specific information regarding its producer, time and place of production, serves as a precious sample for investigating the development

Fig. 9.83 Cizhou tricolor
furnace with dragon and
phoenix pattern, produced in
the Yuan Dynasty, height:
37 cm, mouth rim diameter:
22 cm, in the Capital
Museum

level and features of pottery at the time. In fact, it was a tradition for producers to
put their names on their products, but usually on somewhere less noticeable. With
the inscriptions on the lugs of this furnace in a very obvious location, it is obvious
that the social position of potters had improved in the Yuan Dynasty.

9.7 Porcelain Exports in the Yuan Dynasty

With the grand unity achieved by the Yuan Dynasty, it not only commanded a
large territory, but also enjoyed unprecedented development in land and maritime
transportation. Thanks to this, the export of ceramics expanded in both volume and
reach.

Export of porcelain in the Yuan Dynasty continued the transportation routes of the
Tang and Song dynasties, with the Port of Quanzhou as the most important departure
point. From Quanzhou there were two maritime routes. One headed towards Japan,
starting from Quanzhou and tracking north through the East China Sea to Shandong,
then via the Bohai Sea it traversed the west coast of Korea and reached Kyushu.
Alternatively, it also traveled through the Zhoushan Islands, skirted the coast of
Jiangsu, crossed the East China Sea, entered Korea and headed north along the west
coast of Korea to Kaesong or the Japanese islands. The other route headed towards
Southeast Asia, also departing from Quanzhou, traversed Penghu Lake where it
transferred cargo, or ventured south towards the Southeast Asian regions, then to the

Persian Gulf past the Indian Peninsula, crossing the Red Sea and reaching Egypt or other African areas.[144]

After the Song rulers relocated their capital to Lin'an, the political center of the Southern Song Dynasty shifted southward. Thus, the hub for foreign trade also moved from Guangzhou to Quanzhou, resulting in the Port of Quanzhou becoming the largest port for porcelain exports after Guangzhou. From the Southern Song to the Yuan Dynasty, the Port of Quanzhou played an even more important role than the Port of Guangzhou and greatly contributed to the prosperity of maritime trade. Products from Chuzhou, Zhejiang Province and celadon from Quanzhou, Fujian Province also departed from here on their journey abroad. At the time, Quanzhou was the major port for porcelain exports, followed by Guangzhou, Hangzhou and Mingzhou, forming the four largest ports for porcelain exports.[145]

From September to November, 2001 and March to July, 2002, the Ningbo Municipal Institute of Cultural Relics and Archaeology launched two archaeological excavations of the Zicheng ruins in the city, exploring some 1000 m^2 and 3500 m^2 respectively and unveiling warehouse ruins of government offices of the Song, Yuan and Ming dynasties, with the Yongfeng warehouse in the Yuan Dynasty era Yuanqing Road as the main focus. In the process, researchers discovered many important cultural relics, including over 500 intact or repaired articles from over the generations. Especially worth mentioning is the fact that the porcelain unearthed consisted of products from almost all the major kilns in the Song and Yuan dynasties, including celadon from the Yue and Longquan kilns, *Yingqing* and *Shufu* ware from Jingdezhen, *Yingqing* ware and white porcelain from Fujian, white porcelain from the Dehua kilns, white porcelain from the Ding kilns, and black glazed small cups from the Jian kilns.[146] This discovery provided a glimpse of the prosperity of the Port of Mingzhou, in present-day Ningbo, as a port for porcelain export.

In the Yuan Dynasty, each variety of porcelain had a very specific export market. For instance, large blue and white porcelain, produced by the Jingdezhen kilns with paintings in imported cobalt blue and sophisticated decorations, was mainly sold to the Islamic regions and countries in west Asia. While small blue and white porcelain products painted with domestic cobalt blue and decorated with simple and plain motifs, was exported to Southeast Asia. In addition, according to archaeological research in neighboring countries like the Philippines, a large amount of Chinese porcelain has been discovered, but none was produced by kilns in northern China. Instead, all were produced by kilns in the south, like Jiangxi, Zhejiang, Fujian, Hunan,

[144] Chen Jianzhong & Zeng Pingsha, "Discussion of the Quanzhou Kilns, Exports of Porcelain through the Maritime Silk Road and Other Issues," Chinese Society for Ancient Ceramics (ed.), *Studies on Ancient Chinese Ceramics* (Vol. 14), The Forbidden City Publishing House, 2008, p. 212.

[145] Ye Wencheng, "On the Export Routes of Ancient Chinese Ceramics," Chinese Society for Ancient Ceramics (ed.), *Studies on Ancient Chinese Ceramics* (Vol. 14), The Forbidden City Publishing House, 2008, pp. 380–381.

[146] Shi Zuqing, "Yue Celadon and the Mingzhou Maritime Silk Road," Chinese Society for Ancient Ceramics (ed.), *Studies on Ancient Chinese Ceramics* (Vol. 14), The Forbidden City Publishing House, 2008, p. 141.

Guangdong, and elsewhere. Meanwhile, among the relics found in the shipwrecks of Sinan, South Korea, no blue and white porcelain was identified.[147]

The Customs of Cambodia also provides valuable reference material for research on porcelain exports from kilns in southern Fujian to Southeast Asia. In the work, it mentions "celadon of Quanzhou," which, according to Mr. Chen Wanli, generally referred to porcelain produced in the southern Fujian region. Mr. Chen states that in the Yuan Dynasty, the Port of Quanzhou was the busiest, so kilns in nearby regions, like Tongan, Nan'an, to Yongchun and Xianyou, could well have all exported via the Port of Quanzhou. So it is probable that, while made in different kilns, all the exports from Quanzhou were generally referred to as celadon from Quanzhou.[148] Through rounds of investigations following the founding of the PRC, several kilns relating to exported porcelain have been identified and archaeological research in the Southeast Asian region has also provided relevant objects as evidence.

The most valuable research materials for porcelain exports in the Yuan Dynasty were those salvaged from the shipwrecks of Sinan in 1976. A total of 16,000 pieces were found, which was quite unprecedented as all were from a single ship. Besides, in the excavation of shipwrecks of the Yuan Dynasty on Dalian Island, Pingtan County, Fujian Province in 2006, the samples uncovered were all celadon ware from the Longquan kilns, including plates, bowls and pots. They were made from gray clay, had bluish yellow or dark green glaze inside and out, and some were left unglazed on the ring feet. This batch of porcelain was identified as products of the late Yuan Dynasty.[149]

Apart from those found in shipwrecks, many Longquan products have been found in ancient ruins around the world. For example, in over 40 counties in Japan which were engaged in foreign trade, such as Fukuoka, Saga, Nagasaki, Kumamoto, Kyoto, Nara, Wakayama and Kanagawa, preserved remains of Longquan celadon have been found in their ancient ruins, town sites, tombs and seas. Celadon produced by the Longquan kilns has also been discovered in Egypt, East Africa, the coast of the Mediterranean Sea, Persia, the north shore of the Indian Ocean, Central Asia, and the Indus. Most of these regions were markets for celadon produced by the Yue kilns in the Five Dynasties and the Northern Song. So, it appears that in the Southern Song and Yuan dynasties, celadon produced by the Longquan kilns travelled via the same routes to overseas markets.[150]

Vases exported from the Longquan kilns in the Yuan Dynasty included items with multiple mouths or with pierced lugs and curling dragons, flasks with plate-shaped mouths, large vases with peonies, vases with two rings of lugs, vases with rings of

[147] Ye Zhemin, *History of Chinese Ceramics*, SDX Joint Publishing Company, 2006, p. 470.

[148] Chen Wanli, "Research on Ancient Kilns in Southern Fujian Province," *Archaeological Research on Porcelain of Chen Wanli*, The Forbidden City Publishing House, 1997, p. 230.

[149] Zhao Jiabin, "Ancient Chinese Exports of Porcelain through the Maritime Silk Road," Chinese Society for Ancient Ceramics (ed.), *Studies on Ancient Chinese Ceramics* (Vol. 14), The Forbidden City Publishing House, 2008, pp. 5–6.

[150] Shi Zuqing, "Yue Celadon and the Mingzhou Maritime Silk Road," Chinese Society for Ancient Ceramics (ed.), *Studies on Ancient Chinese Ceramics* (Vol. 14), The Forbidden City Publishing House, 2008, p. 141.

ripples, vases with lotus, peony, double fish and dragon, vases with garlic-shaped mouths, vases for joss sticks, as well as *yuhuchunping* with dragon decorations. For bowls, there were bowls with plum blossoms and the moon, bowls with lotus petals, plain bowls with an open mouth, plain bowls with a tight mouth, goblet bowls and bowls with grass. Furnaces were either *li*-like, furnaces with three feet and two lugs, hexagonal furnaces with lotus, furnaces with twining peony, Eight Trigrams triangle furnaces, furnaces with peony decal, furnaces with peony decorations and animal feet, furnaces with two lugs, animal feet and an animal-shaped lid, or furnaces with chrysanthemum decorations, four lugs and three feet. For pots or vats, there were pots with peonies, grass and lotus-leaf-shaped lids, pots with prismatic lines on the body and a lotus-leaf-shaped lid, grass pots with a round lid, small vats with prismatic lines on the body and a lotus-leaf-shaped lid, small pots with bow string patterns and a lotus-leaf-shaped lid, pots with lotus and a lid, or small jars with a round belly and iron stain patterns. Basins or plates included double fish basins with decal and printings, large basins with decal dragons, large basins with peonies, plates with flowers and grass (one with an inscription indicating the article was exclusively used by the mansion of an official), large plates with lotus patterns and lotus-petal-shaped rims, large plates with lotus, large plates with chrysanthemum, plates with ice crackle patterns, plates with double phoenixes, and plates with iron stain patterns. For pen washers, there were washers with grass, with flowers, with a tight mouth, with small dots or with iron stain patterns. For ewers, there were ewers with peony and chrysanthemum, ewers with dragons, and gourd-shaped ewers. Flowerpots either had petal-shaped rims or were hexagonal with flower patterns. In addition, there were other varieties of exported goods, like small cup holders, ink stone water holders in the shape of a Taoist priest, fish-shaped ink stone water holders, cow-shaped ink stone water holders, herbal medicine crushers, flower boxes and Buddha statues.

Apart from blue and white porcelain from the Jingdezhen kilns and works of the Longquan kilns, *Yingqing* ware from Jingdezhen-style kilns and white porcelain from *Shufu*-style kilns accounted for a large proportion of exports. For *Yingqing* ware, there were pillows with human figures, plum vases with dragons, plum vases with peony, vases with peony and fish-shaped lugs, *yuhuchunping*, vases with plum blossom, small vases with a base (Fig. 9.84), ewers with phoenixes, ewers with grass and elephant-ear-shaped lugs, gourd-shaped ewers, peach-shaped ewers, gourd-shaped ewers with iron stain patterns, plates with leaves and petal-shaped edges, silver-coated plates with dragons and uneven edges, silver-coated bowls with water birds (with inscriptions indicating they were classic ware), silver-coated bowls with lotus and fish, as well as peach-shaped small cups and ink stone water holders in the shape of a child riding a cow. White ware produced by Jingdezhen-style kilns included silver-coated bowls, bowls with thin lines, bowls with a tight mouth, furnaces with two elephant trunks as lugs, plum blossom vases and silver-coated plates with phoenixes. For white ware made by *Shufu*-style kilns, there were bowls with lotus, bowls with grass, bamboo-hat-shaped bowls with phoenixes, inwardly-folding bowls with grass, inwardly-folding bowls with lotus petals, goblet bowls with an open mouth, goblet bowls with flowers and a tight mouth, and plates with chrysanthemum and a fat-lip-like rim, etc.

Fig. 9.84 *Yingbai* vase with
decal plum blossom flower
and a base, produced in the
Yuan Dynasty, height:
24.7 cm, mouth rim
diameter: 2.6 cm, in the
Jiangxi Provincial Museum

9.8 Conclusion

Under the rule of the Yuan Dynasty, China enjoyed a vast territory and active cultural
and business exchanges among different ethnic groups, which allowed people to
expand their horizons. At the same time, a booming commodity economy propelled
the prosperity of civil and business culture, which led to a transition in aesthetic tastes
from the pursuit of gentle and refined beauty in the Song Dynasty to a tolerance for
earthy and sumptuous beauty in the Yuan Dynasty, resulting in a new aesthetic in the
handicraft industry of the period. Its porcelain products also embraced the change
and became a representative and carrier of the culture and art of the new age. Thus,
the landscape of the mainstream porcelain art was changed, from porcelain with one
layer of glaze to products with colorful paintings, from an elite-dominated culture to
a civilian culture. While the Yuan Dynasty was not long lived, it nevertheless played
an important role in the history of Chinese ceramic arts.

In terms of porcelain production during this time, on one hand there was a huge
demand in the domestic and overseas markets, while on the other, as important kilns
in the north declined, those in the south grew by leaps and bounds, especially the
Jingdezhen and Longquan kilns. As has been mentioned above, many kilns declined
in quality, if not in output. Common features of products in the Yuan Dynasty were
that their clay was thick but loose and their glaze thin and dull. For example, the
Longquan kilns boasted charming and glossy glazes as beautiful as jade in the
Song Dynasty, but this feature had basically disappeared in the Yuan period. The
Jingdezhen kilns, however, were an exception; they not only out-performed the Song
Dynasty in terms of quantity, but also in decoration and variety, with their raw mate-
rials much finer, their elutriation more delicate and their firing temperatures higher.
Thanks to these elements, the Jingdezhen kilns dominated the industry in the Ming
and Qing dynasties. Despite this, the Longquan and Cizhou kilns also distinguished

themselves in the Yuan Dynasty with the Longquan kilns ranking top in terms of production and export while the black on white paintings of the Cizhou kilns had an immediate impact on the development of the blue and white porcelain of the Jingdezhen kilns as well as kilns in Yunnan Province. It is difficult for us to tell how these kilns interacted with each other, but we can see the similarities they shared in decoration technique, modes of composition, and motifs, such as various flowers, birds, human stories, etc. Here is a summary of the design and decorative features of Yuan porcelain.

9.8.1 Design

Yuan porcelain was produced on the back of the advanced ceramics technology of the Song Dynasty, which meant that Yuan production techniques should have been more advanced than those of the Song Dynasty. In fact, this was not true, due to the means of production, lifestyle and aesthetic values of the Mongols. In the Yuan Dynasty, people preferred durable, large articles that were more suitable to their lifestyle rather than thin, delicate ones. Foreign trade also favored bulky and durable products, which set the tone for porcelain making in the Yuan Dynasty. In the Song Dynasty, thanks to its advanced technology, the clay was often fashioned in one piece, even for furnaces and vases. However, in the Yuan Dynasty, due to the large sizes, not only was clay formed in pieces, but bases were even made separately and the final article assembled afterwards. Because of the rough workmanship, there were not only marks left where different pieces were joined, but sometimes there was leaking when the products were being used. From extant articles passed down from the Yuan Dynasty, the workmanship on *yuanqi* (open-form wares) and *zhuoqi* (closed-form wares) alike was sub-optimal, especially their bottoms which were large and clumsy. This was especially evident in kilns producing monochrome porcelain.

Porcelain varieties in the Yuan Dynasty were far fewer than in the Song Dynasty, including a wide range of porcelain ware from daily use articles to decorative pieces, burial items and toys. In the Yuan Dynasty, daily use articles prevailed and delicate decorative wares were rarely seen. Daily use porcelain production was dominated by *yuanqi* in the Yuan Dynasty, including bowls, plates, cups, saucers, pen washers and *yi* (used to contain water for washing hands before rituals, like sacrifices). Bowls, the most basic variety, inherited the design from the Song Dynasty, but also made some innovations of their own. Plates had a wide range of applications in the Yuan Dynasty, so their production was more delicate than that of bowls. Most plates were round, large in size and carried a variety of decorations. Some had an open mouth and some a folded rim. Plates with a folded rim were common and almost all kilns produced this variety. They had round or varied rims, with the latter preferred. All plates in the Yuan Dynasty had their decorations inside and no glaze on their gritty bottom. Pen washers were the most varied products among *yuanqi* wares. While inheriting their design from the Song Dynasty, the Yuan pen washers had wide or folded rims, not thin ones like those in the Song. *Yi*, an ancient Chinese washing vessel, had a flat

bottom and open mouth, with a short pouring spout on one side. Since *yi* are rarely found following the Yuan Dynasty, it is regarded as a representative Yuan product.

Vases and pots in the Yuan Dynasty also boasted a wide range of varieties, most of which developed from the basis established during the Song Dynasty, but also differed in several different ways. For example, plum vases in the Yuan Dynasty had large shoulders, leading to an apparent raised belly as well as a raised center of balance for the whole piece. The contours tightened beneath the belly, rendering the object elegant and graceful. Some also had a sharply constricted belly attached to outward-facing feet in order to keep the whole article stable and steady. In the Song Dynasty, most plum vases did not have a lid, while in the Yuan Dynasty, many had a lid which cupped the mouth and featured a bead shape on top (Fig. 9.85). *Yuhuchunping* were also frequently seen in the Yuan period. Their shape remained basically unchanged from that in the Song Dynasty except for a longer head (Fig. 9.86). The traditional ear-shaped lugs in the Song Dynasty were continued and popularized by the Yuan, eventually becoming an exemplar of Yuan porcelain. Another of its features was that many products were coupled with a base. Vases with a flower-shaped rim, and gourd-shaped vases from the Song Dynasty, were also made in the Yuan Dynasty while *gu* vases and *zhi* (an ancient Chinese drinking vessel, with the appearance of a *zun*) style vases had disappeared.

Most pots featured a small neck, straight mouth, large belly and thick clay, with the lower part thicker than the upper part, to make the whole piece look stable. They usually sported one of two types of shoulders: one was a wide shoulder coupled with a round belly and tight upper section, which made the whole article appear chubby; the other was a sloping shoulder, coupled with a tight upper section, which made the object appear balanced and tall. Most pots in this period had lids, which varied.

Fig. 9.85 Blue and white plum vase with twining peony, produced in the Yuan Dynasty, height: 48.7 cm, mouth rim diameter: 3.5 cm, in the Gaoan Museum, Jiangxi Province

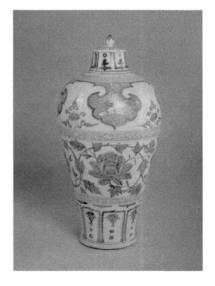

Fig. 9.86 Blue and white *yuhuchunping* with dragon patterns, produced in the Yuan Dynasty, height: 27.2 cm, mouth rim diameter: 8.3 cm, in the Jiangxi Provincial Museum

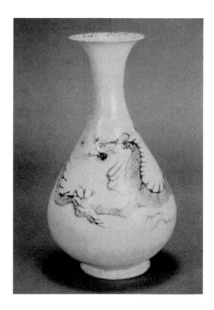

Some were in the shape of beads, or lions. Waving-lotus-leaf lids glazed in green were a typical design for celadon pots of the Longquan kilns. Such lotus-leaf lids were exclusive to the Yuan Dynasty and they served as a benchmark for products made at this time. Other kilns in this period also made similar lids (Fig. 9.87).

Ewers in the Yuan Dynasty varied in design. Most ewers had a delicate body like that of the *yuhuchunping*, coupled with a long, thin spout and curving handle. The spouts were higher than those of the Song Dynasty. Some ewers had a ring on their lids and lugs so the two rings could be tied together in case the lids fell.

Fig. 9.87 Blue and white pot with dragon and lotus pattern and a lid, height: 36 cm, mouth rim diameter: 21 cm, found in a Yuan pit in Gaoan, Jiangxi Province, in the Gaoan Museum

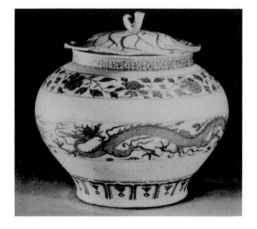

Apart from the above-mentioned varieties, there were also porcelain granaries in the shape of a pavilion, Jun vases with flower-shaped mouths, transparent pierced engraving pillows, underglazed red brown seats with flowers, blue and white water droppers with a dragons, etc. (Figs. 9.88, 9.89, 9.90, 9.91 and 9.92).

Fig. 9.88 Blue and white ewer, produced in the Yuan Dynasty, height: 26 cm, mouth rim diameter: 6.5 cm, in the Jiangxi Provincial Museum

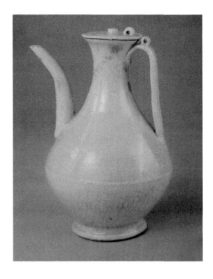

Fig. 9.89 Jun vase with a flower-shaped mouth, two lugs and a camel-shaped base, produced in the Yuan Dynasty, height: 63.8 cm, mouth rim diameter: 15 cm, in the Capital Museum

Fig. 9.90 Blue and white
pierced stage-like pillow,
produced in the Yuan
Dynasty, height: 15 cm,
length: 22 cm, in the
Fengcheng Museum, Jiangxi

Fig. 9.91 Underglazed red
brown seat with flowers,
produced in the Yuan
Dynasty, height: 24.1 cm,
length: 29 cm, in the Palace
Museum

Fig. 9.92 Blue and white
water dropper with dragon,
produced in the Yuan
Dynasty, height: 12 cm, in
the Chongqing Museum

9.8.2 Glaze and Decorations

Throughout Chinese history, there has always been both refined culture and popular culture. Refined culture arose out of the joint influence of Confucianism, Buddhism and Taoism. Ideologically, Confucianism plays a dominant role in this process while from the perspective of aesthetic tastes, Buddhism and Taoism are admired. Over generations, the ceramics industry pursued the gentle, implicit and natural beauty, which peaked in the Song Dynasty with the emergence of celadon, white porcelain, black porcelain, and the fambe porcelain of the Jun kilns, as well as hare-fur glaze, oil spot glaze and tortoiseshell glaze. Such attractive porcelain excelled in glaze and seldom applied complicated decorative patterns. Even if decorated, it was usually engraving and piercing, rarely painting.

But in the Yuan Dynasty, things changed. In literature, a straightforward and popular form of art, drama became a hit. Accordingly, in porcelain making, colorful paintings, which demonstrated folk life but was despised by scholars, began to distinguish themselves in wares like white on black, blue and white porcelain, and red and green porcelain. Refined culture and popular culture both began to merge in the Yuan Dynasty as a result of changes in the social positions of scholars and progress in the commodity economy and social development.

Thus, the history that had been dominated by refined culture in China ended in the Yuan Dynasty, and popular culture assumed a dominant position. This change heralded modern history.[151] The change was reflected in ceramic art through a change in the Song glazes which were replaced by the popular display of colorful paintings in the Yuan, and later the *wucai* (five colors) ware and *fencai* (famille-rose) porcelain of the Ming and Qing dynasties. This marked a significant transition in China's history of ceramic art.

Against such a backdrop, we can see that kilns in the south and north in the Yuan Dynasty shared one feature. Compared to the Song Dynasty, more attention was paid to decoration and less to glaze. This resulted in more decorative patterns and techniques than at any other time in Chinese history as the Yuan learned from the past whilst making innovations of its own.

For example, Longquan celadon was famous for its glaze, which was as thick and attractive as jade. Its color included bluish white, pea green, light blue, balsam green, crust green, grayish yellow, as well as the most charming light greenish blue and plum green. Light greenish blue glazed Longquan porcelain appeared opaque, smooth and gentle. Compared with light greenish blue, the plum green was more glamorous, mature, and bright with a slightly transparent luster, as refreshing as new plums. Glaze and clay making in the Yuan Longquan kilns was a far cry from that in the Song Dynasty, but its decorations were more varied. For instance, there were animals, insects, flowers and geometric patterns put on porcelain articles through techniques like printing and engraving, and embossed decal on large pieces, techniques that were never used by the Song Longquan kilns (Fig. 9.93).

[151] Wang Xiaoshu, *History of Chinese Aesthetic Culture, On the Yuan, Ming and Qing Dynasties*, Shandong Pictorial Publishing House, in 2000, p. 6.

Fig. 9.93 Blue and white *zun* with a lion base, produced in the Yuan Dynasty, height: 21.8 cm, length: 13.4 cm, in the Shanghai Museum

Apart from the Jun kilns, the Cizhou kilns were the only major kiln which remained vigorous against the backdrop of the Yuan Dynasty industrial recession. This was made possible by the unique style of its products. The most productive and influential product of the Cizhou kilns in the Yuan Dynasty was black on white ware, which had been quite special since the Northern Song Dynasty and had been imitated by kilns in the Yellow River Basin. After the Song rulers relocated their capital to the south, the Jizhou kilns also began imitating the Cizhou wares. It even influenced Jingdezhen's blue and white porcelain. In the Yuan Dynasty, black on white ware saw further progress. The prosperity of drama in the Yuan period was also reflected in porcelain making while literature and the arts were also integrated into decorations, not only on Cizhou kiln ware, but also in the blue and white porcelain of the Jingdezhen kilns.

Porcelain with poems and inscriptions have been discovered in Changsha kiln products from the Tang Dynasty. Many such products produced in the Song Dynasty have also been found. For example, the Cizhou kilns produced many products with inscriptions of "*Zhangjiazao,*" indicating that the products were made by the Zhangjia kiln, or a mark serving as a trademark for bowls. Some pots with four lugs also had inscriptions on the belly or shoulder indicating their use. However, after the Yuan Dynasty, there appeared an increasing quantity of porcelain bearing inscriptions. For example, Longquan celadon carried inscribed blessings, names of kilns and producers. Among the Cizhou products there were many pots, vases, pillows, and jars with inscriptions of poems and calligraphy. For example, a cream-color-glazed pot with inscriptions of Yuan poetry produced in the Yuan Dynasty was unearthed

from Mengyin in Shandong Province in 1983. This is a very rare treasure with a total of 150 characters in 17 lines. Some of the inscriptions translate as follows:

> Hearing the call of my lover, I wanted to respond but could not. I was so afraid my parents would also hear the knock on the window, so I stood still beside the door to ask where he was. On hearing him answer me back with a "sweetheart," I broke out in a sweat and begged him to leave as I must turn in. He listened and left. Thus, an affectionate couple were denied their tryst.

This is a precious Cizhou kiln work and symbolizes the artistic advances in the Yuan ceramics industry which inherited the traditional decorative styles of the Song and Jin dynasties. Displaying high aesthetic value, some Cizhou kiln products can also help fill the gaps in the artistic and literary record. In the Yuan Dynasty, there were various porcelain varieties and decorative techniques which mainly focused on the single-glaze style and achieved favorable effects. Despite the fact that red and green Cizhou porcelain was not often seen on the domestic market, it had flowed into the Southeast Asian market, which laid the foundation for the production and export of red and green porcelain from various kilns in the Ming Dynasty, along with the development of polychrome porcelain in the Ming and Qing dynasties.

9.8.3 Artistic Features

Paintings have been found on colored pottery produced over 7000 years ago. After pottery was replaced by porcelain, paintings were also applied to porcelain. For example, the Changsha kilns continued to use paintings on porcelain from the Tang Dynasty. But painting was never as popular as other decorative techniques like engraving, printing and embossment. However, after the Yuan Dynasty, things changed as black on white Cizhou porcelain boomed and its painting technique influenced other kilns. Additionally, the development of the blue and white Jingdezhen porcelain, as well as red and green porcelain in the early Yuan Dynasty, elevated porcelain painting to a new historical high and pioneered the development of polychrome porcelain.

The Jingdezhen kilns did not use paintings as decoration before the Yuan Dynasty. While it is recorded that Jingdezhen "produced pottery since the Han Dynasty (202 BCE–220 CE)," due to limited evidence, the earliest Jingdezhen kiln was found to be from the Five Dynasties. In this period, Jingdezhen produced blue and white plain porcelain. In the Song Dynasty, it started to make *yingqing* porcelain, which was decorated with engraving, but no paintings. In the Yuan Dynasty, Jingdezhen produced blue and white porcelain which boasted beautiful paintings. There are several explanations for this. Some scholars, represented by Mr. Liu Xinyuan, hold that some blue and white porcelain was made on orders from the government, so their decorative motifs came from the then Painting Academy under the Imperial Manufactories Commission. Another view is that apart from the influence of the Cizhou and Jizhou kilns, many scholars and painters were also involved. In the Yuan

Dynasty, the government took little account of scholars. They were no longer able to look to the imperial examinations for relief and were relegated to the status of a 9th class citizen. Their social status was below that of prostitutes, and only marginally above that of beggars. To earn a living, some scholars had to turn to create works of literature, like drama. For painters, since they were dismissed after the Painting Bureau was closed, some of them had to seek employment in society at large, so they might have participated in the design and painting of various motifs on Jingdezhen blue and white porcelain, such as human figures, flowers, birds, fish and insects, etc.[152] But of course, these views are just speculation and lacking hard evidence. But what is worth noting is that some of the motifs, especially the human figures used to tell a story or from a drama, seemed to have been created by professional painters based on a scene or a plot in a story. While they seem to have been influenced by illustrated woodcut paintings, they also tailored their artistic recreations to the specific features of the articles on which the motifs were to be placed. Such motifs usually consisted of a set of images and when you look from one to another, it can appear like a comic strip. Human figures were often painted with brush and ink, featuring an accurate structure and vivid image. In painting mountains and rocks, the artistic features of the four master painters of the Southern Song Dynasty were invoked and "axe-cut" strokes applied, featuring a particular crispness of line and complex multilevel composition. Some scholars believe the designers of the motifs were "painters from the imperial palace or Painting Academy of the Imperial Manufactories Commission because the motifs basically retained the painting style of the administration."[153] They thus conclude that the exquisite human figures on blue and white porcelain were the work of "no ordinary painters."[154] So it is also believed that scholars and painters were involved. The author thinks that after the Southern Song Dynasty, a lot of scholars and painters relocated to Suzhou and Hangzhou, so the chances are that because of the wars in the early Yuan Dynasty, some of them moved to nearby Jingdezhen, where they kept a low profile and remained safe.

Yuan paintings featured a natural, unrestrained, yet cold and remote style which contrasted with the neat and elegant style of the Song Dynasty. Hence, people say paintings in the Tang Dynasty were artistic, in the Song were neat and in the Yuan Dynasty were free. But the paintings on blue and white porcelain were more neat brush and ink works rather than free style. Two factors might have led to this. The first is that at the time, scholars and painters fell into two categories. Some were high-ranking rich people, monks or Taoist priests, or even individuals who had retired to villages and who did not need to worry about their livelihoods. Many of them used painting as a means to express their discontent with the government, to demonstrate their character or to seek enjoyment. Thus, their style was fresh and elegant, decadent, casual or modest. Another category of scholars and painters were forced

[152] Liu Daoguang, *On the History of Ancient Chinese Art and Ideology*, Shanghai People's Publishing House, in 1998, p. 167.

[153] Tang Suying, "On Yuan Blue and White Porcelain with Human Figure Motifs and Associated Issues," *Porcelain of Jingdezhen*, Issue 68, p. 46.

[154] See Footnote 153.

to seek employment for themselves, so they painted porcelain, woodcut paintings, wall paintings or handiwork. In this way, their skills were commercialized, and their works were compelled to cater to popular tastes. Excelling at the neat and realistic painting style of the Southern Song Dynasty, these painters applied their skills to their works. Of course, we cannot say that these painters were directly involved in painting the Jingdezhen blue and white porcelain. But it seems natural and reasonable that their style influenced the Jingdezhen kilns as popular arts at the same time were bound to affect each other. Besides, some of the motifs on blue and white porcelain were so like those on wood blocks that it is highly probable that they were copied from there by these painters.

Additionally, apart from blue and white porcelain, Cizhou black on white porcelain also used lines of brush and ink to reveak a story. It is also possible, therefore, that Jingdezhen blue and white porcelain was influenced by the Cizhou kilns. Is it possible that there were painters coming to the Cizhou kilns and that their style made its way further into the Jingdezhen kilns? Or is it possible this style was affected by Yuan poetry and woodcut paintings, and was popular during this whole period? These are all possibilities awaiting verification.

Paintings of dramas and stories on Cizhou black on white porcelain and on Jingdezhen blue and white porcelain all reflected a demand in the developing commodity economy and in popular culture. With increasing development in the commodity economy, a group of commercial cities emerged in the Song and Yuan dynasties and the number of urban citizens rose sharply. It was during this time and against this background that true popular art boomed. Specific sites for popular art performance, termed *washe*, appeared. In a *washe*, there were several areas, separated by railings, for different performers to display their talents. Yuan drama emerged in these *washe*. Initially, Yuan drama was created by a group of under-appreciated and underestimated writers, like Guan Hanqing, Wang Shipu and Ma Zhiyuan. They wrote drama to express their discontent with the status quo and admiration for the past heroes. The plots of their works were painted on porcelain, reflecting the market demand. As a commodity, blue and white porcelain was made to the taste of its target customers. Among Yuan dramas, there were many genres, such as social stories (popular stories), love stories, and historical stories. The human figures painted on blue and white porcelain mainly came from historical stories like the stories of Meng Tian, a famous general in the Qin Dynasty (221 BCE–207 BCE), Xiao He chasing Han Xin on a moonlit night, the Oath in the Peach Garden from *The Three Kingdoms*, Zhou Yafu, a renowned general in the Western Han Dynasty (202 BCE–8 CE), or Emperor Taizong of the Tang Dynasty and Yu Chigong, his general. As we can see, many emperors and generals appeared in these stories. This demonstrates that the Mongol rulers tried to learn the culture of the Han ethnic group in convenient ways. Additionally, these stories sing the praise of wise emperors and loyal officials, most of which wore clothes in the Han style. To some extent, it was a way for the Han people to cherish the memory of the glorious past and the traditions of their own ethnicity. Blue and white porcelain with images such as these have only been discovered in China, which indicates that the products with such patterns were not exported. Some scholars point out that "Exquisite blue and white porcelain was

exported to the Middle Eastern countries and regions in large numbers, but very few had patterns of stories from Yuan drama. So, it is highly probable that such porcelain was made for collectors."[155] Blue and white porcelain with these images were mainly decorative pots, plum vases and *yuhuchunping*. For Cizhou black on white porcelain, stories were basically put on pillows while some were also earmarked as articles of delight for the eyes. Our current information shows that black on white porcelain with human figures were many, while blue and white porcelain with similar images were few, and that no two products with the same images and the same sizes have been identified. This indicates that such products were not made in large quantities. Instead, they were probably high-grade commodities custom-made for the rich and privileged.

A lot of historical and fictional figures from drama appeared on Cizhou black on white porcelain and on Jingdezhen blue and white porcelain. This was a fashion back in the Yuan Dynasty, and a turning point in porcelain decoration in China. And why? Because before the Tang and Song dynasties, porcelain decorated with human figures was very rare. After this period, though human figures were used, especially by the Cizhou kilns after the Song period, most motifs were children at play and occasionally ladies, but not grownup males. Thus, the human images on black on white and blue and white porcelain signified a significant transition in the history of porcelain decoration. This was the first time a historical tale or drama was completed and finely painted on porcelain, which laid the foundation for various other human figures, like emperors, officials, scholars, ladies, Taoist priests, workers and farmers to be used as motifs on porcelain in the Ming and Qing dynasties. This was also one of the indicators that the ceramic arts had turned from refined to popular tastes. Illustrated in the plum vase in Fig. 9.94 is a plot from *Romance of the Western Chamber*, one of the most famous Chinese dramatic works. Images of this story were popularly used on porcelain made under the rein of Emperor Shunzhi (1644–1661) and Emperor Kangxi (1661–1722) of the Qing Dynasty, but very rarely seen prior to that. This article is the earliest existing work displaying the story of *Romance of the Western Chamber*.

People tended to pay more attention to the paintings on blue and white porcelain while ignoring the contribution of the Cizhou black on white porcelain. As a matter of fact, the paintings on Cizhou products are very important as blue and white porcelain learned from them in terms of their means of expression and motifs. For example, they both utilized various flowers, reed birds, dragons and phoenixes, fish and algae, etc. The widely used water-chestnut rim in black on white porcelain was also appropriated by blue and white porcelain. Such decorations were very popular in Islamic regions, so most exports there applied them. A blue and white bowl with water-chestnut rim housed in Istanbul has three layers of flowers outside, with the middle layer separated as a frame with flowers and decorated with lucid ganoderma and conch patterns. This flower frame also came from the Cizhou kilns, except that it was tighter, finer and neater. This decorative technique became popular on blue and white porcelain in the

[155] Tang Suying, "On Yuan Blue and White Porcelain with Human Figure Motifs and Associated Issues," *Porcelain of Jingdezhen*, Issue 68, p. 45.

Fig. 9.94 Jingdezhen blue
and white plum vase with
story pattern, produced in the
Yuan Dynasty, in the
Victoria and Albert Museum

Fig. 9.95 Iranian plate with
a gazelle, made in
Sultanabad, in the late 13th
to fourteenth century, in the
Berkeley Art Museum

Ming and Qing dynasties, especially for Kraak porcelain exported to Europe. It has
also been found used on exports to Islamic countries. The article in Fig. 9.95 is an
example. It shares many features with its counterparts produced in Islamic regions.
Whether it was China influencing Islamic countries or vice versa, one point remains
unchanged: Different cultures influence each other and learn from each other.

9.8.4 External Factors Affecting the Formation of the Style of Blue and White Porcelain and Its International Influence

Internally, an artistic style in a specific period comes into being due to revolutions
within the society, interaction with other artistic styles, and inheriting styles and

techniques from the past. Externally, the penetration of foreign cultures and their interaction and integration with the local culture also play an important role. Historically, international cultural exchange was always initiated through wars yet ended in commercial exchange. As the Mongol expansion in Eurasia progressed, commerce and the handicraft industry inside China were stimulated. With exchange with Eurasia facilitated, businessmen from Arabian and European countries, and more, flowed into China and brought pearls, spices and handicrafts with them and took Chinese silk, tea and porcelain back home. For a very long time, silk and porcelain were exported in large quantities while at the same time, Europe and west Asia also developed their own silk-making technology and produced products in their own style. However, their demand for porcelain far exceeded that for silk, which invigorated the development of the ceramics industry in Jingdezhen. At the time, Jingdezhen encountered a turning point. On one hand, it had made tremendous achievements which were difficult to outstrip and on the other hand, the unity of the Yuan Dynasty, the integration of its multiple ethnic groups, the huge demand of the overseas markets, and the emergence of new lifestyles and mindsets also called for creative porcelain products.

Such new creations not only blended stories from Yuan drama into decorations of blue and white porcelain to satisfy the domestic market, but also aligned with overseas markets by importing cobalt blue materials and exporting blue and white porcelain to Islamic countries. Faced with new markets, new decorative materials and new tastes, workers at the Jingdezhen kilns were confronted with many headaches. The first was that the Islamic markets demanded totally different products to the domestic market, in terms of both variety and size. Second, technically, the decorative style that Jingdezhen potters were familiar with did not quite fit with the Islamic markets, since they ordered large products which required three or even four times the decorations that the workers were used to applying. Therefore, it seems that they had to develop a brand-new design and decorative plan. Third, it was tricky to paint on white porcelain with imported cobalt blue materials because previously potters were accustomed to molding with wooden or iron molds or even hand shaping, but not painting. Molding was not popular, however, with new customers who lived in a totally different cultural environment. So, potters were required to paint exquisitely on porcelain, a skill they were yet to master.

To resolve these three problems, it required a brand-new creative solution. So new designs were crucial. But domestic designs did not accord with the requirements of overseas markets. Foreign markets called for designs and styles in line with their lifestyles and customs, which was a far cry from the traditional Chinese reality. Additionally, workers lacked experience in decorating large pieces of porcelain. To solve this problem, potters adapted the Islamic style and designed patterns that frequently applied concentric annulus, or four symmetrical parts on plates radiating from the inside to the outside. Hence there arose a new decorative style which featured Chinese motifs, Chinese underglaze technique and Islamic decorative style. This colorful, intriguing and exquisite mixed style was even more magnificent and popular than the traditional Chinese styles.

It is easy to see that early fourteenth century blue and white porcelain produced by private Jingdezhen kilns was very much affected by the Islamic style. On the

Fig. 9.96 Blue and white
pot with cloud and dragon
patterns and animal-shaped
lugs, produced in the Yuan
Dynasty, height: 47 cm,
mouth rim diameter:
14.6 cm, found in a Yuan pit
in Gaoan, Jiangxi Province,
in the Gaoan Museum

rims of many plates, there were lotus, a pattern usually used in Islamic countries and also related to decorations of Islamic carpets. This shows that the Jingdezhen potters had carefully inspected Islamic carpets. And naturally, rich Persian businessmen in Quanzhou at the time also tried to tap into the talents of Chinese potters to fulfil their demands.[156]

The pots and jars produced by the Jingdezhen kilns at the time were quite exotic and most of them were sold to Southeast Asia. They featured small sizes and exquisite decorations, which perhaps were developed along the lines of the pear-shaped vases that Chinese people were familiar with. One easily distinguishable feature of these pots and jars under the influence of foreign factors was that they had a round belly, rather than the traditional cylinder-shaped one. In terms of bowls, the Jingdezhen potters tried very hard to avoid the influence of Islamic countries. Though typical Zhizheng blue and white porcelain was very exotic, their major decorative styles and motifs were traditional Chinese, including fish and algae, human figures, dragons, dragons flying in clouds (Fig. 9.96), dragons swimming in seawater, phoenixes, lions, flying horses, kylins, grass, insects, flowers (especially twining peony and lotus), as well as karma characters (Fig. 9.97).

Auxiliary decorations were usually put on the mouth and feet of an article. On the body, there were usually a few sets of motifs to separate the neck, upper belly, middle belly, lower belly, and feet. Twining flowers (peony, lotus and chrysanthemum), lotuses both upward- and downward-facing, as well as water waves (in motion and still) also featured. Buddhism's Eight Auspicious Symbols were not yet fixed by the Yuan Dynasty, but motifs often seen included flaming pearl, coral, conch shells, rhinoceros horns, lucid ganoderma, double fish, bananas, wheels, umbrellas, vases and endless knots. In addition, fret patterns, banana leaves, the wheel of Dharma,

[156] Margaret Medley & Yu Jiwang, "On the Influence of Islam on Ancient Chinese Ceramics," *Porcelain of Jingdezhen*, Issue 3, 1987, p. 57.

Fig. 9.97 Blue and white plate with lotus pattern, produced in the Yuan Dynasty, in the Shanghai Museum

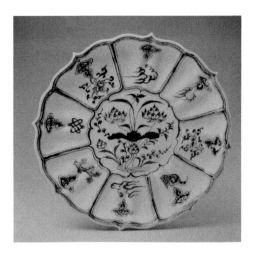

moire, lotus, twining pomegranate, and Chinese flowering crabapple were often used as supplementary decorations. Also, *ruyi*-head-shaped and lozenge-shaped panels were often seen. These were the major motifs in traditional Chinese artistic works. Combining traditions with art in a new age and with foreign cultures, the potters of Jingdezhen created new fashions in porcelain production. This was also a result of the times when various cultures and tastes met and mixed. This new fashion would eventually lead to the beginning of a new era in the ceramics industry.

The emergence of Jingdezhen blue and white porcelain not only paved the way for the boom and export of Ming and Qing blue and white and polychrome porcelain, but also exerted a far-reaching impact over the Islamic culture at the time and gained popularity among the Islamic peoples. Figures 9.98 and 9.99 are both illustrations from a Turkish book which shows how closely blue and white porcelain in the Yuan style was interwoven with the lives of the local people. For example, Bursa, the first major capital of the Ottoman State, was founded in the early fourteenth century, a time when Jingdezhen had begun to make blue and white porcelain. As Bursa was the western end point of the ancient Silk Road, trade caravans traveling through Central Asia to China and the West had to pass through Tabriz and Bursa. Thus, nowadays, in the mosques in Bursa, we can still see many stone statues and glazed tiles like the style of China's blue and white porcelain. For example, while the decorations in the Muradiye Mosque in Edirne were very Islamic and were popular from Bursa to Samarkand, they also carried some elements of the motifs of Chinese blue and white porcelain (Fig. 9.100). Of course, there is a chance that these motifs were originally Islamic and that Islamic culture and Chinese culture just interacted and learned from each other. So, we can see that a civilization scarcely grows by itself. Instead, different civilizations interact with each other and draw upon each other, hence new fashions arise. This was also true of the blue and white porcelain in the Yuan Dynasty.

Fig. 9.98 From *Chinese Treasures in Istanbul*, illustration 6

Fig. 9.99 From *Chinese Treasures in Istanbul*, a grocery store that sells porcelain

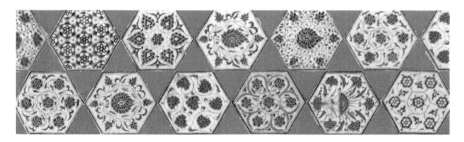

Fig. 9.100 Blue and white hexagonal tiles of the Muradiye Mosque in Edirne

Chapter 10
Ceramics of the Ming Dynasty

10.1 Introduction

10.1.1 Changes in Social, Cultural and Economic Structures

The Ming Dynasty was founded in 1368 and overthrown in 1644, lasting 276 years with 16 emperors. During the Ming Dynasty, China once again achieved stability and prosperity under the prevailing Confucianism; so much so that the ensuing Qing Dynasty had no other choice but to inherit the Ming Confucian-based rule in governing the country.

When the Ming Dynasty was established, China was trapped in economic turmoil as a result of exploitation by the Mongol aristocrats and wars. As a result, the hand-icraft industry was shattered. The entire Huai River Basin, which originates in the Tongbai Mountains in Henan Province and flows through southern Henan, northern Anhui, and northern Jiangsu, entering the Yangtze River at Jiangdu, Yangzhou, was afflicted by war. In some parts of Anhui Province, most households stood empty and farmlands, dykes and canals were almost all laid waste. To recover the economy, it took the Ming rulers great efforts from 1370 to 1398 when they finally completed the task.

After the economic recovery, the social, political and economic structures of the Ming Dynasty underwent a lot of changes, which pushed forward the development of society. From the perspective of the ceramics industry, there are several aspects worth noting. First, changes in the craftsmen system. The founders of the Ming Dynasty learned from their Mongol predecessors and granted craftsmen special positions. In the Yuan Dynasty, there were around 260,000 craftsmen, and the finest among them were chosen to serve the Yuan court by separating them from the others. This special system was applied to the whole industry in the early Ming period and craftsmen were placed into two groups. One group lived and worked in specific factories under the administration of the Ming's Ministry of Works. Another group was required to work for a certain period every year in several second-rate factories that were often far away from one's home. As the economy of regions in the lower reaches

© Foreign Language Teaching and Research Publishing Co., Ltd 2023 643
L. Fang, *The History of Chinese Ceramics*, China Academic Library,
https://doi.org/10.1007/978-981-19-9094-6_10

of the Yangtze River and coastal regions accelerated rapidly (and the demand for labor soared and workers were paid in cash), it affected this system and the number of craftsmen under the Ministry of Works declined steadily. At the same time, the development of a monetary economy pushed the country to replace the forced labor system with an employment regime. Thus, after 1485, craftsmen who were relocated to a province outside their hometowns could pay a sum and avoid having to fulfil their compulsory services to Nanjing or Beijing. As this practice was rolled out, it became legally accepted in 1562. Thus, gradually, all the work of compulsory craftsmen was paid off with taxes, hence the special craftsmen system was gradually phased out. At the same time, those who lived and worked in specific factories under the Ministry of Works were also receiving less and less. From 1403 to 1424 in the Yongle period, the royal factories were estimated to have around 27,000 craftsmen, with every three to five workers being under the charge of a master. By 1615, this number was down to 15,139 and by the end of the Ming Dynasty, the household nature of craftsmen had disappeared completely.[1] From this, we can see how the handicraft industry gradually broke the shackles of the government and was finally free. This was also true of the official kilns in Jingdezhen. After the Jingdezhen kilns freed themselves of government control, they boomed.

Second, the development of a monetary economy. In the early Ming Dynasty, most deals were made in kind and the major source of government revenue came from food surrendered by farmers. However, from the early fifteenth century, with the development of a commodity economy, the forcible acceptance of silver ingots as payment began in commercially advanced regions and areas. For example, Guangdong Province already used silver ingots to pay taxes and by 1423, this practice made its way to the lower reaches of the Yangtze River. In the latter half of the fifteenth century, the use of silver ingots continued to expand, such that it was used as tribute by the provincial administration commissions from 1465, paying taxes on salt production from 1475, and as charges for the forced labor of casual craftsmen from 1485. In the middle and late Ming Dynasty, farmers could also pay sliver ingots to avoid their obligation to perform certain services. The development of the monetary economy granted more freedom to craftsmen and to some extent, facilitated the progress of the ceramics industry in the Ming Dynasty.

The development of the monetary economy led to significant consequences which became abundantly clear in the sixteenth century. First, it made possible the introduction of a policy called "*yitiaobianfa*" (the one whip policy) between 1530 and 1580, which unified the poll tax and the field tax and monetized the Chinese tax system. This measure aimed to streamline administration (since its complexity had given birth to abuse and corruption) and recognized the general application of silver ingots and silver coins, which had been imported from America, to the Chinese economy. After silver ingots had been widely accepted, almost all taxes were paid with them. This economic influence had soon penetrated virtually every aspect of society.

[1] Jacques Gernet, *A History of Chinese Civilization*, translated by Geng Sheng, Jiangsu People's Publishing Ltd., 1995, p. 343.

Third, professional handicraft manufacturing centers had taken shape. Since around 1520, the capital that was normally used to invest in farmland was instead invested in business and handicraft workshops. Land prices kept falling, reaching a low point in the late sixteenth century. This was especially true of the southern regions, and regions from Hangzhou to northeast Jiangxi Province in particular were adversely affected. In fact, this was true of all regions where the monetary economy based on silver ingots and imported silver coins prevailed. At the time, the crisis in the agricultural economy and progress in business and the handicraft industry proceeded in parallel in China.

Peasants who had lost their farmland streamed into the cities and tried to seek a living in small business or the handicraft industry. The abundant labor force helped small handicraft workshops transform themselves into larger ones where hundreds of people were employed. At the time there was already a profession-specific labor market in place where skilled workers were paid high wages while the remaining laboring poor waited at the gates of the large workshops to seek a job.

This situation triggered the emergence of region-based production and distribution centers for handcraft products. Professional production centers became the norm and a characteristic of the social development of the Ming Dynasty. For example, the Songjiang River region became the center of a cotton industry. Despite the farmland in the region, and that to the north of Hangzhou, all being planted with cotton, it still fell short of the demand for raw materials so they were forced to buy from Henan and Hebei. Besides, Suzhou at the time was the production center for quality silk, Wuhu was engaged in professional printing and dyeing while Cixian County in southern Hebei Province was a major metallurgical center. As for Jingdezhen, many kilns were built there and their products were shipped around the nation and even abroad. It was the porcelain center of China.

Fourth, urban development in the Ming Dynasty overtook that in the Yuan Dynasty both in terms of quantity and scale. In the Ming period, at least five cities housed a population of over one million, including Beijing, Nanjing, Suzhou, Hangzhou and Kaifeng, while those with a population of 300,000–500,000 were to be found everywhere.[2] Nanjing, the former capital city of several dynasties, was known as "*Jiqing*" in the Yuan Dynasty while Zhu Yuanzhang, the founder of the Ming Dynasty, changed its name into "*Yingtianfu*." The development of cities prompted the emergence of a business community. From 1573 to 1582, in the early stages of the reign of Emperor Wanli (1573–1619), the handicraft industry and the whole business enterprise in China prospered. In the late Ming Dynasty, business vitality and conflict within Ming society imbued special significance to the period before the Qing rulers ascended the throne. In this period, rapid historical evolution was evident: the Chinese proletariat and petty bourgeoisie came into being, rural life changed under the influence of urban development, and major merchants and industrialists made their appearance. Currency exchangers and money shop owners from Shanxi who set up branches in Beijing, rich businessmen from Dongting Lake, Hunan Province, shipowners who made their fortune in transportation through Quanzhou and Zhangzhou in Fuzhou,

[2] Xue Fengxuan, *Evolution of Chinese Cities and Civilization*, Joint Publishing HK, 2009, p. 217.

Fujian Province, and especially rich merchants from Xin'an (the current Shexian County in southern Anhui Province), constituted a new class. Close to Suzhou, Hangzhou and Nanjing, Jingdezhen enjoyed a favorable geographic location which facilitated the commercialization of its products.

Fifth, with the Imperial College and schools at every regional level established, their students, called *Shengyuan*, could take exams organized by the central government and become "*Jinshi*." Every year, 8000 to 10,000 students graduated from the Imperial College and following graduation they could assume a government post without taking imperial examinations. This was an important source of talent for the civil service. The popularization of official schools improved literacy and reached down to those born to the poorer classes of society.[3] Education led to many scientific advances in the Ming Dynasty, mainly in the areas of practical knowledge. A huge number of scientific or technological works were published, covering pharmacopoeia, botany, agriculture, manual skills and geoscience. For example, *Gongbuchangkuxuzhi* (1615) covered Chinese technological history. In 1637, *the Exploitation of the Works of Nature* was published. An illustrated encyclopedia, it covered a wide range of technical issues such as agriculture, textiles, ceramics, metallurgy, transportation, military weapons, paper and ink.

Sixth, the development of literature. In the late Ming Dynasty, literature for leisure witnessed unprecedented development. This genre of literature was more closely related to oral language than was ancient prose. Oriented towards the public, this kind of literature targeted an audience that was in pursuit of pleasure, not highly educated but also not restrained by the traditional values that were championed by traditional education. The large number of publications showed just how popular they were. For example, *Heroes of the Marshes*, *The Three Kingdoms*, *Pilgrimage to the West* and *Golden Lotus*, the Four Great Classical Novels of Chinese literature, were created by civilians and they remain popular today. Progress in printing and engraving during the reign of Wanli (1573–1619), propelled the flourishing of inexpensive publications, which in return enriched the decorative arts. Decorations from various artistic works absorbed inspiration from publications, including on ceramics.

To sum up, the Ming Dynasty experienced profound social, cultural and economic changes, which presaged the start of a new era. In this new stage, silver exchange skyrocketed in the sixteenth century and continued throughout the Qing Dynasty until around 1820. Apart from copper coins which were used for retail, silver ingots were the only major transaction medium in China until the early twentieth century. In the sixteenth and seventeenth century, the popularization of silver ingots coincided with a boom in maritime transportation (business and piracy) in East Asia along with the prosperity brought about by urban development.

Some manual skills (especially cloth weaving, porcelain making and printing) were about to reach maturity, which ensured China could maintain its role as a major exporter of luxury goods even after the recession in the middle of the seventeenth century. Against a backdrop of urban development and economic boom, the first batch of European explorers set foot on the lands of East Asia: first the Portuguese

[3] Xue Fengxuan, *Evolution of Chinese Cities and Civilization*, Joint Publishing HK, 2009, p. 214.

and Spanish, and then the Dutch in the early seventeenth century. Porcelain accounted for an important portion of the luxury goods exported, driving forward foreign trade in the Ming Dynasty.

10.1.2 International Trade Prospers

The prosperity of the handicraft industry and the commodity economy in the Ming Dynasty would not have been possible without foreign trade. In the mid-sixteenth century, the Western world experienced an expansion in trade, navigation, and exploration, along with religious reform and the Renaissance. European missionaries enthusiastically spread their beliefs across national borders, which was unprecedented in Europe in the Middle Ages, and became more evident from the seventeenth century onwards.

China in the Ming period was a major maritime power. During the reign of Emperor Yongle (1403–1424), China made its famous seven epic voyages led by Zheng He, a fleet admiral, demonstrating China's advanced navigation technology. According to historical records, from 1405 to 1433, Zheng He was commissioned to lead court-supported expeditionary voyages to the Indian Ocean, a phenomenon which was unmatched in the Western world at that time. The largest ship of Zheng He's fleet was 6–10 times the size of Columbus' and 50 times the size of the ship that John Cabot sailed in 1497. Columbus' largest fleet consisted of 17 ships with 1500 crew on board while Zheng He's first voyage comprised 317 ships with around 27,000 sailors. When Ferdinand Magellan, a Portuguese explorer who organized the Spanish expedition to the East Indies from 1519 to 1522, resulting in the first circumnavigation of the Earth, began his voyage, there were only 279 crew members with him, some 1% of Zheng He's crew. Thus, it is obvious that China's navigation capability at the time exceeded that of Portugal and Spain by a significant margin. Many scholars have wondered whether these expeditions were for military and diplomatic purposes or as a way for China to flex its muscles? Or was their aim to supply luxury and novel goods to the privileged? Jacques Gernet, a French sinologist, argues that perhaps all these factors were in play during these trips. It is worth noting that the expeditions aligned with the original designs of Zhu Yuanzhang, founder of the Ming Dynasty, that once the dynasty had been founded, the government should attract foreign delegations to visit the country. Thus, in 1369, Korea, Japan, Vietnam and the Champa Kingdom all sent envoys to China. In 1371, Cambodia and Siam sent representatives. From 1370 to 1390, countries from the Malay Peninsula to the Coromandel coast of India sent envoys. This seems to confirm that one of the purposes of the seven great voyages in the Yongle period was to highlight the authority of the Ming Empire in Southeast Asia and the Indian Ocean.[4] As it happened, the expeditions not only realized political aims, but also resulted in economic gains since, thanks to the seven

[4] Jacques Gernet, *A History of Chinese Civilization*, translated by Geng Sheng, Jiangsu People's Publishing Ltd., 1995, p. 360.

voyages, the trade ties between China and Southeast Asia and the south Indian Ocean were strengthened.

But in the middle of the sixteenth century (the mid-Ming Dynasty), Japanese pirates ran rampant along the southeast coasts which led to a comprehensive maritime ban under the reign of Emperor Jiajing (1522–1566). Despite this, piracy and smuggling continued unabated, at times publicly and at other times in private, depending on how strictly the government regulations were enforced.

Despite the government order to Zhejiang Province to strictly crack down on piracy and uproot illegal trading, the campaign was not welcomed by officials and influential people in Fujian and Jiangsu provinces and thus failed, which resulted in a further boom in the underground maritime trade of Chinese businesses. Unchecked, Chinese merchants were able to sail to the Southeast Asian regions from the port of Yuegang in Zhangzhou, Fujian Province. In this way, foreign trade was in fact legalized, which facilitated trade development. As *Studies on the Oceans East and West* records, "From 1465 to 1505 (under the reign of Emperors Chenghua and Hongzhi, the eighth and ninth emperors of the Ming Dynasty), some rich and powerful families sailed on big ships abroad for trade and earned large fortunes while no tax was levied by the government... Up until the reign of Emperor Jiajing (1522–1566), the eleventh Ming emperor, this problem was very serious." This showed that over a hundred years after the reign of Emperor Xuande (1426–1435), the fifth ruler of the Ming Dynasty, the "ban on maritime trade" was not thoroughly policed and failed completely in the Jiajing period. Amidst the fights with the Japanese pirates, the underground trade of Chinese merchants remained vigorous while more and more people criticized the ban. Eventually, in 1567, the first year of the reign of Emperor Longqing, the 12th Ming emperor, the maritime ban that had lasted around two centuries was eventually abolished.

From the late Ming Dynasty to the mid-Qing, China traded with regions from almost all over the globe, including East Asia, Southeast Asia, Europe and America (via Manila). After the maritime ban was lifted, China's foreign trade flourished. It is estimated that from 1571 to 1821, of the 400 million silver ingots imported from South America and Mexico to Europe, half were used to purchase goods from China. Some scholars even hold that if this was true, it means that China was the largest beneficiary of the great European geographical explorations.

In a nutshell, changes in the cultural and economic structures of Ming society and the prosperity of its foreign trade served as the basis and facilitator of the development of the ceramics industry in this period. It was against this background that the Jingdezhen kilns, along with those in the coastal regions, enjoyed a thriving foreign business.

From the maritime trade routes of Chinese porcelain in the Ming Dynasty, we can see that the Netherlands, Portugal and Spain were the most active states in porcelain trading. The routes to the Netherlands and Portugal travelled through China's Macao and Taiwan, to Jakarta and the Indian Ocean, then rounded the Cape of Good Hope to Europe. For Spain, the route led across the Pacific Ocean to Central America (where the Spanish colonies were located), and then traveled across the Atlantic to reach Europe. These routes were opened after the Wanli period. In contrast, the trade routes

in Asia were the traditional ones from the Tang and Song dynasties which departed from ports in Xiamen and Guangzhou. One traversed the Philippines, Malaysia and Singapore to reach other Southeast Asian nations such as Indonesia, and another began from the coastal ports and proceeded through Malacca, past Thailand to India and then on to the Persian Gulf, arriving in the West Asian nations. Alternatively, it proceeded through the Persian Gulf to Oman and Yemen and then the Red Sea, to arrive in African nations such as Egypt. A map was exhibited when the V&A Museum exhibited its porcelain collections in the National Museum of China. It was probably produced by a European country. On it, the Jingdezhen, Dehua and Yixing kilns, the kilns most familiar to Europe as well as the most productive kilns for export, are mapped out. In fact, the Zhangzhou kilns should also have been counted, but since they were close to the Dehua kilns, perhaps they were regarded as being included in the Dehua kilns. Besides, while the Zhangzhou kilns produced a lot of articles of daily use, especially red and green porcelain, most were exported to Southeast Asia, not to Europe, so the European market naturally paid little attention to it. In the Yuan Dynasty, exports were mainly produced by the Longquan and Jingdezhen kilns while in the Ming Dynasty, the Jingdezhen, Yixing, Dehua and some coastal kilns became the major producers.

In the past, when discussing ceramic history, the Jingdezhen kilns were always the focus while other kilns were basically neglected, especially those in the coastal regions. This was caused by a failure to approach the topic from a global perspective and a lack of attention to how the European geographic explorations affected the culture and economy of China and the world as a whole. This book would like to undertake some explorations in this regard.

10.1.3 Jingdezhen Becomes the National Porcelain Production Center

This author believes that whilst discussing the Ming kilns, we cannot simply discuss Jingdezhen, nor can we ignore the role of Jingdezhen as a national ceramic production center. A typical feature of the economic development of the Ming Dynasty was that many towns became centers for handicraft industries, and the ceramics industry was no exception. Jingdezhen was no doubt an important national production center. From the late Tang to Song dynasties (even including the Liao and Jin), there were many famous kilns around the nation with a wide range of varieties and each had its own market. It is therefore difficult to say which particular variety played the dominant role. But in the Ming Dynasty, while other kilns remained in operation, none could compare with those in Jingdezhen in terms of quantity and quality of its products. After the mid-Ming Dynasty, Jingdezhen products prevailed in virtually all major markets nationwide. Even imperial porcelain was also supplied by the Jingdezhen kilns. For a handicraft production center to come into being, there must

be several contributing factors. For Jingdezhen, this author argues that the following contributors were important.

10.1.3.1 Popularity of Blue and White Porcelain

It was actually in the Yuan Dynasty that the road for Jingdezhen to become a nationally or even globally renowned porcelain producer was paved. In the Yuan Dynasty, the success of blue and white porcelain, underglazed red porcelain, *jilan* (sacrificial blue) and copper red glaze produced with cobalt as the colorant at high temperature and the technique of applying gilt, all prepared the way technically for the emergence of polychrome porcelain and monochrome glaze, and especially blue and white porcelain, which was an important contributor to the prosperity of the Jingdezhen kilns. Before the advent of blue and white porcelain, though there had been many varieties in the Song and Yuan dynasties, porcelain products were basically decorated with engravings, printings, carvings and decal on a single layer of glaze, which was not only complicated but also time-consuming. Even though kilns like the Cizhou kilns painted iron rust on products, its color was too dark and dull. So, with this background, as soon as blue and white porcelain was produced, featuring bright colors and a jade-like glaze, it was an immediate hit at home and abroad. While blue and white porcelain failed to gain favor with the Yuan rulers, it was appreciated by the Ming emperors and so became the major product of both the official and private kilns (Fig. 10.1).

Fig. 10.1 Blue and white flasks with dragons flying in clouds, produced in the Yongle period, height: 45.5 cm, mouth rim diameter: 8.1 cm, in the Nanjing Museum

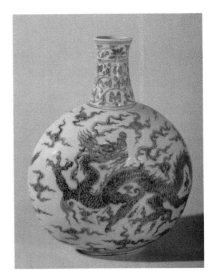

10.1.3.2 Decline of the Major Kilns in Both Northern and Southern China

From the Yuan Dynasty onwards, Jingdezhen products had been popular with the domestic and overseas markets. With the founding of the Fuliang Ceramic Bureau in Jingdezhen, they became the official court kilns, which prompted the development of Jingdezhen. Despite its royal status, Jingdezhen remained one of the major kilns nationwide, along with the Longquan, Cizhou and Jun kilns, but not the dominant one.

After the Ming Dynasty, things changed. Apart from the Jingdezhen kilns, most kilns declined. For example, Jun-school kilns almost ceased operation. Celadon from the Longquan kilns continued to be made in large quantities, but its quality declined and its monochrome glaze was a far cry from the underglazed porcelain, overglazed porcelain, *doucai* ware, and other various polychrome porcelain produced by Jingdezhen. Additionally, since the Longquan kilns were situated in a mountainous region surrounded by rapid streams through which only small ships could pass, its transportation was inconvenient. Its products thus fell short of market demand after the mid-Ming and were gradually squeezed out of the mainstream, launching them onto a downward track. The black on white ware of the Cizhou kilns was still popular in society, but it bore no comparison to blue and white porcelain in terms of clay, glaze or manufacture. What is more, dust tea which had been popular in the Song Dynasty, lost favor among Ming society. Instead, people preferred boiled or brewed tea. Thus, blue and white Jingdezhen porcelain took the place of the Jian dark black ware. With the demise of the major kilns, their skilled craftsmen flowed towards Jingdezhen, pooling their various skills and resources and allowing Jingdezhen products to flow around the country as a whole and even beyond (Fig. 10.2).

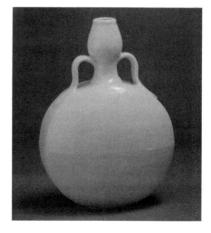

Fig. 10.2 White glazed flask with engravings and double lugs, produced in the Xuande period, height: 29.3 cm, mouth rim diameter: 3.5 cm, in the Shanghai Museum

10.1.3.3 Opening of Trade Routes

IN the late Ming, an important sign of the growing commodity economy was the opening of trade routes around the country. At the time, China could not possibly build a capitalist market. However, as the nation had a clear division of labor geographically and within the handicraft industry, the commodity economy prospered and kept expanding. Responding to the market demands, long-range and short-range trade routes on land and sea were developed and constantly improved.

In the late Ming, waterway transportation was the major vehicle for trade. According to records, "It was found that in the early Ming Dynasty, the products of all official kilns were shipped to Beijing via water transportation." As for private kilns, they also relied on water transport due to its low cost, safety and large carrying capacity. There were two main transport routes for the Jingdezhen kilns. One began on the Changjiang River, to Boyang and Ganjiang lakes, then to Dayuling Mountain, southwest to the Port of Guangzhou and then overseas. The other also started from the Changjiang River, traveling to Boyang Lake, then to the Jiujiang River and to cities on the lower reaches of the Yangtze River. With the opening of trade routes, the expansion of the commodity market and the business boom, merchants and commercial capital were unprecedentedly vigorous. After comparing it with the agricultural industry, some landlords realized that running a business was more lucrative, so they decided to put their capital into commerce. "It was mainly the rich who were seeking profits from business."[5] In Huizhou, "People relied on doing business to making a living. Even those born in rich and powerful families were not ashamed to be engaged in business."[6] In Suzhou, "Retired government officials and officials in office all attached great importance to business."[7] At the time, Jingdezhen porcelain was well-known and naturally attracted lots of merchants to purchase products at a relatively low price and then on-sell them at a high price. For example, Zhu Zuoming from Wucheng, Huzhou County in Zhejiang Province whose ancestors were carpenters and whose brother was engaged in business in Hunan and Hubei, applied himself to the porcelain business with Jingdezhen and accumulated a large fortune up to the late Ming Dynasty. In addition, under the reign of Emperor Jiajing, there was a porcelain businessman called Pan Renshi from Huizhou. The whole story of how he made his fortune as both a merchant and a middleman in Jingdezhen was recorded. In the Ming Dynasty, businessmen from the same place usually forged an alliance and did business together. Thus, many large business groups came into being. Among the top ten business groups in the country, the Anhui, Shanxi, Guangdong, Jiangsu and Fujian business groups and more, established their business organizations or guilds in Jingdezhen. Especially important were businessmen from Anhui who formed a large bloc in Jingdezhen and even controlled its business fortune. They were called

[5] *Local Gazetteer of Dongchang*, Vol. 2, *On Geography, Costumes.*

[6] *Works of Tang Shunzhi*, Vol. 15, *On Cheng Shaojun.*

[7] *Wufenglu*, written by Huang Shengzeng.

the *Huibang*. Thanks to these merchants, Jingdezhen's products traveled around the country and even abroad.[8]

10.1.3.4 Abundant Labor Force

An abundant labor force was also an important factor contributing to the boom of the Jingdezhen kilns. Workers in Jingdezhen mainly came from three sources. The first were peasants who left the countryside and tried to seek a living in the cities. In the Jiajing period (1522–1566), land ownership was more concentrated than ever, as a result of the imperial rewards, land purchases, or peasants' entrustment of their lands to landlords with a view to avoiding tax. As land became increasingly concentrated in the hands of a small number of landlords, farmers were forced to leave their land and seek a living elsewhere. In Jiangxi Province, due to serious natural disasters (including huge floods in 1540), more peasants abandoned their homelands. People from nearby Boyang, Yuhan, Dexing, Leping, Anren, Wannian, Nanchang, Duxian, and other places flocked to Jingdezhen. Without any skills, they became auxiliary workers at the Jingdezhen kilns. The second group consisted of professional craftsmen who passed their skills down through their family, generation after generation. This was the main cohort of workers in the Jingdezhen kilns. These professional and skilled potters were restricted to a work shift of three or four years and were forced to work in official kilns until 1584, the 12th year of the reign of Emperor Wanli, when an employment system was established in the official kilns and people's enthusiasm and skills could be fully deployed. The third group were auxiliary workers from previous official kilns. Long engaged in porcelain production, these craftsmen quickly grasped skills and became adept at their work. These abundant labor resources provided new possibilities for the development of the ceramics industry and led it in a professional direction. By the sixteenth century, the Jingdezhen kilns boasted a fine division of labor with each kiln and workshop making specific products and a clear division of elutriation, glaze and clay making, molding, fettling, painting, glazing and firing, etc. to ensure unified specifications. Such a highly specialized division of labor guaranteed Jingdezhen the capability of improving its quality based on the requirements of the court and its customers as well as production on a large scale (Figs. 10.3 and 10.4).

10.1.3.5 Establishment of the Imperial Vessels Factory in Jingdezhen

Apart from all the above-mentioned factors, the fact that the government set up an Imperial Vessels Factory in Jingdezhen to supply quality products to the court and the imperial family also contributed to the prosperity of the kilns. After the factory was founded, in order to meet the high standards of the court, Jingdezhen spared no effort to develop sophisticated technologies and increase its varieties and quality,

[8] Lan Pu, *Jingdezhen Taolu*, Vol. 8.

Fig. 10.3 Blue and white
pot with lions playing with a
ball, produced in the Xuande
period, height: 18.2 cm,
mouth rim diameter:
15.5 cm, in the Shanghai
Museum

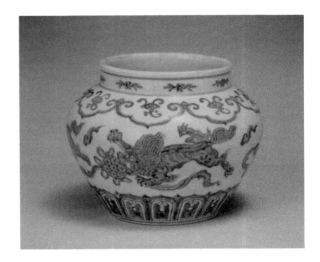

Fig. 10.4 Underglazed red
bowl with twining
chrysanthemum pattern,
produced in the Hongwu
period, height: 16.2 cm,
mouth rim diameter:
40.4 cm, in the Shanghai
Museum

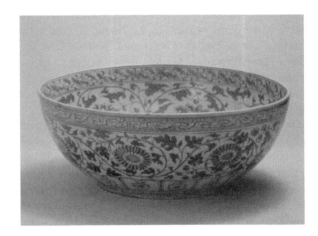

which prompted the development of private kilns. In return, faced with the growing market demand, private kilns also strove for the best. After the mid-Ming Dynasty, the official kilns adopted a measure called "*Guandaminshao*" (the government places the orders and the people fire the product) and assigned production tasks to private kilns to supply royal needs (Figs. 10.5 and 10.6). Thus, in the Ming Dynasty, both the official and private kilns flourished and through their interaction, both made remarkable progress.

The development and prosperity of the private kilns not only contributed to Jingdezhen's role as a national or even global porcelain center, but also gave birth to private workshops and factories, the breeding ground for capitalism in the Ming Dynasty.

Apart from the Cizhou, Longquan and the many other famous kilns of the Song and Yuan dynasties, the kilns around the nation also supplied various roughly made

Fig. 10.5 Blue and white watering pot with twining lotus pattern, produced in the Xuande period, height: 13.5 cm, mouth rim diameter: 7.5 cm, in the Shanghai Museum

Fig. 10.6 Blue and white flask with dragons swimming in sea water, produced in the Xuande period, height: 45.8 cm, mouth rim diameter: 8.1 cm, in the Palace Museum

and finely made porcelain for daily use. Among them, Fahua ware from Shanxi, white porcelain from Dehua, *zisha* (purple clay) ware from Yixing, and fambe glazed porcelain from Shiwan distinguished themselves. At the same time, blue and white porcelain from the Jingdezhen kilns gained popularity on domestic and overseas markets. As its supplies fell short of market demands, kilns outside of Jingdezhen also started to produce blue and white porcelain to cover the deficiency. For example, blue and white porcelain produced by Jingdezhen could not reach some distant areas in Yunnan and Jiangxi due to poor transportation, so kilns in these regions made blue and white porcelain themselves to meet the local demand. For coastal regions like Fujian and Guangdong, thanks to their favorable geographic location, kilns there started to copy Jingdezhen and make blue and white porcelain from the late Ming Dynasty for export. It was their products that were famously exported as "Swatow wares" or "Chaozhou wares." Most of the exports at that time were blue and white porcelain. But there were also *wucai* wares which were developed under the influence of the Jingdezhen kilns. Although each kiln around the country had its own unique features

and development path, generally speaking Jingdezhen was the national porcelain production center and represented the national benchmark in porcelain making.

10.2 Jingdezhen Porcelain in the Early Ming Dynasty

10.2.1 Establishment of the Imperial Vessels Factory

IN 1402, the fourth year of the second Ming emperor Jianwen, the court established the Imperial Vessels Factory in Zhushan, Jingdezhen. This was the so-called "*guanyao*," or official kiln, and its establishment constituted a major event in the ceramic history of Jingdezhen. Founded in the early Ming Dynasty and ending in the late Qing Dynasty, the Imperial Vessels Factory boasted a 500-year history. In the Song and Yuan dynasties, Jingdezhen was already a supplier of imperial porcelain ware. But its tributes to the government were selected from strictly private kilns and "only one in a hundred" pieces could be chosen. "Porcelain products were supplied to the government on imperial orders and no production was permitted when no orders were forthcoming."[9] So, at the time the government did not have a specific organ or official kiln for imperial production and imperial products were supplied by private kilns. According to the *History of the Yuan Dynasty*, in 1278, the Fuliang Ceramic Bureau was set up in Jingdezhen. It was in fact not a production agency, but a government organ in charge of porcelain-related duties like assigning tasks to kilns, purchasing from kilns, transportation and inspection of products. This means that the real official kilns came into being in the Ming Dynasty.

10.2.2 The Imperial Vessels Factory and Ritual Wares

IN ancient China, after a new political power was established, rulers needed to hold ritual ceremonies and pay tribute to the ancestors. In such ceremonies, ritual wares were very important. Traditionally, Chinese ritual wares had strong connotations of etiquette, especially imperial ones which were endowed with holy sacredness. It therefore appeared necessary to build specific kilns to produce imperial ritual wares. This was also true of the Ming Dynasty. Upon the founding of the Ming regime, Zhu Yuanzhang, founder of the dynasty, had begun to issue orders for the establishment of ritual systems and to gather together the wisdom of the scholars to accomplish this. He once said to his Minister of Rites, Niu Liang, that "Rites are the laws of a country and the disciplines of the people, and thus a high priority of the government. This should be the first task of the court, and should be established without delay… We should therefore gather the scholars together to study and discuss

[9] Lan Pu, *Jingdezhen Taolu*, Vol. 1.

the situation, learn from past experience and restore the past traditions. All the ritual systems must be human-oriented and set in stone. Only thus will I be satisfied." For over three decades, the Ming government compiled a huge body of works on rites, including on filial piety, rites of officials towards emperors, rites on officials, official systems and the duties of government organs, etc. Under the reign of Emperor Yongle (1403–1424), *On Rites of the Family* (*Wengongjiali*) was published. Under the reign of Emperor Jiajing (1522–1566), new works like *Records of Ritual Events in the Ming Dynasty* (*Minglundadian*), *On Funeral Rites* (*Siyichengdian*), and *On Heaven Worship* (*Jiaolikaoyi*) were published. Under the rule of Emperors Hongzhi and Zhengde, *Code of the Great Ming Dynasty* (*Daminghuidian*) was complied, a very thorough record of rites in the Ming Dynasty. After revisions by later generations, these ritual works were further improved.[10] Through all the ritual books we can see that the Ming Dynasty attached great importance to the establishment of ritual systems and that it held a myriad of ritual events.

Among all the varied ritual activities, the Ming Dynasty inherited traditions from the Song and Yuan dynasties and used porcelain as ritual ware. Thus, one of the important purposes of the establishment of the official kilns in Jingdezhen was to produce ritual ware for the court, and especially for offering sacrifice. From the Song to the Yuan Dynasty, plain ware was usually used for sacrifice, celadon for the Song and egg-white porcelain for the Yuan. So, what about the Ming Dynasty?

Looking through the relevant records, we find that in various ritual activities, the Ming government used many porcelain wares, and they even had specific requirements for ritual wares in terms of color, quantity, shape and decoration. "In 1369, it was stipulated that ritual wares shall all be porcelain products… In 1530, the porcelain used in each of the four major mausoleums was confirmed. The Circular Mound Altar would use blue, the Square Mound Altar would use yellow, the Temple of the Sun would use red and the Temple of the Moon would use white. Imperial orders were issued to Raozhou in Jiangxi Province to produce porcelain accordingly. For each of the mausoleums, there was a *taigeng* bowl, a *hegeng* bowl, three *maoxue* plates, a chopsticks *zun*, an animal *zun*, 28 mountain-shaped *zun* (wine vessels), *daifu* (food holders), *bian* (bamboo-made food holders), grain holders, and plates, one porcelain drinking vessel, 40 wine cups, and one extra piece of porcelain ware." In 1384, Raozhou completed the production with 1510 white plates and drinking vessels, and 150 extra products, which were submitted to the relevant organs and when required, were to be collected from that organ.[11] Emperor Xuande (1426–1435), the fifth emperor of the Ming Dynasty, sent Zhang Shanzhi to Raozhou to supervise the porcelain production of a few pieces of white porcelain with dragons and phoenixes to be used for sacrifice. The Cizhou kilns were also assigned production of some ritual wares.

Thus, the imperial family used blue, yellow, red and white porcelain as ritual wares. But how can we be certain that the official kilns at the time did in fact produce

[10] Zhang Dexin, *On the Ritual Systems of the Ming Dynasty*, Jilin Wenshi Publishing House, 2001, p. 77.

[11] The *Ming huidian*, Vol. 210.

products in these four colors? From 2003 to 2004, a joint archaeological team from the School of Archaeology and Museology in Peking University, the Jiangxi Provincial Archaeology Institute and the Jingdezhen Ceramic Archaeology Institute conducted investigations over the northeast and southwest sections of the ruins of the imperial Jingdezhen kilns. A total of 1578 m² were excavated, with the deepest part reaching over five meters. The campaign unveiled many important relic sites and unearthed a lot of treasures, including white glazed porcelain, black glazed porcelain, *zijin* glazed porcelain, underglazed blue and red porcelain, underglazed red porcelain, red glazed porcelain, blue glazed porcelain, powder blue glazed porcelain, peacock green glazed porcelain, blue and white *doucai* ware, yellow glazed porcelain, Longquan-style celadon, *ge*-style porcelain, Song-style blue glazed porcelain, and more.[12] Thus, porcelain of the four colors has indeed been identified here, with various varieties, like plum vases, pots with monk-hat-shaped lids, pear-shaped pots, large pots, bowls, plates, cups, cups with lugs, boxes, fruit trays, furnaces, drinking vessels, basins, and vats. Their decorative techniques vary, including engraving, scratching, printing and pen drawing, with motifs such as dragons, phoenixes, fish and algae, and flowers.[13]

Additionally, porcelain made for imperial ritual use usually only had one layer of plain glaze. The official kilns of the Ming Dynasty also produced a lot of blue and white porcelain. Were they also used for ritual events? According to Vol. 7, *Great Gazetteer of Jiangxi Province*, compiled under the reign of Emperor Jiajing, "Before 1528, the seventh year of Emperor Jiajing, all relevant records were lost and thus unable to be explored. Since then, porcelain products submitted to the court have included: ... In 1531, 11,000 porcelain saucers and clocks, 1000 bowls and 300 drinking vessels; In 1536, ...1800 blue and white flower clocks ...; In 1537, 270 drinking vessels and cups; ... In 1541, 19,300 blue and white clocks with dragons playing with balls; ... In 1543, 1000 blue clocks with lugs, 11 ritual plates, 140 saucers, four large soup bowls, 10 *hegeng* bowls, 23 drinking vessels, 80 bamboo-made food holders, grain holders and plates, six large *zun*, six animal *zun*, two chopstick *zun*, four mountain-shaped *zun* (wine vessels) and five regular *zun*." This indicates that apart from blue, yellow, red and white porcelain, blue and white porcelain was also used in ritual events.

This was a major turning point in ceramic history. Before the Song and Yuan dynasties, though there were also polychrome porcelain products, most of them were produced by private kilns to cater to the market demand. So, they failed to make their way into the court and were never part of the mainstream. After the Ming Dynasty, not only did official kilns start producing colorful wares, but such products were even utilized in ritual events. They became one of the major varieties for imperial use, which paved the way for the further development of polychrome porcelain in the Ming and Qing dynasties and its replacement of plain porcelain with one layer glaze, becoming the favored porcelain variety nationwide.

[12] Liu Xinyuan & Quan Kuishan, et al., "A Brief Report on the Excavation of the Imperial Kilns in Jingdezhen," *Cultural Relics*, Issue 5, 2007.

[13] See Footnote 11.

Traditionally, China held a variety of ritual events. Apart from large-scale sacrificial ceremonies, there were also weddings and funerals, etc. In all ritual events and major events related to etiquette, porcelain was used as ritual ware during which time it was not seen as a daily use article, but endowed with a sense of sacredness. Thus, the Ming and Qing dynasties both had high standards of production of ritual wares and strict selection processes. Articles with the slightest flaw would be rejected as being unfit for court use. So, among products earmarked for the court, there were inevitably many products that failed to make the grade. There is no written record as to the specific number of these items, so there is no way we can trace their history. But we can still catch a glimpse from archaeological findings. From 1982 to 1994, in order to assist with a civil construction project, the Jingdezhen Ceramic Archaeology Institute cleared and retrieved "over a dozen tons of shards of unqualified porcelain produced during the Yuan and Ming dynasties, amounting to probably hundreds of millions of pieces" from the Zhushan ruins.[14] This finding reveals two pieces of information. First, considering the relatively short reign of the Yuan Dynasty and the features of the porcelain produced during that time, most of the shards were from the Ming Dynasty. This means that in the Ming Dynasty, Jingdezhen must have had a huge production capacity. Second, wares made for the court were sacred to the common people, so even if some products failed to qualify, they were broken into pieces rather than allowed to flow into the market. The broken pieces themselves were forbidden to be thrown away and thus were buried underground, allowing us then to find them today.

10.2.3 Division of Labor and Technical Features in the Imperial Vessels Factory

In the Song and Yuan dynasties, though the ceramics industry of Jingdezhen was quite advanced, it was still not a handicraft industry because basically people engaged in ceramic making did not seek or accept service to others and they worked independently or as a family. The emergence of the Imperial Vessels Factory in Jingdezhen led to the birth of handicraft workshops. Organized by the government, the agency enjoyed strong financial support and abundant workers who worked in shifts under an indentured craftsmen system, thus building a sound operation.

The division of labor in the Imperial Vessels Factory was very comprehensive and sophisticated, with specific duties performed by highly professional and skillful craftsmen. It not only had workshops on making *yuanqi*, *zhuoqi*, saggers and clay crushing, but also various auxiliary workshops for preparing muddy water, wood, ship's timber and iron as well as 20 kilns each featuring a unique function, which shows that it was apparently fully equipped. With the equipment for various aspects of handicraft work related to ceramic production in place, the factory clearly featured

[14] Liu Xinyuan, *Preface to Official Porcelain Produced in the Yuan and Ming Dynasties Unearthed from Jingdezhen*, Cultural Relics Press, 1999.

a division of labor. How this differed from the handcraft workshops in Europe when capitalism emerged lay in the source of workers and their treatment. This was also one of its weaknesses which hindered it from competing with the private kilns. Most of the workers at the factory worked to complete their service to the government, and only a small number were employed. Those listed as official artisans fell into two groups. One group were long term indentured laborers who performed their duties so that the remainder of their family could be exempted from compulsory service and the other group worked in shifts and on completing their shift, they were free to make their own living. The indentured craftsmen system was a compulsory economic system of the then feudal society which directly exploited surplus labor. Official artisans had no freedom and were unable to change their destiny or even that of their descendants. This system guaranteed the government's absolute control over the abundant labor force, their production and reproduction. Official artisans and those who worked in shifts were all bound to work at the factory with no pay. There was also a service system for poor unskilled workers who did all the heavy and demanding manual work. Thus, in terms of organizational structure of the factory, it was a handicraft workshop while from the perspective of those who worked there, they were still subject to strict rules and retained in a subordinate position. The antagonism between the organizational mode and the workers themselves determined the character of the Imperial Vessels Factory.

Since the porcelain produced by official kilns was used more for ritual ceremonies than to satisfy the extravagant lifestyles of the privileged, this production had high standards to meet in order to bolster the dignity of the government and its rulers. In ancient times, people believed that "It is the mercy from heaven and blessings from the ancestors that enables one to ascend to the throne, so one cannot be too careful in worshiping heaven and the ancestors. The more grand the ceremonies, the more pious one is toward heaven and the ancestors, the more blessings one will receive from them and better sustain the dynastic reign. Thus, in such ritual events, things were presented as extravagantly as possible, regardless of cost."[15] This meant that, in porcelain production, the official kilns strove for perfection, despite the time or cost incurred. With such high standards, artisans in official kilns were pushed to be more skillful than those from private kilns.

At the same time, the Imperial Vessels Factory in the Ming Dynasty inherited the hereditary artisan system from the Yuan Dynasty and required that the services of official artisans run in the family, which ensured that the production techniques were passed down through generations. After the mid- and late-Wanli period (1573–1620), the official kilns ceased operation and artisans began to seek employment in the private kilns, which greatly boosted their production levels. It is therefore fair to

[15] Zhang Dexin, *On the Ritual Systems of the Ming Dynasty*, Jilin Wenshi Publishing House, 2001, p. 115.

say that the Imperial Vessels Factory helped cultivate skillful artisans and pass along the porcelain production techniques.[16]

Earmarked for production for the imperial family, official kilns not only boasted skillful artisans, but also featured advanced furnaces and firing techniques. In the porcelain production process, no matter how much effort is expended, if the final step, that of firing, fails, then all efforts come to nothing. Some say farmers earn a living at the mercy of heaven while potters seek a livelihood from fire. Vital as furnaces were to the production process, the official kilns had to constantly renovate furnaces in order to achieve the highest production level possible and produce products that continually outshone those of private kilns.

In order to conduct an in-depth study of the official kilns in the Ming and Qing dynasties and reveal the historical landscape of porcelain production at that time, the School of Archaeology and Museology of Peking University, the Jiangxi Provincial Archaeology Institute and the Jingdezhen Ceramic Archaeology Institute, with the approval of the State Administration of Cultural Heritage, organized a joint archaeological team and launched several large-scale excavations of the ruins of official kilns from the Ming and Qing dynasties in Jingdezhen from October 2002 to January 2003, October to December 2003 and September 2004 to January 2005.[17]

According to historical records like the *Great Gazetteer of Jiangxi Province, On Ceramics* (1597), the facilities and equipment of the official kilns of the Ming Dynasty were all located in the south of Zhushan, while there are no extant records regarding the north of Zhushan. However, from the discovery in 2004 in the north of Zhushan of ruins such as gourd-shaped furnaces and yards from the early Ming Dynasty, it seems that from the Hongwu period (1368–1398) to the Yongle period (1403–1424), most production activities of the official kilns took place in the north of Zhushan and that it was only after the Xuande period (1426–1435) that the northern site was used to dump waste and rejected porcelain products. According to *Jingdezhen Taolu*, during the Hongwu period (1368–1398), "Apart from the Dalonggang kiln, there were altogether 12 official kilns, like the Qing, Se, Fenghuo, Xia, and Lanhuang kiln." But no detailed locations and structural descriptions of these kilns were recorded. Through the discovery in 2004, the world has a better understanding of the official kilns of Jingdezhen. Archaeological discoveries show that there were seven gourd-shaped furnaces in the north of Zhushan and northeast of the ruins of the official kilns. All the structures were found in the same stratum and so were contemporaneous, all from the Hongwu to Yongle periods. So obviously the structures were closely related and might even be parts of the same kiln. This indicates that in the early Ming

[16] Quan Kuishan & Wang Guangyao, "Analysis of the other half of the Ming Imperial Vessels Factory—On New Discoveries of Ruins of Official Kilns in the Ming and Qing Dynasties," *Forbidden City*, Issue Z1, 2006.

[17] School of Archaeology and Museology, Peking University, Jiangxi Provincial Archaeology Institute and Jingdezhen Ceramic Archaeology Institute, "On the Excavation of the Ruins of Imperial Kilns in Jingdezhen in 2004," *Archaeology*, Issue 7, 2005, p. 35.

Dynasty, it was in the north of Zhushan that most production activities of the official kilns took place.[18]

The ruins of 15 bun-shaped furnaces were also found in the south of Zhushan, southwest of the official kilns. They were from the period immediately following the gourd-shaped furnaces, which means that after the Xuande period, when the gourd-shaped furnaces in the north were abandoned, production was shifted to the south of Zhushan and bun-shaped furnaces replaced gourd-shaped ones, where they remained in use until the Wanli period (1573–1620).[19]

In the Yuan Dynasty, Jingdezhen utilized *longyao* (dragon-shaped furnaces), while in the late Yuan Dynasty, private kilns in the suburbs of Jingdezhen had already started to construct gourd-shaped kilns, with no gas vents at the end of the kilns. Instead, the gourd-shaped kilns had chimneys to increase draft, a result of the influence of the bun-shaped kilns from the north. All these archaeological discoveries testify to the fact that from the Hongwu period (1368–1398) to the Yongle period (1403–1424), gourd-shaped kilns were being constructed in Jingdezhen. With gourd-shaped kilns, production expanded remarkably. However, after the official kilns also adopted the gourd-shaped kilns, they could not guarantee that all items could be fired satisfactorily. Thus reform was necessary and small bun-shaped kilns from the north were adopted which, though less productive, could ensure product quality. Bun-shaped kilns remained in use until the Qing Dynasty when *zhenyao* (with egg-shaped furnaces) were constructed.

Earmarked for imperial production, the official kilns in the Ming Dynasty had their own specific requirements. According to historical records, in building official kiln furnaces, "The mud had to be fine enough and the structures had to be firm enough" such that the quality of the products were guaranteed. The furnaces in the official Jingdezhen kilns, no matter from which period, were thus far better than those in private kilns. What is important here are the bricks. As early as the Hongwu and Yongle periods, kilns were built with arch bricks from the north. These differed from the rectangular bricks normally used in southern kilns, and wasted saggers were never used to build furnaces. As bricks used for official kilns had standard specifications, it seems they were specially made for building official kilns.[20]

Another feature of the imperial kilns was that their furnaces were on such a large scale, far exceeding that of private kilns. According to archaeological discoveries, ruins have been discovered in both the northeast and southwest of Zhushan. In the northeast, at least seven gourd-shaped furnaces from the Hongwu and Yongle periods have been excavated. They were all built on the same stratum, one next to the other. The gates of all the furnaces were in the same line, which meant they were built to a plan. In "On New Discoveries of Ruins of Official Kilns in the Ming and Qing

[18] Liu Xinyuan & Quan Kuishan, et al., "A Brief Report on the Excavation of the Imperial Kilns in Jingdezhen," *Cultural Relics*, Issue 5, 2007, p. 45.

[19] Liu Xinyuan & Quan Kuishan, et al., "A Brief Report on the Excavation of the Imperial Kilns in Jingdezhen," *Cultural Relics*, Issue 5, 2007, p. 46.

[20] Quan Kuishan & Wang Guangyao, "Analysis of the other half of the Ming Imperial Vessels Factory—On New Discoveries of Ruins of Official Kilns in the Ming and Qing Dynasties," *Forbidden City*, Issue Z1, 2006.

Dynasties," Quan Kuishan and Wang Guangyao point out that "As there are modern residential buildings to the south of the excavation area, it is still an open question as to whether there are only seven furnaces, or perhaps even more buried underground. But even if there are only these seven, they are already quite unprecedented in terms of archaeological discoveries."[21] In ancient times, kilns were operated by family units and many potters also worked as farmers. They thus farmed in the farming season and worked as potters in the slack seasons. This author has visited the largest ceramic distribution center in the northwest region, the town of Chenlu, which is close to the ancient Yaozhou kilns and which had retained its mode of production until the Republic of China period (1912–1949). This was also true of Jingdezhen up to the mid-Ming Dynasty: private kilns were scattered in villages in a radius of around 100 km and operated as family-run workshops. With their small scales of production, such kilns had no assembly lines nor division of labor, unlike the large workshops. In contrast, with their large scale of production, the official kilns in the Ming Dynasty had specific divisions of labor and assembly lines. This is one of the major differences between the official kilns and private kilns.

In terms of stacking, the official kilns put empty saggars on the first three layers and the last three layers while the best spots were reserved for greenware to ensure product quality. In contrast to the official kilns, the private kilns filled every space with porcelain wares in order to maximize production. From around the Yongle period, double-layered saggars were introduced into the official kilns, with the exterior roughly made and the interior made with fine clay, which was heat-resistant, thus ensuring that the porcelain products were also resistant to high temperatures.

10.2.4 Influence of the Imperial Vessels Factory on the Ceramics Industry in Jingdezhen

The position of Jingdezhen as a national porcelain production center in the Ming Dynasty, and even as a world-renowned porcelain supplier later, has much to do with the establishment of the Imperial Vessels Factory there, as well as its interaction with local private kilns. First, the high standards of imperial wares demanded advanced production technology. The imperial kilns therefore mastered unparalleled techniques and with government investment, produced the finest porcelain products. Private kilns in Jingdezhen never ceased to imitate the official kilns. With increasing demands for royal use, in the mid- and late-Ming Dynasty the Imperial Vessels Factory adopted a policy of "*Guandaminshao*" to allow private kilns to participate in production for the court. In this way, private kilns in Jingdezhen attracted customers at home and abroad thanks to their high quality, which turbo-charged the porcelain trade and porcelain culture worldwide.

The founding of the Imperial Vessels Factory in Jingdezhen also shifted the local geography and production structure of the private kilns. From investigations into

[21] See Footnote 20.

the ancient ruins of Jingdezhen since 1949, it has been discovered that pre-Ming Jingdezhen ruins are scattered from as far north as Wuyuan and Qimen counties to as far south as Leping City and Poyang County, which indicates that at the time porcelain production was a subsidiary business to agriculture and also that it relied on agriculture. It was in the Yuan Dynasty that porcelain production began to move to urban areas and to embark on a professional path.[22] Even so, in the Yuan Dynasty, porcelain products were only traded in urban areas while the kilns remained in rural areas.

In the Ming Dynasty, and especially after the mid-Ming period, as the central government drew private kilns into the production of imperial ware through the "*Guandaminshao*" system to ensure private kilns met the high standards of imperial ware and also to guarantee sound governance over them, the feudal overlords deliberately drew the kilns which were scattered on the margins of towns into the urban area. Additionally, with the development of the commodity economy, the huge demand at home and abroad spurred the prosperity of the ceramics industry in Jingdezhen. In order to ensure high quality and high productivity, production techniques and supplies of raw materials became increasingly concentrated and the division of labor grew more and more specialized. For example, the regions supplying raw materials to kilns expanded from the southeastern villages of Fuliang County to the northern villages of the county, even reaching as far as Qimen County. Thus, urban Jingdezhen flourished as a result of the porcelain trade and commerce from the Ming Dynasty onward. Even in the 1970s, the old city landscape of Jingdezhen still resembled that in the Ming and Qing dynasties, with Ma'anshan in the east, the middle reaches of the Changjiang River in the west, Xiaogangju in the south and Guanyinge in the north (Fig. 10.7).

The establishment of the Imperial Vessels Factory in Jingdezhen, then, served as an important stimulus for the city's status as a national ceramic center following the Ming Dynasty.

10.2.5 Production Varieties of the Official Kilns

The Jingdezhen Imperial Vessels Factory began construction in the Hongwu period. With the development of the factory, many new varieties of porcelain came into being. First, the products of the official kilns. Based on the 2004 archaeological findings, the Yongle and Xuande periods have been shown to have produced the most exquisite and the greatest volume of products, which were mostly unearthed from small pits, piles, and the basic stratum. Most of the porcelain articles were able to be recovered and they were of various types, including underglazed red porcelain, red glazed porcelain, *zijin* porcelain, blue glazed porcelain, white glazed porcelain, yellow glazed porcelain, peacock green glazed porcelain, blue and white porcelain,

[22] Jingdezhen Committee of the Chinese People's Political Consultative Conference (ed.), *Cultural Accounts of Jingdezhen*, Vol. 1, 1984, p. 153.

Fig. 10.7 Map of Jingdezhen in the Qing Dynasty

doucai ware, *Ge*-style porcelain, official-style Song celadon, and Longquan-style blue glazed porcelain. Among those produced in the Yongle period, red glazed porcelain and underglazed red porcelain accounted for the majority, along with a few pieces of *zijin* porcelain. Among those from the Xuande period, most were white glazed porcelain, *Ge*-style porcelain and blue and white porcelain with a small amount of blue glazed porcelain.[23]

Used for ritual events, many products of the official kilns were plain porcelain with only one layer of glaze and many were made in imitation of the Song Dynasty kiln style, like *Ge*-style porcelain, official-style Song porcelain, and Longquan-style blue glazed porcelain. This reveals the incredible craftsmanship of potters in not only drawing together the specialties of kilns from all over the nation and producing products of a similar style, but also innovating on the basis of tradition and creating many new varieties, such as red glazed porcelain, *zijin* porcelain, blue glazed porcelain, white glazed porcelain, yellow glazed porcelain and peacock green porcelain. Among the innovative products, *xianhong* (bright red) glaze and *tianbai* (sweet white) glaze of the Yongle period represented the highest level at the time (Figs. 10.8 and 10.9).

[23] School of Archaeology and Museology, Peking University, Jiangxi Provincial Archaeology Institute and Jingdezhen Ceramic Archaeology Institute, "On the Excavation of the Ruins of the Imperial Kilns in Jingdezhen in 2004," *Archaeology*, Issue 7, 2005, p. 39.

Production of *doucai* ware in the Xuande period also paved the way for its boom in the later Chenghua period (1465–1487).

It is important to note that, on the basis of the Yuan blue and white porcelain, further progress was achieved in the Ming Dynasty. First, the Imperial Vessels Factory produced blue and white porcelain. Although some scholars hold that in the Yuan Dynasty, official kilns also made blue and white porcelain, this production was earmarked for export or as presents to foreign guests, not for domestic use such as in ritual events where only plain single-layer-glazed egg-white porcelain was used. In contrast, in the Ming Dynasty, official kilns not only produced blue and white porcelain as presents for foreign guests, but also as ritual ware, like blue and white *ding* with dragons flying in the clouds and lion's feet from the Hongwu

Fig. 10.8 *Tianbai* glazed pear-head-shaped pot, produced in the Yongle period of the Ming Dynasty, height: 13 cm, mouth rim diameter: 3.9 cm, in the Yangzhou Museum

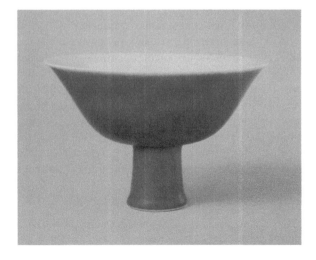

Fig. 10.9 Red glazed goblet bowl, produced in the Yongle period of the Ming Dynasty, height: 9.9 cm, diameter: 18.8 cm, in the Palace Museum

period, blue and white three-footed *ding* with sea water and hills from the Yongle period, or blue and white grain holders and blue and white three-footed furnaces with twining lotus from the Xuande period. All these designs came from traditional bronzeware and had long been applied to ceramic production with a view to replacing the bronzeware. Pottery and porcelain production in imitation of bronzeware can be traced back many years. Especially after the founding of the official kilns in the Song Dynasty, this practice was quite popular. But this was the first time in history that porcelain with decorations was used as ritual ware. For this reason, from the early Ming, the production of blue and white porcelain gradually became mainstream in the Jingdezhen ceramics industry. During the Yongle and Xuande periods, clay and glaze saw remarkable progress in the official kilns. Products during this time featured a fine bluish white clay, translucent, thick glaze and vivid, rich color. What is more, the seven expeditions of Zheng He further strengthened China's trade ties with countries and regions in Asia and Africa, and during this time, smalt, a deep blue pigment which originated from the Middle East, flowed into China on Zheng He's fleet (Figs. 10.10, 10.11 and 10.12). With a high iron and low manganese content, smalt lightened the purple red color in blue cobalt, and with the right atmospheric conditions and temperatures, a beautiful sapphire color could be produced. However, since it contained a high amount of iron, there were usually black dots on the blue decorations, which formed beautiful patterns with a bright blue color. This is one beauty that could not be copied by later generations (Fig. 10.13).

As Emperor Yongle sent fleets, including those of Zheng He, to Southeast Asia, the Middle East and Africa, the court probably ordered porcelain in exotic styles as presents to foreign countries and thus, exposed the Jingdezhen ceramics industry to foreign influence. For example, three vases of the same design but different decorations were offered to the Ardebil Shrine under the reign of Abbasid Caliphate. Through comparison, it was found that these three vases had Chinese-style under-glazed decorations on their soft bodies. Indeed, the earliest porcelain vases produced

Fig. 10.10 Blue and white hand cup with twining lotus pattern, produced in the Yongle period of the Ming Dynasty, height: 4.9 cm, diameter: 9.2 cm, in the Palace Museum

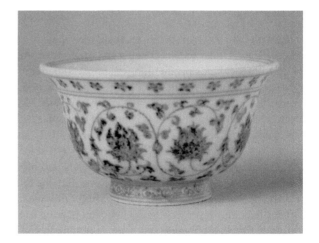

Fig. 10.11 Blue and white
ewer with flower and fruit
pattern, produced in the
Yongle period of the Ming
Dynasty, height: 26.1 cm,
mouth rim diameter: 6.3 cm,
in the National Museum of
China

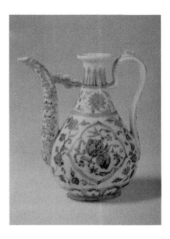

Fig. 10.12 Blue and white
plate with a paradise
flycatcher perching on a
loquat branch, produced in
the Xuande period of the
Ming Dynasty, height:
9.2 cm, diameter: 57.2 cm, in
the Palace Museum

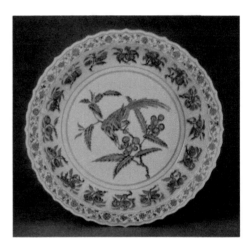

in the Yongle period might have actually originated from a type of glass vase from the
Middle East. Under the strict supervision of government officials during the Yongle
period, Jingdezhen's production was unparalleled both in terms of raw materials and
quality. For example, Fig. 10.14 features a blue and white flask in the style of the
Western Regions. Artisans from Syria had produced glass vases in this style before
the fourteenth century, but it was only in the 14th to fifteenth century that these glass
vases entered China. The moon flask in Fig. 10.14 uses litchi as decoration. Litchi
is widely planted in southern China and was not able to be grown in the north due to
the climate. A tall evergreen tree, litchi has small blossoms in the spring. From this
article, we can see clearly that after blossoming, the litchi bears reddish-pink, roughly
textured fruit. The item is used for holding gift wines, so it probably once held litchi
wine. Litchi also represents good luck and is often used to convey blessings for more
children. Emperors Yongle and Xuande both believed in Tibetan Buddhism and even

Fig. 10.13 Jingdezhen blue and white celestial sphere vase with twining flower pattern, produced in the Yongle period of the Ming Dynasty, in the British Museum

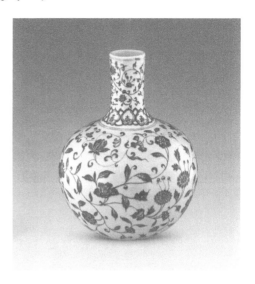

invited monks to live in the royal palace. Thus, in Fig. 10.15, a ewer related to metal articles from Tibet is featured. It has a dragon-shaped mouth, a handle in the shape of an animal and swirl patterns on its neck and belly.

In the early Ming Dynasty, Jingdezhen not only produced blue and white porcelain, but also a lot of other varieties. The most famous of these was underglazed red porcelain. Since red glazed porcelain develops its color from copper oxide, it is very difficult to produce due to the strict requirements of atmosphere and temperature. Thus, some were usually successful and others not. For example, Fig. 10.16 features an exquisite goblet bowl. On the top, it has a bowl with flared edges and on the bottom, a hollow foot with the bottom slightly curling out. The inside of the bowl is painted with a dark dragon glazed in transparent glaze and the outside is underglazed

Fig. 10.14 Jingdezhen blue and white moon flask with litchi decoration, produced in the Yongle period of the Ming Dynasty, in the British Museum

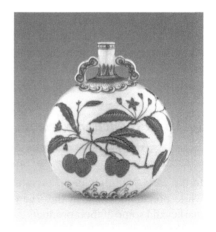

Fig. 10.15 Jingdezhen blue
and white ewer with
dragon-shaped mouth,
produced in the Xuande
period of the Ming Dynasty,
in the British Museum

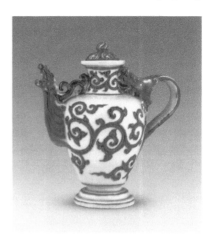

red with a white pattern of two dragons playing with a ball. The inside of the foot is glazed and the outside bears *ruyi*-head cloud motifs between two rings of string patterns. With an elegant design, fine glaze and attractive color, it is a consummate success. Illustrated in Fig. 10.17 is an underglazed red plate. This large plate appears thick. Inside the plate is decorated with three peonies and 16 lotus with their seed-pods surrounding them on the rim. Outside the plate, similar patterns are painted. Normally, pigments with copper oxide are applied to produce red patterns. But these pigments are less stable than cobalt blue materials, so it is very difficult to produce an exquisite article at high temperature. For example, this plate appears dark gray because the copper oxide experienced chemical changes during the firing. In the Hongwu period, a large amount of red and underglazed red porcelain was produced, far more than that produced in the Yuan Dynasty. As a matter of fact, in the Yuan Dynasty, underglazed red porcelain was only initiated and produced in a trial phase. In the early Ming Dynasty, while it entered large-scale production, it was still a rare commodity. The small pot featured in Fig. 10.18 is usually referred to as a "kundikā." It is a water vessel originating from India. Its shape varies a little due to different times and places of production. Popular in the fifteenth century in Southeast Asia, Kundikā were produced to meet the market demands both at home and abroad. The article in Fig. 10.18, despite some small flaws, is a rare treasure of its kind.

10.2.6 Production Varieties and Artistic Features of Private Kilns

In the early Ming Dynasty, private kilns in Jingdezhen mainly produced blue and white porcelain. Back in the Yuan Dynasty, they had also supplied the domestic market and some of their products even made their way into the royal palace, however blue and white porcelain was mainly exported, especially to Islamic countries. After

Fig. 10.16 Jingdezhen red glazed goblet bowl with two white dragons playing with a ball, produced in the Yongle period of the Ming Dynasty, in the British Museum

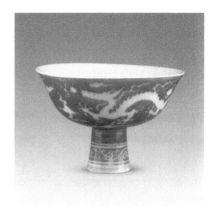

Fig. 10.17 Jingdezhen underglazed red plate with peony patterns, produced in the Hongwu period of the Ming Dynasty, in the British Museum

the Yuan Dynasty was overthrown, porcelain exports became sluggish. In addition, with piracy running rampant in the early Ming Dynasty, the government banned general maritime trade. Thus, Jingdezhen blue and white porcelain was forced to find new customers and it consequently turned to the domestic market.

Blue and white porcelain consumption began to migrate to the domestic market. While it won favor with consumers, it was still in its infancy. Additionally, with the establishment of the Imperial Vessels Factory, the private kilns' best artisans were transferred to the agency, along with the best cobalt blue materials and the best clay. So private kilns could only produce the most basic products with second-class cobalt blue, clay and potters. With changes in raw materials and its target consumers,

Fig. 10.18 Jingdezhen
underglazed red kundikā
with twining peony,
produced in the Hongwu
period of the Ming Dynasty,
in the Victoria and Albert
Museum

product styles, designs and decorations had to change accordingly. Thus, products made for the daily use of common consumers did not have complicated decorations like those made for export to the Islamic states. After all, consumer goods need to consider labor time and costs.

In every era, art inherits and is inherited. Thus, in the Hongwu period, the decorations used on blue and white porcelain shared lots of similarities with that of the Yuan Dynasty, except that it was not as complex. In the Yongle and Xuande periods, Ming blue and white porcelain gradually developed its own characteristics. In terms of variety, vessels like vases and pots which were quite popular in the Yuan Dynasty continued production, but only on a small scale, while bowls, plates, cups and saucers suitable for the daily use of ordinary families emerged.

During this time, blue and white porcelain produced by official and private kilns differed in artistic features. Since official kilns produced for the imperial family and some of their products served as ritual ware, there were specific requirements on their design and decoration. For example, decorations for blue and white porcelain had to be neat and orderly, and dragons, phoenixes, flowers and fruit were among the few limited motifs official products could carry.

In the early Ming Dynasty, the main consumers of blue and white porcelain were the common folk, and they targeted practical and affordable articles in line with their aesthetic tastes. Against such a background, private kilns strove to ensure productivity and cost-effectiveness. In order to cut costs, some kilns even utilized the stacked firing method, leaving marks on the clay. Such products must have been very cheap and not all families would choose to purchase them. In the Yongle and Xuande periods, articles with marks seemed to have disappeared (in fact the Hongwu period saw few as well).

During this time, the products of private kilns did not use fine clay or complicated decorations, but this does not mean that they did not strive to be artistic. Rather,

products in this period had their own unique beauty in design and decoration, especially for bowls. In the early Ming Dynasty, bowls made in private kilns had limited motifs and what motifs were applied were done so on the exterior. Most of them had three to four series of patterns like twining flowers, twigs of flowers, floating cloud patterns, sea water, rails of flowers and fruit, embroidery balls, chrysanthemum and *ruyi* scepter heads. For the sake of convenience, and to save time, these patterns were usually painted with a single stroke. While this method would appear simple, it does require proficient craftsmanship.

The most representative motifs in this period were various forms of clouds and twining flowers. Clouds are one of the most ancient and most common decorations among the traditional patterns. From swirl patterns on primeval colored pottery, to *yunlei* patterns (cloud and thunder patterns consisting of round and square spirals) of the Shang and Zhou dynasties (1600-221 BCE), *juanyun* patterns (curling cloud pattern) of the pre-Qin period (2100-221 BCE), *yunqi* patterns (floating cloud pattern) of the Qin and Han dynasties (221 BCE–263 CE), *liuyun* patterns (flowing cloud pattern) from the Wei, Jin, Northern and Southern Dynasties (220–589), *duoyun* patterns (cloud pattern) from the Tang Dynasty, as well as *tuanyun* patterns (rounds of cloud pattern), *dieyun* patterns (folding cloud pattern) and *ruyi* scepter patterns in the Song, Yuan, Ming and Qing dynasties, all used clouds as the major motif. This shows that cloud patterns suit the traditional aesthetic tastes of the Chinese people and represents the Chinese people's admiration for the universe.

Agricultural civilizations depend heavily on natural conditions. Thus, in ancient China, people attached great importance to observations of nature and natural rhythms such that through changes in weather, people knew when the best time was to farm. With clouds, comes rain, which nourishes crops and feeds lives. So, cloud became a symbol for blessings in ancient times and was imbued with the people's desire for peace, prosperity and good fortune. Thus, as a natural phenomenon, cloud was idealized and transformed into decorative patterns. In the early Ming Dynasty, various cloud patterns were painted on blue and white porcelain, with some curling and floating and some elegant and ethereal, integrating the spatial features of cloud with their mobile beauty.[24] (Fig. 10.19).

Swirl patterns were frequently seen in ceramic decorations. In the early Ming Dynasty, blue and white porcelain was often decorated with twining flower patterns, like lotus, peony, and chrysanthemum as well as Buddhism's Eight Auspicious Symbols on twining flowers, as well as floating cloud and sea water patterns. Twining flower patterns evolved from lotus and honeysuckle patterns which spread to China with Buddhism in the Eastern Han Dynasty (25–220 CE). Lotus is an auspicious flower in Buddhism while honeysuckle patterns, usually used for decorating Buddhist grottoes, originated with Roman architecture and were spread to China via India. In the Tang Dynasty, honeysuckle patterns and floating cloud patterns became transformed into floral scroll patterns, with leaves curling and rolling, forming regular or free style patterns, just like waves in the ocean. Twining flower patterns were

[24] Xu Wen, *On China's Cloud Patterns*, Guangxi Fine Arts Publishing House, 2000, pp. 4, 5 and 8.

Fig. 10.19 A bowl with floating cloud pattern produced during the Hongwu period of the Ming Dynasty

developed on the floral scroll pattern model and became one of the most important motifs in porcelain decorations in the Song, Yuan, Ming and Qing dynasties. From the Yuan to the Ming, twining flower patterns included many varieties of flowers and were combined with auspicious symbols like Buddhism's Eight Auspicious Symbols, dragons and phoenixes to be used in decoration. In the early Ming Dynasty, the curling and swirling flower twig patterns and floating cloud patterns gained favor among potters and became a representative decorative style of the time.

In this period, successive lines were also applied to the decorations. Technically speaking, this might be related to the intrinsic capability of human hands. Because wrists formed a fulcrum, hands could make circular movements and draw spiral patterns. Spiral movements are also easily executed and bestow a sense of elegance. In decorating blue and white porcelain, of the S-shaped twining patterns, lotus represents Buddhism, peony symbolizes wealth, chrysanthemum indicates contentment, Buddhism's Eight Auspicious Symbols, the domain of the immortals, stand for extraordinary power. When these motifs are arranged into an S-shape, it demonstrates blessings. For example, twining peony means wealth that never ends. Clouds, also a symbol of blessing, are also coupled with dragons, phoenixes and peony to represent honor. Thus, all the patterns are endowed with the fondest aspirations of the people.

As a result, articles produced at this time, usually bowls and plates, were decorated with swirling patterns. Not only were the cloud and twining flower patterns swirling, even the centers of flowers were painted into swirl patterns. In addition, branches and twigs were painted like swirling springs and even human figures were painted with strokes of swirling lines.

Decoration of the center of bowls was also interesting in this period. Motifs used on a bowl's center could fall into two categories. One was pictures, like human figures, animals and flowers; the other was Chinese characters, including words of blessing like "*fu*" (Happiness), "*lu*" (Blessings), and "*shou*" (Longevity). The characters were all usually written in cursive script in order to save time and accelerate production. So each character was completed with a single stroke, and with two circles surrounding it. This was a feature at the time. With no restrictions and completed quickly, these decorations seemed casual, natural and plain, giving people a sense

of simplicity, peace, harmony and joy. This was the aspiration of the Chinese people and a beauty which the artifacts pursued. With this spirit, private kilns in Jingdezhen remained prosperous for centuries. The "one-stroke" technique which was developed in the early Ming Dynasty became a major decorative approach of the private kilns and remained in use for centuries until the Republic of China period. As the most free, rough, convenient and natural means of expression, the technique was a great invention of potters from the late Yuan and early Ming period.[25]

10.3 Jingdezhen Porcelain in the Mid-Ming Dynasty

10.3.1 Interaction Between Official Kilns and Private Kilns

In the early Ming Dynasty, the products of private and official kilns differed in terms of design, decoration and color. However, in the mid-fifteenth century, in other words the mid-Ming Dynasty, the traditional designs and decorations of private kilns gradually disappeared, and they began to take on motifs and decorative techniques of the official kilns, such as floral scrolls, pines, bamboo, plum blossom, lotus scrolls, figures from the *Three Kingdoms* and *Heroes of the Marshes*, etc. What led to this change was that many potters from the private kilns had to work in the official kilns for three months every year to fulfil their obligations to the government, so they were exposed to the production style and techniques of official kilns.

The strict operational procedures and detailed division of labor in official kilns had a profound influence on private kilns. In order to produce premium quality porcelain, the imperial kilns had a strict division of labor so that one piece of work had to go through many detailed procedures which were attended to by specific workers who passed along their skills within their family and were tied to their specific duties over generations to maintain their skills and professionalism. The assembly lines adopted in porcelain production were quite an advanced means of production at the time.

Thus, despite the significant amount of time taken to complete their duty, the forced service system also enabled workers to learn advanced technology from the official kilns. With such an exchange of personnel, potters were able to learn from the official kilns and apply their new skills in the private sector. Handymen recruited from nearby towns could also learn some basic skills through their work, and after completing their duties, they could choose to remain in Jingdezhen and make a living. This not only added a new labor force to the official kilns, but it also cultivated a large reserve force for the development of the private kilns.

[25] Fang Lili, *Private Kilns in Jingdezhen*, People's Fine Arts Publishing House, 2002, p. 58.

10.3.2 Jingdezhen Porcelain Under the Reigns of Emperors Zhengtong, Jingtai and Tianshun

In the mid-Ming Dynasty, from the Zhengtong (1436–1449) and Jingtai (1450–1457) periods to the Tianshun period (1457–1464), the country suffered from wars, famines and political turmoil. So, the ceramics industry in Jingdezhen, and especially the official kilns, descended into lethargy and few porcelain wares from this period have been passed down to the present day. This time was therefore generally regarded a "blank period" in the history of the imperial kilns. However, according to historical records, the imperial kilns never ceased operation during these three decades. In an archaeological excavation of the imperial kilns from the Ming and Qing dynasties in Jingdezhen in 2004, a large number of shards of blue and white vats with dragons from the Zhengtong period were discovered. These types of vats were rarely found even in the Yongle and Xuande periods, indicating a large-scale production back in the mid-Ming Dynasty. Meanwhile, discoveries over the years also make it clear that the well-known *doucai* ware of the Chenghua period (1465–1487) actually originated in the Xuande period, matured through the Zhengtong, Jingtai and Tianshun periods and boomed in the Chenghua period.[26] Thanks to these new discoveries, it turns out that the mid-Ming "blank period" was not so blank after all. Even so, not many articles from this time have been identified.

During this time the ceramics industry in fact did experience some development, including in private kilns. According to historical records, in 1436, a man from Fuliang County called Lu Zishun rendered over 50,000 pieces of porcelain to the court as tribute,[27] revealing the considerable production volume of private kilns at the time.

The reign of Emperor Jingtai did not last long. The Jingtai emperor, Zhu Qiyu, ascended the throne in a rush following the Tumu Crisis during which the Mongol Oirat tribes moved southward and launched a large-scale battle against the Ming regime and captured the then Emperor Xuanzong. Suffering from domestic turmoil and foreign aggression, Emperor Jingtai ruled for a short eight years before he was removed.

During this time, the ceramics industry in Jingdezhen also encountered a roadblock. In 1450, the first year of the Jingtai reign, in the regions around Fuliang County, famine was severe. In fact, it was the worst of the three famines which occurred from the Zhengtong period to the Tianshun period. For this reason, it was highly possible that the local ceramic production had to stop or downsize.

Also, since its introduction from West Asia in the Yuan Dynasty, cloisonné grew through the Ming Dynasty and matured in the Jingtai period. During the reign of Emperor Jingtai, cloisonné reached a high level of beauty and craftsmanship and became known as "*jingtailan*" (Jingtai blue) because the enamelware made under

[26] School of Archaeology and Museology, Peking University, Jiangxi Provincial Archaeology Institute and Jingdezhen Ceramic Archaeology Institute, "On the Excavation of the Ruins of the Imperial Kilns in Jingdezhen in 2004," *Archaeology*, Issue 7, 2005, p. 39.

[27] *The Veritable Record of Emperor Xuanzong*, Vol. 23.

Fig. 10.20 *Wucai* incense
Pavilion of the Eight
Immortals with base,
produced in the Tianshun
period of the Ming Dynasty,
height: 19.6 cm, in the
Palace Museum

the reign of Emperor Jingtai was typically blue. With the patronage of the emperor, a lot of expensive materials were used in the production of cloisonné, which might be one of the reasons the porcelain industry experienced adversity and why the poor production volume of the official kilns.

In the early reign of Emperor Tianshun, Jingdezhen began to recover. Craftsmen were recruited, including the skilled individuals of the previous generation, with a view to resuming the boom in the official kilns after the Xuande period.[28] So it should not come as a surprise that after this dark age in ceramic history, the long-stifled official kilns and private kilns experienced great progress and breakthroughs. In the transition from bust to boom, the Tianshun period served as a buffer where the superior traditions and advanced techniques of the Yongle and Xuande periods were inherited and a solid foundation was built for further development of the ceramics industry in the Chenghua period (Fig. 10.20).

During the Tianshun period, blue and white porcelain with human figure decorations were quite popular. Especially paintings of outstanding scholars, depicting the customs of scholars at the time, featuring elegant costumes and floating cloud patterns, quite unique to the era. In the Victoria and Albert Museum, there is a piece from the Tianshun period which allows us to glimpse the nature of the blue and white porcelain of the day. Illustrated in Fig. 10.21, it is a large round jar with its lid missing. The jar looks a little gray and the silhouette lines are rather deep. On its belly there are three scenes. The first scene depicts two scholars in a garden with an attendant; the second pictures three figures sitting around a table with two of them playing Chinese chess and the other watching; in the third scene, one figure is playing the *qin* (a Chinese musical instrument) while the other is listening and an attendant is standing by holding a stick in his hand with a scroll on top of it. Some scholars suggest these decorations might be associated with the four classical scholarly arts,

[28] Wang Zongmu, *Great Gazetteer of Jiangxi Province, On Ceramics*.

namely *qin*-playing, chess, calligraphy and painting, and probably originate from *Jian Deng Yu Hua*, a novel written by Li Changqi in the early fifteenth century.[29]

10.3.3 Jingdezhen Porcelain Under the Reigns of Emperors Chenghua and Hongzhi

Entering the Chenghua period (1465–1487), Jingdezhen's production technology improved even further and its products underwent comparatively major changes. During this time, the unique *doucai* ware of Jingdezhen distinguished itself with its blue color and bright glaze, a premium product in the mid-Ming Dynasty. Thanks to its fame, blue and white porcelain produced by private kilns after the Jiajing (1522–1566) and Wanli (1573–1620) periods also masqueraded as products of the Chenghua period by the addition of certain inscriptions. In the Qing Dynasty, under the reign of Emperors Kangxi (1654–1722) and Yongzheng (1678–1735), lots of porcelain was also produced in imitation of the *doucai* and blue and white porcelain of the Chenghua period (Fig. 10.22).

In the Chenghua period, the porcelain wares were exquisite and elegant with their bodies smooth and glossy, their pigments carefully selected, their colors gentle and peaceful, and their paintings simple, graceful and unrestrained. Their style was unparalleled for some time. There was even a saying that "If you want to view porcelain products from the Ming Dynasty, you must view those from the Chenghua period while in the Qing Dynasty, you must view those from the Yongzheng period." But of course, this referred to the official kilns. As for private kilns, the situation was quite different. The official kilns not only produced elegant and unique blue and white porcelain at this time, but their polychrome ware was also varied. In the Chenghua period especially, *doucai* ware (Fig. 10.23) displayed a bright, clear blue color and a bright red color resembling blood, colors unmatched by products of later generations. Apart from blue and white porcelain and blue and white *doucai* ware, the Chenghua period also produced red glazed porcelain, blue glazed porcelain, yellow glazed porcelain (Fig. 10.24), peacock green glazed porcelain and *Ge*-style porcelain (Fig. 10.25), etc. As for private kilns, the main variety they produced remained blue and white porcelain while colored porcelain was rare.

In the Chenghua and Hongzhi periods, the official kilns normally used the light-colored *tangpo* blue pigment. While not as precious as the imported product, still, all the premium blue pigment was held in the hands of the government. Nevertheless, it was not beyond the realm of possibility that the private kilns were able to lay their hands on some quality blue pigments as well (Fig. 10.26).

From extant products, we can see that the Chenghua period attached great importance to quality and that ineligible products would all be destroyed. Thus, flaws like misshaping and crawling are rarely found in products from this period. Under the

[29] Lv Zhangshen (ed.), *The Beauty of Porcelain* (one of a series of books for promoting international exchange by the National Museum of China), Zhonghua Book Company, 2012, p. 339.

Fig. 10.21 Jingdezhen blue
and white pot with human
figure patterns, produced in
the Tianshun period of the
Ming Dynasty, in the
Victoria and Albert Museum

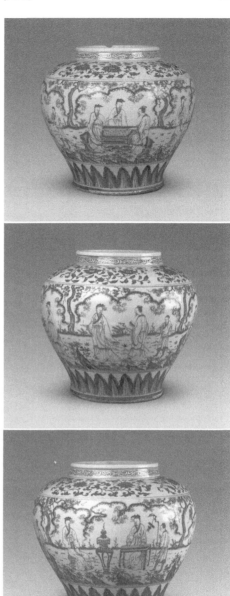

Fig. 10.22 *Doucai* lidded jar with twining flowers and *Tian* (heaven) inscription, produced in the Chenghua period of the Ming Dynasty, height: 8.5 cm, in the Palace Museum

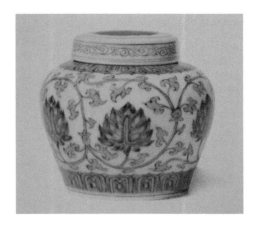

Fig. 10.23 *Doucai* wine cup with chicken pattern, produced in the Chenghua period of the Ming Dynasty, height: 3.3 cm, diameter: 8.3 cm, in the Palace Museum

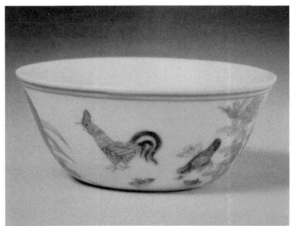

Fig. 10.24 Yellow glazed plate, produced in the Hongzhi period of the Ming Dynasty, in the Capital Museum

Fig. 10.25 *Ge*-style goblet, produced in the Chenghua period of the Ming Dynasty, height: 9.2 cm, diameter: 7.5 cm, in the Palace Museum

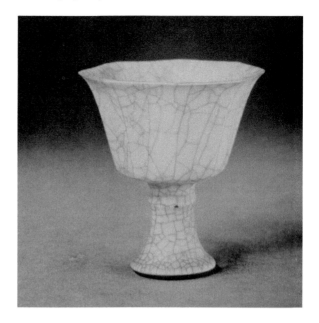

Fig. 10.26 Blue and white bowl with flying dragon patterns, produced in the Chenghua period of the Ming Dynasty, height: 9 cm, diameter: 17 cm, in the Shanghai Museum

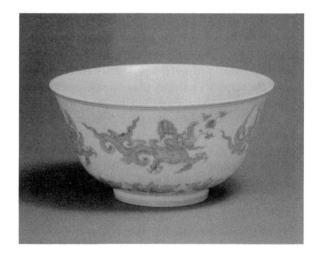

influence of official kilns, private kilns also attached great importance to product quality and most of their products were produced in imitation of the official kilns, in terms of decoration, color and style.

In the Ming Dynasty, private kilns put the reign names of the then emperors on their porcelain later than was the practice of the official kilns. Of the currently surviving products, most carrying inscriptions indicating that they were made in the Hongwu period are actually imitations produced by later generations. In the Xuande period, the imperial kilns in Jingdezhen produced a large amount of blue and white

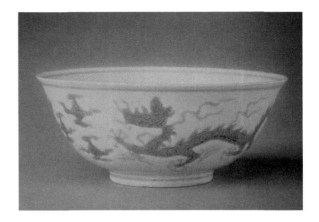

Fig. 10.27 White glazed bowl with green flying dragon paintings, produced in the Hongzhi period of the Ming Dynasty, height: 7 cm, diameter: 16.3 cm, in the Palace Museum

porcelain with inscriptions of the then reign name. However, such inscriptions did not appear to have been popularized among the private kilns, since so far, no private products with Xuande inscriptions have been identified. It was not until the Chenghua period that private kilns started to make products, like blue and white porcelain, with silver-ingot-shaped or lozenge-shaped (two squares overlapping each other in one corner) inscriptions with reign names. Most of the forged products from the Ming and Qing dynasties put inscriptions like "Made in the Chenghua period of the Ming Dynasty," "Made in the Chenghua period" or just "Chenghua" on them.

According to historical records, in the Hongzhi period, the production of the official kilns declined and few products have been passed down through history. In this period, the ceramics industry continued to produce blue and white porcelain, colored glaze and other porcelain following the style of the Chenghua period. But *doucai* ware ceased production at this time. Instead, *jiaohuang* (bright yellow) porcelain and white glazed porcelain with green paintings were the most famous varieties of the Hongzhi period (Fig. 10.27).

Blue and white porcelain dominated ceramic production in the Hongzhi period. The Hongzhi period built on the achievements of the Chenghua period. In recent years, some blue and white porcelain was unearthed from tombs of the Hongzhi period. While these articles had coarse clay and glaze, their decorations were varied, especially some scenes of human figures, which were very diverse and elegant. In addition, plum blossom and bamboo, twigs of flowers, pines and cranes, algae and lotus as well as conchs were frequently applied.

In the Hongzhi period, colored porcelain was much less than in the Chenghua period, both in terms of variety and productivity, let alone the Xuande period. Despite this, yellow glazed porcelain produced in the Hongzhi period was quite renowned. In fact, the Hongzhi period produced the best yellow glazed porcelain the entire Ming Dynasty had ever seen. As the yellow color of this period was so bright, like chicken oil, the color was also known as "bright yellow" or "chicken oil yellow." Yellow glazed porcelain from the Hongzhi period was continued by later generations and even further developed in the Zhengde period (1506–1521). Illustrated in

Fig. 10.28 Yellow glazed plate, produced in the Hongzhi period of the Ming Dynasty, in the Topkapi Sarayi Museum in Istanbul, Turkey

Figs. 10.28 and 10.29 are two pieces of exquisite product from the Ming Dynasty, currently housed in the Topkapi Sarayi Museum in Istanbul, Turkey. The production of polychrome porcelain was not very abundant in the Hongzhi period. To date, only green porcelain and red porcelain have been identified. Of the green porcelain, there were green on white and green on yellow porcelain, with the former forming the majority. Of the red porcelain, there were red on white and blue and red porcelain. The Hongzhi period also produced tricolor porcelain, with red, yellow and peacock green paintings on white bodies.

Inscriptions in the Hongzhi period included *"Hongzhinianzhi"* (Made in the Hongzhi period) in seal characters and *"Daminghongzhinianzhi"* (Made in the Hongzhi period of the Great Ming Dynasty) in regular script on products of official kilns. As for the private kilns, there were square-shaped *"Renzinianzao"* (Made in the year of Renzi, the fifth year of Hongzhi, namely 1492) and square-shaped, double-square-shaped and silver-ingot-shaped *"Damingnianzao"* (Made in the Great Ming Dynasty).

10.3.4 Jingdezhen Porcelain in the Reign of Emperor Zhengde

Maintaining the traditions of the Chenghua and Hongzhi periods and exploring a new landscape in the Jiajing period, the Zhengde period (1506–1521) not only inherited all the features from previous generations in terms of shape, variety and decoration, but also made many innovations and formed a unique style of its own. As more and more large pieces of product were made, porcelain at this time tended to appear thick and coarse. Besides, with increasing demand from the royal palace, porcelain articles were becoming increasingly diverse. However, apart from the most famous variety

Fig. 10.29 Yellow glazed
bowl, produced in the
Zhengde period of the Ming
Dynasty, in the Topkapi
Sarayi Museum in Istanbul,
Turkey

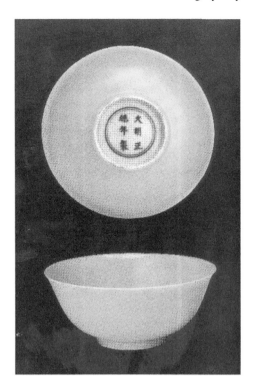

in the Zhengde period, plain tricolor porcelain, other varieties could scarcely surpass
their counterparts in the Yongle, Xuande and Chenghua periods in terms of quality.

What is worth noting is that apart from green on white porcelain, blue and red
porcelain and overglazed *wucai* porcelain, the Zhengde period produced a new variety
called "plain tricolor porcelain." Plain tricolor porcelain had two major character-
istics. First, different from red and blue porcelain and *wucai* porcelain (five-color
porcelain), red was not used in plain tricolor porcelain. In ancient China, on happy
occasions like weddings and birthdays, red was always used, while in funerals,
usually plain colors like white, blue, green and yellow were used. This is how the
name "plain tricolor porcelain" came into being. Like *wucai* porcelain which does
not necessarily display five colors, plain tricolor porcelain also does not necessarily
contain three colors. Instead, it mainly used yellow, blue and purple, but was not
limited to these. Its second feature is that, learning from the production technology
of the Xuande and Hongzhi periods, the glazing techniques in bisque were improved.
Prior to the Zhengde period, colors were applied on glaze at a low temperature after
white porcelain was fired, while in the Zhengde period, colors could be directly
applied to bisque bodies. For example, a plain tricolor pen washer with sea toads,
now housed in the Palace Museum, is a representative piece of plain tricolor porce-
lain from the Zhengde period. It was incised with yellow sea toads and blue sea water
on the exterior and painted purple on the mouth and feet (Fig. 10.30).

Fig. 10.30 Plain tricolor three-footed pen washer with sea toad patterns, produced in the Zhengde period of the Ming Dynasty, height: 10.8 cm, mouth rim diameter: 23.7 cm, in the Palace Museum

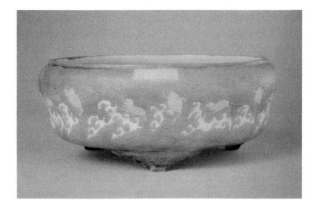

Fig. 10.31 Blue and white bowl with twining flower pattern, produced in the Zhengde period, height: 5.5 cm, diameter: 13 cm, in the Henan Provincial Cultural Relics Exchange Center

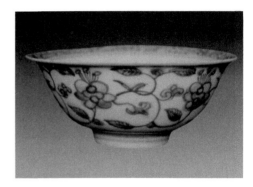

While boasting more varieties, the Zhengde period still mainly focused on the production of blue and white porcelain, both official and private kilns alike. Blue and white porcelain produced in private kilns, especially, accounted for a considerable amount both in terms of variety and quantity. Most articles from this time appeared gray blue due to the pigments used at the time. Apart from plates, vases, furnaces, pen washers and pots, there was a huge number of various bowls passed down through history, which might be related to the burial traditions in society at the time, because after the Zhengde period, common people used bowls as burial objects. As they were often buried outside of coffins in the "*kuang*" (pit), they were also called "*kuang* bowls." (Fig. 10.31).

10.3.5 Artistic Style in the Mid-Ming Period

After the mid-Ming Dynasty, the ceramics industry in Jingdezhen enjoyed steady development. Not only did official kilns produce many new varieties, but markets for the private kilns also expanded further. According to the relevant archaeological

research, porcelain purchased by Guangxi from Jingdezhen in the early Ming Dynasty only accounted for 30% of its locally produced porcelain products, while in the mid-Ming, this number increased to over 50%. Among these, blue and white porcelain formed the majority, followed by white porcelain, pea green glazed porcelain, brown glazed porcelain, sacrificial blue glazed porcelain, peacock green glazed porcelain and aubergine glazed porcelain (*qiepizi* monochrome glazed porcelain), as well as overglazed porcelain with colored paintings, like red, blue, yellow, black and lake blue.[30] This shows that after the mid-Ming, private kilns not only enjoyed broad sales on the domestic market, but also expanded their varieties.

The shapes of porcelain in this period were also diverse. For example, among the daily use articles, there were various vases, *zun*, bowls, cups, plates, saucers, jars, pots, vats, *dun*, boxes, *ding*, furnaces and miscellaneous articles. Among them, *dun* were used as seats by some families in the summer. Boxes included various rouge boxes, powder boxes, inkpad boxes and paint boxes. *Ding* were originally cooking and container vessels but later became ritual or decorative ware. Furnaces were used when burning incense. Miscellaneous articles were often pleasure articles or decorative ware in studies, such as chess sets, folding screens, hat holders, pen racks, pen holders, inkstone water holders, inkstones, pen tubes and pen washers. In addition, there was also ritual ware specifically used for sacrificial ceremonies. From these various products we can see that, at the time, the private kilns in Jingdezhen already produced articles for daily use to meet the demands of people's lives in every respect and that porcelain had become a necessity in the lives of people of all social classes. With the expansion of consumer needs, products were bound to become diverse. Thus, at this time, decorative motifs, techniques and materials were even more varied than in the early Ming Dynasty. And to meet the demands of people of different social classes, private kilns also produced a large amount of fine and exquisite porcelain, thus greatly improving the quality of their products.

In terms of decorative motifs, apart from the traditional motifs and images, under the influence of Islam, porcelain with inscriptions of Arabic characters also came into vogue. This feature can be found in products from the Yongle and Xuande periods and became more popularly applied in the Zhengde period. In addition, articles and human figures from Taoism were also used as motifs since, from the perspective of philosophy, Taoism, rather than Confucianism, was in the ascendancy at the time. The philosophical thought of Wang Yangming was especially popular. He stressed the essential role of the mind. He held that everyone had a conscience, but at times, people's conscience was clouded by the secular world, hence the reality of declining morality and a degrading social atmosphere. To re-ignite people's "conscience," it was necessary to figure out the boundaries between humanity and nature, so that under natural conditions, there is no subject or object. Based on his thinking, Li Zhi developed his "Thoughts on Childlikeness." Li proposed that "Those with a child-like mind have a pure mind. When childlikeness is lost, the pure mind is gone and along with it, a clear conscience. With all these gone, one is not himself/herself

[30] Li Hua & Liu Liehui, "Imports of Jingdezhen Porcelain to Guangxi and its Influence," *Porcelain of Jingdezhen*, 1992, Issue 1, p. 92.

any more."[31] Probably because of people's high praise of this "pure mind" and "childlikeness," motifs of "children at play" increased markedly. While such motifs had always been in use, especially on Cizhou black on white porcelain and Jingdezhen *Qingbai* porcelain in the Song Dynasty, they basically disappeared from Jingdezhen blue and white porcelain in the Yuan and early Ming dynasties. However, after the mid-Ming, these images returned, and in the mid- and late-Ming Dynasty especially, they returned to active service until the Qing Dynasty. In addition, since Jingdezhen was not far from Suzhou, Hangzhou, Yangzhou and Nanjing where scholars were concentrated, its stationery was prized and affected by these scholars. The fact that many of their products had depicted scholars enjoying natural scenery or their home lives proves the point.

In terms of decorative style, first, influenced by the official kilns and also with the emergence of the *fenshui* technique (mixing pigments with water and channeling the filtered fine paint onto clay with an engraved framework of images), after the mid-Ming Dynasty, private kilns produced some extremely exquisite products comparable to that of the official kilns. Second, since the handicraft industry progressed slowly, traditions were passed along for many generations before they vanished into the perennial stream of history. Thus, the "one stroke" technique, which had been popular in the early Ming Dynasty, while it had lost its position in the mainstream, was still used in some commonly seen daily ware. In this way, this simple and time-saving technique maintained its presence and developed further. Third, the development of a specific art form in a given era will certainly be influenced by other forms of art from the same era. Hence, apart from the above-mentioned factors, silk motifs and literati paintings at the time also played a role in the formation of the decorative style of Jingdezhen in the mid-Ming Dynasty.

The Ming Dynasty was a high point for silk production and many new varieties came into being in this period. Its decorations mainly included auspicious motifs of birds, flowers and geometric patterns, such as round-shaped flying phoenixes, phoenixes flying among flowers, *ruyi*-head clouds, dragons flying in cloud, drifting petals, twining peony and lotus, twigs of flowers and fruit, chrysanthemum, pomegranate, peach blossom, hibiscus, creeping weed, Buddhism's Eight Auspicious Symbols, lozenges, silver ingots, tortoiseshell patterns and coin patterns. These patterns also appeared on Jingdezhen porcelain. It thus appears that these decorations were popular at the time. Apart from patterns, silk and porcelain also shared some similarities in decorative style. For example, round-shaped patterns and overlapping patterns which were developed following the mid-Ming, became a major feature of Jingdezhen porcelain in the late Ming and the Qing. Besides, silk decorations in the Ming Dynasty highlighted the startling contrast of colors in decorations, not only in terms of brightness, but also hues. For instance, green would go with yellow patterns, red complemented gold or yellow and white was matched with dark patterns. These matches also affected the decorative style of Jingdezhen. Multi-colored porcelain emerged in the mid-Ming Dynasty, like the representative yellow glazed blue plates with twigs of flowers and fruit of the Xuande period, green

[31] Li Zhi, *Fenshu*, Vol. 3, *On Childlikeness*.

on white bowls with dragons of the Chenghua period, green on yellow goblets with flowers in the Zhengde period, and yellow on blue and white bowls with dragons.[32] Though these products were all made by official kilns, by the late Ming Dynasty and into the Qing and beyond, they were introduced to private kilns and produced in a large quantities.

In addition to silk patterns, literati paintings and genre paintings also affected the decorative styles of private kilns. Among literati paintings, there were scenery paintings, flower and bird paintings and human figure paintings. Human figure paintings used by private kilns in the mid-Ming Dynasty were different from those in the Yuan Dynasty. In terms of technique, the Yuan Dynasty was strongly influenced by woodcut paintings, so its paintings were neat and precise. In terms of content, most motifs used in the Yuan Dynasty came from Yuan poetry or novels, usually depicting a scene or a plot. So, they were usually very down-to-earth. In contrast, in the mid-Ming Dynasty, influenced by literati paintings popular at the time, human figure paintings were also casual and natural but the majority reflected the lives of scholars, immortals or Taoist priests. With their strong scholarly connotations, these paintings expressed the interests and pursuits of the scholars of the day.

But of course, paintings by craftsmen differed from those of the literati. For craftsmen, paintings on porcelain aimed to cater to the market demands and seek a living, instead of expressing their feelings as scholars did. Serving different purposes, their painting styles were bound to be different. Simplicity was important for craftsmen. But sometimes, too much simplicity gave the impression of shoddiness, dullness and lack of action. Thus, they tended to add various floating cloud patterns in the background, such as the shape of the Ganoderma lucidum mushroom, *ruyi*-head, or flowing water. Usually such floating cloud patterns were coupled with thick and thin curves, overlapping and repetitive arcs, and varied lines, making the whole picture look ethereal while catering to the consumers' taste for sophisticated patterns. For different motifs, different techniques were applied. For example, for daily use bowls and plates, their decorations were relatively free, simple and casual. A whole pattern was drawn with one stroke in a short period of time, with finer details added later. Such a technique required experience and craftsmanship. For larger and more delicate articles like plum vases, pots with lids, *ding* and furnaces, it was more delicate and elaborate. Figures usually featured with clothes flowing delicately in the wind, standing on sturdy grass, bracing against strong winds, or silhouetted against a backdrop of cloud patterns and with green mountains and clear water or with the edges of a building or a pavilion looming behind them. Complicated as they were, these paintings pursued accuracy as well as spirit. Thus, they required more effort and demanded a high price (Fig. 10.32).

[32] Ye Peilan, *Famous Wucai Porcelain*, Taiwan Arts Book Company, 1996, pp. 85–87.

Fig. 10.32 A plum vase
with an immortal pattern,
produced by a private kiln, in
the Tianshun period of the
Ming Dynasty

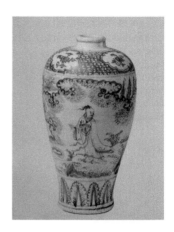

10.4 Jingdezhen Porcelain in the Late Ming Dynasty

In the late Ming Dynasty, ceramic production in Jingdezhen experienced a profound revolution which was a huge impetus to industrial development and also paved the way for the emergence and prosperity of capitalism in the ceramics industry in the region. Factors leading to this revolution include the following.

10.4.1 Opening Up of Overseas Markets

Chinese porcelain had been exported in large quantities since the Song and Yuan dynasties and gained great popularity in Southeast Asia, Africa, Europe, and elsewhere. Zheng He's great expeditions in the early Ming Dynasty signified a new era for the porcelain trade in Chinese history. Before his trips, products exported overseas were mainly Longquan celadon ware and products of a similar style made by kilns in the southeast coastal regions. At the time, apart from the Longquan kilns, the major kilns had all declined while blue and white porcelain was yet to be produced on a large scale. After the government began to pay attention to blue and white porcelain and established official kilns, with imported smalt, production of blue and white porcelain grew by leaps and bounds. Its fine quality and exquisite beauty won favor on both the domestic and foreign markets, thus establishing a favorable reputation for Chinese porcelain on the international market. Since Zheng He's expeditions were official activities, the blue and white porcelain that travelled along with him was basically bespoke and so not commercialized on a large scale (Fig. 10.33).

In the early Ming Dynasty, a strict maritime ban was adopted, hindering the development of maritime trade. Despite this, some maritime trade activities continued under the table, challenging the government policy. In the mid-Ming Dynasty, after Portugal and the Netherlands established trade ties with China, merchants from these

Fig. 10.33 Underglazed
vase with double lugs and
dragons flying in cloud,
produced in the Hongwu
period of the Ming Dynasty,
height: 45.5 cm, mouth rim
diameter: 10.9 cm, in the
Shanghai Museum

two countries often smuggled exports from China to Southeast Asia, the Middle East
and the Far East with the help of residents and smugglers from Guangdong and
Fujian Province. According to *Studies on the Oceans East and West*, "Under the
reign of Emperors Chenghua and Hongzhi, there were some powerful and privileged
families engaged in maritime trade. Smugglers profited a lot from this business
while the government had no right to deprive them of their fortune... By the Jiajing
period, smuggling was already a severe problem." These facts show that more than a
century after the Xuande period, the "maritime ban" had some loopholes and by the
Jiajing period, it had failed completely. Under the reign of Emperor Longqing (1567–
1572), the policy was finally abolished. With the opening of the foreign markets, the
porcelain trade became a lucrative business. A major difference between the porcelain
trade in the Ming Dynasty with that of the Song and Yuan was that apart from exports
shipped on large official fleets, a large amount of porcelain was smuggled by residents
in coastal regions and transferred to European countries (Fig. 10.34).

The boom in the commodity economy greatly stimulated production of the official
and private kilns in Jingdezhen. From the Jiajing period to the Wanli period (1573–
1620), the number of official kilns doubled and redoubled while private kilns grew to
over 900 by the Jiajing period. "The number of craftsmen and manual workers in kilns
was in the hundreds of thousands."[33] Not only did the foreign market flourish, but
the domestic market also prospered as "porcelain traders all gathered in Jingdezhen
and Jingdezhen products sold in over a dozen provinces."[34]

[33] Tang Ying, *An Illustrated Book on Porcelain Affairs*, Vol. 20.

[34] Lan Pu, *Jingdezhen Taolu*, Vol. 8.

Fig. 10.34 *Wucai* jar with images from *Pilgrimage to the West*, produced in the Jiajing period of the Ming Dynasty, height: 28.5 cm, in the Idemitsu Museum of Arts of Japan

10.4.2 Reform Measures in the Imperial Vessels Factory

10.4.2.1 The Implementation of "Guandaminshao"

The Imperial Vessels Factory was administrated by the Ministry of Works. Every year, the ministry assigned specific porcelain production tasks to the factory, which was called "*buxian*" (ministerial quota). Apart from the ministerial quota, sometimes in order to cater to the demands of the court, extra tasks would be assigned, which were termed "*qinxian*" (imperial quotas).

Before the Imperial Vessels Factory was founded in Jingdezhen, regular government offerings had not yet begun. After its establishment, initially, the imperial quota was very small. Following the Jiajing period, with the opening of foreign markets, the commodity economy grew rapidly and yielded high profits, therefore, the government attached greater importance to porcelain production. As a consequence, the mode of production in the official kilns also changed. From 1529 to 1571, the annual production expanded from more than 2000 pieces to over 100,000, with market demand growing steadily. With large orders and high requirements in terms of quality, Jingdezhen faced tremendous pressure. Overburdened with heavy workloads, Jingdezhen had to find a solution, so the authorities adopted a new system that allowed the official kilns to complete their "ministerial quota" while they assigned part of the "imperial quota" to private kilns through the "*Guandaminshao*" policy.

"*Guandaminshao*" is in fact a form of exploitation of the private kilns. After finishing their assigned jobs and submitting the finished products, the Imperial Vessels Factory would undertake a very strict selection process. If private kilns were not capable of completing their tasks or if their products fell short of the standards of

the Imperial Vessels Factory, the agency would sell its own products to these kilns at high prices for them to accomplish their "imperial quota." According to the *Great Gazetteer of Jiangxi Province, On Ceramics*, "Porcelain under the ministerial quota was produced by official kilns while that under the imperial quota was distributed to different private kilns. If their products accorded with the relevant standards, they would be accepted. If not, these private kilns were forced to purchase porcelain from the official kilns at high prices to reach their required quotas. This caused great difficulties for private kilns." Nominally, private kilns were paid. But in reality, the payment was extremely low. For example, a large vat made by the Imperial Vessels Factory was valued at 58 *Liang* or taels of silver (50g) and 8 *Qian* (5g) and a second large vat 50 taels. If produced by private kilns, even after bargaining, they were only paid 23 taels for a large vat and 20 taels for a second vat. In making blue and white porcelain, lacking quality cobalt pigment, the private kilns had to purchase it from workers at the factory, who sold them substandard pigment, taking advantage of them.[35] This system must have led to lots of misery for the private kilns and their workers in Jingdezhen. But despite this, it also spurred on progress in the private kilns.

Firstly, implementation of this system allowed private kilns in Jingdezhen to produce not only coarse daily ware, but also high-quality fine porcelain for imperial use, which helped improve their technological expertise and production standards, and won for them a reputation as quality producers, similar to that of the official kilns. As private kilns attracted more and more attention on the domestic and foreign markets, many merchants came to Jingdezhen to place orders and purchase products from them. It is thus assumed that, without this system and without the stimulus of the court demands, it is doubtful whether the private kilns in Jingdezhen would have gained such a broad market or that the ceramics industry in Jingdezhen would have enjoyed such advanced development.[36]

Secondly, this system imposed a heavy burden and pressure on the private kilns. In order to complete tasks assigned by the government, the private kilns had to adjust their organizational structures and methods of production and reform their production techniques, tools and procedures so as to produce porcelain of equal quality to the official kilns. In order to increase efficiency, private kilns adopted a strict division of labor and divided their porcelain production procedures into very specific steps, like sourcing raw materials, refining raw materials, preparing clay and glaze, shaping, glazing, firing, coloring, baking and packing. According to their different duties, workers were categorized into 17 groups, each responsible for a specific part of the work. Thus, it appears that there was a very complicated and detailed division of labor. In fact, there was a further specific division within each duty. For example, among the 17 categories of workers, there was one called clay painters. Among the clay painters, some prepared pigments, some designed motifs, some painted, some matched colors,

[35] Chinese Ceramic Society (ed.), *History of Chinese Ceramics*, Cultural Relics Press, 1982.

[36] Michael Dillon, "Jingdezhen as an Industrial Center of the Ming Dynasty," *Porcelain of Jingdezhen*, 1981, Issue 1.

some applied colors and some fired the furnaces.[37] This was the division of labor during production. There was also a division of labor in the indirect production activities closely associated with porcelain production. For example, there were workers mending kilns, collecting wood, chopping wood, preparing saggers, making bricks, cleaning, making articles from bamboo strips, carpenting, making buckets, repairing molds, making iron articles, making mortars and producing knives. All these duties required some skill. Together, they formed a team, without a specific number but in a fixed proportion, enabling porcelain production to proceed in a smooth and orderly manner. Just like Song Yingxing, a Chinese scientist and encyclopedist in the late Ming Dynasty put it, "A complete product, which was originally just a ball of clay, was finished by dozens of hands."[38]

In this way, each worker focused on one specific part of a job and each duty was very specific and detailed. Workers were able to develop their specific craftsmanship and constantly improve their skills, and a streamlined production process was established. This transformation significantly changed the production of private kilns in terms of both quality and quantity and helped improve productivity in the ceramics industry. The division of labor in the private kilns was the historical prerequisite to the division of labor in workshops and endowed workshops with capitalistic features. This was the most advanced means of production at the time.

The "*Guandaminshao*" system also allowed raw materials which were traditionally monopolized by government to flow into private hands. Since the Yuan Dynasty, the raw materials in Jingdezhen had been under the control of the government. For instance, Macang Mountain in Jingdezhen produced quality clay. However, private kilns were prohibited from exploiting the clay there since raw materials from Macang Mountain were reserved for the court. In addition, there was no way for private kilns to acquire quality cobalt blue pigment. However, after involving private kilns in the production for imperial use, in order to ensure production quality, a specific amount of quality clay and pigment had to be sold to private kilns, which had to be used on imperial production only. Despite this, this was finally a means for private kilns to lay their hands on quality raw materials. This was one of the reasons why the quality of products made by private kilns improved remarkably.

10.4.2.2 Recruitment System Implemented in Some Regions

In the early and mid-Ming Dynasty, the craftsmen system prevailed in official kilns. Under this system, potters were burdened with a heavy workload but were only offered coarse food and nothing else as payment. Workers, therefore, had no enthusiasm for production. They often slacked at work, missed their shifts, hid themselves, pretended to be someone else, or even ran away to express their resentment or as a means of fighting the system. For example, in 1430, the fifth year of the Xuande

[37] Lan Pu, *Jingdezhen Taolu*, Vol. 3.

[38] Song Yingxing, *Exploitation of the Works of Nature*, Vol. 7, *On White Porcelain*.

reign, many craftsmen working in Beijing fled.[39] This phenomenon ran increasingly rampant later. By 1450, the first year of the Jingtai reign, a total of 34,800 workers were estimated to have run away. In 1485, the 21st year of Chenghua, over 3000 workers from the Arms Bureau escaped.[40] In this context, in 1485, a dual system of "buying one's way out of compulsory service" or "shifting" was introduced. In 1562, the 41st year of Jiajing, the dual system was replaced by "buying one's way out of compulsory service" only, thus liberating 80% of craftsmen. But this led to a declining labor stream for the government-run handicraft industry. After the mid-Ming Dynasty, government-run handicraft businesses died out one after another. Faced with the worsening business climate, the Imperial Vessels Factory was forced to change in order to maintain, not to mention increase, its productivity. In an attempt to motivate potters, the factory replaced the craftsmen system with a recruitment system, so that all workers were recruited by the agency. But their wages were still very low. They were usually paid 0.25 *Qian* (5 g of silver) per day, or 0.35 at most. Thus, their monthly wages were a mere 7.5 *Qian*, or 10.5 at most. In addition, some artisans were "captured" to work for official kilns. In February 1547, an official in Jiangxi reported to the government that "In order to make bright red tableware, high rewards were offered, and skillful artisans were retained, but the production failed anyway."[41] Workers captured and forced to work in the Imperial Vessels Factory still had no personal freedom. But compared with those under the craftsmen and shifting systems, potters under the recruitment system could adapt to an advanced mode of production featuring a division of labor at its center. This system also stimulated employees' enthusiasm to some extent. With the decline of the official kilns in Jingdezhen, private kilns were further boosted and surpassed previous generations in terms of production technology, quality and quantity of products as well as their business patterns.

10.4.3 The Development of Capitalism

Thanks to the reasons noted above, the ceramics industry in Jingdezhen enjoyed rapid growth in the late Ming Dynasty. A number of private kilns began to concentrate on the production of fine quality porcelain. They may be classified into several groups, including "*guanguqihu*" (official ancient ware kilns), "*jiaguanguqihu*" (fake official ancient ware kilns), "*shangguqihu*" (upper-class ancient ware kilns) and "*zhongguqihu*" (middle-class ancient ware kilns).[42] These various official and private kilns began to compete ferociously. During the Tianqi (1621–1627) and Chongzhen (1628–1644) periods, the official kilns ceased operation. However, overseas demand doubled and redoubled, which pushed the production quality and quantity of private

[39] *Veritable Records of the Ming*, Vol. 63, "Records for February 1430.".

[40] *Veritable Records of the Ming*, Vol. 261, "Records for January 1485.".

[41] *Gazetteer of Fuliang County, On Ceramics*, 1783.

[42] Lan Pu, *Jingdezhen Taolu*, Vol. 2.

kilns to an unprecedented level. Especially after the constraints of the official kilns were removed, private kilns in Jingdezhen were ushered into a golden era. All these factors together contributed to the emergence of capitalism, which in turn facilitated a boom in the ceramics industry in Jingdezhen.

The development of the private kilns in Jingdezhen was boosted in the late Ming Dynasty, leading them to surpass even the official kilns. Kilns employing dozens of workers and controlling a certain amount of capital had attained the scale of a handicraft workshop, exhibiting characteristics of the early stage of capitalism. With such workshops, Song Yingxing's claim that "A complete product, which was originally just a ball of clay, is finished by dozens of hands" was able to be realized. Relations between kiln owners and their workers continued to be restrained by traditional feudalism. They were usually bonded by birthplace, village, family and other ties. But they had already established an employment relationship, so they basically had shared interests.

According to the *Great Gazetteer of Jiangxi Province, On Ceramics*, in the Jiajing period, the furnaces of private kilns were renovated such that, while consuming the same amount of fuel, a furnace could produce over three times the products of official kilns. Additionally, since private kilns produced a wide variety of products, fine and coarse, high and low quality, they made better use of the space in a furnace than the official kilns. In this way, they saved fuel and improved productivity.

In the late Ming Dynasty, private kilns had also mastered various motifs and techniques by breaking free from the traditional styles of the official kilns, and drawing the better parts from literati paintings, woodcut pictures and New Year paintings. Apart from flowers and fruit, their motifs now also included various animals, like tigers, cows, cats, shrimps, parrots and mandarin ducks, sketches of landscapes and human figures, as well as poems, which was a direct result of the influence of scholars. These various motifs endowed a renewed vigor to the private kilns (Fig. 10.35).

While official kilns also produced some products for export, their major task was to supply the court, so almost none of their products could be found or circulated in the market.

In contrast, the private kilns enjoyed a wide market. They produced coarse products for peasants in rural areas, supplied ordinary porcelain for domestic and overseas markets and made high quality products. After the Jiajing period, the "imperial quota" was usually completed by private kilns. They also produced high-quality decorative porcelain for landlords and high-ranking officials to meet their demand for luxury and extravagance. Products made for this purpose manifested the wisdom of craftsmen in the private kilns. According to Wang Zongmu, an official from the Ming Dynasty, "Porcelain production is lucrative. Buyers do not care about prices while producers make novel products to attract consumers. Some articles are as expensive as one *Liang* sliver ingots. Others with decorations like flowers, grass, human figures, animals or landscapes or articles like vases and basins are also numerous, and priced as high as several *Liang*. Articles like *suiqi* (a porcelain variety with cracks in the glaze) and golden plates can cost over a dozen *Liang*. Such products are usually collected as family assets." Kilns focusing on producing high-quality porcelain for the "imperial

Fig. 10.35 *Wucai* lidded box with human figure patterns, produced in Jiajing period of the Ming Dynasty, diameter: 21.3 cm, in the Idemitsu Museum of Arts

quota" were called "*guanguqihu*" (official ancient ware kilns). Others were categorized as "fake *guanguqihu*" kilns, "*shangguqihu*" (upper-class ancient ware kilns), and "*zhongguqihu*" (middle-class ware kilns). This categorization is elaborated in *Jingdezhen Taolu*. "*Guanquqihu* kilns were the best kilns in Jingdezhen. Initiated in the Ming Dynasty, they were generally known as '*guangu*', but they had different production varieties. They selected quality raw materials and produced fine products, just like the official kilns. As their products were eligible for imperial use, there was a '*guan*' (official) in their name. Among today's *guangu* kilns, there are some using light green color and painting in light blue in imitation of famous ancient kilns. If one assumes that there were official kilns in Kaifeng and Hangzhou, one would be wrong. Fake *guanguqihu* kilns emerged in the Ming Dynasty. They did not copy the style of the official kilns in Kaifeng and Hangzhou. Instead, they imitated the *guanguqihu* kilns in Jingdezhen, hence the 'fake' in their name. The *Shangguqihu* kilns, also initiated in the Ming Dynasty, produced the second-best porcelain in Jingdezhen. They featured fine raw materials and production techniques. The *Gu* in their names indicates people's admiration for ancient porcelain ware. The *Zhongguqihu* kilns produced less favored products than the *shangguqihu* kilns in the Ming Dynasty. Their raw materials were not as good as those of the *shanguqihu* kilns, so neither was the quality of their products."[43]

[43] See Footnote 42.

10.4.4 Ceramics Industry in Jingdezhen

10.4.4.1 The Jiajing Period

Beginning in the Jiajing period (1522–1566), the private kilns in Jingdezhen further expanded and the quality of their products improved. Thanks to the developing capitalism and the involvement of private kilns in official production through the "*Guandaminshao*" system, some high-class private kilns not only produced clay and glaze equal in quality to that of the official kilns, but they also broke the traditional shackles and made innovations in terms of decoration. In the *Great Gazetteer of Jiangxi Province*, it states that between official and private kilns, there was no insurmountable gap as was the case in the past [2]. Since the "imperial quota" was almost completely accomplished by private kilns, it promoted their technical advancement and facilitated the emergence of polychrome porcelain. As for the official kilns, their production hit an historic record. Based on the records available, the Jiajing administration assigned a total of 600,000 pieces of porcelain to Jingdezhen. With the unfinished 300,000 or more pieces from the Hongzhi period, this grew the production quota to almost one million. Part of this task was accomplished under the "*Guandaminshao*" system. This means that in the Jiajing period, the official and private kilns alike had reached an unprecedented production high and their production varieties and decorations were also more varied than ever. Especially worth mentioning was polychrome porcelain. Though it paled in comparison to the *wucai* ware of the Xuande period and *doucai* ware of the Chenghua period, polychrome porcelain in the Jiajing period was unprecedented in terms of variety and it was responsible for a boom in private kiln production (Figs. 10.36 and 10.37). Still, blue and white porcelain continued to dominate porcelain production in Jingdezhen during this period and colored glaze also enjoyed some progress.

In the Jiajing period, apart from supplying coarse products to rural regions, private kilns also produced high-quality fine products for the middle-class and upper-class landlords and officials such as "Ware for the Haos," "Ware for the Shens," "Collections of the Bowu House," plates and bowls used by "Qingluo Pavilion," plates with the 16 children of the "Junshou House," "Fine articles of the Chang House," "Ware of Dongshu Hall" and "Ware of the Des," etc.[44]

Blue and white porcelain produced by official kilns used cobalt blue materials imported from the Western Regions, making them appear bright and gorgeous. According to the *Great Gazetteer of Jiangxi Province, On Ceramics*, which was completed in the Jiajing period, there were three kinds of cobalt blue materials used in Jingdezhen. The first was *Potang* blue, produced in Leping. The second was *Shizi* blue, produced in Ruizhou and the third was that imported from the Western Regions. But in private kilns, apart from the "*Guanguqihu*" kilns, other kilns had no opportunity to use imported cobalt blue. Thus, the *Jiangxi Annals, On Ceramics* also states that among the official kilns, imported cobalt blue was so popular that *Shizi* blue was

[44] Chinese Ceramic Society (ed.), *History of Chinese Ceramics*, Cultural Relics Press, 1982, p. 379.

Fig. 10.36 *Wucai* plate with dragon pattern, produced in the Jiajing period of the Ming Dynasty, diameter: 20.5 cm, in the Idemitsu Museum of Arts

Fig. 10.37 Polychrome pot with flower and bird patterns, produced in the Jiajing period of the Ming Dynasty, height: 36.9 cm, in the Palace Museum

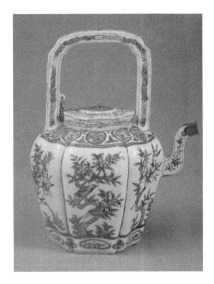

phased out gradually. With different pigments, the blue and white porcelain produced by the official and private kilns resulted in different colors.

Because the Jiajing Emperor admired Taoism, therefore both the official and private kilns during his reign featured many motifs reflecting Taoist concepts, such as Li Tieguai (Iron Crutch Li, one of the Eight Immortals in the Taoist pantheon) making elixir, the Eight Immortals greeting the God of Heaven, cranes, deer, branches of

flowers, lucid ganoderma and the Eight Trigrams. Some previously rarely seen motifs were resurrected and left a far-reaching influence on later generations, including the *Chi* (a legendary dragon), flying dragons, tiger cubs, words of blessing above flower patterns, carp diving, fish and algae, railings, trees and rocks, Liu Hai and the Three Legged Toad (a Taoist legend) and dragonflies (Figs. 10.38 and 10.39).

Realistic-style flowers were usually depicted as having a similar shape to melon seeds, with small leaves and thick veins. Some veins were depicted as thick parallel lines. Leaves of the peony, Chinese herbaceous peony and chrysanthemum usually had the appearance of duck webbing with zigzagging edges. Curling leaves of twining lotus were long, resembling a roll of ribbons. Petals of peony formed tight arc-shaped lines with lines inside the petals, similar to the way Chinese herbaceous peony and lotus were depicted. This was also true of the Longqing and Wanli periods. The umbrella-shaped lucid ganoderma was painted with grids, a form which persisted into the Wanli period. When painting babies, the back of the head was large, with three tufts of hair on the head. They were often painted in dark robes. Twigs of twin chrysanthemum, peony and lotus flowers on one stalk started to come into vogue

Fig. 10.38 Blue and white jar with human figure patterns, produced in the Jiajing period of the Ming Dynasty, height: 40.3 cm, in the Capital Museum

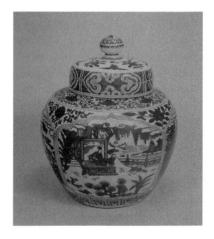

Fig. 10.39 Blue and white bowl with fish and algae pattern, produced in the Jiajing period of the Ming Dynasty, diameter: 15 cm, in the Capital Museum

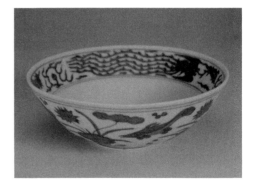

in this period. The lines were usually rigid, but some were quite fluid and vibrant. Generally, lines were thin and stiff, but a few also exhibited clear layers and bright colors.

The Jiajing period boasted more varieties of blue and white porcelain than the Chenghua, Hongzhi or Zhengde periods. Some varieties from the Yongle and Xuande periods had disappeared, such as octagonal candlesticks, barrel-shaped ware, flasks and moon flasks. But traditional daily wares like bowls, plates, goblets, *yuhuchunping*, ewers and plum vases were produced by almost every generation, although they did adopt some small changes over time. In addition, double-gourd vases (Fig. 10.40), *fangsheng* (a square-shaped measuring vessel), square-shaped boxes with lids, square-shaped gourd bottles, bowls with bun-shaped centers, goblet bowls, reverse bell-shaped bowls, tripod furnaces with straight, erect lugs, *yu*-shaped jars (a broad-mouthed receptacle for holding liquids), drum-shaped stools, and *chujizun* and *jue* ware in the bronzeware style were very popular in the Jiajing period. What is more, typical official ware featured fine, thin clay and smooth, shining glaze. In this period, Jingdezhen produced for the court and the domestic market, but also supplied foreign exporters, especially for the European market, which had actually been initiated in the Zhengde period. From 1510 to 1600, Portuguese merchants took control of ports in Goa, Hormuz, Malacca and Macao, and dominated the Chinese porcelain trade to the Middle East and Europe. Portuguese merchants dealt with a wide variety of commodities, including fabrics from India, spices from Indonesia, porcelain from China, as well as silver and bronzeware from Japan. Initially, Portuguese merchants ordered porcelain with western patterns from China. Illustrated in Fig. 10.41 is a plate custom-made for Portuguese merchants. Potters of Jingdezhen painted peony and "IHS" mixed with scenery patterns. "IHS" is the initials of the name of Jesus in Greek and short for "Iesus Hominum Salvator" (Jesus, Savior of Human Beings) in Latin. This monogram was a hit in the fifteenth century. The Society of Jesus, which was founded in 1534, used "IHS" as its logo.[45] In Fig. 10.42, the blue and white ewer was among the first batch of Chinese armorial porcelain. It has the typical features of ewers exported to the Middle East in the sixteenth century. Despite the orders of the Jiajing administration prohibiting foreign trade between 1522 and 1557, smuggling failed to cease in the 1540s. The silver sections of the ewer were added in Turkey, probably in an attempt to mend some broken parts. Thus, in general, we can see that blue and white porcelain developed by leaps and bounds in the Jiajing period thanks to a wide market.[46]

In the Jiajing period, apart from blue and white porcelain, polychrome porcelain also enjoyed a modicum of development. In the early Ming Dynasty, probably because of the government bans, private kilns almost solely produced blue and white porcelain, and rarely made faience. Faience was produced from the Zhengde period, and by the Jiajing period it was being produced on a large scale and had achieved

[45] Lv Zhangshen (ed.), *The Beauty of Porcelain* (one of a series of books for promoting international exchange by the National Museum of China), Zhonghua Book Company, 2012, pp. 58, 65.

[46] Lv Zhangshen (ed.), *The Beauty of Porcelain* (one of a series of books for promoting international exchange by the National Museum of China), Zhonghua Book Company, 2012, p. 69.

Fig. 10.40 A double-gourd blue and white vase with *Fu* (Blessings) and *Shou* (Longevity) markings, produced in the Jiajing period of the Ming Dynasty, height: 33 cm, in the Capital Museum

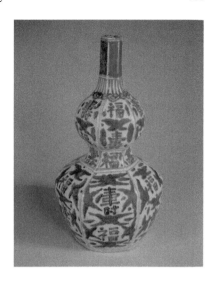

Fig. 10.41 Jingdezhen blue and white plate with "IHS" inscription, produced in the Jiajing period of the Ming Dynasty, in the British Museum

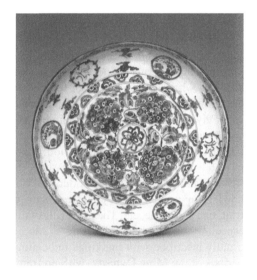

remarkable progress. Vol. 5 of *Jingdezhen Taolu* records that the "Cuigong kiln" produced products in imitation of the Xuande and Chenghua periods, and that its products ranked "No. 1 among private kilns." From extant articles from that time, we can see that polychrome porcelain produced by private kilns at the time was similar in style to that of blue and white *wucai* porcelain produced by official kilns of the same period. Mainly using red and green, its major varieties included plates, bowls, vases and jars. It used motifs like flowers, grass, fish and algae, human figures, landscapes, high pavilions and buildings, as well as scenes from drama and novels. In painting motifs, one method was to draw red or green outlines first, and then fill in

Fig. 10.42 Jingdezhen blue
and white armorial ewer with
a Portuguese shield-shaped
coat of arms, produced in the
Jiajing period of the Ming
Dynasty, silver parts added
in around the nineteenth
century in Turkey, in the
Victoria and Albert Museum

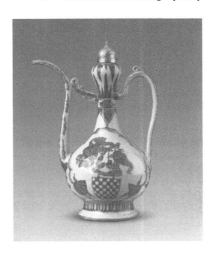

the color with a different green or red. Another measure was to paint the background in red and draw the major motifs in green or vice versa. Sometimes, red and green were used together to compose a picture.

Apart from red and green porcelain, blue and white *wucai* porcelain also emerged. This variety combined the production techniques of underglazed blue and white porcelain and overglazed polychrome technology (Fig. 10.43). It was very similar to blue and white *doucai* ware, but the difference was that blue and white comprised the main part of *doucai* while in blue and white *wucai* porcelain, blue and white was only part of the picture. Despite this, compared to ordinary *wucai*, blue and white *wucai* featured brighter and heavier blue and the whole picture looked more beautiful. It was in the Wanli period that blue and white *wucai* porcelain was the most advanced. But its style took shape in the late Jiajing period. Most blue and white *wucai* porcelain were products of official kilns, including plates (Fig. 10.44), bowls, pen washers, pots, jars, *fangsheng*, decorated with flying phoenixes, flowers, fruit, fish and algae, etc. The pots with swimming fish in a lotus pond with algae were especially vivid. Many such articles can be found at home and abroad. They were usually inscribed with markings indicating they were made in the Jiajing or Wanli periods of the Ming Dynasty, with no frame around the markings (Fig. 10.45).

In this period, Jingdezhen also introduced a new variety called *jincai* (gold color), an all gilt decoration painted on glaze, which was very popular in Japan. In Japan, *jincai* was known as "*kinrande*" (gold brocade).[47] Used as a luxurious ware by rich families, it was made by adding gold to red and green colored ware. Not much *jincai* porcelain has been found in China or Europe, but a considerable amount is housed in Japan. In the past, people used to believe that this was because *jincai* was custom-made by Japanese. But what is strange is that the author recently discovered two pieces of porcelain of the same variety in the Chinese collections in the Topkapi Sarayi Museum in Istanbul, Turkey (Figs. 10.46 and 10.47). They shared the same

[47] Fujioka Ryōichi, *On Porcelain: Red Porcelain of the Ming Dynasty*, Heibonsha, 1979, p. 103.

Fig. 10.43 Blue and white *wucai* lidded jar with fish and algae pattern, produced in the Jiajing period of the Ming Dynasty, height: 48 cm, in Musée Guimet

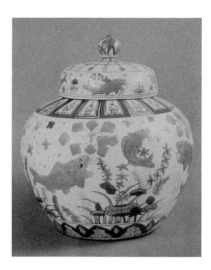

Fig. 10.44 *Wucai* plate with dragon pattern, produced in the Jiajing period of the Ming Dynasty, diameter: 20.5 cm, in the Idemitsu Museum of Arts

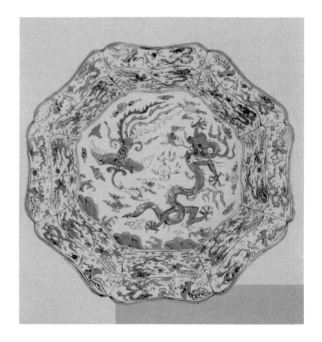

style as the "*kinrande*" exported to Japan. The *liuli* glazed water jet with engraved dragon in Fig. 10.47 is a traditional product of Turkey made in the late sixteenth century. This shows the possibility that *jincai* originated in the Islamic world and later gained favor with the Japanese. (Of course, there is a chance that *jincai* ware was not produced by Jingdezhen because in the late Ming Dynasty, kilns in and around Zhangzhou also produced red and green ware and *jincai* was closer to its

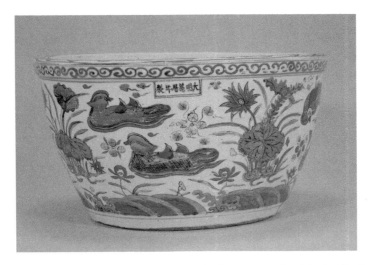

Fig. 10.45 Blue and white *wucai* vat with water animal pattern, produced in the Wanli period of the Ming Dynasty, diameter: 58.5 cm, in the Victoria and Albert Museum

style.) There was a wide range of varieties of *jincai*, but not many had inscriptions of the years of production, and those that did have such markings were all from the Jiajing period. So, generally we believe that *jincai* ware was specific to the Jiajing period (Figs. 10.48 and 10.49).

In ceramic history, the use of gold is found in color pottery from the Sui and Tang dynasties. The famous gold-decorated bowls produced by the Ding kilns in the Song Dynasty applied gold-painted flowers, plants, or birds in white, black or purple ware

Fig. 10.46 Gilt color-painted water jet with peacock and peony patterns, produced in the Ming Dynasty, in the Topkapi Sarayi Museum in Istanbul, Turkey

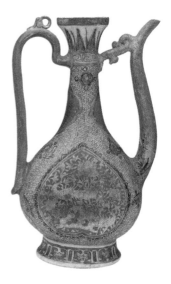

Fig. 10.47 *Liuli* glazed water jet with engraved dragon, produced in the Ming Dynasty, silver parts added in the seventeenth century by the Ottomans, in the Topkapi Sarayi Museum in Istanbul, Turkey

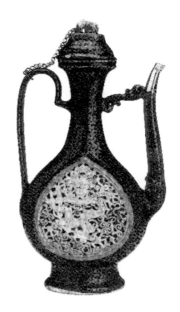

Fig. 10.48 *Wucai* gilt ewer decorated with engraved crane, produced in the Jiajing period of the Ming Dynasty, height: 28.9 cm, in the Gotoh Museum, Japan

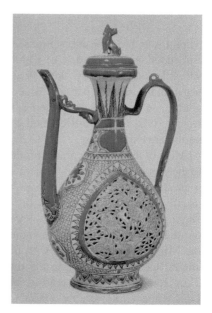

which were regarded as superior products at the time. Besides, tea bowls in the Jian style were usually inscribed with "*shoushanfuhai*" (Longevity like the mountains and a sea of blessings), or poems written in gold. Some blue glazed wine cups with gold decorations were unearthed from Baoding, Hebei Province. According to *Essential Criteria of Antiquities*, "The Yuan Dynasty tended to produce articles with small feet,

Fig. 10.49 *Wucai* gilt
large-belly bottle decorated
with flowers, produced in the
Jiajing period of the Ming
Dynasty, height: 29.2 cm, in
the Nezu Museum, Japan

paintings and '*Shufu*' inscriptions inside" and "There was also some dark blue ware
embedded with gold, most of which were wine bottles or cups, which looked most
adorable." Additionally, there is also a record that "embedding gold in porcelain
began in the Xuande period." Blue and white polychrome porcelain embedded with
gold made in the Yongle period in the early Ming Dynasty can also be seen today.
Despite this, few gold-decorated Jingdezhen products produced before the Jiajing
period are extant today.

Most of the gold-decorated products produced in the Jiajing period bore no marks
of the year of production, which means that all of these were products of private kilns,
as products of official kilns always had year markings. Those without year markings
usually had other inscriptions like "*changmingfugui*" (Longevity and Wealth) or
"*fuguijiaqi*" (Wealth and Fine Ware). There was a small number of privately made
products with year markings, indicating they were made in the Jiajing period of
the Ming Dynasty, painted with blue pigment inside a double circle. This was a
similar means of indicating the time of production to that used by official kilns.
Thus, some of the Jiajing gold-decorated porcelain might have been made by private
kilns while some were by official kilns and the rest were products produced under
the "*Guandaminshao*" system. At this time, gold-decorated products were mainly
exported to Japan as commodities rather than offerings to the government. And
additionally, the official kilns basically only produced in response to the "ministerial
quota."

10.4.4.2 The Longqing and Wanli Periods

Before 1607, the 35th year of Wanli, the official kiln production was substantial. After that, it began to decline. Both blue and white porcelain and polychrome porcelain achieved much progress in the Wanli period, especially blue and white *wucai* ware. After the mid-Wanli period, the craftsmen system collapsed and production at the Imperial Vessels Factory shrank. At the same time, the standards of "imperial quota" porcelain rose. Thus, in order to meet the higher demand, the private kilns highly stressed quality and made much progress in their production techniques.

At this time, Jingdezhen was not only home to many artisans engaged in the handicraft industry, but also many trading houses and shops selling the products of these artisans. According to the *Great Gazetteer of Jiangxi Province*, "Though a small place, Jingdezhen was dominated by the ceramics industry, and merchants, freighters, purchasers coming from afar, all gathered there." Porcelain made by private kilns was sold to porcelain houses or shops, from whence it made its way to the nation as a whole via individual merchants.

As the *Great Gazetteer of Jiangxi Province* records, "From the north and south, east and west, wherever merchants set foot, there was always transactions of Jingdezhen porcelain and merchants would make profits."

Foreign trade in the Ming Dynasty can be categorized into two sections, and each was guided by quite different policies. In the early Ming Dynasty, the tribute trade predominated, and trade by individuals with foreigners was strictly prohibited. Nevertheless, smuggling was becoming increasingly difficult to contain, especially as the Portuguese used Shuangyu Island in Zhejiang Province and the Port of Yuegang in Zhangzhou, Fujian Province as hubs to work together with Chinese merchants on underground dealings. Many Japanese were also involved, making the regions the clandestine international trading centers of East and West Asia.

In 1567, the first year of Longqing, the maritime policy that had lasted for 200 years was abolished. With the opening of the Port of Yuegang in Zhangzhou, Chinese merchants were allowed to sail abroad. In this legal trading environment, trade was boosted. Therefore, despite the political turmoil, social instability, and the dramatically declining production of the official kilns, the private kilns, as producers of porcelain commodities, were scarcely affected. Instead, without competition from the official kilns, the private kilns were free to develop. In the Longqing period, blue and white porcelain and *wucai* porcelain saw further advance in their production techniques. In this period, premium cobalt blue materials from Zhejiang and second-class materials from Luling, Yongfeng and Yushan were used on blue and white porcelain and *wucai* ware, so their colors varied. Some were bright with a purple tinge, some were dark and gray, and a few were elegant and clear. No less beautiful than that produced by the official kilns, some blue and white porcelain produced by private kilns featured thin clay, neat design, bluish, smooth and rich glaze, with simple decorations like mountains, rocks, flowers, twigs, birds, rabbits, the moon, pines, bamboo, plum blossom, bees and deer and *panchi* (a kind of dragon with horns). Their inscriptions were cursive and intense. Like blue and white porcelain, *wucai* ware of this period was also outstanding. The colors used on *wucai* ware were

extremely pure and bright (different from the Jiajing period when the red on *wucai* was quite light), forming a sharp contrast. Coupled with blue and white colors, *wucai* ware appeared colorful and vigorous. Apart from blue and white porcelain and *wucai* ware, other varieties in this period included red and green ware, *doucai* ware (mostly imitating the Chenghua period), red glazed blue and white porcelain, and yellow glazed porcelain.

From the mid-Wanli period, China's porcelain trade with Southeast Asia and the Western world entered a new era. Millions of pieces of Chinese porcelain flowed all over the world on Portuguese and Dutch merchant ships. At the time, the European upper class embraced Chinese porcelain collecting as a fashion, which greatly boosted the porcelain exports from Jingdezhen. After 1602, Dutch Merchants started to introduce popular vessel designs and decorations from Europe to China so that Jingdezhen could produce daily ware suited to the habits and tastes of Europeans. Thus, at this time, apart from traditional flowers, birds, animals and human figures, clan emblems, foreign languages, compasses, sacred books, water spray pictures and Western landscapes were also added as decorations. On the edges of ware, twigs, flowers and fruit were added. Popular varieties at this time were kundikā jars, plates with flower edges, bowls and engraved ware. This kind of porcelain was usually called Kraak porcelain by Europeans. Due to the heavy demand at home and abroad, the Wanli period produced more varieties than ever. Almost all types of daily and decorative ware can be found in this period, including various frequently-seen boxes, stationery (mountain-shaped pen holders, ink slabs, paperweights, seal boxes, pen holders and pen tubes), and blue and white and *wucai* boxes with folded rims and bases. New varieties included wall vases, *tongping* (elephant-leg vases), *zanpan* (a large plate composed of several smaller plates), cricket containers, chess jars, various large plates, tableware and salt saucers, etc. Illustrated in Fig. 10.50 is a bowl custom-made for a Portuguese customer. On its wall there are four blue arms, each with a monster with two human heads and five animal heads. On the two sides of the emblems, there are two ribbons with the Latin inscription "Septenti nihil novum" (Don't tell anecdotes to the wise) while the remaining decorations are all traditional Chinese. Figure 10.51 is a vase with decorations similar to that of the 8-Reales silver coins of Spain. These coins are one of the earliest currencies in the world and the US dollars are based on them. On the other side of the vase is the image of a literatus painted in bright blue, with an attendant serving at his side. This is a typical article combining traditional Chinese elements with a European style.[48]

The development of blue and white porcelain produced by official kilns can be divided into two parts in the Wanli period. First, on inheriting the traditions from the Jiajing period, the official kilns adopted Mohammedan blue from the Western Regions and decorations from the Jiajing period. As their reign names were rarely inscribed on products, it is very difficult to distinguish products from the Jiajing and Wanli periods. In 1596, the 24th year of Wanli, the Mohammedan blue was almost exhausted, so blue pigments from Zhejiang Province gradually came into use. The

[48] Lv Zhangshen (ed.), *The Beauty of Porcelain* (one of a series of books for promoting international exchange by the National Museum of China), Zhonghua Book Company, 2012, pp. 72–75.

Fig. 10.50 Jingdezhen Kraak bowl with blue coat of arms and inscriptions, produced in the Wanli period of the Ming Dynasty, in the British Museum

Fig. 10.51 Jingdezhen vase with blue coin decorations and Chinese scenery pattern, produced in the Wanli period of the Ming Dynasty, in the British Museum

domestically produced pigments from Zhejiang were no match for the quality of the imported product. But thanks to improved techniques, the blue tones were quite light, clear and bright. As for private kilns, they were only able to acquire the lesser quality pigments for use, so initially, their products had the same appearance as those produced in the Jiajing and Longqing periods. Later, the color appeared gray blue and then dark and rather blotchy. By the late Wanli period and up to the Tianqi period, the color was even lighter, and the human figures painted on bowls and plates were quite small.

Traditional motifs like dragons, phoenixes, twining lotus and children at play still dominated decorations on the blue and white porcelain from official kilns. Other decorations which had been popular in the Jiajing period as well as Sanskrit decorations were also widely used. In contrast to the official kilns, the private kilns used some unique motifs like children playing with flowers, lions walking past flowers, brocade patterns, paneled decorations, lucid ganoderma in the shape of *ruyi*-head

clouds with several bamboo leaves on top or on the two sides, lions playing with balls and long ribbons, simple, loose twigs of flowers with long, curling leaves, some resembling spirals or a spring. Flowers and birds were frequently used, with the movement of the birds exaggerated and nimble: some flew among bamboo or forests and some stood on or leapt from mountains, rocks, flowers or grass. Insects and animals were often painted in this period, like horses, wasps and macaques, and placed at the center of plates, indicating good will. Round dragons were also popular with their scales simplified to look like saw teeth. Elks from the Heavenly Palace, indicating "handsome salary" were used at the center of porcelain articles. This was inaugurated in the Wanli period and its effect lasted well into the early Kangxi period. Other unique motifs used at this time on the bottom center of pieces also included folding fans and twigs of Sophora japonica.

Known as "Kosometsuke" in Japan and Kraak ware in Europe, blue and white plates with paneled decorations and fritted rims were produced as exports to Europe in the Wanli period. This kind of plate featured a thin body, smooth glaze and divided foliated radial panels on the side walls, decorated with flowers, duckweed and auspicious Buddhist symbols. The bottom was decorated with motifs like magpies, mountains and rocks, bamboo, flowers and grass, and clouds. All the decorations appeared vivid and fine, creating a unique and exotic flavor. As Fujioka Ryōichi states in his book, "'Kosometsuke' ware was produced around the Wanli time and was mainly exported by the East India Company to Europe and Southeast Asia. In the Edo period, it was also sold on the Japanese market in large quantities. Before long, Japan started to copy its style and began its own exports." (Fig. 10.52). Some exported products were decorated with Latin inscriptions. Some exotic blue and white porcelain, like deep bowls with fritted rims, big plates with folded rims and kundikā were also major export varieties. They utilized techniques like paneled decorations and engraving and appeared very exotic.

Prior to the Wanli period, *wucai* ware was a traditional variety which had been popular since Jiajing times. Not much innovation was made in the genre until the Wanli period when blue and white *wucai* production techniques reached their peak. Highly prized, *wucai* ware at this time was reputed and loved both at home and

Fig. 10.52 Blue and white plates with paneled decorations and fritted rims, produced in the Jiajing period, height: 5.6 cm, diameter: 17.8 cm, in the Palace Museum

abroad. It thus also attained a high economic value. Previously, *wucai* ware had been exported in large quantities and so it was long known to the world. Major varieties of *wucai* ware included plates, bowls, pen washers, vases, *zun*, loop-handled teapots, square *ding*, lidded boxes, pen tubes, ship-shaped pen holders (Fig. 10.53) and seal boxes. Most of the exports were produced by official kilns, so the major motifs utilized on them were dragons, phoenixes, flowers and grass, as well as children at play, the Eight Immortals and dozens of deer. Different from the simple style of the Chenghua period, blue and white Wanli *wucai* ware featured complicated decorations. In using colors, it favored red, light green, dark green, yellow, brown, purple, and blue with a special highlight on red, so as to create a rich and bright image (Fig. 10.54).

Fig. 10.53 Blue and white *wucai* ship-shaped pen holder with dragons, produced in the Wanli period of the Ming Dynasty, 10.5 × 29.7 cm, in the Capital Museum

Fig. 10.54 *Wucai* pen holder with dragon and phoenix patterns, produced in the Wanli period of the Ming Dynasty, height: 8.9 cm, length: 29.9 cm, in the Shanghai Museum

Underglazed red porcelain was rarely seen in the official kilns during the Wanli period. Even if there were a few bright red wares, they were not numerous. In private kilns, there was also a very small amount of underglazed blue and red porcelain, with bright blue and iron red colors. While few in number, underglazed red porcelain was indeed produced in the Wanli period. Thus it seems that some claims that underglazed red porcelain failed to be passed down is not strictly true.

Apart from the above-mentioned varieties, there were also *jincai*, blue and white purple porcelain, blue and white red porcelain, blue and white green porcelain, blue on red porcelain, white on blue porcelain, white on blue glaze porcelain, white on brown glaze porcelain, red on white glaze porcelain, yellow glazed *wucai* ware, yellow glazed purple ware, yellow glazed green ware, green glazed yellow ware (Fig. 10.55), green glazed purple ware, blue glazed ware, *Ge*-style porcelain (crackled glaze porcelain), *yingqing* porcelain, *dongqing* glazed porcelain and aubergine glazed porcelain, etc.

Apart from all these varieties, the Wanli period also tended to produce products with styles from former generations. Among articles passed down through history, most blue and white porcelain and *doucai* ware made in imitation of the Hongwu, Yongle, Xuande and Chenghua periods was actually produced in the Wanli period. Why the Wanli period modeled previous eras, the litterateur and historian from the Ming Dynasty, Wang Shizhen argues: "People used to favor paintings of the Song Dynasty. But in the last three decades, Yuan paintings started to become a hit. With such paintings, the value of porcelain rose ten-fold. Official kilns used to favor the Ge and Ru kiln style, but in the recent 15 years or so, the Xuande and even the Yongle and Chenghua styles have been popular, with their prices increasing ten-fold." Wang Shizhen was born in 1526, the fifth year of Jiajing, and died in 1590, the 18th year of

Fig. 10.55 Green lidded jar with yellow dragons, produced in the Wanli period, height: 18.5 cm, in the Palace Museum

Wanli. From his record, we can see that in the late Jiajing and early Wanli periods, the styles of official products of the Xuande, Yongle and Chenghua periods were popular. In order to make huge profits, some copied these styles.

10.4.4.3 Products of Private Kilns in the Tianqi and Chongzhen Periods

The Tianqi (1621–1627) and Chongzhen (1628–1644) periods were a troubled time for the Ming Dynasty. With rising peasant revolts, the Ming Dynasty, which had ruled China for over two and a half centuries, eventually embarked on the road to its own demise.

Under the reign of Emperor Wanli, the Imperial Vessels Factory was given huge orders, sometimes unprecedentedly large. But the products the center was required to produce were basically of no practical use, such as chessboards, screens, pen tubes, decorative ware and even vats exceeding one meter. As the center regularly made large products in the hundreds of thousands, it needed huge supplies of raw materials. So, the pits on Macang Mountain were dug deeper and deeper and gradually they were all depleted. Workers digging the pits were forced to work very hard while the managers of the Imperial Vessels Factory did their best to underpay them and profit themselves. Suffering from hard work and injustice, the workers rose up in resistance time after time, which forced Emperor Wanli to issue an order in his later years that all porcelain production activities should cease and the relevant officials removed from Jingdezhen. The clouds over Jingdezhen immediately vanished. The unrealistic orders that drove Jingdezhen to distraction suddenly disappeared and no tasks remained for the Imperial Vessels Factory to complete. While some scholars hold that the operations of the official kilns did not stop entirely, it is a fact that the official products from the Tianqi and Chongzhen periods were few. Thus, private kilns dominated porcelain production in Jingdezhen at this time (Figs. 10.56 and 10.57).

In the mid-Wanli period, a certain amount of production of the Imperial Vessels Factory was transferred to private kilns. And did the decline of the official kilns affect the private kilns? This was not a concern, because at the time, Jingdezhen was already a world-famous porcelain producer and it had a good market. As a matter of fact, the demands on it were more than it could supply. For the foreign markets alone, it is recorded that, in the late Ming Dynasty, following the Portuguese and Spanish merchants, Dutch colonists engaged in trading Chinese porcelain. They purchased porcelain from China's coastal regions and used Batavia (now Jakarta) in Indonesia as a transfer station, or shipped Chinese porcelain direct to Batavia, and then transported their products to Southeast Asia, West Asia, and the Netherlands through the East India Company in large quantities. According to conservative estimates, from 1602 to 1644, the Dutch East India Company (VOC) shipped over 4.2 million pieces of Ming porcelain to the Indonesian islands. In 1636 alone, around 380,000 pieces of porcelain travelled to such Indonesian islands as Banten, Bali, Ambon, Palembang, the west coast of Sumatra, Achin and Borneo. The Dutch East India Company also customized products based on specific demands of the Southeast Asian nations. In

Fig. 10.56 Blue and white
pen holder with human figure
patterns, produced in the
Chongzhen period, height:
21.5 cm, diameter: 20.3 cm,
in a private collection

Fig. 10.57 Plate with deer
pattern, produced in the
Tianqi period, in a private
collection

1635, a director in Taiwan reported to head office in the Netherlands on orders of
Chinese porcelain, saying that he had ordered large plates and bowls, vessels for cold
drinks, large jars and cups, salt boxes, small cups, mustard pots, shallow plates with
wide edges and basins with water bottles. The samples were captioned in Chinese
characters.[49]

Chinese merchants were also involved in competition with each other. According
to a Dutch account, after Dutch colonists invaded Java, the fleets of the Dutch East
India Company often encountered Chinese commercial ships in the coastal areas
of Java, loaded with beautiful porcelain and silk. In 1625, a Chinese fleet sailed to
Batavia to trade goods. This was not the only fleet destined for Southeast Asia. The
Dutch also noticed that in 1626, among ships which embarked from Fujian, four

[49] Ye Wencheng, *Collection of Research Papers on Historical Chinese Export Ceramics*, The
Forbidden City Publishing House, 1988, p. 69.

arrived in Batavia, four in Cambodia, four in Vietnam, three in Siam (now Thailand), one in Pattani, and over 100 relatively small ships in the relatively close city of Manila. Loaded on the ships was the most expensive and most popular product, Chinese porcelain.[50] All these records were made during the Wanli to Chongzhen periods. It shows that exports at this time were basically all produced by private kilns and found their way abroad through private channels. And apart from a small number, most of the exports were produced in Jingdezhen.

Apart from the Dutch East India Company and individual Chinese merchants, Japanese businessmen also traveled to Jingdezhen and bought porcelain. The domestic demand was also huge, especially in regions around Jiangxi Province like Suzhou, Nanjing and Hangzhou. Rich people and merchants from these cities bought Jingdezhen porcelain in huge quantities, which drove hundreds of private kilns in Jingdezhen to operate without stop. While produced in large quantities, these products were mostly daily use articles and, as commodities, they lacked due care and attention. Worn over time, they often ended up broken or discarded.

Meanwhile, some exports were custom-made for foreign customers. Frequently seen abroad, these items were rarely found at home. In a report from Han Petetz Cohen to his employer, the Dutch East India Company, on Oct 10, 1616, the 44th year of Wanli, he wrote: "I hereby report to you that these porcelain products were made in a distant hinterland city in China. We customized the whole sets of products and prepaid the fees. Because these products are not used in China, they are earmarked for export. So, no matter whether we suffer a loss or make a profit, they must all be sold abroad."[51] Illustrated in Fig. 10.58 is a blue and white vase with the Garden of Gethsemane. Scenes of Jesus' suffering and resurrection are pictured on the four sides. This vase was designed on the European glass and pottery bottles of the time. Figure 10.59 is a blue and white jar with six circled panels around the body. Two of the panels have "IHS" inscriptions beneath a cross, above which are three arrows signifying the trinity of Father, Son, and Holy Ghost, with light and angels surrounding. The remaining four panels are inscribed with "S" and "P" respectively, circled by neat frames. "S" and "P" represent the Jesuit College of St. Paul's Cathedral. Built between 1594 and 1602, the Cathedral was the largest in Asia. It also functioned as a college. Now only the facade is conserved.[52] The decidedly un-Chinese patterns on the jar appear like the patterns on embroidered fabrics of Europe in the early seventeenth century. These are typical Western religious motifs. Even if these products remained in China, nobody would understand the patterns, let alone use them. That is why many quality products made by private kilns were not seen on the Chinese market.

Ceramic production in Jingdezhen had two outstanding features at this time. The first was that the official kilns had all basically stopped production and were replaced by private kilns. This signified a prosperous and booming growth period for the

[50] Zhu Jieqin, *Collected Papers on the History of Relations between China and the Outside World*, Henan People's Publishing House, 1984, p. 211.

[51] Chinese Ceramic Society (ed.), *History of Chinese Ceramics*, Cultural Relics Press, 1982, p. 410.

[52] Lv Zhangshen (ed.), *The Beauty of Porcelain* (one of a series of books for promoting international exchange by the National Museum of China), Zhonghua Book Company, 2012, pp. 80–81, 76–77.

Fig. 10.58 Jingdezhen blue
and white square vase with
Jesus' crucifixion and
resurrection, produced in the
Tianqi to Chongzhen
periods, in the British
Museum

Fig. 10.59 Jingdezhen blue
and white jar with "IHS"
inscriptions, produced in the
Tianqi to Chongzhen
periods, in the British
Museum

private kilns. Without the restraints and control of the official kilns, private kilns
could produce according to market demand. The other feature was that before the
Wanli period, raw materials were controlled by the official kilns. Thus, premium clay
from Macang Mountain was all specified for official or imperial use and private kilns
were prohibited from accessing it, let alone using it. In the late Wanli period, after
Macang Mountain had been depleted, Jingdezhen potters found quality kaolin on
Kaolin Mountain. In the *Gazetteer of Fuliang County, On Ceramics*, it is recorded
that in 1604, the 32nd year of Wanli, some officials proposed specifying kaolin for

official use, but this met with opposition. So, the Ming court lifted the order, not out of mercy, but pressured by the critical social turmoil in cities like Wuchang. At the time, the Ming Dynasty was already on the verge of collapse.

In order to break free from the shackles of the official kilns, and boosted by the unprecedented supply of quality kaolin and the lifting of the maritime ban, adventurous and visionary private kilns in the Longqing period opened the broad foreign market to Jingdezhen porcelain, thus allowing private kilns to enter an age of expansion.

Catering to different demands, potters made products with different features, varieties and styles. For example, in Japan, people in the region dominated by Furuta Oribe, a daimyō and celebrated master of the Japanese tea ceremony, liked using ware in a rough and casual style in tea ceremonies, so Jingdezhen potters made a special batch of blue and white porcelain painted in freehand brushwork, looking abstract, robust and bold, called Kosometsuke in Japan, and "private blue and white porcelain" in modern China. It resembled the red and blue porcelain made in the Tianqi period. In addition, in order to cater to the tastes of rational and scientific-minded Europeans, potters made a new kind of blue and white porcelain decorated with geometric patterns and painted in realistic brushwork. This variety was known as "Kosometsuke" in Japan and "Kraak" ware in Europe. Its decorative patterns were neatly arranged and its central motifs were usually luxurious vessels and other still objects, a style favored by Europeans. Famous still life paintings from Northern Europe were often featured on porcelain (Fig. 10.60). More complicated and neater than "Kosometsuke," "Shonzui" porcelain was tailor-made for tea ceremony lovers of the Kobori Enshū school (Fig. 10.61). Noting these varieties made for different target consumers, we can see that the private kiln potters were highly resourceful, adaptable and creative. This period marked a very prosperous and successful era in the ceramic history of Jingdezhen. But such prosperity and success was created by private kilns, not the official kilns, so few records have been left over the centuries. Also, since most of the products made during this time were for daily use, lacking due care and maintenance, very few have been passed down to the present. Most products were also custom-made for foreign consumers, so today, few are to be found at home in China. Thus, due to various factors, many varieties produced at this time cannot be seen in China today, not even in museums. But in neighboring Japan, these products travelled the oceans, so they were highly valued, and thus were well preserved. In fact, the Jingdezhen private kilns of the late Ming Dynasty are always a popular and eye-catching subject in Japanese academia. Many Japanese scholars have studied this issue and published books or papers, including *Kosometsuke and Shonzui (Chinese Blue-and-White Tea Ceramics)* and *Gosu Polychrome and Nanjing Polychrome* written by Saito Kikutarô, "Jingdezhen in the Late Ming Dynasty" by Sato Masahiko and *Ming Red Ware Designs* by Fujioka Ryōichi. But in China, this history has yet to be fully explored. As Mr. Feng Xianming states, "In the late Ming Dynasty, Chinese porcelain was sold to Europe and America. Mexico even discovered shards of Ming *wucai* ware produced by Jingdezhen at a railway construction site. Our predecessors have done a lot of hard work on studies of the official kilns in the Ming Dynasty. While there is still doubt about the specific time

Fig. 10.60 Blue and white
plate with flowers and birds,
produced in the Wanli
period, diameter: 20 cm, foot
diameter: 11.5 cm, height:
4 cm, in the collection of a
Western antiques dealer

Fig. 10.61 Blue and white
tea bowl (Shonzui),
produced in the Chongzhen
period of the Ming Dynasty,
custom-made for tea masters
of the Kobori Enshū school

of the establishment of the Imperial Vessels Factory, as well as production in the Zhengtong, Jingtai and Tianshun periods and many other issues, the discovery of the ruins of the Imperial Vessels Factory provides us with important information for further study. As for the private kilns, there are scarcely any systematic studies, especially on export porcelain in the Ming Dynasty."[53]

While scant information or real objects have survived locally regarding the private kilns in the Tianqi and Chongzhen periods, Japan has many studies and real objects from this time, especially exported ones. We will thus have to use Japanese studies and research findings as a reference in discussing private kilns of this period. In the seventeenth century, Chinese blue and white porcelain exported to Japan was known

[53] Feng Xianming (ed.), *Chinese Ceramics*, Shanghai Chinese Classics Publishing House, 1993, p. 468.

as Kosometsuke (old blue-and-white). *Ko* refers to the late Ming Dynasty (or the early Edo period in Japan) and *sometsuke* refers to blue and white porcelain.

Blue and white porcelain produced at this time included plates, small wine cups, vases, bottles, and bowls. They were all ordinary articles of daily use which could be made and painted easily and rapidly. Their main motifs were mountains and water, flowers and birds, and human figures, usually taken from the paintings of Dong Qichang, a Chinese painter and art theorist of the late period of the Ming Dynasty, and from the imagination of painters. The paintings were therefore quite free and bold, forming a unique style.

For painting motifs, painters relied on original paintings, but were not bound by these. They usually used original layout structures and artistic conceptions while adding their own creativity and innovation. Considering the workloads they were required to complete every day, painters had to be as quick and concise as possible, which made the unique free, casual and simple style possible. Porcelain with such decoration was popularly employed in tea ceremonies in the territory of Furuta Oribe.

When the glaze wore off the rims or edges of the foot, marks like those of insects were revealed and referred to simply as "insect marks" by Japanese academia.[54] They believed that the marks were caused by a decline in the quality of the clay and glaze. If the clay was not fine enough, the clay shrinkage would be greater than that of the glaze, so the glaze would wear off. The author thinks that the causes are more than this. From the Wanli period, Jingdezhen started to utilize a new type of clay, kaolin. While this clay features excellent properties, it took some time for potters to know how to use it. Additionally, while the clay type was changed, the glaze remained unchanged. It also took some time to find out how a new variety of clay and the traditional glaze could be made to work well together. If we examine articles produced from the Wanli to the Chongzhen periods, we can see that almost all of these had "insect marks," both large and small. Apart from that which was exported to Japan, porcelain shipped to Europe can also be found to have such marks. In Fig. 10.62, we can see clearly a jar which has such insect marks on its rim and foot.

Under the leadership of Furuta Oribe, the Japanese tea ceremony flourished. Japanese people often built models in wood and took them to Jingdezhen to order the tea vessels they required. Thus, during the Tianqi and Chongzhen periods, a certain amount of blue and white porcelain was custom-made tea ware for Japanese customers, with clear Japanese designs and motifs.

Japanese tea ware featured a thick body, which differed from the other products Jingdezhen usually made.[55]

Red and green porcelain in the Tianqi period was also known as Tianqi red porcelain in Japan. Red and green porcelain can be dated back a long time. In the Song Dynasty, the Cizhou kilns had produced delicately painted red and green porcelain which influenced Jingdezhen in the following years. Combined with blue and white

[54] Gu Yanwu, *On the Benefits and Shortcomings of the Empire's Local Administration*, cited from the *Gazetteer of Chenghai County*.

[55] Sato Masahiko, *Ceramic History of China*, Heibonsha, 1978, p. 213.

Fig. 10.62 Jingdezhen blue
and white lidded jar with a
Persian figure, produced
during the Tianqi and
Chongzhen periods, in the
British Museum

porcelain by Jingdezhen potters, a new variety of red and green porcelain was introduced. But, before the Tianqi era, there were not many varieties of red and green porcelain. Even for the few varieties available, their paintings were quite rigid, due to the continuing restraint and restrictions of the official kilns. In the Wanli period especially, under the "*Guandaminshao*" system, potters from private kilns had to adhere to the imperial styles. From the reign of Emperor Tianqi, the private kilns were suddenly free, and their vigor and vitality were stimulated immediately. Private kilns not only produced for the imperial family, the privileged and the rich, but also for the common public and overseas markets. Heavy demand from these markets pushed artisans to create and innovate, thus creating the simple, elegant, natural, individualized and unconventional blue and white porcelain as well as red and green porcelain.

In the early Tianqi period, red and green colors were stippled on private blue and white porcelain, hence the name red and green porcelain. Free from the shackles of the official kilns, potters at this time were given full rein and initiated color paintings of red and green. This developed rapidly from red and green paintings to red, green and yellow paintings, fully demonstrating the unique beauty of the red and green colors. Learning from literati paintings of the day, but not blindly, porcelain painters created simple and cheerful paintings, quite different from those of the Jiajing and Wanli periods (Fig. 10.63). Articles from this time were usually inscribed with "*Tianqijiaqi*" (Fine Works of the Tianqi Period) on the bottom.[56]

Since red and green porcelain is painted red and green on glaze, this technique was often used to conceal flaws or marks like "insect marks" by painting a red sun, a tree, a house or a mountain. Sometimes, the method resulted in surprisingly attractive outcomes.

[56] Saito kikutarô, *The Great Ceramic Series, Gosu Polychrome, Nanjing Polychrome*, Heibonsha, 1976, p. 108.

Fig. 10.63 Deep red and green bowl, produced in the Tianqi period of the Ming Dynasty, custom-made for Japanese tea masters

Seemingly simple and plain, red and green porcelain in the Tianqi period also demonstrated the superb craftsmanship of potters. Some blue and white *doucai* ware was even more sophisticated than the *doucai* ware made by official kilns in the Chenghua period.

The Tianqi era produced both thick and thin blue and white porcelain in the private kilns. Most of the thick-clay products were exported to Japan while the thin-clay ones were sold at home or to other countries. As to red and green porcelain, most were made thick, shaping a unique style of its own. This also testifies to the fact that most red and green porcelain was earmarked for the Japanese tea masters. Today, Japan still has many such products, like the cross-shaped hand bowls custom-made for tea masters in the territory of Furuta Oribe, a treasure of red and green porcelain of the Tianqi era (Fig. 10.64).

Tea masters in Furuta Oribe's territory favored blue and white porcelain with freehand brushwork, as well as red and green porcelain. Illustrated in Fig. 10.65 is a representative of their custom-made Jingdezhen products. This bowl has a leafy peach tree with fruit, a peach-petal-shaped rim, and a series of pictures depicting a scholar and his attendant leaving home to take the imperial examination. A poem praying for success is also inscribed on the bowl. Another representative of Japanese

Fig. 10.64 Red and green cross-shaped hand bowl, produced in the Tianqi period of the Ming Dynasty, custom-made for Japanese tea masters in the territory of Furuta Oribe

Fig. 10.65 *Wucai* hand bowl with a peach tree (a piece of colored Shonzui), produced in the Chongzhen period

custom-made porcelain is a deep slanting bowl with thick body and "insect marks" on the rim, which also manifests a casual, even slovenly style.

Figure 10.66 depicts a shallow plate with lotus-petal-shaped rim, also a representative red and green ware of the Tianqi period. The algae is painted in blue while the background is stippled in black, red and green. At the center of the plate is a red fish. Illustrated in Fig. 10.67 is a tea bowl, casually painted red, green and yellow on the wall with swirling blue patterns in between. The thick and thin stripes and cold and warm colors are mixed, giving the object a simple and gracious appearance.

Japanese-style red and green porcelain was produced from 1621 to 1627, under the reign of Emperor Tianqi, while Japanese-style blue and white porcelain with freehand brushwork was produced until around 1635, the eighth year of Chongzhen.[57] While combined, they accounted for around one tenth or one twentieth of the total production of blue and white porcelain in the Tianqi period, not much has survived. Red and green porcelain featured a short-lived popularity and limited volume. Perhaps it was because it was too thick and clumsy or maybe because there was other quality *wucai* ware like colored Shonzui (blue and white *wucai* ware with Japanese characteristics) and Gosu polychrome (red and green wares produced in the coastal regions around Fujian). In general, red and green ware produced in the Tianqi period is rarely seen at home. All the articles mentioned above are housed in Japanese museums.

There was also some blue and white porcelain made specifically for the Western market. The rational and scientifically-minded Europeans could scarcely accept the simple, casual and free-style blue and white porcelain which had been custom-made for the Japanese market. So, Jingdezhen potters designed some very graphic and decorative blue and white porcelain for the European market, including bowls, pots, vases and plates. Plates formed the majority among these items. They were usually

[57] See Footnote 56.

Fig. 10.66 *Wucai* shallow plate with lotus-petal-shaped rim, produced in the Chongzhen period, custom-made for Japanese tea masters

Fig. 10.67 *Wucai* tea bowl with colored stripes, produced in the Tianqi period, custom-made for Japanese tea masters

separated into several geometric parts and decorated with flowers and fruit, etc. Between the large geometric segments were small ones, decorated with Buddhism's Eight Auspicious Symbols and keyūra patterns. These decorations looked like petals of flowers, so they were called Kosometsuke in Japan (Kraak in Europe)[58]. Major motifs painted at the centers of plates were still life paintings, or landscape paintings and bird-and-flower paintings in the Chinese style. Different from the casual and free style that Japanese favored, these products featured a fine quality, and thin and

[58] Sato Masahiko, *Ceramic History of China*, Heibonsha, 1978, p. 214.

meticulous clay. In order to avoid "insect marks" on rims, which in the eyes of the Japanese were a mark of beauty rather than a flaw, a brown glaze was put on the mouth. These completely different styles of porcelain reflected the utterly different aesthetic tastes of West and East.

These kinds of products were very popular among European customers who were willing to pay high prices for quality porcelain ware. In order to earn high profits, the Dutch East India Company regularly visited China to purchase them. Based in the now New Delhi, capital of India, the Dutch East India Company set up a branch in Taiwan and ordered porcelain through Chinese merchants. The earliest order the company made for Jingdezhen product was 1608, through Chinese merchants in the east end of the Malay Peninsula. From the records of orders the company made to Jingdezhen at its peak period we can see that their orders were very specific regarding varieties, shapes and sizes of products, all catering to the daily utility values of Europeans. Custom-made by the Jingdezhen potters, once finished, the products were shipped immediately to Europe. Thus, this porcelain is rarely seen in Jingdezhen or museums around the nation. Even if some did remain in China, it would generally be plates, while no bowls, pots or jars have ever been found. Europeans cherished such porcelain treasures to the extent of mounting them in silver. For example, some porridge bowls were decorated with lotus-shaped handles, which were used for holding healthy drinks or food for children or their mothers. Such bowls were often very thin, so a metal ring with two lugs was placed on the base, linking the bottom with the mouth to avoid scalding. Additionally, some wine jars were decorated with metal tulip patterns on the neck and lotus on the body, imitating the silverware of Europe. Usually a silver cap was placed on the spout and a sliver chain was used, linking the cap with one of the silver rings on the neck. These silver accessories were not only practical, but also made the porcelain overall appear more beautiful and glamorous.

Like the Japanese orders, orders from the Dutch East India Company were also presented with wooden models and pattern models for the reference of the Jingdezhen potters. The most popular vase at the time was a square vase. Its design was based on European glass wine bottles. The neck featured a painted tulip, a popular flower among Europeans at the time. The decorative skills on the European porcelain included paneled flower patterns and other extremely bold techniques used by private kilns. Figure 10.68 features a red and green *doucai* ware painted with the Virgin Mary, however the Virgin Mary depicted in this picture looks like Avalokitesvara, a goddess admired by the Chinese people. This article is a typical red and blue ware product of the Tianqi period, with bold, natural paintings, thick clay and "insect marks" on the rim and edges.

The beginning of the Tianqi period in 1621 to the eighth year of the Chongzhen period (1635) marked the late era of Tianqi style red and green porcelain. Many new varieties of polychrome porcelain were taking shape, but compared to the typical Tianqi red and green ware, which used red, green and yellow colors on a foundation of blue and white, the later period saw red and green ware dominated by red colors on white clay with no blue colors except for inscribed production dates. This ware

Fig. 10.68 Red and green vase with Virgin Mary, produced in the Tianqi period of the Ming Dynasty

was called "*wucai* ware of the great Ming Dynasty" by the Chinese and "Nanjing polychrome" by the Japanese.[59]

Initially, only red, green and yellow were painted on bisque. Like the cross-shaped hand bowl mentioned above, while carrying some blue and white patterns, it was dominated by red, yellow and green. This demonstrates the transition from red and green ware of the Tianqi period to *wucai* ware of the late Ming Dynasty (Fig. 10.69). The difference between these was that the former was bold and natural while the latter was precise and rigorous. *Wucai* ware in the late Ming Dynasty was usually decorated with four or five colors on white clay. Even if some blue color remained, it was never major. The glaze on the mouth of Tianqi period red and green ware often wore off. But in the late Ming Dynasty, a brown-colored *zijin* glaze was often applied to those articles that easily wore off. Brown, purple and black were also often painted on porcelain ware. At the time, glamorous *wucai* ware was already quite developed and advanced, with a variety of colors and a unique style. Under the influence of the boldness of Tianqi red and green ware, *wucai* ware was

[59] Saito kikutarô, *On Porcelain, Kosometsuke, Shonzui*, Heibonsha, 1979, p. 106.

Fig. 10.69 *Wucai* plate with Taihu lake stone, peony and bird patterns, produced in the Chongzhen period

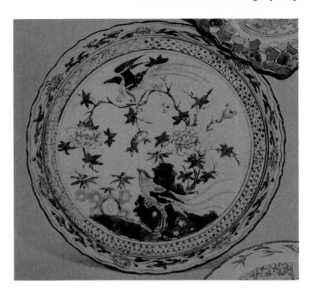

transformed into a magnificent array of styles. Apart from the huge demands at home, Japanese consumers, the East India Company and the Dutch East India Company also placed large orders. This period marked a heyday for exports from the private kilns in Jingdezhen to the outside world.[60]

It is unfortunate that there was no marking of the exact production date of *wucai* ware in the late Ming Dynasty. Usually, the ware only bore a few fake inscriptions like "Made in the Chenghua period of the Ming Dynasty" or "Made in the Jiajing period of the Ming Dynasty." Apart from these, there were also *"Fu"* (Blessings) inscriptions in regular or cursive scripts. These *"Fu"* inscriptions were deformed and usually imprinted on the porcelain. They were popular from 1635 onwards, the eighth year of Chongzhen. After the end of the Chongzhen period, these inscriptions were replaced by rabbits or Buddhism's Eight Auspicious Symbols, etc.

Among the red and green porcelain produced in the Tianqi period, plum blossom tree plates used plum trees and the moon as motifs, a typical feature of literati and woodcut paintings. Among the Kosometsuke ware there were plates depicting the scenery along the Yangtze River and inscribed poems with seven character lines such as one written by Li Bai, a great Tang Dynasty poet, and called *"Wangtianmenshan."* Similar motifs and poems were also applied in *wucai* ware in the late Ming Dynasty.

Ever since Dong Qichang, a famous painter from the late Ming Dynasty, literati paintings had become a hit. Following advances in woodcut technology, it was not difficult to obtain a quality painting album for reference in porcelain making. Jingdezhen was also physically close to Huizhou in Anhui Province, a woodcut production center. With such geographic advantages, the potters from Jingdezhen were deeply affected.

[60] See Footnote 59.

Woodcut paintings often featured thin, tight lines, also a feature of "Nanjing poly-chrome." For example, in Fig. 10.70, the cockscomb, hen and chicks were painted using thin, tight lines. But the plate is also decorated with two colorful butterflies, birds, bamboo leaves, rocks and grass, an adaptation from woodcut and literati paint-ings. The plate is also glazed in *zijin* on the rim and inscribed with the traditional "*Fu*" (Blessings). Another representative product of this time is an octagonal plate with a figure fishing under a tree. This is a typical literati painting, with the figure, the mountain and the rocks on the right, and inscriptions in clerical script, leaving much blank space. Illustrated in Fig. 10.71 is a plate with a pair of roosters under a pomegranate tree, painted entirely in lines in the woodcut style. This style of neat design and abrupt pause and transition is a basic technique used in paintings on *wucai* ware.

Developing from red and green to red, green and yellow, and then to red, green, yellow, blue and purple, blue and white porcelain began to be outlined in black, and painted in red, light red, green, yellow, dark purple and purple depending on the specific conditions. *Wucai* ware at this time reached a high point in terms of color matching and painting technique, which laid a solid foundation for the maturity of *wucai* ware in the Kangxi period (1661–1722).

During the Tianqi and Chongzhen eras, plates dominated *wucai* ware. In this period, *wucai* ware produced in private kilns was more a product of the potter's imagination or a custom-made product than being bound by traditional style, which was different from the official kilns. Thus, this period produced many unique *wucai* products with their own style.

During this period, a variety termed "Shonzui" porcelain, an even more exquisite and delicate blue and white porcelain variety than "Kosometsuke," was ordered by Japanese tea masters and specially produced for the Japanese market. The casual, natural and free "Kosometsuke" style was loved by Japanese tea masters in the land

Fig. 10.70 *Wucai* plate with a hen, produced in the Chongzhen period

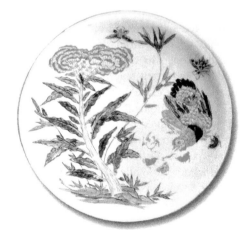

Fig. 10.71 Jingdezhen red
and green ware with a pair of
roosters under a
pomegranate tree, produced
in the Tianqi period, in the
Museum of East Asian Art

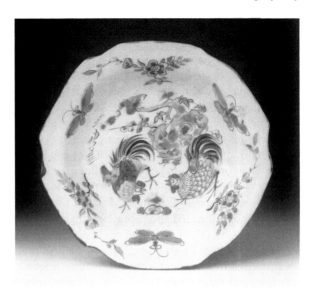

of Furuta Oribe while "Shonzui" porcelain was favored by tea masters of the Kobori
Enshu school.

In the early Chongzhen period, the famous "Kosometsuke" (Kraak porcelain) was
unable to meet the demand of Southeast Asia and Europe. At the same time, the tea
masters of the Kobori Enshu school also ordered porcelain of a similar style to the
Kosometsuke, only neater, more decorative and more Japanese from Jingdezhen,
hence the emergence of "Shonzui" ware for daily use. It seems that "Shonzui" ware
was developed from "Kosometsuke."[61] A typical decorative approach of "Kosomet-
suke" was to equally divide the lip of a plate into four parts like four panels, decorated
with flowers like lotus and separated by narrow, long lines which were decorated with
geometric patterns. In the well sits the main motif. Different from the Tianqi *wucai*
ware or red and green ware, the "Kosometsuke" paintings were more decorative and
graphic. Learning from "Kosometsuke," "Shonzui" ware shared a similar style but
also developed its own features. For example, it featured more varied decorative
methods and often featured contrasts in its paintings. Such products were usually
glazed in *zijin* glaze on the rim (Figs. 10.72 and 10.73).

"Colored Shonzui" was produced on the foundation of the "Shonzui" product
and was so named by the Japanese. In China it was called blue and white *doucai*
ware. It featured different styles similar to *wucai* and red and green ware from the
Tianqi period. Different from Tianqi *wucai*, it placed more emphasis on graphics
and decoration. While not necessarily products of "Shonzui," they did, however,
share the same style. Despite inscriptions like "Made in the Jiajing period of the
Ming Dynasty," some products might have been made under the reign of Emperor
Chongzhen, just like some "Shonzui." Products of private kilns at this time rarely

[61] Sato Masahiko, *The Ceramic History of China*, Heibonsha, 1978, p. 216.

Fig. 10.72 Jingdezhen
Shonzui blue and white plate
with Buddhism's Eight
Auspicious Symbols,
produced in the Tianqi period
of the Ming Dynasty, in the
Museum of East Asian Art

Fig. 10.73 Jingdezhen
Shonzui blue and white plate
with pine, bamboo and plum
blossom pattern, produced in
the Tianqi period of the
Ming Dynasty, in the
Museum of East Asian Art

put the reign names of the current emperors on them. Instead, they simply used inscriptions like "Made in the Jiajing period," "Made in the Jiajing period of the Ming Dynasty," "Made in the Chenghua period of the Ming Dynasty," "Made in the Xuande period of the Ming Dynasty," or "Made in the Xuande period." "Made in

Fig. 10.74 Jingdezhen
"colored Shonzui" porcelain,
produced in the Tianqi period
of the Ming Dynasty, in the
Museum of East Asian Art

the Jiajing period of the Ming Dynasty" and "Made in the Chenghua period of the
Ming Dynasty" were used most frequently (Fig. 10.74).

"Shonzui" ware and "colored Shonzui" ware alike were often inscribed with "
五良大甫吴祥瑞造" (Made by the Wuliangdafu, Wu Xiangrui). Who then was this
Wu Xiangrui? Was he Japanese or Chinese? This question is still very contested in
Japan while in China the issue has been scarcely documented. The name "五良大
甫" was recorded in a Japanese book published in 1800. It mentions that porcelain
produced in Nanjing was inscribed with "五良大甫吴祥瑞造." "祥瑞" (*xiangrui*)
transcribes as Shonzui in Japanese. Shonzui was a Japanese potter from Matuzaka,
Ise. He travelled to China and learned how to make porcelain in Jingdezhen. In
1513, when he returned to Japan, a man named Li Chunting wrote him a poem to
farewell him. Its name is *Damingzhengde Kuiyouliuyueshuo Song Jvshi Wuliangdafu
Guiriben* (大明正德癸酉六月朔送居士五良大夫归日本), or *Farewelling Wuliang
on his Return Home to Japan in June 1513*. What is worth noting here is that in
contrast to the poem, the inscription on the porcelain articles were "大甫" not "大
夫." Besides, 1513 coincides with the late period of Ashikaga Yoshitane, the 10th
shōgun of the Ashikaga shogunate during the Muromachi period in Japan. At that
time, Japan did not make blue and white porcelain. So it seems this explanation does
not make sense.

Some think "五良大甫" was a Japanese exegetic pronunciation of "五良太夫."
But recently, a plate with the inscription "五良太夫" has been discovered, and is
believed to have been made at least in the late seventeenth century, around 20
years after "Shonzui" came to Japan, by which time such exegetic pronunciation
had already been phased out.

A tea master from Osaka expressed an alternate point of view in a book, holding that "Shonzui" was the name of a place. This master, called "五良太甫" from Ise, came to a place named "Shonzui" to learn porcelain making in the late Ming Dynasty and after finishing his studies, he returned to his home country. Inscriptions of "五良大甫吴祥瑞造" were put on porcelain because it was not really appropriate to put "五郎太甫" or "五郎太夫" hence "五良大甫." Thus, this view regarded the potter's name as "五郎太甫" with "Shonzui" being the name of a place. But this opinion also does not hold water as there was no such place called "Shonzui" in China.

An article published in *Studies on Shonzui* argued that "Shonzui" was a Japanese potter called "伊藤五郎太夫" (Itten) and revealed results on studies of his tomb. After returning from China, Itten was the first to take the porcelain-making techniques of Jingdezhen back to Japan, making him the "ancestor" of Japanese porcelain. As an account from a book published in 1941 reveals, before the Kutani kiln began operation, Gotō Saijirō, founder of the kiln, serendipitously gained the assistance of Itten and initiated *wucai* ware.[62]

According to Saito kikutarô, the "甫" in "五良大甫" was on the right. If it were deleted, it would be "五良大." The "大" (*da*, meaning big) here actually refers to the eldest son in a family. Just like in *Heroes of the Marshes,* a character called Wu Song was also called Wu Erlang (the second son of the Wu household) and his elder brother Wu Dalang (the first son of the Wu household). This author once found a white glazed pottery pillow with engraved peony patterns with the inscription "舜陶佳皿李五大宅圣置" (*Shuntaojiamin Li Wuda Shengzhaizhi*). *Shuntaojiamin* was a typical inscription applied to porcelain in the late Ming Dynasty while Li Wuda was the eldest among five sons of the Li household. Based on this manner of interpretation, "五良大" was the eldest among the five sons of the Wu household and "Shonzui" was his name.

In *On Porcelain, Kosometsuke, Shonzui*, Saito kikutarô wrote that an art museum in Ashiya, Hyōgo Prefecture houses a thin-clay teapot in the "Shonzui" style. Its body is fully inscribed with four-line poems with five characters to a line from the Tang Dynasty with inscriptions of "*Wurenshi*" and "五良大甫吴祥瑞造." Here the "*Wu*" in "*Wurenshi*" should be the birthplace of the producer. It fits the Chinese custom of placing the nationality before the name, and it ends with a "甫" (*fu*). To jokingly take "五良大甫" as an exegetic pronunciation of "五郎太夫" might be the result of a sense of humor by the then Japanese tea masters. At the time, tea masters would all know the producer "Shonzui" was a Chinese potter, but maybe the later generations mistakenly took the joke seriously and believed him to be Japanese.[63]

Apart from eight-character inscriptions, private kilns also applied "*Fu*" (Happiness) or "*Lu*" (Blessings) inscriptions on "Shonzui" ware, written in variants of the characters incised on copper seals with double line frames. Such inscriptions indicated good luck, as did "Shonzui," which means auspicious omens in Chinese. Thus, the name "Wu Shonzui" is closely associated with wishes for good luck and its motifs

[62] Saito kikutarô, *On Porcelain, Kosometsuke, Shonzui*, Heibonsha, 1979, pp. 107–108.

[63] Saito kikutarô, *On Porcelain, Kosometsuke, Shonzui*, Heibonsha, 1979, p. 109.

were often auspicious.[64] But of course it is difficult to discover whether "Shonzui" ware was produced in Jingdezhen, since a piece of porcelain in the "Shonzui" style housed in the Museum of East Asian Art is indicated to have been made in the Zhangzhou kiln in Fujian Province. If this is true, we need to take a new look at the Zhangzhou kilns, because this article represents a highly advanced production and painting technology.

In short, despite suffering from political turmoil and social instability in the Tianqi and Chongzhen periods, and official kilns even having ceased production for some time, thanks to the extensive foreign market, the ceramics industry in Jingdezhen not only was not affected, but indeed, it made further progress and created many new varieties which targeted consumers from different places and which paved the way for an even greater boom in foreign trade in the early to mid-Qing Dynasty.

10.4.5 The Rise and Fall of Private Kilns During the Tianqi and Chongzhen Periods as Evidenced in Foreign Documentation

The Dutch East India Company recorded the highs and lows of Jingdezhen porcelain imports from 1635. According to the company, in 1636, the parent company shipped 25,380 pieces of Chinese porcelain back home and the Taiwan branch 136,164 pieces. After that, its imports doubled and redoubled.

In the following year, with the lifting of the Japanese maritime ban, foreign ships, including luxurious Japanese merchant ships with red seals indicating government permission, along with Dutch merchant ships and Chinese merchant ships from the South China Sea all plunged into the porcelain trade. Thus, over 750,000 pieces of porcelain were exported. One merchant from Kyoto was engaged in trading Chinese artifacts. He was fond of porcelain and traded a considerable amount of them. In 1649 he modeled and had Nanjing merchants commission Jingdezhen to custom-make tea vessels favored by the Oribe tea masters along with water pots and hand bowls that were popular with the Enshu tea masters. At the same time, the Dutch East India Company moved from Hirado to Nagasaki and continued to trade Chinese porcelain.[65]

In the same year, a former official from the Ming Dynasty, Mr. Zheng Zhilong, father of Zheng Chenggong, had five ships loaded with a total of some 10,000 pieces of porcelain bound for Nagasaki which led to many disputes both inside and outside the city. The following year, the Ming Dynasty was overturned. In 1644, the Ming capital, Beijing, was overtaken by the Qing armies and the Qing regime relocated its capital to Beijing, even before the fires of war had cooled. In the winter of the same year, Dorgon was dispatched to wage war in regions south of the Yangtze River.

[64] See Footnote 63.

[65] Saito kikutarô, *The Great Ceramic Series, Gosu Polychrome, Nanjing Polychrome*, Heibonsha, 1979, p. 124.

The Dutch East India Company always made direct purchases from Jingdezhen. But from 1644 onwards, the company was only able to do business through the hands of rich Chinese merchants. It is documented that in May 1644, over 300,000 pieces of porcelain were purchased and in December, 146,000 pieces. All were quality blue and white porcelain and *wucai* ware from Jingdezhen. They were first transported to Taiwan and then shipped to the home country.[66]

The vibrant culture of the regions south of the Yangtze River helped produce glamorous *wucai* porcelain and "Shonzui" *doucai* ware. The last few years of the Ming Dynasty was the heyday of porcelain production in these regions. As the Ming regime faced collapse, the rich and privileged all flooded south of the Yangtze, making the region extremely prosperous. This served as the proving ground for *wucai* ware in the late Ming Dynasty.

But such prosperity did not last long. In 1645, the Qing armies overran Nanjing and the Ming rule was ended. Thus, the boom in the private kilns of Jingdezhen in the more than two decades since 1621 eventually came to an end.

In 1644, only 65,906 pieces of porcelain were purchased from Jingdezhen by the Dutch East India Company, a far cry from the earlier numbers. Affected by war, this number further declined in 1647 and by 1649, it was down to zero. For this reason, when the company relayed the story of the difficulties in purchasing Chinese porcelain, people lamented that the "Chinese era" was over.[67]

Under the reign of Emperor Shunzhi, the official kilns which had ceased operation for some time resumed production and were placed under the charge of officials of the Qing administration. At this time, kilns were mostly ordered to make big vats with dragons, so the long-free kilns and their potters were once again pooled together to work for the government.

10.4.6 The Significance of the Independent Development of the Private Kilns in Jingdezhen

IN the long ceramic history of China, fleeting as it was, the free and independent development of private kilns in Jingdezhen in the late Ming Dynasty left a glorious legacy. Despite the long history of porcelain exports in China, exports in this period were unprecedented in terms of quantity, scale, range, variety and influence.

In the late Ming Dynasty, private kilns in Jingdezhen not only wrote a glorious page in their history, but they also brought the Chinese ceramic culture to the whole world and had a far-reaching influence on different cultures. At the time, Jingdezhen porcelain was exported to various nations and regions like India, Persia, Egypt, the Philippines, Java, Sumatra, Borneo, Siam, Cambodia, Korea, Japan, Portugal, Spain, the Netherlands, and France, and became a hit in these countries and regions. The

[66] See Footnote 65.

[67] Saito kikutarô, *The Great Ceramic Series, Gosu Polychrome, Nanjing Polychrome*, Heibonsha, 1976, p. 125.

Japanese scholar Mikami Tsugio studied the maritime trade route which gradually prospered from the late Tang Dynasty and named it the "Ceramic Road." The route began in ports in Southeast China, travelled through the Malay Peninsula and Indian sub-continent, then either crossed countries in the South Pacific region or the Indian Ocean, past the Persian Gulf and Mediterranean, and reached the Arab regions, East Africa and western Europe. India was a connection point in the maritime route and therefore the Netherlands used India as a springboard and established the Dutch East India Company, through which much porcelain was shipped to countries in Europe. Meanwhile, regions like India, Ceylon, Annam and Ryukyu were also major customers of Jingdezhen porcelain. Thus, it seems that the "Ceramic Road" was closely associated with the large exports of Jingdezhen porcelain. It is therefore fair to say that the late Ming period marks an important era for the products of private kilns in Jingdezhen to "go global." This helped set up a bridge for cultural and economic exchange between the Chinese people and people from the rest of the world. This is therefore a very significant time in history. Products from this period, boasting beautiful bodies, elegant designs and delightful colors, gained much popularity once exported overseas.

According to *History of the Ming Dynasty, On Foreign Countries*, people in Văn Lang "originally used banana leaves as food vessels, and after trading with the Chinese people, the leaves were replaced by porcelain ware." *Studies on the Oceans East and West*, completed in the late Ming Dynasty, also clearly recorded "porcelain used by common families." This shows that at this time, porcelain ware was already generally accepted as food vessels in Asia and Africa. In recent years, many porcelain articles have been unearthed from these regions, confirming this point. Among the porcelain vessels used in these regions, a large proportion came from Jingdezhen. Catering to different tastes in different regions, Jingdezhen produced products with auspicious Islamic motifs for the Islamic world and made products with motifs in the exotic style of Europe. Their products were thus extremely popular among the local consumers.

The worldwide spread of Jingdezhen porcelain expanded the range of artistic artifacts that people around the world could admire and exerted an especially positive influence over painting, architecture, arts and handicrafts, and even religions and cultures in western Europe, opening up a channel for cultural communication between East and West. Boasting artistic values in its design and painting along with its practical applicability, Jingdezhen porcelain won the favor and admiration of people of all social rankings in many countries. European people took to Chinese porcelain collecting, especially that from Jingdezhen, as a measure and symbol of their wealth. They generally utilized porcelain as decoration and appreciated it as a delight. This shows that porcelain art had entered the artistic field, which was bound to exert some influence on people's aesthetic tastes.

After 1720, Europeans obtained the formula for porcelain making from Jingdezhen through some missionaries and started porcelain production themselves. Thus, from 1720 to 1760, Europe began to move from purchasing porcelain to imitating the production process. During this time, Europe had great aspirations for China. They not only tried to copy porcelain production from China, but they also

drew from other areas such as manufacturing and decorative endeavors like architecture, furniture, and glass. This imitation affected and facilitated the emergence of the "Rococo style" which became popular in France in the late eighteenth century before sweeping across Europe. This style stressed light colors, smooth luster, and elegant curves, and displayed a natural, graceful and unrestrained aesthetic, a product of introducing and absorbing the essence of various forms of art, including Chinese porcelain art, based on the traditional European artistic style. This style covered many aspects like painting, architecture, art and handicrafts.

In the late Ming Dynasty, porcelain production techniques were regarded as mysterious secrets, leading to inquiry and imitation by many foreign nations. Such copycat technologies first spread to China's neighboring countries like Korea, Vietnam and Thailand, and eastwards to Japan, westwards to Persia, and then through west Asia and East Africa to Europe. A Japanese scholar once stated that Jingdezhen was the birthplace of the world's porcelain production. He pointed out that Arita in Saga Prefecture in Japan had over 300 years of history in porcelain production and had been directly and indirectly affected by the production techniques and decorative motifs of Jingdezhen in the late Ming Dynasty. Even now, the artistic style of those times can still be seen in its products.

In recent years, Dr. Yang Silin, a Chinese scholar in Germany concluded after years of research and investigation that the earliest porcelain that Europe produced, Meissen porcelain, was actually not invented by a German. It was in fact produced, based on the imitation of porcelain products from Jingdezhen and after the discovery of "kaolin" in a place near Meissen. Its techniques were therefore, to a large extent, affected by those of Jingdezhen in the late Ming and early Qing period. For example, the Meissen kiln not only copied blue and white porcelain and "sang de boeuf" or "oxblood" from Jingdezhen, but it also imitated their designs. That some foreigners came to China to learn porcelain making is a well-documented fact. For example, it was recorded that imperial porcelain made for the rulers of Koryo in the Joseon Dynasty was copied from Jingdezhen, in imitation of its blue and white porcelain from the Xuande and Zhengde periods. In the fifteenth century, Annam especially hired porcelain artisans from China to learn porcelain making. From the Southern Song Dynasty, Japan had started to learn porcelain making from China. In 1511, in order to crack the secret, Japan sent envoys to China. From the fifteenth century, China's porcelain techniques spread to Europe and it was in Venice where thin, light and translucent porcelain was first produced. François Xavier d'Entrecolles (1664–1741, Chinese name: Yin Hongxu), a French Jesuit priest, came to Jingdezhen in 1712 and learned Chinese techniques of manufacturing porcelain and sent the secret formula and main raw materials of porcelain making in Jingdezhen back home. He was the first Westerner to have introduced a major porcelain production raw material, kaolin, to the West, which triggered the interest of French authorities who then issued an order to search for it at home, leading to the production of real hard-paste porcelain in Europe. Around the mid-eighteenth century, Britain, Sweden, Denmark and the Netherlands, all followed the trend and imitated the production of Chinese porcelain, thus leading to the emergence of hard-paste porcelain and a new era in the history of porcelain production in Europe.

Another extremely interesting historical anecdote worth mentioning is that, in the late Ming Dynasty, porcelain produced by private kilns in Jingdezhen was so popular around the world that their products witnessed excessive demand and created huge profits, attracting the attention of certain countries. In pursuit of economic gain, Siam, the Champa Kingdom, and Persia also copied porcelain production from China. In particular, Japan, a close neighbor of China, took advantage of its geographic location adjacent to China and tried to learn from Jingdezhen. The production techniques of Jingdezhen thus actually exerted a far-reaching influence over Japan's porcelain production.

In the early Edo period, Japan started to produce small white glazed porcelain items in Arita. In painting blue and white porcelain, Japan mostly copied flower and grass patterns from Koryo. At the time, Sakaida Kakiemon (the first generation of the Kakiemon family) made an attempt to paint red and green porcelain. It is difficult to tell whether he was influenced by red and green porcelain from Jingdezhen, or from Fujian or Swatow. But his products were definitely early red and green Imari ware. The Tokyo National Museum currently houses two red and green bowls, one with chrysanthemum patterns and the other a yellow glazed tricolor bowl with birds and dragons. Their simple style resembles the red and green ware from Fujian and Swatow and some speculate that they were works of the first generation of the Kakiemon family. But it is also possible that before red and green ware from Jingdezhen came to Japan, Fujian and Swatow product had already arrived. Therefore, when the imitation of the manufacture of red and green porcelain began, potters started with handy objects from Swatow.

In the early Qing Dynasty, with the reestablishment of official kilns, the bold and free red and green ware produced by Jingdezhen in the Tianqi and Chongzhen periods had gradually disappeared at home, but were brought back to life in the hands of Japanese potters. Generally, the patterns seen in the red and green porcelain of the Tianqi period, "colored Shonzui" and "Kosometsuke," were revived in Kutani ware from the early Kakiemon period.

In the early Shunzhi period (1644–1661) of the Qing Dynasty, Jingdezhen ceased export of porcelain for daily use to Europe while at the same time, regions around Imari, Japan began imitating Jingdezhen products. The Kakiemon family, under the influence of Jingdezhen, gradually matured and began porcelain exports to Europe from 1661. In 1672, shops similar to those in Jingdezhen which painted on overglazed colored porcelain were set up in Arita and were called "red painting shops" by the Japanese. When shops like these crowded together on a street, the street was named "red painting street." Thus, from this period onwards, the Dutch East India Company began purchasing porcelain from Japan. Initially, these Japanese products basically copied Jingdezhen and sometimes inscriptions like "Produced in the Chenghua period of the Ming Dynasty" or "Produced in the Jiajing period of the Ming Dynasty" were placed under the base.[68] (Fig. 10.75).

Many Japanese believed Shonzui from "*Wuliangdafu wuxiangrui*" mentioned above was the originator of Japanese porcelain (because they believed Shonzui,

[68] (Japanese) Nagatake Takeshi, *Famous Ceramics of Japan, On Imari*, Heibonsha, in 1973.

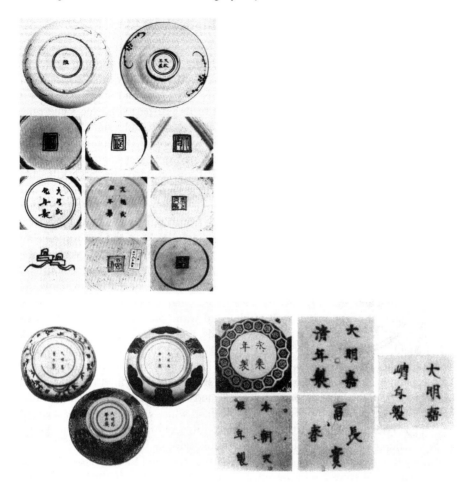

Fig. 10.75 Inscriptions on Ancient Imari ware

or *xiangrui* in Chinese, was a Japanese craftsman who studied porcelain making in Jingdezhen for 20 years before returning home). But this author holds that the originator of Japanese porcelain was not only Shonzui, but also an entire generation of artisans working in private kilns in Jingdezhen in the late Ming Dynasty. It was their hard work that made the Japanese porcelain culture possible. Additionally, these potters made great contributions to the development of the ceramics industry at home and laid a solid foundation for the emergence of exquisite and magnificent porcelain products during the reign of Emperor Kangxi.

10.5 Ceramic Industries Outside Jingdezhen

Since the Ming Dynasty, Jingdezhen has gradually become the national center for porcelain production. Its boom could not have been possible without the fact that official kilns were located there. The popularity of its blue and white porcelain in the domestic and foreign markets also added to its prosperity. At the same time, apart from the Jingdezhen kilns, kilns in other places around China were also in operation. While not as good as Jingdezhen in terms of production scale, variety, quality or influence, they were also an important part of China's ceramics industry. In the Ming Dynasty, daily use ceramics had been produced by large kilns like Cizhou and Longquan since the Song Dynasty. Porcelain of varying quality was also produced by many provinces nationwide. Among them, *fahua* wares from Shanxi, white porcelain from the Dehua kiln, *zisha* ware from Yixing and fambe wares from Shiwan were representative of the period. Meanwhile, blue and white porcelain produced by Jingdezhen was so popular at home and abroad that supply was not able to satisfy the market demand, so kilns outside Jingdezhen began to produce blue and white porcelain to supply regions that Jingdezhen failed to cover. For example, the remote Jianshui and Yuxi kilns in Yunnan Province, and kilns in Beiliu and Rongxian County, Guangxi began production of blue and white porcelain to meet their own local demand. With their advantageous locations, kilns in coastal regions like Fujian and Guangdong provinces also started to make blue and white porcelain in large quantities. This production was initiated in the late Ming Dynasty when Jingdezhen, also producing in substantial amounts, could still not meet market demand, hence the emergence of the famous "Swatow wares" and "Chaozhou wares" on the foreign market. Most of the export porcelain was blue and white with some *wucai* ware, all developed under the influence of Jingdezhen. In this section we will therefore discuss the production of export porcelain in the coastal regions.

Among the large volume of porcelain exports in the late Ming Dynasty, "Swatow wares" and "Kraak wares" were the most eye-catching varieties. It is useful to discuss their naming and sites of production.

① "Swatow Wares"

The name "Swatow wares" was coined by foreign merchants who came to China to purchase porcelain. But why this name? Where did "Swatow wares" come from? These are questions scholars have been studying. Before the 1980s and 1990s, in the eyes of Westerners, "Swatow" referred to porcelain produced in Shantou, formerly Romanized as Swatow in Guangdong Province. For example, according to *The Chinese Potter: A Practical History of Chinese Ceramics* written by Margaret Medley and published in 1976, "Swatow wares" were believed to be "products produced by kilns in the northern part of Shantou, in the north of Guangdong Province." The Japanese understanding of Swatow wares is that its place of origin was "unknown" and that it probably came from kilns in South China or "kilns in Guangdong and

Fujian." It turns out that such speculation is very close to the reality.[69] Sumarah Adhyatmanz wrote that Shantou might be the port for export of such porcelain. Shantou was translated into Swatow by the Dutch and pronounced as Swatow in the Fujian dialect. But we now know that this kind of product was produced in Pinghe County, Zhangzhou, Fujian Province as well as some places in Guangdong.[70] However, in *Chinese Export Porcelain Chine de Commande*, D. F. Lunsingh Scheurleer wrote that "Swatow wares" was the name for coarse porcelain, coined by Chinese merchants. Shantou, located in the coastal region of Southeast China, was in Southern Guangdong Province. According to journals of the Dutch East India Company, "Swatow wares" came from the Zhangzhou River, in the coastal area of Fujian Province. Some people also regarded them as originating from the Dehua kilns.[71]

In *Chinese Export Porcelain Chine de Commande*, D. F. Lunsingh Scheurleer wrote that "Swatow wares" might have been produced in the latter half of the sixteenth century to the end of the Ming Dynasty in 1644 as exports destined for India, the Indonesian islands and Japan.[72] The author has seen some of such "Swatow wares" in museums in the Netherlands, which were brought back home by Dutch travelers from regions like India, the Indonesian islands and Japan. So, if Jingdezhen porcelain was earmarked for the European market, then it is highly possible that "Swatow wares" were targeted at the Southeast Asian regions and Japan.

So where exactly were "Swatow wares" produced? This is also a topic attracting the attention of Chinese scholars. After years of study and discussions, there was no definitive conclusion until in the 1980s when archaeologists in Fujian Province began to discover kilns producing "Swatow ware" products in Zhangzhou in quick succession, and launched excavations of kilns in Nansheng Town, Pinghe County, in Zhangzhou. Samples found in these kilns immediately attracted the attention of experts at home and abroad. It turns out that "Swatow wares" were actually produced in the Zhangzhou kilns. Meanwhile, similar "Swatow wares" and "Kraak porcelain" were also found in kilns in Pinghe County and the Dehua kilns in Fujian Province. Later exports of these varieties of products were found in Japan and Southeast Asian regions. Thus, academic circles eventually concluded that "Swatow wares" were not produced in Shantou. Rather, they were produced by kilns in Fujian and Guangdong provinces and exported through Shantou.

In "An Attempted Discussion on Kraak Porcelain," Mr. Xiao Fabiao addressed the question from an historical standpoint and pointed out that from the mid-Ming Dynasty, non-governmental trade between China and Japan peaked. At the time, many businessmen from Fujian Province were engaged in business in Nagasaki. He further tells the story of how Zheng Zhilong monopolized the maritime trade with

[69] Zhou Lili, "Discussions on Blue and White Porcelain Produced by the Zhangzhou Kilns in the Late Ming and Early Qing Dynasties," Chinese Society for Ancient Ceramics (ed.), *Studies on Ancient Chinese Ceramics* (Vol. 13), The Forbidden City Publishing House, 2007, p. 237.

[70] Sumarah Adhyatman, *Zhangzhou (Swatow) Ceramics: Sixteenth to Seventeenth Centuries Found in Indonesia*. Jakarta, 1999.

[71] D. F. Lunsingh Scheurleer, *Chinese Export Porcelain Chine de Commande*. New York: Pitman Publishing Corporation, 1974, p. 41.

[72] See Footnote 71.

foreign countries in the coastal regions of Fujian. The Netherlands, Portugal and Spain could only trade with China with his authorization. Xiao also pointed out that in the late Ming and early Qing period, after Zheng Zhilong and his son, Zheng Chenggong, dominated the maritime trade, Japan became the transfer point in trade between China and the Netherlands. At this time, China's porcelain exports were mainly shipped to Japan before being transferred to central Asia, west Asia, and Europe. Thus, it was actually the Zheng family who manipulated the maritime trade rather than the Portuguese pursuit of high profits that drove exports in this period. When products arrived at their destinations after the transfer, it would be difficult for people to know where exactly they had come from. So perhaps, initially they were named Kraak ware but produced elsewhere, and only later named for their port of exit, Shantou, hence "Swatow wares." It seems natural that after transfer and redistribution via transfer points, end users had no idea of the place of origin of such porcelain.[73] So "Swatow wares" are probably not necessarily produced in Shantou. Instead, they were possibly products of Zhangzhou or other places in Fujian Province.

② "Kraak Porcelain"

The term "Kraak porcelain" and its relation to "Swatow wares" is also worth exploring. The name "Kraak porcelain" was initially proposed by Western businessmen. Despite several understandings of the term, the majority view agrees that it was named after a captured merchant ship. If this is true, "Kraak porcelain" serves as a general term for Chinese export porcelain transported by the ship "Kraak." This term was so generally used that even blue and white porcelain produced in the late Ming Dynasty with motifs like flowers, birds, human figures and animals placed on the interior bottom and six to eight paneled floral patterns on the walls were also regarded as "Kraak porcelain." Since similar products were also found among "Swatow wares," "Kraak porcelain" was believed to have been produced in the area between Jingdezhen and Shantou. Sometimes, these two terms were used interchangeably. As for the relation between them, scholars hold that while the term "Kraak porcelain" was originally used as a general term for Chinese export porcelain and products of a similar style, it also referred specifically to wares with natural scenery on the interior base and paneled decorations on the interior walls. Thus, the term refers to porcelain of a special decorative style. It could therefore have been produced in Jingdezhen or other places like Zhangzhou. But "Swatow wares" were different. Initially, it should be included among "Kraak porcelain." But with the narrowing down of the range of "Kraak porcelain," only some "Swatow wares" remained "Kraak porcelain," so these two terms should not be confused or used interchangeably.[74]

[73] Xiao Fabiao, "An Attempted Discussion on Kraak Porcelain," *Cultural Relics in Southern China*, 2000, Issue 2.

[74] Zhou Lili, "Discussion on Blue and White Porcelain Produced by the Zhangzhou Kilns in the Late Ming and Early Qing Dynasties," Chinese Society for Ancient Ceramics (ed.), *Studies on Ancient Chinese Ceramics* (Vol. 13), The Forbidden City Publishing House, 2007, p. 238.

Fig. 10.76 Large Kraak
blue and white pot with kylin
pattern, produced in the
Ming Dynasty

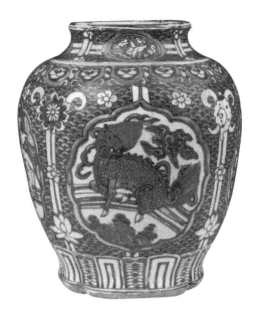

"Kraak porcelain" has a specific style. Rose Kerr notes that designs of "Kraak porcelain" changed with the times, but one typical feature that remained unchanged were the paneled decorations. For example, in Fig. 10.76, an auspicious symbol in Taoism, an imaginary kylin, is painted in the oval panel of the large pot. It is a typical style of "Kraak porcelain" produced for the Middle East market that the body is fully painted with complex motifs. This variety of product was also used for decorative purposes in Europe. A similar pot was recovered from wrecks of the sunken ship "San Diego." Loaded with a large amount of goods, this galleon sank off Fortune Island, outside Manila Bay in 1600. Over 500 pieces of blue and white porcelain have been recovered from the wreck, and most have been "Kraak wares."[75] (Figs. 10.77 and 10.78).

The reason why the author has tried to elaborate the two terms "Swatow wares" and "Kraak porcelain" is in the hope that readers might understand that in the late Ming Dynasty, due to a shortfall in Jingdezhen's production, kilns in coastal regions like Fujian and Guangdong fully capitalized on their favorable geographic locations to produce products of a similar style to that of Jingdezhen and meet the market demand. This was an important feature of the export market at the time and we will look into these alternate kilns now in more detail.

[75] Rose Kerr & Luisa E. Mengoni, *Chinese Export Ceramics*. V&A Publishing, 2011.

Fig. 10.77 Blue and white garlic-head shaped vase with paneled decorations, produced in the Wanli period of the Ming Dynasty

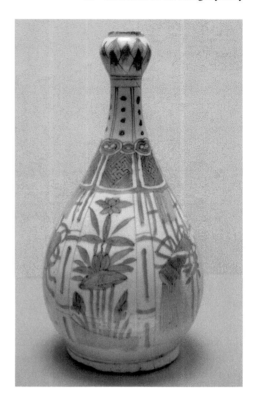

Fig. 10.78 Blue and white plate with paneled mountain and river scenery, produced in the Wanli period of the Ming Dynasty

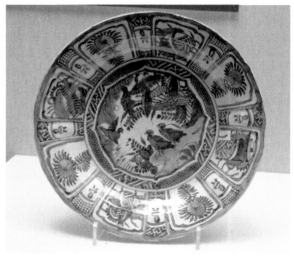

10.5.1 The Dehua Kilns

Situated in the central part of Fujian Province and close to the Port of Quanzhou, the Dehua kilns enjoyed favorable transportation, so their production also maintained a close association with the overseas market. From the Song and Yuan dynasties, under the influence of Jingdezhen, the Dehua kilns had produced a lot of *qingbai* porcelain for Southeast Asia and Africa.

In 1472, the eighth year of the Chenghua period, the government relocated the Maritime Trade Bureau, which had been in Quanzhou for three centuries, to Fuzhou, indicating that the days of the Port of Quanzhou being a major port for export had ended. When foreign trade was repressed, porcelain export was also affected, and thus exports of Dehua products were also depressed. However, this depression was soon ended by external and internal factors.

After the Jiajing period, the entry of Europeans into Southeast Asia changed the politics and trade in this region. Since Europe was still unable to produce porcelain at this time and Southeast Asia, west Asia, and Africa continued to rely on China for porcelain supplies, once the Port of Quanzhou collapsed, the Ports of Anhai and the nearby Yuegang in Zhangzhou, Fujian Province rose as smuggling centers for the non-governmental trade. Porcelain flowed overseas "illegally" from here. But the problems caused by the maritime ban soon revealed themselves and the government realized that it was necessary to compromise and gradually lifted the ban. In 1567, the government officially abolished the policy and set up a "*yangshi*" (foreign market) in the Port of Yuegang to facilitate foreign trade. Thus, non-governmental trade flourished immediately and the southern Fujian maritime trade once again entered a period of expansion. Goods transported overseas included silk products, porcelain, and tea. Products of the Dehua kilns flowed abroad in large quantities through the ports of Yuegang and Anhai. Considerable amounts of white porcelain produced in the Dehua kilns have been discovered in many places in Asia, Africa and Europe. Apart from pieces of sculpture, many varieties of porcelain were exported, including plum blossom vases, porcelain lions, boxes, *jue*-shaped (a Chinese ritual bronze shape) cups with dragons and deer, porcelain seals, cylindrical cups with plum blossom, and pierced relief crab pen washers on a lotus-shaped base. Archaeological research has identified 32 Dehua kiln sites from the Ming Dynasty. From their layer structures and furnaces, we can see that production and export from the Dehua kilns was more influenced by the international market than by the change of dynasties. Thus, in the late Ming Dynasty, the Dehua kilns were not only unscathed by the then political turmoil, but they helped usher in a golden era for the ceramics industry.

Since the clay of the white porcelain produced by the Dehua kilns was made of material with a high content of silicon dioxide and a potassium oxide content also as high as 6%, after firing, the clay was thick, tight and translucent. The glaze applied to white porcelain was also different from that of the northern areas in the Song and Tang dynasties and the bluish white glaze of Jingdezhen. Instead, it was smooth, bright and creamy white. In sunlight, pink or milky white colors were visible, hence it was also compared to "lard" or "ivory." After the Dehua kiln white porcelain made

its way to Europe, the French remarked that it was as white as "goose down" and called it "Blanc-de-chine" (China white), and if the white color included a slight reddish tinge, then it was even more valuable.

Dehua white porcelain mainly fell into two categories, namely vessels or sculptures. Of the vessels, there were ritual wares and articles for daily use. Among the ritual wares, there were mainly candlesticks, incense burners, vases, jade-like and bronze-like ritual wares, and more. Among those for daily use, there were wine glasses, cups, bowls, stationery like brush pots, pen holders, pen washers and seals. And for the sculptures, there were Buddhist and Taoist sculptures, like those of Bodhidharma, Maitreya, Avalokitesvara, Sakyamuni and Guan Yu. There were innumerable distinguished porcelain sculptors at the time, like He Chaozong, Zhang Sushan and Lin Chaojing, whose names were usually inscribed on the back of their works. Of these, He Chaozong was the most well-known. Nevertheless, most of the porcelain sculptures with the names of their creators from the Ming Dynasty that can be seen today are fake products (Figs. 10.79 and 10.80).

From products passed down through history, we can see that ritual wares and sculptures constitute a considerable portion of Dehua wares. Some of them might have been produced for the market and some were produced for imperial use. Among the collections of the Qing palace, there were many treasures of Dehua white porcelain from the Ming and Qing periods, thus we can see that the Dehua kilns not only produced for civilian use, but also served as official kilns.

Fig. 10.79 A standing statue of Bodhidharma by He Chaozong, produced in the Ming Dynasty, height: 42 cm, in the Palace Museum

Fig. 10.80 A white glazed
Avalokitesvara statue,
produced in the Ming
Dynasty, height: 33 cm, in
the Dehua Cultural Relics
Protection and Management
Committee collection, Fujian
Province

Of the Qing palace collections, most are ritual wares, with a small number of
practical items. Ritual ceremonies were an important part of life in the imperial palace
in the Ming and Qing dynasties, as emperors and their spouses took Buddhism as
their spiritual pillars and worshiped the Buddha daily. Various chapels were therefore
built for this purpose. It is estimated that when the Palace Museum was founded, there
were around 50 to 60 chapels, along with numerous shrines and altars in halls and
chambers. The popularity of Buddhist events in the imperial palace placed enormous
demand on Buddhist statues and ritual wares.

It is likely that white porcelain from the Dehua kilns had made its way into the
imperial palace from the mid- and late-Ming Dynasty as offerings. Additionally,
judging from the quality and design of the collections of the Qing palace, we can see
that they were exquisite, and much superior to their counterparts produced for civilian
use. These collections were therefore probably made especially for the imperial
palace as offerings from the Fujian region.[76] All the statues and ritual wares in
Figs. 10.81, 10.82, 10.83 and 10.84 are of high quality and are now housed in the
Palace Museum.

Since superior quality was a feature of Dehua porcelain, in order to demonstrate
its beauty, it rarely used colored decoration in its production. Its major decorative
techniques were therefore scratching, decal, pierced engraving and embossment. Its

[76] Huang Weiwen, "Study on the Qing Palace's Collections of White Porcelain from the Dehua
kilns," *Collected Papers on Studies of Ancient Ceramics of Dehua Kilns*, 2001, p. 109.

Fig. 10.81 A seated statue
of Avalokitesvara with
gourd-shaped inscriptions of
"*He Chaozong*" and
"*Bojiyuren*" on the back,
produced in the Ming
Dynasty, height: 22.5 cm,
width: 14.5 cm, in the Palace
Museum

Fig. 10.82 Dehua white
glazed statue of Maitreya,
with a square-shaped
inscription in relief and seal
character on the back,
produced in the Ming
Dynasty, height: 16.2 cm,
width: 13.5 cm, in the Palace
Museum

decorative motifs were usually simple, like plum blossom, leaves, spiral patterns,
fret patterns, crabs, small animals, and bronze-like animal faces and *taijitu* (a *taiji*
diagram) in the Taoist style, even for articles of daily use (Figs. 10.85 and 10.86).

Dehua porcelain produced in the Ming Dynasty not only commanded an extensive
market at home, but also sold well abroad. As the American scholar John Ayers wrote,
the Dehua kilns from Fujian Province started porcelain production in the late Song

Fig. 10.83 Dehua white
glazed statue of
Bodhidharma crossing a
river, produced in the Ming
Dynasty, height: 25 cm,
width: 11 cm, in the Palace
Museum

Fig. 10.84 Dehua white
glazed incense burner with
lion-shaped lugs, produced
in the Xuande period of the
Ming Dynasty, height:
8.3 cm, mouth rim diameter:
12.1 cm, foot rim diameter:
9.7 cm, in the Palace
Museum

Fig. 10.85 Dehua white pot
with dragon pattern,
produced in the Ming
Dynasty, height: 13 cm, in a
private collection

Fig. 10.86 Dehua white cup
with gold tiger pattern,
produced in the Ming
Dynasty, diameter: 14 cm, in
a private collection

Dynasty (in fact it was the Tang Dynasty), and reached its peak in the seventeenth century. At the time, merchants from the West found Dehua porcelain unique and of a high quality. In the 1980s, over 700 pieces of Dehua wares were recovered from the Hatcher Cargo (1643), including bowls, cups, boxes with lids and statues of Avalokitesvara.[77]

Dehua white porcelain was exported to Europe in the late Ming Dynasty. For example, illustrated in Fig. 10.87 is a beautiful and elegant teapot. While it might have been produced as a wine pot, the Europeans used it as a teapot. Other pots of the

[77] John Ayers, "Blanc de Chine", *Transactions of the Oriental Ceramic Society* 51 (1986/1987): 13–36. *Blanc de Chine: Divine Images in Porcelain*. New York, 2002.

Fig. 10.87 Dehua white
glazed teapot, produced in
the Chongzhen period of the
Ming Dynasty, height:
19 cm, width: 17 cm, in the
Peabody Essex Museum in
the USA

same style have yet to be discovered, a smaller teapot of similar style was uncovered
from the Hatcher Cargo which could be dated back to 1643–1646. It looked ordinary
and its handle was on one side. The item in Fig. 10.87 is exquisite and features neat
engraving, which are quite extraordinary decorations for a teapot. The silversmith
who decorated it appears to have been quite touched and attracted by its simple and
elegant beauty, thus going to great efforts to decorate it. The pot and the interior of
the lid were not glazed.

In 2001, archaeologists launched a salvage excavation on the site of the Jiabeishan
kilns from the Ming Dynasty. Three dragon-shaped furnace sites were discovered and
a batch of tools, molds and porcelain samples unearthed. The tools were flat-bottom
cylindrical saggers; some were inscribed with characters (like *lai*, or come in Chinese)
and symbols. There were molds for bowls, cups, saucers, etc., which fitted with
unearthed porcelain wares. Most of the samples uncovered were milk white porcelain
(mentioned above; also known as "as white as lard and ivory" or "Chinese white"),
which were almost all made with molds, printings, decal, underglazed scratching
or simply plain-colored. Their varieties were varied, like bowls, saucers, cups, pots,
plates, pen washers, ink holders for daily use, and furnaces, vases, jars, lamps, boxes,
inkslabs, inkstone water holders, candlesticks and incense burners for decorative
purposes, as well as sculptures (Buddhist, Taoist and Confucian figurines and lion-
shaped candlesticks, etc.). Various decorations were applied to the objects such as
flowers, grass, rare birds, auspicious animals, *yunlei* and geometric patterns. Most
of the unearthed porcelain had the same or similar counterparts among overseas

collections. So, it seems the Jiabeishan kilns were a major production center of exported white porcelain among the Dehua kilns.[78]

Past records also often described white porcelain produced by the Dehua kilns, but there are no records of its production of blue and white porcelain. Since a piece of Dehua white vase with lion-shaped lugs housed in the Shanghai Museum is engraved with inscriptions in the blue and white style, some scholars hold that the Dehua kilns might also have produced blue and white porcelain in the Ming Dynasty. But some scholars differ with this view and believe that in the Zhengde period, the Dehua kilns only occasionally used cobalt blue as a raw material for porcelain production, but that in the entire Ming Dynasty, the Dehua kilns never made blue and white porcelain in large quantities.[79]

Since the 1970s to 1980s, some Kraak wares have been found or unearthed in Dehua and Pinghe counties in Fujian Province. As a matter of fact, there has long been an argument regarding the place of origin of "Kraak porcelain" and "Swatow wares." But in the early 1990s or even earlier, evidence of production was finally identified in Pinghe and Dehua. Subseqently, exported porcelain of the same varieties was also found in Japan and some Southeast Asian nations. Among them, Japan was found to have the most Kraak wares, occurring in almost every Japanese prefecture. For example, Aomori Prefecture, Iwate Prefecture, Tokyo, Aichi Prefecture, Kyoto, Nara Prefecture, Hyōgo Prefecture, Okayama Prefecture, Fukuoka Prefecture, and Nagasaki Prefecture have all reported blue and white porcelain produced by the Pinghe kilns, and especially Kraak porcelain.[80]

Additionally, a museum in Jakarta, Indonesia, houses a blue on white bowl inscribed with Arabic characters. On the outside it is painted with five circles, each inscribed with the same Arabic characters, meaning "There is No God except Allah and Muhammad, his prophet." The end of the sentence is concluded with a long character. Produced by the Dehua kilns, it is inscribed with "*chenghuanianzhi*" (Made in the Chenghua period) on its bottom.

Bowls with circles and spots produced by Dehua kilns have also been found in Africa. In Issue 1 of *Cultural Relics* in 1963, Mr. Xia Nai introduced a piece of Chinese blue and white porcelain unearthed from Tanganyika with an illustration in his article titled "Porcelain as Evidence of Exchange Relations Between China and Africa in Ancient Times." Similar porcelain with circles and spots has been unearthed from the Tongling, Lingdou, Houjing, Dongtou, Shipaige, Housuo,

[78] Li Jianan, "Archaeological Discovery and Research on Locations of Ancient Porcelain Exporters in Fujian Province," Chinese Society for Ancient Ceramics (ed.), *Studies on Ancient Chinese Ceramics* (Vol. 14), The Forbidden City Publishing House, 2008, p. 188.

[79] Ye Wencheng & Luo Lihua, "Several Issues regarding Blue and White Porcelain of the Dehua Kilns, Collected Papers of Studies on Dehua Porcelain," Editorial Committee of *Collected Papers of Studies on Dehua Porcelain* (ed.), 2002, p. 196.

[80] Ye Wencheng, "Production and Export of Blue and White Porcelain in Fujian Province," Chinese Society for Ancient Ceramics (ed.), *Studies on Ancient Chinese Ceramics* (Vol. 13), The Forbidden City Publishing House, 2007, p. 190.

Hongsi, Bufushan, Anyuan, Yaolong, Shipizai, Shilinzi, and Sutian kilns in Dehua, indicating that it was a variety widely produced among the Dehua kilns.[81]

From the information above, we can see that it was in the mid-Ming Dynasty that blue and white porcelain was produced in the Dehua kilns. But it is also possible that the inscriptions indicating such porcelain was produced in the Chenghua period was incorrect as it was a typical practice to put previous reign names on products produced later.

Some scholars point out that the Zhangzhou and Dehua kilns produced blue and white porcelain at around the same time. But shortly thereafter, the Zhangzhou kilns entered a peak period of blue and white porcelain production from the Wanli period to the end of the Ming Dynasty and into the early Qing Dynasty while the Dehua kilns were never found to have had large scale production of blue and white porcelain. So, from the existing discoveries, white porcelain was the major product of the Dehua kilns. Thus, large scale production of blue and white porcelain from the Dehua kilns might have occurred after the end of the Ming and early Qing periods, which is consistent with the current archaeological studies.[82]

Why the Dehua kilns produced blue and white porcelain in large quantities was mainly due to the substantial demand from the overseas market. In the Ming Dynasty, through governmental and non-governmental trade as well as the seven expeditions of Zheng He, blue and white porcelain was spread to the overseas markets and won favor with foreign consumers. In the late Ming Dynasty, especially, when Dutch colonists occupied Taiwan, Dutch merchants used Taiwan as a base and transported Chinese porcelain from Fujian to the whole world. Blue and white porcelain was a major product among these exports. As recorded in *The Dutch East India Company and Porcelain* by T. Ferk, "From around 1604, exported porcelain to Europe was almost all blue and white."[83] So in order to cater to the demands of the foreign markets, the Dehua kilns, as kilns producing for export, adjusted the varieties they produced in a timely manner and shifted to making blue and white porcelain. This became the main driving force for the development and prosperity of Dehua blue and white porcelain. Despite all the records regarding blue and white porcelain produced by the Dehua kilns, so far very few articles have been discovered. The author has visited the Dehua Ceramics Museum and also examined many records, but has scarcely seen any real blue and white Dehua wares from the Ming Dynasty, including photos.

[81] See Footnote 80.

[82] Li Jianan, "Research on the Production and Circulation of Ancient Blue and White Porcelain in Fujian Province from the Perspective of Archaeological Discovery," Chinese Society for Ancient Ceramics (ed.), *Studies on Ancient Chinese Ceramics* (Vol. 13), The Forbidden City Publishing House, 2007, p. 202.

[83] Cai Yi & Liu Wei, "Analysis of the Influence of Jingdezhen Blue and White Porcelain on the Development of Blue and White Porcelain in Fujian Province," Chinese Society for Ancient Ceramics (ed.), *Studies on Ancient Chinese Ceramics* (Vol. 13), The Forbidden City Publishing House, 2007, p. 283.

10.5.2 The Zhangzhou Kilns

10.5.2.1 Locations and Products of the Zhangzhou Kilns

"Zhangzhou kilns" is a general name for kilns in Zhangzhou, Fujian Province in the Ming and Qing dynasties. The Zhangzhou kilns were located in counties like Pinghe, Zhangpu, Nanjing, Yunxiao, Zhaoan and Hua'an. Among them, the kilns in Nansheng and Wuzhai in Pinghe County were especially concentrated and representative. Since the 1980s, archaeologists have launched several rounds of research on these regions. Since 1994, staff from the Fujian Museum have initiated archaeological investigations on the Huazailou kiln in Nansheng, the Dalong and Erlong kilns in Wuzhai (1994), the Tiankeng kiln in Nansheng (1997) and the Dongkou kiln in Wuzhai (1998), and uncovered a plethora of findings.

The prosperity of the Zhangzhou kilns is probably around the late Ming and early Qing dynasties. The Dutch scholar Barbara Harrisson writes that such porcelain was first produced in the sixteenth century and ceased production in the seventeenth century. Until 1662, Fujian was under the control of Zheng Chenggong, a Ming loyalist who resisted the Qing conquest of China in the seventeenth century. When the Jingdezhen kilns were destroyed in war, the Zhangzhou kilns, under the protection of Zheng Chenggong, remained intact and continued operation and export.[84] Thus, based on their advantageous geographic location, the Zhangzhou kilns boomed while the Jingdezhen kilns suffered from wars and had difficulty exporting.

Items excavated reveal that most products of the Zhangzhou kilns were blue and white porcelain, with a small amount of white porcelain, celadon, blue glazed porcelain, brown glazed porcelain and *wucai* ware (also known as red and green ware). Blue and white porcelain appeared blue gray, blue black, or green black, but mostly blue gray. Its clay was white or gray white and usually unglazed at the bottom. Large articles like plates and bowls often had a gritty bottom while on the interior of the bottoms of bowls and saucers there were usually laying marks from stacked firing.

Regarding the texture of Zhangzhou porcelain, Western documents record that "Zhangzhou porcelain was thick, with a gritty and glazed bottom."[85] In the late seventeenth century, Louis le Comte, a French Jesuit, also described Zhangzhou wares by saying that "Those wares brought from Fujian were not as good as rumor had it. They were black and rough, even worse than our 'Fayence'." This shows that at the time these products were produced to fill a gap in Jingdezhen's capacity to export. Given the limited production opportunity, the quality of the products could hardly be guaranteed. This is from the historical record. The author has also viewed some very exquisite blue and white porcelain from the Zhangzhou kilns that were produced at this time. For example, Fig. 10.88 is a piece of blue and white porcelain

[84] Barbara Harrisson, *Swatow in het Princessehof: The Analysis of a Museum Collection of Chinese Trade Wares from Indonesia*. Leeuwarden, the Netherlands, 1979.

[85] Michael Flecker, "A Cargo of Zhangzhou Porcelain Found off Binh Thuan Province," Vietnam, *Oriental Art* 48 (5, 2002/2003): pp. 57–63.

from the Zhangzhou kilns housed in the Museum of East Asian Art. Its decoration is clearly in the "Shonzui" style. While the author categorizes "Shonzui" porcelain as products of the Jingdezhen kilns, it was in fact difficult to tell if they were all produced by Jingdezhen. Because "Shonzui" porcelain was produced for export, there was virtually no marks to indicate its place of production. So, as indicated by the museum, if this piece of treasure was really produced by the Zhangzhou kilns, we should take a fresh look at the position of the Zhangzhou kilns in the ceramic history of China. Perhaps the Zhangzhou kilns are more important than we thought. In the Wanli period, Jingdezhen had been confronted with the depletion of the soil on Macang Mountain, though luckily it soon discovered new soil resources on the nearby Kaolin Mountain. Despite this, during this short interregnum, new products were required to supply the emerging international market in the sixteenth and seventeenth centuries. Besides, wars also disrupted production in Jingdezhen. Thus, kilns in coastal regions, like the Zhangzhou kilns, could have made good use of this opportunity and supplied the huge export demands and enhanced their own productivity. In past research, such a possibility has been understudied because few of these products earmarked for export could be found at home, and those that did remain at home were mainly export rejects. With the advance in information and people-to-people exchange, scholars are now able to visit museums around the world and see ancient exported porcelain with their own eyes. In addition, with technological advances, the capacity to salvage sunken ships and conduct underwater archaeological investigations is improving, so further studies into this issue are under way and those buried secrets are awaiting discovery. With the limits of this manuscript, we are only able to offer a brief introduction to the Zhangzhou kilns. However, the author believes there will be treatises discussing the Zhangzhou kilns specifically in the near future.

10.5.2.2 Target Markets of the Zhangzhou Kilns

Some scholars argue that thanks to foreign consumer admiration for blue and white porcelain produced in Fujian Province, especially for Kraak and Swatow porcelain, their producers, such as the Zhangzhou kilns, enjoyed rapid development. Their popularity also indicates that blue and white porcelain produced in Fujian was an important part of foreign exports.[86] We should therefore understand that the Zhangzhou kilns were an important supplier to the overseas market.

According to current archaeological research, blue and white porcelain produced by the Zhangzhou kilns was also supplied to local and neighboring regions, as some pieces have been found in tombs in Pinghe and Zhangpu. Zhangzhou blue and white porcelain was also excavated from the ruins of the Weihui Temple in Yunxiao County. In 2005 when the Fujian Museum's Institute of Archaeology launched an excavation

[86] Ye Wencheng, "Production and Export of Blue and White Porcelain in Fujian Province," Chinese Society for Ancient Ceramics (ed.), *Studies on Ancient Chinese Ceramics* (Vol. 13), The Forbidden City Publishing House, 2007, p. 194.

Fig. 10.88 Zhangzhou blue
and white cup with lid,
produced in the Tianqi
period of the Ming Dynasty,
height: 8.9 cm, in the
Museum of East Asian Art

campaign on Lianhuachi Mountain in Zhangzhou, a batch of blue and white porce-
lain produced by the Zhangzhou kilns in the late Ming and early Qing period was
uncovered. Among the finds there were bowls, plates, saucers, and more, decorated
with poems and flowers. The relevant archaeological findings are currently being
processed. Among these discoveries, not much Zhangzhou blue and white porcelain
was found. Even within a larger range, at the provincial level or national level, there
has been no systematic report of discoveries of Zhangzhou blue and white porcelain
to date. This shows that it probably did not occupy a large share of the domestic
market in its day.

As most Zhangzhou blue and white porcelain was exported, some items have been
found abroad. From the end of 1998 to early 1999, the Underwater Archaeology
Research Centre of the National Museum of China organized some experts for an
archaeological investigation in the Xisha Islands and found a batch of samples of
blue and white porcelain produced by the Zhangzhou kilns in a sunken ship. The San
Diego, a Spanish galleon sunk in 1600 and discovered off the coast of the Philippines,
the Witte Leeuw, a Dutch sailing ship sunk in 1613 and found around Saint Helena,
The Hatcher, sunk in the South China Sea in 1643, and the Binh Thuan, sunk in the
South China Sea in the late Ming Dynasty, were all found laden with Zhangzhou
blue and white wares.[87]

A number of blue and white wares have been identified or excavated from several
ancient ruins in various places including Japan and Southeast Asia. For example,
in the Kansai region of Japan, including Osaka, Nagasaki, Sakai and Hirado, large

[87] Li Jianan, "Research on the Production and Circulation of Ancient Blue and White Porcelain in
Fujian Province from the Perspective of Archaeological Discovery," Chinese Society for Ancient
Ceramics (ed.), *Studies on Ancient Chinese Ceramics* (Vol. 13), The Forbidden City Publishing
House, 2007, p. 203.

amounts of Zhangzhou blue and white porcelain and *wucai* wares (known as "Gosu polychrome" in Japan) and small amounts of monochrome glazed porcelain were unearthed from a stratum coinciding with the second half of the sixteenth century to the first half of the seventeenth century. Indonesia was also found to hold many unearthed Zhangzhou wares. For more details, books like *Swatow, The Chinese Ceramic Found in Indonesia* and *16–17 Century Ceramics of Zhangzhou Kilns Found in Indonesia* can provide more information on China's ancient trade in porcelain. In addition, the National Museum of Indonesia has special showcases for Zhangzhou blue and white porcelain, *wucai* wares and plain tricolor porcelain. The University of Michigan houses a batch of cultural relics from the Philippines. Among them, there are a considerable number of Zhangzhou wares uncovered from many ruins and tombs in the Philippines. In the Topkapi Sarayi Museum in Istanbul, Turkey, there are also some pieces of Zhangzhou porcelain, which according to some scholars, were transported to the then Ottoman Empire via Egypt after it was conquered by the empire.

Fustat, in the southern suburbs of Cairo in Egypt was once the most famous trading port in East Africa. A large amount of Chinese porcelain has been discovered in the ruins of Fustat, including blue and white porcelain, *wucai* wares and monochrome glazed porcelain produced by the Zhangzhou kilns, according to recent reports.[88]

Export porcelain from the Zhangzhou kilns was also documented in the West. For example, the British scholar Jorge Welsh wrote that Chinese, Portuguese and Dutch merchants were engaged in extensive barter exchange in Japan and Southeast Asia, trading Zhangzhou porcelain for spices. Zhangzhou porcelain had also become family heirlooms and symbols of social positions in Indonesia, Borneo (now Kalimantan), and the Philippines.[89] Some Zhangzhou porcelain was even transported to the American colonies via Britain. Manila Mail liners also traded many Zhangzhou wares to New Spain, established during the Spanish colonization of the Americas, as revealed by unearthed articles from Constitution Square in Mexico.[90] All these suggest that, despite a short life span, the Zhangzhou kilns had a significant production capacity and a lasting influence.

What is worth noting is that by the end of the Ming Dynasty, Europeans basically knew nothing about Chinese faience. Most of their Chinese imports were blue and white porcelain. Even the founding of the Zhangzhou kilns was to supply foreign exports. But the Zhangzhou kilns not only produced blue and white porcelain; they also produced red and green porcelain which was earmarked for Southeast Asian nations and Japan. Illustrated in Fig. 10.89 is a Zhangzhou plate, now housed in the Museum Boijmans Van Beuningen in Rotterdam. It is only one piece amongst the

[88] Li Jianan, "Research on the Production and Circulation of Ancient Blue and White Porcelain in Fujian Province from the Perspective of Archaeological Discovery," Chinese Society for Ancient Ceramics (ed.), *Studies on Ancient Chinese Ceramics* (Vol. 13), The Forbidden City Publishing House, 2007, p. 204.

[89] Jorge Welsh, *Zhangzhou Export Ceramics: The So-Called Swatow Wares*, by Teresa Canepa. London, 2006, p. 50.

[90] William R. Sargent, *Treasures of Chinese Export Ceramics: From the Peabody Essex Museum.* Distributed by Yale University Press, 2012, p. 162.

Fig. 10.89 Zhangzhou red
and green scenery plate,
produced in the Wanli
period, rim diameter:
42.8 cm, foot diameter:
19.5 cm, height: 9.7 cm, in
the Museum Boijmans Van
Beuningen

extensive collections of Chinese porcelain in the museum. It is a large, deep plate with
its rim flared up, its bottom glazed (albeit unevenly), and with grit and production
marks evident. It is glazed in iron red, green and turquoise on both the exterior and
the interior. In the center it is painted with a complex landscape, decorated with
rugged stones, ships, a bridge, towers and a pavilion. Such scenes are often seen
in Jingdezhen blue and white porcelain. So maybe the Zhangzhou kilns copied the
style from the Jingdezhen kilns. In addition, on the edge of the main motif, there
are six oval patterns with knuckled edges decorated with aquatic plants, pine trees
and river scenery inside and half-moon-shaped flowers and lozenge-shaped patterns
outside. They look stunning against the background of densely decorated flowers and
spiral-shaped patterns. On the exterior of the plate there are four large red ribbons.
This decorative style is very similar to that of Kraak wares, representing the fashion
of the era.

Christiaan J. A. Jörg wrote in *Famille Verte: Chinese Porcelain in Green Enamels*
that these kinds of plates are usually called Swatow plates. However, they were
produced in the Zhangzhou kilns, Fujian Province, not in Swatow, and green enamel
was applied to them. Completed in a very short time, they appear coarse, but also
have their own charms. The decorations of these plates usually imitate the Jingdezhen
exports.[91]

In addition, the article illustrated in Fig. 10.90 is a piece of red and green ware
produced by the Zhangzhou kilns in the Wanli period for the Japanese market. It is
now housed in the Museum of East Asian Art.

[91] Christiaan J. A. Jörg, *Famille Verte: Chinese Porcelain in Green Enamels*. Groninger Museum,
2011, p. 14.

Fig. 10.90 Zhangzhou red and green plate with flower pattern, produced in the Wanli period, diameter: 38.1 cm, in the Museum of East Asian Art

10.5.2.3 Differences Between Zhangzhou "Kraak" Porcelain and Jingdezhen "Kraak" Porcelain

If Zhangzhou blue and white porcelain was produced to meet foreign demands that Jingdezhen kilns had failed to cover, then this was because of the advantageous geographic location of the Zhangzhou kilns. But were there any differences between Zhangzhou blue and white porcelain and that produced by the Jingdezhen kilns? And if there were, what were they?

We can see that the Zhangzhou kilns had a relatively shorter history of producing blue and white porcelain than the Jingdezhen kilns, which was mainly at the end of the Ming and early Qing dynasties. Thus, the design of the Zhangzhou products were much simpler and their major products were daily use articles such as bowls, plates and pots, among which large plates were especially representative. Among the blue and white porcelain produced by the Zhangzhou kilns, one type of "Kraak" plate with folded rims was quite similar to the style of the Jingdezhen kilns. Custom-made for the Middle East and European markets, such plates shared some features with silver ware, gold ware, glass ware and pottery from the local region from the 9th to sixteenth century, so they were very popular in these regions in the sixteenth century. In addition, the designs of most Zhangzhou kiln blue and white ware had no direct links with the Jingdezhen kilns, but had some association with large plates produced by the Jingdezhen kilns in the late Yuan and early Ming period.

"Kraak porcelain" originally referred to all exported porcelain from the end of the sixteenth century and the early seventeenth century. Later, this term referred especially to the most representative blue and white porcelain with motifs such as

flowers, grass, insects, birds, animals, scenery and human figures at the bottom and six to eight rectangular panels with auspicious symbols and flowers as decorations. Porcelain with such decorative styles was basically all targeted at foreign markets and was not very popular on the domestic market. Thus, the Zhangzhou and Jingdezhen kilns should both have produced wares based on foreign demands and tastes, without any direct relation between themselves. According to published information, panels in radial patterns had been applied to Islamic pottery long before "Kraak porcelain." For example, a color-painted pottery plate from 1525, now housed in the Louvre Museum, also carries similar patterns. The Jingdezhen and Zhangzhou kilns must have learned from the foreign culture and developed and applied this to "Kraak porcelain." In the painting panels, both kilns adopted domestic motifs, with some similarity to each other, but not completely.

One difference between "Kraak porcelain" produced by the two kilns is that the rim lines at the bottom of Jingdezhen Kraak porcelain usually corresponded with that of the walls in polygonal or circular shapes while for Zhangzhou Kraak wares, they are basically all in circular shapes. Also, both have paintings in the panels. For Jingdezhen porcelain, the paintings appear rigorous and graphic with neat lines outside. In contrast, the patterns on Zhangzhou wares appear loose, free and casual. They also differ in painting technique. For instance, the Jingdezhen kilns often drew outlines before filling in colors while the Zhangzhou kilns sometimes combined outlining with coloring and sometimes painted in a boneless style, meaning forms were made with ink and color washes rather than outlines. Illustrated in Fig. 10.91 is a Zhangzhou blue and white Kraak plate with scholar patterns, similar to its counterparts produced by the Jingdezhen kilns in terms of motif, but more casual, simpler and looser. In addition, some of the Zhangzhou blue and white porcelain adopted the one-stroke technique from the Yuan Dynasty in painting, which was also used in red and green porcelain produced by the same kilns (Figs. 10.92, 10.93 and 10.94).

Apart from "Kraak porcelain," decorations of Zhangzhou blue and white porcelain produced in the late Ming Dynasty were quite different from that of the Jingdezhen kilns in terms of motif and design. In fact, in the late Ming and early Qing period, decorations on Jingdezhen blue and white porcelain which were greatly affected by the then woodcut and drama art were very traditional, paying meticulous attention to realism and delivering a simple yet intense arrangement. Highlighting the connotation of motifs, Jingdezhen blue and white porcelain adopted flowers, grass, insects, water birds and animals in its decoration, inheriting the traditional ink and wash painting style. The Zhangzhou kilns were different. Their decorations were as complex as possible, vigorous and similar to the Islamic and Western styles.

When analyzing the origin of the decorations on blue and white porcelain, we can see that porcelain like "Kraak wares" with paneled decorations had been popular since the Jin and Yuan dynasties. However, panels on Chinese porcelain were usually two to four loosely arranged lozenge-shaped or cherry-apple-shaped patterns on the belly of *zhuoqi* articles. In contrast, panels on Zhangzhou blue and white porcelain

Fig. 10.91 Zhangzhou blue and white Kraak plate with erudite scholar patterns, produced in the Ming Dynasty, in the Istanbul Museum in Turkey

Fig. 10.92 Zhangzhou blue and white plate with a pine tree, bamboo and plum blossoms, produced in the Wanli period of the Ming Dynasty, diameter: 40.2 cm, in the Museum of East Asian Art

were often tightly arranged round-shaped, windowpane-shaped, or stretched-flower-shaped patterns on plates and saucers. Such decorations were rarely seen on traditional Chinese porcelain while popular on color-painted pottery in places like Iran in the thirteenth and fourteenth centuries. They both painted colors outside panels

Fig. 10.93 Blue and white
bowl with flowers, grass and
water birds, paneled
decorations and folded rim,
produced in the Wanli period

Fig. 10.94 Blue and white
bowl with flowers, grass and
a small bird, paneled
decorations and folded rim,
produced in the Wanli period

and were fully decorated with brocade patterns. The difference is that the brocade
patterns on Zhangzhou ware were often from Chinese silk products.

This demonstrates the fact that the decorations on Zhangzhou blue and white
porcelain, while featuring some Chinese characteristics, were mainly drawn from the
Western arts. It therefore appears that such Zhangzhou products were custom-made
based on specific foreign demands.

In terms of motifs, the Zhangzhou kilns adopted many traditional Chinese patterns,
like flowers, birds, mountains, water, animals and human figures, just like the
Jingdezhen kilns. But in painting, Jingdezhen porcelain featured the traditional
Chinese ink and wash painting style while Zhangzhou products were much affected

Fig. 10.95 A Kraak plate, produced in the Ming Dynasty, in the Peabody Essex Museum

by the Western style.[92] For example, this author viewed a Kraak plate produced in around 1590 in the Peabody Essex Museum in the USA. Its description indicated that it was produced in Jingdezhen. But in the opinion of the author, it must have been produced in Zhangzhou, not Jingdezhen, as it was obviously custom-made for foreign export, with its main motif drawn from Western legends (Fig. 10.95).

Illustrated in Fig. 10.96 is a red and green plate. It is not a blue and white ware, but its decorative style is very close to that of Kraak porcelain, with Persian inscriptions in the green and red circles and on the lip. The inscription within the red circle reads: "Ah, Mohammed/ Ah, Allah/ Amad/ Mohammed/ Abu Bakr/ Osman Umar/ Allah." Those on the lip might be understood as: Praise be to God, my great Lord.

Within the green circles, there are four different inscriptions, each repeated twice:

I ask for God's forgiveness

There is no God but Allah, and Mohammed is God's messenger

Ah, Opener

The king of Salem.[93]

Similar porcelain earmarked for foreign export could frequently be seen in the Zhangzhou kilns.

Zhangzhou porcelain on one hand featured a foreign style and on the other hand, imitated Jingdezhen porcelain. In Fig. 10.97, the plate's decorations were copied

[92] Zhou Lili, "Discussion of Blue and White Porcelain Produced by the Zhangzhou Kilns in the Late Ming and Early Qing Dynasties," Chinese Society for Ancient Ceramics (ed.), *Studies on Ancient Chinese Ceramics* (Vol. 13), The Forbidden City Publishing House, 2007, p. 236.

[93] William R. Sargent, *Treasures of Chinese Export Ceramics From the Peabody Essex Museum.* Distributed by Yale University Press, 2012, p. 112.

Fig. 10.96 Zhangzhou red and green plate, produced in the Longqing period of the Ming Dynasty, diameter: 37.7 cm, in the Peabody Essex Museum

from the Kraak wares of Jingdezhen, with 16 parts in the interior and two dragons playing with a ball on the exterior bottom. The image of two dragons playing with a ball was very rarely seen in Kraak porcelain as it is a typical Chinese motif. The 16 parts on the plate includes 8 large parts, painted with peony, lotus, chrysanthemum and pomegranate, and 8 small parts in between, painted with coins and fish scales. Additionally, there are many "卍" symbols on the rim. The exterior is inscribed with light blue characters and the base is glazed.[94]

The author also notes that with changes in clay after the Wanli period, most Kraak porcelain produced in Jingdezhen carried "insect marks," a phenomenon where the molten glaze withdraws into "islands" leaving bare clay patches. For example, the two plates illustrated in Figs. 10.98 and 10.99, housed in the Peabody Essex Museum and Museum of East Asian Art respectively, have a shared feature: while delicately painted, there are clear crawl marks on the rim. Illustrated in Figs. 10.100 and 10.101, the two plates, also housed in the Peabody Essex Museum and Museum of East Asian Art respectively, while relatively coarsely painted, have smooth rims.

Apart from blue and white porcelain and red and green porcelain, the Zhangzhou kilns also produced many other varieties unique to themselves. For example, in Fig. 10.102, though also a piece of red and green ware, its green appears relatively cold and different from that of the Jingdezhen and other kilns. In addition, its motif could have originated from a part of a European map. This plate is thus named a marine chart plate. In the center, there is a green belt marked with 24 black characters circling a Chinese compass. On the compass there are also some characters. At the same time, the green belt is also surrounded by 24 red characters, representing the Ten Heavenly Stems and Twelve Earthly Branches, which were used in combination

[94] William R. Sargent, *Treasures of Chinese Export Ceramics: From the Peabody Essex Museum.* Distributed by Yale University Press, 2012, p. 170.

Fig. 10.97 Zhangzhou red and green plate, produced in the Longqing period of the Ming Dynasty, diameter: 37.6 cm, in the Peabody Essex Museum

Fig. 10.98 Jingdezhen blue and white Kraak plate with crickets, height: 8.4 cm, diameter: 52.6 cm, in the Peabody Essex Museum

as the most important counting system in the Chinese calendar. On the rim, there are iron-red symbols of the Eight Trigrams, each standing for Heaven, Lake, Fire, Thunder, Wind, Water, Mountain and Earth. Between the Eight Trigrams and the Ten Heavenly Stems and Twelve Earthly Branches are Portuguese galleons, fish, marine organisms and mountain ridges. Among them, the galleons and marine organisms are typical signs used on European maps in the fifteenth and sixteenth centuries. The ocean and the sky are manifest in almost abstract iron-red spirals, encompassing four constellations. The land was the mysterious Penglai Island, which is often said to be

Fig. 10.99 Jingdezhen blue
and white Kraak plate with
four deer pattern, produced
in the Wanli period of the
Ming Dynasty, diameter:
20.5 cm, in the Museum of
East Asian Art

Fig. 10.100 Zhangzhou
blue and white Kraak
porcelain with Li Bai, a great
Chinese poet, drunk pattern,
produced in the Wanli
period, height: 6 cm,
diameter: 21 cm, in the
Peabody Essex Museum

where the Eight Immortals travel to have a banquet.[95] It is quite interesting how a single plate could link traditional Chinese culture and Western navigation together. What is more, the Zhangzhou kilns also produced turquoise-painted porcelain, brown

[95] Brian McElney, *Chinese Ceramics & The Maritime Trade Pre-1700*, in Museum of East Asian Art, Bath, 2007, p. 146.

Fig. 10.101 Zhanghzou
blue and white Kraak plate
with scenery and human
figure patterns, produced in
the Wanli period, diameter:
20.5 cm, in the Museum of
East Asian Art

glazed porcelain with engravings, and more, which were quite special and unique.
But studies on these wares at home are very rare (Figs. 10.103 and 10.104).

Fig. 10.102 Zhangzhou red
and green plate with a
marine chart pattern,
produced in the Wanli
period, diameter: 37.6 cm, in
the Peabody Essex Museum

Fig. 10.103 Zhangzhou brown-glazed jar with engraved cranes, produced in the Wanli period, diameter: 20.5 cm, in the Museum of East Asian Art

Fig. 10.104 Zhangzhou plate with a turquoise-colored lion, produced in the Wanli period, diameter: 15.1 cm, in the Museum of East Asian Art

10.5.3 The Chaozhou Kilns

By the end of the Ming Dynasty, the Chinese ceramics industry had a broad overseas market, thanks to the popularity of blue and white porcelain. Meanwhile, in the Age of Discovery, many European nations sent merchant ships to China and purchased large quantities of porcelain, especially blue and white porcelain, greatly facilitating development of the ceramics industry in the coastal regions. Apart from kilns in Fujian, where the famous "Swatow wares" were produced, kilns in the Guangdong region also produced many "Chaozhou wares" for export.

From unearthed blue and white porcelain produced in Guangdong, we can see the maturity of blue and white porcelain must have occurred in the mid to late Ming Dynasty at the earliest, when porcelain production was common. To date, kilns producing blue and white porcelain have been found in over a dozen counties and cities like Raoping, Huilai, Jieyang, Boluo, Huidong, Haifeng, Lianjiang, Luoding, Shixing, Gaozhou, Xingning, Dapu, Pingyuan, Wuhua and Xinfeng.[96]

Situated in Chaozhou, the Chaozhou kilns were a major producer of blue and white porcelain in Guangdong Province. Historically, Chaozhou was the political, economic and cultural center for the eastern Guangdong region, as well as being an important hub of porcelain production in Guangdong. The current Shantou, Jieyang, Meizhou and Zhangpu were all under the administration of Chaozhou at some stage in history. Under the reign of Emperor Qianlong in the Qing Dynasty, Chaozhou was said to "govern nine counties under its administration." Kilns producing blue and white porcelain in Chaozhou were spread all over the eastern Guangdong region, including in Dapu, Raoping, Huilai, Xingning, Wuhua, Pingyuan, Jiexi, Fengshun, and Fengxi. With an advantageous geographic location, the eastern Guangdong region was endowed with abundant natural resources for porcelain production. Additionally, with a profound history and intimate cultural interaction with the Central Plains region, the Chaozhou kilns gradually developed their own ceramic culture.

Chaozhou has a long history of porcelain production. In the Tang Dynasty, it was said to have 36 kilns on the two sides of the Hanjiang River, including the "Shuidong" kiln on Bijiashan Mountain, to the east of Chaozhou and the Fengshan kiln to the west. From the Five Dynasties Period to the Song Dynasty, the ceramics industry in Chaozhou continued to grow. Especially after 1068, under the reign of Emperor Shenzong (1048–1085), Wang Anshi's New Policies were introduced, initiating sweeping reforms. Under the reforms, it was provided that foreign trade be settled not in gold, silver or copper, but instead it was to be a barter exchange with silk and porcelain, which greatly stimulated and expanded foreign trade. At the same time, situated between Quanzhou where the Maritime Trade Bureau was based and Guangzhou, an important port, Chaozhou was eligible to conduct foreign trade at both places. Thus, Chaozhou was well placed as a production base from the Tang and Five Dynasties periods, boasting abundant clay and fuels and convenient waterway

[96] Feng Suge, "Guangdong Overseas Transport and Ancient Ceramics Export," Chinese Society for Ancient Ceramics (ed.), *Studies on Ancient Chinese Ceramics* (Vol. 13), The Forbidden City Publishing House, 2007, p. 287.

transportation enabling foreign export. With the expansion of the scale of its ceramic production, Chaozhou rapidly grew to be an important base for porcelain export in the Northern Song Dynasty and was known as "the ceramic capital of Guangdong Province in the Song Dynasty." Like the Dehua kilns, the Chaozhou kilns also copied *qingbai* porcelain from Jingdezhen and produced and exported it in large quantities in the Song Dynasty. In the Yuan Dynasty, afflicted by war, the Chaozhou kilns declined, but quickly recovered.

From the above, we can see that the Chaozhou kilns had a time-honored history in porcelain production. But this was not all. In fact, the Chaozhou kilns also had a long history in making blue and white porcelain. Mr. Li Bingyan argues that the Northern Song Dynasty Bijiashan kiln painted porcelain already displayed features of blue and white porcelain and shows that it had grasped the basic production techniques of blue and white porcelain and was capable of sample production based on customer demand. In the Yuan, Ming and Qing dynasties, blue and white porcelain was largely demanded by the overseas market, especially the Middle Eastern market, thus promoting its production in regions like Gaopo, Jiucun and Huilai.[97] So it seems that the Chaozhou kilns were among the first to produce blue and white porcelain in the coastal regions of Guangdong and Fujian. Around the Bijiashan kiln, there is abundant cobalt ore and even to this day there are cobalt factories there. The blue and white porcelain produced there thus has its own special color, usually with brownish yellow, rust, or light blue spots, which is caused respectively by some small amounts of copper oxide, manganese oxide or cobaltous oxide in the glaze.

The author has learned of a concept called "coastal ceramic producers" online, which indicates that "coastal ceramic producers" are the links between domestic porcelain producers and overseas markets. When products of a certain kiln became popular in the international market, the coastal ceramic producers in port regions would imitate the success and push their own products onto the market. Thus, coastal ceramic producers would often produce varieties popular on the international market, and the Chaozhou kilns were no exception. The Chaozhou kilns produced large amounts of blue and white porcelain for export in the Ming Dynasty in order to meet the demands that Jingdezhen failed to cover. In the mid- and late-Ming Dynasty, under the influence of the private kilns in Jingdezhen, potters from kilns in regions like Gaopo, Jiucun and Huilai began attempting to make blue and white porcelain with simple paintings of cobalt blue. Through trial and error, they eventually produced smooth, jade-like daily use porcelain using high-quality kaolin and firing at 1300 °C. They were thus able to meet the market demand successfully.[98]

[97] Li Bingyan, "Blue and White Porcelain of the Chaozhou Kilns," Chinese Society for Ancient Ceramics (ed.), *Studies on Ancient Chinese Ceramics* (Vol. 13), The Forbidden City Publishing House, 2007, p. 299.

[98] Li Bingyan, "Blue and White Porcelain of the Chaozhou Kilns," Chinese Society for Ancient Ceramics (ed.), *Studies on Ancient Chinese Ceramics* (Vol. 13), The Forbidden City Publishing House, 2007, p. 306.

10.5.4 Yunnan Blue and White Porcelain

Yunnan blue and white porcelain was already quite developed in the Yuan Dynasty and with the advent of the Ming Dynasty, it enjoyed further development. The mid- and late-Hongwu period to the Chenghua period was a boom era for Yunnan blue and white porcelain after its prosperity in the late Yuan Dynasty. During this period, its blue and white porcelain was unique in style and exquisite in design and production, making Yunnan the largest producer of blue and white porcelain in Southwest China. Meanwhile, during this period, Yunnan blue and white porcelain began to spread to Southeast Asian nations like Vietnam, greatly expanding its influence.[99]

In the early Ming Dynasty, Yunnan blue and white porcelain continued to develop on the back of its prosperity in the late Yuan Dynasty, thanks to many historical and social factors. In the early Ming Dynasty, the government continued to have garrison troops, peasants and merchants open wasteland and grow food grain on a large scale in Yunnan. In order to strengthen the frontier region, the government recruited around 400,000–500,000 laborers of Han ethnicity from the inland regions to relocate to Yunnan and engage in opening wasteland for farming. At the same time, some wealthy merchants were also attracted by Yunnan's abundant resources and broad market, so many flooded to this region for farming, creating an upsurge in Han migration to Yunnan.

Meanwhile, in the early Ming Dynasty, transportation in Yunnan enjoyed further development thanks to the Yuan post system. The government set up a wide network of post and lodging stations for postmen as well as garrison stations along post routes to ensure traffic security. Since the early years of the Ming Dynasty, a traffic system linking post stations, military fortresses and sentry posts had taken shape. The garrisoned soldiers, while guarding the homeland security, also shouldered the responsibility of safeguarding traffic security, which to some extent promoted local economic development and strengthened Yunnan's exchange with the inland regions.[100] With the development of traffic and population migration, economic and cultural ties between Yunnan and the inland were constantly enhanced, greatly facilitating economic progress and the development of the handicraft industry in Yunnan.

According to discoveries to date, apart from kilns which had produced blue and white porcelain from the Yuan Dynasty, such as the Jianshui, Yuxi and Luochuan kilns from Lufeng County, there also emerged the Bailongjing kilns from Lufeng County and the Jingtian kilns from Fengyi Town, Dali City which mainly produced blue and white porcelain. In terms of production technique, from the mid-Hongwu to the Chenghua periods, the Jianshui, Yuxi and Luochuan kilns largely inherited the traditions of the late Ming and made some further improvements.

[99] Wang Kun, "On the Rise and Fall of Blue and White Porcelain in Yunnan," Chinese Society for Ancient Ceramics (ed.), *Studies on Ancient Chinese Ceramics* (Vol. 13), The Forbidden City Publishing House, 2007, p. 5.

[100] See Footnote 100.

Of these, the Jianshui kilns were the most representative. Situated in the north of Wanyao Village, about two km north of Jianshui County, the ancient sites of the Jianshui kilns can be classified into three groups from south to north. The first group included the Jiang, Gao, Daxin, Xiaoxin, Zhang and Yang kilns, centered around the Hong kiln. The second were the Huguang, He, Chen, Jiu, Old, New, Xiang, and twin Chens' kilns, centered around the Zhang kiln. The last covered the Daba, the old and new Pan kilns, the Antai, Tu, and Yuan kilns centered around the old Pan kiln. These kilns, old and new, were closely located with shards piling up like mountains, reflecting the rich history of the village in porcelain making. Named after family names, many kilns must have been family-run. Outsiders also helped produce porcelain, like people from "Huguang" (Hunan and Hubei) in the Huguang kiln, and kilns also changed with the times. This showed that there were abundant raw materials surrounding the Jianshui kilns. For instance, clay and pigment could be found in nearby Majiapo, Hongshuitang and Jinhuasi. Along with mountains and rivers, Wanyao Village was endowed with great advantages for producing porcelain. Thus, the advantageous geographic location, abundant fuels, clay and pigment in the region served as a solid foundation for the Jianshui kilns to produce blue and white porcelain.[101]

From the large amounts of blue and white porcelain unearthed from relic sites of the Jianshui kilns, we can see that compared with their counterparts, Jianshui blue and white porcelain had special local features. First, the design of the Jianshui products look simple, solemn, rough and thick, a far cry from the delicate and elegant style of Jingdezhen blue and white porcelain. Second, apart from large pots, most articles featured wide ring feet and a shallow or flat bottom. Generally, articles had ring or horizontal feet on a gritty bottom that was sometimes glazed; it was not a shallow bottom with a wide round foot or a flat bottomexcept for large pots. Third, with a high lime content, after firing, the glaze crawled markedly, leaving sand holes, air bubbles or cracklings on products. Additionally, since there was also a high iron and low sodium and potassium content in the glaze, the surface of Jianshui porcelain did not appear very smooth. Instead, it was a little green or yellow, not as attractive as the crystal-clear surface of Jingdezhen porcelain. Fourth, with a high content of manganese and iron in the pigment, after firing, Jianshui porcelain appeared dark gray, steel gray, blue gray or slate blue, which was again quite different from that of Jingdezhen. Fifth, in firing, the Jianshui kilns used support pins, saggers or stacked firing techniques. Sixth, Jianshui blue and white porcelain carried various decorative motifs and patterns, vigorous or vivid, painted in smooth strokes, different from but equally as spectacular as that on the blue and white porcelain produced by the private kilns in Jingdezhen.[102]

[101] Huang Xiaohui, "A Brief Account of Blue and White Porcelain from the Jianshui Kilns in Yunnan Province," Chinese Society for Ancient Ceramics (ed.), *Studies on Ancient Chinese Ceramics* (Vol. 13), The Forbidden City Publishing House, 2007, pp. 81–82.

[102] Huang Xiaohui, "A Brief Account of Blue and White Porcelain from the Jianshui Kilns in Yunnan Province," Chinese Society for Ancient Ceramics (ed.), *Studies on Ancient Chinese Ceramics* (Vol. 13), The Forbidden City Publishing House, 2007, p. 83.

Compared to the decorations on the blue and white porcelain made by private kilns, Jianshui kiln decorations were more varied and special. In terms of motif, there were geometric patterns, plants, animals, human figures, landscapes and courtyards, as well as auspicious symbols. These motifs, and especially the auspicious symbols, expressed the people's fervent wishes and sometimes reflected their livelihoods, social realities and civil practices. Geometric patterns, including brocade patterns, fret patterns, water waves with slashes, cloud patterns, and floral scrolls were put on the interior and exterior edges of bowls and plates, and the necks, shoulders, legs and ring feet of *yuhuchunping* and helmet-shaped jars as auxiliary decorations. Sometimes, such patterns were transformed or abstracted to supplement major motifs.[103]

From the blue and white porcelain produced in the early Ming Dynasty, we can see that the Yunnan ceramics industry continued to grow on the basis of the prosperity of the late Yuan Dynasty, especially the blue and white porcelain produced during the Hongwu period, which clearly inherited the designs, decorations and techniques applied in the late Yuan. After entering the Yongle period, the decorations on blue and white porcelain grew more and more simple, with a clear composition structure and smooth strokes. However, by the Xuande period, the decorations were increasingly varied, the lines thicker, colors darker and more and more lotus and chrysanthemum were applied. From the Zhengtong to the Tianshun periods, production of blue and white porcelain in Yunnan increased and featured multi-layered decorations of various types. Apart from animals and plants, which had been in vogue for a long time, motifs with human figures also came into use. At the same time, the glaze was a little yellowish, the blue was dark and strokes were smooth or heavy. By the Chenghua period, blue and white porcelain fell into two categories, a dark-gray-prone kind and a light-prone kind, with plants, animals, and human figures as motifs and tight, clean decoration structures. At this time, blue and white porcelain with kneeling children or animals painted with different shades of color were quite artistic.[104]

After the mid-Ming Dynasty, Yunnan blue and white porcelain started to decline as the local society was afflicted by turmoil, riots and wars. As it is recorded, "There has never been 15 consecutive war-free years for local officials."[105] Additionally, following this period, society was burdened with increasingly heavy taxes and corruption so that people led a miserable life.

After the mid-Ming Dynasty, massive flows of quality and inexpensive porcelain from Jingdezhen delivered shocks to the Yunnan ceramics industry to some extent. On one hand, developments in the transport system and business made it possible for large amounts of blue and white porcelain to enter Yunnan. On the other hand, boasting advanced technology, the Jingdezhen kilns mastered large-scale production

[103] Huang Xiaohui, "A Brief Account of Blue and White Porcelain from the Jianshui Kilns in Yunnan Province," Chinese Society for Ancient Ceramics (ed.), *Studies on Ancient Chinese Ceramics* (Vol. 13), The Forbidden City Publishing House, 2007, p. 84.

[104] Ge Jifang, "Yunnan Blue and White Porcelain in the Yuan and Ming Dynasties," *Chinese Blue and White Porcelain*, the People's Publishing House, 2003, pp. 34–36.

[105] Liu Kun, "Nanzhongzashuo, Mountains and Rivers," *Historical Records of Yunnan*, Vol. 11, p. 325.

and so produced products of fine quality at a low price. Under such circumstances, the local blue and white porcelain was overshadowed. With no competitive edge, the local products were gradually phased out of the market.[106]

Further, the demise of Yunnan blue and white porcelain was also associated with a change in the custom of cremation. Since the Nanzhao Kingdom (738–902), a polity centered on present-day Yunnan during the eighth and ninth centuries, some ethnic groups of the *Yi* language family had adopted the custom of cremation. After the Yuan Dynasty, local blue and white jars and pots served as major burial objects for cremation. Thus, in some sense, the boom in Yunnan blue and white porcelain during the Yuan and early Ming dynasties, especially jars, could not have been possible without this custom. After the Ming government banned cremation in its law, with severe punishments such as flogging or exile if it was violated, people's demands for blue and white wares were considerably reduced. Therefore, after the Ming Dynasty, there were obviously less large articles, and an increasing number of small articles. With blue and white jars as its most advanced and developed product, kilns in Yunnan would inevitably be affected by the abolition of cremation.[107]

According to recent discoveries of blue and white porcelain in Yunnan, production of the commodity was reduced after the mid-Ming Dynasty and the quality of products also dropped. Following the early Qing Dynasty, hardly any Yunnan blue and white porcelain can be identified, so it is highly probable that from the early Qing Dynasty, kilns in Yunnan had ceased production of blue and white porcelain.[108]

10.5.5 Guangxi Blue and White Porcelain

In the late Ming Dynasty, the huge consumer demand for blue and white porcelain not only spurred the development of the ceramics industry in coastal regions, but also in regions far away from Jingdezhen where its products failed to reach, especially in Guangxi.

Following archaeological research, some kilns producing blue and white porcelain have been identified in Guangxi. The oldest kilns to make blue and white porcelain were from the late Ming and early Qing period, while most kilns were after the mid-Qing Dynasty. Most of their products were also roughly made articles for daily use. Their designs were quite simple, including bowls, plates, saucers, vases, pots, *zun*, jars and spoons. Blue and white wares have been identified in

[106] Wang Kun, "On the Rise and Fall of Blue and White Porcelain in Yunnan," Chinese Society for Ancient Ceramics (ed.), *Studies on Ancient Chinese Ceramics* (Vol. 13), The Forbidden City Publishing House, 2007, p. 8.

[107] Wang Kun, "On the Rise and Fall of Blue and White Porcelain in Yunnan," Chinese Society for Ancient Ceramics (ed.), *Studies on Ancient Chinese Ceramics* (Vol. 13), The Forbidden City Publishing House, 2007, p. 9.

[108] Wang Kun, "On the Rise and Fall of Blue and White Porcelain in Yunnan," Chinese Society for Ancient Ceramics (ed.), *Studies on Ancient Chinese Ceramics* (Vol. 13), The Forbidden City Publishing House, 2007, p. 10.

regions like Guilin, Lingchuan, Quanzhou, Guanyang, Lingui, Fuyong, Zhaoping, Hezhou, Wuzhou, Cangwu, Liuzhou, Liujiang River, Guping, Pingnan, Beiliu, Xingye, Guigang, Hengxian County, Nanning, Chongzuo, Tiandong, Tianyang and Baise. Among them, around the tomb of the Jingjiang Prince of the Ming Dynasty, west of Yaoshan Mountain and east of Guilin, the most blue and white wares were unearthed, including plum vases, vases, *zun*, pots, bowls and plates.[109]

Studies on Guangxi blue and white porcelain are few. Here the author mainly cites some results of Yu Fengzhi. According to Yu, the production techniques of blue and white porcelain in Guangxi were imported from Jingdezhen. After the late Northern Song Dynasty, craftsmen from Jingdezhen went to Lingnan, south of the Nanling Mountains, a geographic area covering the modern Chinese provinces of Guangdong, Guangxi, and Hainan as well as modern northern Vietnam, in search of a favorable environment for opening up new kilns to produce white porcelain. Apart from Guangzhou and Chaozhou in Guangdong Province, they also established kilns in Tengxian County, Rongxian County and Beiliu, and produced white porcelain on a large scale. These areas were endowed with quality clay, abundant fuel and a developed transportation system, so their products could not only make their way into the inland markets, but also travel through the Xijiang River eastward to Guangzhou and then overseas. In the 200 years of development in Guangxi, white porcelain was not only engraved, scratched and molded on clay and glazed in brown, green and red, but also decorated with colored characters. Molded decorations were easy to apply and low cost. They were therefore suitable for productions of scale and popular in the market. In contrast, complicated decorations, featuring high costs, were not favored by consumers and thus were gradually squeezed out of the market.

The production and decoration techniques of white porcelain paved the way for the production of blue and white porcelain in Guangxi. In Lingtong Village, Pingzheng Town, Beiliu City, there lies an ancient blue and white kiln relic site. In the Song Dynasty, these kilns produced *qingbai* porcelain as there was quality clay in the local region. Archaeological research has revealed considerable amounts of blue and white shards, which were from incense burners, pillows, medium-sized and small bowls, cups, and plates, with bowls and plates forming the largest portion.[110]

According to research, four relic sites producing blue and white porcelain have been identified in Rongxian County, mainly in Liufu Village and Yangcun Village, Yangcun Town, south of Rongxian County, as well as Baifen Village, Langshui Town and Guyan Village. Samples collected at these sites vary but mainly consist of daily use articles, such as bowls, plates, saucers, pots, jars, cups, covers and support plates used in porcelain firing. All the bowls, plates and saucers had ring marks in the interior bottom and were glazed on the exterior bottom with a heart-shaped bulge, the same method of firing as that of Beiliu. Their clay also varied. Red clay was hard and soil

[109] Wei Renyi, "Blue and White Porcelain Unearthed in Guangxi and its kilns," Chinese Society for Ancient Ceramics (ed.), *Studies on Ancient Chinese Ceramics* (Vol. 13), The Forbidden City Publishing House, 2007, p. 309.

[110] Yu Fengzhi, "A Preliminary Exploration of Blue and White Porcelain Kiln Sites in Beiliu and Rongxian County in Guangxi," Chinese Society for Ancient Ceramics (ed.), *Studies on Ancient Chinese Ceramics* (Vol. 13), The Forbidden City Publishing House, 2007, p. 335.

red clay was loose. White, smooth clay, yellow clay and gray white clay were also present. Their blue color appeared dark gray or dark blue. The glaze at the bottom was light gray, steel gray, or dark green. Their decorations were mainly flowers in freehand style, including chrysanthemum, bamboo leaves, floral scrolls, webs, algae, fish and shrimps, rounds of chrysanthemum, "*Shou*" (Longevity) characters, and Tibetan characters. The design of bowls also varied, including some with an open mouth, others a tight mouth or in a funnel shape.[111]

When taking a general look at articles unearthed from Beiliu and Rongxian County, we find that in terms of design and decoration, most of them were produced in the mid-Ming to late Qing Dynasty, with a few produced in the Republican period. Articles produced in the Ming Dynasty included blue and white furnaces, bowls and pillows, with thick bodies, smooth, tight clay, pale blue bases, and blue or steel blue glazes. Their decorations were generally simple, bold, natural and vivid. At the bottom or foot, there were usually double rings or heart-shaped bulges.[112]

Blue and white porcelain in Guangxi was mainly produced to supply local demands, thus its market was a far cry from that of Guangdong, Fujian or Yunnan, let alone Jingdezhen. But in the final analysis, the Guangxi kilns aimed to serve the local people and their products indeed met local demand.

10.5.6 Yixing Wares

The Yixing kilns are located in Yixing, Jiangsu Province, and known as the "capital of pottery." The Yixing kilns have built an independent system of their own in the industry. Legend has it that Yixing wares were invented by Fan Li, a prominent Chinese statesman from the Spring and Autumn period and the founding father of Chinese commercial business. In fact, in the Neolithic Age over five thousand years ago, Zhangzhu, Shushan and Dingshan Towns in Yixing already had kilns producing pottery. By the Han Dynasty, Yixing was producing daily use pottery in large quantities. After the Ming Dynasty, the pottery industry in Yixing entered its heyday and its "*zisha*" wares and "*Yijun*" wares, products in the Jun style produced in Yixing, were famous around the world (Fig. 10.105).

The producers of Yixing wares were mainly concentrated in Shushan and Dingshan Towns. Shushan mainly produced *zisha* wares, a kind of hard, purple-red-brown or light-yellow or purple black unglazed pottery made with fine clay and fired at around 1200 °C. Dingshan mainly produced *Yijun* wares, a glazed pottery in varying varieties. Their glaze colors included azure, sky blue, pea green as well as bluish

[111] Yu Fengzhi, "A Preliminary Exploration of Blue and White Porcelain Kiln Sites in Beiliu and Rongxian County in Guangxi," Chinese Society for Ancient Ceramics (ed.), *Studies on Ancient Chinese Ceramics* (Vol. 13), The Forbidden City Publishing House, 2007, p. 336.

[112] Yu Fengzhi, "A Preliminary Exploration of Blue and White Porcelain Kiln Sites in Beiliu and Rongxian County in Guangxi," Chinese Society for Ancient Ceramics (ed.), *Studies on Ancient Chinese Ceramics* (Vol. 13), The Forbidden City Publishing House, 2007, pp. 337–338.

Fig. 10.105 Peach-shaped *zisha* cup, produced in the Ming Dynasty, height: 8.4 cm, diameter: 10.5 cm, in the Nanjing Museum

white. Some *Yijun* wares shared many similarities with "*Guangjun*" wares, products in the Jun style produced in Guangdong. More details follow.

10.5.6.1 *Zisha* Wares

The Yixing *Zisha* wares can be traced back to the Song Dynasty and experienced a boom in the Zhengde period of the Ming Dynasty. By the Wanli period, various quality and exquisite products were already being produced, thanks to the work of dozens of famous craftsmen. Among the *zisha* wares, the most famous were *zisha* teapots; this was clearly associated with the fashion of tea drinking among scholars. People summarized the merits of *zisha* teapots as follows. First, the original flavor of the tea could be maintained; second, after using a pot many times, the pot itself could flavor boiling water without adding any fresh tea leaves; third, the tea flavor would not spoil easily; fourth, they are heat-resistant and can be boiled on a gentle fire; fifth, they transmit heat slowly, thus avoiding scalding; sixth, repeated use will freshen up the pots, rather than wearing them out; seventh, their color changes easily, providing a certain amount of entertainment.

As an exquisite artifact, the popularity of *zisha* teapots elevated many talented craftsmen. Among the recorded pottery artisans, most were *zisha* producers. For example, famous *zisha* craftsmen from the Ming Dynasty included Gong Chun, Shi Dabin, Xu Youquan, Li Zhongfang, Dong Han, Zhao Liang, Yuan Chang, Li Maolin, Ou Zhengchun, Shao Wenjin, Shao Wenyin, Chen Yongqing and Chen Xinqing. According to *Yangxianminghuxi* (*A Record of Teapots in Yangxian*, a former name for Yixing), Gong Chun, from the Zhengde and Jiajing periods, was among the earliest famous craftsmen to make *zisha* teapots. Some even regarded him as the founder of *zisha* teapots. *Zisha* teapots made by famous artisans have been highly prized since

Fig. 10.106 Pumpkin-shaped *zisha* teapot, produced in the Ming Dynasty, height: 11.2 cm, mouth rim diameter: 3 cm, in the Nanjing Museum

the Qing Dynasty, so later generations have made many copycat products, making it difficult to identify authentic items (Fig. 10.106).

The clay used to make *zisha* wares was usually mixed with kaolin, quartz and mica, with a high iron content. The firing temperature was usually between 1100 and 1200 °C in an oxidizing atmosphere. On completion, products had a water absorption rate of less than 2%, meaning their porosity was between that of pottery and porcelain. Before the Wanli period, no saggers were used in firing, so *zisha* wares usually had glaze or dust on them. In addition, the earliest *zisha* wares were made quite rough, but became increasingly fine and exquisite over time.

10.5.6.2 *Yijun* Wares

Yijun wares were glazed pottery produced in Dingshan, Yixing. It is said that Ou Ziming, a local Yixing resident from the Wanli period, was the founder of *Yijun* wares, hence the name "Ou kilns" or "*Yijun* kilns." According to *Yinliuzhaishuoci*, "The Ou kilns, also named the *Yijun* kilns, were founded by Ou Ziming from Yixing in the Ming Dynasty. Generally, the products were in imitation of the Jun style, hence their alternative name of *Yijun*." Apart from Jun style, the Ou kilns also produced products in the Ge and official kiln style. Generally, *Yijun* wares, with purple or white bodies, were thickly and opaquely glazed, appearing thick and primitive. The white bodies were made of white clay from Yixing while the purple bodies were made of purple clay from Yixing. The glaze was mixed with a fusing agent containing P_2O_5, thus making the glaze look opaque. Colorant containing iron, copper, cobalt

and manganese was applied directly onto greenware before firing at around 1200 °C. Sharing some similarities with the Jun kilns from the Song Dynasty, this kind of product was called *Yijun* ware in the Ming and Qing dynasties. In terms of production techniques, however, there were large differences. For example, the Jun kilns in the Song Dynasty adopted a reduction atmosphere while the *Yijun* kilns chose an oxidizing atmosphere.

The Ou kilns used a very precious grayish blue glaze, said to be "blue shining in gray and as bright as iris japonica." Two colors were painted on the one article, dark gray and blue on a thin glaze over a greyish white body. There were many varieties of products in the Ou kiln stable, including vases, *yu* (a broad-mouthed receptacle for holding liquid), *zun*, furnaces as well as Buddha statues.

In the late Ming Dynasty, *zisha* teapots began to attract attention on the European market, but it was only in the Qing Dynasty that large quantities of them were exported and copied in Europe. Illustrated in Fig. 10.107 is a teapot made for the domestic market. Under its base, it was inscribed with marks indicating that it was made by Mengchen from Youshan Hall in 1627. According to *Records on Famous Pottery in Yangxian*, compiled by Wu Qian in around 1800, Hui Mengchen was a famous potter from the Tianqi period of the Ming Dynasty to the early Kangxi period of the Qing Dynasty. Later, this pot traveled to Europe and gold and silver accessories were added. From 1675, potters in Delft in the Netherlands began to produce pottery modeled on Yixing wares. At almost the exact same time, John Dwight (1633–1703) from Fulham, London, began his trial of producing red pottery. In around 1690, the Elers brothers from London successfully produced pottery in the Yixing style. More details regarding how Europeans made *zisha* teapots in the Yixing style will follow in the next Chapter.

Fig. 10.107 Yixing teapot with decal, produced in 1627, with accessories added around 1628–1650, in the Victoria and Albert Museum

10.5.7 The Shiwan Kilns

Shiwan Town is located in the west of the Chancheng District, Foshan City, Guangdong Province, around 20 km from Guangzhou. In the past, this town had around 100 hills, with abundant clay and sand. Sludge in the Dongping River, the main river to the south of the town provided rich metals, shells, and straw ash, which could be turned into glaze materials. All these factors prepared Shiwan for pottery production. There were also nine rivers flowing northwest to southeast past kilns in the north, in the center and in the south entering the Dongping River, which formed a natural traffic network and provided water, raw materials and transportation routes for pottery production.[113]

In the Tang Dynasty, the Shiwan kilns were quite developed. By the Song Dynasty, with furnace renovations and progress in production technologies, the product quality of the Shiwan kilns was improved and its production had expanded to a major scale, making the Shiwan kilns one of the major producers of pottery in Guangdong.[114] To date, a considerable amount of bluish yellow glazed pottery has been unearthed from Tang tombs, some of which are decorated with exquisite glazed pottery sculptures. Additionally, in regions like Damaogang and Xiaomaogang, quite a few steamed bun kiln ruins from the Tang Dynasty have been identified, the earliest kilns ever discovered in Shiwan.[115]

Inheriting the traditions of the Song Dynasty, the Shiwan kilns continued to produce articles for daily use with simple glaze colors as its main line of business in the Yuan Dynasty. According to articles unearthed or passed down through history, most of its products featured blue glaze, black glaze, sauce yellow glaze or fambe glaze. This last glaze was extremely rare, so it might signify the initial stage of producing imitation Jun style ware.[116]

In the Ming and Qing dynasties, the Shiwan kilns prospered. From the late Song Dynasty to the early Ming Dynasty, groups of potters fled to the south from the north because of wars. Prosperity from foreign trade also created significant demand for porcelain exports and with the development of the handicraft industry in Shiwan, wastes, after being processed, could easily be turned into raw materials for glaze. All these factors propelled the progress of the pottery industry in Shiwan. At this time, the Shiwan kilns successfully copied all the styles of famous kilns nationwide

[113] Huang Xiaohui, "Exploration of the Reasons for the Formation, Development and Prosperity of the Shiwan Kilns," Chinese Society for Ancient Ceramics (ed.), *Studies on Ancient Chinese Ceramics* (Vol. 11), The Forbidden City Publishing House, 2005, p. 204.

[114] Zeng Guangyi, "On the Artistic Pottery of the Shiwan Kilns," *Essence of the Shiwan Kilns*, Lingnan Art Publishing House, 2002.

[115] Huang Jing, "Discussing Guang Jun: Good Imitations of Jun Ware," Chinese Society for Ancient Ceramics (ed.), *Studies on Ancient Chinese Ceramics* (Vol. 11), The Forbidden City Publishing House, 2005, p. 198.

[116] Huang Xiaohui, "Exploration of the Reasons for the Formation, Development and Prosperity of the Shiwan Kilns," Chinese Society for Ancient Ceramics (ed.), *Studies on Ancient Chinese Ceramics* (Vol. 11), The Forbidden City Publishing House, 2005, p. 206.

and created its own unique fambe glaze. Apart from the Guangdong and Guangxi regions, Shiwan products also made their way abroad.[117]

In the Ming and Qing dynasties, China's commodity economy developed rapidly as many cities and towns emerged, and handicraft workshops and factories blossomed. Foshan, an emerging commercial town at the time, enjoyed rapid growth in the handicraft industry and in commerce, and was successful in becoming "No. 1 among the four famous towns nationwide" and one of the "four major commercial centers" in the Qing Dynasty. All these factors contributed to the development of the Shiwan kilns. In the mid- and late-Ming Dynasty, there had been industrial organizations for pottery while the concept of employers and employees had been turned into reality and signs of capitalism were revealing themselves. In addition, the prosperity of commerce and the handicraft industry drove progress in the arts and culture in civil society so that artistic activities like celebrations for the coming of autumn, paper-cuts, woodcuts, painting, and Cantonese opera were boosted and in turn provided ideal inspiration and a reference for pottery art in the Ming and Qing dynasties.

Meanwhile, overseas demand also greatly boosted the growth of the Shiwan kilns. In the Tang Dynasty, Guangdong already had close trade ties with the Southeast Asian nations, India and Arabian countries. At the time, Guangzhou was an important hub for foreign trade nationwide and apart from silk products, porcelain was a major export which flowed abroad from there. In 971, the court set up the Maritime Trade Bureau in Guangzhou and later the "*Shibowu*" or Maritime Trade Office, was established in Foshan, to especially take charge of the increasingly flourishing foreign trade. According to *Zhufanzhi*, or *Records of Foreign People*, by Zhao Rushi in the Southern Song Dynasty, Chinese merchants who were engaged in trade in Southeast Asia all traded in pottery and *qingbai* porcelain. Zhu Yu from the Song Dynasty also recorded exports in Guangzhou in the late Northern Song Dynasty. According to Zhu, "Commercial ships used for export are dozens of meters deep, with spaces taken up by different merchants… Most of the exports are pottery, with small items put inside larger ones in order to save space. Even so, there is not much space left vacant." At the time, kilns in Chaozhou, Huizhou and Guangzhou all produced porcelain while the Shiwan kilns alone were producing pottery. Thus, these "large and small items" must have been from the Shiwan kilns. From the Southern Song to the Yuan Dynasty, the ceramics industry in Guangdong experienced an unprecedented decline. However, large amounts of Chinese porcelain have been discovered in present-day Malaysia, Brunei, Singapore, the Philippines and Indonesia. According to both domestic and foreign research, such products must have been produced by the Shiwan kilns in Guangdong or the Jinjiang kilns in Fujian. By the Ming and Qing dynasties, with the rapid development of foreign trade in Guangdong, the government set up the "*Guankou*" (customs) or "*Xingzhan*" (serving as both warehouses and middlemen) to take charge of foreign trade. Close to Guangzhou, Foshan was also a prosperous

[117] Huang Jing, "Discussing Guang Jun: Good Imitations of Jun Ware," Chinese Society for Ancient Ceramics (ed.), *Studies on Ancient Chinese Ceramics* (Vol. 11), The Forbidden City Publishing House, 2005, p. 199.

foreign trade center. According to local records, in the Ming and Qing dynasties, Foshan already had "hundreds of thousands of households closely located side by side" and "merchants coming to Guangdong all counted Foshan as one leg of their trips."[118]

By this time, the Shiwan kilns had entered an unprecedentedly prosperous era thanks to the renovation of their furnaces. Based on the dragon-shaped furnace designs from the Song and Yuan dynasties, the Shiwan kilns renovated the structures as well as the loading and firing techniques of furnaces in the Ming and Qing dynasties, thus technologically improving the quality of their products. Additionally, the emergence of industrial pottery organizations pushed the production structures of the Shiwan kilns to be more detailed and specific with their professional division of labor. For example, an organizational structure similar to that of Jingdezhen, which featured a clear and linked workflow, took shape. Thus, pottery organizations signaling the professional production of pottery emerged in the Jiajiang period.[119]

Apart from fambe glaze modeled on the Jun kilns from the Song Dynasty, the Shiwan kilns excelled at learning from other well-known kilns from different ages. For example, the Shiwan kilns could produce "light greenish blue glaze" in the Guan (official) style, "100-fold crackle" in the Ge style, *fending* in the Ding style, *meiziqing* (plum green) in the Longquan style, "brown on white" in the Cizhou style, "partridge feather" in the Jian style, and various color glazes in the Jingdezhen style. As a producer of pottery, Shiwan was the only area nationwide that was able to so successfully mimic other porcelain producers.

The Shiwan kilns also imitated the designs of other kilns. For instance, apart from the Four Treasures of the Study, namely brush, ink stick, paper and inkstone, as well as drawing sets and decorative wares from the Jun kilns, the Sihwan kilns also copied daily use articles, such as vases, *zun*, bowls, and plates. The Shiwan kilns not only learned from the historically famous masterpieces of the large kilns, but also copied bronzewares from the Shang and Zhou dynasties, like *zun*, *ding*, *yi*, *gu* and pots, natural articles and scenery including melons and fruit, fish and insects, birds and animals, and rocks. However, the Shiwan kilns were not only good at imitating, they were also extremely creative and innovative. In fact they were very well-known for their creativity.[120] Shiwan learned from others and outpaced them by adding their own ingenuity. This is the greatest contribution that the Shiwan potters made to China's pottery industry.

In the early Ming Dynasty, apart from daily wares, Shiwan also produced many incense burners, candlesticks, statues of Avalokitesvara, statues of Buddha and

[118] Huang Xiaohui, "Exploration of the Reasons for the Formation, Development and Prosperity of the Shiwan Kilns," Chinese Society for Ancient Ceramics (ed.), *Studies on Ancient Chinese Ceramics* (Vol. 11), The Forbidden City Publishing House, 2005, p. 211.

[119] Huang Xiaohui & Qiu Licheng, "Discussion on the Exports of the Ancient Shiwan Kilns and Relevant Issues," Chinese Society for Ancient Ceramics (ed.), *Studies on Ancient Chinese Ceramics* (Vol. 14), The Forbidden City Publishing House, 2008, p. 333.

[120] Huang Xiaohui, "Exploration of the Reasons for the Formation, Development and Prosperity of the Shiwan Kilns," Chinese Society for Ancient Ceramics (ed.), *Studies on Ancient Chinese Ceramics* (Vol. 11), The Forbidden City Publishing House, 2005, p. 209.

statues of the God of Earth, which was a result of the heavy influence of Buddhism and Taoism. In the mid-Ming Dynasty, the Shiwan kilns began to produce flowerpots, fish tanks, flower stools, and screen walls by kneading. At the same time, products like glazed tiles, glazed ridge tiles and glazed ridge decorations also came onto the market.[121]

10.6 The Burgeoning Maritime Trade in Porcelain During the Ming Dynasty

10.6.1 Ports for Ceramic Export in the Ming Dynasty

IN the Ming Dynasty, with changes in the location of overseas-connected ports, Quanzhou began to decline. Thus, at this time, Fujian's porcelain, especially blue and white porcelain, was mainly exported through the Port of Yuegang in Zhangzhou, Xiamen, Anping or Fuzhou. Because of its proximity to East and Southeast Asia, Fujian's blue and white porcelain mainly flowed into countries in these regions such as Japan, Thailand, Indonesia, Malaysia, the Philippines, and Singapore. Some Fujian exports were then transferred to Europe, or East Africa or were transported directly to Europe. Therefore, from the Ming and Qing dynasties, more Fujian ports undertook the task of porcelain export, with an expanding trading capacity and range of destinations.[122]

In 1472, the Maritime Trade Bureau was relocated from Quanzhou to Fuzhou and Fuzhou was officially opened to Ryukyu's tribute trade. Some Ryukyuan tombs from the period remain in Fuzhou today. Opening ports facilitated cargo flows from China to the rest of the world, through both public and private channels. The Seven Expeditions led by Zheng He in the early Ming Dynasty propelled the tribute trade to a peak. During Zheng's voyages, the Port of Changle in Fuzhou served as an anchor ground for his fleets. Jingdezhen blue and white porcelain also traveled abroad during these trips.[123]

During the Hongwu period, the government issued maritime bans on four occasions in an effort to prohibit foreign trade via private channels. Subsequently, during the reign of Emperors Yongle, Xuande, Zhengtong and Tianshun, the government persisted with this policy and codified the ban in law. Thus, the maritime bans and

[121] Huang Jing, "Discussing Guang Jun: Good Imitations of Jun Ware," Chinese Society for Ancient Ceramics (ed.), *Studies on Ancient Chinese Ceramics* (Vol. 11), The Forbidden City Publishing House, 2005, p. 199.

[122] Ye Wencheng, "The Production and Export of Blue and White Porcelain in Fujian Province," Chinese Society for Ancient Ceramics (ed.), *Studies on Ancient Chinese Ceramics* (Vol. 13), The Forbidden City Publishing House, 2007, p. 194.

[123] Zhou Chunshui, "Exploration of Porcelain Exports Via the Ming River from Shipwrecks of *Wanjiao* One," Chinese Society for Ancient Ceramics (ed.), *Studies on Ancient Chinese Ceramics* (Vol. 14), The Forbidden City Publishing House, 2008, p. 24.

the administration of the Maritime Trade Bureau coexisted for a period. Prior to the mid-Ming Dynasty, the government tried to maximize its control and monopoly over maritime trade and adopted a policy of tribute trade featuring a practice of "frequent banning and occasional opening up." This policy, however, exerted such a burden on the government that after the mid-Ming Dynasty, it constantly adjusted its foreign trade policy. First, it allowed ships from non-tribute countries to enter Guangdong and trade goods. Second, due to "riots caused by Japanese pirates," the Maritime Trade Bureaus in Fujian and Zhejiang were closed and only the Guangdong Bureau remained functional. Such measures greatly boosted foreign trade among individual merchants in Guangdong. Thus, the Port of Guangzhou became the only legal trading port in China and regained its position as the largest port on China's maritime Silk Road.[124]

In 1567, the first year of Emperor Longqing, the Ming court officially recognized the legal status of the Port of Yuegang in Zhangzhou as a trading port. Yuegang thus overtook ports in Fuzhou and Guangzhou to become the largest trading port in the southeast coastal regions. Through this port, large amounts of Chinese tea, silk, porcelain and iron wares flowed abroad.

Blue and white porcelain produced by the Jingdezhen kilns was the most popular product on the foreign market at the time. However, Jingdezhen could not have satisfied such a huge demand both at home and overseas. It therefore seems natural that kilns in Guangdong and Fujian, where major trading ports were located, seized the opportunity and produced blue and white porcelain in imitation of Jingdezhen.

10.6.2 Export Routes for Jingdezhen Porcelain in the Ming Dynasty

To meet the overseas demand, the Jingdezhen kilns produced large amounts of porcelain in the Ming Dynasty. How then was the porcelain shipped overseas? This is a topic worth discussing. As an inland city, Jingdezhen is distant from the sea, so its products required transportation to trading ports first before flowing to the rest of the world.

From ancient times, Jiangxi had other kilns producing porcelain apart from Jingdezhen and their products were also exported worldwide. Liu Lushan suggests the following routes linked the Jiangxi kilns with trading ports:

First, Jingdezhen porcelain travelled downstream via the Changjiang River while Jizhou and Ganzhou products traveled down the Ganjiang River, into Poyang Lake and then into the Yangtze River and entered the sea to reach ports in Yangzhou, Hangzhou, Ningbo, Quanzhou and Guangzhou.

[124] Huang Jing, "Guangdong Maritime Silk Road and Ceramics Exports," Chinese Society for Ancient Ceramics (ed.), *Studies on Ancient Chinese Ceramics* (Vol. 14), The Forbidden City Publishing House, 2008, p. 319.

Second, kilns in Jiangxi shipped their products down the Ganjiang River through Poyang Lake and into the Xinjiang River, then travelled back to Hekou Town in Qianshan County, across Quzhou and Jinhua, to reach Ningbo via the Fuchun River. The products could also travel through Chong'an, Fujian Province on to Wuyi Mountain, then through Jianyang to arrive at Jianning or via Guangze to Shaowu and Shunchang, reaching Nanping, then sailing down the Minjiang River to Fuzhou, after which they were transferred to Quanzhou. They could also travel through Pucheng to Longquan, and down the Oujiang River to Wenzhou.

Third, Jiangxi porcelain travelled upstream via the Ganjiang River to Gongjiang and Jinshui to Ruijin, then passed Changting and Longyan, down the Jinjiang River to Zhangzhou and Quanzhou.

Fourth, porcelain products travelled upstream via the Ganjiang River to Ganzhou, then via the Zhangshui River to Dayu, passing Meiguan, then down the Zhenshui River into the Beijiang River, a major tributary of the Pearl River, and downstream to Guangzhou.

Apart from the first route, the other three combined waterway transportation with overland transportation.[125]

Most scholars hold that exports from Jingdezhen mainly traveled on waterways through various ports while a combination of road and maritime transportation was a second choice. The major route would therefore appear to be via the Changjiang River and Poyang Lake to the Yangtze River and thence to ports in Southeast Asia. This route played an important role in the exports, especially after the Meiguan ancient road, which crossed Guangdong and Jiangxi, was abandoned.

In the view of Liu Lushan, the Ming Dynasty was the peak period for China's porcelain exports to Southeast Asia and it was in the Ming and Qing dynasties that China's porcelain exports reached its zenith. Jingdezhen blue and white and *wucai* porcelain along with Canton porcelain (porcelain purchased from Jingdezhen and decorated in Canton) sold well on the European and American markets, which was mostly transported from Meiling, in Jiangxi, to Guangzhou and then overseas. As Liu cites Han Huaizhun, an expert on porcelain, "In the Ming and Qing dynasties, Jingdezhen porcelain traveled from the Changjiang River to the Ganjiang River, passing Dayuling on land before sailing the Zhenshui and Beijiang rivers to reach Guangdong," from whence it proceeded overseas. In the mid-1960s to the early 1980s, lying on the ancient routes of Jiangxi and Guangdong, Nancheng, Guangchang and Huichang were discovered to have many pieces of blue and white porcelain from the Wanli period (the "Kraak" porcelain very rarely seen in China). This shows the importance of this transport route for Jiangxi porcelain on its journey abroad. This route had been popular from the Southern Song Dynasty through the Yuan until the Ming and Qing period.[126]

[125] Liu Lushan, "Exploration of the Ancient Routes to Ports for Porcelain Exports in Jiangxi," Chinese Society for Ancient Ceramics (ed.), *Studies on Ancient Chinese Ceramics* (Vol. 14), The Forbidden City Publishing House, 2008, p. 391.

[126] Liu Lushan, "Exploration of the Ancient Routes to Ports for Porcelain Exports in Jiangxi," Chinese Society for Ancient Ceramics (ed.), *Studies on Ancient Chinese Ceramics* (Vol. 14), The Forbidden City Publishing House, 2008, pp. 396–397.

Western scholars tended to pay more attention to the route through the Pearl River. For example, in *China to Order*, Daniel Nadler wrote that if you wanted to transport porcelain to the coastal regions of Guangdong, you needed first to transport it to the Yangtze River, then after entering the sea, travel southward to the Pearl River estuary and on to Guangzhou. This trip is around 1700 miles. For decades, maritime transportation was subject to bad weather or piracy and most importantly, obstruction from government officials, heavy tax burdens and blackmailing. Porcelain exports would therefore normally choose an overland route before finally arriving at Guangzhou on water. In the view of Nadler, to accomplish this, the exports needed to travel to Nanchang by water first, then southward to Dayu via the Ganjiang River, proceed overland to Nanxiong via Meiling, then to Guangzhou via the Beijiang River. It is an arduous trip from Dayu to Nanxiong via Meiling because thousands of workers had to carry boxes of porcelain on their backs via rocky marble steps for a whole day.[127]

According to Daniel Nadler, the five porcelain trade routes from Jingdezhen to port or overseas destinations were:

i. Jingdezhen—Poyang Lake (by water)—Fuhe River (by water)—Guangchang County (Shicheng warehouse)—Ninghua County (manual lifting)—Qingxi River—Yongan County—Zhangping County (manual lifting)—Jiulong River (overland)—Zhangzhou or Xiamen—overseas.

ii. Jingdezhen—Poyang Lake (by water)—Fuhe River (by water)—Guangchang County (Shicheng warehouse)—Changting County (manual lifting)—Tingjiang River (small boats)—Dapu Town, Meixian County, Guangdong Province—Chaozhou— overseas.

iii. Jingdezhen—Poyang Lake (by water)—Fuhe River (by water)—Guangchang County (Shicheng warehouse)—Dongshankan, Ningdu County (manual lifting)—Meijiang River (by water)—Gongjiang River (by water)—Junmenling, Huichang County—Wuping County (manual lifting)—Zhenping County, Guangdong Province (small boats)—Hanjiang River (large boats)—Chaozhou—overseas.

iv. Jingdezhen—Poyang Lake (by water)—Nanchang-Ganjiang River (by water)—Wan'an, Fujian Province—Ancient road of Meiling—Nanxiong, Guangdong Province—Beijiang River (by water)—Guangzhou (an official route, a total of 600 km).

v. Jingdezhen—Poyang Lake (by water)—the Yangtze River (by water)—Guangzhou (by water) (the longest route).

Apart from Guangzhou, at the time exports were also shipped overseas from ports in Quanzhou, Zhangzhou, Chaozhou and Xiamen.

[127] Daniel Nadler, *China to Order: Focusing on the XIXth Century and Surveying Polychrome Export Porcelain Produced during the Qing Dynasty (1644–1908)*. Paris, 2001, p. 22.

10.6.3 The European Market Preference for Chinese Blue and White Porcelain

From the mid-Ming Dynasty, blue and white porcelain dominated production among private kilns because at this time, blue and white porcelain was not only popular with the Asian and African markets, but it had also found its way onto the European market. It was from the period of the Crusades that Europe started to discover Chinese porcelain. With the opening of maritime routes between Asia and Europe and the blossoming of the maritime trade, more and more Chinese porcelain flowed to regions around the world.[128]

Large shipments of blue and white porcelain entered Europe from the Age of Discovery. In 1498, Vasco da Gama, a Portuguese explorer, opened the sea route from western Europe to the east by way of the Cape of Good Hope, which paved the way for the massive trade between East and West. In 1511, after the Portuguese capture of Malacca, the Southeast Asian market and trade with China was further expanded. In 1513, Portuguese merchants ventured ashore in Guangzhou. In 1517, eight ships from the West arrived at Saint John's Island to the southeast of Macao and initiated trade with China. From that time onwards, China's porcelain exports to Europe were facilitated.[129] In 1587, the Portuguese East India Company was founded. In 1600, with the permission of Queen Elizabeth, the British East India Company was established, closely followed by the establishment of the Dutch East India Company in 1602. Subsidiaries of the Dutch company were subsequently set up in Denmark, Austria and France.[130] The Swedish East India Company (SOIC) made its appearance quite late, in 1731. In 1652, the Netherlands took over Taiwan, replacing the dominant Portuguese role in the West Pacific region. Maritime trade wars had some effect on exports of Jingdezhen porcelain, but once the Netherlands had established its dominant position, Dutch merchants became the largest purchasers of Jingdezhen porcelain. The establishment of branches of the East India Company in Europe enabled large exports of Chinese porcelain, thus meeting the market demand in Europe.

From the Wanli period of the Ming Dynasty to the early Qing Dynasty, blue and white plates and bowls dominated China's porcelain exports. In the early stages of exports to Europe, kilns produced articles with traditional styles but with exotic features based on information learned through export.[131]

[128] Huang Xiuchun, "Analysis of the Artistic Value of Porcelain Exports in the Ming and Qing Dynasties," Chinese Society for Ancient Ceramics (ed.), *Studies on Ancient Chinese Ceramics* (Vol. 14), The Forbidden City Publishing House, 2008, p. 297.

[129] Huang Xiuchun, "Analysis of the Artistic Value of Porcelain Exports in the Ming and Qing Dynasties," Chinese Society for Ancient Ceramics (ed.), *Studies on Ancient Chinese Ceramics* (Vol. 14), The Forbidden City Publishing House, 2008, p. 295.

[130] Ingrid Arensberg, *The Swedish Ship Gotheborg Sails Again*, Guangzhou Publishing House, 2006, p. 14.

[131] Huang Xiuchun, "Analysis of the Artistic Value of Porcelain Exports in the Ming and Qing Dynasties," Chinese Society for Ancient Ceramics (ed.), *Studies on Ancient Chinese Ceramics* (Vol. 14), The Forbidden City Publishing House, 2008, p. 297.

Fig. 10.108 Blue and white cup with British silver accessories, produced in the late Ming and early Qing period, accessories added in London, from around 1650–1690, in the Victoria and Albert Museum

Stimulated by market demand, from the late Wanli period to the early Kangxi period, the private kilns in Jingdezhen changed their styles in blue and white porcelain and product type according to the influence of the trends in the literati and woodcut paintings. This variety of product had thin clay, bright, cheery colors, and natural and refreshing subjects, and were termed "transitional porcelain" by Western scholars. Thanks to their superior quality, large volumes were sold abroad and gained much popularity on the European market.

Transitional porcelain was loaded onto ships to Europe from 1635 onwards. This type of porcelain was partly produced, based on samples provided by the Dutch East India Company, so it was mainly in the European style, such as beer mugs, candlesticks, mustard pots, beakers and salt cellars. However, no "custom-made products" displayed any signs of being influenced by Western tastes. Most exports, in Chinese style or Western style, carried decorations similar to those on products earmarked for the domestic market. For example, some motifs were affected by literati factors, which reflected the fashion and social position of literati at the time.[132] The article in Fig. 10.108 demonstrates a freestyle overglazed motif of human figures, featuring the style of "transitional porcelain." Such decorations were usually copied from popular novels or woodcut paintings. With some silver parts added in Britain, the pot was turned into a large beer mug.

"Transitional porcelain" was heavy, with bright and slightly purplish dark blue decorations on a white base. At the time, the most exquisite porcelain was not

[132] Christiaan J. A. Jörg, "Porcelain and the Dutch China Trade, 1729–94," translated by Li Bing, Chinese Society for Ancient Ceramics (ed.), *Studies on Ancient Chinese Ceramics* (Vol. 14), The Forbidden City Publishing House, 2008, p. 285.

produced for emperors, but for merchants, so that European consumers could purchase the best blue and white porcelain of the day. Apart from motifs used in the Wanli period, new motifs adopted from myths, fairy tales, novels, legends, and heroic stories also came into use, depicting beautiful ladies, natural scenery, plants, willows, sometimes against the backdrop of mountains. In natural scenes, there were usually human figures, looking elegant, like drama actors. To break free from past obstacles, Jingdezhen painters adopted a free and natural decorative style, which incorporated existing traditions.

While in the late sixteenth century, Jingdezhen already boasted advanced productivity and relations of production, due to the tense supply-demand situation, Jingdezhen could not fulfil the market demands. Therefore, kilns in Fujian seized the opportunity and learned from Jingdezhen to develop themselves into independent blue and white porcelain producers and supplied the overseas market. Despite the fact that kilns in Fujian lagged behind Jingdezhen in terms of production technique and product quality, thanks to the massive scale of the export demands, production of blue and white porcelain gradually developed to a large scale and the region replaced Jingdezhen to become a major producer for some specific markets. The prices of Fujian blue and white porcelain were quite competitive and the region's convenient transportation also facilitated its prosperity.[133] Even part of the well-known "Kraak wares" at the time were produced in Fujian. Apart from the Fujian kilns, many kilns in Guangdong also produced blue and white porcelain in large quantities. Some scholars believe the Guangdong kilns were involved in the production of many "Kraak wares" and "Swatow wares." But according to what this author has learned, blue and white porcelain exported to Europe mainly came from Jingdezhen while "Swatow wares" from coastal regions of Fujian mainly went to Southeast Asia and Japan.

10.6.4 Sample-Ordered Porcelain for the European Markets

Before the "transitional porcelain" of the late Ming Dynasty, European consumers had always been happy with "Kraak wares" which were in the traditional Chinese style in terms of design and decorative style. With the emergence of "transitional porcelain," Chinese export porcelain changed because the European market demanded more than articles in the Chinese style; instead they welcomed products in the European style. Therefore, porcelain wares were custom-made for European buyers to suit their own tastes. These articles were usually designed by Europeans and made by Chinese potters and it was from this time that Europe began to import custom-made porcelain from China. Such porcelain wares were most exquisite, quite unlike those produced in the Wanli period.

On Oct 23, 1635, Hans Putmans, a Dutch governor stationed in Taiwan wrote to the headquarters of the Dutch East India Company regarding changes in style. He said that Chinese merchants sent him various painted wooden articles and told

[133] See Footnote 132.

him that they were samples for porcelain products. The merchants also promised if ordered this year, delivery could be made in the following year.[134]

In 1639, the captain of a Dutch merchant ship, Castricum, came to Taiwan with an order for a total of 25,000 pieces of porcelain from the Dutch East India Company based in Amsterdam. All these porcelain wares were to be made based on wooden models sent from the Netherlands. There was a letter specifying the varieties ordered, along with many models for reference. The letter also made clear that all the products must be exquisite and transparent and decorated with blue and white patterns. The captain demanded that the Chinese merchant Jusit return the wooden models once the order was complete. The negotiation was conducted with the help of a translator called Cambingh. The order included 300 fruit plates, 200 small wine pots, 200 jars and 300 large, deep saucers. The plates had to be light in weight, thin at the bottom and round. Thus, it appears that porcelain at this time was being influenced by the West. While the decorations on porcelain remained mainly in the Chinese style, a few were quite exotic. For example, Dutch houses and tulips came into play.[135] Considering how much Dutch people loved tulips, it is highly possible that such decorations were made by copying from wooden models. Or perhaps, they came from porcelain tiles in the second quarter of the seventeenth century because Chinese people might possibly have known about porcelain tiles by that time. In 1686, a book named "*Chinese Encyclopedia*" mentions that porcelain tiles had already been introduced to China.[136] However, there might be another explanation for the motifs on porcelain tiles. They might come from similar designs on Anatolian wares from the sixteenth century. Miedema holds that they can be traced back to the so-called weird decorations. They also share some similarities with the floral decorations on Majolica porcelain from Italy.[137] Of these possibilities, the last is the most plausible, and it might also have influenced Chinese porcelain painters. Chinese human figures were also utilized by Dutch potters. For example, in the late seventeenth century, one potter put Chinese human figures and tulips together on the neck of a large water pot. We can also see tulip motifs on porcelain from Frankfurt and Hanau in Germany and Nevers in France.

Mugs, spice saucers, salt cellars, mustard pots, lamp holders, gorgelets and various plates and saucers were also listed in the Dutch order, along with barber bowls (after 1637), seasoning pots, goblets, octagonal chalices, flower pots, pear-shaped wine pots with spouts, oil pots, vinegar pots, liquor cooling cups, teacups, drinking cups, chamber pots and boxes for holding medicine.[138]

[134] D. F. Lunsingh Scheurleer, *Chinese Export Porcelain Chine de Commande*. New York: Pitman Publishing Corporation, 1974, p. 102.

[135] Dingeman Korf, *Tiles*. London, 1963.

[136] Prof. G. Schlegel, "De betrekkingen tussen Nederland en China Volgens Chineesche Bronnen," *Taal, Land en Volken kumde Vom Nederl andsch-Indie*. Vol. 42, 1893, p. 26.

[137] H. Miedema, *Kraak Porselein en Overgangsgoed*, p. 31.

[138] D. F. Lunsingh Scheurleer, *Chinese Export Porcelain Chine de Commande*. New York: Pitman Publishing Corporation, 1974, p. 90.

10.6.5 Blue and White Porcelain Produced in Other Countries

Blue and white porcelain produced by Jingdezhen in the Ming Dynasty was very popular in many countries, thus enjoying a huge market at home and abroad. However, the production of Jingdezhen alone could not have possibly met the market demands. Therefore, kilns which were influenced by or which copied Jingdezhen blue and white porcelain emerged, such as those in Yunnan, Guangxi, Fujian and Guangdong mentioned above. In addition, kilns abroad also showed great interest in Chinese blue and white porcelain. Some neighboring countries, especially Japan, not only imported finished products, but also attempted to learn the production techniques of blue and white porcelain. For example, Japanese potters came especially to China to learn how to produce blue and white porcelain, and set up the Imari and Kaseyama kilns, which produced products resembling those of the Chinese private kilns in the Ming Dynasty in terms of design and decoration.[139]

So, in the 1650s when Chinese porcelain exports were partially cut off, Imari wares began to find their way onto the European market as replacements, thus ushering in an era of Imari ware. This was an important opportunity for the development of Imari wares, which in return further stimulated Imari wares' imitation of Jingdezhen exports.

In addition, Iran and Turkey were also producing blue and white porcelain. Called "Persian blue and white porcelain," it was Shāh Abbās the Great (1571–1629), the strongest ruler of the Safavid dynasty, who invited Chinese potters to his country to produce blue and white porcelain. Since no clay was found within the borders of Persia, only one variety of white glazed blue pottery was developed. Despite this, "Persian blue and white porcelain" was very much influenced by its Chinese counterparts and decorations like dragons, phoenixes, twining flowers and peony adorned the wares. Not only did Persian potters copy Chinese blue and white porcelain, but some local painters also imitated Chinese porcelain decorations, especially dragons, phoenixes, and kylin.[140] They also liked lotus and their lotus patterns looked almost exactly the same as those from China (Figs. 10.109, 10.110, 10.111, 10.112 and 10.113). What is more, Persian potters also adopted other techniques in decoration and created their own style. For example, in Fig. 10.114, a Mashhad plate in the Chinese style is framed in black lines and blue color with a few deer playing in the forest, forming a vivid and lovely picture. With patterns similar to the *yingqing* inscriptions of Jingdezhen on the rim, this plate combined a Chinese style with its own creativity and ingenuity. Apart from blue and white porcelain, Chinese *doucai* wares also seemed to have influenced Persian potters (Fig. 10.115). Apart from

[139] Liu Wei, "On the World's Imitation of Chinese Porcelain," Chinese Society for Ancient Ceramics (ed.), *Studies on Ancient Chinese Ceramics* (Vol. 14), The Forbidden City Publishing House, 2008, p. 539.

[140] Liu Wei, "On the World's Imitation of Chinese Porcelain," Chinese Society for Ancient Ceramics (ed.), *Studies on Ancient Chinese Ceramics* (Vol. 14), The Forbidden City Publishing House, 2008, p. 538.

ceramics, blue and white porcelain and *doucai* wares also influenced Persian murals and decorations (Figs. 10.116 and 10.117). At the time, Islamic countries were not yet able to manufacture porcelain, so they just put a layer of white engobe on pottery and then added blue painted decorations before firing with a layer of transparent glaze. Their production of *doucai* wares adopted double firing, just like Jingdezhen. Islamic potters were superb. If you did not look carefully enough at their products, you would hardly notice whether they were glazed or not. Only from certain angles might you observe their true quality, looser and darker than that of Chinese porcelain (Fig. 10.118).

Fig. 10.109 Syrian lotus bowl, produced in the fifteenth century (Ming), in the Berkeley Art Museum

Fig. 10.110 Syrian pot, produced in the first half of the fifteenth century (Ming), in the Berkeley Art Museum

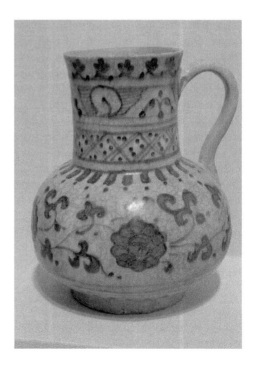

Fig. 10.111 Turkish glazed blue and white plate, produced in the second half of the sixteenth century (Ming), in the Berkeley Art Museum

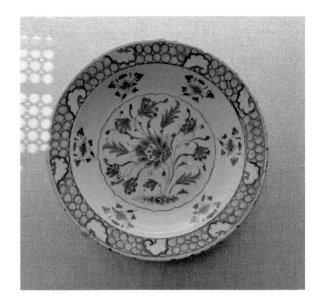

Fig. 10.112 Iranian glazed blue and white pottery plate in the Chinese style, produced in around 1500 (the Hongzhi period of the Ming Dynasty), in the Berkeley Art Museum

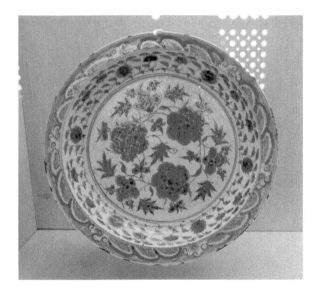

Vietnam also made blue and white porcelain. Vietnam was known as the "Champa Kingdom" or "Annam" in the past. China has had intimate relations with Vietnam from ancient times. As early as the fifteenth century, Vietnam had invited Chinese potters to teach porcelain production techniques in their country. Under the influence of China, Vietnam produced many blue and white wares in the Chinese style, especially blue and white porcelain and black on white porcelain produced in the late fourteenth century in imitation of the Yuan style. They closely resembled their

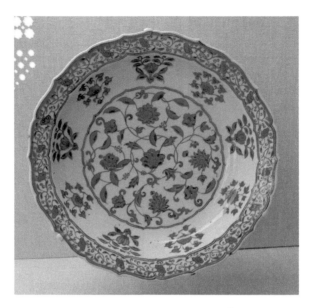

Fig. 10.113 Turkish glazed blue and white pottery plate in the Chinese style, produced in the first half of the sixteenth century (Ming), in the Berkeley Art Museum

Fig. 10.114 Iranian Mashhad plate with birds, deer, trees and flowers in the Chinese style, produced in the first half of the seventeenth century (Ming), in the Berkeley Art Museum

Chinese counterparts in terms of design and decoration. Difficult to distinguish, some even replaced Chinese porcelain in exports to the Middle Eastern region.

Thai blue and white porcelain was also produced. According to foreign documents, from 1294 to 1300 (the 31st year of Emperor Zhiyuan to the fourth year of Emperor Dade), the King of Siam (the then Thailand) paid two visits to Beijing, capital of the Yuan regime, and brought back Chinese potters to teach porcelain-making skills.

Fig. 10.115 Turkish Izhik
water pot, produced in the
first half of the sixteenth
century (Ming), in the
Berkeley Art Museum

Fig. 10.116 Syrian
Damascus-made octagonal
tile with a peacock
surrounded by plum trees,
produced in the
mid-sixteenth century
(Ming), in the Berkeley Art
Museum

Fig. 10.117 Syrian Damascus-made hexagonal tile, produced in the mid-fifteenth century (Ming), in the Berkeley Art Museum

Fig. 10.118 Turkish Izhik tile with Saz leaves and Chinese cloud patterns, produced in around 1575 (the Wanli period of the Ming), in the Berkeley Art Museum

Korea also made blue and white porcelain. Once blue and white porcelain had been produced in the Yuan Dynasty in China, it soon arrived in Korea. However, its imitation of blue and white porcelain occurred quite late, mainly from the Yuan Dynasty, judging from their designs, decorations, sketching and paintings. Compared to the Jingdezhen Ming product, Korean blue and white porcelain was poorly made with coarse clay, inferior glaze, gritty bottoms and dark colors. However, their utilization of thick lines was quite remarkable (Fig. 10.119).

From the above, we can see that following the maturity of its production techniques of blue and white porcelain in the Yuan Dynasty, Jingdezhen had constantly exerted influence over neighboring countries and helped promote production of blue and white porcelain in many areas. This is a great contribution of Chinese culture to the world.

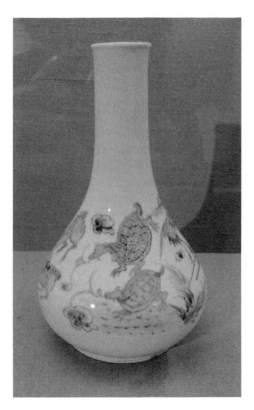

Fig. 10.119 Korean blue and white wine bottle with turtles, produced in the Joseon Dynasty, in the Metropolitan Museum of Art

10.7 Conclusion

10.7.1 An Era Dominated by Polychrome Porcelain

The Ming Dynasty served as an important era in the history of Chinese ceramics. Especially from the Zhengde period to the Jiajing and Wanli periods, great transformations were underway. First, merchants from countries like Portugal, Spain, the Netherlands and Japan came to China to purchase porcelain. Thus, Jingdezhen was serving traditional customers in Asia and Africa on the one hand while it welcomed new ones from Europe and Japan on the other. At the same time, European overseas explorations and global trade were emerging, linking the world and initiating the beginning of globalization. The increasing expansion of the global market and the close interactions between various civilizations also changed China's ceramic production and the Chinese people's aesthetic tastes. Before the Ming Dynasty, Chinese porcelain was dominated by plain porcelain. While in the Song and Jin dynasties, kilns like Cizhou started to produce polychrome porcelain, including iron rust porcelain, black porcelain with engravings and red and green porcelain, these products were monotonous in both design and color. Additionally, while widely recognized by society at large, these polychrome wares were not part of the mainstream of the ceramics industry and thus were not able to gain favor with the court, literati, scholars or the privileged. By the Ming Dynasty, especially after the Jiajing and Wanli periods, in order to cater to the various demands of the international market, Chinese ceramic production changed from an era dominated by plain porcelain to a new age dominated by polychrome porcelain. This was especially true of Jingdezhen as its kilns gradually developed tricolor porcelain, red and green porcelain, *jincai* porcelain, *doucai* wares and *wucai* wares on the foundation of blue and white porcelain. At this time, Jingdezhen's decorative patterns, motifs, painting methods, and production techniques were unprecedented, thus driving forward production of blue and white porcelain and polychrome porcelain in many regions both at home and abroad, especially in coastal regions. From that time forward, China has remained a world-renowned producer of porcelain, and Jingdezhen a major hub of porcelain production.

10.7.2 Artistic Features of Ming Ceramics

In terms of design, daily use porcelain wares produced in the Ming Dynasty included vases, *zun*, bowls, cups, plates, saucers, pots, jars, vats, *dun* (garden stools), boxes, *ding*, furnaces, and various other articles. Among these, *dun* were also named *liangdun* (cold *dun*) in Jingdezhen, which meant they were used in summer. Boxes included various porcelain boxes, like rouge boxes, powder boxes, inkpad boxes, and paint boxes. *Ding* and furnaces were originally cooking and food vessels in the ancient past and later became ritual or decorative wares. Furnaces were also used for

burning incense. Other articles included playthings, or decorative wares in studies, such as *weiqi*, screens, cap tubes, pen racks, pen holders, inkstone water holders, ink slabs, pen tubes and pen washers. Apart from these, there were also sacrificial wares used for sacrificial ceremonies. From these articles, we can see that ceramic wares had penetrated every corner of people's lives and served as daily necessities.

In terms of decorative motifs, apart from many traditional motifs and patterns, Taoist articles and characters from Taoist stories were increasingly applied to porcelain, especially from the mid-Ming Dynasty when Taoist culture prevailed in the imperial palace. Meanwhile, under the influence of Islam, porcelain with Arabic scripts also appeared, a technique initiated in the Yongle and Xuande periods while also popular in the Zhengde period.

Apart from religious factors, ceramic art was also affected by other contemporaneous forms of art. For instance, the Ming Dynasty saw a high tide in silk production and many new varieties came into being during this age. Its decorations mainly included auspicious motifs of birds, flowers and geometric patterns, such as phoenixes flying in circles, phoenixes flying among flowers, *ruyi*-head clouds, dragons flying in clouds, drifting petals, twining peony and lotus, twigs of flowers and fruit, chrysanthemum, pomegranate, peach blossom, hibiscus, creeping weed, Buddhism's Eight Auspicious Symbols, lozenges, silver ingots, tortoiseshell patterns and coin patterns. These patterns also appeared on Jingdezhen porcelain, so it seems that these decorations were very popular at the time. Apart from patterns, silk and porcelain also shared some similarities in decorative style. For example, round-shaped patterns and overlapping patterns which were developed from the mid-Ming Dynasty, became a major feature of Jingdezhen porcelain in the late Ming and Qing dynasties. In addition to silk patterns, literati paintings and genre paintings also affected the decorative styles of private kilns. Porcelain decorations at the time emphasized auspicious connotations and patterns with homophonic blessings. For instance, the blue and white *doucai* pot in Fig. 10.120 was painted with a fish algae pattern with a golden fish on it. Fish is "*yu*" in Chinese, a homophone for "*yu*" (surplus). Painted gold, it symbolizes surplus wealth.

10.7.3 The Influence of Literati Paintings on Porcelain

In the early years of the Ming Dynasty, rulers were committed to reviving customs of the Han ethnic group. In the Hongwu period, the Song system was revived, and the Painting Academy was reestablished. With the endorsement of the rulers, a painting industry flourished with the emergence of various schools and genres. Influenced by capitalist factors, professional painters and literati painters gathered in certain major commercial cities in regions south of the Yangtze. In reaction to politics, economic status, geographic background, teacher-student relations, and other factors, various genres with specific features came into being, such as the Painting Bureau school, the Zhejiang school, the Wu school, the Songjiang school, the Jiangxia school and the Xiulin school. After Su Shi, a great Chinese writer, poet and statesman from the Song

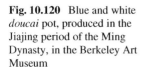

Fig. 10.120 Blue and white *doucai* pot, produced in the Jiajing period of the Ming Dynasty, in the Berkeley Art Museum

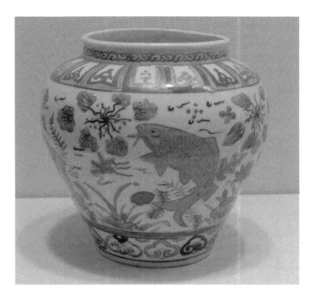

Dynasty, proposed the concept of "literati painting," the differences between "literati paintings" and "craftsmen paintings" gradually became clear. In the opinion of Su Shi, literati paintings not only emphasized drawing technique, but also pursued poetic beauty, not boldness and openness, but tranquility and ease.[141] In the Ming Dynasty, this style remained in vogue, so despite the folk culture's realistic depiction of human society after the mid-Ming Dynasty, the literati paintings were still centered on natural landscapes in an attempt to express the profound aspirations of their creators. Motifs like gods, monks, scholars and recluses were depicted in literati paintings, playing musical instruments, drinking tea, discussing Taoism, reciting poems, or riding horses in forests or in courtyards, followed by attendants. Such images are not to be found on porcelain produced in the mid-Ming Dynasty.

Before the mid-Ming Dynasty, graphic patterns dominated the decorations on Chinese porcelain. Naturally, there were also some paintings of stories on blue and white porcelain in the Yuan Dynasty, but just simple line drawings. It was in the mid-Ming Dynasty that literati paintings were drawn with brush and ink on porcelain. Because the products were underglazed, the paintings were painted directly onto unfired and water-absorbing greenware, which could display the polishing effect that the water and ink literati paintings sought. The figures on such pictures were either relaxed and comfortable, or extraordinarily refined and graceful, displaying the easy lifestyle of the then scholars and recluses (called "erudite scholars" by craftsmen and their paintings "paintings of erudite scholars") (Fig. 10.121). Affected by the literati paintings, pictures on porcelain emphasized both technique and artistic conception, such that the subject of a painting was usually drawn with a few strokes to outline its

[141] Liu Daoguang, *On the History of Ancient Chinese Art and Ideology*, Shanghai People's Publishing House, 1998, p. 193.

Fig. 10.121 Blue and white bowl with paintings of erudite scholars, produced in the Hongzhi period of the Ming Dynasty, in the Jingdezhen Academy of Private Kiln Art

character. Human figures were often integrated with an open or tranquil background. In addition, there were also paintings of fairies, gods or Taoist priests appearing spirited and generous against backdrops of buildings, pavilions, landscapes or clouds (see Fig. 10.32).

Other common images included *"Nanjilaoren"* (God of Longevity) on bowls produced in the Jingtai period,[142] "Paintings of erudite scholars" on blue and white pots produced in the Jingtai period, "The Eight Immortals celebrating a birthday" on pots produced in the Jingtai period, "The Eight Immortals crossing the sea" on blue and white bowls produced in the Tianshun period, "Carrying a *qin* (a Chinese musical instrument) to visit a friend" on plum vases produced in the Tianshun period, "Gods" on plum vases produced in the Tianshun period, "Human figures, buildings and pavilions" on pots produced in the Chenghua period, "Playing chess in a courtyard" on blue and white pots with lids produced in the Chenghua period, "Paintings of erudite scholars" on blue and white pots with lids produced in the Hongzhi period, "Human figures riding horses" on tripod furnaces produced in the Hongzhi period,[143] "Worshiping the moon" on incense burners produced in the Hongzhi period, "Paintings of erudite scholars" on incense burners produced in the Hongzhi period (Fig. 10.122), "Human figures, buildings and pavilions" on sets of boxes,[144] and "Dining reception in a courtyard" on *kongming* bowls produced in the Zhengde period.[145]

Apart from blue and white porcelain, such motifs were also applied to red and green wares. Representative articles include "Eight Immortals" red and green incense

[142] Zhu Yuping, *Identification and Appreciation of Chinese Porcelain*, Shanghai Chinese Classics Publishing House, 1993, p. 27 (Fig. 2).

[143] Tie Yuan, *Blue and White Porcelain from the Ming Dynasty*, Hualing Press, 2001, p. 61 (Figs. 2 and 3), p. 63 (Figs. 2, 3 and 4), p. 65 (Figs. 2, 3 and 4), p. 71 (Figs. 1 and 4).

[144] Li Zhengzhong & Zhu Yuping, *A General Study of Ancient Chinese Porcelain*, Taiwan Arts Book Company, 1992, p. 150 (Fig. 178).

[145] Ma Xigui, *Famous Blue and White Porcelain*, Taiwan Arts Book Company, 1993, p. 64 (Fig. 45).

Fig. 10.122 Blue and white furnace with paintings of erudite scholars, produced in the Hongzhi period of the Ming Dynasty, in a private collection

Fig. 10.123 Blue and white horse-riding bowl, produced in the Chenghua period of the Ming Dynasty, in the Jingdezhen Academy of Private Kiln Art

tubes with bases produced in the Tianshun period and red and green horse-riding bowls produced in the Chenghua period.[146] (Fig. 10.123).

Paintings of human figures on blue and white porcelain produced in the mid-Ming Dynasty differed from that of the Yuan Dynasty in the following respects. In painting technique, the Yuan Dynasty was influenced by woodcut paintings, thus the Yuan paintings were neat and rigid. In terms of motifs, the Yuan Dynasty mainly adopted figures and plots from the then Yuan verses or novels, thus adopting a rather low-brow style. In contrast, the Ming Dynasty was influenced by the literati paintings, thus free and casual. The Ming Dynasty motifs mainly displayed the lives of scholars, fairies, gods and Taoist priests in pursuit of enjoyment and aesthetic beauty, thus quite highbrow.

Since the mid-Ming Dynasty, literati painting in Suzhou, Hangzhou and Nanjing had exerted a significant influence on the ceramic art of Jingdezhen, especially the Zhejiang and Wu schools. By the late Ming Dynasty, despite social turmoil and the impending change of regime, some scholars living in the Jiangsu and Zhejiang region still led a casual, free and comfortable life and pursued ease and self-emancipation. The rise of the School of the Mind (*Xinxue*) represented by Wang Yangming along

[146] Ye Peilan, *Famous Wucai Porcelain*, Taiwan Arts Book Company, 1996, p. 18 (Figs. 11 and 13).

with Zen philosophy in the late Ming Dynasty further enhanced the traditional values of "*xian*" (idleness), "*jing*" (cleanness), "*kong*" (emptiness), and "*ji*" (loneliness) in literati paintings. Many scholars indulged in cultivation of the mind in order to cut themselves off from all concerns and perfect themselves. Building on the traditions of the Wu school, the Songjiang school played a dominant role in art circles. Representative and influential painters at this time included Dong Qichang, Chen Jiru, Mo Shilong and Zhao Zuo. Meanwhile, with progress in block printing, works of these painters could be printed in large volumes and made into albums. Taking these albums as reference, Jingdezhen potters were able to copy some images or patterns onto porcelain and produce products suited to the tastes of scholars and painters. Thus, some articles produced from the Tianqi to the Chongzhen periods, which were usually used by scholars, like blue and white pen holders, pen washers and incense burners, were decorated with such literati paintings. Painted with ink mixed with water, these images were often painted in a light and casual manner. Images frequently seen in literati paintings were transferred to porcelain, such as the drunk Li Bai (a great Chinese poet), Wang Xizhi (a great Chinese calligrapher) observing geese, Su Dongpo (Su Shi) and the inkstone, Zhou Maoshu (a Song dynasty Neo-Confucian philosopher and cosmologist) and lotus, Tao Yuanming (a Chinese poet) admiring the beauty of chrysanthemum, sitting alone under a pine tree, an old man fishing or carrying a *qin* to visit a friend. Compared with figure paintings in the mid-Ming Dynasty, these images no longer included cloud patterns. Even if there was cloud, it would invariably be delicate and superficial. Such images appeared more tranquil and highbrow. In addition, perhaps in an attempt to cater to scholars' pursuit of ease and simplicity, an article would be decorated solely with such paintings, with no other decoration on the neck, shoulder, or bottom, like blue and white porcelain of the past. Sometimes, in order to avoid dullness, a dark pattern was inscribed on an inconspicuous area. Apart from figure paintings, flowers and natural scenery often seen in literati paintings were also applied to porcelain.[147] In their paintings, artisans tried to copy the shades of color, the polishing effect and the smooth, bold drawings from literati paintings while also adding their own creativity, making the pictures vivid and interesting. Apart from the articles mentioned above, some vases and pots also adopted this decorative approach and only placed some simple or casual patterns on the neck.[148] Such a decorative method had rarely been seen previously.

10.7.4 Influence of Ming Woodcut Paintings on Porcelain

The popularity of woodcut paintings in the Ming Dynasty also injected vigor and vitality into the development of ceramic art. In the early period, woodcut paintings were mainly illustrations of Buddhist sutras, coinciding with the heyday of Buddhism. In the Five Dynasties and Song Dynasty (and especially in the Song

[147] Tie Yuan, *Blue and White Porcelain from the Ming Dynasty*, Hualing Press, 2001, pp. 121–127.
[148] Tie Yuan, *Blue and White Porcelain from the Ming Dynasty*, Hualing Press, 2001, pp. 113–121.

Dynasty), woodcut paintings found wider application and experienced unprecedented prosperity thanks to the flourishing of the book publishing industry and the reform of printing technologies. By the Yuan Dynasty, opera, novels and storytelling were quite developed and popularized, paving the way for the fully-fledged development of woodcut paintings. From the Wanli period of the Ming Dynasty to the early Qing Dynasty, with the development of the commodity economy and urban areas, popularized and entertaining folk literature entered an unprecedentedly active stage. Various operas and novels were published, facilitating the development of the woodblock printing industry and illustration art. This period marked a boom in woodcuts in Chinese history, with an unprecedented number of works, varieties and artistic styles. Opera, novels and storytelling scripts were also illustrated with woodcut paintings and captions which made the plots more real and entertaining for readers. These illustrated paintings not only strengthened the development of opera and novels, but also served as one of the most popular artistic forms of the day. Many painters were also involved in creating woodcut paintings, including Tang Yin, Qiu Ying, Chen Hongshou and Ding Yunpeng. A large group of woodblock print artisans also emerged and workshops and bookshops offering woodblock prints appeared all over China, mainly in Huizhou, Jinling (today's Nanjing), Jianning, Hangzhou and Beijing, amongst others. Of these, Huizhou produced many extraordinary works and highly skilled artisans, representing the highest level of the art of woodcut painting. Notably, the Huang and Wang families passed on the skill from generation to generation and produced many excellent artisans. For example, *Heroes of the Marshes* and *Romance of the Western Chamber* by Huang Zili and *Romance of the Western Chamber* and *The Story of Pipa* by Huang Yikai featured superb craftsmanship and exquisite skill. Painters and carving workers worked closely together. Painters meticulously elaborated every detail and carving workers were given full license to their creativity so that every detail was demonstrated vividly such that even complicated techniques such as *feibai* (flying white) could be displayed. The woodcut paintings of Huizhou were truly the best in woodcut art in the Ming Dynasty.

Apart from vivid woodcut painting illustrations in novels, many albums of paintings were published, such as the most representative *Gu Painting Album, Painting Album of Poetry*, and *Painting Album of Tang Poems*. In fact, patterns commonly seen on porcelain in the late Ming and early Qing periods, such as the moon, parenthesis-shaped clouds, small dots of moss, human figures painted in freehand style, water-wave-shaped lines, and banana leaves used to decorate the mouths and rims of porcelain were all from these three albums as well as the *Painting Album of Jieziyuan,* which was published later. Products produced by private kilns in the late Ming Dynasty, articles retrieved from a sunken ship in Vung Tau, Vietnam, and blue and white porcelain produced by official kilns in the Kangxi period were all found with elements of woodcut paintings from the late Ming Dynasty.[149] For example,

[149] Huo Hua, "On the Historical Role of Blue and White Porcelain Exports in the 17th Century in the History of Ancient Ceramics: A Bridge between Private Kilns in the Late Ming Dynasty and Official Kilns in the Qing Dynasty," Chinese Society for Ancient Ceramics (ed.), *Studies on Ancient Chinese Ceramics* (Vol. 14), The Forbidden City Publishing House, 2008, p. 280.

Fig. 10.124 Jingdezhen blue and white incense burner painted with a story from *The Three Kingdoms*, produced in 1625, in the British Museum

Fig. 10.124 features an incense burner from the late Ming period. At the bottom, it is inscribed with *"Tianqiwunian Wumingdongxiang"* (Wu Dongxiang in the fifth year of Tianqi, 1625). We still do not know who Wu Dongxiang was; perhaps the owner or the donor of the article? Painted on the burner is a story from a well-known Chinese novel called *The Three Kingdoms*. The picture illustrates how Zhao Yun, a military general from the late Eastern Han Dynasty and early Three Kingdoms period, bravely and singly saved the son of Liu Bei, Zhao's master and a major warlord of the time, after Liu' s wife drowned herself in a well. Such stories were also from albums of woodcut paintings.

Attractive and exquisite woodcut paintings and various painting albums served as an important source of creativity for potters. Thus, after the Wanli period, both blue and white porcelain and *wucai* wares experienced profound changes in style as skillful potters applied neat designs, structures, lines and dots from woodcut paint-ings to their decorations. Sometimes, potters even outlined blue patterns with cobalt blue materials without water and showcased a picture with lines only, without the addition of colors. Apart from decorative styles, woodcut paintings also influenced decorative motifs used by private kilns in Jingdezhen. At the time, motifs in woodcuts were mainly derived from popular opera, novels, or story-telling scripts, as well as various historical records, local gazetteers and painting albums of famous artists. So, woodcut motifs touched on almost every aspect of people's lives. Drawing from the unique motifs and their means of expression on woodcuts, *wucai* wares and blue and white porcelain enjoyed rapid progress and laid a solid foundation for their further development and progress in the Kangxi period of the Qing Dynasty.

10.7.5 The Impact of International Trade on Ceramic Styles

In the Ming Dynasty, the most important and also the most easily neglected factor contributing to the development of ceramic art after the Jiajing and Wanli periods was the opening up of the foreign market and cultural exchange between East and West which had a profound influence on the ceramics industry and its transformation. As William R. Sargent points out in his *Treasures of Chinese Export Ceramics*, "From the late sixteenth century to the nineteenth century, cultural exchange between China and the West was not limited to porcelain trade and art, but also religion, politics, gardening, architecture, music and languages. With the introduction of tea and tea wares, household lives in the West were greatly affected and the dietary habits of Westerners experienced revolutionary changes. With the introduction of exotic articles like paint, silk, wall coatings, furniture, paintings, porcelain and other Chinese artistic artifacts into people's lives, the Western world gave voice to their own aspirations, which included revolutionizing their indoor decoration with luxurious imports from China." "To acquire luxurious Chinese goods (especially tea, silk, and porcelain) was the motive for engaging in global competition and establishing and maintaining a global porcelain trade network. However, the chain effects swept the whole world for more than a century, not once nor uni-directional, but time after time through two-way interaction between East and West, until this day."

From the above, we can see that today's globalization actually began from the Jiajing and Wanli periods when China began to sell porcelain to Europe. The porcelain trade was the beginning of China's globalization experience. The global flow of Chinese porcelain and other goods not only changed the way of life of the Western world, but also affected the formation of new aesthetic tastes of the Chinese and new styles of ceramic art because such interaction and influence was both two-way and incremental.

So, apart from literati and woodcut paintings, ceramic art in the Ming Dynasty was also affected by foreign arts and cultures. With the lifting of the "maritime ban" in the Longqing period (1567–1572), the opening up of maritime routes to Europe and the increasing trade exchange among nations, Chinese ceramic production entered a new historic era, featuring a wider market and broader horizons, and absorbed new stimuli and new aesthetic ideas. Many foreign merchants came to Jingdezhen to order porcelain who on the one hand were attracted by the extraordinary ceramic art of the area, but were also desirous of presenting new requirements based on their own culture, customs and aesthetic tastes. At times they even brought models of their own design to Jingdezhen. Their artistic interests and ideas in turn affected how Chinese potters produced porcelain, thus a unique artistic form came into being at this time. For example, in order to cater to the Japanese market, from the Jiajing period, potters began to put *jincai* on porcelain. Although *jincai* had already been applied to porcelain previously, it was very rare, and it was not until the Qing Dynasty that *jincai* was popularized to the extent of it appearing glamorous. Meanwhile, under the influence of European culture, neat and complex patterns were increasingly popular, reaching a peak in the Qing Dynasty. In fact, with the emergence of capitalism and

Fig. 10.125 Blue and white "Kraak" bowl, produced in the Chongzhen period of the Ming Dynasty

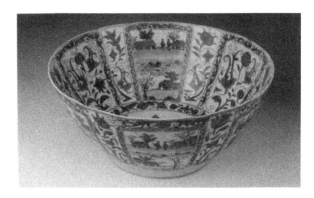

the influence of foreign cultures, the Chinese people's aesthetic tastes also changed from the pursuit of purity to that of resplendency, from "nature-dominant" to "people-centered," and from natural beauty to artificial beauty. Thus, historically, the Ming Dynasty was an important transitional period from traditional society to the modern and ceramic art at this time experienced profound change from the traditional literati style to the modern worldly style.

At this time, a variety of export porcelain called "Kraak porcelain" by Europeans and "Kosometsuke" by the Japanese came into being and attracted much attention in the markets of Europe, Japan and the Middle East. We have noted that some black on white porcelain produced by the Cizhou kilns and blue and white porcelain produced by the Jingdezhen kilns had adopted paneled decorations, especially on blue and white porcelain exported to the Islamic world. By the Wanli period, this technique had gained much favor among the European consumers while exerting a profound influence on Islamic culture.

Illustrated in Fig. 10.125 is a bowl from a set of "Kraak wares" produced for the Middle East and European markets in the Chongzhen period (1628–1644) of the late Ming Dynasty. It features thick outlines, complex motifs, scenes of a story and flowers like carnations, tulips, and others with solid branches, which might originate from the Iznik ceramics and Osman silk products of the sixteenth century or the soft paste blue and white porcelain from the early Safavid Dynasty of the seventeenth century. Among them, tulips were very popular in the "tulip mania" of the Netherlands of the 1630s.[150]

"Kraak wares" were not only popular among Chinese exports to Europe and West Asia, but also among exports to Japan. For example, Fig. 10.126 is a blue and white loop-handled water pot with aquatic animals and plants. This wood-bucket-shaped water pot was especially made for Japanese tea ceremonies where it was used to hold clean water to clean teacups and make tea. On its body, there are wood-plank-shaped panels. The lid and the upper part of the panels carry flying cranes, eternal signs of Laozi, a deity in religious Taoism, as well as traditional *ruyi*-head clouds. On the lower portion, there are various sea plants and fish, such as carp, mandarin fish, crabs

[150] Rose Kerr & Luisa E. Mengoni, *Chinese Export Ceramics*. V & A Publishing, 2011, p. 23.

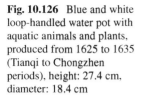

Fig. 10.126 Blue and white loop-handled water pot with aquatic animals and plants, produced from 1625 to 1635 (Tianqi to Chongzhen periods), height: 27.4 cm, diameter: 18.4 cm

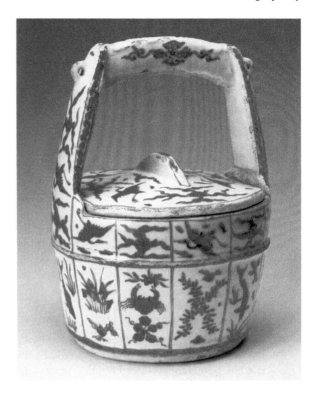

and shrimps. On the edges of the handle and top of the lid are curling patterns. Peony along with twining lotus was a motif frequently seen on export wares in the 1630s and 1640s. A bulge around the belly was made in imitation of an iron loop around a wooden bucket. In the bluish glaze of the pot there are numerous pores. On the edges of the handle and lids, as well as the middle of the body, there are many "insect marks," with grit on the bottom of the pot.[151] These are typical features of export porcelain in the Wanli, Tianqi and Chongzhen periods.

These Kraak wares exported to Europe, the Middle East and Japan have both characteristics of products of the Cizhou kilns and artistic features of the then Middle East, Europe and Japan. Such cultural interaction affected ceramic production in Jingdezhen in the Ming Dynasty, thus giving birth to a new decorative style. We can see from this that mutual influence and integration of different civilizations serve as the basis for all cultural and artistic innovation.

[151] Julia B. Curtis, *Trade Taste & Transformation: Jingdezhen Porcelain for Japan, 1620–1645.* China Institute in America, 2006, p. 35.

Chapter 11
Ceramics of the Qing Dynasty

11.1 Introduction

Established by the Manchus from Manchuria, the Qing Dynasty came to rule China in 1644 and remained in power until 1912. Nurhaci, a Jurchen leader, was originally a Ming vassal from Jianzhou and was deeply influenced by the Han culture. He unified the various Jurchen tribes, organized the "Eight Banners," military-social units that included Manchu, Han, and Mongol elements, ordered the creation of a new written script for the Manchu language based on the Mongolian vertical script, and declared himself the "Bright Khan" of the Later Jin (gold) state in 1616. His son Hong Taiji, who reigned from 1627 to 1643 and was given the posthumous temple name of Taizong, renamed the dynasty the Great Qing in 1636. The change of name might have been influenced by Taoist philosophy and the name may have been selected in contrast to the name of the Ming Dynasty (明), which consists of the Chinese characters for "sun" (日) and "moon" (月), both associated with the fire element of the Chinese zodiacal system. The character *Jin* (金, gold) can be conquered by fire, so it is inauspicious. While the character *Qing* (清) is composed of "water" (氵) and "azure" (青), both associated with the water element. This association would justify the Qing conquest as defeat of fire by water. This change of name also reflected how profoundly the Qing founders were affected by the Han culture. They worshiped Confucianism and employed a large number of Han officials and generals.[1]

11.1.1 *Influence of Qing Emperors on the Culture of the Time*

Under the reign of Emperors Kangxi (1662–1722), Yongzheng (1723–1735) and Qianlong (1736–1795), Chinese society experienced another boom.

[1] Xue Fengxuan, *Evolution of Chinese Cities and Civilization*, Joint Publishing HK, 2009, p. 229.

© Foreign Language Teaching and Research Publishing Co., Ltd 2023
L. Fang, *The History of Chinese Ceramics*, China Academic Library,
https://doi.org/10.1007/978-981-19-9094-6_11

It is especially evident during the reign of these three emperors that the Qing rulers pursued a rule based on ethics and how they tried to legitimize their regime. From Emperor Kangxi's ascension to the throne, the court began to show clear concern for proper human relationships and any loss of respect or resistance to its rule. Thus there was a trend towards suppressing unorthodox and decadent works, leading to the virtual extinction of literary works under the reign of Emperor Kangxi. By the time Emperor Qianlong ascended the throne, almost all works produced to that date which criticized ethnic minority groups, like the Manchus, or works of questionable motivation, all disappeared after being censored or destroyed.

The result was that sweeping waves of social and political criticism in the seventeenth century were resolutely repressed and this also accelerated the decline of "folk" literature, a distinctive form of art in the late Ming Dynasty. Meanwhile, Emperor Kangxi and his successors gradually managed to reconcile with scholar-bureaucrats, stabilized domestic society, lifted the prosperity of the country, encouraged and employed large numbers of scholars in bookmaking, thus making the eighteenth century one of the most glorious periods in the history of Chinese thought. Chinese scholars at this time pooled wisdom from traditional aesthetics, literature and philosophy, thus reaching an unprecedented level. Boasting encyclopedic knowledge, they also strove for truth, enjoyment and a meticulous insistence on the golden mean. Therefore, in the opinion of Jacques Gernet, Chinese scholars in the eighteenth century could be on a par with French scholars and philosophers in the Age of Enlightenment. Looking back through history, we can see the first major event in publishing during the reign of Emperor Kangxi was the massive publication of the *History of the Ming Dynasty*. It was also in the Kangxi period that the *Gujin Tushu Jicheng,* or *Imperial Commissioned Compendium of Literature and Illustrations, Ancient and Modern*, a vast encyclopedic work, was compiled and accomplished. It is estimated that 57 official publications were unveiled with the support or sponsorship of the government during the reign of Emperor Kangxi. The most important work of the Qing Dynasty, the *Siku Quanshu,* or *Complete Library in Four Sections*, was the largest collection of writing in Chinese history compiled under the sponsorship of Emperor Qianlong. This complete encyclopedia contains all the published and unpublished works housed in imperial libraries and collected from private hands. Such national bookmaking campaigns were very conducive to progress in literature, the arts and academia. In addition, rich merchants, as collectors of rare books and sponsors of literary creations and creators, played a distinctive role in cultural development.[2]

Emperors Kangxi, Yongzheng and Qianlong were all quite open-minded and interested in Western painting, architecture and machinery as well as literature and arts. Jiao Bingzhen, a noted painter and astronomer in the Kangxi period, applied Western perspectives to 46 illustrations of his famous *Gengzhitu (Drawings of Tilling and Weaving*, illustrations on different stages of farming and silk processing), which

[2] Jacques Gernet, *A History of Chinese Civilization*, translated by Huang Jianhua, et al., Hunan Education Publishing House, 1994, p. 460.

were reproduced and distributed in the form of wood engravings in 1696, and part of which were applied to porcelain commissioned by Emperor Kangxi.

Emperor Qianlong demanded such illustrations be included as decorations in the Summer Palace, an imperial garden in the Qing Dynasty. The Jesuits Giuseppe Castiglione and Jean Denis Attiret were responsible for paintings in the imperial buildings. Giuseppe Castiglione, a talented painter, served the Qing court for nearly five decades until his death. He worked together with Chinese painters in painting landscapes, human figures, indoor scenes and palaces. Together with Jean Denis Attiret and Jean-Damascène Sallusti, he was engaged in the creation of a series of 16 *Copper Battle Prints*, commissioned by Emperor Qianlong in commemoration of his military campaigns. The rulers' enthusiasm for art, their interest in Western science, paintings and architecture as well as the attention they gave to traditional ethnic values, affected the Chinese ceramic arts of the day in terms of motif, content, decorative method and style.

11.1.2 The Pursuit and Recovery of "Practical Learning"

In the second half of the seventeenth century, Chinese scholars manifested a strong interest in practical science. Gu Yanwu, a famous geographer, economist and philologist of the period, traveled throughout the country and devoted himself to study. Gu Zuyu, a Qing geographer, completed *Dushi Fangyu Jiyao*, or literally *The Essence of Historical Geography* or *The Essentials of Geography for Reading History*, on the basis of his thinking, reading and traveling in his late 20s–50s. Huang Zongxi, while a political theorist and philosopher, completed eight works in mathematics, astronomy, music theory and more. Yan Yuan, a staunch supporter of "practical learning," believed the ritual laws of Neo-Confucianism were wrong, resulted in harm and should be completely discarded. Through studies of the ancients, he was convinced of the practical usefulness of the ancient culture and proposed the prioritization of archery, driving and mathematics. Yan Yuan redeemed the good name of manual labor and ingenious workmanship. He regarded the combination of skill with reality as a form of knowledge and held that if there was no "practice" there would be no true "knowledge."

The pursuit of practical science and practical learning began in the late Ming Dynasty. Such pragmatism facilitated the early development of science and technology in various fields in China and directed people's attention to the production techniques of articles of practical use. In the Ming Dynasty, officials designated to supervise and manage kilns in Jingdezhen knew virtually nothing about ceramic technology, nor did they care to know. While in the Qing Dynasty, especially from the Kangxi period to the Qianlong period, superintendents in Jingdezhen were not only responsible for administrative affairs, but they were also technocrats. For instance, Lang Tingji, the Grand Coordinator in Jiangxi Province, was assigned to supervise porcelain production in Jingdezhen from the 44th to the 51st year of the Kangxi period, namely 1705–1712. Lang had a profound knowledge of ceramic history and

loved antiques. The kilns under his supervision were also called "Lang kilns." Liu Tingji of the Qing period states that the Lang kilns produced articles in the ancient style with such advanced techniques that their products looked like the real ancient wares, and that their products like gold-painted wine cups with five-fingered double dragons and eggshell bowls manifested "truly wonderful craftsmanship." The Lang kilns created a kind of precious red glazed porcelain called "*langyaohong*" or Lang kiln red, which revived the copper based high temperature red glaze production technology which had been lost for over 200 years since the mid-Ming Dynasty. Apart from *langyaohong*, the Lang kilns also produced valuable plain tricolor porcelain. Tang Ying, also a Superintendent in the imperial kilns in Jingdezhen, a learned scholar and excellent painter, served the court for nearly three decades and took charge of porcelain production for both Emperor Yongzheng and Emperor Qianlong. Thanks to his devoted efforts, he amassed a wealth of experience in porcelain making and products produced under his supervision were all quite splendid; he thus won the favor of both the two emperors he served. In the Qianlong period, the official kilns were thus also known as "Tang kilns." Products at this time featured various designs, gorgeous decorations, amazing colors, and auspicious motifs like twining lotus, double fish and lucid ganoderma, which were mainly put on bowls, plates and vases. Tang Ying was the longest serving superintendent at the Jingdezhen imperial kilns with the most remarkable achievements. He not only boasted a profound experience in porcelain affairs, but also scientifically summarized porcelain production technologies in theory, and compiled works like *Taowuxulve, Taoyetushuo* (*Illustrations of the Manufacture of Porcelain*), *Taochengjishi* and *Taowushiyilungao*. Thus, it seems thanks to the high importance attached to practical learning, some senior government officials began to value technologies and to pay attention to handicraft activities. This is an important factor which contributed to the peak of porcelain production in Jingdezhen in the Kangxi, Yongzhen and Qianlong periods (Figs. 11.1 and 11.2).

11.1.3 The Boom in Handicrafts and Commerce in the Early Qing Dynasty

In the eighteenth century, the Qing regime fully and successfully utilized the technologies of pre-industrial times. It appears that, after the internal conflicts and wars of the late Ming and early Qing periods, the Chinese economy boomed once more, just like the Wanli period had, but on a larger scale and to a higher level.

At the time, handicraft production was flourishing, including the textile industry in Songjiang, southwest of Shanghai, tea production in the lower reaches of the Yangtze River, paper-making in Fujian, the iron industry in Wuhu, the hardware industry in Guangzhou, the fine cotton industry in Nanjing, the silk industry in Suzhuo and Hangzhou as well as the lacquerware industry in Yangzhou. Jingdezhen, a national porcelain production center, was home to hundreds of thousands of workers who

Fig. 11.1 Black plain
tricolor *bangchuiping*
(rouleau-shaped vase),
produced in the Kangxi
period of the Qing Dynasty,
height: 44 cm, in the Palace
Museum

produced to supply the court, the orders of the rich, as well as for export to Japan,
the Korean peninsula, Russia, the Philippines, the Indian sub-continent, Indonesia,
and even Europe.

As a large global manufacturer and exporter, China's aesthetic tastes affected the
whole world, including Europe. In the eighteenth century, blue and white porcelain,
furniture and antiques of the Kangxi period were especially popular in Europe. As
Jacques Gernet writes: "Chinese gardens and architecture were made fashionable at
Kew in 1763 thanks to W. Chambers (1726–1796), and China helped to guide the
feeling for nature in the direction which was developed by the Romantic movement."[3]
(Figs. 11.3 and 11.4).

The eighteenth century Qing economic boom not only made possible more and
more large handicraft workshops, professional and centralized production bases, and
prosperous exports, but also a flourishing domestic trade and an expanding network
of industrial and commercial organizations. At the time, China's commercial network
not only covered various provinces at home, but also Mongolia, Central Asia, and the
entire Southeast Asia. In major cities, there were regional commercial groups which
provided accommodation, banking services, and more, facilitating the prosperity of
the economy and the urbanization of the labor force.

[3] Jacques Gernet, *A History of Chinese Civilization*, translated by Geng Sheng, Jiangsu People's
Publishing Ltd., 1995, p. 435.

Fig. 11.2 Yellow enameled
bowl with rock and grass
patterns, produced in the
Yongzheng period of the
Qing Dynasty, height:
5.2 cm, diameter: 10.3 cm,
foot rim diameter: 4 cm, in
the Palace Museum

11.1.4 Foreign Trade in Porcelain During the Qing Dynasty

After Emperor Shunzhi died in 1661, Emperor Kangxi assumed the throne. In 1674,
led by Wu Sangui, the Revolt of the Three Feudatories broke out in Southern China.
After years of battles, the revolt ended with the victory of the Qing forces in 1681.
During this time, the Jingdezhen kilns suffered significant damage. With the support
of Emperor Kangxi, efforts were made to recover the porcelain arts and techniques.
The emperor adopted the advice of Ferdinand Verbiest, a Flemish Jesuit missionary,
and commissioned the construction of 27–30 workshops around the imperial palace
in Beijing where various techniques were practiced to produce metal ware, glassware,
jade ware, lacquerware, ivory ware, porcelain ware and enamel ware. In 1722, after
Emperor Kangxi passed away, his fourth son, who was later known as Emperor

Fig. 11.3 Gilt famille-rose
armorial plate, produced in
the Qianlong period,
diameter: 35.5 cm, foot rim
diameter: 20.5 cm, height:
5 cm, in the City Museum of
Gothenburg

Fig. 11.4 Gilt famille-rose
armorial plate, produced in
the Qianlong period,
diameter: 22.4 cm, foot rim
diameter: 13.3 cm, height:
2.5 cm, in the City Museum
of Gothenburg

Yongzheng, was chosen to be the new emperor. After Emperor Yongzheng passed
away in 1736, Emperor Qianlong ascended the throne. Like his grandfather, Emperor
Qianlong ruled the country for 60 years. From Kangxi to Qianlong, China reached
a peak in cultural, political and economic development, known as the "Kang-Qian

Age of Prosperity" in Chinese history. The foreign trade in Chinese porcelain also peaked at this time.[4]

The Dutch East India Company, which traded large amounts of Chinese porcelain in the Wanli and Jiajing periods but had to stop during the Chongzhen and Shunzhen periods, had sent an envoy, Pieter van Hoorn, to the Qing court to reestablish trade ties as early as the early Qing period under the reign of Emperor Kangxi. The delegation arrived in Beijing in 1667 but met with some obstacles. Nevertheless, in 1679 when the company sent three ships to Guangzhou, they finally made it. The captains of the ships managed to return with goods valued at three tons of gold on their ships. However, their second voyage three years later again failed, with only a small volume of goods loaded on board in Guangzhou. In order to trade with China, Rijckloff van Goens, Governor-General of the Dutch East Indies allowed Chinese citizens to engage in trade in Batavia in 1680, and from 1695 Chinese merchants began to trade in tea, silk and porcelain there.[5]

In 1699, the Qing government finally decided to open the Port of Guangzhou to foreign trade, marking a major event in trade history. Even so, foreign trade was still banned at times in practice. Before long, a British merchant ship called the Maccles-field was allowed entry into Guangzhou and returned home fully laden. It was only in the eighteenth century that Qing authorities started to adopt an open policy towards foreign trade. In 1715, the British East India Company gained permission to set up an office in Guangzhou, the first one ever, and this was followed by counter-parts from France (1728), the Netherlands (1729), Denmark (1731), Sweden (1732), Austria and the USA (1784).[6] Even merchants from India and Armenia established their own offices. Since the late seventeenth century, Russia had been trading with China.[7] The Ostende Company, a chartered trading company in the Austrian Nether-lands (part of the Holy Roman Empire, currently Belgium) founded in 1721, and the Spanish Manila Company were also engaged in trade with China. Thus, it seems China's trading partners in the Qing Dynasty expanded from Portugal, Spain, the Netherlands and Britain in the Ming Dynasty to a much wider range of countries and regions, initiating a high tide in the porcelain trade and also symbolizing a global reach for Chinese porcelain.

[4] D. F. Lunsingh Scheurieer, *Chinese Export Porcelain Chine de Commande*, Pitman Publishing Corporation. 1974, p. 60.

[5] See Footnote 4.

[6] D. R. J. de Hullu, "Over den Chineschen Handel der O.I.C.", *Taal, Land en Volkenkunde*, 73, 1917, p. 59.

[7] D. F. Lunsingh Scheurieer, *Chinese Export Porcelain Chine de Commande*, Pitman Publishing Corporation. 1974, p. 61.

11.1.5 Difficulties Faced by China in the Late Qing Dynasty

After the "Kang-Qian Age of Prosperity," China hit a downward path. In the last quarter of the eighteenth century, corruption swept the entire bureaucratic system. It seems the extravagant lifestyle of the emperors and the court had infected the upper classes. In the latter years of Emperor Qianlong and the early nineteenth century, symptoms of social turmoil and unbalanced wealth distribution had already manifested themselves.

The world experienced great changes in the nineteenth century. In the latter half of the nineteenth century, through industrial revolution, much progress was made technologically in the West while China failed to move forward and thus continued to mainly rely on handicraft production. China was a large producer in the 18th and the first half of the nineteenth century. However, from the late nineteenth century onwards, China turned into an importer, purchasing steel, machinery, railway equipment, weapons and even daily use articles from abroad. At this time, China was almost reduced to a completely agrarian and semi-colonial nation which was forced to import industrial goods due to its own poor industrial base. This represented a turning point in Chinese history. From that point forward, third world countries and regions became the subjects of rich and powerful countries. It was in the late nineteenth century when mechanized production emerged and boomed that this turning point finally arrived.

China was confronted with two major challenges. The first was domestic political and economic crises and the second was pressure caused by the military and economic expansion of the Western capitalist powers. From the late sixteenth century to the late eighteenth century, the national production of silver increased tremendously, showing a constant growth in wealth. Meanwhile, the price ratio of silver to gold kept going down. In the second half of the nineteenth century, the Western powers adopted the gold standard system, which further accelerated the devaluation of silver. At this time, the Chinese economy not only suffered from losses in trade, but was also afflicted with war reparations forced on it by aggressors. Burdened with domestic wars and turmoil, poverty led by currency devaluation, and increasingly frequent famines and floods, the Chinese economy staggered and even declined in the latter half of the nineteenth century.

From the late nineteenth century, the foreign powers bullied and plundered China one after another. The tragedy that China suffered was shared with colonial regions all around the world. While the various Western aggressions and privileges that the foreign forces grabbed through military power were not the sole or major reason for China's failed attempt at modernization, they certainly contributed to it. A consolidated tax of a mere 5% was levied on foreign goods entering China with no transit taxes, while heavy transit taxes were imposed on Chinese goods. Such a distorted system left China to face exorbitant expenditures on imports.

Before signing the Treaty of Shimonoseki, China managed to afford the war reparations. However, from around 1900, these costs were so overwhelming as to

virtually destroy the Chinese economy. For example, the Sino-Japanese War of 1894–1895 incurred reparations from China which reached as much as three times its annual national revenue, while the Boxer Protocol imposed an indemnity which finally led to the bankruptcy of the Qing government. After the Treaty of Shimonoseki was signed, the government had to turn to French and Russian banks to borrow money, with customs duties as security, thus the entire national tax system fell under the control of foreign powers, as did all revenues.

From 1895, the Qing government had been smothered with war reparations, loans from foreign banks, and expenditure to build a modern army. Apart from these, other factors also came into play and shaped and weakened the Chinese economy. Affected by the world economy, the Chinese economy was increasingly fragile. Catering to foreign demands, Chinese agriculture shifted its focus to plantation farming at the expense of abandoning crop growing, while the handicraft industry turned to processing industrial goods (like imported cotton yarn and weaving). Between 1893 and 1899, large amounts of cloth from Europe (especially Britain) flowed into China while from 1899 to 1900, exports of American cotton goods to China experienced a surge, leading to the death of the cotton and textile industries in some regions of China. Thus, during this time, some sectors experienced a short boom before their sudden collapse.

In 1920, China's import of cotton goods peaked, followed by its decline due to the poverty of society as a whole. Ceramic products, a traditional Chinese export, lagged behind that of Japan, and even Europe, including countries like Britain, Germany, and France in terms of quality, thanks to progress in mechanized ceramic production in these countries. According to an article in *Zhonghangyuekan*, in the early years of the Republic of China period, a Nanyang (an old name for Southeast Asia) Consul in China wrote in a report that "People in *Nanyang* were accustomed to Chinese porcelain… But Chinese porcelain was neither as attractive as its counterpart from Europe and the USA, nor as inexpensive as its Japanese counterpart. So, it seems Chinese ceramic products are caught in a bind."

As Chinese handicrafts lost favor in the market, many cities and towns which relied on the industry faced unprecedented decline, including Jingdezhen, a major national ceramic center. By 1877, the third year of Emperor Guangxu, the imperial kilns of the Ming and Qing dynasties were already decimated. Despite over 110 private kilns in operation in Jingdezhen, their facilities and techniques were unremarkable. Only a handful of painters still boasted superior craftsmanship, a skill which was quite valuable. Year after year, products were made in imitation of ancient wares, but their quality was found wanting, and very few were sold. Traditionally famous kilns, like Cizhou in Pengcheng, Hebei Province, Yaozhou in Tongchuan, Shaanxi Province, Jun in Yuxian County and Ru in Baofeng, Henan Province, as well as those in southern regions like Shiwan in Guangdong, Yixing in Jiangsu, Longquan in Zhejiang and Dehua in Fujian could either barely sustain themselves or had already ceased production. As the kilns closed, their techniques were lost. Some kilns were even bereft of workers and know-how as they teetered on the verge of collapse.

11.2 Jingdezhen Porcelain in the Early Qing Dynasty

11.2.1 Prosperity and Development

In the early Qing Dynasty, production in Jingdezhen was quite sluggish, even including the official kilns. Under the reign of Emperor Shunzhi, the imperial court assigned tasks to Jingdezhen to produce vats and slates but ended up in failure. In 1674, the 13th year of Emperor Kangxi, due to the revolt of Wu Sangui, the base of ceramic production in Jingdezhen was almost completely ruined. It was not until 1680, the 19th year of Kangxi, that Jingdezhen recovered and achieved progress in leaps and bounds, becoming a prosperous region once again.

An individual named Shen Huaiqing in the early Qing Dynasty notes: "The porcelain of Changnan Town (present-day Jingdezhen), flows all over the country and even beyond to foreign countries. Workers in porcelain affairs are numerous, usually tens of thousands."[8] In the early Qianlong period, Tang Ying also describes the then ceramic production in *Taoyetushuo* (*Illustrations of the Manufacture of Porcelain*), saying "Though covering a small area of several kilometers, Jingdezhen is surrounded by mountains and rivers. Famous for porcelain, Jingdezhen attracts merchants from all sides here. Boasting 200–300 private kilns, Jingdezhen is home to hundreds of thousands of potters and workers who rely on this business for a living."

Under the "*Guandaminshao*" system, the scale of the imperial kilns was not as large as it had been in the Ming Dynasty. Normally, only a designated number of personnel (around 20–30) worked in the imperial kilns on a routine basis while when there were production tasks, more would be employed. When the clay was finished in the imperial kilns, it would be transferred to private kilns for firing. The internal structure and division of labor of the imperial kilns was clearly much simpler in the Qing Dynasty than in the Ming Dynasty, with only a few sections like molding, color painting and firing. As for auxiliary workshops that served in porcelain production, such as those in charge of the production of saggers, plaster, wood, ships, ropes and buckets, they might also have been transferred to private hands and no record was identified in the imperial kilns. What is more important is that the 20 imperial kilns in the Ming Dynasty, which further expanded to 58 in the Xuande period, could no longer be traced in the Qing Dynasty. This shows that the imperial kilns were only responsible for molding and color painting in the Qing Dynasty, apart from the second firing of exquisite color enamel ware, while the remaining production procedures were completed by private kilns. It therefore appears that the "*Guandaminshao*" system implemented in the late Ming Dynasty was more generally and thoroughly put into practice in the Qing Dynasty. Under this system, quality official porcelain and quality private porcelain were made by the same chambers, except that official products made in these kilns were earmarked for imperial use. Apart from awards to individuals or entities that were dispatched directly by emperors, even imperial relatives had no direct access to imperial kiln

[8] Zhu Yan, *Taoshuo* (*On Ceramics*), Zabianshang.

products. So private kilns not only undertook tasks for official kilns and supplied daily use wares for the common public, but they were also required to produce quality porcelain to meet the demands of the privileged and for export. Such quality products were normally sourced from "*guanguqi*" kilns, with lesser quality ones from "*jiaguanguqi*" kilns, followed by "*shangguqi*" kilns. While the private kilns were "people's kilns", their products were obviously mostly supplied to landlords and bureaucrats. Private kilns had a wide market, ranging from emperors, high officials and the nobility, to common people in terms of social ranking, who lived as distant as overseas or as close as in the nearby countryside. So private kilns at the time must have been very numerous and bustling. The size of the kilns was often five times that of the Ming Dynasty. So, if there were 200 private kilns in Jingdezhen in the early Qing Dynasty, they would have been equivalent to 1000 in the Ming Dynasty. In terms of the number of private kilns in Jingdezhen, the Ming Dynasty was thus a far cry from the Qing Dynasty. In terms of the scale of production, division of labor and employment relations, the Jingdezhen ceramics industry had clearly entered the stage of operating in units of handicraft workshops in a capitalist form. But of course, all this could not have been possible without the solid foundation that was laid in the late Ming Dynasty.

11.2.2 Jingdezhen in the Eyes of Europeans

Jingdezhen, the national ceramic production center in the Ming Dynasty, further expanded its international market in the late Ming, making itself a household name around the globe. The development of Jingdezhen in the Qing Dynasty has been documented in many works, like the *Gazetteer of Fuliang County*, *Local Gazetteer of Raozhou*, *Local Gazetteer of Jiangxi*, *Great Gazetteer of Jiangxi Province*, *Jingdezhen Taolu* by Lan Pu, *Taoshuo* (*On Ceramics*) by Zhu Yan and *Jingdezhen Taoge* (*Potters' Songs from Jingdezhen*) by Gong Shi. By the Qing Dynasty, Jingdezhen could also be found in many European records, which allows us a peek into how Europeans viewed China and Jingdezhen, and also helps fill in some gaps in the Chinese records and provides a composite picture of the culture and history of Jingdezhen as a major ceramic city in the Qing Dynasty.

Rose Kerr, an English art historian specializing in Chinese art, especially Chinese ceramics, wrote in "The Porcelain City: Jingdezhen in the Sixteenth Through Nineteenth Centuries" that the earliest European books that took account of Jingdezhen were written by missionaries who usually only visited Macao, Guangzhou and some other southern cities in China. The information collected was crucial to the preaching of religion and conducting trade. Gaspar da Cruz, a Portuguese Dominican friar, obtained detailed and accurate information regarding porcelain production during his stay in Guangzhou in 1556. In 1569, an account of his travels entitled *Treatise on things Chinese* was published, and it was widely read and cited in the Western world. In the book he writes:

> There is another province called Jiangxi... Jingdezhen in that province, is a place where all the beautiful and exquisite porcelain products are made... From my perspective, porcelain is made from a white and soft stone... After it is completely smashed, it is placed into vats of water... When fully soaked in the water, potters use the floating fine particles to make porcelain. The products are dried under the sun before being painted. Painters tend to use a very beautiful cobalt blue pigment and after the paintings are dry, they are ready to be fired.[9]

By the late eighteenth century, François Xavier d'Entrecolles, a French Jesuit priest, returned home with more detailed first-hand information regarding Jingdezhen. He was born in Lyons and entered the Society of Jesus in 1682. In 1689, he arrived in China. Initially proselytizing in Jiangxi, he then became Superior of the French Residence in Beijing and eventually died in Beijing in 1741. François Xavier d'Entrecolles learned Chinese, which allowed him to observe Jingdezhen directly through the 1682 printing of the *Gazetteer of Fuliang County*. D'Entrecolles sent home two detailed, very comprehensive and well-structured letters on the composition and production of porcelain which he penned on Sept 1, 1712 in Raozhou and Jan 25, 1722 in Jingdezhen respectively. At this time, European factories were attempting to plunge themselves into porcelain production. Thus, the letters of D'Entrecolles, a very important source of intelligence, were very much welcomed by his mother country.

The first D'Entrecolles letter was very long and informative while the second further complemented and corrected some details in the first letter. These two letters covered most of the detailed information available in Chinese documents, but more comprehensive, with information on people in the handicraft industry. Some of the personal information might have been obtained with the help of Chinese Catholic converts. "Besides what I have seen myself, I have learned many particulars from the Christian converts, among whom there are many who work with porcelain, and from others who make a business of it." These letters were written in French and later translated into English and have been cited many times in French and English papers and works. What interested people the most regarding D'Entrecolles's letters was his description of the way of life in Jingdezhen:

> There are reportedly 18,000 families in Jingdezhen. Also, there are some great merchants whose factories occupy a vast area and contain a prodigious number of workers. It is said that there are more than a million souls here, who consume each day more than 10,000 loads of rice, and more than a thousand pigs... But notwithstanding the expense of living, Jingdezhen is the home of a mass of poor families who wouldn't be able to subsist in the surrounding cities. One also finds here many young workers and weaker people. It is the same way for the blind and for the cripples who spend their lives grinding pigments.

What these poor workers were grinding were pigments to be used in painting porcelain. He continued:

> As for the colors of porcelain, there are some of all varieties. One hardly sees any in Europe except those that are a bright blue on a white background. I believe, however, that tour

[9] William R. Sargent, *Treasures of Chinese Export Ceramics: From the Peabody Essex Museum.* Distributed by Yale University Press, 2012.

merchants have also brought over some others... There is some porcelain where the land-scapes are made up of nearly all colors, heightened by the brilliance of gilding. They are very beautiful if one can get the expensive kind.

Bright-colored overglaze porcelain was usually more expensive than blue and white porcelain because the blue color was painted under the glaze and required only one high-temperature firing in a furnace. Firing in large kilns was the most tiring job of all, and it usually took four to five professional masters and two assistants. Before a firing, there was a whole day for all the preparation work and in the following three days, all the workers had to be highly vigilant with no time to sleep or rest.

The pigments used in overglaze porcelain were more expensive. It took a lot of training for a skilled painter to master the mixed use of pigments and turpentine, glue and water. Pigments mixed with turpentine were generally applied in outlines, pigments with glue for light polishing, while pigments with water made the whole picture clear and distinctive. Overglaze decorations were applied on fired ceramics, before being returned to a low-temperature fire, a process which was accomplished in *honglu* (red furnaces) in an independent workshop.[10]

Due to limited production scale and costs, many family-run kilns fired using red furnaces, thus they were called "*hongdian*" (red painting shops). They could buy undecorated bisque of varying quality from large kilns and then decorate them with overglaze paintings. As thousands of "*hongdian*" were lined up on both sides of a street in the Jingdezhen city center, the street was called *Ciqijie* (Porcelain Street).

As one can imagine, Jingdezhen is not simply a mass of houses. The streets are drawn in straight lines, which cut each other and cross at certain distances. But all the space there is occupied; the houses are densely packed, and the streets are too narrow; in traveling them one seems to be in the middle of a carnival. One hears on all sides the cries of the porters trying to make a passage.

This heavily crowded business inevitably brought the risk of fire. In fact, fire was quite frequent in Jingdezhen and there were times when all the factories and houses burnt down. The *Great Gazetteer of Jiangxi Province* recorded several large fires in 1429, 1473, 1476, 1493 and 1494 which inflicted much suffering on most areas of the city.

As D'Entrecolles writes in his letter:

It is not surprising therefore that one sees frequent conflagrations, and because of that the spirit of fire has many temples. The current Mandarin has built a temple that he dedicated to the spirit of fire. The worship and the honors that one renders to this spirit are not paid back by rarer conflagrations though. Only a short time ago there was a fire that burned eight hundred homes. But they ought to be nearly replaced now to judge from the multitude of

[10] Author's note: The first firing in Jingdezhen was fueled by firewood, with a temperature of around 1330°C. After processing, the fired white body needs a second firing in a furnace called a *honglu* (red furnace), with a temperature of around 800 °C. The second firing was powered by charcoal, not wood. As red furnaces do not take up much space, many kilns had their own red furnaces. Furnaces fueled by wood were usually large and required a large workforce, so not all kilns were equipped with one and had to rent one or more from others when required.

masons and carpenters who work in this area. The profit to be gained from renting out these shops makes people extremely active in repairing this kind of damage.[11]

D'Entrecolles also described how thousands of furnaces densely lined the crowded streets and how a fire burnt down 800 houses not long before he wrote his letter.

Georges Francisque Scherzer, a French consul at Wuhan and Guangzhou in the 1880s, visited Jingdezhen to gather industrial intelligence on porcelain production. He died in 1886 on his way back home. He spent three weeks from November to December 1882 in Jingdezhen collecting intelligence and specimens for Manufacture Nationale de Sèvres, the then national porcelain factory of France. He paid particular attention to the processing procedure and raw materials for porcelain production. In the name of collecting gifts, he got hold of samples of porcelain stone, clay and glaze materials. In an attempt to thwart his suspicious behaviors, local officials scheduled his visits to kilns at night. However, after the principal officials left, the supervision was relaxed. But of course, there were other barriers preventing such industrial espionage. When Scherzer wrote to one of his friends in Beijing, he mentioned that even in the daytime, he dared not peek out from his sedan because he was afraid local people would throw porcelain shards at him.

Despite this, he managed to discover porcelain stone deposits some five miles outside of the urban district:

In a picturesque place, we traveled down a winding path into a canyon. We stopped at a yard with busy workers. I found some pieces of smashed porcelain stone. After smashing it, it required washing twice before it could be shaped into the shape of a brick. With much effort and prices as high as around 50 times normal, I finally took possession of some such bricks.

In the early twenty-first century, Jingdezhen was a large industrial city with a population of over 300,000, with districts on either side of the Changjiang River. In the late nineteenth century, while little effort was spent on city construction, the backbone of the city, the ceramics industry, attracted numerous people to work and live there. As Scherzer reported:

Surrounded by mountains on four sides, Jingdezhen is well-endowed with porcelain stone and clay. On the left bank of the river, it extends around ten li. But it is not suitable for living as mountains and tombs could be seen there... I estimate the city is home to over 500,000 people, three quarters of whom are low-ranking workers at workshops and kilns earning 5 to 10 wen per day, apart from meals.[12]

The two letters of D'Entrecolles were much cited in Europe, including by *Chinese Export Porcelain Chine de Commande.*

According to D'Entrecolles, Jingdezhen has no encircling wall and is administered by officials dispatched by the imperial court. Officials designated here were responsible for maintaining the legal and social order with the support of the police. Each street has a chief appointed by the mandarin, and if the street is long there are several. Each chief has ten

[11] Daniel Nadler, *China to Order: Focusing on the XIXth Century and Surveying Polychrome Export Porcelain Produced during the Qing Dynasty (1644–1908).* (Paris, 2001), p. 30.

[12] William R. Sargent, *Treasures of Chinese Export Ceramics: From the Peabody Essex Museum.* Distributed by Yale University Press, 2012, pp. 33–40.

subalterns who are each responsible for ten houses. They are responsible for good order and must run out at the first disturbance, to make peace and to give a report to the mandarin under threat of the bastinado, which is applied very liberally. Each street has its barricades that are closed during the night and the large streets have several. One man watches at each barricade and he only opens the gate at the barrier at a certain signal. In addition to that, the mandarins of Fuliang make rounds. Moreover, strangers are not permitted to sleep in Jingdezhen. It is necessary for them to spend the night on their boats or else they can spend the night at the home of a friend who is then responsible for their conduct.[13]

For the origins of the two letters of D'Entrecolles, Daniel Nadler expresses a different view in *China to Order: Focusing on the XIXth Century and Surveying Polychrome Export Porcelain Produced during the Qing Dynasty*, which translates as follows:

In 1712, in the name of investigating Chinese Catholic converts, D'Entrecolles was allowed entry into Jingdezhen for the first time. In September of the same year, he submitted a comprehensive report to his superior. A decade later, in 1722, the last year of the reign of Emperor Kangxi, D'Entrecolles paid his second visit to Jingdezhen and again wrote down his observations in a report. In his reports, he gave a detailed, comprehensive and well-structured picture regarding Jingdezhen and its production of porcelain, which had never been revealed in Chinese documents. Cautious and careful as he was, he managed to keep his behaviors free from any suspicions of the Chinese people. Some doubted that figures in his report were exaggerated. But as he was so observant and meticulous, and he put his seal on the reports, people basically accepted the figures as they were. As a matter of fact, as his reports came from his direct observations, they have been directly cited frequently.

From this description, it appears D'Entrecolles did not just happen to interest himself in the manufacture of porcelain in Jingdezhen and share it with his superior, but deliberately attempted to obtain intelligence of porcelain production in Jingdezhen.[14]

This work also cites part of his letters:

Jingdezhen is located on a plain surrounded by high mountains. Those to the east and against which the town is backed, form on the outside a sort of semicircular space. The mountains that cross the plain give rise to two rivers that meet here. One of them is rather small, but the other is quite large and forms a good port for nearly three miles in the vast basin where it has lost most of its swiftness. One sometimes sees in this large port up to three rows of boats, one behind the other. Such is the spectacle that presents itself to view when one enters Jingdezhen through one of the gorges. The whirling flames and smoke that rise in different places make the approach to Jingdezhen remarkable for its extent, depth and shape. During a night entrance, one thinks that the whole city is on fire, or that it is one large furnace with many vent holes.

There is a never-ending line of boats coming to Jingdezhen loaded with petuntse and kaolin, and that after having purified these materials, the residue that remains accumulates in time and forms great heaps. I have added that there are three thousand furnaces at Jingdezhen and

[13] D. F. Lunsingh Scheurieer, *Chinese Export Porcelain Chine de Commande*, Pitman Publishing Corporation, 1974, p. 24.

[14] William R. Sargent, *Treasures of Chinese Export Ceramics: From the Peabody Essex Museum*. Distributed by Yale University Press, 2012.

that these furnaces are filled up with saggers and porcelain, that the saggers can only last for 3 or 4 firings, and that often a furnace-full is completely lost...[15]

According to *China to Order*, in 1712 when D'Entrecolles visited Jingdezhen, things were much better than decades earlier in the Ming Dynasty because back then, soldiers were recruited in Jingdezhen, which often led to severe riots and casualties. In contrast, during the Qing Dynasty, workers were paid, but quite lowly, so workers had a lot of complaints.

Ancient records regarding the ceramic history of Jingdezhen, like *Taochengjishibei* (*Tablet of Records of Porcelain Manufacturing*), *Taoshuo* and *Jingdezhen Taolu*, have all been translated into English. With this record and relevant English documents at hand, D. F. Lunsingh Scheurleer wrote in *Chinese Export Porcelain Chine de Commande* that in 1683, Emperor Kangxi commanded the rebuilding of Jingdezhen and its kilns and designated Zang Yingxuan as supervisor. In 1677, on the suggestion of Zang, taxes were levied on land use in Fuliang, which provided Zang with some funds to purchase necessary raw materials for reconstruction and to pay workers. Following Zang's nomination as Superintendent in Jingdezhen in 1683, the imperial kilns under his governance recovered and prospered. He even invented several kinds of glaze himself. Following that, China's ceramics industry began to recover.

Under the initiative and endorsement of Zang Yingxuan, working conditions were much improved and the techniques of new potters were introduced, hence the emergence of fine white porcelain. White porcelain was glazed with a layer of transparent glaze and resulted in very exquisitely made products. Zang also reformed the system of recruiting sculptors from Fuliang and Poyang, so thousands of workers were happy with their work and could also have been satisfied with their wages. But D'Entrecolles did not think their wages were high enough, not even the painters who did an excellent job of painting flowers, animals and scenery on porcelain. It is a real pity that the *Jingdezhen Taolu* did not take account of how much workers were paid, just the method of payment. For example, workers making paste were paid only in April and October, with a small amount paid at the end of the year. Potters and supervisors, meanwhile, were paid at the Dragon Festival (the fifth of May on the lunar calendar), July, October and one day prior to New Year. According to local customs, goods purchased on the local market were paid for every January and March.[16]

During the Kangxi period, the division of labor and production flows were further developed. According to D'Entrecolles, the division of duties in Jingdezhen's ceramic factories had been specified and detailed to the maximum, with various sections working on decoration, embossment, pierced engraving, gold plating, marking, and painting, etc. There were also professional painters, some in charge of landscapes and some of birds and other animals. As D'Entrecolles writes, human figures were

[15] Daniel Nadler, *China to Order: Focusing on the XIXth Century and Surveying Polychrome Export Porcelain Produced during the Qing Dynasty (1644–1908)*. (Paris, 2001), pp. 30–31.

[16] D. F. Lunsingh Scheurieer, *Chinese Export Porcelain Chine de Commande*, Pitman Publishing Corporation. 1974, p. 24.

the most difficult to execute, and the system appeared to allow very little individuality in the process of painting.

D'Entrecolles also discussed the qualifications of porcelain painters:

These Hoa-pei or painters of porcelain are little less destitute than the other workers. This is not astonishing since the abilities of one of them would not pass for a beginning apprentice in Europe. All the skill of these painters and in general for all of the Chinese painters, is not founded on any principle, and only consists in a certain routine helped by a limited turn of imagination. They don't know any of the beautiful rules of this art. It is necessary to acknowledge however, that they paint some flowers, animals and landscapes on porcelain that are admirable. They also do the same on fans and on lanterns of very fine gauze. The work of painting in any given laboratory is divided among a large number of workers. One makes only the first colored circle that one sees next to the edge of the porcelain; another traces flowers that a third one paints; this one does water and mountains; that one birds and other animals. Human figures are ordinarily the most badly painted.

Here he is describing the production process of Jingdezhen porcelain. D'Entrecolles also writes in his letters, "It is said that one piece of fired porcelain passes through the hands of seventy workers. I have no trouble in believing this after what I have seen myself."[17] Here he describes what Song Yingxing claims in *Exploitation of the Works of Nature*: A complete piece of Jingdezhen ware, which was originally just a ball of clay, was finished with dozens of hands.

D'Entrecolles told his European friends that "Mandarins, who know of the ability of Europeans to make inventions, have asked me to get from Europe new and original designs, that could be presented to the emperor as something unique. On the other hand, the Christians press me strongly not to furnish such samples, for the mandarins are not so understanding as our merchants when the workers tell them that something is impractical. And the bastinado is often applied liberally before the mandarin abandons a design which promises great advantages." From here, we can see that at the time the Qing government attached high importance to the porcelain trade with Europe and strove to meet the market demands of Europe.

Finished products required transportation from Jingdezhen to Beijing. In 1736, Tang Ying, the Superintendent of Jingdezhen, described how this was done. Every year in August, porcelain products, 16,000–17,000 pieces of first-class wares and 6000–7000 premium ones, were shipped on flat boats to Beijing. First-class porcelain produced by private kilns were reserved for the royal families of European and other countries.[18]

It is also recorded in *China to Order* that:

In the following centuries (the 16th to the 19th century), apart from natural evolution, things remained unchanged in Jingdezhen. After the mid-19th century, Jingdezhen kilns were again ruined in the Taiping Revolution... But they were rebuilt soon and resumed production until the Qing Dynasty was overturned...

[17] D. F. Lunsingh Scheurieer, *Chinese Export Porcelain Chine de Commande*, Pitman Publishing Corporation. 1974, p. 28.

[18] See Footnote 17.

From the foreign documents we can see that while very few Europeans had direct contact with Jingdezhen, through the eyes of missionaries and merchants, the production and trade of Jingdezhen in the Qing Dynasty can be traced in records which fill in some of the gaps in the Chinese accounts. Meanwhile, we should also note that Jingdezhen had already become a world-renowned city and attracted the attention of Europe in the Qing Dynasty.

11.2.3 Reform of the Imperial Kilns

In the Qing Dynasty, the name of the Ming imperial kilns, *Yuqichang* (Factory of Imperial Wares) was changed to *Yuyaochang* (Factory of Imperial Kilns). Compared with that of the Ming Dynasty, the Qing imperial kilns underwent some reforms, which played a positive role in the development of the ceramics industry in Jingdezhen.

Though reformative measures had been adopted by the official kilns from the Jiajing period of the Ming Dynasty, they were not thorough nor concrete. It was in the Qing Dynasty that the feudalistic forced-labor system was abolished and the paid employment system introduced. According to Vol. 2 of *Jingdezhen Taolu*, there were 28 employees who were paid, based on their work done in an imperial kiln, including one supervisor, two clerks, one director and one deputy director of the porcelain selection department, seven foremen (one residential, with the remainder taking a night shift every ten days), two jade article makers, one amanuensis, one motif painter, one director in charge of *yuanqi*, one in charge of engraving, one in charge of blue and white porcelain, one in charge of putting greenwares into furnaces, one guarding furnaces, one porter, one footman, one comprador, and one doorkeeper. The employees were also granted meals at work. Other workers were also employed and paid. This system not only stimulated the enthusiasm and motivation of the workers, but it also made possible competition between private and official kilns, thus driving forward progress in both.

While the "*Guandaminshao*" system had been practiced since the late Ming Dynasty, it was quite different from that in the Qing Dynasty. Generally speaking, the Ming imperial kilns produced and fired porcelain wares themselves. Only when confronted with excessive "imperial quotas," a limited time to complete them, or technologically challenging tasks would imperial kilns assign part of the production missions to private kilns for firing. These assigned tasks were mainly compulsory. While calculated on piece-work, there was not much in it for the private kilns, not even managing to cover the costs of firing, such that "private kilns claimed themselves too poor to afford the costs of the assignments" or even "got used to suffering the losses." This situation cast a shadow over the development of commodity economy and set up a confrontation between the private and official kilns, leading to a negative response from private kilns by "supplying sub-standard products." (Fig. 11.5).

By the Qing Dynasty, things changed with the "*Guandaminshao*" arrangements. The system was not as compulsory as it had been in the Ming Dynasty, nor did it

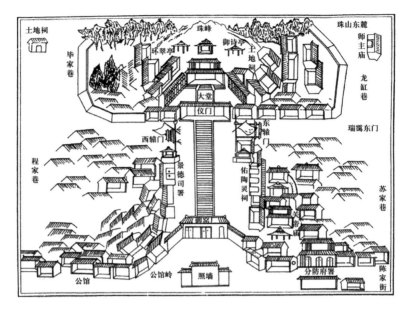

Fig. 11.5 Plan of an imperial kiln in the Qing Dynasty

inflict forced services on private kilns. Instead, an equal relationship was established on a voluntary basis between official and private kilns. According to *Taoluyulun*, "Nowadays, official wares are produced by private kilns under the '*Guandaminshao*' system. Fees are paid accordingly to private producers with no compulsory services." *Taoshuo* also states that "Before firing starts, workers are recruited, and raw materials prepared. All relevant fees are paid at market prices." In this way, driven by profit, private kilns were very active. Besides, one distinctive feature of Qing imperial production was that almost all products were fired in private kilns. But of course, not all private kilns were qualified to undertake official production. Only senior and quality kilns were eligible for this honorable task. Detailed depictions of the situation can be found in Vol. 4 of *Jingdezhen Taolu*: "In the past, imperial kilns had large furnaces with empty saggers. Now, most products are fired in private kilns. Only the *Baoqing* kilns may undertake firing tasks. And what is *Baoqing*? All bisque wares that are fired produce *qing* (blue) wares (qualified products). Otherwise they fail to reach the qualifying standards and compensation needs to be made. This is not only true of the official kilns, but also of private kilns." This pushed private kilns to guarantee product quality and constantly strive for excellence in order to maintain their good names as "*Baoqing*" kilns. As most imperial kilns introduced private kilns into their production process through the "*Guandaminshao*" system, the popularity of certain designs and motifs of official wares in private kilns was made possible. Thus private kilns, as producers of both imperial and commodity wares, were highly likely to produce quality porcelain products for the market based on official ware designs. As is recorded in the *Xujinzhaishi*, or *Poems of Xu Jinzhai*, "Private kilns

are enthusiastically imitating official kilns," hence the trend towards the style of the official kilns, and competitions between private and official kilns.

In addition, in contrast to the Ming Dynasty when superintendents of ceramic production were almost all eunuchs, in the Qing Dynasty, this post was assumed by those who were interested in porcelain and porcelain research. This put an end to the uprisings by greedy eunuchs trying to profit themselves. In addition, the Qing Dynasty produced several influential superintendents whose contributions spurred on the progress in the Jingdezhen ceramics industry.

Under the influence of the superintendents, the kilns under their administration were named after them, such as the "Zang kilns," the "Nian kilns," the "Lang kilns" and the "Tang kilns."

During the Kangxi period, monochrome glazed porcelain produced by the "Zang kilns" was especially famous. According to the *Jingdezhen Taolu*, "Monochrome glazed porcelain from the Zang kilns was fine and smooth, with all colors represented. Especially attractive were those snakeskin green, eel yellow, *jicui* (peacock green), and yellow spot items. Besides, yellow, purple, and green, red and blue glazed porcelain was also extremely attractive. Meanwhile, the Tang kilns continue to copy the Zang kiln style." In addition, the Lang kilns under the charge of Lang Tingji, also made many achievements, especially in imitating the eggshell porcelain of the Ming Dynasty and the blue and white porcelain of the Xuande period. What is more, the Lang kiln red glaze was also quite special and known as "*langyaohong*" (Lang kiln red or "ox blood" red). Vol. 5 of the *Jingdezhen Taolu* also describes the Nian kilns under the administration of Nian Xiyao in the Yongzheng period: "The Nian kilns in the Yongzheng period were official kilns under the charge of Nian Xiyao. Following imperial orders, the Nian kilns selected quality raw materials and produced fine porcelain articles… Most of their *zhuoqi* wares were in egg-white color and their *yuanqi* wares were as bright and smooth as silver; both were decorated with blue patterns or neat dark patterns, appearing both traditional and innovative." Vol. 2 also notes that "Porcelain at this time was mostly imitative of the style of the Ru kilns, as attractive as azure after rain." *Zhuyuantaoshuo* also states that "Azure porcelain produced in the Yongzheng period was especially marvelous. Graceful, charming and enchanting, it left red porcelain far behind." It is true that Yongzheng porcelain was copied from the Ru kilns, but azure porcelain had been produced from the Kangxi period as a unique variety different from that of the Ru kilns. In fact, the azure porcelain produced by the Nian kilns also distinguished itself. The "Tang kilns," administered by Tang Ying who served the post for over two decades in Jingdezhen, represented the achievements in ceramic production that were made in the Qianlong period. According to Vol. 5 of *Jingdezhen Taolu*, "Tang Ying knew well how to select raw materials and control fire, so the products he produced were very smooth and fine. Products produced in imitation of famous ancient kilns were very beautiful and the glaze produced in imitation of famous glazes was also marvelous. Artisans working in the Tang kilns achieved an excellent level of craftsmanship. Additionally, innovation was achieved in the production of many varieties of porcelain ware, such as *yangzi* (foreign purple), *faqing*, *moyin*, *moshuicai* (water ink brushwork), enamel, *yangwujin* (foreign *wujin*), white on black, gilt on black ground, and azure fambe,

etc. The clay was made using quality soil while the paste was fine, thick or thin. So, currently, the Tang kilns have basically integrated all the best qualities of the previous generations." In fact, the Tang kilns did integrate all the best features of previous generations in terms of decorative approach, design, and technology. The various competent superintendents who committed themselves to the ceramics industry in Jingdezhen in the early and mid-Qing period, to some extent promoted progress in the industry (Figs. 11.6, 11.7 and 11.8).

Fig. 11.6 Blue and white *wucai gu*-style vase with garden patterns, produced in the Kangxi period, height: 41.6 cm, in the Palace Museum

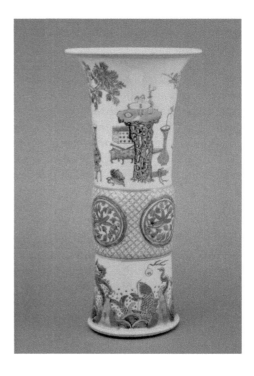

Fig. 11.7 Yellow enameled bowl with peony pattern, produced in the Kangxi period, height: 5.4 cm, diameter: 10.8 cm, foot rim diameter: 4.4 cm, in the Palace Museum

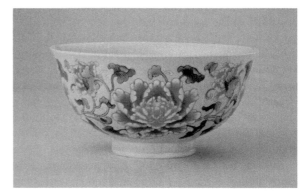

Fig. 11.8 Blue and white *wucai* vase with flower and bird patterns, produced in the Kangxi period, height: 71.5 cm, in the Philadelphia Museum of Art

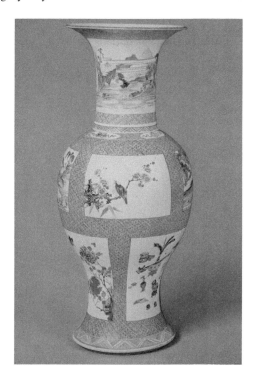

11.2.4 The Export of Private Porcelain

The commercialized development of Chinese society was on the one hand made possible by the natural course of social development and on the other by the influence of the world economy and the commodity economy. From the fifteenth and sixteenth centuries, European geographic discoveries facilitated the porcelain trade between China and Europe. By the Qing Dynasty, from the latter half of the seventeenth century to the eighteenth century, the Chinese porcelain market further expanded around the globe. Especially in Europe, porcelain was not only popular as articles of daily use, but also served as a symbol of wealth among the upper classes. In the early Qing Dynasty, the foreign market placed huge demands on Chinese porcelain. Chinese porcelain mainly flowed abroad as "presents" of the Qing government to foreign diplomats or through trade. Generally speaking, gifted porcelain was made by official kilns while export porcelain was made by private kilns.

In the early Qing Dynasty, Jingdezhen porcelain was not only sold to traditional markets like Japan and Europe, but new consumers, like the Russian Empire in the north also ordered various tailor-made products from China. At the time, countries and regions in America and Africa made various attempts to purchase Chinese porcelain while Southeast Asian nations and regions like Borneo, Java, Sumatra and Malaya were important destinations for Chinese export porcelain. Some of the exports were transacted directly with Jingdezhen while some were produced with

Fig. 11.9 Blue and white
plate with landscape pattern
and brown glazed rim,
produced in the Kangxi
period, diameter: 54 cm, foot
rim diameter: 3.3 cm, height:
8.4 cm, in the collection of a
Western antiques dealer

bisque made in Jingdezhen before being further processed in Guangzhou and other coastal cities (Fig. 11.9).

In discussing the porcelain trade at this time, the expansion of the European market is especially worth mentioning. In the first half of the eighteenth century, many European countries were permitted to open trade offices in Guangzhou. The British East India Company was the first to do so (in 1715), followed by France (1728), the Netherlands (1729), Denmark (1731) and Sweden (1732). This provided further convenience for Chinese porcelain exports. With the development of foreign trade, in 1720, the 59th year of the Kangxi period, merchants in Guangzhou organized an agency called "*Gonghang*" which stipulated in Article 8 of its rules that "Exquisite porcelain wares are not to be traded among individuals. Sellers, no matter whether gaining a profit or suffering a loss, must hand in 30% of their transaction amounts to the agency."[19] Under the control of Qing officials, *Gonghang* was obviously a feudalistic tax agency. In fact, the Qing officials had long been involved in the porcelain trade and profited from it. For instance, in 1716, it was Qing officials with whom a British merchant ship signed a porcelain trade contract. This shows that the porcelain trade played an important role in China's foreign trade. In this period, ships of certain countries gained permits to enter Guangzhou directly (in the past, such permits were just temporary). For example, from 1712, two ships from the Netherlands sailed to Guangzhou every year, which facilitated regular shipments of Chinese porcelain to Europe.

With the boom of the porcelain trade, specific shops for porcelain transactions and ordering were set up. According to the *London Guide* published in 1774, there were at least 52 such shops in London.[20] Most export porcelain was produced by private kilns in Jingdezhen while a certain amount was custom-made, based on contracts to

[19] Han Huaizhun, *Ancient Chinese Export Ware Found in Nanyang*, the Youth Book Co., 1960, p. 27.

[20] John Golasmieh Phillips, *China Trade Porcelains*. 1974, p. 34.

cater to the demands of foreign markets, especially those earmarked for the European market (Fig. 11.10).

Illustrated in Figs. 11.11 and 11.12 are two blue and white plates which the author once viewed and shot at the Victoria and Albert Museum. One of the plates is painted with a Chinese lady playing with a child with paneled decorations on the rim. Though the paneled decorations are farming scenes, tulips which were treasured by Europeans are placed between the panels, indicating its destination as an export to Europe. The other plate is painted with three Europeans playing musical instruments with landscape scenes in the Chinese style in the panels on the rim.

Fig. 11.10 Blue and white floral plate, produced in the Kangxi period, diameter: 24.2 cm, foot rim diameter: 13.6 cm, height: 2.8 cm, in the collection of a Western antiques dealer

Fig. 11.11 Blue and white plate with a Chinese lady playing with a child, produced in the Kangxi period, in the Victoria and Albert Museum

Fig. 11.12 Blue and white
plate with landscape and
human figure patterns,
produced in the Kangxi
period, in the Victoria and
Albert Museum

According to Vol. 2 of *Jingdezhen Taolu*, "'*Yangqi*', or foreign articles, are earmarked for foreign consumers. They are normally sold by Guangdong merchants to foreign markets. Such products feature various unique designs and there are no fixed styles every year." This means that the varieties, designs and decorations of porcelain wares needed to adapt to the demands of the European market annually (Figs. 11.13, 11.14 and 11.15).

By the mid-Qing Dynasty, the major change on the international scene was the emergence of the American market and the establishment of porcelain manufactories in Europe. Compared with the trade routes in the Ming Dynasty, the Qing porcelain export also flowed to Arita and Satsuma in Japan as well as Stafford, Liverpool and London in Britain, apart from the traditional markets. But of course, this was not the

Fig. 11.13 Blue and white
floral plate, produced in the
Kangxi period, diameter:
33 cm, foot rim diameter:
18 cm, height: 3.7 cm, in the
collection of a Western
antiques dealer

Fig. 11.14 Blue and white octagonal goblet with landscape, flower and bird patterns, produced in the Kangxi period, diameter: 8 cm, foot rim diameter: 5 cm, height: 11.2 cm, in the collection of a Western antiques dealer

Fig. 11.15 Blue and white vase with paneled Chinese lady patterns, produced in the Kangxi period, in the Victoria and Albert Museum

end of the matter: the message was clear: Chinese porcelain was no longer dominant in the market as a whole. More and more competitors to China's dominance had begun at arise. The USA, while a late-comer to the international market, was a large consumer. Initially, the USA imported porcelain from Britain and from the second half of the eighteenth century, it started to buy porcelain wares from China directly. It was because of the American consumers that the Chinese porcelain trade was able to sustain its prosperity into the late nineteenth century.

11.2.5 Jingdezhen Porcelain in the Early Qing Period

In the early Qing Dynasty, after the Shunzhi transition, by the time of Kangxi, the rule of the Qing was already stabilized and the social economy had recovered, ushering in a period of comprehensive prosperity. Apart from some strong-arm measures to reinforce its autocracy, the Qing government also adopted some new policies to pacify society. For example, the policy of "*gengmingtian*" (the ownership of farmland was handed over to farmers in an effort to accelerate land reclamation and increase government revenues) and "*tandingrumu*" (meaning the apportionment of the poll tax to the field tax, a tax reform in the early Qing period which made taxation easier by allowing the payment of levies on the basis of the field area farmed, not by the number of people in farming families). The abolition of the "craftsman system" especially, which had been applied since the Ming Dynasty, offered relative relief to peasants and craftsmen from exploitation and suffering.

Jiangxi was afflicted with much suffering from the Ming's fight against the Qing forces up to the early Kangxi period. The people also suffered heavily from the ravages and exploitation of the Qing armies, which led to a decline in ceramic production in Jingdezhen. During the Revolt of the Three Feudatories, the ceramics industry in Jingdezhen was once again devastated.[21] By 1680, the 19th year of Kangxi's reign, the court sent Xu Tingbi to Jingdezhen to take charge of ceramic affairs. From that point onwards, the production of the official kilns began to recover and revert to its previous course.

In the early Qing Dynasty, prior to 1683, the 22nd year of the Kangxi period, with the persistence of forces opposing Qing rule in the southern coastal regions of Fujian, Guangdong, Jiangsu and Zhejiang, a strict maritime ban was introduced from the Shunzhi to the early Kangxi periods. By 1684, the maritime ban was finally lifted and people from regions south of the Yangtze River, Zhejiang, Fujian and Guangdong were allowed to sail overseas on ships of over 500 *dan* (1 *dan* equals approximately 50 kg). From that time forwards, large-scale trading, including that of porcelain, got back on track.

The rebounding foreign trade and the massive production of daily wares for the domestic market led to an unprecedented prosperity for the official kilns, the private

[21] Geng Baochang, *Appraisal of Ming and Qing porcelain*, The Forbidden City Publishing House, 1993, p. 185.

kilns and the Jingdezhen ceramics industry as a whole. Drawing from each other, the official and private kilns kept improving their production technology and made constant innovations in terms of production varieties. The unparalleled blue and white porcelain, the splendid *wucai* wares, the vivid wares produced in ancient styles and the emerging famille-rose porcelain and enamel wares laid a solid foundation for the pending boom in ceramic production in the Yongzheng and Qianlong periods.

The porcelain at this time was made from extremely fine clay, thus featuring a compact, durable and pure quality. There was more kaolin in the clay and less calcium oxide in the glaze, along with other better quality raw materials and finer processing techniques compared with the Ming Dynasty. Firing temperatures at this time also almost reached the standards of modern hard-paste porcelain. With a fine, smooth paste, the glaze applied to the wares appeared extremely bright and colorful. We will now discuss several specific varieties produced during different periods of the Kangxi reign.

11.2.5.1 Export Porcelain

Export porcelain produced following the Ming Dynasty achieved new progress with unprecedented new designs, varieties and production volumes. Articles frequently seen included tall *huahu* (flower *zun*) with flaring mouth (Fig. 11.16), round-shaped or hexagonal pots, hanging washing vases with spout, *tongping* (elephant-legged vases), *zun* pots, kundikā, basins, boxes, soup plates, *xi* (a washing utensil), ear cups, as well as shallow plates with folded floral edges, and bowls. Export porcelain was usually tall, at times with tall knobs, like blue and white porcelain (Fig. 11.17), *wucai* wares, *wujin* (mirror black) glazed porcelain, gilt craig blue glazed porcelain, brown glazed porcelain with paneled decorations (Fig. 11.18) and blue glazed porcelain with paneled decorations. Gilt *yangcai* porcelain could also be decorated with paneled patterns. In addition, there was a variety of porcelain imitating Japanese styles, such as shallow plates with folded rims, large *gu* (a type of ancient Chinese ritual bronze vessel), *zun* and pots, usually decorated with *wucai* patterns, blue and white patterns, red paintings and gold decorations (Figs. 11.19, 11.20, 11.21 and 11.22). Among them, pots, kundikā pots, ewers, chrysanthemum-shaped vats, octagonal bowls, large plates, plates with flower-shaped rims and plates with folded rims inherited the traditional features of the late Ming Dynasty.

11.2.5.2 Color Glaze

New varieties of color glaze were invented in the Kangxi period, such as the precious *langyaohong* (Lang kiln red, or oxblood), *jiangdouhong* (mottled peach blossom), *jihong* (sacrificial red) and *jilan* (sacrificial blue) glaze. (1) *Langyaohong* refers to red glazed porcelain produced in the Lang kilns under the charge of Lang Tingji during the Kangxi period. Adept at imitating red glazed porcelain produced in the Xuande and Chenghua periods of the Ming Dynasty, the representative product of

Fig. 11.16 Blue and white
gu with auspicious animal
patterns, produced in the
Kangxi period, height: 50 cm

Fig. 11.17 Blue and white
teapot with flower and grass
patterns and silver
accessories, produced in the
Kangxi period

the Lang kilns, the *langyaohong*, was actually an imitation success. Since it was produced by the Lang kilns, it was named *langyaohong*. *Langyaohong* featured a vitreous deep bright red color the shade of oxblood, thus also known as "oxblood." *Langyaohong* articles had crackles, and transparent glaze on their bodies. As the glaze was quite fluid, when it flowed down from top to bottom, it left wheel-shaped white lines at the mouth of the article. The transitional section from white to red was called "*dengcaobian.*" In order to keep glaze from flowing down beyond the foot, the foot is whittled so the glaze does not flow further, hence the saying "*tuokou chuizu*

Fig. 11.18 Blue and white brown-glazed lidded pot with double lugs, produced in the Kangxi period

Fig. 11.19 Blue and white plate with iron-red basket patterns, produced in the Kangxi period

langbuliu," indicating that the mouth remains partly unglazed and that the glaze flows down to the foot but no further. The Lang kiln porcelain usually had off-white or red glazed bottoms (Fig. 11.23). (2) *Jiangdouhong* (mottled peach blossom) is a variety of color glaze as famous as *langyaohong*. Invented during the Kangxi period, *Jiangdouhong* glaze utilized a copper base in its formula to achieve the mysterious spots of green erupting from the glaze like moss, thus also called "*taohuapian*" (pieces of peach blossom), "*meirenzui*" (drunk beauty) or "*wawalian*" (baby face). Green moss on the glaze was actually a defect produced during the firing, but it appeared most attractive on the light red body. *Jiangdouhong* was very difficult to produce, thus generally no large pieces were made and not many articles have been passed

Fig. 11.20 Gilt blue and white octagonal plate with iron-red patterns, produced in the Kangxi period

Fig. 11.21 Blue and white plate with iron-red patterns, produced in the Kangxi period

Fig. 11.22 Blue and white round plate with iron-red flower patterns, produced in the Kangxi period

down through the generations, making extant pieces very valuable. Thus, during the early twentieth century, many copycat products were produced (Figs. 11.24 and 11.25). (3) *Jihong* (sacrificial red) was another variety of red glazed porcelain from the Kangxi period. It differed from both the bright, glassy and crackled *langyaohong* and the light and smooth *jiangdouhong*. Its glaze was even, opaque and rich, and typically had an "orange-peel" surface. There were *jihong* vases, bowls and plates, etc. used as sacrificial vessels. Some articles had no markings underneath while some had "*Daqing Kangxinianzhi*" (Made in the Kangxi period of the Great Qing Dynasty) or blue "*Daming Xuandenianzhi*" inscribed in two lines in regular script in a double-circled square. An orange-peel surface, an opaque, rich glaze and a white bottom with official inscriptions are the three distinctive features of *jihong* porcelain which distinguish it from *langyaohong* porcelain. (4) *Jilan* (sacrificial blue) glaze was produced from the Yuan Dynasty. Using around 2% cobalt to produce the blue color, it featured an even and opaque orange-peel surface. Since its products, like plates, bowls and vases, were mainly used as sacrificial vessels, *jilan* glaze was also called sacrificial blue. Most *jilan* wares were produced by official kilns and some were inscribed with "*Daqing Kangxinianzhi*" (Made in the Kangxi period of the Great Qing Dynasty) in two lines in regular script within a double-circled square, while some were not.

Apart from the above-mentioned glazes, there were also sky-blue glaze (Fig. 11.26), *salan* glaze (snowflake glaze), *qing* glaze (light blue glaze), yellow

Fig. 11.23 *Langyaohong* glazed vase, produced in the Kangxi period, height: 20.2 cm, mouth rim diameter: 6 cm, in the Palace Museum

Fig. 11.24 *Jiangdouhong*
glazed beehive-form water
pot (*taibaizun*), produced in
the Kangxi period, height:
8.7 cm, mouth rim diameter:
3.5 cm, in the National
Museum of China

Fig. 11.25 *Jiangdouhong*
glazed amphora-shaped vase
(*liuyeping*), produced in the
Kangxi period, height:
15.3 cm, mouth rim
diameter: 3.4 cm, in the
Shanghai Museum

glaze (Fig. 11.27), white glaze, green glaze and *zijin* glaze. In sum, the color glazes
of the Kangxi period were numerous.

Fig. 11.26 Sky blue glazed *zun* with dragon-shaped lugs, produced in the Kangxi period, height: 22.4 cm, mouth rim diameter: 11.8 cm, in the Palace Museum

Fig. 11.27 Yellow glazed lifting-handle teapot with a phoenix-shaped spout, height: 13.3 cm, in the Palace Museum

11.2.5.3 Blue and White Porcelain

Apart from color glaze, blue and white porcelain in the Kangxi period was another representative product of the time. According to *Taoya* (*Ceramic Refinements*), "Blue and white porcelain from the Yongzheng and Qianlong periods was a far cry from that of the Kangxi period. Though not as striking as that of the Ming Dynasty, blue and white porcelain from the Kangxi period was unparalleled in the Qing Dynasty." The official kilns at this time focused on color glaze porcelain, so the private kilns

Fig. 11.28 Blue and white
plate with flower and grass
patterns, produced in the
Kangxi period

were the major producers of blue and white porcelain, mainly small articles, except
for plates with flower patterns (Fig. 11.28).

Developing from the late Wanli period to the early Qing Dynasty, typical Kangxi
blue and white porcelain was made with cobalt blue materials that were produced in
Zhejiang. As the wet cleaning approach was replaced by calcination in processing
the cobalt blue, the colors of blue and white porcelain were rendered even brighter
and richer (Fig. 11.29). Water-lined patterns produced from the late Ming Dynasty
were common in typical Kangxi blue and white porcelain. Also, as artisans became
increasingly adept at applying the raw materials to create different shades and layers
of colors, multicolored patterns were created and thus the name "*wucai* blue and
white porcelain" was used.

The major blue and white wares produced by the official kilns were small arti-
cles like plates, bowls, and pots, decorated with dragons, phoenixes, pines, bamboo,
plum blossom, as well as various flowers. Large pieces of blue and white porce-
lain commonly seen at this time such as phoenix-tail-shaped vases, *bangchuiping*
(rouleau-shaped vases) and *Guanyin* vases (vases looking like that held by Aval-
okitesvara), were basically all produced by private kilns. Their decorative motifs and
patterns were various, including those reflecting folk culture, like four ladies and
16 children playing in a courtyard and paintings of pomegranate (both of which
expressed hope for more children), the Eight Immortals celebrating a birthday,
Buddhism's Eight Auspicious Symbols, scenes from *Xiaojing*, or the *Classic of Filial
Piety*, *Gengzhitu* (*Illustrations of Tilling and Weaving*), as well as scenes or plots from
novels, opera and other genres of literature, such as *Three Kingdoms*, *Heroes of the
Marshes*, *Investiture of the Gods*, *Romance of the Western Chamber* and *Pilgrimage
to the West*. Some motifs also reflected the lifestyles and interests of scholars, such
as Seven Sages of the Bamboo Grove (a group of Chinese scholars, writers, and
musicians from the third century), Eight Drunken Immortals (eight ancient Chinese
scholars who loved wine and pursued Taoism), Drunk Zhang Xu Creating Callig-
raphy (a Chinese calligrapher and poet from the Tang Dynasty) and *Xiyuanyaji* (a
water and ink painting of Li Gonglin, a Chinese painter, civil officer and antiquarian
in the Northern Song Dynasty) (Figs. 11.30, 11.31 and 11.32).

Fig. 11.29 Blue and white
pot with cloud patterns on
the shoulder, produced in the
Kangxi period, height: 81 cm

Fig. 11.30 *Wucai* lidded pot
with figures from *Romance
of the Western Chamber,*
produced in the Kangxi
period, height: 21.7 cm, in
the Palace Museum

Blue and white porcelain of the Kangxi period, especially that produced in private kilns, mostly carried no year of production. This was because the county leader at the time, Qi Zhong, issued an order prohibiting production dates on porcelain. Markings on the porcelain of this period were usually fake, imitating the practice of the Xuande, Chenghua, Jiajing and Wanli periods, and especially the former two.

Fig. 11.31 Blue and white
wucai gu with human figure
patterns, produced in the
early Qing Dynasty, height:
53.6 cm, in the Chang
Foundation Gallery, Taipei

In this period, blue and white porcelain was exported overseas in large quantities, and there was an active interaction with foreign cultures. For example, Fig. 11.33 depicts a blue and white vase with crooked handles, indicating a certain mysterious connection with the glass vessels of Venice or Islamic porcelain in the seventeenth

Fig. 11.32 Bowl with patterns from the *Three Kingdoms*, produced in the Kangxi period, a piece of blue and white porcelain produced in Jingdezhen, in the Berkeley Art Museum

Fig. 11.33 Blue and white
porcelain, produced in the
Kangxi period, height:
22.3 cm, in the Peabody
Essex Museum in the USA

century. In Fig. 11.34, this special bowl is called a glass-cooling bowl. When cold
water is poured into the bowl, a glass of hot water would be hung over the bowl and it
would rapidly cool down. The eight semicircular cuts on the edge help hold a glass.
This type of Monteith had been popular since the late seventeenth century through the
entire eighteenth century. In Europe, similarly designed bowls were made in ceramic,
silver, pewter, glass, as well as tinplate. Though featuring a European style, the bowl
in Fig. 11.34 is entirely decorated with Chinese motifs. For example, the eight white
panels on the exterior are decorated with blue flowers, dragons, phoenixes, kylin,
and other various auspicious animals. The center of the bowl is decorated with many
treasures. The design of the mug in Fig. 11.35 is also believed to have originated from
tin-glazed mugs of the Netherlands. Generally, there were four sizes of such mugs,
namely four inches, seven inches, 10 inches and the largest 13.5 inches as illustrated
in Fig. 11.35 (10.2 cm, 17.8 cm, 25.4 cm and 34.3 cm respectively). The 10-inch
mugs were usually used for chocolate drinks while the largest were probably only
made for decorative purposes. The blue decorations on the mug might come from
embroidery, with French bowknots, silk patterns and chain-shaped stitches. It seems
this article not only features the unique Chinese style of the Kangxi period, but also
demonstrates interactions between China and Europe in terms of artistic features,
designs and decorative motifs.[22]

The West speaks highly of Kangxi blue and white porcelain. For example, D. F.
Lunsingch Scheurleer, a German scholar wrote in *Chinese Export Porcelain Chine*

[22] William R. Sargent, *Treasures of Chinese Export ceramics from the Peabody Essex Museum.*
Distributed by Yale University Press, 2012, p. 128.

Fig. 11.34 A Monteith
bowl, produced in the
Kangxi period, height:
15.5 cm, diameter: 33 cm, in
the Peabody Essex Museum
in the USA

Fig. 11.35 A lidded mug,
produced in the Kangxi
period, height: 34.3 cm,
diameter: 12.1 cm, in the
Peabody Essex Museum in
the USA

de Commande that under the reign of Emperor Kangxi, the production techniques of
blue and white porcelain peaked. Aesthetically, it was the most beautiful porcelain the
world had ever seen, with exquisite design, thin glaze and at times light blue patterns.
Louis Le Comte, a French Jesuit, pointed out in his *Memoirs and Observations Made
in a Late Journey through the Empire of China* (the English version published in
1698) that blue and white porcelain was the most popularly produced variety. Articles
found in the Netherlands show how much blue and white porcelain was exported. So
generally, even the most ordinary blue and white wares are precious. In decorating

Fig. 11.36 *Wucai* lidded pot with dragon and phoenix patterns, produced in the Kangxi period

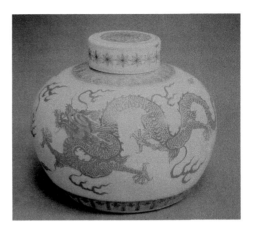

blue and white porcelain, exquisite paintings of human figures, animals, trees, grass and flowers were evenly applied.[23]

11.2.5.4 *Wucai* Wares

The most outstanding porcelain in the Kangxi period were *wucai* wares. *Wucai* wares were developed on the basis of blue and white *doucai* wares and had been quite advanced from the Jiajing and Wanli periods. Blue and white *wucai* wares in particular were produced with underglazed blue and white techniques, a variety that was already quite dominant at the time. By the Kangxi period, *wucai* porcelain was mainly produced by color painting on white-glazed porcelain while blue was seldom used. Featuring bright colors, exquisite paintings, and various varieties, *wucai* porcelain was an equal match for the then famous blue and white porcelain (Fig. 11.36).

According to *Yinliuzhaishuoci*, "In the Qing Dynasty, *yingcai* (hard color, *wucai*) and blue and white porcelain both reached a peak in the Kangxi period." However, there are no specific records of *wucai* wares produced by the imperial kilns in the early Qing Dynasty. Of those passed down from the Kangxi period, we can confirm that most official products were small articles like plates and bowls with conventional decorations. Generally, large articles with bright colors and vivid patterns were produced by private kilns.

An important breakthrough in *wucai* ware during the Kangxi period was the invention of overglazed blue and black colors. The overglazed blue was even heavier than that in blue and white porcelain while the black at this time was lustrous and attractive in a polychrome picture (Fig. 11.37). Black could be used in outlining, forming a sharper contrast than the blue in blue and white porcelain. Meanwhile,

[23] D. F. Lunsingh Scheurieer, *Chinese Export Porcelain Chine de Commande*, Pitman Publishing Corporation. 1974, p. 24.

Fig. 11.37 *Wucai* pot with
human figure patterns,
produced in the Kangxi
period, in the Capital
Museum

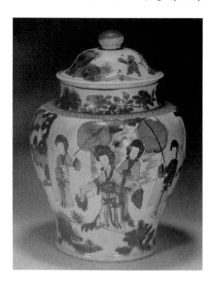

black could only be achieved by applying a layer of green. So, at this time, Jingdezhen
potters trialed different shades of transparent green (called *shuilv* or water green,
kulv or bitter green, and *dalv* or big green by locals). Yellow, blue, aubergine, iron
red, brown and black colors, as well as gilt technique were also adopted. Porcelain
decorated with such colors was called *yingcai* or *wucai* wares. Their decorative
motifs were usually very Chinese. After this technique had spread to Europe, it
was named Famille Verte by A. Jacquemart in 1862, a noted French sculptor and
animalier. Famille Verte, meaning "green family" in French, indicated that this group
of porcelain wares was characterized by decorations painted in green.[24]

As noted by the *Taoya*, "Color paintings during the Kangxi period were excellent,
with *Gengzhitu* the best among human figure paintings in the official kilns. Paintings
like those of dragons, phoenixes and lotus were quite conventional, not as creative as
those produced by the private kilns which were mostly wild animals and ancient trees
painted in freestyle." This comment is quite apt. Paintings on private products like
wucai cups, bowls, boxes, pots, phoenix-tail-shaped vases, *bangchuiping* (rouleau-
shaped vases), and large plates, were free from the shackles of the official kilns, and
were thus varied. Apart from flowers, magpies, ancient costumes and beautiful ladies,
many characters and plots from operas and novels were used as motifs on porcelain.
Especially precious were *daomaren*, paintings of fighting soldiers (Figs. 11.38 and
11.39). The human figure painting style was deeply affected by Chen Laolian, a
famous painter in the late Ming Dynasty, whose paintings featured simple but strong
lines, red or black outlines of faces and clothes, and a layer of various bright colors,
creating a clear and joyful feeling. Later generations compared it to soft-paste famille-
rose porcelain and called it "*yingcai*" (hard color) or "*gucai*" (ancient color). *Yingcai*

[24] Christiaan J. A. Jörg, *Famille Verte Chinese Porcelain in Green Enamels*. Groninger Museum,
2011.

porcelain featured a bright, translucent glaze, vigorous lines, durable and fast colors, and always looked new and refreshing (Figs. 11.40 and 11.41). This author has viewed a section of a *wucai* wine pot in the shape of the Chinese characters *wujiang* (meaning Longevity), produced in the Kangxi period. Consisting of two characters indicating best wishes for longevity, this pot was a masterpiece from the Kangxi period. It could have been a birthday gift, as it is decorated with traditional symbols of longevity (Fig. 11.42).

The author has also viewed a very exquisite *wucai* bowl produced in the Kangxi period, as illustrated in Fig. 11.43. It is glazed green, along with other colors, on its white body. Mandarin ducks (*yuanyang*, a symbol of conjugal affection and fidelity in Chinese culture) swimming in a lotus pond and birds perching and singing in reeds are meticulously depicted, reflecting the superb craftsmanship and fine painting style of the Jingdezhen painters and potters of the day. Left unpainted, the white

Fig. 11.38 *Wucai* plate with figures from *Heroes of the Marshes*, inscribed with "*Wenxinzhai*" under the bottom, produced in the Kangxi period, in the Victoria and Albert Museum

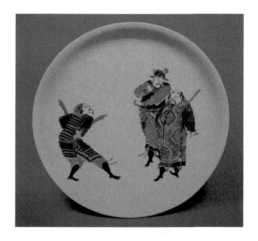

Fig. 11.39 *Wucai* plate with figures from *Heroes of the Marshes*, produced in the Kangxi period, diameter: 38 cm, in the Palace Museum

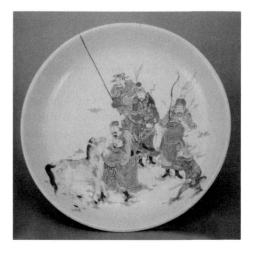

Fig. 11.40 Plain tricolor
fruit plate, produced in the
Kangxi period, in the
Idemitsu Museum of Arts

Fig. 11.41 Plain tricolor
bowl with engraved dragon
and flower patterns,
produced in the Kangxi
period, in the Capital
Museum

space manifests a sense of peace and tranquility. Mandarin ducks, a popular motif
used on porcelain, when combined with lotus (*lian* in Chinese, meaning linking
and consistent), carry a specific auspicious connotation. Lotus, sometimes called
hehua (*he* flower) and sometimes *lianhua* (*lian* flower), similar to mandarin ducks,
symbolizes a harmonious marriage and constant happiness.

11.2.5.5 *Sancai* (Tricolor) Porcelain

"*Susancai*" (plain tricolor porcelain) had appeared quite refined since the Zhengde
period of the Ming Dynasty. By the Kangxi period, further development was
achieved. Apart from yellow, green and purple colors, a blue color specific to the
period was introduced. Meanwhile, the methods of applying the colors on porcelain
were also varied. For example, some colors were painted directly on the bisque before
the application of a layer of translucent glaze and firing at low temperature. The plain
tricolor fruit plates frequently seen today are made using this approach. Some were
also painted with background colors on white bodies before being painted with plain
colors, like green, purple and white on yellow bodies, and yellow and purple on green
bodies. There was also a variety of black plain tricolor porcelain, a very rare variety.

Fig. 11.42 *Wucai* wine pot
in the shape of the Chinese
characters *wujiang*, produced
in the Kangxi period, in the
Berkeley Art Museum

Plain tricolor porcelain produced by official kilns often had white bodies, yellow bodies or egg and spinach (tiger skin patterns), marked with official signs. Meanwhile, those produced by private kilns usually had no markings. They were classified as coarse or fine products, with some marked with inscriptions from the Ming Dynasty and some marked with stamps. They varied in both variety and size. Large articles included phoenix-tail-shaped vases, *bangchuiping*, pots and human statues, among which some phoenix-tail-shaped vases and *bangchuiping* were as high as one meter or more. In addition, there were also small products like cups and jars. Plain tricolor

Fig. 11.43 Jingdezhen *wucai* bowl with mandarin duck patterns, produced in the Kangxi period, height: 8.5 cm, diameter: 17.2 cm, in the Victoria and Albert Museum

Fig. 11.44 Tea pot,
produced in the Kangxi
period, height: 12 cm, in the
Peabody Essex Museum in
the USA

lotus cups were common, consisting of two lotus leaves, each covering half of the cup while the intervening lotus stem was hollow inside, allowing the user to drink.

Plain tricolor porcelain was also a popular export. The author viewed many pieces of plain tricolor porcelain in the Dresden State Art Collections in Germany and the Peabody Essex Museum in the USA. For example, in Fig. 11.44, the teapot from the Peabody Essex Museum has a bamboo-like body, handle, spout and lid. This design was very popular among the Yixing potteries and might have been created after the style of the Yixing teapots of the time.[25]

Porcelain produced in the Kangxi period appears antique, heavy and plain. Though made with fine, compact clay, affected by the heavy style of the late Ming Dynasty, porcelain produced in the early Kangxi period featured a heavy body. It was only in the mid- to late-Kangxi period that porcelain bodies began to grow thinner.

Porcelain of this period boasted numerous designs, varieties and sizes. Among the large *zhuoqi* articles were *zun*, *gu* and fish tanks, of varying designs, large and with a standardized production methodology; all in all they were far better than their counterparts produced in the late Ming Dynasty. Common varieties like blue and white porcelain, *wucai* porcelain and *sancai* wares all sported new designs. Blue and white porcelain still dominated the private kilns. New varieties which emerged from the Shunzhi period onwards, like the new modeled helmet-shaped jars, flower *zun*, incense burners and pen holders were increasingly popular. Export porcelain in the Kangxi period featured unique and varied designs and sold well in the foreign market. Export porcelain at this time played an important role in foreign trade and cultural exchange in the Qing Dynasty and can be readily found in western European countries to this day.

[25] William R. Sargent, *Treasures of Chinese Export ceramics from the Peabody Essex Museum*. Distributed by Yale University Press, 2012, p. 177.

Fig. 11.45 Overglazed gilt
lady statues, produced in the
Qing Dynasty, in the
Victoria and Albert Museum

Decorative techniques at this time included painting, printing, scratching, decal, pierced engraving and sculpting (Fig. 11.45). The decorative motifs on blue and white porcelain and *wucai* wares were also various, covering many aspects of society.

The early Kangxi decorative style inherited many features of the Shunzhi period. Bold and exquisite, the porcelain decorations were unique. While heavy, products of the private kilns were neatly made with various decorative patterns, such as human figures, garden scenery, kylin and Chinese bananas. By the mid-Kangxi period, under the influence of painters like Dong Qichang, Chen Hongshou and Liu Panyuan, the decorations on porcelain featured whole images of paintings with broad structures and far-reaching connotations, such as human figure paintings, landscape paintings, paintings reflecting the interests of scholars, the three durable winter plants, namely pine, bamboo and plum blossom, *Qiushengfutu*, Wang Xizhi (a great Chinese calligrapher) observing geese, Mi Fu worshiping a mysterious stone, as well as figures, scenes and plots from novels and opera popular among civil society, such as *Romance of the Western Chamber*, *The Three Kingdoms*, Yue Fei (a Chinese military general during the Southern Song Dynasty), and three legendary figures from the late Sui and early Tang period (Qiuranke, Li Jing and Hongfunv). Since the Yuan Dynasty, woodcut paintings had been an important source of inspiration for the Jingdezhen potters. By the Kangxi period, this inspiration had peaked. Potters reinterpreted paintings on woodblock, books and silk scrolls, and applied their own ingenuity in painting porcelain. For example, the *bangchuiping* (rouleau-shaped vase) in Fig. 11.46 depicts the story of *Romance of the Western Chamber* in the form of a series of pictures. Large and tall, this vase has four rows of decorations, each with 24 panels of scenes, which serves as a valuable reference for how various patterns are selected, laid out and depicted. Decorated with figures and plots from popular novels and opera, such products were very attractive to consumers both at home and abroad. But after the

Fig. 11.46 Jingdezhen blue
and white *bangchuiping* with
scenes from *Romance of the
Western Chamber*, produced
in the Kangxi period, height:
75 cm, diameter: 22.4 cm, in
the Victoria and Albert
Museum

Kangxi period, this style gradually fell out of favor and few pieces had such serial decorations applied.

In addition, after 1691, the 30th year of the reign of Kangxi, the emperor expanded the convening of imperial examinations and honored the Han culture, leading to large amounts of porcelain being inscribed with poems and essays. For example, images like the top scholar of an imperial examination touring the high street, the top scholar of an imperial examination presenting himself before the emperor, etched in *ao*-head (a huge legendary turtle) relief, Su Dongpo writing poems, all of which reflected this social milieu. Figures riding horses or with knives or scenes of hunting with bow and arrow in Qing costumes also featured prominently as Emperor Kangxi drew upon the lessons of the Ming Dynasty, advocating that his offspring should carry forward the riding and shooting traditions of the Manchu ethnicity and place equal emphasis on civilian culture and military strength. In addition, rural scenes such as *Gengzhitu* on porcelain, reflected to some extent the affluent society of the early Qing Dynasty (Fig. 11.47).

Private kiln paintings, especially those with seals or painted with halls and chambers, were free from the rules of the official kilns and featured smooth lines and vivid images, quite typical of the time. In order to cater to foreign demands, export porcelain produced by private kilns during the Kangxi period attached great importance to artistic design and the selection of pigments. The painters achieved an excellent standard of craftsmanship. Apart from traditional paintings, paintings in the Japanese style, and those with patterns such as human figures from the West, flowers, scenery and more, custom-made for merchants from Portugal, the Netherlands, and France were also most attractive.

Fig. 11.47 *Wucai* imperial
plate with *"Gengzhitu"*
pattern, produced in the
Kangxi period, in the
Victoria and Albert Museum

The clay was processed to a very fine and pure degree, as fine and white as flour. Thanks to the detailed division of labor in clay making and the mastery of the correct firing temperatures, Kangxi porcelain featured hard and compact bodies, even smoother than those of the Ming Dynasty and beyond. Among the products of the private kilns in the early Qing Dynasty, there were occasionally a few pieces with loose, rough bodies made with impure clay. Some articles had white marks on their unglazed gritty bottoms and unglazed feet, which had previously been white brown. But the color was not as heavy as it had been in the Ming Dynasty. Such marks could still be encountered until the Qianlong period.

Large articles and *zhuoqi* wares usually sported heavy bodies, consisting of segments which were made separately and assembled into a whole piece afterwards. Still, because of the meticulous skill, the finished product was very neat and smooth where the different parts joined together, thus not as obvious as similar items produced in the Ming Dynasty. With a pure glaze, the glaze and the body were perfectly integrated. White glazed, pinkish white glazed or blue glazed alike, porcelain articles demonstrated a hardness and smooth gloss on jade-like bodies.

On some less obvious sections of some of the private products, there were sometimes flaws that appeared like "insect marks" where the glaze did not adhere properly to the body, giving the appearance of crawl marks. These marks were especially common on articles such as incense burners, *tongping* (elephant-leg vases), plum vases, *danping* (gall bladder vases), flower pots, pen holders, plates and bowls produced during the early Kangxi period, and so a brownish glaze was applied to rectify the problem on many products from the late Ming through to the early Qing Dynasty. In the early Kangxi period, round-foot wares were quite common, sometimes with marks left by knives. There was sometimes an arch-shaped slope between the ring feet and the bottom, and at other times, a sloping cut. Over time, the high, deep feet were replaced by feet of a moderate height, while for square vases, the

bottoms were usually wide, gritty and glazed. Apart from plain tricolor wares, most products had linen marks under the feet.

11.3 Jingdezhen Porcelain in the Mid-Qing Dynasty

11.3.1 Official and Private Kilns Boom

Over the centuries, Chinese rulers have "ascended the throne through military power," but military power alone was not enough to govern the country. Chinese rulers thus promoted traditional courtesy and music, established various systems, built relevant institutions and advocated education so that a common ethical standard and goal of an ideal society were established for the elite and beyond them for society at large. After the founding of the Qing regime, the rulers adopted the basic national policy of "respecting and stressing Confucianism" culturally and accepted the Confucian ideas of "rule through virtue" and "rule by rites," attached great importance to ritual and musical education and vigorously promoted governance through culture and education. The government built many schools to promote public education, searched for ancient books and records while also vigorously encouraging bookmaking to gather together the traditional cultural heritage and to revive traditional culture. Meanwhile, in order to strengthen its feudal autocracy, the Qing government launched a literary inquisition to officially persecute intellectuals for any offensive writing such that nothing which could damage the image of the government could survive. This literary inquisition was especially notorious in the Qing Dynasty. From Emperor Kangxi to Emperor Yongzheng to Emperor Qianlong, cases of literary heresy continued to be prosecuted for over a century, especially during the Qianlong period. Cajoled and threatened by the powers that be, scholars, while discontent with the cultural repression of the government, chose to revive the ancient culture in a move to safeguard their own dignity, maintain the existing cultural heritage and fight against repression and suppression. At the same time, while reflecting on the experience of the Ming regime, many believed that the root cause of its overthrow was because of a departure from traditional culture. Therefore, in the Qing Dynasty, there was a clear trend to revive tradition, which, combined with the social environment at the time, led to a profound and persistent wave of restoration of traditional culture.

This wave made possible a school dominated by restoration ideology in academic circles, called the Han school. While in terms of social culture and customs, there was a high tide in collecting ancient wares. In the eyes of people of the period, a piece of bronzeware, a seal, a piece of porcelain, an ancient inkstone, an ancient *qin*, or a traditional painting were all testament to a part of history and would lead to the admiration of the culture of the past. In academic circles, when someone happened across a piece of ancient ware, they were bound to invite friends over to appreciate it together, discuss its period of production and its producer, and exchange views on it. Apart from scholars, businessmen in the Qing Dynasty also liked to associate

with men of letters and pose as lovers of culture. On one hand, they made friends with famous scholars and tried to ingratiate themselves into their circle. On the other hand, they purchased antiques by any means possible to showcase their aesthetic tastes. This fashion was not only a hit among scholars and businessmen, but also among the common public. In this way, an antique and pro-antiquity market emerged (Figs. 11.48 and 11.49).

Initially, it was in the official kilns that production of ancient-style porcelain prospered, and great achievements were made. As for private kilns, there had been workshops like "*guanguqizuo*" (official ancient ware workshops), "*shangguqizuo*" (upper-class ancient ware workshops), "*zhongguqizuo*" (middle-class ancient ware

Fig. 11.48 Blue glazed creel-shaped *zun*, produced in the Yongzheng period, height: 36 cm, mouth rim diameter: 20.5 cm, in the Palace Museum

Fig. 11.49 Blue glazed flask with lotus motifs, produced in the Yongzheng period, height: 29.6 cm, mouth rim diameter: 4.6 cm, in the Palace Museum in Taipei

workshops), "*youguqizuo*" (glazed ancient ware workshops), "*xiaoguqizuo*" (small ancient ware workshops), and "*changguqizuo*" (common ancient ware workshops). In official ancient ware workshops, it was said that "Products made in imitation of ancient famous kilns were suspected as products of the official kilns in the Song Dynasty, but they were not." This shows that copycat products made at this time were so well executed that it was difficult to distinguish them from authentic products of official kilns in the Song Dynasty. Meanwhile, there were also various workshops specifically copying from the famous kilns of the Song Dynasty. It is recorded in *Jingdezhen Taolu*, written in the late Qianlong period, that "Initially, there were kilns producing products in imitation of the Longquan kilns of the Song Dynasty while now only official ancient ware workshops and middle-class ancient ware workshops do that. Besides, crackled glaze porcelain producers also copied Longquan glaze. But no matter whether they were specifically copying from the Longquan kilns or Longquan glaze, or they were copying and producing other varieties, these kilns produced products fine or coarse in quality, large or small in size, and light or heavy in color. While porcelain from the Ding kilns was also a model for imitation among kilns in Jingdezhen… Ru porcelain was imitated by the official ancient ware kilns and the best of their products were said to be like sky blue after rain. The style of the Guan kilns (official kilns) was also specially modeled by some kilns while now these kilns produce more than just products in this style. Crackled glazed porcelain producers also copied the Guan style. There were no kilns which produced solely in the style of the Ge kilns, but there were some crackled glazed porcelain producers copying its style along with others, hence they were also called Ge-style kilns. Initially, products produced in the Ge style could be identified while now only the designs of Ge porcelain are copied and thus the products carry hardly any feature of the Ge kilns." From this record, we can catch a glimpse over how private kilns in the early and mid-Qing Dynasty imitated the ancient kilns. It seems imitated production in the early Qing Dynasty was better than that of the mid-Qing Dynasty. The reason for this might be because products in imitation of ancient wares were mostly designated as ritual wares, sacrificial wares, and decorative wares in the palace while unsuitable for daily use by the common public, therefore had a limited market. Thus, after some time, when the market demand had been met, the kilns had to slash production.

The Jingdezhen kilns in the Qing Dynasty not only copied from famous Song kilns like the Ru, Ge, Jun, Ding, Longquan, Jian, Hutian, and Jizhou kilns, but also modeled on their counterparts from the Ming Dynasty. For example, the *langyaohong* of the Kangxi period arose from the imitation of the bright red glaze of the Ming Dynasty. At the time, porcelain production in Jingdezhen was basically a comprehensive expression of the beauties of all the famous kilns around the world. Such mass imitation resulted in the emergence of many innovative varieties. This was also true of glaze. Based on the previous heritage, Jingdezhen innovated masterfully and created unprecedented types of glaze. If we categorize glaze at this time into four groups, red, blue, yellow and black, there were the following colors. Red glaze (including purple glaze): *jihong* (sacrificial red), *jihong* (accumulated red), *zuihong* (drunk red), *jihong* (chicken red), ruby red, *zhuhong* (scarlet red), *dahong* (oriental red), bright red, *mohong* (wiping red), coral, *yanzhishui* (light carmine), *yanzhihong*

Fig. 11.50 Lavender gray
glazed pot with a
monk-hat-shaped lid,
produced in the Yongzheng
period, height: 19 cm, spout
length: 14.5 cm, in the
National Museum of China

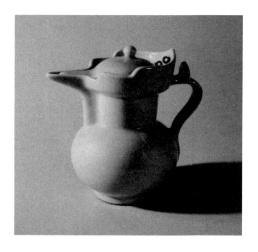

(carmine), pink, *meirenzui* (drunk beauty), *jiangdouhong* (mottled peach blossom), *taohualang* (peach wave), *taohuapian* (peach petal), *haitanghong* (crabapple red), *wawalian* (baby face), *meirenlian* (beauty face), *yangfeise* (light pink), *danqie* (light aubergine), *yundou* (light kidney bean), *junzi* (jun purple), *qiepizi* (aubergine), *putaozi* (grape purple), rose violet, *rushupi* (suckling-mouse pink), persimmon red, date red, orange red and *fanhong* (iron red), etc. Blue glaze (including blue glaze and green glaze): sky blue, bean green, *dongqing* (plum green), pear green, *xiejiaqing* (greenish gray), shrimp green, *zhanbaoqing* (purplish green), *guapilv* (melon-peel green), *gelv* (cadmium green), *guolv* (fruit green), peacock green, parrot green, okra green, *songhualv* (dark green), *putaoshui* (grape water), *xihushui* (West Lake water), *jilan* (sacrificial blue), sapphire, *yuzilan* (bright light blue), *molan* (wiping blue) and *biequn* (turtle), etc. Yellow glaze: light yellow, beeswax yellow, ivory yellow, *jinjiang* (gold), *zhimajiang* (sesame paste), *chayemo* (tea dust), *biyan* (snuffing tobacco), *caiwei* (vegetable yellow), *shanyupi* (eel skin), brownish yellow and *laosengyi* (old mafor yellow), etc. Black glaze: *wujin* (mirror black), *gutong* (bronze), black brown and iron oxide brown, etc.[26] (Figs. 11.50 and 11.51).

Official kilns were better than private kilns at producing various kinds of glaze at this time. Since the early Qing Dynasty, superintendents of the imperial kilns in Jingdezhen had had a personal interest in porcelain and porcelain research. Some of them even made great achievements in this regard, facilitating the progress of the whole industry. Official kilns could also afford to produce regardless of the market demand, time or cost and had access to the best artisans and raw materials, they therefore were responsible for many breakthroughs. Tang Ying was the most remarkable of all the superintendents of the Jingdezhen imperial kilns. From 1728, the sixth year of the Yongzheng period, Tang Ying served at the post for over two decades. He not

[26] Xu Zhiheng, *Yinliuzhaishuoci*, notes by Tu Chongyang, *Porcelain of Jingdezhen*, Vol. 5, Issue 5, pp. 53–54.

Fig. 11.51 Sacrificial red
glazed plum vase, produced
in the Yongzheng period,
height: 25.1 cm, mouth rim
diameter: 5.7 cm, in the
Palace Museum

only attached great importance to practical work, but also summarized his experi-
ence and documented it. His works, *Taochengjishibei* (*Tablet of Records of Porcelain
Manufacturing*) written in 1728 and *Taoyetushuo* (*Illustrations of the Manufacture of
Porcelain*) written in 1730 remain important works regarding porcelain production in
Jingdezhen during the Qing Dynasty. Serving this position for decades, the Imperial
workshops he worked in bore his name, *Tangyao* (the Tang kilns). His remarkable
achievements in porcelain production would not have been possible without the
support from and cooperation of private kilns. According to *Jingdezhen Taolu*, "In
the early Qing Dynasty, attempts to produce dragon vats kept failing until the Tang
kilns cooperated with private kilns." Tang Ying also recorded in *Taoyetushuo*, "When
the paste was finished, it was put into saggers and transported to private kilns for
firing."

With the support and assistance of private kilns, production at the official kilns in
Jingdezhen during the Yongzheng and Qianlong periods reached an unprecedented
level, boasting products of extraordinary craftsmanship, exquisite quality and glam-
orous decoration, which elevated the position of porcelain from articles of daily use
to collections to be appreciated. But of course, this related to the technical level only.
From the perspective of artistic value, porcelain transited from articles of daily use
to luxury goods. But the decorations on porcelain were too pretentious and poor
aesthetic taste was propelling porcelain art in Jingdezhen towards a dead end.

Jingdezhen's private kilns gradually became less bold, free, individualized and
creative than they were, and started to move towards the style of the official kilns.
While advancement was made in terms of technique, the private kilns lost the
creativity and flexibility that they had exhibited in the late Ming and early Qing,
and especially in the Kangxi period.

While the Yongzheng and Qianlong periods were a period of prosperity for both
the official and private kilns according to today's academics, Jingdezhen also met

with competition on the international market. The wide international market in the late Ming and early Qing periods was no longer the exclusive domain of the Jingdezhen potters and the massive demands for porcelain were no longer met by Jingdezhen alone. Three factors contributed to this situation. First, products modeled on Jingdezhen porcelain were manufactured in many places and flowed onto the international market, such as Imari ware produced in Japan. Second, the introduction of Canton porcelain. Third, some European countries had already started to order bisque wares from Jingdezhen and then transported them back home for further processing. Due to these three factors, exports of the private kilns in Jingdezhen were cut. The introduction of Canton porcelain played an important role in this regard. From the mid-Qing Dynasty, merchants from coastal regions in Guangdong went to Jingdezhen to buy bisque wares and then transported them back to Guangzhou for colorful painting. When completed, such products were shipped overseas and became the major export variety. According to *Zhuyuantaoshuo* written by Liu Zifen in the Qing Dynasty, "When maritime trade was opened up, Western merchants arrived first in Macao before they gradually shifted their initial destination to Guangzhou. In the mid-Qing period, numerous merchant ships were engaged in maritime trading and commerce boomed. Since the European market favored colorful paintings, Chinese businessmen catered to their tastes by supplying polychrome porcelain to their European consumers. They first ordered bisque wares from Jingdezhen, painted colorful decorations in the Western style on them in Guangdong and fired them on the south bank of the Pearl River before they were finished and sold to Western merchants." These products were commonly known as Canton porcelain. When an American traveler visited a Canton porcelain workshop on the south bank of the Pearl River in Guangzhou in 1769, the 34th year of the Qianlong reign, he described the workshop as follows. "In a long hall, around 200 potters were painting motifs on porcelain, including senior workers as well as child laborers of six to seven years old." There were over one hundred such factories at the time.[27] Canton porcelain replaced part of what its private kiln counterparts in Jingdezhen had produced. But for blue and white porcelain, Jingdezhen still played a dominant role in the market and exported large quantities overseas.

11.3.2 Reform in the Treatment of Products of the Official Kilns that Failed to Qualify

Due to the sacred nature of official wares, since the early and mid-Ming Dynasty, sub-standard products from the official kilns had to be broken into pieces and buried underground. Following the Longqing and Wanli periods, this practice was basically abandoned. Instead, products falling short of the standard for imperial use were put into storage. As for how to further deal with them, there did not seem to be a

[27] Chinese Ceramic Society (ed.), *History of Chinese Ceramics*, Cultural Relics Press, 1982.

clear rule.[28] After the establishment of the Qing Dynasty, things changed. According to Quan Kuishan, before 1728 when Tang Ying was named Superintendent of the Jingdezhen imperial kilns, sub-standard products were scattered all over the imperial kilns. Staff at the kilns could dispose of them freely. Thus, some of the sub-standard products were broken, and some were lost. It seems similar to what occurred during the Longqing and Wanli periods. After Tang Ying took charge of the imperial kilns, unqualified porcelain articles were valued and registered before they were transported to Beijing together with qualified products every year from 1729, the seventh year of Yongzheng, to 1742, the seventh year of Qianlong. After arriving in Beijing, the substandard products were either put into warehouses, sold or put into temporary storage before being sent away as gifts by the emperors. After 1742, under the imperial orders of Qianlong, sub-standard products were no longer sent to Beijing. Instead, they were sold locally. But at the request of Tang Ying, yellow wares were allowed to be transported to Beijing for the use of the court or to be given as gifts.[29]

Superficially, it would appear that the reform on how to deal with unqualified porcelain was based on Tang Ying's initial proposal. But this was in fact a social trend and an inevitable outcome of the development of the commodity economy. With the development of a commercialized society, the sacred nature of official products was weakened. After the Longqing and Wanli periods of the Ming Dynasty, capitalism enjoyed a rapid development in China and the porcelain trade also registered a new record. Products of the official kilns were not only sacred articles for sacrificial ceremonies and ritual events, they were also commodities with value in the market. This trend was even more pronounced during the Qing Dynasty. If in the Ming Dynasty, sub-standard products survived the destiny of being broken into pieces and luckily remained intact, no one would dare sell them on the market. But in the Qing Dynasty, it was completely different. Sub-standard products were allowed entry onto the market and transacted as commodities. We can see from this that Chinese society was becoming increasingly pragmatic and commercialized.

11.3.3 Porcelain Production Under the Reign of Emperor Yongzheng

Though a short-lived reign of only 13 years, the Yongzheng period boasted an unprecedentedly high level of production expertise in porcelain manufacturing. Under the management of several very competent superintendents, the official kilns in Jingdezhen during this period attracted the best craftsmen nationwide and took orders directly from the emperor who was a big fan of porcelain. At times, shapes, patterns, and varieties of porcelain could only be put into production with the approval of the emperor and some designs were even made by the emperor himself. Under the direct

[28] Quan Kuishan, "Observations on How to Deal with Jingdezhen Unqualified Porcelain for Imperial Use in the Ming and Qing Dynasties," *Cultural Relics*, Issue 5, 2005.

[29] See Footnote 28.

guidance and supervision of Emperor Yongzheng, a new variety was created, based on *wucai* porcelain and enamel ware. Famille-rose porcelain eventually became one of the major production varieties in both official and private kilns in Jingdezhen. The creation of famille-rose porcelain is another major achievement in overglaze porcelain after the production of *wucai* porcelain in Jingdezhen. While not reaching its peak until the Yongzheng period, it was during the Kangxi period that a solid foundation had been built for its production and it was being exported overseas. For example, among the wreckage of the foundered Swedish East Indiaman Gotheborg that hit a rock and sank fully laden at the harbor mouth of Gothenburg within eyesight of its home port in 1745, two pieces of delicate famille-rose porcelain from the Kangxi period were identified (Figs. 11.52 and 11.53).

As the manufacture of famille-rose porcelain drew much experience from enamel ware, especially in clay painting, when discussing the production of famille-rose porcelain, we need to start with enamel ware. Due to Emperor Kangxi's preference for Western paintings, several Western painters were especially invited to the court to serve the emperor. At this time, batches of Western handicraft works flowed to the Qing court through foreign envoys and missionaries. Among them, the elegant and striking enamel ware drew the attention of the emperor. In the eyes of the emperor, the European enamel ware was an even better choice for the sumptuous decoration of the royal palace than the then popular *wucai* and *doucai* ware, so he issued an order demanding that two of the Western painters in the palace, Matteo Ripa (1682–1745)

Fig. 11.52 Famille-rose washtub with flower and bird patterns, produced in the Kangxi period

Fig. 11.53 Famille-rose plate with paneled floral patterns, produced in the Kangxi period

and Giuseppe Castiglione, try to produce enamel ware with a bisque instead of a bronze body.

In March, 1716, Matteo Ripa wrote in a letter: "The Emperor is fascinated by European enamel ware and the way we apply colors to it. He has tried every means to introduce the latter to the palace and even set up a special workshop to investigate the production of enamel ware. Several pieces of large enamel wares purchased from Europe and pigments used for decorating Chinese porcelain are all available here. The emperor asked Giuseppe Castiglione and me to paint on enamel ware. But we both think it is an intolerable drudgery to work in the royal workshop full of people from dawn to dusk. But unable to violate the order of the emperor, we have to do as he asks. As amateurs of this art, we know nothing about it and thus paint terribly. After the emperor sees our paintings, he says: 'Enough is enough.' Thus, we are relieved from this job." Humorous as the letter is, it shows how Emperor Kangxi attempted to transfer the art of enamel ware to Chinese porcelain.[30]

The most famous color used on enamel ware is rose, a basic color in Western decoration, but unseen in Chinese *wucai* wares. This color is produced with gold chloride, which was invented by Andreas Cassius, a Dutch chemist in around 1650 in Leiden, the Netherlands. It was put into use in the seventeenth century in Europe and later introduced to China and applied to the manufacture of enamel wares until it was applied to porcelain in the Kangxi period.

Thanks to the rose color, a new variety of porcelain emerged under the influence of bronze enamel ware, known as "Famille Rose" in Europe. Due to its bright color, "as colorful as a rainbow", it soon replaced *wucai* wares and became the favorite of the emperor. The royal painters were not satisfied with the chunks of rose pigment imported from Europe, so they soon invented many new varieties of rose glaze materials in the palace.

These rose glaze materials were initially invented by imperial craftsmen in the imperial workshop in the royal palace in Beijing and were used to decorate small bowls and cups with various flowers, such as peony, looking exquisite, elegant and unique. Such flowers displayed shades and appeared dimensional, with their petals in pink, leaves in green and the background in bright yellow. Some bowls and cups were decorated with bright overglazed blue while some were painted with pink lotus growing out of blue water. Such novel royal porcelain, marked with "*Kangxi Yuzhi*" (Imperial production of the Kangxi time) at the bottom, looked most refreshing (Fig. 11.54).

From the 27th to the 59th year of the Kangxi reign (1688–1720), the trial to apply enamel decorations on bisque basically succeeded and the pigments used were all imported from overseas, including red, yellow, white, pink, blue, purple, green and black. Enamel wares produced in the Kangxi period were mainly decorated with floral motifs. With Western artisans participating in their creation, the enamel wares were, more or less, affected by the luxurious and extravagant Baroque style popular

[30] Daniel Nadler, *China to Order: Focusing on the XIXth Century and Surveying Polychrome Export Porcelain Produced during the Qing Dynasty (1644–1908).* (Paris, 2001), p. 25.

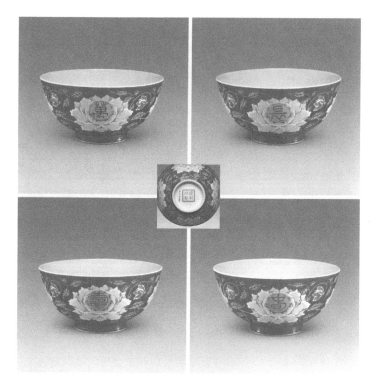

Fig. 11.54 A set of Jingdezhen enamel bowls with peony patterns on a blue background, produced in the late Kangxi period, height: 76 cm, diameter: 145 cm, in the British Museum

in Europe at the time, which happened to meet the resplendent decorative demands of the royal palace (Fig. 11.55).

Following the accession of Emperor Yongzheng, his preference for enamel ware surpassed even that of his father, Emperor Kangxi. He often engaged himself in the design and revision of manuscripts on enamel wares. At this time, painting of enamel wares was completed as a joint effort between craftsmen from the Painting Academy and Western artisans. As for the motifs, it was no longer restrained within floral patterns as in the Kangxi period. Instead, influenced both by traditional Chinese realistic paintings and Western paintings, it was more colorful, varied and dimensional. Monotonous pigments could no longer meet the demands for the multi-layered effect of color contrast and various decorative styles, and imported Western pigments could no longer fully express the artistic conception of traditional Chinese painting. So, craftsmen at the palace started to produce pigments themselves. Through long-term efforts, the royal artisans successfully created 18 kinds of pigments for enamel wares, nine more than the imported ones. Based on the aesthetic tastes of Emperor Yongzheng, enamel wares produced at this time were products of the joint efforts of the painters of sacrificial wares, those from the Painting Academy and Western

Fig. 11.55 Enamel bowl
with paneled flower patterns,
produced in the Kangxi
period, height: 7 cm,
diameter: 14.8 cm, foot rim
diameter: 5.7 cm, in the
Palace Museum

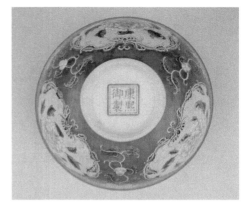

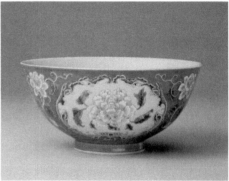

painters, and influenced by traditional Chinese realistic paintings and Western paint-
ings. Its structure basically drew from the tradition of integrating poems, calligraphy,
paintings, and seal marks together from traditional Chinese paintings, with the blanks
filled in with delicate, neat poems written in regular script in small characters, and
various seal marks and poems in between. Seals, cut in relief or in intaglio, were
stamped at the end of poems or in the blank spaces within pictures, creating a similar
tone to that in books. Such a style was even applied to painting famille-rose porce-
lain, strengthening the bond between porcelain decorations and paintings of the time
(Figs. 11.56, 11.57 and 11.58).

While looking magnificent and glamorous, enamel ware also featured relatively
realistic paintings. However, due to the high cost of its pigments, it was difficult
to popularize, so was only available in the royal court. Under such circumstances,
Jingdezhen potters introduced solvents and white pigment, based on pigments for
traditional *wucai* wares, thus watering down the color of paintings and lowering the
firing temperatures, making their articles appear softer and gentler. Arsenic was also
added into pigments of enamel ware, producing a "glassy white" color and hence
the new variety, famille-rose porcelain.

Fig. 11.56 Enamel bowl with various flower patterns, produced in the Yongzheng period of the Qing Dynasty, height: 5.5 cm, diameter: 10.1 cm, foot rim diameter: 3.9 cm, in the Palace Museum

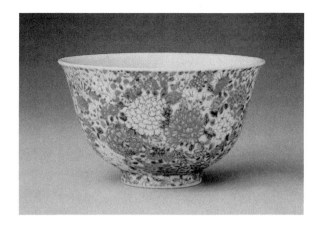

Fig. 11.57 Gilt enamel vase with flowers on a cream-colored body, produced in the Qianlong period of the Qing Dynasty, height: 20.5 cm, mouth rim diameter: 5.1 cm, foot rim diameter: 5.7 cm, in the Palace Museum

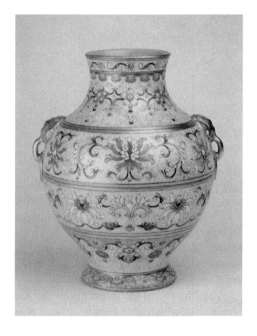

Also known as "*ruan cai*" (soft color), famille-rose porcelain was a new variety branching out from enamel ware. Mixed with lead powder and glazed in glassy white, the colors were toned down, layers of decorations were created, the color range was expanded, and the colors applied appeared more gentle, soft and dimensional. Among the pigments of famille-rose wares, a subgroup of colors, including lemon chiffon, light pink, pine green, and jade pink, were characterized by an opaque glassy white, looking powdery and featuring thick layers of enamels. Another feature of famille-rose porcelain was that an opaque glassy white enamel was employed as a base for coloring garments or flower petals and that colored enamels were either mixed

Fig. 11.58 Gilt enamel vase
with various flowers and two
lugs, produced in the
Qianlong period of the Qing
Dynasty, height: 14.1 cm,
mouth rim diameter: 5.5 cm,
foot rim diameter: 6.1 cm, in
the Palace Museum

with "glassy white" or brushed on top of it to create variations in tone. Created
using *wucai* ware as a basis with the introduction of pigments of enamels, famille-
rose porcelain had a wider color range and was more varied in tone. In addition,
with powdery colors, it appeared gentler and softer, without the "fiery passion" of
wucai paintings. Meanwhile, with its special coloring methods, variations of tone
were created, making paintings look real and expressive, which of course was also
developed based on enamel ware.

After the initial development in the Kangxi period, famille-rose porcelain soon
blossomed, which could not have been possible without the superb craftsmanship of
the painters, the excellent leadership of Superintendent Tang Ying, and governmental
intervention. During his 13 year reign, Emperor Yongzheng led a frugal life, but was
very interested in and passionate about porcelain, thus pushing the production of
royal porcelain wares to reach high benchmarks for imperial use.

Famille-rose porcelain produced in the Yongzheng period was the most magnifi-
cent ever. Famille-rose wares produced in this period not only featured a fine quality
but were also very large in number. In order to meet the demands of the court and
society, both official and private kilns produced. The combined use of poetry, callig-
raphy, paintings and seals also reflected the aesthetic tastes of the then producers and
connoisseurs.

Fig. 11.59 Jingdezhen
famille-rose bowl painted
with poppy pattern, produced
in the Yongzheng period, in
the British Museum

Illustrated in Fig. 11.59 is a famille-rose bowl painted with poppy in opaque white, pink and red pigments. Like enamels, such opaque materials also consisted of a strong base silicate, greatly expanding the tonal range. Although also outlined in black like *wucai* wares, its pigments were foreign which were capable of creating various shades of colors when mixed with oil. Thus, in order to create the gentle tone of flower petals, painters applied even thinner and gentler lines on petals than those on the leaves, making them appear more varied and exquisite than *wucai* wares.

By the Qianlong period, famille-rose porcelain was even more preferred for imperial use. Pigments for famille-rose porcelain could not only be used for painting various motifs and patterns on porcelain but could also be used to decorate articles produced in imitation of wood, stone, bronze, gold and silver wares, as well as other artifacts. Based on traditional overglazed paintings, new varieties were created in the Qianlong period, like blue and white famille-rose porcelain, graviata famille-rose porcelain, and paneled famille-rose porcelain. Graviata enhances the tone of the colors in the base color glaze by etching into the enamel, but not through it, to the paste beneath. It usually exhibits as a feathery design of scrolling leaf-like patterns and appears very complex and multi-layered, with obvious similarities to the rococo style. In the Qianlong period, it was recorded as "*jinshangtianhua*" (adding flowers to embroidery) in imperial documents and called "*pahua*" (rake flowers) by the Jingdezhen potters. Paneling is another decorative method which applies paint to two or four sides of an article and leaves round, lozenge, or fan shapes which are then decorated with mountains, country cottages, flowers, birds, insects, fish or human figures. Sometimes a series of pictures are applied to illustrate a story. Famille-rose porcelain in the Qianlong period, by borrowing painting techniques from the West and applying traditional porcelain production techniques, featured various shades of colors and appeared refreshing and gorgeous.[31]

Since famille-rose porcelain was even more expressive than *wucai* porcelain, it became a hit once it was developed. It not only became a major production variety in the official kilns but was also widely produced by private kilns, displaying a vigorous

[31] Cai Yi, "Famille-rose Porcelain in the Qing Dynasty and Its Export," Chinese Society for Ancient Ceramics (ed.), *Studies on Ancient Chinese Ceramics* (Vol. 14), The Forbidden City Publishing House, 2008, p. 373.

momentum to take the place of *wucai* wares in the market. At this time, famille-rose porcelain produced in official kilns was extremely exquisite and delicate while that produced in private kilns was very natural and unrestrained. Official and private kilns alike, both applied human figures and flowers in decoration. Among the flower patterns, corn poppy was the most representative. The painting method for peony changed and round-shaped blossoms became popular. Paintings of ladies were very exquisite and background articles like tables and windows were painted in a realistic style. But compared with official kilns, private kilns lagged in innovation. In the production of famille-rose porcelain especially, the private kilns followed virtually every step of the official kilns and lacked its own character and style (Figs. 11.60 and 11.61).

The official kilns in the Yongzheng period mainly produced famille-rose porcelain while production of blue and white porcelain was reduced. Meanwhile, for the private kilns, blue and white porcelain remained one of the major production varieties. Beautiful and expressive, famille-rose porcelain was nevertheless costly to produce and complicated to paint, thus suitable only as high-end exquisite decorative wares for the upper classes while for the common public, the low-cost, productive and relatively expressive blue and white porcelain remained the better choice. Thus, in the Yongzheng period, famille-rose porcelain dominated official kiln production while blue and white porcelain dominated the private kilns. Blue and white porcelain produced by official kilns at this time featured few varieties and rigid patterns. In contrast, the private kilns offered various designs of blue and white porcelain with various motifs and patterns, such as bowls, plates, saucers, cups, pots, vases, *zun*, vats,

Fig. 11.60 Famille-rose celestial-sphere vase with eight peaches, produced in the Yongzheng period, height: 50.6 cm, mouth rim diameter: 11.9 cm, foot rim diameter: 17.7 cm, in the Palace Museum

Fig. 11.61 Famille-rose *yuhuchunping* with lotus patterns, produced in the Yongzheng period, height: 27.6 cm, mouth rim diameter: 8.3 cm, foot rim diameter: 11.5 cm, in the Palace Museum

incense burners, candlesticks, porcelain ink slabs, and pen holders. The pigments used at this time were basically the same as those used in the Kangxi period. They were produced in Zhejiang in colors like dark blue, light blue and bright green. The decorations used can be divided into three categories. First, some inherited the style of the Kangxi period and were also influenced by famille-rose porcelain and Western paintings, thus more delicate and exquisite than in the Kangxi period. In terms of painting motifs, variations in color was stressed through outlining and polishing, creating varied tones and shades. Human stories, flowers, and landscapes were motifs frequently seen. This blue and white porcelain often featured bright, stable colors, stable designs, thick, fine bodies, clear, smooth and hard glazes, and jade-like gritty bottoms. Dark floral patterns were usually applied to shoulders and ring feet. Articles with human figure patterns were neat and conveyed profound artistic connotations. Most articles were without marks. The second type was lightly painted blue and white porcelain and influenced by woodcuts and traditional Chinese paintings. This category emphasized outlining and was occasionally polished. Phoenix-shaped and dragon-shaped cloud patterns, and various flowers were normally applied as motifs. Under the base, it was often glazed in white, iron or iron red, or it remained gritty without glaze. A typical feature of this period were vases featuring high, deep round feet. The third category were those produced in imitation of Ming blue and white

porcelain, especially that produced during the Xuande period. Creating a similar effect to the imported cobalt blue materials, such porcelain featured heavy coloring, obvious polishing, and black dots purposefully drawn with brushes, in an effort to imitate the naturally formed iron dots on Xuande blue and white porcelain. But the black dots created by humans rather than by nature merely floated on the surface of the glaze and was far from the natural product on Xuande blue and white porcelain.

Apart from famille-rose and blue and white porcelain, *wucai* ware was another major variety produced by the Jingdezhen kilns during the Yongzheng period. *Wucai* ware which was a hit in the Kangxi period was being replaced by famille-rose porcelain at this time, especially in official kilns. But in private kilns, *wucai* ware still had its place. While not as varied and striking as in the Kangxi period, *wucai* ware produced in private kilns in the Yongzheng period had its special features. Under the influence of famille-rose porcelain, the colors of *wucai* ware were not as bright and glamorous, its decorations were not as complex, and its painting strokes were not as vigorous as previously.

The production of export porcelain also brought new styles and fashions in decoration to Jingdezhen porcelain. Apart from famille-rose, a new variety introduced from Europe, there was also overglazed porcelain painted with imported pigments from Europe, which was known as "*yangcai*" (foreign color) in Jingdezhen. Traditionally, pigments were mixed with water or gel to achieve various shades of color while different colors were not to be mixed. Thus, the colors of *wucai* wares in the Kangxi period were mostly primary colors with no intermediate colors, appearing very bright and glamorous. *Yangcai*, however was different. It used oil to mix colors, and different colors could also be mixed together, thus creating various colors with different shades and tones, especially from the Qing Dynasty as Europeans flocked to Jingdezhen and Guangzhou to order armorial porcelain. The manufacture of armorial porcelain required red which could only be produced by mixing red and black. The adoption of *yangcai* offered solutions to this. There was only iron red in Kangxi *wucai* wares while the production of *yangcai* wares required various red colors, such as light red, dark red, carmine, rose, and magenta. For Kangxi *wucai* wares, the black would wear off if not covered with a layer of green, which required much work, while the black in *yangcai* wares could be fired directly without any peeling off. As illustrated in Fig. 11.62 depicting two Scottish soldiers, the plate is painted in *yangcai* and gold. As *yangcai* could be mixed randomly, apart from the mixed red and black, there are also black colors in different tones.

In around 1700, overglazed porcelain in silver came into being. The newly emerged silver oxide added a unique color for decorating overglazed porcelain, which was most frequently applied on armorial porcelain. Also, a new color in the *yangcai* palette called "*jinshui*" (gold water) emerged by mixing with gel and known as "*yangjin*" (foreign gold) in Jingdezhen. It could be mixed, diluted, painted and dealt with in a similar manner to oil. Previously, gold on porcelain had been achieved using genuine powdered gold which was high in cost and poor in brightness. In contrast, *yangjin* was low cost and extremely shiny. D'Entrecolles once described the overglazing techniques of silver and gold pigments: "Above all, there is a variety of porcelain which is painted with scenery and mixed with almost all colors, glazed

Fig. 11.62 Jingdezhen gilt painted plate with patterns of Scottish soldiers, produced in the Qianlong period, diameter: 23 cm, in the Victoria and Albert Museum

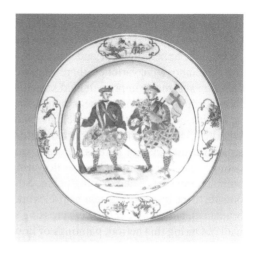

in gold and shining out in all their brightness. If needed, it is worth manufacturing." But for the official kilns which always put quality first, they would rather use genuine gold, arguing that it appeared poised and durable, and not as showy as *yangjin*. Nevertheless, with the establishment of contact and the initiation of trade with the West, the porcelain trade accelerated the variation of the decorative methods of Qing porcelain and facilitated the emergence of a range of innovative varieties.

Apart from the above-mentioned varieties, the Jingdezhen ceramics industry also made some achievements in the decoration of high-temperature polychrome porcelain and various color-painted porcelain on a color base during the Yongzheng period (Fig. 11.63).

So far, we have discussed several major varieties produced by the Jingdezhen kilns. Now, we will move on to the features of the designs, decorations, glazed surfaces, and bodies during this time. Different from the heavy, antique style of the Kangxi period, porcelain in the Yongzheng era featured a light, exquisite, neat

Fig. 11.63 One of a pair of yellow-glazed bowls with incised patterns, produced in the Yongzheng period, in the Berkeley Art Museum

and bewitching style, manifesting a feminine beauty in contrast to the masculine beauty of the Kangxi period. Most porcelain articles had thin bodies, even the large-sized ones, appearing neat and balanced, but not heavy. In terms of design, apart from the innovative varieties, there were many pieces that imitated previous popular varieties and many unprecedented varieties that imitated real objects like begonia, lotus seedpods, melons, pomegranates, wicker, and chrysanthemum petals.

In terms of decoration, the delicate and elegant style of the Kangxi period was inherited, but the Yongzheng period featured finer strokes, and clearer and simpler structural design. For motifs, flowers were the most frequently used, including peony, peach blossoms, Chinese flowering crabapple and chrysanthemum, along with autumn scenes and drifting petals. Sometimes flower motifs extended from the outside to the inside of porcelain articles and were called *guozhihua* (flowers crossing branches), *guoqianghua* (flowers crossing walls) or *guoqianglong* (dragons crossing walls). During this period, paintings of flowers and birds were heavily influenced by the "*mogu*" (boneless) technique (which means forms are made with ink and color washes rather than outlines) of Yun Shouping; landscape paintings were dominated by the "Four Wangs Paintings" (paintings of Wang Shimin, Wang Jian, Wang Hui, and Wang Yuanqi, leaders of the Orthodox school of painting in the early Qing period), only with lighter colors and finer strokes than in the Kangxi period. Meanwhile paintings of soldiers in combat and characters from *Romance of the Western Chamber* remained in vogue. At the same time, paintings of beautiful ladies came into fashion. For example, Fig. 11.64 features a plate which is painted in *yangcai* and gold with a paneled lady dressed in traditional elegant Han costumes embroidered with various motifs inside and eight pink lozenge-shaped petals outside. She sits with a fan in one hand, and several pieces of porcelain and bronzewares on the ground behind her, one of which holds a large fan and many scrolls of calligraphy and paintings. There is also an incense-burner table at her back, with articles for amusement and offerings. Two children are playing around her, with one presenting a longevity peach to her. In such a warm and sweet familial atmosphere, her character as a lady of high status in the court or married into an official family is delicately implied. The children around her show that she is a mother while the decorations around her reveal her scholarly and cultural accomplishments. The character in this plate is very similar to the image of an ideal lady in traditional Chinese paintings as seen in the *Twelve Portraits of Beauty*. Portraits of ladies at this time depicted beautiful, thin and tall female figures, a practice that was associated with the then fashion of worshiping the beauty of slim and fragile ladies. The tradition of inscribing poems on porcelain from the Kangxi period continued to prevail during the Yongzheng era. Motifs in imitation of those on blue and white porcelain from the Xuande period and *doucai* wares from the Chenghua period were applied, revealing unique characteristics. Polishing was especially applied to lines of blue and white porcelain in an attempt to create the polishing effect of smalt cobalt blue. *Doucai* wares were made exactly as their counterparts from the Chenghua period had been, making it hard to distinguish them in terms of decorative motif only (Figs. 11.65, 11.66 and 11.67).

During the Yongzheng period, clay was finely selected, smashed, cleaned, and made into paste. With strict technical standards and the correct firing temperatures,

Fig. 11.64 Jingdezhen gilt
famille-rose plate with a lady
and her children, produced in
the Yongzheng to Qianlong
periods, diameter: 20 cm, in
the Victoria and Albert
Museum

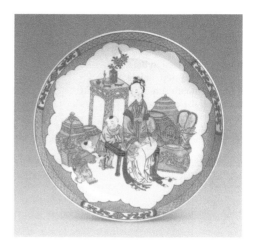

Fig. 11.65 Famille-rose
pipa zun with human figure
patterns, produced in the
Yongzheng period, in the
Palace Museum

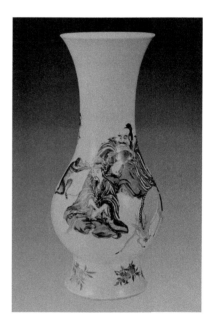

bisque wares were hard, white, smooth, neat and light, comparable to the white glazed
porcelain of the Yongle and Chenghua periods in the Ming Dynasty. In the sunshine,
sunlight seems to be able to pass through, displaying spotless bodies, some of which
displayed light blue colors (the Ming ones were red), even, smooth paste, and fine,
neat unglazed gritty bottoms. Some glazed surfaces of blue and white porcelain
had orange-peel wrinkles, which aimed at creating a similar effect to the blue and
white porcelain from the Xuande period of the Ming Dynasty. There were also
heavily glazed surfaces, looking like clouds and haze, mostly in pure white, known

Fig. 11.66 Famille-rose
"gall bladder" shaped vase
with butterflies flying around
flowers, produced in the
Yongzheng period, height:
37.6 cm, mouth rim
diameter: 4.1 cm, foot rim
diameter: 11.6 cm, in the
Palace Museum

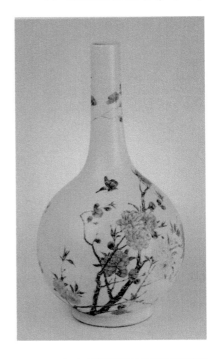

Fig. 11.67 Jun-style glazed
zun, produced in the
Yongzheng period, height:
23.9 cm, mouth rim
diameter: 11.4 cm, in the
National Museum of China

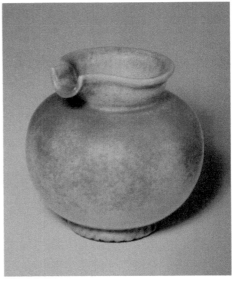

as "*mengyou*" (veiled glaze). Blue and white porcelain differed in glaze, heavy or light, and in color, white or bluish white. The commonly seen bluish white glazed porcelain was slightly glazed at the bottom and under the feet, appearing especially glassy.

11.3.4 Porcelain Production Under the Reign of Emperor Qianlong

The Qianlong period marks the end of the peak of China's feudal society. Under the veneer of prosperity there were hazards of decline and crisis. The official kilns endeavored to pursue luxurious and sumptuous decorations and designs displaying amazingly superb craftsmanship. Such a pursuit was not necessary for beauty, but to cater to the tastes and exhibitionist mentality of the emperor and the privileged. Thanks to such pursuits, the porcelain art of Jingdezhen was eventually led into a dead end, furnishing risks for the decline of the ceramics industry in Jingdezhen in the future. But of course, at the time, all this was hidden and nothing but prosperity and progress were manifest. Therefore, in the eyes of some antique dealers and their works of appreciation and authentication of porcelain wares, this was an historical high for the ceramic art of Jingdezhen.

At this time, in order to cater for the tastes of the then emperor and upper classes, the official kilns produced various novel products with superb craftsmanship and complex and glamorous decorations, regardless of cost and time. Such attempts also affected some private kilns, focusing on producing quality products.

Private kilns at this time can be placed into two categories. One produced fine, quality porcelain products and the other produced coarse daily-use products. The former category produced mainly for the privileged, officials and upper-class land-lords. At the time, the middle- and upper-class landlords' quest for elegance meant that the porcelain design of the period were even more complicated than in the Yongzheng period, with commonly-seen varieties like *tianqiuping* (celestial sphere vases), *huluping* (double-gourd vases) and *niutouzun* (cow-head *zun*). Novel products like *zhuanxinping* vases (rotating vases), *zhuanjingping* vases (neck-rotating vases), and sets of openwork vases were manufactured regardless of cost. Porcelain in imitation of animals and plants developed to a new high in the Yongzheng period, including walnuts, lotus seeds, arrowheads, peanuts, lotus roots, dates, chestnuts, water chestnuts, crabs, and sea snails, all of which appeared vivid and delicate. In addition, there were also porcelain products made in imitation of various other artifacts like lacquerware, woodwork, bronzeware, bamboo ware and jade ware. These objects not only sought to mirror the original articles in terms of design, but were almost as good as the genuine article in terms of quality and color.

Porcelain stationery produced at this time also reached an unprecedented level in terms of variety and quality. For instance, famille-rose pen holders, ink rests, pen tubes, paperweights and inkpad boxes were all novel and exquisite. Others like *ruyi*

Fig. 11.68 Famille-rose
gourd-shaped wall vase with
paneled flower decorations
on an aubergine background,
produced in the Qianlong
period, height: 22.3 cm,
mouth rim diameter: 6 cm, in
the Palace Museum

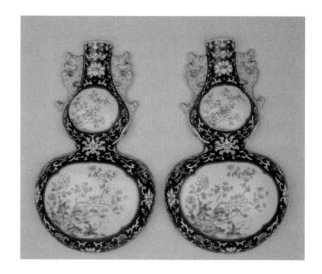

scepters and dragon-head belt hooks which were once made of jade were replaced
by famille-rose items. Snuff bottles, gaining popularity from the Yongzheng period,
were also produced in blue and white porcelain and famille-rose porcelain by the
Qianlong period, as well as in jade and enamel. More and more original and unique
decorative porcelain articles appeared. Of the small vases, double-conjoined vases
enjoyed rapid development along with triple-conjoined, quadruple-conjoined, and
six and nine conjoined vases. Gourd-shaped hanging porcelain with Buddhism's
Eight Auspicious Symbols and porcelain table screens also appeared. Earmarked
for the luxurious lifestyle of the privileged and landlords, most such products were
made in accordance with their tastes. In this way, potters in private kilns blindly
followed the styles and decorative approaches of official kilns, gradually losing their
own ingenuity and creativity (Figs. 11.68 and 11.69).

Most of the quality products from the official kilns were decorative porcelain
and antique-style porcelain while the coarse products of private kilns were mainly
made for the daily use of the common public. Produced in large quantities, products
from private kilns were transported all over the nation. Among their products, the
unique free, bold, simple and natural style of the private kilns could still be seen. But
no innovative varieties emerged at this time, as most products simply inherited the
traditional style of the late Ming Dynasty. Major varieties at this time included the
following.

11.3.4.1 Blue and White Porcelain

Blue and white porcelain was still one of the major production varieties of the
Jingdezhen kilns during the Qianlong period, featuring stable, deep and serene blue
colors. The shades of its blue colors manifested some regular patterns of change

Fig. 11.69 Famille-rose yellow plate set with flower graviata, produced in the Qianlong period, bottom rim diameter: 34.5 cm, in the Palace Museum

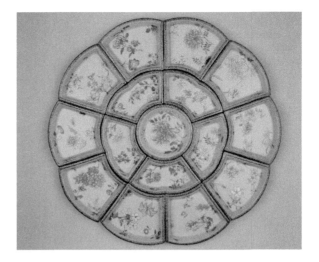

throughout this period, however. Initially, the blue colors maintained the features of instability and polishing as they had during the Yongzheng period, a natural phenomenon in the transition between the reigns of the two emperors. Gradually, the blue colors were dominated by bright ones with a stable manifestation and clear patterns. In the mid-Qianlong period, there was one type of blue and white porcelain which appeared blackish blue, with vague layers of decoration, dark shades of color, mainly bluish white or white glaze and of fine quality. In the later period, the blue colors appeared gray, especially those produced in private kilns. Affected by famille-rose porcelain, blue and white porcelain at this age placed an emphasis on exquisite decorations and varied color tones. Motifs applied were mainly modeled on works of famous painters of the day while also absorbing Western painting techniques. Such motifs were painted by outlining, polishing, wrinkling and scraping with pigments mixed with different amounts of water for heavy or light colors, thus creating a fresh, bright and dimensional picture (Fig. 11.70).

Those with markings and the larger items had similar colors to those produced in official kilns. But the markings on products of the private kilns were not as neat as those from the official kilns. Some private kiln blue and white porcelain had similar color tones to those from the Yongzheng period, such as Xuande-style plates with twining lotus patterns, which were glazed underneath or had a gritty bottom. Most articles were unglazed at the bottom (Fig. 11.71).

It was fashionable to produce blue and white porcelain in the style of the early Ming Dynasty during the Qianlong period. For example, Fig. 11.72 features an incense burner consisting of two parts. On the upper part, decorated with flower patterns, there are two rows of pierced holes and holes on the knob to release the aroma when the incense is burning. Inside the burner there is some dry incense soot mixed with tiny straws, indicating it had previously been used. The lower half is decorated with two parallel rows of whirling floral patterns. Made in the fashion of copying from the early Ming style, this piece of porcelain resembles its counterparts

Fig. 11.70 Blue and white
porcelain, produced in the
Qianlong period, in the
Berkeley Art Museum

Fig. 11.71 Blue and white
gourd-shaped porcelain,
produced in the Qianlong
period, height: 59.6 cm,
mouth rim diameter:
10.4 cm, in the Jingdezhen
Ceramics Museum

from the early fifteenth century in terms of design and motif. It has the marking
"*Jindingshengzao*" (Made by Jin Dingsheng) written in a horizontal manner on the
ring foot, not a standardized format for court use markings, so it does not appear to
have been made for royal use. "*Jin Dingsheng*" might be the painter or producer of
the incense burner. Illustrated in Fig. 11.73 is a pair of candlesticks made as sacrificial
wares for a temple in Dongba, east of Beijing, under Superintendent Tang Ying in

Fig. 11.72 Jingdezhen blue
and white incense burner
with twining flowers,
produced in the Qianlong
period, height: 39.7 cm,
diameter: 19 cm, in the
Victoria and Albert Museum

1741 in Jingdezhen. Each of the candlesticks consists of three parts. Their shape is modeled on iron ware while their motifs and decorative style are from porcelain of the early Ming Dynasty.

11.3.4.2 Famille-Rose Porcelain

By the Qianlong period, like the official kilns, private kilns also experienced progress in manufacturing famille-rose porcelain. Apart from white glazed famille-rose porcelain and overglazed famille-rose porcelain, underglazed blue and white famille-rose porcelain was also produced. Under the influence of the literati paintings of the time, famous lines of poems as well as seals were placed on porcelain articles. At this time, famille-rose porcelain was mainly decorated with human figures, flowers and feathers while landscape paintings were less frequently used than previously.

During the Qianlong period, both fine and coarse famille-rose porcelain were produced. Articles of extremely poor quality were known as "*caofencai*" (coarse famille-rose porcelain). Large amounts of coarse famille-rose porcelain were produced by private kilns, including vases, pots, plates, bowls, cups, saucers and stationery, many of which were large. In contrast, finely made wares were mainly used for decorative purposes or luxurious articles of practical use for the upper classes and landlords, such as various graviata or overglazed paneled famille-rose plates and bowls, known as "*shijin*" (meaning a mixed combination). What is more, it was also popular to put famille-rose decorations on monochrome glazed porcelain like azure, sacrificial red, lavender gray, and turquoise.

Various overglazed famille-rose porcelain and enamel wares with complex and delicate decorations dominated decorative porcelain in the Qianlong period. For

Fig. 11.73 Jingdezhen blue
and white candlesticks with
inscriptions of Tang Ying,
produced in the Qianlong
period, height: 65.5 cm,
bottom rim diameter: 23 cm,
in the Victoria and Albert
Museum

example, Fig. 11.74 is a gilt enameled openwork *zhuanxinping* vase with four
segments smartly assembled, including the exterior vase, the neck, the interior vase,
and the base. Inside the exterior vase there is a second vase which can rotate. Both
vases are decorated with glaze and gold. The exterior vase is painted with stylized
palm leaves on the rim, peony on the neck and ring foot, flowers on cloud-shaped
yellow panels on the shoulder and swirling flowers on the blue belly. Through the
pierced decorations of the Taoist Eight Trigrams on the exterior vase, part of the small
vase inside can be seen. It is typical of the Qianlong period to apply red, yellow and
blue colors as background colors on famille-rose porcelain.[32]

11.3.4.3 Underglaze Blue and Red Porcelain

In the Qianlong period, porcelain painted with decorations of both underglaze red
porcelain and blue and white porcelain, known as underglaze blue and red porcelain,

[32] Lv Zhangshen (ed.), *The Beauty of Porcelain* (one of a series of books for promoting international
exchange by the National Museum of China), Zhonghua Book Company, 2012, p. 378.

Fig. 11.74 Jingdezhen gilt enameled openwork *zhuanxinping* vase, produced in the Qianlong period, height: 20 cm, in the Victoria and Albert Museum

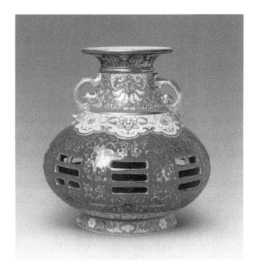

demonstrated stable colors, both deep and superficial, thick and transparent, complementary and offering balance and harmony. The flowers, birds, and leaves appear very real. Much of the underglaze blue and red porcelain similar to this was produced in private kilns, including celestial sphere vases with dragons flying in the clouds, plum vases with twining peaches, fingered citron and pomegranate patterns, vases with deer walking around a pine tree, bats flying in clouds or the Eight Immortals, pots, plates, bowls and boxes.

New varieties were also invented, like underglaze blue and red porcelain with a pea green or azure background. Produced by both official and private kilns, such products featured various designs and decorations. Most of them were in the larger sizes and carried paneled decorations. For example, there was underglaze blue and red porcelain with a pea green background and paneled decorations, most of which were painted with deer walking around a pine tree. There was also underglaze blue and red porcelain with a blue background and paneled crane decorations. The blue colors featured different shades. Some were light sky blue while others were heavy and opaque, known as "*zhuanlan*" (brick blue), and still others had a black brown glaze base and some had clear cut marks.

A commonly seen design in the Qianlong period was a pea green glazed tripod incense burner with twining lotus patterns marked with the 57th year of the Qianlong period (1792). Vertically inscribed in a triangular panel supported by twining lotus was a mark indicating that it was offered by a disciple called *Qipingxuan* to the Cibaoan Temple in 1792.[33]

In addition, blue and white rouge purple porcelain was also a common sight at this time. Often, a flower-shaped space was left in blue and white porcelain which was then painted with rouge purple pigments, forming a beautiful picture. There were

[33] Geng Baochang, *Appraisal of Ming and Qing porcelain*, The Forbidden City Publishing House, 1993, p. 277.

also products painted in rouge purple only. This variety of products was basically all produced by private kilns, most of which were tureens and plates.

11.3.4.4 *Jincai* Porcelain

Jincai porcelain was an overglazed variety which emerged in the late Ming Dynasty under the influence of Japan. Popular in the Qianlong period, this porcelain was painted with motifs like landscapes, human figures, feathers, and flowers or inscribed with poems or articles within an outline or on the mouth or foot, or as markings. Many *jincai* wares were manufactured, such as Buddha statues, the wheel of Dharma, Avalokitesvara *zun*, awl-handle-shaped vases, *jiaotai* vases, small vases, small boxes, cuspidors, *linglong* plates (Devilswork), bowls, pierced statues and sculptures. Featuring a distinctive golden color and glamorous gloss, *jincai* porcelain from this period was much better than its counterparts from the late Qing Dynasty. Heedless of cost and decorated with the *jincai* technique, porcelain produced in the Qianlong period demonstrated its luxurious and magnificent style (Fig. 11.75).

Quality porcelain of the Qianlong era featured elegant, neat designs with exquisite quality, but appeared less heavy and stolid than in the Kangxi period and less delicate than in the Yongzheng period. Novel varieties were invented, with a vigorous style and

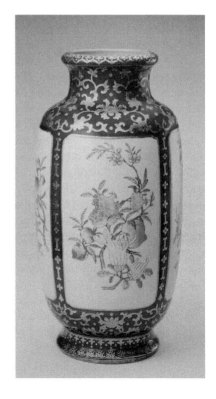

Fig. 11.75 Blue glazed vase with paneled peach, fingered citron and pomegranate patterns, produced in the Qianlong period, height: 38.2 cm, mouth rim diameter: 11 cm, foot rim diameter: 12.5 cm, in the Palace Museum

produced at a high cost. Small pieces of stationery and articles for pleasure were quite outstanding, featuring various delicate and exquisite designs, and complicated and meticulous workmanship. Decorative porcelain frequently seen at this time included celestial sphere vases, *shangping* (reward vases), *huluping*, wall vases, snuff bottles, incense burners and flower *zun*. Porcelain articles for daily use at this time also varied. The most representative were tablewares, such as sets of plates and bowls, known as *zhuoqi* (tablewares) in Jingdezhen. They had similar designs to ordinary plates and bowls, but were created in sets and decorated with unified decorations. Among them, some had common shapes and motifs, but different colors, known as "*shijinqi*" (mixed wares). There were often more than a dozen colors utilized in a single set of mixed wares, including red, yellow, green, purple, blue, marble, turquoise, and various other color glazes with gilt decorations. Sometimes, various twig patterns were added to graviata porcelain, such as plates, bowls, cups, saucers and spoons of various sizes and designs, all of which were popular tablewares at the time. By the Xianfeng period (1851–1861), there was a huge gap between quality and coarse porcelain. For example, quality porcelain had clear markings, just like official wares, while for poorly made items, the markings were crude and sometimes only half a character was added in place of a whole character. For example, most tablewares with ancient-style designs or decorations bore neat inscriptions, but only half-characters in cursive script. Private kilns also produced many large porcelain articles, such as ground vases, which could be as high as 100 cm or more and known as "*dajianping*" (large pieces of porcelain). Based on the traditional calculation method of Jingdezhen potters, large-sized porcelain could be called "*wubaijian*" (five hundred *jian*), "*babaijian*" (eight hundred *jian*), and even "*qianjian*" (one thousand *jian*) or "*wanjian*" (ten thousand *jian*), with *jian* being a benchmark for height. What is more, there were also large vats, fish tanks and large plates, usually inscribed with blue and white marks, or engraved marks for those produced by official kilns, and with gritty bottoms for those produced by private kilns (Fig. 11.76).

Decorative motifs in the Qianlong period were varied and colorful. Apart from the traditional ones, most were themed on traditional ethics and blessings for good luck, wealth and longevity, such as pomegranate seeds (symbolizing abundant children), hordes of children, five bats (*fu* in Chinese pronunciation, meaning blessings) surrounding a peach or the character *shou* (longevity), five sons battling over a hat (hat may be pronounced as *kui* in Chinese, a homophone for another character which symbolizes the best candidate in a national entrance examination), five sons passing the civil examinations, *sanyangkaitai* (symbolizing the auspicious beginning of a new year), *jiqingping'an* (luck and peace), Buddhism's Eight Auspicious Symbols, the Eight Immortals celebrating a birthday and *yueyuejianxi* (12 magpies, regarded as birds of joy, hovering around a tree, symbolizing good luck for all months of the year). Motifs which called for blessings were commonly used and widely popular in the late Qing Dynasty. In addition, motifs praising or feigning peace were also common, including *anjuleye* (living and working in peace and contentment), *haiyanheqing* (peace reigns over the land), *gewushengping* (singing and dancing to extol the good times), *renshounianfeng* (good health and good harvests), *haiwutianchou* (offering birthday congratulations), *jinbaotu* (ethnic tribes offering treasures to the court),

Fig. 11.76 Famille-rose
openwork *zhuanjingping*
vase, produced in the
Qianlong period, height:
41.5 cm, mouth rim
diameter: 19.5 cm, in the
Palace Museum

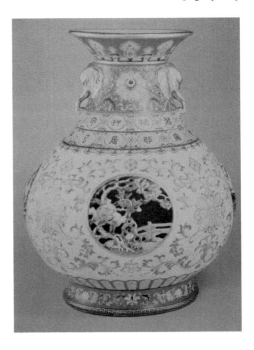

yuqiaogengdutu (scenes of the four lines of agriculture, namely fishing, woodcutting, farming, and reading). Since the Ming Dynasty, Jingdezhen decorative motifs had been closely associated with contemporary paintings. By the Qing Dynasty, this had become even more pronounced. For landscape paintings, the styles of Dong Hao and Zhang Zongcang dominated; for paintings of children at play, paintings by Jin Tingbiao played a significant role while for paintings of flowers and birds, the style of Jiang Tingxi exerted much influence. In terms of artistic technique, by copying from famous kilns over generations, and modeling after the style of artifacts like jade ware, bronzeware, carved lacquerware, ivory and wooden articles, rattan plaited articles, as well as glass ware, the skills of clay making, color mixing and firing reached an unprecedented level.

During the reign of Emperor Qianlong, private kilns attached great importance to clay making, thus producing fine and exquisite paste. Without finely made paste, complex and novel designs and special and precise techniques could not be applied. The high purity of paste is an important prerequisite for neat design and optimal thickness.

The glaze on blue and white porcelain remained bluish white, with different shades of color. The glazed surface featured a hard texture and rich gloss, appearing smooth and neat. Occasionally there were some articles with slightly waving glazed surfaces and some had a somewhat pinkish white surface. Exquisite famille-rose porcelain had a hard and spotless jade-like surface while coarse articles featured a bluish white surface. On neat surfaces, extremely small wrinkles could be spotted occasionally while some also had very small spots, called "*qiaomaidi*" (buckwheat background).

Most polychrome porcelain had a circle of jigsaw marks near the foot, close to where the body was glazed. The gritty bottom, while also smooth, was not as good as that in the Yongzheng period. The front part of the foot was relatively thick while the middle part was round, and occasionally glazed gold or black.

Export porcelain remained a significant part of porcelain production in Jingdezhen during this time. From the artifacts uncovered from the famous "Gotheborg" shipwreck we can get a glimpse of the export volume of the Qianlong period to Europe. "Gotheborg," a wooden merchant ship built in the eighteenth century by Sweden and also one of the largest long-haul ships of the Swedish East India company, was launched in 1738 and made its maiden voyage from January 1739 to June 1740 to the Port of Guangzhou in China, followed by its second and third voyages to the same destination from February 1741 to July 1742 and May 1743 to September 1745 respectively. However, it sank during its third voyage on its way back into the harbor of Gothenburg. All sailors survived, but the people on shore could only watch as the goods on board sank into the sea as they arrived to welcome the ship home. Nothing could be done to save the ship. This ended the service of the ship. Aboard the wrecked ship, there were large amounts of Jingdezhen porcelain. Illustrated in Figs. 11.77, 11.78, 11.79 and 11.80 are other products destined for Sweden on this ship. The blue and white single-handled cuspidor with peony decorations in Fig. 11.81 was salvaged from the Geldermalsen, a Dutch East India Company merchant ship which sank in 1752. At the time, such cuspidors were probably utilized by people chewing tobacco leaves.

According to records, from the 15th to the 20th year (1750–1755) of Qianlong's reign, an estimated 11 million pieces or sets of porcelain were exported to Sweden through Guangzhou. Within 20 years from 1766 to 1786, the East India Company purchased over 11 million pieces or sets of Chinese porcelain and shipped them to Sweden. At the time, Chinese porcelain was a symbol of position and power in the eyes of Europeans and people took pride in possessing such treasures. The fact that

Fig. 11.77 Blue and white soup bowl with a farming scene, produced in the Qianlong period

Fig. 11.78 Blue and white plate with flower and fighting chicken pattern, produced in the Qianlong period

Fig. 11.79 Blue and white lotus-shaped plate with mountain, stone, flower and bird patterns, produced in the Qianlong period

Fig. 11.80 Blue and white octagonal soup bowl with landscape and pavilion patterns, produced in the Qianlong period

porcelain recovered from the wreck of the Gotheborg, after auctioning, covered the total cost of the sunken ship, shows the value of Chinese porcelain in the West.

Nevertheless, by this time Jingdezhen's porcelain exports were already starting to meet with competition as some European countries initiated efforts to quite competently imitate the production of Jingdezhen porcelain. Illustrated in Fig. 11.82 is a blue and white basin with flower and bird pattern, a product from 1750 and modeled on Chinese blue and white porcelain. This is a Rörstrand Porcelain product, the first

Fig. 11.81 Blue and white single-handled cuspidor with peony decorations, produced in the Qianlong period, mouth rim diameter: 12.5 cm, foot rim diameter: 8.3 cm, height: 8.5 cm, in collection of a Western antiques dealer

Fig. 11.82 Blue and white basin with flower and bird pattern, produced in 1750, mouth rim diameter: 22 cm, foot rim diameter: 12 cm, height: 4 cm, in the City Museum of Gothenburg

porcelain factory to be established in Sweden. Its high quality makes it difficult to distinguish it from its counterparts from Jingdezhen.

Apart from international challengers, the Jingdezhen kilns also met with strong competition at home in producers of Canton porcelain. In fact the paste for Canton porcelain was made to order in Jingdezhen and then decorated in Guangzhou (usually romanized as Canton at the time). It was a new export variety produced for the convenience of transport and manufacture. Canton porcelain emerged in the Yongzheng period and blossomed in the Qianlong and Jiaqing periods, serving as a major export variety. Since the export ware was made, glazed, and fired in Jingdezhen but decorated in Canton before being exported, it was named "Canton porcelain."

11.3.4.5 Canton Porcelain

During the Kangxi period, export porcelain, including blue and white and *wucai* porcelain, was all produced in Jingdezhen before it was distributed and sold in Guangzhou. This was also true for most of the Yongzheng period. After 1728, the dazzling famille-rose porcelain came into being. Originally produced in the royal kiln in the palace in Beijing, this overglazed porcelain moved to be manufactured in the Jingdezhen imperial kilns, leading to a wave of imitation by private kilns.

In 1729, the British East India Company was permitted to set up its first factory in Guangzhou. During the six decades of the reign of Emperor Qianlong from 1736 to 1795, the emergence of famille-rose porcelain occurred in the early years of the reign, probably during the period 1740–1750, in Guangzhou.

Western documents carry many descriptions of Canton porcelain and here is an excerpt.

Before the early 18th century, export porcelain was glazed in Jingdezhen. Every year, detailed patterns, models, and drafts were sent to Jingdezhen from Guangzhou by European dealers. However, in the mid-18th century, in passing along the totally exotic designs to Jingdezhen potters, it inevitably involved inherent and potential misunderstandings and mistakes. So eventually, this time and effort consuming procedure was phased out. An alternative arrangement was to send finished bisque wares to Guangzhou and decorate them there. In this way, foreign merchants and managers could personally supervise decoration of porcelain as they demanded. John Richardson Latimer from Newport County, Delaware, once visited China five times as a supercargo. In a letter to his mother dated Oct 19, 1815, he mentioned this convenient way of doing business in Guangzhou.

A few days ago, I visited the potter who made porcelain for me and saw his warehouse and workshop. He is not the richest, but I was still amazed at his workshop. When I walked into the first room, I saw one person packing porcelain products while some were working on boxes and some were wrapping up each piece of porcelain. The second room was a painting room. Many men and boys were hired to paint on porcelain. They were closely next to each other, painting colors and gold with a small pen, just like in school. How much effort and attention it would take to paint with such a small pen... After the pigments on porcelain wares dried, they were sent to a hot place, looking like a furnace, for firing. These products were fired to very high temperatures, then transferred to another furnace with a lower temperature for cooling down, before they were put under normal temperatures.[34]

Daniel Nadler wrote that foreign trade originated in Guangzhou. Trading houses took special orders from foreign merchants and sent their requirements to Jingdezhen for manufacturing. On completion, products were delivered to merchants in Guangzhou and then shipped overseas. Apparently, communications between Jingdezhen and Guangzhou could go wrong at times, thus causing trouble. In around 1740–1750, muffle furnaces, a kind of furnace in which the subject material was isolated from the fuel and all of the products of combustion, including gases and flying ash, were launched in Guangzhou.[35] Unglazed porcelain was transported from

[34] William R. Sargent, *Treasures of Chinese Export Ceramics: From the Peabody Essex Museum.* Distributed by Yale University Press, 2012, p. 246.

[35] Author's note: Muffle furnaces were known as "*honglu*" (red furnaces) locally, furnaces especially for firing overglazed porcelain.

Jingdezhen to Guangzhou and decorated there before being subjected to a second firing in muffle furnaces at around 850 °C. In this way, the special motifs that the foreign merchants demanded, like coats of arms or initials, could be put on porcelain in Guangzhou before being shipped overseas. As time passed, complicated decorative motifs emerged. But the bisque was always made in Jingdezhen while the decoration was completed either in Jingdezhen or in Guangzhou. Sometimes major motifs were put on in Jingdezhen with auxiliary ones applied in Guangzhou. There were also some which were entirely glazed in muffle furnaces near the Pearl River.

In the late eighteenth century, a knight also reported that "Curiosity drove us to merchants in Guangdong every day. The most frequently visited places for us are embroidery workshops and porcelain painting workshops…" "In Jingdezhen, there are many porcelain kilns and workshops. Painters need to paint on porcelain before it is enameled. If you want to apply motifs from Europe on porcelain, you need to send the motifs to Jingdezhen first and you will see porcelain with such motifs the next year. If you don't want to wait, you can purchase enameled white porcelain and find potters to paint on it in Guangdong, before firing it into enamel ware."[36]

These descriptions show that foreign merchants were not able to immediately acquire ready-made porcelain with the various designs and decorations that they desired. Instead, export porcelain needed to be custom-made. So Chinese potters in fact produced according to the demands of Western customers, both in terms of design and decoration. The earliest special foreign order of Chinese porcelain was blue and white porcelain custom-made for Portuguese consumers in the early sixteenth century. After that, China had special agencies that were in contact with foreign customers to take orders and deliver any relevant requirements to Jingdezhen for manufacturing.

The Netherlands had a strong demand for Chinese porcelain. Shareholders of the Dutch East India Company, especially, sent various utensils to China so that Chinese potters could model them. They not only sent various pieces of glazed earthenware, silverware and pewter ware popular in Europe, but they also specially made some wooden wares as models and shipped them to China. In the eighteenth century, the Dutch also sent drawings of Cornelis Pronk (1691–1759), a Dutch draughtsman, painter and porcelain designer, to China.

Daniel Nadler also describes how Chinese people were very adept at manufacturing porcelain and maximizing profits. When in the 1740s the production of enamel ware (famille-rose porcelain) was transferred from Jingdezhen to Guangzhou, it helped better serve the demands of European customers.

Similarly, exquisite blue and white porcelain was called "Nanjing" porcelain in Europe in the eighteenth and nineteenth centuries. It was custom-made for the West and could only be made in Jingdezhen as Guangzhou was not able to produce underglazed porcelain at that time. However, there was also some porcelain which was painted in Jingdezhen and overglazed in Guangzhou. In order to make as much profit

[36] Daniel Nadler, *China to Order: Focusing on the XIXth Century and Surveying Polychrome Export Porcelain Produced during the Qing Dynasty (1644–1908)*. (Paris, 2001), p. 51.

as possible, European merchants even shipped bisque to Europe for decoration or occasionally transported European bisque to Guangzhou for decoration.

From the above, we can see that Canton porcelain was further glazed in red, yellow, green, purple or pale pinkish purple, based on the bisque produced in Jingdezhen or shipped over from Europe. The most popular colors were pale pinkish purple and *jincai* which suited Western tastes. Light colors and fine making were the major features of Canton porcelain during the Yongzheng period while at other times, Canton porcelain featured bright, strong colors. Motifs were usually painted in fine Western oil-painting style, resulting in a dimensional image. As for the content of the motifs, some were Eastern and some were Western, including human figures and scenery displaying the Western lifestyle and flowers, birds, and ladies in the traditional Chinese style. Some were also painted or inscribed with the coats of arms of royal families, privileged families, regions and ethnic groups, most of which were large plates, sometimes wholly covered with Western designs (Figs. 11.83, 11.84 and 11.85).

In the mid-eighteenth century, Canton porcelain was exported in large quantities. At the time, British merchants were the most important customers in Guangzhou, therefore export porcelain was mainly designed and decorated in the British style. In the late 18th and early nineteenth century, export porcelain producers paid special attention to the tastes of American consumers. Compared with those produced for Dutch consumers, products tailor-made for America featured even brighter colors. Such collections can now be found in palaces all over the Western world. For example,

Fig. 11.83 Canton Happy Man Family coffeepot, produced in the Qianlong period

Fig. 11.84 Canton Happy
Man Family coffeepot
(section), produced in the
Qianlong period

Fig. 11.85 Canton Happy
Man Family mug, produced
in the Jiaqing period

some large bowls with passionflower patterns were used for flower arrangements. At
one time, the Jingdezhen kilns produced a batch of quality Canton porcelain modeled
on human figures in traditional Qing costumes and scenes from opera and novels like
Romance of the Western Chamber and *Romance of the Three Kingdoms*.

Illustrated in Fig. 11.86 is a gilt famille-rose armorial teapot with a globular body,
domed lid, round knob, looped handle and straight spout with silver-mount. The
arms of a noble Swedish family, the von Utfalls, fill almost the entire body of the
pot. Supported by blue twigs of flowers, the lid is painted with blue flowers and
black and gold decorations. This pot was ordered either by Peter Jeansson von Utfall
(1711–1745) or Jacob Jeansson von Utfall (1715–1791). Peter von Utfall made four

Fig. 11.86 Gilt famille-rose armorial teapot, produced in the Qianlong period, length: 7 cm, height: 11 cm, foot rim diameter: 5.8 cm, in the City Museum of Gothenburg

voyages as captain from 1733 to 1743. The first went to India and the other three to Guangdong in China from 1736 to 1743. He died during his last stay in Guangzhou and was buried in a graveyard for Europeans northwest of the factory town. Jacob von Utfall also served in the Swedish East India Company, twice as assistant and twice as supercargo, before he settled in the Nääs estate east of Gothenburg. Later, from 1753 to 1766, he was a director of the company. This teapot could have been ordered from Guangzhou.

Illustrated in Fig. 11.87 is a gilt famille-rose punchbowl with saucer. It has a wide mouth and is decorated with gilt blue patterns on the rim and with a main motif of a red rose, coupled with smaller blue and yellow flowers and green leaves. The exterior of the rim is inscribed with Anna, in Swedish. The piece was carried from Guangdong by Captain Gabriel Gadd as a gift to his wife Anna. Gabriel Gadd, a lieutenant in the Swedish navy, captained two Swedish East Indiamen to Canton from 1799 to 1801. These pieces of porcelain show that, thanks to the advantageous geographic location of Canton, much famille-rose porcelain was processed and exported from here. With foreign businessmen traveling and living here, this was a bustling commercial port.

In sum, by the Qianlong period, Jingdezhen porcelain no longer dominated the international market. Rather, many potential competitors were emerging.

Fig. 11.87 Gilt famille-rose punchbowl with saucer, produced in the Qianlong period, mouth rim diameter: 29 cm, foot rim diameter: 14.5 cm, height: 12 cm, in the City Museum of Gothenburg

11.4 Jingdezhen Porcelain in the Late Qing Dynasty

11.4.1 Transition from Peak to Trough

The eighteenth century was a great turning point in human history. Events like the Industrial revolution in Britain, the Enlightenment Movement in France and the American War of Independence had all shaken and reshaped the world and propelled it forward from an agricultural to an industrial society. During this period, China was enjoying the "Kang-Qian Age of Prosperity." However, by this time, compared to the rising capitalist society of the West, Chinese feudal society was declining. Enjoying a seeming boom and prosperity, the Qing Dynasty was in fact heading towards decadence. If we say that signs of this decadence had already manifest themselves from the late Qianlong period, then the relevant effects were being seen to play out by the Jiaqing period.

Emperor Qianlong left his successor, Emperor Jiaqing and the ensuing Emperor Daoguang a very difficult political situation of corruption, a rising population and increasing financial difficulties. In order to cut expenses, following the Jiajing period, emperors could no longer indulge their interest in porcelain making like their predecessors had. The post of superintendent of the imperial kilns in Jingdezhen was abolished and replaced by local officials. Although the official kilns in Jingdezhen had declined by this time, private kilns still commanded a huge international market. In the 20th year of the reign of Emperor Daoguang (1840), the outbreak of the Opium War shook the whole world and turned China into a semi-colonial country. With the disintegration of China's self-sufficient economy and a forced opening to the outside world, the Qing regime was trapped in turmoil and its people subject to much suffering. By the Xianfeng period (1851–1861), the Taiping Rebellion almost toppled the Qing Dynasty. The Qing court also signed a series of unequal treaties with foreign powers under military defeat or threat, which allowed them many privileges. Suffering from domestic strife and foreign aggression, the Qing regime sank to its nadir in the slowdown after the Qianlong period. And the ceramics industry in Jingdezhen, including the private kilns, suffered the same fate.

Looking back, however, we can see that by the end of the Ming Dynasty, the private kilns in Jingdezhen, rather than being affected by political turmoil, actually thrived as the official kilns embarked on a downward path. So why was this response different? In the view of this author, apart from the decline in the nation's fortunes, the reason why the Jingdezhen private kilns declined in the late Qing period was due to the following three factors:

11.4.1.1 The Shackles of an Agricultural Civilization

While the entire Western world headed rapidly towards a modern industrial society, China remained a traditional agricultural society. Despite the fact that by the late Ming Dynasty capitalism had emerged in China, by the Qing Dynasty, with the

strengthening of the Chinese central autocratic system, capitalism was stifled and never boomed. So even if business groups in the ceramics industry formed as products of the emerging capitalism of the time, and in the early stage of their formation they expanded the limited range of passing along porcelain-making skills within families to regions and facilitated growth of capital and workers in the industry, due to its intrinsic conservative nature, this mechanism only further restrained the development of the Jingdezhen ceramics industry in later periods because of the following reasons: First, each industry formed its own groups which were bound by geographic or biological relations. Business groups in the ceramics industry to some extent limited the employment freedom of potters and the system of paying piecework also imposed some restrictions. Second, skills and techniques could only be passed on within business groups themselves or even within families, hence restraining the spread of traditional techniques and even leading to their loss. For example, the *Wei* family who had been adept at making furnaces from the Yuan and Ming dynasties, failed to pass on this skill to later generations. The technique of making *jihong* (sacrificial red) was only known within one family by modern times and was later lost as a result. Additionally, restricted by industrial rules, porcelain producers were content with conventional practice and lacked any awareness of innovation. As is recorded, "Porcelain for daily use was poor and shabby, and no improvement was made to cater to consumers' demands." By the late Qing Dynasty, "Some potters adopted printing techniques in porcelain decoration," which was "highly efficient and cost-effective." "However, others were outraged and deprived them of their painting devices, leading to fights and disasters."[37] Stifled by the restrictions of business groups, it was difficult for the private kilns in Jingdezhen to manage to innovate.

11.4.1.2 Market Recession

In the late Ming Dynasty, despite the social turbulence, the private kilns in Jingdezhen enjoyed an expansive domestic and international market. However, by the late Qing, they were confronted with a sluggish market both at home and abroad. From the eighteenth century onwards, countries like France, Italy, Germany, Britain, and Austria all attempted to imitate Chinese porcelain and indeed succeeded. Along with the growth of the Japanese ceramics industry over about two centuries, the export of Jingdezhen porcelain changed fundamentally. What is more, by the late Qing Dynasty, due to the Opium War, a low 5% fixed tariff was levied on foreign goods entering China while "*lijin*" (transit duties) were exempted entirely. In contrast, Chinese goods bound for other countries had heavy transit duties levied on them. Such an unequal and distorted practice increased import volumes considerably. Thus, by this time, after losing most of their foreign markets, the previously impregnable role that private kilns played in the domestic market thanks to their time-honored techniques and fame, was threatened by the entry of foreign imported porcelain (mainly from Japan) and hence

[37] Liang Miaotai, *Research on the Jingdezhen Urban Economy in the Ming and Qing Dynasties*, Jiangxi People's Publishing House, 1991, p. 214.

the demise of the Jingdezhen ceramics industry. The total number of private kilns dropped from 200 to 300 to around 100, with some running under capacity and a remarkable contraction of the work force.

11.4.1.3 Depletion of Kaolin

In the late Qing Dynasty, the decline of the mining industry on Kaolin Mountain contributed to the fall of the Jingdezhen ceramics industry. In "An Historical Examination of Kaolin," Mr. Liu Xinyuan holds that from the 59th year of the Qianlong reign (1794), no records regarding the massive exploitation of kaolin could be identified. While there were some pits and mill tailings around Kaolin Mountain, they were a far cry from that of the late Ming and early Qing periods. According to 1839 records in Vol. 4 of *Wuchan* from the *Local Gazetteer of Nankang* in the Tongzhi period, "Jingdezhen kilns take charge of porcelain production. The kaolin they use is white clay produced by Lushan Mountain. It is a necessary raw material for paste production for coarse and fine porcelain alike, even for imperial porcelain." This demonstrates that by this time, white clay from Lushan Mountain (namely Xingzi kaolin) had already replaced the kaolin from Kaolin Mountain.

Mined from Lushan Mountain, some 200 km from Jingdezhen, Xingzi kaolin traveled through Poyang Lake to Changjiang River to reach Jingdezhen, over four times the distance from Macang or Kaolin Mountain to Jingdezhen. Besides, on the Changjiang River section, the kaolin must travel against the current, which further lengthened the time en route. With low productivity and long traveling distances, Xingzi kaolin was several times more expensive than its counterparts from Macang and Kaolin Mountain that had been the source in the Ming and early Qing period. So, porcelain production costs in the late Qing Dynasty were much higher than that in the late Ming and early Qing periods. What is more, in 1840, the mining of Xingzi kaolin hindered irrigation, worsened the condition of the land and affected agricultural taxes, and was therefore banned several times by the government.

Thus, faced with national turmoil and a market recession on the one hand, and a shortage of raw materials on the other, ceramic production in Jingdezhen plummeted, leading to much misery for the potters.

11.4.2 Jingdezhen Porcelain During the Jiaqing, Daoguang and Xianfeng Periods

After Emperor Qianlong passed away, Emperor Jiaqing (1796–1820) ascended the throne. In 1820, after the death of Emperor Jiaqing, Emperor Daoguang (1820–1850) reigned, followed by Emperor Xianfeng (1850–1861). These three emperors presided over the most difficult times in China. During this time, the Jingdezhen ceramics industry remained in decline.

The death of Emperor Qianlong marked the fall of the royal kilns in Beijing and the imperial kilns in Jingdezhen as porcelain workshops in the royal palace were dismantled and officials in the imperial kilns in Jingdezhen were removed due to corruption. The successor to Emperor Qianlong, Emperor Jiaqing, differed from his predecessors and was not interested in porcelain.

In the 1820s, there was a huge flood in the Yellow River, which inundated many villages and land. Even the Beijing-Hangzhou Grand Canal ceased operation. In 1825, the water transportation of grain to the capital city Beijing for the first time shifted to sea transportation. Under the poor leadership of Emperor Daoguang, the Qing government failed to manage the flood and dredge the grand canal, so thousands upon thousands of people whose livelihoods depended on canal transportation lost their source of income.

Emperor Daoguang tried strenuously to control opium. However, under his rule, the first Opium War broke out. From 1850 to 1861, over a decade of the reign of Emperor Xianfeng, more serious social conflicts erupted. Months after Emperor Xianfeng assumed office, the Taiping Rebellion broke out and the rebel forces over-took many central provinces in China. Unable to properly manage the domestic affairs, the Qing court also had serious frictions with Britain. In 1856, there had been a series of attacks on the Thirteen Factories, also known as the Canton Factories, a neighborhood along the Pearl River in southwestern Guangzhou with warehouses and stores which were the principal and sole legal site of most Western trade with China in the late Qing period, culminating with their complete destruction by fire. Due to the second Opium War, Guangzhou was occupied by British and French forces for two years from 1857.

In 1853, the Taiping army started to levy taxes on the Jingdezhen kilns, a signif-icant event which affected porcelain production in Jingdezhen. In 1856, under the command of Li Hongzhang, a Chinese politician, general and diplomat of the late Qing dynasty, the Qing court took control of Jingdezhen. But reconstruction and recovery of the Jingdezhen kilns, mainly imperial kilns, was slow. During the Tongzhi period, there was an imperial order dated 1864, which suggested Jingdezhen should have been back on track with normal operation at this time. Stephen W. Bushell, an English physician attached to the British Legation in Beijing, was quite interested in Chinese porcelain. In 1896, he wrote that the Jingdezhen imperial kilns were reconstructed in 1866.

Though opinions differ regarding the specific time of reconstruction of the Jingdezhen imperial kilns, a general view holds that production in Jingdezhen ceased for a decade. Thus, after painters had finished decorating the bisque stocks from Jingdezhen, the red furnaces for overglazing porcelain had to be shut down.

This production halt serves as a watershed in the decoration of Chinese export porcelain. Decorative motifs developed before the Taiping Rebellion were rarely seen after the reconstruction of the Jingdezhen kilns and the resumption of porcelain decoration in Canton. Though painters in Canton occasionally drew inspiration from previous patterns, many new motifs were developed and prevailed.

Given such a context, Jingdezhen porcelain production barely produced any new varieties. The dominant varieties during this time remained blue and white porcelain,

underglaze blue and red porcelain, famille-rose porcelain and *wucai* ware, etc., listed as follows.

① Blue and white porcelain. The style and means of expression of blue and white porcelain at this time were quite similar to that in the Qianlong period and not much change was seen. By the Jiajing period, most blue and white porcelain continued to demonstrate stable colors, but some featured vague layers of decoration and thin and unstable colors. In the early Daoguang period, like the Jiaqing, blue and white porcelain featured stable blue colors which were not all that bright, but very elegant and attractive and no spots or halos were found. In the late Daoguang period, some blue colors lacked depth and stability because of loose clay and poor integration with the glaze. The shades of the colors in the Xianfeng period were similar to those of the Jiaqing period. During the Daoguang period, fine and exquisite blue and white porcelain appeared very bright while the coarse products were an unstable dark gray or light blue and featured unevenly glazed surfaces. By the late Xianfeng period, blue and white porcelain had light colors and halos while underglaze red porcelain was light red or pink, or even dark brown.

② Underglaze blue and red porcelain. Underglaze red porcelain produced by private kilns in the Jiaiqng period featured a thin, dark glaze which was less bright than in the Qianlong period and sometimes with a halo. By the Daoguang period, bowls with round-shaped phoenix patterns were typical among the underglaze red porcelain. They featured unevenly glazed surfaces in the shape of a wave, and uneven color shades. During the Xianfeng period, underglaze red porcelain produced by private kilns had clumsy, heavy shapes and light or nonexistent colors, and wave-shaped glazed surfaces.

③ *Wucai* wares. After the Qianlong period, few *wucai* wares were produced by private kilns except for some produced in imitation of those of the Kangxi period, which were quite exquisite and beautiful (Fig. 11.88).

④ Famille-rose porcelain. This was the major variety of high-quality porcelain produced by private kilns during the Jiaqing, Daoguang and Xianfeng periods (blue and white porcelain was the major variety of coarse porcelain produced by private kilns). Before the Jiaqing period, articles featuring full decorations (*wanhuajin*, or hundreds of flowers pattern) included vases, pots, cups and bowls. Famille-rose porcelain with a white background was rarely seen as most articles at this time had colored backgrounds and were painted with rigid motifs. While also produced in large quantities, its varieties and designs were not as varied as previously. By the Daoguang period, famille-rose porcelain featured light colors. But this period also produced some quality products. Some with inscriptions, especially, were quite astounding, like pots inscribed with "*Shendetang*," lantern-shaped vases with "*Jingsitang*," tureens, snuff bottles, flower pots, and fish tanks, as well as pots with "*Zhanhuaibao*" inscriptions and gourd and butterfly patterns, tight-mouthed pots with "*Daoguangdingweidingfuhangyouhengtangzhi*" (made by *Youhengtang* in 1847) and decorated with Rosa chinensis. During the Xianfeng period, the production volume and quality of official kilns both dropped while

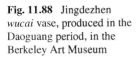

Fig. 11.88 Jingdezhen
wucai vase, produced in the
Daoguang period, in the
Berkeley Art Museum

private kilns continued to produce famille-rose porcelain for daily use in large amounts, such as teapots, plates, and bowls. Celadon glazed (*dongqing*) famille-rose porcelain which was produced in large quantities among private kilns was rarely seen from the Jiaqing period. Instead, common articles of the period were round pots with gourd and butterfly patterns, plates and bowls. In the early Jiaqing period, gilt porcelain was quite popular and *jihong* porcelain, *jilan* porcelain, brown glazed porcelain, yellow glazed porcelain, *guapi* (melon peel) porcelain, and pea green porcelain were all produced in certain quantities. During this time, snuff bottles were in vogue among the literati and officialdom, hence snuff bottles in various designs and glazes were manufactured.

Other overglazed varieties such as tricolor porcelain, green on yellow porcelain, purple on green porcelain, gilt *jilan* porcelain and gilt red porcelain remained in production though their designs and shapes were increasingly clumsy and their paintings coarse, except that gilt *jilan* and gilt red porcelain of the Daoguang period was exquisite (Figs. 11.89 and 11.90).

During the Jiaqing period, private kilns in Jingdezhen basically continued the traditions of the Qianlong period and not much innovation was made in terms of shape, pattern or color. Generally speaking, their techniques were not as good as previously and their designs were not as exquisite, delicate or balanced. During the Daoguang period, the production techniques were poor, shape design was clumsy and the production style was basically the same as in the Xianfeng period, while in the

Fig. 11.89 Famille-rose vase with two lugs and dragon, phoenix and peony patterns, produced in the Jiaqing period, height: 25.5 cm, mouth rim diameter: 9 cm, foot rim diameter: 9.4 cm, in the Palace Museum

Xianfeng period the clumsy style was even more pronounced. For example, the neck of the *yuhuchunping* was obviously shorter and some in this range became a popular design in the late Qing period. During this time, private kilns tended to produce sets of porcelain for daily use, usually five pieces, seven pieces or nine pieces per set. Bowl sets and plate sets were also pieced together with several articles of different shapes and designs, coupled with leather or lacquer boxes that matched them. Usually, the products of private kilns had no inscriptions while occasionally a few pieces were inscribed in cursive script. Tablewares varied, including plates, bowls, cups, dishes, pots, pans, ladles and spoons. There were thin articles as well as thick ones produced with fine or coarse techniques. The exquisite ceramic wares were mostly gilded, and especially striking were famille-rose porcelain wares. Graviata famille-rose porcelain and green glazed porcelain were very popular during the Qianlong reign and this influence extended to the private kilns in the late Qing Dynasty in their production of porcelain sets.

The decorative motifs in the Jiaqing period were of the same basic style as the Qianlong period. Both realistic and freestyle paintings were employed, but generally thin, prudent lines and rigid structures were featured. Like the Qianlong period, techniques like engraving, printing, scratching, piercing and decal were applied, only they were not as neatly or exquisitely executed as before. The products of private kilns during the Daoguang period were mainly painted with flowers, grass, insects, butterflies, fruit and vegetables. "*Guozhihua*" patterns (flower patterns on both the walls of porcelain bodies and the lids which could link together) popular in

Fig. 11.90 Famille-rose
bowl with various flowers on
a golden background,
produced in the Jiaqing
period, height: 9 cm,
diameter: 23 cm, foot rim
diameter: 10 cm, in the
Palace Museum

the Yongzheng period remained in vogue, except the patterns were different. During
the Yongzheng period, green bamboo and blooming peach as well as phoenixes were
popular while during the Daoguang period, bitter gourd and grape were common.
Under the influence of literati paintings of the time, figure paintings were frequently
themed on ladies and children at play. The most representative motifs of figure
paintings during the Daoguang period were those from *Wushuangpu,* a popular wood
block print from the early Qing Dynasty of the painter's imagined portraits of 39
heroes and heroines over generations. When painted on porcelain, usually two to
four figures were chosen and painted symmetrically on the major section of porcelain
products, with their names and biographies flanked on the right-hand side of the
figures. Auspicious motifs also accounted for a significant proportion of the porcelain
decorations.

The Jiaqing paste was made in a similar manner to that of the Qianlong period, with
neat shapes. *Yuanqi* articles, especially, were easily confused with those produced in
the Qianlong period. During the Daoguang reign, both thick and thin paste bodies
were produced, with the former mainly earmarked for *zhuoqi* wares of uneven thick-
ness and clumsy designs and the latter mainly for *yuanqi* wares with white, fine
bodies. Thin plates and bowls produced by private kilns were usually of loose quality
and would not ring when knocked with the fingers. Ceramics produced by private

kilns during the Xianfeng period were similar to those of the Daoguang period and were loose, coarse and ponderous in the latter period. *Zhuoqi* wares had a thick rim, thin wall on the belly and a loose quality while *yuanqi* wares were also not as firm and fine as desired.

In the early Jiaqing period, glazed surfaces were still as smooth as those in the Qianlong period while small-sized articles were quite different, featuring thin glaze, bluish color, inadequate gloss and sometimes wave-shaped wrinkles, hence the term "wave glaze." This was even more pronounced by the Daoguang and Tongzhi periods as the earlier period featured whitening colors and the latter bluish colors. During the Jiaqing period, many products of the private kilns had cursive script added and at times only half a character. During the Daoguang period, products with inscriptions of "*Shendetangzhi*" (Made by *Shendetang*) were very popular and exquisite in the context of the prevailing production techniques. Deviating from the tradition of inscribing seal characters, the Tongzhi period began to turn to regular scripts. Some products imitating other wares featured poor writing and shabby calligraphy.

Shendetang (Shende Hall) was where Emperor Daoguang studied and later became an imperial office for attending to national affairs, hence porcelain with red inscriptions of "*Shendetangzhi*" was especially made for imperial use. According to the imperial records, porcelain with inscriptions of "*Shendetangzhi*" were all made by official kilns and exhibited exquisite craftmanship and the highest quality, basically representing the highest quality porcelain artifacts of the day. Apart from scenery, human figures, and children at play, flower patterns were mostly applied as motifs. In *Guwanzhinan* (*Guidance on Antiques*), Zhao Ruzhen, a famous scholar from the late Qing Dynasty, states that "Emperor Daoguang was famous for his frugality. Upon ascending the throne, he immediately cut hundreds of *liang* of silver from the imperial palace decoration budget. He also stressed economy in porcelain production and therefore not many exquisite products were manufactured. Only those decorated with grass and insect patterns were popular at this time and the rest were not worth mentioning." During the reign of Emperor Daoguang, tea drinking was popular both inside and outside the court and thus large quantities of the various relevant utensils like teacups, teapots, tea trays and saucers appeared. However, among those housed in the Palace Museum and marked "*Shendetang*," there are only teacups, mainly famille-rose porcelain, and nothing more. This might have been because of the fact that *Shendetang* was located in the Yuanming Yuan (the Old Summer Palace) and most of the imperial vessels there were lost or destroyed with the palace and only a few pieces survived. Teacups with inscriptions of "*Shendetang*" not only served for imperial use for Emperor Daoguang but were also treasured by Emperors Xianfeng, Tongzhi, Guangxu and Xuantong, due to their exquisite workmanship. They were often therefore copied by later generations. For example, those produced in the Guangxu period featured weak writing in blackish red paint. Those produced in the Republic of China period had similar shades of color to that during the Daoguang and Xianfeng periods, only with tender and delicate but discontinuous lines which tended to divert in opposite directions, leaving a hollow space in between (Fig. 11.91).

Official porcelain during the Daoguang period was generally marked with six characters in three lines of "*Daqingdaoguangnianzhi*" (Made during the Daoguang reign

Fig. 11.91 Famille-rose tureen with lucid ganoderma and daffodil patterns, produced in the Daoguang period, height: 8.2 cm, diameter: 10.7 cm, foot rim diameter: 4.6 cm, in the Palace Museum

of the Great Qing Dynasty) in blue seal script, along with some in red or gilded items. Articles like *chayemo* (tea-dust) glazed porcelain and *lujun* glazed porcelain were also inscribed with the six-character marks. Occasionally, a few pieces of famille-rose porcelain were inscribed with the four-character gilt red marks "*Daoguangnianzhi*" (Made during the Daoguang reign) in seal script. At this time, those marked with names or places like "*Tuisitangzhi*" (Made by the Tuisi Hall) and "*Zhuzhurenzao*" (Made by the Master of Bamboo) were mostly of high quality (Figs. 11.92 and 11.93).

During the eleven years of Emperor Xianfeng's reign (1850–1861), the country was trapped by political corruption and economic recession and people led a miserable life. The Taiping Rebellion which aimed at overturning the rule of the Qing government experienced its heyday during the Xianfeng period and greatly shook the reign of the Qing court. During this time, the Qing government concentrated all its economic and military strength into putting down the rebellion and had no other energy or resources for porcelain production to support the luxurious lifestyle of the palace. In the early Xianfeng period, the imperial kilns produced a limited amount of imperial porcelain and sacrificial wares while after 1855, the fifth year of Xianfeng's reign, these kilns basically ceased operation. Afflicted by warfare between the Taiping forces and the Qing armies in regions south of the Yangtze River, the Jingdezhen ceramics industry not only slashed production, but also declined in terms of production technology, and the private kilns suffered the same fate.

Fig. 11.92 Famille-rose tureen with sprigs of plum blossom, produced in the Daoguang period, height: 10 cm, diameter: 11.5 cm, foot rim diameter: 4.7 cm, in the Palace Museum

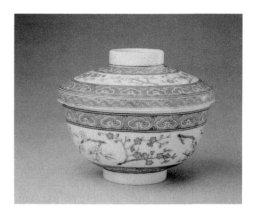

Fig. 11.93 Famille-rose blue and white bowl with bamboo and daffodil patterns, produced in the Daoguang period, height: 6.7 cm, diameter: 14.2 cm, foot rim diameter: 6.3 cm, in the Palace Museum

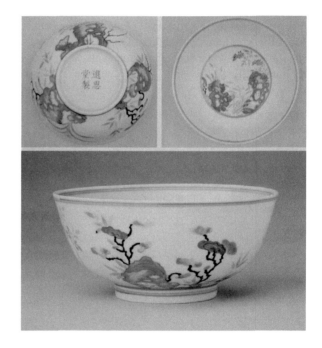

From 1853 to 1854, the third and fourth year of Xianfeng's reign, the Jingdezhen imperial kilns officially resumed production of traditional varieties such as Jun-style or Guan-style (official-style) square-shaped vases with two lugs, Ge-style glazed square-shaped vases with the Eight Trigrams pattern, azure glazed vases with elephant-ear-shaped lugs, blue and white *yuhuchunping* (*shangping*), blue and white *yuhuchunping* with pine tree, bamboo and plum blossom patterns and *jihong* glazed *yuhuchunping*. Apart from *zhuoqi* wares in limited quantities, the imperial kilns also produced 42 varieties of *yuanqi* wares in various quantities, some as numerous as 200 pieces or more and some as few as only a dozen, amounting to around 2100

pieces in total. During the Xianfeng reign, porcelain production was very limited. Collections housed in the Palace Museum from this period are a far cry from other times. Limited as they are, when the Yuanming Yuan was burnt down by British and French forces, they were either ruined or dispersed. So to date, very rarely have treasures from this period been identified.

Like the Daoguang period, Xianfeng porcelain had clumsy shapes and seemingly fine clay (a shared feature of the Jiaqing, Daoguang and Xianfeng periods). However, paste produced during this time was actually loose, coarse and heavy. Glaze at this time appeared whitened and uneven. Thinly glazed surfaces lacked gloss and smoothness and had tiny orange-peel holes while the heavily glazed surfaces resembled the "wave glaze" of the Daoguang period. These features were not only shared by the Daoguang and Xianfeng periods but were common during the whole late Qing period. During Xianfeng's reign, year marks on porcelain produced by both official and private kilns were in blue or red, inscribed in regular script and without frames. The six-character inscriptions "*Daqingxianfengnianzhi*" (Made during the reign of Emperor Xianfeng of the Great Qing Dynasty) were neatly drawn in two lines of regular script, while seal script and seals were rare. Most private porcelain carried no marks (Figs. 11.94 and 11.95).

Fig. 11.94 Graviata famille-rose porcelain with paneled patterns on a yellow background, produced in the Xianfeng period, height: 7 cm, diameter: 17.5 cm, foot rim diameter: 6.5 cm, in the Palace Museum

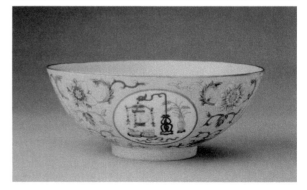

Fig. 11.95 Famille-rose bowl with patterns of the Eighteen Arhats (Disciples of the Buddha), produced in the Xianfeng period, height: 7 cm, diameter: 17.3 cm, foot rim diameter: 6.4 cm, in the Palace Museum

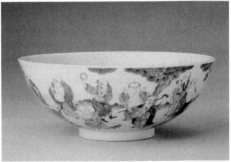

11.4.3 The Demise of Jingdezhen Following the Tongzhi Period

By the late Qing Dynasty when Emperor Tongzhi (1862–1875) ascended the throne, China had experienced two Opium Wars, forcing the Qing government to sign unequal treaties like the Treaty of Nanking, the Beijing Convention, and the Treaty of Tianjin with foreign imperialist powers, which allowed the opening of ports in cities like Guangzhou, Fuzhou, Xiamen, Ningbo and Shanghai for unequal trade, reducing the Qing court to the direct control of the foreign aggressors. Meanwhile, huge volumes of European goods were dumped onto the Chinese market, leading China onto a semi-feudal, semi-colonial path and a decline in China's national industries.

And the private kilns in Jingdezhen were not spared. As mentioned previously, during the Daoguang and Xianfeng periods, the private kilns in Jingdezhen were confronted with a shrinking foreign market while the domestic market still had a huge thirst for porcelain, especially products for daily use. However, by the Tongzhi period, even the domestic market was increasingly sluggish due to the following reasons.

11.4.3.1 Dumping of Foreign Porcelain

By this time, Europe had already grasped the technology of porcelain making and was quickly capable of machine production. So instead of importing porcelain from China, Europe saw China as a huge consumer market. Based on their strength and the unequal treaties signed with China, they accelerated the dumping of goods on China and caused a huge shockwave to China's national economy. Apart from the import duties paid at customs plus another 2.5% in transit tax, all goods entering China were free to travel anywhere within China. In this way, foreign goods found no difficulties in flowing into every corner of the country without any extra costs or taxes. The foreign imperialist powers even forced China to agree to foreign merchants' rights to free trade without paying any other taxes. With the free flow of foreign goods into China, the role of China's customs in protecting its national industries and agriculture was paralyzed. This unfavorable situation was a heavy blow to the Jingdezhen ceramics industry, but not as heavy as it was to other handicraft industries, as Jingdezhen was endowed with abundant natural raw materials and low labor costs, thus it was somewhat resistant. Prior to the Sino-Japanese War of 1894–1895, Jingdezhen was therefore yet to hit rock bottom. However, after the war and based on the Treaty of Shimonoseki signed as a consequence of the war, the imperialist powers were allowed to set up factories in China and to run capitalist industries with China's raw materials and cheap labor force, which deprived China's porcelain industry of its final advantages. Machine-made porcelain produced by factories run by foreign powers was low in cost and free from local taxes, thus it soon seized a large market share. The Jingdezhen ceramics industry was faced with stiff competition. *On Jingdezhen Ceramic Affairs* recounts, "In recent years, extravagance has been back in vogue and people love to purchase foreign goods; it seems they have gone crazy. For example, flourishing trading ports like Beijing, Tianjin, Shanghai and Wuhan all favor porcelain imported from Japan, such as tablewares with blue rims and barrel-shaped teacups, a virtual necessity in tea houses, inns, and social venues. Even shops in distant and dilapidated places display stylish foreign porcelain. It seems imported goods have become so popular they have penetrated almost every corner of daily life."[38] Porcelain manufactories run by foreign merchants were all mechanized, thus enjoying low costs and high efficiency. By capitalizing on China's raw materials and cheap labor, they were so competitive against the domestic porcelain industry that this was a major contributing factor to the difficulties faced by the Jingdezhen ceramics industry.

11.4.3.2 Unfair Taxes

Another important factor leading to the downfall of the Jingdezhen private kilns was the heavy burden and exploitation of the taxation system. As the foreign capitalist

[38] Xiang Chao, *On Jingdezhen Ceramic Affairs*, Sales Department of the Jingdezhen Kaizhi Printing Bureau, Hanxi Printing House, 1920.

forces dumped goods on China and invaded with its capital, they also supported the Chinese feudal forces politically and economically with a view to transforming the Qing government into a bureaucratic, feudal and comprador-dominated capitalist regime. This contrived mechanism bestowed various privileges on foreign goods and foreign-owned factories, allowing them to run rampant across the country and squeeze the domestic products out of the market. Meanwhile, it also dismantled the unified Chinese market so that even domestically produced products were levied taxes at customs passes. Naturally, such exorbitant taxes and levies were inseparable from the internal and external problems of the day. Under such circumstances, Jingdezhen's porcelain could not be spared. According to *On Jingdezhen Ceramic Affairs*, "To export Jingdezhen porcelain, a local tax called the out-of-town tax must be levied first before passing through two passes at Guxian County and Raozhou. At Hukou, an official duty must be paid. These are levies just within Jiangxi Province. Once outside the province, depending on where the products go, taxes cannot be avoided. For example, when transported to Sichuan or Hunan Province, the products need to travel through Hubei Province first where taxes must be paid in Wuxue, while extra duties are to be paid in Hankou, Xinhe, Yingwuzhou and Guanyinzhou. To enter Sichuan, the goods have to travel through Yichang, Shashi, Kuiguan, Wanxian County, Chongqing, and Luzhou to reach Chengdu while to enter Hunan, they have to pass through Xindi, Chenglingji, and Yuezhou to Changsha. All these places require taxes. Though there are different rates in different places, basically around 10% (Jiangxi Province officially requires a 12% tax rate), for every pass porcelain goods travel through, there will be at least a half day or one day delay. So, it is simply not possible to make a rapid and smooth trip. Thus, when dealing with porcelain business outside of Jiangxi Province, merchants have to take into account costs of around 60% of the cost of a product, including taxes and transportation fees, as well as other incidentals."[39]

11.4.3.3 Poor Working Conditions and Incomes

With the dual oppression of imperialism and feudalism, the Jingdezhen ceramics industry labored under a heavy burden, while its potters lived in misery, with long working hours, poor working conditions, and low incomes. The working hours of the Jingdezhen potters have been described as follows: "From the spring to the autumn equinox, work starts at six o'clock in the morning and ends at five o'clock in the afternoon. The night shift ends at ten o'clock at night. From the autumn to the spring equinox, it begins at seven o'clock in the morning and ends at six o'clock and the night shift ends at eleven o'clock. In summer and autumn, a break is allowed after noon for paste makers and painters only. Firing of porcelain never stops at the kilns; different shifts will simply take over the job, so there is basically no rest time. As for festivals, leave is permitted on the fifth and sixth of the fifth lunar month for the Lunar Festival, the 15th and 16th of the seventh lunar month for the Ghost

[39] See Footnote 38.

Festival, and the day before and after the Mid-autumn Festival. Otherwise, there are no holidays." Workers toiled and moiled for over ten hours every day and there were no weekends. Their work environment was also extremely poor. For example, in the painting workshops, "They are very crowded with dozens of workers. The kerosene lamps used there are made with tinplate. With so many people breathing in such a small area with the smell of the kerosene lamps, the workshops were misty and smoky, making it hard to see even within an arm's length, which hurt the workers' eyes as well as their lungs."[40]

"Potters are frequently exposed to lead, such as when painting and coloring, as pigments of famille-rose porcelain and *yangcai* porcelain contain lead. If not careful, it is very easy to inhale lead into internal organs, thus poisoning the blood. When exposed for a long time to lead, people would grow sallow and skinny and vulnerable to diseases. For those Jingdezhen workers who became prematurely senile, it is mainly due to this reason."[41] Ordinary paste makers and painters were supplied with poor food, worked long hours in a poor environment and were subject to occupational diseases. For kilnsmen responsible for firing, "Firing is the most demanding job. The first day after firing begins, it is fine, while on the second day, workers have to closely watch the fire and add fuel without blinking. If workers get sleepy and take a nap, the fuels can be inadequate, or their minds might drift, and the porcelain products can possibly result in deformation, cracking, or turning yellowish."[42] Besides, workers responsible for filling the furnaces had to work in high temperatures, which was very toilsome and led to a susceptibility to tuberculosis. So generally, nobody liked to do this job.

With their heavy workload, poor working conditions and low wages, the creativity of the potters and painters was massively curtailed. Some workers even learned to cheat on their workmanship and materials, and thus delivered shoddy products. The author of *Taoya*, out of pity, even contrasted the present and the past production conditions to illustrate how the Jingdezhen ceramics industry had entered a downward spiral. The author holds that there were complicated reasons for the decline in product quality. For instance, in terms of paste making, in the past, clay was fine and smooth while now it was coarse. In craftsmanship, previously it was exquisite but now it was shoddy; glaze was fine and smooth but now it was dull; pigments were bright but now they were dark; designs pursued antique beauty and profound linkages while now it was vulgar; paintings were vivid and neat while now they were moronic; firing was highly valued and perfection was pursued, but now it was careless. In a nutshell, he concluded, "Poor craftsmanship produces shoddy products."[43]

[40] See Footnote 38.

[41] "A Few Habits Jingdezhen Workers Should Change," *People's Monthly*, Vol. 1, Issue 3.

[42] *Great Gazetteer of Jiangxi Province*, Vol. 7, *On Ceramics*.

[43] Xiang Chao, *On Jingdezhen Ceramic Affairs*, Sales Department of the Jingdezhen Kaizhi Printing Bureau, Hanxi Printing House, 1920.

11.4.4 Jingdezhen Porcelain During the Tongzhi, Guangxu and Xuantong Periods

By the late Qing Dynasty, disturbed by the wars and chaos caused by the Taiping Rebellion, and as Chinese society was reduced to a semi-colonial status, the national industries became increasingly sluggish. During this time, the production of the Jingdezhen imperial kilns continued to shrink, with poor craftsmanship and quality. The predicament at the time can be glimpsed in the then grand coordinator of Jiangxi Province, Liu Kunyi's memorial to the throne in 1874, the 13th year of Tongzhi's reign (1862–1875). According to Liu, the official kilns were destroyed during the Xianfeng period (1908–1912). "Due to warfare, during this reign, excellent potters all disappeared. So, the potters available now are all new hands and their products are far from qualified to be presented for imperial use…".

In such a context, the Jingdezhen kilns could no longer produce large amounts of extravagant and ornamental porcelain as they had in the mid-Qing Dynasty. Instead, articles for daily use dominated production of the private kilns and even official kilns would produce only necessary porcelain products for marital ceremonies, birthday celebrations, receptions and awards for the court.

With the decline in the technological level, porcelain bodies were thicker in the Tongzhi period than in the Xianfeng period, with a loose paste, usually in pinkish white or steel gray. Glaze at this time was also poorer than previously. Painting motifs usually conveyed profound connotations, a common feature during the Tongzhi, Guangxu (1875–1908) and Xuantong periods. Porcelain produced by official kilns, along with artifacts such as silk products, tended to apply auspicious motifs expressing wishes for blessings, fortune, longevity and happiness, as major decorative motifs.

In 1868, the seventh year of Tongzhi's reign, the Grand Coordinator of Jiangxi Province ordered the production of porcelain for the grand wedding of Emperor Tongzhi. A total of 120 firings were made, producing 7294 pieces, most of which were yellow-glazed famille-rose porcelain decorated with "*wanshouwujiang*" (Wishing You a Life Everlasting), longevity flowers, double golden happiness, a hundred butterflies, the red character *xi* (Happiness), the character *shou* (Longevity), *wanshouwanfu* (Long Life and Blessings Beyond Measure), the golden character *xi* (Happiness) on a red background, and more. According to imperial records, these offerings fell into 10 groups and 24 varieties in each group, giving a total of 672 pieces. Among them, large bowls, medium-sized bowls, soup bowls, bowls for yellow rice wine, wine cups and large, medium and small plates and saucers formed the majority (a set of tableware consisting of 148 pieces is a typical Chinese-style table setting produced by the official kilns in the late Qing Dynasty). Meanwhile, among the sets of tableware there were tureens, tea caddies, powder boxes, rouge boxes, flowerpots, and narcissus pots. These articles made for sets of tableware were usually called "*dahunzaoqi*" (wares made for weddings). However, some pieces have been lost and so not many whole sets of tableware from the period remain intact today.

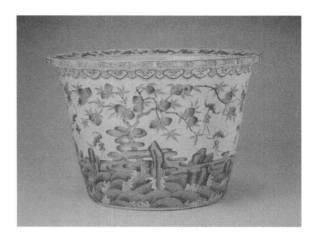

In 1870, the ninth year of Tongzhi's reign, the imperial kilns specially produced a hundred large fish tanks and over 10,000 pieces of other wares for the Tihe Hall where Empress Dowager Cixi had her meals when she occupied the Chuxiu Palace. All of these wares were marked with "*Tihedianzhi*" (Made for the Tihe Hall). Their bodies, glaze and paintings were almost as exquisite as products marked with "*Shendetang*" that were produced in the Daoguang period. Apart from fish tanks, there were also lantern-shaped vases and various flower pots among this batch of products, most of which were decorated with famille-rose flowers on a yellow or green background while some were painted with blue dragons flying among white clouds, bamboo, orchids, plum blossom and chrysanthemum or grisaille painted flowers (*mocai*). Some large pieces were even painted with *wucai* and famille-rose patterns, or blue glazed famille-rose patterns. Yellow glazed porcelain with incised Rosa chinensis and wares of grisaille painted flowers featured heavy bodies. During the Republic of China era, famille-rose porcelain in imitation of those marked with "Tihe Hall" was often produced (Fig. 11.96).

The Jingdezhen official kilns produced few exquisite products during the Tongzhi period, apart from those especially made for wedding ceremonies in the palace and a small amount of ornamental porcelain. As for private kilns, while they produced a large quantity, most were poor in quality.

However, from the late nineteenth century to the early twentieth century, some finely made ancient-style porcelain and decorative ceramics were produced in private kilns, though they were not among the mainstream products at the time. Major products during this time are as follows.

11.4.4.1 Blue and White Porcelain

Blue and white porcelain produced by private kilns in the Tongzhi and Guangxu periods displayed features typical of the late Qing Dynasty, with some featuring

bright, cheerful colors, some dark brown colors, and some bright purplish blue. Typical of the time, porcelain color was unstable, the motifs were vague at times, and the outlines blurred with dull strokes. But there were also some very excellent pieces featuring skillful craftsmanship, beautiful colors, light and heavy shaded strokes, and vivid and interesting scenery and figure motifs. During the Guangxu period, many private kilns modeled on the blue and white porcelain that was produced in the Kangxi period, only their technique was poor, inscriptions cursive, paste yellowish, glaze dense and colors unstable. In contrast, by the Xuantong period, blue and white porcelain featured bright and beautiful colors, much better than that of the Tongzhi and Guangxu periods. Representative products from this period included bowls painted with pine trees, bamboo and plum blossom, or rare animals, decorative vases, *yuhuchunping*, tureens, large bowls, cups and plates.

11.4.4.2 Underglaze Red Porcelain

With poor technique in using copper red pigments, underglaze red porcelain during the Tongzhi period was basically too light and copper red motifs were no longer being used as major motifs on porcelain. By the Guangxu period, the colors of underglaze red porcelain were of different shades, with some heavy purple, and some quite light. Major products of underglaze red porcelain and underglaze blue and red porcelain were large-sized vases, *zun* and snuff bottles.

11.4.4.3 *Wucai* Ware

Catering to market demands, the private kilns in the late Qing period started to produce *wucai* wares in imitation of the Kangxi period. However, the colors of most such products were too bright and their glaze too heavy, while they lacked luster and featured coarse decorative patterns. In comparison, the Guangxu period was better than the Tongzhi period. During the Guangxu period, color painted porcelain on a white background as well as blue on white porcelain modeled the Kangxi *wucai* ware. The former featured bright red, yellow and green colors on a white background. Among them, the red color appeared dry and lean, and some seemed excessively dark. Blue and white *wucai* ware modeled on the Kangxi period had a bright blue color but lacked shades of color and a dimensional sense in their motifs. Blue and white porcelain and *wucai* ware in imitation of the Kangxi period, including vases, pots, plates and bowls, usually had loose paste, poor glaze and unstable colors. On some, inscriptions or decorative patterns were copied from the Ming and Kangxi periods, only the inscriptions appeared cursive. Coarse products of the private kilns were of poor quality and were easily distinguished as imitations. But of course, there were some quality ones. For example, Fig. 11.97 is a *wucai* tall vase produced in the Guangxu period modeled on the style of the Kangxi period. Its body slightly narrows inward while its neck is straight and rim a little flared. Its glaze is a little yellowish. The whole piece is decorated with *wucai* patterns, mainly a large landscape on its

Fig. 11.97 Jingdezhen
wucai landscape vase,
produced in the Guangxu
period, height: 47 cm,
maximum diameter:
12.2 cm, bottom diameter:
12 cm, in the Rijksmuseum
in Amsterdam

body, including pine trees, bamboo, waterfall (with a bridge), a dining crowd in a
pavilion, as well as a ship loaded with many people. The neck is also painted with
similar pictures. On its shoulder, there are four *ruyi*-head-shaped panels painted with
flowers like chrysanthemum and plum blossom. Between the shoulder and the body
lies a narrow streamer with *ruyi*-head-shaped motifs. Above the bottom is a set of
green balusters.[44]

Such *wucai* wares, though beautiful, delicately decorated, and imitating the style
of Kangxi *wucai* ware as best they could, were totally different from those in the
Kangxi period and were not an equal match. First, such wares had rigid, fragile
paintings, not as bold and vigorous as in the Kangxi period. Second, they lacked
creativity. However, as a representative of *wucai* ware of the late nineteenth century,
the vase in Fig. 11.97 is still an interesting sample as its decorations are not only
copied, but also has its own features.

11.4.4.4 Famille-Rose Porcelain

Tongzhi famille-rose porcelain was quite prominent among the polychrome porce-
lain of the late Qing. After the Opium War, Chinese people began to realize that

[44] Christiaan J. A. Jöry, *Famille Verte: Chinese Porcelain in Green Enamels.* Groninger Museum,
2011, p. 179.

blue and white porcelain produced in Jingdezhen was no competition for the Euro-
pean machine-made porcelain. They therefore turned their eyes to overglazed poly-
chrome porcelain which occupied the majority share of the mass market. Famille-
rose porcelain was the most popular variety of polychrome porcelain during this
time. Famille-rose pigments had a lot of powder and the glaze was usually heavily
applied. Bright blue colors and a yellow background were often featured. By this
time, opaque white was no longer in use, so famille-rose porcelain was not very
bright or glossy. In painting famille-rose porcelain, official kilns also painted by
adding layers of pigments, mostly blue ones. Major motifs included hundreds of
children, children at play, bat patterns (due to the homophone of the Chinese word *fu*
for "bat" and *fu* for "prosperity and good fortune," the bat had become a symbol
of good luck), double happiness and hundreds of butterflies, magpie and plum
blossom, *kuifeng* (*kui* phoenix, an imaginary phoenix pattern), twining flowers,
paneled "*wanshouwujiang*" (imperial birthday wish), etc. Major shapes included
square vases with pierced handles, decorative vases, globular vases, bowls, teapots,
tablewares and pots. Different from that produced in the early Qing, famille-rose
porcelain produced in the late Qing Dynasty was painted with different shades and
multiple layers of colors while avoiding the glassy white glaze and thus dark and
dusty. A typical feature of the Tongzhi period was polychrome painting on a colored
background, such as blue, green, pink and red paintings on a light yellow background
or pink and red motifs on a light green or light purple background (Fig. 11.98). Much
famille-rose porcelain still found its way abroad during this time. The author has seen
two pieces of famille-rose porcelain from the Tongzhi period in the Metropolitan
Museum of Art in New York (Figs. 11.99 and 11.100). Due to considerations of
lowering costs and improving efficiency, while painted with complex motifs, paint-
ings on famille-rose porcelain were not exquisite nor neat enough. For example,
illustrated in Fig. 11.101 is a large plate with rose patterns, produced by a private
kiln and exported to the USA. This is a product of mass production and its colors are
dazzling.

Famille-rose porcelain produced in the Guangxu period carried a variety of colors,
but basically were light and not bright enough. Still, various polychrome porcelain

Fig. 11.98 Famille-rose
square-shaped flowerpot
with lotus patterns on a
yellow background,
produced in the Tongzhi
period, height: 19 cm, mouth
rim: 29 × 28 cm, foot rim:
26 × 26 cm

Fig. 11.99 A plate from a
set of famille-rose tableware,
produced in the Tongzhi
period, in the Berkeley Art
Museum

Fig. 11.100 A bowl from a
set of famille-rose tableware,
produced in the Tongzhi
period, in the Berkeley Art
Museum

Fig. 11.101 Famille-rose
plate, produced in the
Tongzhi period, height:
37.2 cm, width: 29.2 cm

pieces at this time boasted a high quality. Dinner sets in the Western style marked
with "*Jixiangruyi*" (Good Luck and Happiness) was a new variety invented at this
time. Large-sized articles popular in this period included decorative vases, glob-
ular vases, dragon and phoenix *zun*, as well as *bangchuiping*. In the late Guangxu
period, soft, light pigments with little powder were applied, creating a thin glaze
and tender shades of color. Influenced by Qing painters like Yun Nantian and Xu
Gu, floral patterns featured fine, tender strokes and clear layers. Compared with

that in the Tongzhi period, Guangxu famille-rose porcelain had lighter colors and finer workmanship, such as globular vases with hundreds of butterflies, decorative vases with bats and clouds, and lotus-shaped cups with straws. Besides, there was also a variety of famille-rose porcelain painted on a colored background, which was usually known as wedding ceramics, often in yellow with a floral background, painted in bright colors and inscribed with "*Wanshouwujiang*" in panels on the ware. Those marked with "*Dayazhai*" (Studio of the Great Odes) produced in the Guangxu period exhibited an advanced level of production. They were often heavily painted with bright flowers and birds on light turquoise, dark green, or pale pinkish purple backgrounds on fine and compact bodies. Articles frequently seen included flowerpots, pots, tureens, vases, *zun* and narcissus pots. Often these articles were horizontally inscribed with "*Dayazhai*" on the rim, sealed with *Tiandi yijia chun* (the Whole World Celebrating as One Family) and "*Yongqingchangchun*" (Eternal Prosperity and Enduring Spring) in red on the base (Fig. 11.102). Such wares were much copied during the Republic of China era, but they were unevenly glazed and coarsely painted. Besides, famille-rose *zun* with hundreds of deer and globular vases with peach patterns produced in the Guangxu period, which were modeled after those of the Qianlong period, featured bright colors, vague layers, clumsy shapes, and heavy, loose bodies and glaze, a far cry from the originals of the Qianlong days. In the late Guangxu period, famille-rose porcelain was lightly painted and later known as "*guangcai*" (Guangxu famille-rose porcelain).

During this time, private kilns produced many products modeled on famille-rose porcelain, *doucai* ware, rouge purple ware and blue and white porcelain in the Qianlong style, including vases, *zun*, pots, vats, and basins. Qianlong-style famille-rose square-shaped vases were frequently seen, usually painted with genre paintings such as luxurious patterns, ladies and children at play, and mostly inscribed with Qianlong marks and some even with Kangxi marks. A shared feature of these wares was that their workmanship was poor.

Fig. 11.102 Famille-rose square-shaped flowerpot with flower and bird patterns on a yellow background, produced in the Guangxu period, height: 15 cm, mouth rim: 17.5 × 13 cm, foot rim: 14 × 10 cm, in the Palace Museum

11.4.4.5 *Mocai* Porcelain (Grisaille)

After the Jiaqing period, *mocai* porcelain came into vogue among private kilns in Jingdezhen. *Mocai* porcelain was originally produced as export porcelain ordered by Western merchants in Jingdezhen. Its painting style was heavily influenced by Western copperplate etching. Black dominated its colors, coupled with red, which made the products elegant and dimensional. *Mocai* wares emerged in the Kangxi period and were popular during the Yongzheng and Qianlong periods. After 1730, *mocai* porcelain became a hit in Europe. Fully black-decorated tablewares were destined to be used in funerals while most grisaille-painted porcelain, with motifs of fable and fairy patterns, gained much popularity among consumers. *Mocai* porcelain had its own special charm with the perfect combination of black and gold or dark brown colors, or with the sharp contrast between its perfect etching and the red and gold swirl patterns of its frames. It could also be painted with a monochrome dark brown color modeled on European presswork. At times, *mocai* porcelain was decorated entirely in the Chinese style on the rims while its motifs were Western, and sometimes vice versa. In the early period, *mocai* porcelain was custom-made based on European samples.

For example, Fig. 11.103 is a plate painted with Flora, goddess of flowers, and her husband, Zephyr, god of the wind. Lying on the bank of a pond, Flora is gazing at her image in the water while the god of the wind is placing a garland on her head as a gesture to celebrate the coming of spring. This plate is decorated in black in the wood cut style, while red has been added to the figures and rims, enriching the whole picture and rendering it dimensional.[45] This Western painting style exerted a significant influence over the Jingdezhen private kilns after the Jiaqing period, and led to the production of *mocai* wares for the domestic market. Given the demands of the domestic market, the contemporary painting style was integrated into the Western style, thus creating a new technique which featured light, soft colors, fine strokes, and the combined use of heavy and light color shades, leaving a lingering effect and inscribing unique scenes of landscape and human figures. Varieties of similar *mocai* porcelains included square vases, flower pots, pots, basin and tureens.

11.4.4.6 *Qianjiang* Porcelain

During the Qianlong period, there was another variety of export porcelain which was painted in the *mocai* style coupled with light red and light green colors. For example, the plate's colors in Fig. 11.104 varies with different shades of red and black, and coupled with a little blue and green, appears refreshing and unique. By the late Qing and Republican era, many artisans in Jingdezhen had begun to combine this style with China's poetry, calligraphy, and paintings and apply it to porcelain, thus integrating decorative paintings on porcelain with traditional Chinese paintings and creating

[45] William R. Sargent, *Treasures of Chinese Export Ceramics from the Peabody Essex Museum.* Distributed by Yale University Press, 2012, p. 301.

Fig. 11.103 *Mocai* plate
with Flora pattern, produced
in the Qianlong period,
diameter: 22.5 cm, in the
Peabody Essex Museum in
the USA

a new horizon for porcelain decoration, later known as the "*jiangcai*" style. This style originated with a Yuan Dynasty literati painting style where landscapes were outlined with ink and complemented by strokes of pale umber for a polishing effect. A major representative of this painting style was Huang Gongwang, a Yuan painter and one of the "Four Masters of the Yuan Dynasty." Based on *mocai* paintings, "*Qianjiang*" paintings were outlined with varied tones of black glaze and decorated in pale umber, light green, grass green, light blue and purple, before being fired at low temperatures (650–700 °C). *Qianjiang* enamel, an overglazed enamel, was a type of *yangcai*. Different from famille-rose, it can be directly applied on bisque after mixing with black, red, and light green colors in turpentine, thus making it convenient to use. In contrast, due to its complicated technique, a detailed division of labor, and the generally poor educational background of potters, production of famille-rose porcelain was completed by those who could only master one specific part of a job in porcelain production. So those who could paint were unable to fill in colors, those who could paint landscapes were unable to paint other motifs like flowers, birds, fish or insects, and those who could paint human figures were unable to paint floral motifs from garments, or paint inscriptions. They thus had to turn to others for help. Their works therefore lacked personality and character. While *qianjiang* porcelain potters in the late Qing Dynasty were generally more well-educated and were able to master the skills of painting landscapes, human figures, flowers and birds. Additionally, *yangcai* was easily colored, so a single potter could finish all the work from design to polishing, making it possible for the potter to display their own style and personality. It is therefore fair to say that the emergence of *yangcai* served as a turning point in ceramic art in Jingdezhen from the late Qing to the Republican

Fig. 11.104 *Jiangcai* plate
with pattern of a fisherman,
produced in the Qianlong
period, diameter: 22.9 cm, in
the Peabody Essex Museum

era because potters were allowed to express individuality and character. This marks
an important milestone in the development of ceramics industry in Jingdezhen.

11.4.4.7 *Jincai* Porcelain

Jincai ware was another variety that emerged in the late Ming Dynasty under the
influence of Japan and the West. By the late Qing, it was already established as a tradi-
tional Jingdezhen porcelain product. It featured bright red colors and sterling gilt,
usually seen on official wares. Products of varying shapes and with cursive inscrip-
tions produced by the private kilns usually created relatively poor *jincai* enamel,
resulting in bright colors similar to modern *jincai* porcelain. *Jincai* was also applied
to *wucai* ware, *doucai* ware, blue glazed *yuhuchunping*, decorative vases, square
vases with elephant ears, square vases with pierced ears, bowls and plates, etc. *Jincai*
blue glazed porcelain was often painted with motifs like dragons and phoenixes,
dragons flying in clouds, flower garlands, and decorations in the ancient style.

Generally speaking, late Qing Jingdezhen porcelain displayed many unique
features of the time in terms of shape, decoration and scale of production.

On the question of shape, the *yuanqi* and *zhuoqi* of the official kilns inherited
traditional designs, some of which were very similar to their predecessors in terms
of size, color and decoration. Meanwhile, under the orders of the Empress Dowager
Cixi, Jingdezhen made a specific and unprecedented batch of products of unique
design, including decorative wares and daily use wares marked with "*Dahunlizaoqi*"
(Made for Grand Weddings) or "Tihe Hall." There were also vases, *zun*, vats and

boxes with neat shapes but looking heavy and clumsy. Generally, bowls and plates were still in the traditional design. A new variety at this time was a paneled bowl with decorations on a red background, featuring deep, high walls. Cuspidors and ash cellars were popular products. From the Xianfeng to the Xuantong periods, apart from a small number of wares, most products were not as delicate as previously, well short of the level of the Yongzhong and Qianlong periods. The designs and shapes of porcelain at this time were also different from previous generations. Decorative wares such as vases and *zun* were much reduced while most products were articles of daily use. Vases popular at this time included decorative vases, *yuhuchunping*, square vases with pierced ears, *cong*-style vases, square vases with elephant ears, flasks with straight necks, garlic-head-shaped vases, pomegranate-shaped vases, lantern-shaped vases, round-shaped boxes, and goblet plates. Private porcelain included vases with a flaring mouth, vases with lion-shaped lugs, gourd-shaped vases, helmet-shaped jars, as well as porridge jars, bird feeder jars, incense burners, fish tanks, flower pots, narcissus pots, tureens, *penghe* boxes (hand-held boxes), *jiehe* boxes (sets of boxes with one on top of another), hair oil boxes, cuspidors, water pots, seal boxes, brush washers, brush pots, hat holders, teapots, tea caddies, wine warmers, wine cups, plates, saucers, buckled bowls, soup spoons, snuff bottles, pillows, stools, hanging screens, star gods of good fortune (*Fu*, *Lu* and *Shou*), the Eight Immortals and Avalokitesvara statues. During the Tongzhi, Guangxu and Xuantong periods, "gall bladder" shaped vases, tea caddies, hat holders, teapots, tea bowls and sets of bowls and plates were quite popular. The "Gall bladder" shaped vases came in different sizes, including "*yibaiwushijian*" (one hundred and fifty *jian*), "*sanbaijian*" (three hundred *jian*), "*wubaijian*" (five hundred *jian*), as well as "*yiqianjian*" (one thousand *jian*). After the Guangxu period, it became popular to produce wares in imitation of various Kangxi, Yongzheng and Qianlong period items, including blue and white porcelain, *wucai* wares, famille-rose porcelain, and monochrome porcelain. But these imitations rarely resembled the genuine ones. Flowerpots and tablewares (bowls and plates) were common. The double-lug decorative method popular since the mid-Qing Dynasty was still in vogue by the late Qing period and took the shape of phoenixes, *panchi* (dragon-like animals), and double lions. Famille-rose globular vases with peaches and vases with deer-head-shaped lugs modeled on those of the Qianlong period were also produced in quantity. The copycat products, while highlighting quality and boasting an advanced production level, were also marred by some of the ills of the production practices of the time. Compared with the genuine products, they were heavy and coarse, clumsy in design, cursive in painting and dull in decoration structure (Figs. 11.105 and 11.106).

In terms of decoration, apart from traditional motifs like dragons and phoenixes, cranes, Buddhism's Eight Auspicious Symbols, more auspicious motifs came into use, such as five bats surrounding the Chinese character *shou* (Longevity), *changshou* patterns (Longevity), "*wanshouwujiang*," double happiness, Spring Festival scenes, scenes of a bountiful harvest, parenting scenes, "*guadiemianmian*" (symbolizing best wishes for progeny), "*tanhuajidi*" (ranking high in national civil exams), *qilin-songzi* (kylin delivering children to a family), "*sanyangkaitai*" (auspicious beginning to the new year) and "*jiangshanwandai*" (long live the dynasty). Hydrangea,

Fig. 11.105 Famille-rose square-shaped vase with paneled flower and bird decoration on a light green and lotus-decorated background, produced in the Xianfeng period, height: 29 cm, mouth rim diameter: 8.9 cm, foot rim diameter: 8.7 cm, in the Palace Museum

Fig. 11.106 Gilt famille-rose vase with drawings of the Five Cardinal Confucian Relationships and elephant-ear-shaped lugs, produced in the Guangxu period, height: 130 cm, mouth rim diameter: 36.8 cm, foot rim diameter: 39 cm, in the Palace Museum

Chinese wisteria and Terpsiphone incei were also applied as novel decorations. Painting, motifs were very graphic, some lean and neat and some coarse and simple. Popular motifs included dragons flying in clouds, phoenixes flying in clouds, dragons and phoenixes, *kuifeng*, dragons swimming in the sea, cranes, the Eight Trigrams, Buddhism's Eight Auspicious Symbols, nine lions, bats and clouds, five bats, star gods of good fortune (*Fu*, *Lu* and *Shou*), the Eight Immortals celebrating a birthday, five sons passing civil examinations, succeeding as top candidate in the national

civil examinations, children at play, 24 stories of filial piety, "*niannianyouyu*" (May you have Plenty, Year after Year), landscapes and human figures, pine trees, bamboo and plum blossom, the character "*shou*" (Longevity), twigs in the shape of "*shou*" (Longevity), "*fulushouxi*" (Happiness, Affluence, Longevity and Joy), twining lotus, plum blossom, lotus, chrysanthemum, Chinese flowering crabapple, gourds and butterflies, flowers and butterflies, flowers and birds, mandarin ducks and lotus, lucid ganoderma, Rosa chinensis, grapes, three leaves, nine peaches, Chinese cabbage, "*shoushanfuhai*" (As long-lived as the mountains and a sea of blessings), "*longfengchengxiang*" (Dragon and phoenix bring auspiciousness), and ancient-style patterns. There were also drawings of the five cardinal Confucian relationships, Sima Guang breaking the vat, Zhu Zi's Family Maxims, and patterns of horses and monkeys (symbolizing the rich and powerful) (Figs. 11.107 and 11.108). The *xi* (Happiness) character was very popular during the Xianfeng, Tongzhi and Guangxu periods, but such blue patterns differed in terms of expression at different times. During the Xianfeng period, double happiness patterns were neatly inscribed in thin strokes. During the Tongzhi period, the inscriptions were not as neat and the strokes not as thin. By the Guangxu period, the writing was extremely messy, with wide strokes and vague character style. Porcelain decorations at this time, apart from traditional motifs, were influenced by a batch of *jinshi*-style painters (in the realistic and antique style), thus ancient-style vases became a hit at this time.

Realistic paintings and neat graphic paintings at this time dominated decorations in the official kilns while freehand brush work played a major role in private kilns. By

Fig. 11.107 Gilt famille-rose leaf-shaped plate with bats and *shou* characters on a blue background, produced in the Guangxu period, height: 4 cm, mouth rim: 23 cm × 12 cm, foot rim diameter: 12 cm × 6 cm, in the Palace Museum

Fig. 11.108 Famille-rose
vase with plant and insect
pattern on a blue background
and two *chi*-shaped lugs,
produced in the Guangxu
period, height: 22.2 cm,
mouth rim diameter: 7.4 cm,
foot rim diameter: 5.5 cm, in
the Palace Museum

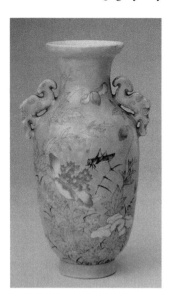

the late Tongzhi and Guangxu periods, soft-paste freehand paintings were popular, modeled after the works of famous painters from the Ming and Qing dynasties, including Shen Shitian, Tang Liuru, Hua Yan, and Zhu Da. In addition, a group of painters from Shanghai had a major influence on Jingdezhen famille-rose porcelain in the late Qing Dynasty. Hailing from the bottom of society, they were permanent residents of Shanghai and their works were free from the aloofness and refinement popular among traditional literati painters. Instead, their motifs were very down-to-earth and thus popular among the populace. Three painters were particularly notable, namely Ren Xiong, Ren Xun and Ren Yi. Ren Xiong was the pioneer of this school of paintings. He inherited the artistic traditions initiated by his fellow townsman Chen Hongshou, a great painter from the late Ming and early Qing period. Xiong was not bound by the Chen style, however. Figures under his brush "had clothes painted with strong and vigorous strokes, featuring a similar style to Chen while also displaying his own unique character." With a similar painting style to his brother, Ren Xun was also a student of Chen Hongshou and painted in a realistic style, incorporating inscriptions, and mastered both delicate and rough paintings. From the Yuan Dynasty to the late Qing Dynasty, Jingdezhen polychrome porcelain was already sufficiently mature, especially famille-rose paintings which had formed many rules and procedures of production. Polychrome decoration on porcelain was closely associated with the art of painting in those days, especially by the late Qing period. With loose management in the official kilns, private kilns were allowed to utilize motifs and techniques that had been previously prohibited. Among the painters in private kilns, a group not only painted traditional Chinese paintings, but also learned calligraphy, poetry, and engraving, so they were no longer ordinary workers. Instead, they turned themselves into local celebrities and were respectfully termed porcelain artisans. As a result,

their paintings on porcelain were more closely related to contemporary paintings than ever.

The paste and glaze at this time had several features. Similar to that of the Xianfeng period, the paste of the official kilns was fine and white while that of the private kilns was coarse, loose, heavy and clumsy, with some relatively thin and light. When knocked, *yuanqi* wares would ring like bronzeware. These were common features of porcelain produced in the late Qing Dynasty. Products of the official kilns and those marked with "Tihe Hall" were exquisitely and smoothly glazed, resembling enamel ware while ordinary products were poor in terms of hardness, had thin, whitish glaze, and loose paste when heavily glazed. By the Guangxu period, private porcelain was poor in quality and those modeled on Kangxi wares were of mixed quality. Compared with the originals of the Kangxi period, products of the Guangxu period had thin paste, were light in weight, and poor in hardness. By the Xuantong period, products from the private kilns generally had thin bodies and rang when knocked, similar to modern porcelain wares. In terms of color, private products were bluish white while some were pure white, similar to that of modern porcelain (Fig. 11.109).

Most official products from the Tongzhi, Guangxu and Xuantong periods with reign year marks were inscribed with "*Daqingnianzhi*" (Made in the Great Qing) without panels in regular script. One of the varieties at this time was inscribed with "Tihe Hall" in seal characters or "*Dayazhai*" in regular script. Private kilns often had no year marks during the Tongzhi and Guangxu periods. Among those which had marks, apart from those in regular script, there was also one type which was a dark-red sealed irregular mark in seal characters, written in intaglio or in relief. Official products in the Xuantong period included blue and white porcelain, red glazed porcelain, and *mocai* porcelain. Blue and white porcelain was all marked in regular script with six characters in two vertical lines without panels, featuring neat

Fig. 11.109 Famille-rose
yuhuchunping with flower
and butterfly patterns,
produced in the Xuantong
period, height: 30 cm, mouth
rim diameter: 8.7 cm, foot
rim diameter: 12 cm, in the
Palace Museum

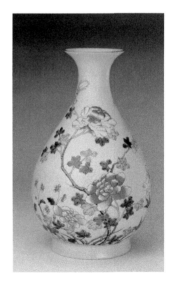

Fig. 11.110 Famille-rose
soup basin with *fu*, *lu* and
shou patterns, produced in
the Xuantong period, length:
19 cm, width:16.7 cm, total
height: 16.5 cm, tray: length:
19.7 cm, width:16.5 cm,
height: 2.6 cm, in the
collection of a Western
antiques dealer

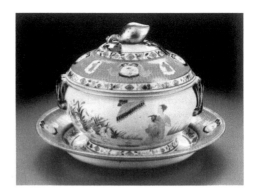

and elegant calligraphy and in a bright and cheerful style. Private wares, meanwhile, usually had no year markings.

Though export had been greatly curtailed by this time, some products with Chinese decorations and styles remained in vogue in Europe. For example, the famille-rose soup basin with the *fu*, *lu* and *shou* patterns produced in the Xuantong period in Fig. 11.110 is painted with complex decorations in bright colors. Its ancient-style patterns, including the "*shou*" character, coins, deer, bats and butterflies, also carry auspicious connotations. Its lid is painted with sword and sheath patterns; the center of the plate is painted with a vase, symbolizing peace, and its rim is decorated with lozenge-shaped patterns. This piece might be one of a set of tableware ordered by Mr. and Mrs. Kneier when they visited Guangzhou in 1910, showing their interests, their aspirations for peace and their artistic tastes. The famille-rose octagon-shaped plate with *fu*, *lu* and *shou* patterns in Fig. 11.111 was produced in the Republican era and is now in the collection of a Western antiques dealer. Similar to the one in Fig. 11.110, its center is also decorated with ancient-style patterns, including the "*shou*" character, coins, deer, bats and butterflies. The rim is decorated with brocade patterns. The shape of these two pieces of porcelain are entirely in the European style while their decorations and means of expression are Chinese, indicating that some Chinese auspicious motifs were popular in Europe as well. Though Europe was capable of producing porcelain for daily use in large amounts by machine back then, some Chinese products with strong spiritual and artistic value were still able to find a place in the European market.

11.4.5 Division of Labor

As a result of the development of China's feudal society, capitalism emerged in the mid-Ming Dynasty. Workshops based on an employment system came into being in

Fig. 11.111 Famille-rose
octagon-shaped plate with
fu, *lu* and *shou* patterns,
produced in the Republic of
China era, mouth rim: 21 cm
× 21 cm, foot rim: 15 cm,
height: 3.5 cm, in the
collection of a Western
antiques dealer

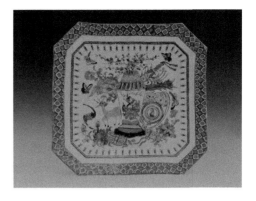

the silk, ceramics, mining, and metallurgical industries, etc. These capitalist work-shops were developed on the basis of the feudal handicraft industries, and had trans-formed their production into producing commodities, a consequence of the natural development of China's feudalism.

After the late Ming and early Qing period, with the boom in demand from over-seas markets, the Jingdezhen ceramics industry required a set of systems and regu-lations that suited large-scale production in workshops to meet the ever-increasing market demands. Thus, after the late Ming Dynasty, capitalism not only flourished in Jingdezhen, but a complete suite of mechanical and professional technologies was developed to service the demand. These technologies were developed and constantly improved through practice, strict selection by the court, strenuous efforts and time, and thus in time they became very refined. The complex production procedures and strict division of labor not only gave birth to a special labor, economic management and social organization model, but also helped establish a special production process and professional division of labor.

An outstanding feature of the Jingdezhen ceramics industry over recent centuries was the detailed and strict division of labor, which came into being thanks to the emergence of capitalism. As legend has it, Shennong, a mythological Chinese deity in Chinese folk religion, was credited with being the God of farming and pottery making, which indicates the close relation between agriculture and pottery making since ancient times. Before the Yuan Dynasty, the ceramics industry was an integrated part of agriculture in Jingdezhen, rather than an independent industrial enterprise, and private kilns were basically by-line businesses run within the family unit and dispersed amongst the rural regions some 100 km or so around Jingdezhen while the Jingdezhen downtown area was where porcelain wares were traded. There were also some workshops producing and firing porcelain, and operating in an unprofessional fashion outside of the downtown area.

According to investigations of the ancient Jingdezhen kiln sites after 1949, ancient kiln sites from before the Song Dynasty covered the whole area from Wuyuan County and Qimen in the north to Leping and Poyang County in the south, showing that

ceramic production at the time depended on agriculture as a side business in a small-scale peasant economy. It was not until the Yuan Dynasty that ceramic production moved onto a professional path and into urban areas.[46]

By the Ming Dynasty, especially after the late Ming period, the Jingdezhen ceramics industry boomed further. In order to ensure high quality and high productivity in the industry, interactions between production techniques and the sourcing of raw materials were strengthened, thus requiring a high concentration of these areas. Meanwhile, the sourcing of raw materials also expanded from the southeast regions in the then Fuliang County to northern areas of the county and beyond to Qimen County close to Huizhou. As the government set up imperial kilns in Zhushan and with the implementation of "*Guandaminshao*" policy, the feudal rulers specifically ordered the private kilns that were dispersed within the suburbs to concentrate in the downtown area in order to better serve the imperial kilns and allow better supervision of the private kilns. Therefore, from the Ming Dynasty, the Jingdezhen urban area had been a hub of porcelain production.

Zhushan, where imperial kilns of the Ming and Qing dynasties were based, was located on relatively high ground, thus free from the intrusion of floods. For the same reason, private kilns were also set on high ground north of Zhushan. Thus, a strip of land about two kilometers wide from "Dongjiawu," along "Wulong Mountain," through "Baiyun Temple" where the No. 1 People's Hospital of Jingdezhen is located, to "Leigong Mountain" on the right of the old Cathedral, was allocated to private kilns and known as the "*Sanshansiwu*" area. By the late Ming Dynasty, paste rooms and chamber houses were further developed along the southern side of "Wulong Mountain" to "Xuejiawu," "Yaowangmiao," and the east of "Zhushan," reaching "Qingfengling." The famous Xiaonan kiln in the late Ming Dynasty was situated in "Qingfengling."

From the east gate of the imperial kilns to the north, private kilns in "Longgang Lane," "Dengjialing," "Sanjiaojing," "Xujia Street" and "Wulong Mountain" were linked together and became the most prosperous area in Jingdezhen. In addition, "Lishidu," no more than 1 km away from "Banbian Street" and "Xujia Street," was a port where porcelain stone from Qimen County was unloaded and from which Jingdezhen porcelain was exported in the Ming Dynasty. Xiaogangju, where the Hutian kilns were based, was located on the southern border of Jingdezhen, only 2.5 km away from the famous Hutian kiln relic site.

The concentration of private kilns in the Jingdezhen urban area not only made Jingdezhen a trading hub for porcelain, but also a production center for ceramics, thus breeding various independent yet interrelated sectors with different divisions of duties in porcelain production, such as kilns producing *yuanqi* and *zhuoqi*, and workshops for porcelain painting, various *chai* kilns (burning pine wood), *cha* kilns (burning miscellaneous wood) and red painting shops (for the polychrome porcelain industry) as well as auxiliary sectors supporting porcelain production, such as those producing clay, firewood, hay, porcelain grading and temperature supervision in firing, etc.

[46] Jingdezhen Committee of the Chinese People's Political Consultative Conference (ed.), *Cultural Accounts of Jingdezhen*, Vol. 1, 1984, p. 153.

Within every sector, there was also a very detailed and specific division of labor which was only possible after the family-run handicraft industries were transformed into manual workshops. Only manual workshops had enough capital and labor resources for such a division of labor. Meanwhile, sourcing and elutriation of porcelain stone in rural regions around Jingdezhen also changed from a self-sufficient mode, and more and more people became engaged in exploiting and producing raw materials for porcelain making professionally and commercially. After centuries of development since the mid- and late-Ming Dynasty, Jingdezhen was already equipped with a very complete production system with a specific and detailed division of labor by the end of the Qing Dynasty.

The very special and specific division of labor in the Jingdezhen ceramics industry was a result of long-term practice and was actually unprecedentedly strict and detailed. According to *On Jingdezhen Ceramic Affairs*, "In porcelain making, you might think it is not hard to produce porcelain for daily use and that the key only lies in clay making and firing. But in fact it requires complex procedures and a detailed division of labor, which would take a long time to tell the story in full. Generally speaking, porcelain stone must be ground and elutriated; in making paste, clay must be dense and compact; in firing, temperatures must be high and stable; in painting decorations, superior craftsmanship is essential. All these procedures combined make it possible to produce a piece of porcelain. With such a division of labor, each performs his own duties and plays his own roles. Nobody is allowed to encroach on his responsibilities or work on others' tasks. In this way, everybody takes care of his own business and together they accomplish a common goal in producing porcelain wares successfully. This is indeed a very detailed and specific division of labor."[47] Such a division of labor allowed potters to hone their skills and become more and more professional and specialized, thus leading them to become engaged in a single business for a lifetime. To some extent, this made it easy for each procedure in porcelain making to reach perfection, which was conducive to the improvement of the technological level and quality of Jingdezhen porcelain. This assembly-line method of production and division of labor was a result of the development of capitalism in Jingdezhen.

By the Qing Dynasty, while detailed, the division of labor in Jingdezhen mainly fell into three parts. "Jingdezhen potters are not from one sector, but actually are categorized into three sectors, paste making, *hongdian* (red painting shops), and kilns for firing. Each of them performs their own duties and excels in them. Their skills are only passed along within their own sectors. Concentrating on their own business, they master excellent craftsmanship. Most of the workers are from Nanchang, Poyang, Duchang, Fuzhou, Qimen and Wuyuan. Focusing on their own duties, the skills of the workers are passed down through generations within families so that several famous family names are well known and an irreplaceable part of the business of the day, so it seems that it is not a coincidence that the porcelain business is practiced by these families over generations."[48]

[47] Xiang Chao, *On Jingdezhen Ceramic Affairs*, Sales Department of Jingdezhen Kaizhi Printing Bureau, Hanxi Printing House, 1920.

[48] See Footnote 47.

Paste making can also be divided into two groups, namely the making of *yuanqi* and *zhuoqi*. For *zhuoqi*, there were 11 specific lines of business, including the large piece industry, the *Ding* white ware industry, the light painted ware industry, the lantern industry, the *guangu* industry, the engraving industry, the spoon industry, the *bogu* ware (ancient-style ware) industry, etc., while for *yuanqi* wares, there were also 11 sectors, such as the bodiless ware industry, the four large wares industry (blue and white porcelain, famille-rose porcelain, *linglong* porcelain and polychrome porcelain) and the ancient ware industry. As for kilns, there were *chai* kilns (burning pine wood) and *cha* kilns (burning miscellaneous wood). The red painting shops (of the polychrome porcelain industry) fell into four categories, one painting the four large wares (blue and white porcelain, famille-rose porcelain, *linglong* porcelain and polychrome porcelain), one painting bodiless porcelain, one painting grisaille wares and one painting tureens. In firing porcelain, there were furnaces, filling furnaces, building furnaces and making bricks. Different sectors were monopolized by potters from different regions. For example, the owners of furnaces were mostly from Duchang, in the family names of Feng, Yu, Jiang and Cao. Workers in charge of firing *yuanqi* wares were also mainly from Duchang. Those responsible for filling up furnaces were recorded as follows in the *Jingdezhen Taolu*. "It is said that originally, this line of business was dominated by people from Leping, who then took people from Poyang as apprentices in the early Kangxi period. Later, the Poyang people took on the Duchang potters as apprentices and the Duchang potters began to rise while the Poyang workforce began to decline."[49] The furnace building business had been passed down through the Wei family since the Yuan and Ming dynasties. Later, the Duchang potters "mastered the technique and engaged themselves in the business of repairing furnaces." The Duchang workers therefore played a pivotal role in all lines of the porcelain-making business in Jingdezhen. In addition, potters from Fuzhou and Fengcheng dominated the production of *zhuoqi*, workers from Xinjian in Nanchang were mainly responsible for manual work, while for color painting and engraving, artisans from Fengcheng prevailed.

Apart from paste making, color painting, and firing, there were many auxiliary businesses contributing to ceramic production in the private kilns. For example, the sagger industry could be divided into large sagger and small sagger businesses. The packing and transportation industry included nine sectors such as hay packing, porcelain grading, tying knots, cutting bamboo strips, making bamboo baskets, packing porcelain wares into baskets, selecting porcelain, loading, collecting firewood and transportation. The repair industry was vital to the enterprise, as was instrument production, including molds, knives, and brushes. Services included sedan and horse services, sales in porcelain shops and porcelain houses, and raw materials provisioning, including pigments, porcelain stone, glaze, limestone and firewood. These auxiliary businesses composed an integrated and organic operation mechanism in porcelain production together with the principal lines of business, thus endowing Jingdezhen with a complete production and marketing mechanism. And all these

[49] Lan Pu, *Jingdezhen Taolu*, Vol. 4.

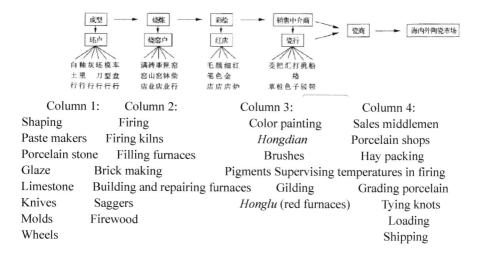

Column 1: Column 2: Column 3: Column 4:
Shaping Firing Color painting Sales middlemen
Paste makers Firing kilns *Hongdian* Porcelain shops
Porcelain stone Filling furnaces Brushes Hay packing
Glaze Brick making Pigments Supervising temperatures in firing
Limestone Building and repairing furnaces Gilding Grading porcelain
Knives Saggers *Honglu* (red furnaces) Tying knots
Molds Firewood Loading
Wheels Shipping

Column 5: Porcelain merchants
Column 6: Domestic and overseas markets

Fig. 11.112 Chain graph of the production and marketing of products from the Jingdezhen private kilns

businesses had their own industrial groups, composing a clear and connected work structure, as mentioned in the *Jingdezhen Taolu*.[50] (Fig. 11.112).

11.4.6 Guilds in Jingdezhen

11.4.6.1 Introduction

AN organizational structure comprising the various production links and divisions of labor in the Jingdezhen private kilns was required to restrain and guide collective behavior. In fact, there were many complex relations between different industries in the production and marketing of porcelain, including confrontational, conflicting and competitive relations as well as geographic and bloodline relations. A mechanism therefore developed to coordinate these relations and help manage competition, resolve conflict, and organize individuals with a view to maintaining order. The

[50] Lan Pu, *Jingdezhen Taolu*, Vol. 3.

mechanical structure of the Jingdezhen ceramics industry was visible in some of the rules and regulations of the relevant industries, and these arose during the process of porcelain production and marketing in an effort to cope with various problems. Hence various communities of common interest were formed, such as *hangbang* (industrial groups based on industries), *huiguan* (business houses based on geographic relations), and *gongsuo* (comprehensive industrial organizations based on industries, regardless of the origin of members). The formation of these organizations was very important for potters as they endowed them with an identity and offered them support.

Among the various private kiln porcelain production industries in Jingdezhen, there were many groups, clubs and associations. These organizations, which came into being based on industries, geography and blood relations, not only played a vital role in the ceramics industry, but were also significant in the political and economic development of Jingdezhen, since Jingdezhen's development was centered on porcelain production. From the mid-Ming Dynasty when capitalism emerged, Jingdezhen porcelain became world-renowned and found its way to all corners of the world, attracting poor and bankrupt peasants from Jiangxi and nearby regions to seek a living there. This helped supply the constant labor force necessary for the massive production capacity of Jingdezhen. Meanwhile, in order to make their fortune, merchants from outside Jiangxi also flocked to Jingdezhen, thus giving the city both its local character and its exotic features. This has been recorded by many scholars in the Qing Dynasty. For example, "Nestled amongst a host of mountains, there is a town called Jingdezhen located to the south of Guyi, a prosperous place in the south. Based on its pillar industry, ceramic production, it produces various products and attracts people from all over the country, making itself a center of much hustle and bustle."[51] "Jingdezhen, situated to the south of the Changjiang River, produces porcelain that flows all over the nation and even beyond. Workers involved in porcelain making are estimated to be in the tens of thousands. A lot of people gather in this region. Perhaps because of its mountainous nature, it has become a major hub in the region.[52] "Jingdezhen, a large town belonging to Fuliang County, is a major producer of porcelain and attracts people from all quarters to work and contribute their skills here, a major contribution to the world."[53] According to the *Gazetteer of Fuliang County*, "rich merchants and businessmen all gather in Jingdezhen" and "People in Jingdezhen are very rich, with its aggregate wealth even larger than an ordinary province." Similar sayings were also common among the people. Thus, we can see how prosperous and attractive Jingdezhen was at the time, which was extremely rare in China.

As a world-famous porcelain city, Jingdezhen had a huge floating population, a population that exceeded even that of its locals. "To the south of the Changjiang River there is a town called Taoyang, about 20 *li* (half a kilometer) away, which has different customs to those of Guyi… Stretching over 13 *li*, Jingdezhen has more than 100,000 households, about seven to eight tenths of whom are engaged in porcelain

[51] Lan Pu, *Jingdezhen Taolu*, Vol. 8, *Taoshuozabianshang*.

[52] See Footnote 51.

[53] See Footnote 51.

production and trading. Among them, only two to three tenths are local residents…"[54] These "seven to eight tenths" of people were about two thirds of the total population of Jingdezhen and they were engaged in the porcelain business. They were mostly from regions near Jingdezhen and especially Duchang and Poyang, followed by Leping, Yugan, Maoyuan, Fuzhou and Nanchang, along with Anhui, Jiangsu, Fujian, Guangdong, Hubei and Henan provinces. As recounted by Lan Pu in *Jingdezhen Taolu*, "Jingdezhen has business, transportation and population connectivity with over a dozen provinces. It has vehicular and pedestrian gridlock and attracts people from all quarters. With tens of thousands of households, Jingdezhen is indeed the largest metropolis south of the Changjiang River."[55] In *Taoyangzhuzhici*, Zheng Tinggui also wrote that "With thickly dotted houses on winding streets, potters in Jingdezhen work on painting blue and white porcelain day and night. However, now most porcelain workers in Jingdezhen are from Duchang and Poyang and the local kilns are few."

The surging number of merchants and workers from outside Jingdezhen provided a solid social backdrop for the emergence of various industrial and business organizations. The immigrant population needed to turn to these organizations to safeguard their own interests and maintain friendly contacts with their fellow townsmen. Since these organizations were largely based on geographic or blood relations and different people from the same regions or of the same lineage monopolized different industries, their gatherings or events usually took place in their *huiguan* or academies established in different regions. When a non-native came to Jingdezhen to eke out a living, being a stranger in a strange land, he/she had to resort to his/her native industrial or business organizations by joining them and becoming a member so that he/she could be protected and aided in time of need. "Whether close to each other or not, as long as we are from the same place, we help each other." This mechanism of mutual assistance, popular among the lower classes of society, prevailed in the ceramics industry.

11.4.6.2 Various *Huiguan* in Jingdezhen

In the Ming and Qing dynasties, *huiguan* represented business organizations that were mainly defined by the geographic origins of members. During this time, in order to protect the interests of their industries, craftsmen established *huiguan* in many places. Those who came to Jingdezhen to work on porcelain making or engage in porcelain trading all tended to set up *huiguan* in Jingdezhen from the late Ming Dynasty. Such *huiguan* became an important platform for various porcelain-related industries. *Huiguan* were generally based on geographic relations and their members were basically from the same locality. Meanwhile, established by merchants who had migrated to Jingdezhen for the porcelain business, these *huiguan* were also involved in economic activities. Each *huiguan* had its own academy to provide education for

[54] See Footnote 51.

[55] Lan Pu, *Jingdezhen Taolu, Preface.*

the children of their members. Also, as various sectors of the porcelain production process were monopolized by different groups of people with the same geographic origins or blood relations, members of *huiguan* shared these same origins and worked in the same sectors, so various industrial events were held in the *huiguan* and relevant functions were also performed by the *huiguan*. Most *huiguan* came into being in the Qing Dynasty. In 1815, the 20th year of Jiaqing's reign, there were seven *huiguan*, including the Huizhou, Nanchang, Suhu (Suzhou and Huzhou), Raozhou, Duchang, and Linjiang Town *huiguan*, plus the Jingyang Academy, with others established in the following years. According to research, before the founding of the People's Republic of China, Jingdezhen hosted 27 *huiguan* which could be dated back to the Qing Dynasty. The boom in *huiguan* culture was closely associated with the flourishing development of private kilns in Jingdezhen. In the early Qing Dynasty, the booming ceramics industry accelerated the growth of the population of Jingdezhen. Since the Yuan and Ming dynasties, tens of thousands of floating populations lived and worked in Jingdezhen, thus making Jingdezhen known as a "hub of 18 provinces." The development of the ceramics industry mobilized a thriving commercial industry and a prosperous market, leading to the economic status of Jingdezhen being "larger than that of a province." Attracting merchants and labor from all sides, Jingdezhen became a metropolis inhabited by people from many different regions. To compete with players in the same industry, protect one's legitimate interests, pass along skills to later generations and maintain friendly contacts with people, a small group was required. At the time, Jingdezhen porcelain had been exported to many places around the globe, however, foreign merchants seldom traveled to Jingdezhen themselves to make purchases or to place orders. Instead, it was up to Chinese merchants from various places to transport Jingdezhen porcelain to Hong Kong, Taiwan, Guangzhou and Fujian for export. This required people to stay in Jingdezhen to purchase porcelain and take care of transportation to these places, hence various business groups and representative offices were attracted to the city. *Huiguan*, which arose as a response to these demands, can be divided into three groups. The first were those based on *xian* (county) and *fu* (an administrative level, one level higher than the county) units, such as the Ji'an Huiguan which covered one *fu* and ten counties, including Jishui, Taihe, Yongfeng, Ninggang, Yongxin, Suichuan, Wan'an, Anfu, Lianhua and Ji'an, the Nanchang Huiguan, which included one *fu* and eight counties, including Nanchang, Xinjian, Fengcheng, Jinxian, Jing'an, Fengxin, Wu'ning, and Xiushui, along with the Raozhou Huiguan which covered one *fu* and seven counties, and the Huizhou Huiguan which covered one *fu* and six counties. Some were entirely based on the county unit, such as Fengcheng, Ningbo, Wuyuan, Qimen, Fengxin, Hukou, Rongcheng, and Fuliang. There were a lot of people from Duchang who flocked to Jingdezhen to seek a living, so there was an old Duchang Huiguan built in the Ming Dynasty and a new one established later, hence the existence of two *huiguan* for Duchang County. The second category included those organized by people coming from different but adjacent places, such as the Suhu Huiguan (for those from Suzhou and Huzhou). The third was based on a province, such as the Fujian, Hubei, Shanxi and Hunan Huiguans (Figs. 11.113 and 11.114).

Fig. 11.113 Layout of the
Fuzhou Huiguan

11.4.6.3 The Complex *Hangbang*

In Jingdezhen, the porcelain metropolis known as a hub of 18 provinces, merchants and craftsmen from both inside and outside Jiangxi Province lived in a migrant society with varying social customs and different ways of life, and even dialects that caused communication barriers. Thus, whether it was to enable friendly contact with each other or to facilitate the smooth running of their business, they needed an organization to bond with each other. Hence *hangbang*, based on geographic and blood relations, and *gongsuo*, based on specific industrial sectors, came into being and facilitated such bonding. Some hold that organizations based on geographic relations were more advanced than those based on blood relations while those based on industrial sectors were more advanced than those based on geographic relations. However, it should be noted that all three did not emerge in strict chronological order, but actually coexisted, operating independently while also mutually influencing each other.[56] This was true of the Jingdezhen ceramics industry and its relevant supporting service industries. Many people in the same industry were from the same place or hailed from the same origin, therefore, many sectors were monopolized by people from one region or sharing the same origin.

[56] Ma Min, *Between Officials and Merchants: Merchants in the Revolutionary Changes of Modern Society*, Tianjin Renmin Press, 1995, p. 244.

Fig. 11.114 Layout of the
Nanchang Huiguan

The Jingdezhen ceramics industry boasted a time-honored history, excellent craftsmanship, and a detailed and complex division of labor, thus giving birth to various business and industrial organizations. Within a period of more than a century, a host of organizations relating to various sectors centered on porcelain production came into being. Among the hundred or so such organizations, there were merchants' *hangbang*, master handicraftsmen's *hangbang*, workers' *hangbang* specific to the industry, as well as *Huibang* (Huizhou Hangbang), *Dubang* (Duchang Hangbang), *zabang* (*hangbang* covering regions other than Huizhou and Duchang) which were formed on the basis of geography. Interlinked with each other and bonded by both industrial and geographic relations, their activities and functions centered on *huiguan*.

11.4.6.4 Merchant *Hangbang*

Merchant *hangbang* in Jingdezhen consisted of porcelain shops and porcelain merchants who were closely related and coexisted in one *hangbang*. In the late Ming and early Qing period, a porcelain merchant *gongsuo* of eight factions was established in the Suhu Huiguan, comprising the eight factions of Ningbo, Shaoxing, Guandong (northeast China), Echeng, Guangdong, Tongcheng and Suhu (Suzhou and Huzhou). According to estimations in the early Republican era, based on birth places or places

adjacent to one's birthplace, merchants in Jingdezhen from outside of town could be categorized into 26 groups. For Hubei Province alone, there were seven sub-factions of counties or villages which boasted abundant wealth such that they secured equal positions as provincial level *hangbang*. These 26 groups were Chuanhu, Henan, Guandong, Tongcheng, Liangkoubang, Guangdong, Suhu (Suzhou and Huzhou), Ningshao (Ningbo and Shaoxing), Nanchang, Neihe, Gunan, Kangshan, Yangzhou, Guoshan, Jindou, Fengxi, Xiaogan, Tongqing, Tongxin, Makou, Huangma, Sanyi, Liangzitianjin, Hunan and Jiujiang. These also belonged to one of three *zabang*, namely Du, Wei or Za. They all experienced both conflict and cooperation with each other, and there were more *hangbang* to emerge in the future. These organizations played an active role in Jingdezhen's communication and exchange with the outside world and dominated the transportation and marketing of Jingdezhen porcelain.

11.4.6.5 Master Handicraftsmen's *Hangbang*

The Jingdezhen ceramics industry incorporated a detailed division of labor in various sectors. To differentiate the sectors, there were eight industries and 36 branches. Among the 36 branches, there were kiln work, furnace filling, building and repairing furnaces, and porcelain firing; paste making including blue and white porcelain, famille-rose porcelain, *linglong* porcelain and polychrome porcelain; brick making and large and small sagger making; hay packing and transportation; repair; some 11 service industries which boasted an abundant labor force of individuals who had either mastered specific skills or who were physically fit, including the most prominent sedan service. Workers from these industries had some privileges to themselves. For example, workers in the sagger and brick industry had access to a prostitute for free or a perk from the gambling houses. The major bosses of *hangbang* could open gambling houses and offer loans to make money. These industries had strict rules and insiders were not allowed to release industrial information to outsiders, especially technological secrets. In some industries, skills and techniques were only passed on to sons and grandsons rather than sons-in-law or granddaughters. Without the permission of industrial leaders, no new members could be recruited and no new policy could be introduced. Each industry usually ran in families. For example, in the ceramic knife industry, there were not only industrial rules in the sector, but clients were even inherited. People in this industry could walk away from any of their clients while clients were not allowed to turn to others for knife making. Ceramic knife shops could even "sell" their clients to others. Thus there was a saying in Jingdezhen that "To get involved in the ceramics industry, you need first to choose a line of business." In fact, the ceramics industry was not alone; every industry required a good choice of sector, or one would be ostracized or victimized, making it difficult to work or do business in Jingdezhen.

Eight industries and 36 branches was a very general categorization. According to the author's long-term field investigation, the number of sectors in Jingdezhen porcelain making far exceeded this. One of the major businesses was *hongdian*, which took charge of overglaze painting. Additionally, "spoons," "*fending*," "engraving"

and "inlaid ware" were not included in the 11 service industries. What is more, in porcelain marketing, there were also porcelain shops and porcelain houses; in the raw materials sector, there were porcelain stone, glaze, limestone, pigment and gilt industries, etc. There were also additional sectors such as brush shops. All these industries had their own *hangbang* organizations. For example, for kilns, there were "*Taocheng*" and "*Taoqing*" *hangbang*, consisting of *chai* kilns (burning pine wood) and *cha* kilns (burning miscellaneous wood). Based on the specific needs of each industry, industrial organizations were set up. For example, there were specific *zhuoqi* guilds, called "*Tongrenyao*," with seven branches, including "*fending*," "*dajian*" (large-sized pieces), "*guan'gai*," "*huashi*" (slippery stone) and "*danmiao*" (light painting), administered by organizations for laborers and organizations for owners.

11.4.6.6 Worker *Hangbang*

Worker *hangbang* were generally categorized by types of work in each industry, and these were subdivided. For example, in the clay making industry, there were throwing workers, hand-pressing workers, paring workers, glazing workers, paste setting workers, and chore men; for the firing industry, there were temperature supervisors, paste carriers, top sagger putters, bottom sagger collectors, chore men and intern potters; in the sagger industry, there were sagger makers, paring workers, chore men, assistant workers, mud haulers, and soil hammering workers. In general, there were various types of work and workers. In order to preserve their own interests, workers established various *hangbang* specific to their sectors, such as "*fenghuoxian*" for firing workers, which organized regular gatherings for members. For those putting small-sized porcelain into saggers, there were "five *fu* and 18 industrial sectors" in the *hangbang*. Five *fu* (an administrative level higher than county) referred to Nanchang Fu, Nankang Fu, Raozhou Fu, Jiujiang Fu and Fuzhou Fu. The 18 industrial sectors covered all sectors in the industry. Each group had several chiefs (also called *shangjieshifu*) who oversaw the affairs of the group. From April 1 to 18 every year in the Chinese lunar calendar, each of these 18 groups would host a gathering and invite people to wine and dine. The group to do so on April 1 was called group No. 1, and on April 2 group No. 2 and so forth. Different groups had different numbers of members. Among them, group No. 10 had the largest number of members, accounting for about one third of the entire industry. There were also workers' organizations for *fending* kilns, *hongyuanshe* for paste making workers, *xingyishe* for paring workers, *yishe* for engravers, *yuelishe* for paste painters, and *juyingshe* for those wearing straw sandals. These five organizations together were known as the "Five Industrial Organizations" which all had revenues from rentals. Heads of these organizations were called head bosses or deputy bosses and they contributed capital to employ workers. As the *zhuoqi* industry was monopolized by *zabang*, and *zabang* were dominated by those from Fuzhou, the *hanghui* of these five sectors were set up in the Fuzhou Huiguan. Employers and employees in the spoon industry each had their own organizations to safeguard their interests. The one for employers was called the "Spoon

Organization" while the one for employees the "Spoon Union." Thus, employers and employees in many sectors had their own industrial organizations and groups.

Although numerous, most of these organizations and groups were under the control of the three major groups which controlled the economic lifeline of Jingdezhen, namely *dubang*, *zabang* and *huibang*. In fact, every aspect of business in Jingdezhen was controlled and monopolized by these three large groups.

With a time-honored history in porcelain manufacturing, the official kilns of Jingdezhen were established during the Ming and Qing dynasties. As foreign trade prospered and demand boomed at home, Jingdezhen became a major porcelain production center. Not only its products, but its production mechanism, including its modes of operation and cultural compositions are all worth studying. Complicated as they are, due to limited space, we are only able to offer a brief introduction here.

11.5 Ceramic Industries Outside Jingdezhen

Though Jingdezhen was the backbone of ceramic development in the Qing Dynasty, kilns outside of Jingdezhen also enjoyed growth during this time. According to statistics, there were over 40 major porcelain producers around the nation during the Qianlong period, in places like the current Hebei, Shandong, Henan, Shanxi, Shaanxi, Sichuan, Jiangsu, Anhui, Fujian, Jiangxi, Hunan and Guangdong. Especially famous were the kilns in Cixian County and Tangshan in Hebei Province, Boshan and Linqing in Shandong Province, Pingding in Shaanxi Province, Qimen in Anhui Province, Liling in Hunan Province, Dehua in Fujian Province, Guangzhou, Shiwan and Chaozhou in Guangdong Province, Yixing in Jiangsu Province, and Rongchang in Sichuan Province. Famous and characteristic varieties produced by these kilns included white porcelain and blue and white porcelain from the Dehua kilns, blue and white porcelain produced in Shaanxi, black glazed porcelain produced in Boshan, underglazed porcelain produced in Liling, Canton porcelain produced in Guangdong, *zisha* wares produced in Yixing, Jun-style wares produced in Shiwan, and *kehuatao* (pottery with floral engravings) produced in Sichuan. We will introduce some representative kilns during this period.

11.5.1 The Yixing Kilns in Jiangsu

Based on the development during the Ming Dynasty, the Yixing kilns experienced new growth during the Qing Dynasty. According to *Chongkanjingxixianshi* (*The Revised Gazetteer of Jingxi County*), Yixing had been a prosperous town with tens of thousands of households prior to the Qianlong period, and the ceramics industry was the pillar industry of the region, thus the area was known as the capital of pottery. In the Qing Dynasty, *zisha* wares, *yijun* wares and daily use pottery all enjoyed rapid progress.

From the Wanli period, Yixing *zisha* wares experienced a boom. After the Qing Dynasty was established, *zisha* wares were no longer playthings of scholars. Instead, thanks to their remarkable craftsmanship, they made their way into the court as imperial tribute. Relevant records can be found in the documents of the inner court of the Qing government, especially during the Qianlong period. The Palace Museum even housed a *zisha* tea caddy engraved with Emperor Qianlong's name, which was part of a set of teawares that accompanied the emperor on his outings. In a rattan plaited box, this set of wares comprised a stove, a pot and a tea caddy, etc. In fact there were more than one set of such teawares housed in the Palace Museum, which suggests they might have been imperial offerings from Yixing to the palace.

The Qing Dynasty saw unprecedented varieties of *zisha* wares. Apart from teawares such as tea caddies and cups, flower *zun*, boxes with chrysanthemum patterns, incense plates, and assorted cups were also produced in large quantities. Potters also liked to make articles in the shape of fruit and gourds, such as water chestnuts, narcissus, sagittaria sagittifolia, peanuts, and upside-down lotus, as well as articles modeled on bronzewares.

Apart from red and purple clays, there were also white, black, yellow, pear-peel, and green clay for *zisha* wares.

During the Kangxi, Yongzheng and Qianlong reigns, numerous *zisha* potters distinguished themselves. For instance, Chen Mingyuan from the Kangxi period, alias Hefeng, also called Huyin, made various tea and decorative wares. His products modeled on fruit and gourds were especially lifelike. Extant *zisha* wares in such a style are basically all modeled on his products. Chen Hanwen, Yang Jichu, and Zhang Huairen from the Yongzheng and Qianlong periods were also very well-known artists from this time.

In past studies on ceramic history, much attention was paid to the Yixing *zisha* wares' important position in the domestic ceramic production arena but little on their export and external influence. From a European road map of Chinese porcelain export routes in the 17th to nineteenth century, only the Jingdezhen, Yixing and Dehua kilns were specially marked, which shows that they were the most impressive and popular producers of Chinese porcelain for European consumers. The Dutch East India Company in Batavia described in 1679 "seven pieces of Zhangzhou red tea caddy pottery," and in 1768 mentions "320 pieces of Macao red tea caddy pottery."[57] In the same year, the "Ternate" was loaded with 1635 tea caddies bound for Amsterdam, which might have been produced in Yixing. In the Netherlands, they were called East India tea caddies or India tea caddies because they made their way there via the Dutch East India Company and Batavia. Similar to those produced in Central America, *zisha* wares were usually known as boccaro/buccaro. Since tea drinking started to gain popularity in Europe around the mid-seventeenth century, there was an increasing demand for Chinese teapots. Gradually, China started to custom-make teapots to European orders, which made teapots one of the major varieties of export porcelain.

[57] T. Volker, *Porcelain and the Dutch East India Company*, p. 216.

Europeans began to import Yixing *zisha* wares from the mid-seventeenth century, which initiated competition between European pottery and Yixing pottery and led to a revolution in the European pottery industry. Ary de Milde from Delft in the Netherlands around 1675, Joseph Elers from Stafford in the UK around 1690, and Johann Friedrich Böttger from Meissen Porcelain around 1710 had all succeeded in producing products modeled after Yixing *zisha* wares.[58]

Yixing *zisha* wares accounted for an important proportion of the collections of Queen Mary II of England. She kept part of her collections of *zisha* wares in Huis Honselaarsdijk, a residence of her husband King William III, who was born in the Netherlands. When Thomas Bowery, a fellow townsman of the Queen visited the Netherlands in 1698, he described the late Queen's residence as "filled with Chinese porcelain and her cloaks were decorated with exquisite red Chinese decorative patterns, very remarkable."[59]

For a very long time, China's secrets regarding the production methods and raw materials of ceramics had always fascinated Westerners. Pehr Osbeck, a Swedish explorer and naturalist, was curious about *zisha* wares. He wrote, "Do we know what brown clay or red clay pottery is made of? Shouldn't we come to China and see with our own eyes how they make it?".[60]

Edward Sylvester Morse (1838–1925), an American zoologist and orientalist, visited Japan and learned archaeology, architecture and art in 1877. In 1880, he settled in Salem and became Chairman of the Peabody Museum in 1914 (predecessor of the Peabody Essex Museum in the USA). When he was in Japan, he acquired a *zisha* teapot for his collection (Fig. 11.115). Covered with green rust, this pot must have been used frequently. One of its feet is in the shape of half a lotus seedpod, with the visible seedpod inside. The lid is in the shape of an inverted mushroom. Around the spout and the upper part of the pot are decorative patterns including watermelon seeds, nuts, lotus seedpods and peanuts. Water chestnut patterns look like bats, which is homophonous with *fu* (meaning blessings) in Chinese, signifying happiness. Besides, water chestnut is pronounced as *lingjiao* in Chinese, with *ling* sounding the same as another Chinese character symbolizing smart or intelligent.[61] For Chinese people, it would be easy to grasp the various symbolic meanings on this pot while for Westerners, it would undoubtedly be difficult. However, Westerners admire how the pot integrates realistic art with the wisdom of the potters. Marked on the pot is a line of poetry declaring that "Water tastes like that of the Three Gorges and the fragrance of the tea is even better than that from Lu'an" which could have

[58] William R. Sargent, *Treasures of Chinese Export Ceramics: From the Peabody Essex Museum.* Distributed by Yale University Press, 2012, p. 222.

[59] Phillip N. Allen, "The Yixing Export of the 17th and 18th Centuries", *Transactions of the Oriental Ceramic Society* 53 (1988/1989), pp. 87–92.

[60] G. J. P. A. Anders, Christiaan J. A. Jöry, W. B. Stern, and N. Anders-Bucher, "On Some Physical Characteristics of Chinese and European Red Wares," *Archaeomentry* 34:1 (February, 1992): 43–52. Terese Tse Bartholomew. I-Hsing Ware. New York, 1977.

[61] William R. Sargent, *Treasures of Chinese Export Ceramics: From the Peabody Essex Museum.* Distributed by Yale University Press, 2012, p. 125.

Fig. 11.115 Yixing *zisha*
tea caddy, produced in the
Jiaqing period, height:
15.9 cm, width: 11.2 cm, in
the Peabody Essex Museum
in the USA

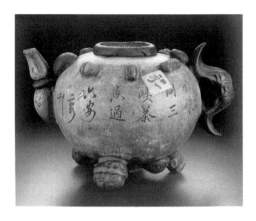

Fig. 11.116 Yixing teapot
with silver ornament,
produced in the Kangxi
period, height: 10 cm, width:
18 cm, in the Peabody Essex
Museum in the USA

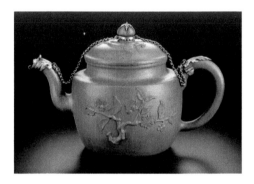

been adapted from a similar line. Western scholars hold that the engravings on the
pot were created by Shao Erquan, a famous *zisha* potter in China.[62]

Here is the story of its origin. In around 1816, Chen Mansheng (alias Chen Hong-
shou, 1768–1822), a Qing official and scholar, was appointed Head of Liyang County
in the Yixing area. Chen was a big fan of pottery teapots and he hired some superior
artisans to attempt innovation, including one called Shao Erquan. Shao was one of
the best potters at the time and was especially good at calligraphy and engraving. As
a celebrity, his works were often imitated by later generations, so the engravings on
this pot might not necessarily derive from his hand.

The tea caddy illustrated in Fig. 11.116 has a plum blossom tree pattern on both
sides and a dragon surrounding the knob. An export product from China to Europe,
this pot had a silver ornament linking the spout, the knob and the handle added in
order to display its value.

Due to their popularity, *zisha* teapots were not only widely imitated by European
potters in the 17th and early eighteenth century, but also remained in use in Europe
until the mid-nineteenth century. As a matter of fact, the charm of Yixing *zisha*

[62] See Footnote 61.

Fig. 11.117 A Dutch *zisha* teapot, produced from 1680 to 1700 (in the Kangxi period of the Qing Dynasty), height: 10.5 cm, width: 13 cm, in the Peabody Essex Museum in the USA

wares has enchanted potters around the world, which explains why they are widely and frequently.

The artifact in Fig. 11.117 was the work of a Dutch potter called Ali De Milder, the first one to successfully produce products modeled on Yixing *zisha* wares. A gold chain with pearls was added to link the knob and the handle.

The phoenix-shaped *zisha* pot in Fig. 11.118 was made by Johann Friedrich Böttger from Meissen Porcelain who started copying the style of Chinese ceramics from around 1710, beginning with phoenix-shaped *zisha* pots and then phoenix-shaped porcelain. In his work report of 1734, Johann Joachim Kändler described how Meissen Porcelain Manufactory modeled phoenix-shaped *zisha* teapots. The ornament on the knob looks like a sun rising from the sea and the tail of the phoenix becomes the handle of the pot. Such pots could only be used as wine pots or simply for decorative purposes.[63]

From the above discussions we can see that apart from the Jingdezhen and kilns coastal kilns, Yixing pottery was also very influential on the international market. The author holds that this should be attributed to the fashion of tea drinking in Europe at the time.

11.5.2 The Shiwan Kilns in Guangdong

From the early to the mid-Qing Dynasty, thanks to social and economic progress, people had increasingly high standards in decorations on architecture (including temples and ancestral halls) which led to the rapid progress of the Shiwan kilns in Guangdong. For example, with the massive production of architectural ornaments, such as ridge tiles, various motifs and complicated techniques were developed and

[63] William R. Sargent, *Treasures of Chinese Export Ceramics: From the Peabody Essex Museum.* Distributed by Yale University Press, 2012, p. 126.

Fig. 11.118 German-made phoenix-shaped *zisha* pot, produced in 1710 (during the reign of Emperor Kangxi), height: 11.2 cm, width: 15.2 cm, in the Peabody Essex Museum in the USA

by the mid-Qing period, there were specific workshops producing ridge riles, such as "*Wenrubi*," "*Wuqiyu*," "*Quanyucheng*," "*Meiyu*," "*Yingyu*" and "*Junyu*."

Before the Ming Dynasty, the Shiwan kilns mainly produced daily use articles such as boilers, bowls, plates, pots, vats, *shapen* (a utensil used by the people of Guangzhou), and flower pots, which were mainly sold within Guangdong Province and beyond to Guangxi, Fujian, Shanghai, etc. During the Zhengde period of the Ming Dynasty, the Lun family of Haikou, Shiwan, built a new type of furnace called the *nanfengzao*, which was energy-efficient and temperature-controllable, thus replacing the old *longyao* (dragon-shaped furnaces). This greatly aided a rise in production, a realization of technical breakthroughs and eventually contributed to the production of color painted pottery, rather than the simple monochrome wares which were dominated by blue. The Shiwan kilns entered a most glorious era during the Qing Dynasty. Under the reign of Emperors Qianlong and Jiaqing, based on the ceramics industry, Shiwan had become a major town in Nanhai County where trade and commerce prospered and flourished. "The prosperity of Nanhai County did not lie in people, but in Shenghui, Foshan and Shiwan." The booming commercial economy further contributed to the rapid growth of the ceramics industry in Shiwan. According to records, "In its heyday, Shiwan was home to 107 kilns employing 60,000 workers"; "Among the 6000–7000 households in Shiwan, about 50–60% were engaged in the ceramics industry." The ceramics industry in Shiwan increased from eight lines of business in the Ming Dynasty to 28 in the late Qing and early Republican era. There were about a thousand ceramic shops, and over a thousand kilns, with over 60,000 people depending on this industry directly or indirectly for their livelihoods. Shiwan ceramics offered a variety of products and found wide applications in almost all sectors of people's lives. In the Pearl River delta, household decorative appliances, architecture, and daily use articles were all closely associated

with Shiwan ceramics.[64] At this time, the Shiwan ceramics industry had entered a boom period of growth, with an expanding work force, and a greater variety of products and increased production. Based on the type of product, *"hanghui"* (industrial organizations) were founded as private and independent management agencies, and strictly ensured that cross-sector production was prohibited. Major *hanghui* in Shiwan included the *"chabaohang"* (teapot industry), *"dapenhang"* (big basin industry), *"ganghang"* (vat industry), *"guwanhang"* (antique industry), as well as the "flowerpot industry." According to statistics, by the late Qing Dynasty, there were as many as 26 *hanghui* spanning various sectors.[65]

One distinguishing characteristic of the Shiwan kilns was that they were good at imitating products of other famous kilns, including the Longquan, Ge, Cizhou, Jizhou, and Jian kilns, as well as famous products like tricolor porcelain of the Tang Dynasty. Especially famous were their imitation Jun wares. The history of the Shiwan kilns' imitation of the Jun kilns can be categorized into four parts. From the mid-Ming period to the early Qing Dynasty was the initial period when mainly ancient-style vessels were modeled on the Jun kilns, including *xi* (a washing utensil), vases, pots, plates, *zun* and tripods. Dominated by blue and red, the Jun wares' glaze style was also copied and gradually became the feature of traditional varieties of Shiwan products. From the mid- to late Qing was their boom time when apart from vessels and utensils, purple glaze (aubergine glaze) and *shannianhong* red glaze were also invented. In addition, pottery sculptures became the mainstream product, including human figures, animals and real objects.[66]

The Shiwan kilns were not only good at "imitating," they also attached great importance to innovation, therefore their Jun-style ceramics had clear differences with the originals. For example, Jun porcelain was dignified and in good taste while Jun-style porcelain produced in Guangdong offered more varied shapes, which mainly included vessels and sculptures, and boasted high ornamental value. For vessels, there were ancient-style plum vases, *cong*-shaped vases, olive-shaped vases, garlic-head-shaped vases, *yuhuchunping*, *shuangerping* (vases with double lugs), flower receptacles, wall vases, gall bladder vases, flasks, melon-shaped vases, and double fish vases as well as stools in drum, square, octagonal, or hexagonal shapes. For sculptures, there were monks as well as other figures from all levels of society,

[64] Huang Weihong, "Production and Export of the Shiwan Kilns in Guangdong," Chinese Society for Ancient Ceramics (ed.), *Studies on Ancient Chinese Ceramics* (Vol. 14), The Forbidden City Publishing House, 2008, p. 346.

[65] Huang Jing, "Discussion on Guang Jun: Good Imitations of Jun Ware," Chinese Society for Ancient Ceramics (ed.), *Studies on Ancient Chinese Ceramics* (Vol. 11), The Forbidden City Publishing House, 2005, p. 199.

[66] Huang Jing, "Discussion on Guang Jun: Good Imitations of Jun Ware," Chinese Society for Ancient Ceramics (ed.), *Studies on Ancient Chinese Ceramics* (Vol. 11), The Forbidden City Publishing House, 2005, p. 200.

Fig. 11.119 A sculpture of
Mi Fu (a Chinese painter,
poet and calligrapher in the
Song Dynasty), produced in
the Qing Dynasty, height:
16.6 cm, in the Guangdong
Museum

whose main feature was vividness, with even their clothes and wrinkles lifelike and
their hands and faces unglazed.[67] (Fig. 11.119).

In addition, Shiwan's Jun-style glaze appeared rich, with the best in blue, rose
violet, *mocai* and *cuimaoyou* (feather blue glaze). The main features of such products
were heavy bodies, dark bisque, and rich and glossy glazes which were close to those
of the Jun kilns, demonstrating the technical level of the Shiwan kilns. However,
Shiwan's imitation of the Jun kilns was not mechanical. Instead, they innovated as
they imitated. For example, the fambe glaze of the Jun kilns had only one layer while
the Shiwan Jun-style glaze had two layers, one as a base and one as a surface, usually
in rust color, which served to fill in the pores on the surface of the bisque and reduce
the consumption rate of the surface glaze such that the glaze on the base and surface
inter-penetrated each other and the color of the glaze was intensified, producing a
smooth and glossy surface.

Among the Jun-style glazes, there was a prominent variety called "*yulinqiang*"
(rain splashing on walls), which looked like white raindrops on a blue glazed back-
ground. Beautiful and varied as it was, it was like a squall suddenly appearing in a
clear summer sky.

After the mid-Ming period, the Shiwan ceramics industry enjoyed rapid devel-
opment and became the pillar industry in the region, and its products were exported
in huge volumes. In the Ming and Qing dynasties, among the porcelain exports
shipped through the Port of Guangzhou, those from Shiwan were second only to
Jingdezhen.[68]

[67] Huang Jing, "Discussion on Guang Jun: Good Imitations of Jun Ware," Chinese Society for
Ancient Ceramics (ed.), *Studies on Ancient Chinese Ceramics* (Vol. 11), The Forbidden City
Publishing House, 2005, p. 201.

[68] Huang Jing, "The Guangdong Maritime Silk Road and Ceramics Exports," Chinese Society
for Ancient Ceramics (ed.), *Studies on Ancient Chinese Ceramics* (Vol. 14), The Forbidden City
Publishing House, 2008, p. 326.

11.5.3 The Dehua Kilns in Fujian

11.5.3.1 White Porcelain

The Dehua kilns continued to grow in the Qing Dynasty on the basis of their development in the Ming in terms of both production quantity and variety. During the Ming Dynasty, Buddhist offerings and sculptures, such as Disciples of the Buddha and Avalokitesvara, were the major products of the Dehua kilns. By the Qing period, while these were still produced in large numbers, daily use articles such as various wine cups, vases, pots, bowls and *xi* were also generally made.

By the Qing period, compared with that of the Ming Dynasty, Dehua white porcelain had a distinctively different feature. Its glaze was no longer slightly reddish, but rather, "oil white." It was also a little bluish, which might have been caused by an increased amount of iron oxide or poor control during the reduction firing.

From the late Ming Dynasty, Dehua porcelain had been exported to South East Asia and Europe and by the early Qing Dynasty, its export had further expanded. In the early Qing period, though all export porcelain traveled overseas through the Port of Guangzhou, already a famous brand on the international market, the Dehua kilns continued to receive constant orders.

The Dehua kilns were famous for its sculptures. By the Qing Dynasty, they started to produce sculptures earmarked for export to the Western market, including sculptures of famous Western merchants, their families and the Virgin Mary. Meanwhile, articles of practical use produced for the domestic market, such as tea caddies, large shallow plates, and incense burners, have also been found among the collections of European collectors and collectors in other regions. In addition, the Meissen Porcelain Manufactory in Germany and the Chelsea Porcelain Manufactory in the UK as well as other porcelain manufacturers in Europe had all copied from the Dehua kilns, which further indicates the popularity of Dehua porcelain in the West.

The wine cup illustrated in Fig. 11.120 is a representative of Dehua products which, boasting various varieties, had been produced in large quantities and exported to Europe. In Europe, they were often taken as treasures to be exhibited or embellished with silver or gold ornaments. This cup is engraved with relief plum or magnolia blossom, and its twig forms the base of the cup. This is a typical decorative pattern for such cups. The gilt ornamentation on the cup has no markings, and it might have been put on between 1750 and 1800 in France.

There are records regarding cups of similar design. A similar cup appears in the still life painting of Leonard Knijff (1650–1721), a Dutch draughtsman and painter, only without any ornament. In his *Portrait of Mrs. Brian* (1750), Jacques-Andre-Joseph Aved (1702–1766), a French painter, depicts a large wine cup in his painting. The Dresden Porcelain Collection of the Dresden State Art Collections also houses 10 such cups, with some gilded and some not. The "Dashwood", an East India Company ship, also listed 2335 "white cups," 540 "white teacups," and 940 "cups with Hua Mulan patterns" (a legendary female Chinese warrior) in its inventory. These cups could be products of the Dehua kilns. Some 43 similar cups were also listed among

the inventory of Augustus II the Strong, King of Poland in 1721. Three years later, similar cups produced by Meissen and Saint Claude modeled on Dehua cups were also found on the inventory records of Philippe II, Duke of Orléans.[69]

Illustrated in Fig. 11.121 is a set of French-style candle holders with twigs composed of Dehua cups, which is known as *cande-labres* in French or *cande-labra* in English. In the middle of the candle holders, several Dehua cups are placed together mouth to mouth and bottom to bottom. The triangular base is built of three Dehua kiln-shaped wares. On top of the holder, there is a figure seated on the back of a lion with a flute on his back. Apart from the Dehua cups, other parts, including the holder, the tray, the base and the gilded and inlaid ornaments were all made in Europe.

Illustrated in Fig. 11.122 is a pomegranate-shaped teapot produced in Dehua as an export in the late 17th to the early eighteenth century. Made from two molds, this pot has a clear line in the middle. Tea leaves and twigs are nailed into the pot. Approaching from the handle, tea twigs end in the body and link with the lid, and through the lid are connected with twigs around and under the spout. After being exported to Europe, such pots were seen as precious collectables by Europeans and Western porcelain factories tried to copy their style. Many teapots had silver ornamentation further added. Johanneum recorded in 1721 that there were five such teapots in the Japanese Palace of the Dresden State Art Collections (N5–N9), one of which had a bronze chain affixed and another a bronze inlaid ornament.[70]

Apart from daily use white porcelain, the Dehua kilns also exported large numbers of porcelain sculptures to Europe during the Qing Dynasty. The Dehua kilns were

[69] William R. Sargent, *Treasures of Chinese Export Ceramics: From the Peabody Essex Museum.* Distributed by Yale University Press, 2012, p. 204.

[70] William R. Sargent, *Treasures of Chinese Export Ceramics: From the Peabody Essex Museum.* Distributed by Yale University Press, 2012, p. 206.

Fig. 11.121 A set of gilded
Dehua white glaze porcelain
candle holders, produced
from the Kangxi to Qianlong
periods, height: 39.8 cm, in
the Peabody Essex Museum
in the USA

Fig. 11.122 Dehua white
teapot, produced in the
Kangxi period, height:
9.5 cm, width: 13.3 cm, in
the Peabody Essex Museum
in the USA

adept at making sculptures and it was not difficult for them to transform their produc-
tion techniques in making Avalokitesvara and Disciples of the Buddha sculptures into
producing European-style sculptures for export. At times the traditional Chinese
style was even combined with the Western religious style in producing sculptures.
For example, Fig. 11.123 is a sculpture of Avalokitesvara holding a child in her arms.
In China, people tend to pray to Avalokitesvara for children and when Avalokitesvara
and children are painted together, it usually symbolizes the wish for Avalokitesvara to
give a family one or more children, or to protect children. Many European merchants,
out of curiosity, purchased statues of Avalokitesvara produced by the Dehua kilns.
Meanwhile, many European businessmen also purchased them because of the simi-
larity between Avalokitesvara and the Virgin Mary. In order to cater to the market
demand, Dehua potters made some adjustments to the Avalokitesvara statues based

Fig. 11.123 Dehua
sculpture of "Virgin Mary
and the Holy Son", produced
in the Kangxi period, height:
33.6 cm, in the Peabody
Essex Museum in the USA

on the image of the Virgin Mary and the Holy Son by putting a cross on the neck of Avalokitesvara and changing the gestures of the hands of the child.[71]

Apart from religious patterns, there were many motifs reflecting family life on the Dehua sculptures exported to Europe. For example, there is a set of sculptures of a family in Fig. 11.124. While in the eyes of Europeans it might have appeared difficult to manufacture, this was not the case for the Chinese porcelain artisans. As early as the Han Dynasty, Chinese potters had been producing voluminous sets of sculptures. In order to make such products, the Dehua potters adopted double-mold techniques, which were also applied in the making of the "Dutch family" sculpture illustrated here. The hats worn by the two men in the statue were made separately, as were the two children. With the two children dressed neatly and properly in the sculpture, it was no doubt an ideal family. In making this piece, two molds were required, with different table articles in each mold. For example, there is a bowl with food on the table in this sculpture while the other has a chessboard and a chess box. In the winter of 1701, many such "Dutch family" sculptures were listed on the inventory of the "Dashwood," a ship of the British East India Company.[72]

Despite being recorded as "Dutch family" in the British inventory list, according to Christiaan J. A. Jörg, the term "Dutch family" represents Westerners. The reason they are called "Dutch" is because it was Dutch merchants who usually purchased porcelain from China and shipped products to the European markets via Batavia. Though direct documents supporting this view are yet to be identified, this opinion

[71] William R. Sargent, *Treasures of Chinese Export Ceramics: From the Peabody Essex Museum.* Distributed by Yale University Press, 2012, p. 207.

[72] William R. Sargent, *Treasures of Chinese Export Ceramics: From the Peabody Essex Museum.* Distributed by Yale University Press, 2012, p. 209.

Fig. 11.124 Dehua "Dutch family" sculpture, produced in the Kangxi period, height: 15 cm, width: 16 cm, in the Peabody Essex Museum in the USA

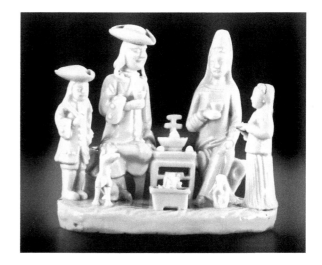

Fig. 11.125 Dehua "player" sculpture, produced in the Kangxi period, height: 15.3 cm, width: 9 cm, in the Peabody Essex Museum in the USA

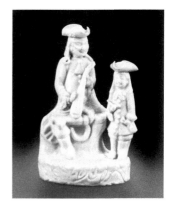

could certainly explain some of the outstanding questions regarding the origin of the term "Dutch family."[73]

From such statues we can see how Chinese culture has influenced the Western world. In Fig. 11.125, a man is playing a *pipa* and a child is standing next to him with a long pipe in one hand and a handkerchief in the other. The *Pipa* is a four-stringed Chinese musical instrument. In China, *Qin* (*guqin*), *Qi* (game of Go), *Shu* (calligraphy) and *Hua* (painting) are regarded as necessary skills of well-educated scholars. Here we can see that Europeans also mastered the skill of playing the *pipa*. Alternatively, this article might have been ordered by European merchants and custom-made by Dehua potters for the purchasers to pose as admirers of Chinese culture.

[73] William R. Sargent, *Treasures of Chinese Export Ceramics: From the Peabody Essex Museum.* Distributed by Yale University Press, 2012, p. 210.

Fig. 11.126 Dehua "Dutch
man and monkey" sculpture,
produced in the Kangxi
period, height: 33.6 cm,
width: 12.2 cm, in the
Peabody Essex Museum in
the USA

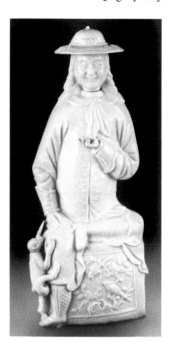

Figure 11.126 is a sculpture of a Western-style Dutch man made by the Dehua
kilns. The Dutch man is sitting on a stool painted with traditional Chinese flower
and bird patterns, while a monkey is clearly attracted by a banana in his left hand
and trying to jump up and climb onto his right leg. The back of the artifact is not
glazed. Its open base suggests that it was made with a thin plate. The body of the
man is made with two molds and his curly hair is even part of one of the molds. The
monkey, his hat, hands and head were added later. For a long time, such Western
figures were always termed Dutch people. In 1703, among private products loaded
onto the "Dashwood," there were artifacts termed "Dutch family," "Dutch cavalry"
and "Dutch people."

During the Age of Discovery and European expansion, the monkey was a popular
animal and was usually regarded as a pet and taken back home to the European
continent as a symbol of world travel and distant shores. From the 17th to the early
eighteenth centuries, monkey patterns were frequently applied to European paintings,
interior designs and folk paintings, as a demonstration of the wealth and knowledge
of a family. It also symbolized the aspiration of Europeans for the distant Asian life.[74]

[74] William R. Sargent, *Treasures of Chinese Export Ceramics: From the Peabody Essex Museum.*
Distributed by Yale University Press, 2012, p. 212.

11.5.3.2 Blue and White Porcelain

In the Qing Dynasty, the Dehua kilns continued to produce blue and white porcelain in large quantities. In the late Ming Dynasty, when Dutch colonists took over Taiwan, Taiwan was used as a hub by Dutch merchants to transfer porcelain made in Fujian and bound for export destinations all over the world. Blue and white porcelain had been a major export product at this time. Situated in Fujian Province and adjacent to Taiwan, the Dehua kilns enjoyed a favorable geographic location for the Dutch merchants to purchase and export porcelain products. Some scholars hold that as blue and white porcelain became a major export variety, the traditional Dehua white porcelain declined in terms of quality. In *Minchanluqi*, Guo Baicang from the Qing Dynasty writes that "The Dehua kilns in Dehua County were famous for white porcelain. Before the Shunzhi period, Buddha statues, *zun*, *lei* (an ancient vat-shaped wooden wine-vessel), vases, plates, saucers and *jia* (an ancient bronze wine vessel) produced by the Dehua kilns were all very exquisite and delicate, with their color a little pinkish white. Dehua porcelain was also still extremely expensive. However, Dehua Buddha statues were not as good as those produced in 'Hetai' while the quality of its vases and plates was not as good as those produced by the Ding kilns. Featuring thick, coarse bodies and smooth, thin glaze, Dehua wares gradually lost favor in the market." Zhou Lianggong from the late Ming and early Qing period also recorded in *Minxiaoji* that "Porcelain wares produced by the Dehua kilns in Fujian Province feature delicate designs and exquisite workmanship. When I first used a Dehua cup to drink tea, it was colorless. I blamed my attendant for his poor skills in serving tea. Following a change of hands, it remained so. A friend told me that 'If you replace it with a Jingdezhen cup, it would look a refreshing green.' I followed his advice and it turned out to be true. From this, we can see that Dehua wares at this time were already falling behind their predecessors, featuring heavy and clumsy bodies and poor colors." However, according to the author's investigations into foreign documents in English, while Dehua white porcelain produced in the Qing Dynasty was not as good as that produced in the Ming Dynasty, European merchants, especially Dutch merchants still mainly purchased white porcelain from Dehua rather than blue and white porcelain. Thus, it seems Dehua blue and white porcelain was not earmarked for the European market, but for the Asian and African markets.

As Dehua white porcelain declined in quality, in order to meet the foreign demand for blue and white porcelain, the Dehua kilns strove to produce blue and white porcelain with the help of Jingdezhen potters who, due to their suffering from wars and plagues in the late Ming period, had difficulties in making a living in Jingdezhen where the export of porcelain was struggling, and were forced to relocate to the southern Fujian region. With the technical expertise of the Jingdezhen potters and the favorable geographic location of Dehua, the Dehua kilns' export of blue and white porcelain experienced rapid development.

During the Shunzhi and Kangxi periods of the early Qing Dynasty, propelled by internal and external factors, Dehua blue and white porcelain was produced in large quantities and became a major variety in the Dehua ceramics industry. According to research, 177 blue and white kiln relic sites have been identified in Dehua County,

the largest on record. Among them, over 70 sites focused on export. Almost all Qing kiln sites that have been identified so far have been confirmed as blue and white porcelain producers, demonstrating an unprecedented production scale and capacity. What is worth noting is that Dehua blue and white porcelain not only affected blue and white production in the Yongchun and Anxi kilns along the Jinjiang River (they produced in similar style to the Dehua kilns), but also to some extent stimulated the production of blue and white porcelain in the entire Fujian Province due to the flow of Dehua potters. Dehua blue and white porcelain produced in the Qing Dynasty has been excavated from many ruins in Fujian and Taiwan, even in the Penghu Islands. There are also many pieces in private collections. However, not much has been found on the mainland (very few pieces have been reported), and so we can confirm that a large proportion of Dehua's blue and white porcelain was produced to supply the markets in the neighboring and adjacent regions.[75]

a. Production Periods and Sites

The production of Dehua blue and white porcelain may be divided into several stages, namely initiation, flourishing, boom, and decline. The initiation period spanned from the mid-Ming period to the Shunzhi period of the early Qing Dynasty, when production of blue and white porcelain was on a trial basis. Major kilns in this period were mainly located in Xunzhong and Sanban in Yongchun, and Gekeng which bordered with Youxi County, represented by the Dongtou kilns in Xunzhong, Qudougong kilns in Longxun, and the Xiacangwei, Shifang, Shuangxikou and Sutian kilns in Gekeng. However, not many extant wares have been identified from this time, probably because of its limited production. The flourishing period was in the early Qing Dynasty when the Qing court, under the reign of Emperors Kangxi, Yongzheng and Qianlong, issued maritime bans, thus prompting coastal residents and capital to flow inward, facilitating ceramic development in Dehua. Looking through the local family trees, we can see that almost every household in Dehua and the neighboring regions was engaged in the ceramic business. During the busy farming seasons, people worked on farmland and during the off-season, they engaged in the ceramic business. In local gazetteers, there were also laudations by local officials and scholars of the flourishing ceramics industry. Major kilns at this time were mainly situated in Xunzhong, Sanban and Shangyong, represented by the Shipaige, Housuo and Dongtou kilns from Xunzhong, the Xin and Meiling kilns from Sanban, the Houliaoan kilns from Shangyong and the Niutouweishan kilns in Yangmei. The boom period was in the mid- and late-Qing periods, during the reigns of Emperors Jiaqing and Daoguang. Blue and white porcelain dominated ceramic production during this time and kilns could be found in most villages all over the county. With a voluminous production, high quality and various decorative motifs, much of the blue and white porcelain from this period has been passed down. The Dehua blue and white porcelain at this time was very similar to that of the Jingdezhen kilns. The period of

[75] Li Jianan, "Research on the Production and Circulation of Ancient Blue and White Porcelain in Fujian Province from the Perspective of Archaeological Discovery," Chinese Society for Ancient Ceramics (ed.), *Studies on Ancient Chinese Ceramics* (Vol. 13), The Forbidden City Publishing House, 2007, p. 204.

decline ranged from the late Qing period to the Republican era. Blue and white porcelain at this time featured light colors, poor motif structures and clumsy designs. In addition, other varieties of porcelain also came into being during this time and the major operating kilns were located in the eastern region and represented by the Qianou, Chalin'an, Dongtou and Lingdou kilns in Xunzhong and the Shangliao kilns in Sanban.[76]

b. Modes of Production

The blue and white kilns in Dehua usually occupied an area of no more than a few hundred square meters. Such relatively small sizes indicate that at the time, kilns were basically small-scale organizations. In the 1950s, in Baomei Village, Xunzhong, Dehua County, almost every household was engaged in the ceramic business. During the busy farming seasons, people worked on farmland and when farming was slack, they worked in the ceramic business. However, in Dehua, *jieji* furnaces (also called Dehua furnaces, similar to dragon-shaped furnaces) were used for firing, which were very costly. Thus, a means of production featuring "making paste separately and firing together" was devised. In this way, every household, as a workshop, produced paste themselves. When there was enough paste, several workshops put their paste together for firing. It was said that this method was quite "ancient." In fact, this method of production could also be found in Jingdezhen as there were workshops dedicated to making paste and others dedicated to firing. But the difference was that Jingdezhen serviced a larger market, thus requiring a more professional division of labor. So even though the Jingdezhen ceramics industry had been integrated with agriculture before the Yuan Dynasty, from the Ming and Qing periods, ceramic production was entirely independent.

c. Production Techniques

The furnaces used for blue and white production in Dehua mainly included dragon-shaped furnaces and *jieji* furnaces. Dragon-shaped furnaces were usually built on mountains with a slope and looked like a dragon breathing fire, hence the name. Such furnaces could be heated and cooled easily, used for fast-firing and could sustain reduction firing. *Jieji* furnaces, a specific kind of furnace unique to Fujian, were developed on the basis of the chamber-based dragon-shaped furnaces of the Song and Yuan dynasties. In terms of shape, *jieji* furnaces no longer looked like dragon-shaped furnaces, but appeared like several bun-shaped furnaces linked together.

To fire, each piece of ware was put into a single sagger, thus appearing very neat. In addition, when firing blue and white wares it was very popular in the Dehua kilns to place the items mouth to mouth, and especially for small saucers and cups, thus they were usually unglazed on the rims. In pad firing, bedders were usually applied, instead of sand, which was adopted by other kilns in Fujian. When sand was used as a pad in firing, it helped increase the room for loading. However, after firing, a

[76] Chen Jianzhong & Zeng Pingsha, "Discussion on Quanzhou Blue and White Porcelain and Related Issues," Chinese Society for Ancient Ceramics (ed.), *Studies on Ancient Chinese Ceramics* (Vol. 13), The Forbidden City Publishing House, 2007, pp. 210–211.

circle of grit was often left on the bottom of products, making them known as blue and white wares with a gritty bottom.

d. Decoration and Design

The development of Qing Dehua blue and white porcelain was based on its own historical character and the influence of the Jingdezhen and other kilns in the southern Fujian region. In terms of shape, there were articles of practical use, such as bowls, plates, cups, and saucers, as well as decorative wares like vases, *zun*, incense burners, and flower *zun*. Motifs commonly seen were animals, plants, landscapes, human figures and poetry. With various motifs and free-style paintings, Dehua blue and white porcelain boasted typical artistic features of the private kilns. Its blue color was mainly gray blue as well as the occasional bright blue, and the surface displayed a glazing effect. When heavily applied, colors would occasionally reveal dark spots. For inscriptions, double characters were the most frequently seen, and there were also single-character inscriptions, auspicious inscriptions, signatures, marks of years, or seals. One special feature of Dehua blue and white porcelain was that, based on the Dehua kilns' advantages in producing white porcelain, the paste of blue and white porcelain was especially white, which gave full play to its blue paintings. Though varied, Dehua blue and white porcelain was dominated by articles of practical use, such as bowls, saucers, plates, vases and incense burners, while statues were few.

Dehua blue and white porcelain was clearly affected by Jingdezhen in terms of motif and painting. However, compared to Jingdezhen, motifs on Dehua wares, even identical motifs, appeared more rigid and graphic (Figs. 11.127, 11.128 and 11.129). But there were also some items which featured vivid motifs, like the plate in Fig. 11.130. There were also some bowls and plates painted with paneled flowers, reminiscent of Ming "Kraak wares," only more graphic and simpler. Probably due to an increased market demand, Dehua wares featured easily mastered motifs, which saved time in the making (Figs. 11.131 and 11.132).

e. Foreign Trade

The Dehua kilns were adjacent to several of the important foreign trade ports in the southeast coastal regions of ancient China, including the ports of Fujian, Quanzhou, Zhangzhou, and Xiamen, where large volumes of Chinese porcelain flowed overseas from the Song and Yuan dynasties. Therefore, apart from the domestic market, Dehua products were traditional export wares. In 1684, the 23rd year of Kangxi's reign, the Qing court lifted the maritime ban, facilitating the rapid growth in production and export of Dehua blue and white porcelain.

As a matter of fact, Dehua blue and white porcelain was, to some extent, mainly produced for the overseas market in the Qing Dynasty. From the distribution of kiln sites in Dehua, we can see that most kilns were situated on the riverside. For example, in Shangyong, the kilns were mainly located on either side of the Dazhangxi River and its tributaries, which made it easy to transport porcelain wares to the ports of Anping and Fuzhou, and thence overseas. Dehua blue and white porcelain was mainly earmarked for the Asian and African market, not the European market. In

Fig. 11.127 Dehua blue and white plate with "*Bon voyage*" pattern, produced in the Qing Dynasty, diameter: 23 cm, in a private collection

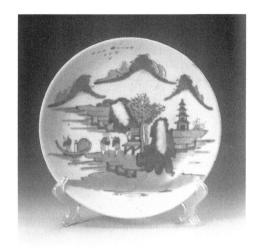

Fig. 11.128 Dehua blue and white plate with "Visiting one's friend carrying a *qin*" pattern, produced in the Qing Dynasty, diameter: 26 cm, in a private collection

recent years, large amounts of Dehua blue and white wares have been excavated in Tanganyika (now Tanzania), in East Africa, and Syria in Asia. According to the investigations of some foreign experts and scholars in Dehua, and research materials that were presented after viewing unearthed articles from Dehua, new batches of blue and white wares have been discovered in Indonesia, India, Sri Lanka, Vietnam, Cambodia, Thailand, the Philippines, and Singapore.[77] Based on this, is it possible that due to a poorer quality and prestige than that of Jingdezhen, Dehua wares were

[77] Ye Wencheng & Luo Lihua, "Several Issues regarding Blue and White Porcelain of the Dehua Kilns," Editorial Committee of *Collected Papers on Studies on Dehua Porcelain* (ed.), *Collected Papers on Studies on Dehua Porcelain*, 2002, p. 203.

Fig. 11.129 Dehua blue and white plate with golden pheasant, produced in the Qing Dynasty, diameter: 27 cm, in a private collection

Fig. 11.130 Dehua blue and white plate with "Drinking tea in the morning" pattern, produced in the Qing Dynasty, height: 4.5 cm, diameter: 20.9 cm, foot rim diameter: 12.1 cm, in the Dehua Ceramics Museum in Fujian Province

Fig. 11.131 Dehua blue and white paneled plate in Kraak style, produced in the Qing Dynasty, in the Dehua Ceramics Museum in Fujian Province

Fig. 11.132 Dehua blue and white bowl with paneled flowers, produced in the Qing Dynasty, height: 16.6 cm, diameter: 39.4 cm, foot rim diameter: 14.9 cm, in the Dehua Ceramics Museum in Fujian Province

exported to meet the demands of a market that could not afford Jingdezhen blue and white porcelain?

There were few Dehua blue and white wares among export wares to Europe. But what seems strange is that while Dehua blue and white porcelain was rarely exported to Europe in the Qing Dynasty, as mentioned previously, its white porcelain was still very much exported to Europe, especially to the Netherlands. This is because Dehua is very close to the Port of Xiamen. In 1544, Portuguese merchants had set foot in Xiamen, and in 1624, Dutch merchants came to Xiamen and dislodged their Portuguese counterparts and set up their own trading service. Later, British merchants also came to Xiamen to do business. So, we can see that Xiamen was an important trading port for the European merchants' porcelain trade. From the map of maritime trade routes of porcelain in the Ming Dynasty, we can see that Europeans listed the Dehua kilns as one of China's three major porcelain producers. The author holds that this might be closely related to the role of the Port of Xiamen as a major trading port at the time. This author once viewed a blue and white plate painted with a panorama of Xiamen in the Qing Dynasty in the Peabody Essex Museum which might have been a product custom-made by Dehua or Jingdezhen potters on the orders of Dutch merchants since the top of the plate was inscribed with "Deslad Eymoey" on the rim, which might come from "De stad," which is Xiamen in Dutch (Fig. 11.133).

So why did European merchants come to Dehua for white porcelain rather than blue and white porcelain? In the view of the author, the reason is that it was a tradition for Europe to import white porcelain from the Dehua kilns. In the eyes of Europeans, Dehua white porcelain was the best white porcelain China produced while for blue and white porcelain, Jingdezhen kilns ranked top. This also shows that Dehua blue and white porcelain had not commenced maximum production in the Ming Dynasty while even in the Qing Dynasty it still lagged behind that of Jingdezhen. Besides, after the Qing court issued orders to limit foreign trade to the Port of Guangzhou only, the Port of Xiamen was closed down, causing difficulties for European merchants to ship porcelain home from there.

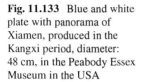

Fig. 11.133 Blue and white plate with panorama of Xiamen, produced in the Kangxi period, diameter: 48 cm, in the Peabody Essex Museum in the USA

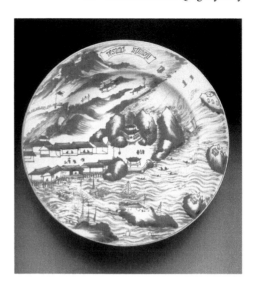

11.5.4 The Chenlu Kilns in Tongchuan

The Chenlu kilns in Tongchuan, Shaanxi Province, developed on the basis of the Yaozhou kilns. In the Tang and Song dynasties, the Yaozhou kilns were centered on Huangbao Town, Tongchuan, while spanning the two sides of the Qihe River, known historically as the "ten *li* of pottery workshops." Meanwhile, there were other kilns like the Shangdian, Chenlu, and Yuhua kilns that ranged over hundreds of *li*. With wars and turbulence raging over generations, most kilns ceased operation, except the Chenlu kilns, which operated until the Qing Dynasty and established themselves as an important porcelain producer in the northwest region.

With a history of 800 years of porcelain manufacturing, the town of Chenlu was the largest porcelain maker in Shaanxi, even in the northwest region, from the Ming and Qing dynasties. Many Chenlu blue and white wares were inscribed with "*Lushan*" (Lushan Mountain), "*Tongguanlushan*" or "*Tongyilushan*," clearly indicating their place of origin. Since the late Yuan period, the Chenlu kilns had gradually replaced the central role of Huangbao Town for the Yaozhou kilns and become the center of porcelain production among the Yaozhou kilns.[78]

Centered on the town of Chenlu, the Chenlu kilns ranged around three kilometers from east to west from Yongxingbao to Xibaozi, and around two kilometers from south to north from Nanbaozi to Beibaozi. In the downtown region, there were 11 production areas, including Shangjie, Nanbaozi (Xinxing), Shuiquantou, Pozi, Wanli, Songjiaya, Xibaozi, Zuitou and Yongxing.

[78] Du Wen, "Overview of Blue and White Porcelain Produced by Private Kilns in Weibei, Shaanxi Province," Chinese Society for Ancient Ceramics (ed.), *Studies on Ancient Chinese Ceramics* (Vol. 13), The Forbidden City Publishing House, 2007, p. 349.

The author paid a visit to the town of Chenlu in 2003 and visited some senior artisans there. They recalled the porcelain-making traditions and organizational structure of the Chenlu kilns back in the Republican era. They even showed the author some products or photos of themselves or their fathers or grandfathers for reference. Even though the information they provided was from the Republican era, due to the slow transformation of the traditional agricultural society, many of the traditions of the Republic of China era could be dated back to the Qing and even the Ming dynasties. Based on the relevant records, the author would like to offer a brief account of the ecological environment, porcelain-making resources, traditional method of production, products, and decorative styles of the Chenlu kilns.

11.5.4.1 Ecological Environment and Porcelain Making Resources

Situated in a mountain region of the Loess Plateau in the central region of Shaanxi, the town of Chenlu had 11 natural villages and over 2000 households stretching from the foot to the top of the mountains and home to more than 10,000 people. These households, along with some kiln houses for paste making and firing, were all cave houses. Some scholars even think cave houses were inspired by the porcelain furnaces. If this is true, then the cave houses here could be used for both living and for porcelain making. What is different is that cave houses for porcelain making had high, stout chimneys while those for living had thin, short ones. So it is easy to judge the density of the kilns by simply observing the chimneys (Fig. 11.134). In Chenlu town there were walls constructed from used saggers everywhere. Originally, this was a means of making good use of waste materials, but gradually it became a unique feature of the region (Fig. 11.135).

The tradition of porcelain making in Chenlu was closely related to its geographic environment and natural resources since the region was abundant in porcelain stone and coal. Generally, to be a porcelain producer, it requires a geographic location that

Fig. 11.134 An old kiln site, shot by the author in the town of Chenlu

Fig. 11.135 The town of
Chenlu, a wall built by used
saggers, shot by the author in
the town of Chenlu

is close to mountains and rivers. For the town of Chenlu, situated on a mountain, it
had the Fanhe River at the foot of the mountain. When the author visited Chenlu in
2003, the river had already dried up. When stepping bare-footed into the river, the
water would not even cover the entire foot. Local seniors said the river had been very
deep many years ago, with blue sky and white clouds reflected in the river. Boasting
porcelain stone, fuel and water, the Chenlu region had a natural basis for porcelain
making. Illustrated in Fig. 11.136 is part of the dried-up Fanhe River.

Fig. 11.136 The spent river
of the town of Chenlu, shot
by the author in the town

Fig. 11.137 Porcelain
shards, shot by the author in
the town of Chenlu

According to archaeological research, the town of Chenlu "has abundant layers
of cultural heritage, as deep as 10–30 m, like mountains of porcelain sleeping
here."[79] And, "Through scientific research and comprehensive analysis over part
of the stratum, a preliminary judgment is that since the late Yuan period, the produc-
tion scale and level of the Chenlu kilns were better than those of the Yaozhou kilns
in Huangbao Town at the same time. Hence, the Chenlu kilns gradually inherited the
style of the Yaozhou kilns and replaced the Yaozhou kilns as the largest kilns and the
major porcelain producers in Shaanxi and even the northwest region as a whole."[80]
The author also witnessed these stratum layers of cultural heritage during visits to
Chenlu (Fig. 11.137).

11.5.4.2 Industrial Division of Labor and Organizational Structure

There were three kinds of kilns in Chenlu. One focused on producing bowls, known
as bowl kilns; one specifically produced large vats, basins and pots, called urn kilns,
and the third concentrated on other wares, such as teapots, vases, *zun* and jars, named
black kilns which required high technological standards, so they were not easy to set
up and run. These three kinds of kilns operated independently without interfering
with each other and were passed along within families from generation to generation,
a situation which was described as an "orderly running of three categories of kilns."

The family-based or clan-based technological monopoly restricted technical
competition and development on the one hand, but it also helped keep the local
production scale and market stable for nearly a millennium, which was also a funda-
mental feature of an agricultural civilization. From the perspective of the technical

[79] Xue Dongxing & Zhuo Zhenxi, "New Archaeological Discoveries in the Kiln Ruins of Chenlu,
Tongchuan, Shaanxi Province," Chinese Society for Ancient Ceramics (ed.), *Studies on Ancient
Chinese Ceramics* (Vol. 8), The Forbidden City Publishing House, 2002, p. 127.
[80] See Footnote 79.

division of labor, as producers of coarse products for daily use, the Chenlu kilns did not have as specific a division of labor and strict workflow as the Jingdezhen kilns. Instead, each potter here was master of more than one skill. In fact from kneading paste to decorative painting, to glazing and firing, potters here needed to master all the skills required for porcelain making.

In terms of industrial division of labor, apart from "orderly running three categories of kilns," there were also various auxiliary industries supporting the production of the Chenlu kilns. Workers from other counties were reduced to unskilled work in workshops and served as auxiliary workers. With outsiders banned from technical work, it also helped protect the industrial monopoly and prevent any outflow of technologies. Because of the monopoly, skilled work was only reserved for local potters while the rest was left to outsiders. Thus, in Chenlu, those performing unskilled work were called "*gongzuo*" (meaning laborers) while outsiders seeking job opportunities in Chenlu were also called "*gongzuo*" (meaning manual job seekers).

The kilns here could independently complete all the work from extracting raw materials, washing porcelain stone, paste making, shaping, and color painting, to firing. Some smaller-sized kilns with limited financial capacity had to work together in groups for at least part or the whole process of porcelain making, such as firing or exploiting porcelain stone. Generally, local kilns ran within the family unit with the skilled work reserved for family members and the rest for other employees.

In 2003, during a visit to Chenlu, the author met a senior artisan who was more than 80 years of age and whose surname was Ren. According to this veteran, his family's workshop had more than 20 workers during the Republican era, the second largest kiln in the village at the time. This shows that family-run workshops were not large. The ceramics industry was both a pillar industry here in Chenlu, but also a supplementary business to agriculture, because people here were engaged in both agriculture and ceramic production, even during the Republic of China era. Every household here managed both kilns and farmland. In slack farming seasons, they would work on porcelain manufacturing while in busy farming seasons, they were peasants. Their crops were usually consumed by themselves and not for sale. All other expenses had to be covered with money earned from the porcelain business. This was a tradition which can be traced back to the Jin and Yuan dynasties.

According to local traditions prior to the Republic of China era, boys started to learn to work in kilns with their fathers once they turned 12 or 13. Through years of learning and practice, they would generally learn all the necessary skills without an official apprenticeship. So, there was no concept of masters and apprentices. Chenlu people loved their home and would not leave their hometown if it was not necessary, not even for study. People usually remained in their hometown and engaged in porcelain production for a lifetime.

11.5.4.3 Auxiliary Porcelain Production Industries

Apart from kilns, there were also many industries that supported porcelain manufacturing, including transportation, sales, and the production and repair of relevant tools

and equipment. The people engaged in these auxiliary industries were mostly farmers and workers from neighboring regions around the town of Chenlu. For example, there were dealers and mongers from Fuping who came to Chenlu during the farming off-season, and there were also bearers from all around the area who gathered in Chenlu and waited to transport porcelain out of Chenlu with porcelain wares piled in baskets and loaded on mules to wend their way through narrow mountain roads. Stonemasons and blacksmiths also came to Chenlu to seek work since stone wheels often needed repairing and steel knives used for paste making and shovels used for mining coal often required replacement. Thus, apart from potters, there were also many craftsmen from other industries in Chenlu who contributed to the local ceramics industry.

If we say that manual workers and bearers made money by using their physical strength, dealers and mongers earned a living from the information they mastered and the social networks they managed to build, because craftsmen like stonemasons, blacksmiths and carpenters, lived off their skills. There are two points worth noting here. First, the different people who were engaged in the various auxiliary industries in Chenlu all came from set areas, therefore these industries were also monopolized by specific regions and clans. Second, these workers attended their farms during the busy farming seasons and were only engaged in these industries in the slack seasons. Thus, their auxiliary work was highly seasonal and they never abandoned the agricultural industry. What is more, as farmers, they tended to follow folk customs and revered industrial gods, so they held sacrificial rites for the kiln gods in different seasons every year.

11.5.4.4 Varieties and Decorations

The Chenlu kilns produced a range of products, including tablewares like bowls, plates, cups, saucers, pots, and food boxes, vessels like pots, jars and vats, decorative wares like vases, *zun*, hat boxes and hat tubes, as well as daily use articles for farming households that are no longer seen today, such as porcelain pillows, oil lanterns, and mine lamps. In addition, there were also sacrificial wares, porcelain statues, and toys, etc. (Figs. 11.138, 11.139 and 11.140).

In terms of glazes, there were green, ginger, black, brown, tea dust, blue and white, *xianghuang* (fragrant yellow), blue on white, black on white, iron rust, red and green, etc. In terms of decorative method, painting still dominated, with color painting on blue and white porcelain, engraving, printing, scratching, etching, carving, decal and piercing occasionally employed.

The major decorative patterns for the Chenlu kilns were flowers, while human figures and landscapes were also occasionally utilized. The paintings were generally in traditional freehand style, and very general and simple realistic paintings were also occasionally applied. This decorative style emerged for two reasons. First, products were all made for the daily use of the common public, so they needed to be cheap and useful. It was thus necessary to save time and labor in manufacturing such products in order to cut costs. Second, local potters did not have a detailed division of labor and usually one potter mastered all the skills for porcelain making, unlike Jingdezhen.

Fig. 11.138 Hat box, a
piece of decorative ware,
shot by the author in the
town of Chenlu

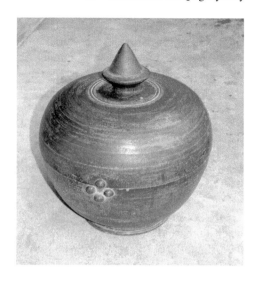

Fig. 11.139 Porcelain
pillow, an article of daily
use, shot by the author in the
town of Chenlu

Fig. 11.140 Bowl, a piece
of tableware, shot by the
author in the town of Chenlu

As a result, the Chenlu potters were not as skillful as their Jingdezhen counterparts in terms of painting. Additionally, unlike the Jingdezhen kilns which undertook tasks to supply imperial porcelain regardless of time or cost, the Chenlu kilns were faced with a consumer market. In fact, the Jingdezhen private kilns' method of production was similar to that of the Chenlu kilns. This shows that, among the various factors contributing to the formation of any given form of folk art, market demand was a major factor.

In "New Archaeological Discoveries in the Kiln Ruins of Chenlu, Tongchuan", Xue Dongxing and Zhuo Zhenxi write that "Through investigations of the relic sites of the Chenlu kilns, the large amount of real objects and materials found there along with our initial research results serve as a new, accurate and important basis for the judgment and authentication of porcelain produced in Northern China in this period. In the relic sites, a certain amount of black on white porcelain was discovered which could be dated back to the Yuan, Ming and Qing periods, including bowls, plates, basins, goblets, pots, and vases, among which basins and pots were quite plentiful. Their decorative patterns included human figures, animals, plants, flowers and leaves as well as inscriptions such as '*Jinyumantang*' ("Gold and jade fill the hall," a wish for abundant wealth or many children in the family), '*Changmingfugui*' ("Longevity with wealth and honor"), and '*Shou*' ("Longevity")." Decorative patterns were generally painted in freehand brushwork and based on the shapes of articles which was clearly different from the black on white porcelain produced by the Cizhou kilns, which proved the theory that Cizhou black on white porcelain was produced by the Chenlu kilns to be wrong. Meanwhile, *xianghuang* glazed porcelain and double-color glazed porcelain, the producers of which could not be confirmed in the past, have also been identified as products of the Chenlu kilns. In addition, large quantities of blue and white porcelain from the late Qing to the Republican period found here could serve as an important basis for research on the production and development of blue and white porcelain production in northern China at this time."[81]

In other words, archaeological research reveals that many black on white wares that were once taken as products of the Cizhou kilns were actually produced by the Chenlu kilns, along with some yellow glazed porcelain and double-color glazed porcelain whose place of origin had been unknown. Most importantly, many blue and white wares produced from the late Qing period to the Republican period have been discovered in Chenlu, which confirms the Chenlu kilns' important position as a major porcelain producer of blue and white porcelain in northern China.

11.5.4.5 Blue and White Porcelain

According to Du Wen, the Chenlu kilns started to produce blue and white porcelain from the late Qing Dynasty and their production techniques were sourced from

[81] Xue Dongxing & Zhuo Zhenxi, "New Archaeological Discoveries in the Kiln Ruins of Chenlu, Tongchuan, Shaanxi Province," Chinese Society for Ancient Ceramics (ed.), *Studies on Ancient Chinese Ceramics* (Vol. 8), The Forbidden City Publishing House, 2002, p. 130.

Jingdezhen. According to the *Local Gazetteer of Tongguan County, On Commerce and Industry*, "The Hedongpo kilns produced porcelain several *li* to the east of the county (Tongguan was a former name for Tongchuan). In 1901, the 27th year of Guangxu's reign, the county suffered a major famine. Pan Minbiao, an official from Jiangxi came to the region on orders to help relieve the disaster. Considering the geographic location of the county favorable for producing porcelain, Pan and the local authorities decided to chip in and set up ceramic factories and to renovate the local kilns. Clay was collected from Kaizi Mountain, 20 *li* south of the county. In 1902, a local called Zhao Zhiqing was sent to visit Jingdezhen and came back with over a dozen potters. They started to produce on a trial basis in the Xiyue Temple in Xi'an and succeeded, before they relocated back to Tongguan in 1905. Though their products were not as good as that of Jingdezhen, every batch of products was capable of producing several excellent pieces with which they composed several sets of tableware which were presented to the Empress Dowager of the Qing court, Cixi, and received high praise. After five to six years, much progress was achieved. However, after Pan Minbiao died, shareholders of the Tongguan kilns either returned to their hometowns, relocated to other places, or became bankrupt, so financing the ceramics industry could no longer be sustained and gradually the local kilns ceased operation. Only relic sites of the kilns now remain."[82] According to Du Wen, this record shows that the production of the Hedongpo kilns in Tongchuan involved the participation of Jingdezhen potters. The Yaozhou Ceramics Kiln Museum houses a blue and white black glazed vase produced by the Chenlu kilns, with a plate-shaped mouth and four lugs produced in 1877, the third year of Emperor Guangxu, which indicates that apart from the Hedongpo kilns in Tongchuan, the Chenlu kilns were also able to produce blue and white porcelain in the early Guangxu period.[83]

When this author visited the town of Chenlu, the local blue and white wares impressed me deeply. While production of blue and white porcelain could no longer be seen, there were still various vivid products produced and retained by local artisans and their predecessors, most of which were produced in the late Qing and Republican eras. The existence of such articles also proves Du Wen's opinions to be correct (Figs. 11.141, 11.142, and 11.143).

Du Wen once wrote that blue and white porcelain produced in Weibei (north of the Weihe River, mainly referring to Shaanxi Province) in the late Qing and Republican periods featured various designs that were destined for decorative or practical daily use. For articles of daily use, there were large-sized oil vats, bowls and plates, sets of boxes, etc. For stationery accessories, there were pen tubes, ink boxes and inkstone water holders. There were also blue and white vases and tureens for decorative and/or practical use. Bowls and plates were the most commonly seen among the daily use wares. There were also many daily use articles specific to Shaanxi Province with local features, including various bowls and plates. Bowls produced here usually featured

[82] *Local Gazetteer of Tongguan County*, Vol. 11, *On Commerce and Industry*, 1949.

[83] Du Wen, "Overview of Blue and White Porcelain Produced by Private Kilns in Weibei, Shaanxi Province," Chinese Society for Ancient Ceramics (ed.), *Studies on Ancient Chinese Ceramics* (Vol. 13), The Forbidden City Publishing House, 2007, p. 349.

Fig. 11.141 A traditional
Chenlu product (vase), shot
by the author in the town of
Chenlu

Fig. 11.142 A traditional
Chenlu product, shot by the
author in the town of Chenlu

high feet, which was convenient for hand-held use, known as "*laowan*" (old bowls) in
civilian society. The substantial production of high-feet blue and white bowls reflects
the dietary habits of the local people (Figs. 11.144 and 11.145).

According to Du Wen, Weibei blue and white wares, by copying the decorative
style of Jingdezhen blue and white porcelain, were also much inspired by folk arts
such as paper-cutting, barbola and New Year paintings. Blossoming peony, rounds
of chrysanthemum, plum blossom, and peaches were favorite motifs on Weibei blue
and white wares, along with money trees, courtyards, flowers and trees, landscapes
and pavilions, as well as children, horses, lions, magpies perching on plum trees, and

Fig. 11.143 A Chenlu pot, shot by the author in the town of Chenlu

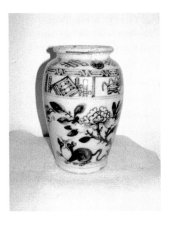

Fig. 11.144 A blue and white bowl produced in Chenlu, shot by the author in the town of Chenlu

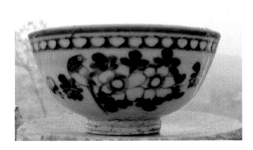

Fig. 11.145 A blue and white bowl produced in Chenlu, shot by the author in the town of Chenlu

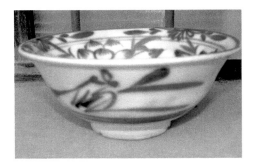

fish swimming around lotus, etc. With uncomplicated strokes, potters expressed their aspirations for a happy life. Featuring a bold, coarse and free style, the decoration of Weibei wares fully demonstrated the simple and plain beauty of northern wares. Weibei blue and white wares produced in the late Qing and Republic of China eras, while being coarse products for daily use, featured strong local character, plain strokes, simple, vivid artwork and bold design, which revealed the artistic taste of folk arts in the Weibei region and served as a typical representative of Shaanxi folk

Fig. 11.146 A Chenlu vat, shot by the author in the town of Chenlu

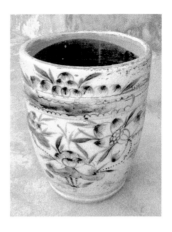

Fig. 11.147 A Chenlu vat, shot by the author in the town of Chenlu

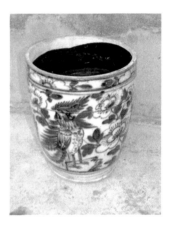

art.[84] During the author's visit to the town of Chenlu in 2003, products of a similar style were visible. Blue and white wares across the entire Weibei region, including that of the Chenlu kilns, had a similar style, which could have been the result of mutual influence (Figs. 11.146, 11.147 and 11.148).

According to the investigations of the author, while the production of Chenlu blue and white porcelain drew on experience from Jingdezhen, their styles were quite different due to differences in raw materials, target markets, and cultural backgrounds. First, Jingdezhen blue and white porcelain was painted directly on bisque before the application of a layer of transparent glaze. In contrast, Chenlu blue and white wares, with dark bisque bodies, appeared coarse, so they needed a layer of engobe before painting and the paint colors were not as translucent as those of Jingdezhen. Second, faced with a huge market, Jingdezhen supplied the royal

[84] Du Wen, "Overview of Blue and White Porcelain Produced by Private Kilns in Weibei, Shaanxi Province," Chinese Society for Ancient Ceramics (ed.), *Studies on Ancient Chinese Ceramics* (Vol. 13), The Forbidden City Publishing House, 2007, p. 351.

Fig. 11.148 A Chenlu pot,
shot by the author in the
town of Chenlu

court, the international markets and the various classes of the domestic market. The
Jingdezhen kilns thus boasted various decorative methods, and a detailed, strict and
specific division of labor. However, in the Chenlu kilns, one ordinary potter mastered
all the skills from making paste to painting and firing. Potters here, therefore, did
not have as high a level of professional expertise as their counterparts in Jingdezhen.
Products here were also mostly supplied to common people in nearby villages and
counties rather than markets far from the region, let alone for export. Thus, Chenlu
ceramics were mainly large and coarse wares decorated with simple motifs like land-
scapes, human figures, flowers, birds and animals. Third, as the Chenlu kilns were
located in the northwest, apart from the Jingdezhen kilns, their own creative style
was also influenced by the Yaozhou kilns. Their flower motifs were especially special
with rows of lines on petals, looking like stitches from embroidery, an obvious influ-
ence of the local embroidery. In terms of motif, lotus dominated the flowers. alfalfa,
a vegetable popular in the region, was also a motif frequently observed. With a few
strokes, this pattern appeared both simple and bold.

11.5.5 Others

From the above we can see that Jingdezhen was still the center of ceramic production
in the Qing Dynasty while there were also other producers around the nation. Some
of the producers catered to the demands of the domestic market while some produced
to supply the overseas market, like the Shiwan kilns in Guangdong and the Dehua
kilns in Fujian.

In addition, in the early years of the Qing reign, the government adopted a maritime
ban and a "closed door" policy, prohibiting trade by foreign merchants in regions
like Jiangsu, Zhejiang and Fujian, and leaving Guangzhou as the only legal trading
port. In the mid-Kangxi period, the Qing court decided to set up more trading ports

Fig. 11.149 Canton
globular vase with female
figures and two lugs,
produced in the Guangxu
period of the Qing Dynasty

in Guangzhou, Zhangzhou, Ningbo and Yuntai Mountain (the present Lianyungang). In 1775, the 40th year of Kangxi's reign, the Qing government closed all the trading ports except the Port of Guangzhou, which monopolized the foreign trade of the Qing Dynasty with the outside world.[85] To facilitate production and transportation, a new overglazed variety of porcelain came into being in Guangzhou, called Canton porcelain. Canton porcelain was famous for its "glamorous colors and magnificent designs." Its shapes and decorations were usually tailor-made and based on the Western life style, heavily featuring a Western artistic character while its decorative motifs were quite Chinese, including flowers, landscapes, realistic paintings of courtyards, as well as human figures in traditional Qing costumes, which were highly appreciated and admired by consumers in Europe and America. From the Qing Dynasty, Canton porcelain had been one of the major export wares.[86] By the late Qing period especially, it had been a common practice to purchase bisque from Jingdezhen and decorate it in Guangzhou (Figs. 11.149, 11.150, 11.151, 11.152 and 11.153).

Apart from the above-mentioned kilns, some other kilns, though not as active as in the Ming Dynasty, managed to sustain operation into the Qing period. For example, the Longquan kilns were a time-honored kiln in China's ceramic history. According to the long-held view of academia, by the mid- and late-Ming periods, due to the large-scale squabbling of peasant potters and the cruel rule and heavy taxes of the feudal overlords, the ceramics industry in Longquan collapsed. The quality and quantity of Longquan products plummeted, and workers had to turn to other businesses to make a living. However, according to the *Local Gazetteer of Longquan County* published

[85] Feng Suge, "Guangdong Overseas Transport and Ancient Ceramics Export," Chinese Society for Ancient Ceramics (ed.), *Studies on Ancient Chinese Ceramics* (Vol. 14), The Forbidden City Publishing House, 2008, p. 312.

[86] See Footnote 85.

Fig. 11.150 Canton
double-lug *zun* with paneled
human figure patterns,
produced in the Guangxu
period of the Qing Dynasty

Fig. 11.151 Canton vase
with lady and children
patterns, produced in the
Guangxu period of the Qing
Dynasty

Fig. 11.152 A custom-made
Canton wine cup, produced
in the Guangxu period of the
Qing Dynasty

Fig. 11.153 Canton stool with lady and children patterns, produced in the Guangxu period of the Qing Dynasty

in 1994, "In July 1641 (the 14th year of Emperor Chongzhen), 27,000 pieces of porcelain were shipped from Fuzhou to Japan. In October of that same year, 30,000 pieces of Longquan celadon were loaded onto 97 ships and landed in Nagasaki, Japan." Emperor Chongzhen was the last emperor of the Ming Dynasty. During his reign, large batches of Longquan celadon were shipped overseas, which showed the massive influence of the Longquan kilns. According to archaeological research, in the late Ming and early Qing periods, there were over 160 kiln sites remaining in Longquan. Before the Qing court was established, there were still more than 70 sites. After entering the Qing Dynasty, it was highly possible that the Longquan kilns still managed to operate and maintain a certain level of production.[87] In "Longquan-style Celadon Wares in the Qing Dynasty" (*Palace Museum Journal*, Issue 2, 1982), Ye Peilan introduces six pieces of Longquan celadon housed in the Palace Museum that were produced in the Qing Dynasty with reign marks spanning throughout the entire Qing period. Through discussions and analysis of these artifacts, she writes in "On Terminus Ante Quem of Production of Longquan Kilns from Several Pieces of Longquan Celadon Ware with Markings of Years Housed in the Palace Museum" that these wares show that due to recovery and development in the early Qing period, Longquan celadon wares had already reached a high quality, featuring dark, deep colors, tight bonding of bisque and glaze, and the occasional red color by the Kangxi period, almost equal to the level attained during the early and mid-Ming periods. Products in the Shunzhi period had similar features to that produced in the late Ming period, with heavy bodies, glassy gloss, and crackles. After the Qianlong period, the Longquan kilns experienced a reduction in scale and lost its glamor in terms of shape, body and glaze bonding, and decoration when compared to the Yuan and Ming periods. Instead, it shifted to mainly focus on articles of daily use and sacrificial wares used in temples, which were not of good quality. Thus, considering the wares with the marks of Emperor Tongzhi and Guangxu, the terminus ante quem of the

[87] Zhong Qi, "Study on Terminus Ante Quem of Production of the Longquan Kilns," *Collection World*, 2006, Issue 6.

Longquan kilns should be the late Qing period.[88] But this question is still under discussion and it is hoped that there will be more research to prove the point.

11.6 Porcelain Export in the Qing Dynasty

11.6.1 Opening of the Port of Guangzhou

In the early Qing Dynasty, due to the presence of anti-Qing forces in coastal areas, the Qing court adopted a very strict maritime ban, prohibiting "even a decking plank from entering the water and not a single good may travel across borders." This meant that the "tribute trade" that had been dominated by governments since the Yuan and Ming periods was seriously affected. However, overseas demand for Chinese goods remained strong. With the official trading channels blocked, to meet these demands people turned to smuggling. In August 1683, the 22nd year of Emperor Kangxi, the Qing government formally recaptured Taiwan. Completing the grand quest to reunite China, Emperor Kangxi decided to lift the maritime ban in 1684, hence the Qing's foreign trade was back on track and bound for prosperity.[89]

The porcelain trade between Europe and China began in the late Ming period and peaked in the late seventeenth century, the early Qing period. The Philippines, Indonesia, Malaysia, Vietnam and Thailand in Southeast Asia, and Portugal, Spain, the Netherlands, and Britain in Europe were major foreign consumer markets for Chinese porcelain. According to the Dutch East India Company in Batavia, there were over 3,000,000 pieces of porcelain shipped to Europe from China. Orders made by foreign consumers requested various designs and sometimes samples were sent as models. Placing orders in commercial trade thus in fact became an important channel for foreign cultures to be imported and Chinese culture to be exported.[90] By the eighteenth century, with surging demand from the European market, Chinese porcelain export reached an unprecedented level. "For example, in 1792, 1492 *dan* (a unit of weight, 50 kg) of porcelain wares were exported to the USA from the Port of Guangzhou, 180 *dan* to France and around 400 *dan* to Britain. According to

[88] Ye Peilan, "On Terminus Ante Quem of Production of the Longquan Kilns from Several Pieces of Longquan Celadon Wares with Markings of Years Housed in the Palace Museum," Chinese Society for Ancient Ceramics (ed.), *Studies on Ancient Chinese Ceramics* (Vol. 12), The Forbidden City Publishing House, 2006, pp. 274–275.

[89] Huang Weiwen, "On Plain Tricolor Porcelain of the Kangxi Period from the Perspective of Collections housed in the Peabody Essex Museum in the USA," Chinese Society for Ancient Ceramics (ed.), *Studies on Ancient Chinese Ceramics* (Vol. 14), The Forbidden City Publishing House, 2008, p. 454.

[90] Zhang Kai, "On Exported Blue and White Porcelain in the Qing Dynasty," Chinese Society for Ancient Ceramics (ed.), *Studies on Ancient Chinese Ceramics* (Vol. 14), The Forbidden City Publishing House, 2008, p. 365.

Fig. 11.154 Panorama of
Guangzhou, in the Peabody
Essex Museum in the USA

incomplete statistics, before the Opium War, the annual export of China porcelain
stood at around 5000 *dan*."[91]

Based on the above-mentioned documents, we can see that Guangzhou was the
largest trading port for porcelain in China during the Qing Dynasty. This author
once visited a museum in a small city near Boston which housed many Chinese
porcelain wares from the eighteenth and nineteenth centuries. It also included scenes
by Western painters of the Guangzhou, Macao and Hong Kong areas that they had
observed, in an attempt to introduce the Chinese porcelain trade with Europe to
their citizens. Through these depictions and collections, we can see that even before
and after the Opium War, there were significant porcelain interactions with overseas
markets occurring in Guangzhou, Hong Kong and Macao.

Illustrated in Fig. 11.154 is a panorama of Guangzhou, which was painted in 1800,
a watercolor painting donated anonymously to the Peabody Essex Museum. This
picture shows the prosperity of Guangzhou as a major international port. Through
the detailed portraits in Figs. 11.155 and 11.156, we can catch a glimpse of the
flourishing Guangzhou at the time. Many Chinese-style cargo ships rest on the waters
and there are various trading offices with national flags on the shore, clearly featuring
a European style, forming a sharp contrast with the nearby Chinese buildings. We can
only see small Chinese-style cargo ships while no large European ones are visible,
because foreign merchant ships were not permitted within the Port of Guangzhou at
the time according to the regulations of the Qing government.

Figure 11.157 is another oil painting created in 1850 and titled *Whampoa, Ca*, a
present to a man called Lewis A. Lapham, as indicated by a note under the painting.
It depicts an island called Whampoa (Huangpu), 70 miles north of Macao and 10
miles south of Guangzhou, where Western merchant ships to Guangzhou plying the
porcelain trade usually berthed. Upon arrival, captains, supercargoes, and merchants
would go ashore while the rest of the crew would remain on board. This was the
custom until the outbreak of the Opium War in 1840. The picture was painted from

[91] Huang Weiwen, "On Plain Tricolor Porcelain of the Kangxi Period from the Perspective of
Collections housed in the Peabody Essex Museum in the USA," Chinese Society for Ancient
Ceramics (ed.), *Studies on Ancient Chinese Ceramics* (Vol. 14), The Forbidden City Publishing
House, 2008, p. 467.

Fig. 11.155 Part 1 of the
panorama of Guangzhou, in
the Peabody Essex Museum
in the USA

Fig. 11.156 Part 2 of the
panorama of Guangzhou, in
the Peabody Essex Museum
in the USA

the vantage point of Danish Island, with a small hill covered with many tombs and
tombstones closest to the viewer. In these tombs rest those who had traveled with
foreign merchant ships to China but who unfortunately died here. From the number
of tombs, we can imagine just how many foreign merchant ships there would have
been plying the trade at the time.

From these two pictures, we can surmise that European merchant ships usually
berthed on islands around Guangzhou, such as Whampoa. As crew members waited
on board or ventured ashore, the captains and merchants would depart for Guangzhou
to discuss business with local businessmen. After the deals were done, goods would
be loaded on Chinese ships that would ferry the goods to the islands where their ships
were berthed and the goods would be transferred to the foreign ships for sailing.

According to the log of a captain of the Swedish East India Company, when a
merchant ship sailed into Chinese waters, a Chinese navigator would be taken on

Fig. 11.157 *Whampoa, Ca,* in the Peabody Essex Museum in the USA

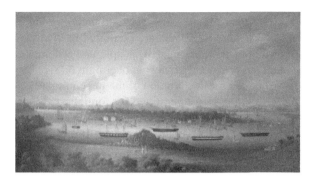

board to help navigate the ship through the precipitous entrance to the Pearl River, called "Humen" by the Portuguese. At Humen, Chinese seamen would board to complete the relevant paperwork before the ship continued on its journey to the upper sections of the Pearl River and reach Whampoa, some 15 km from Guangzhou, to the applause of the crew. Large, and with a deep draught, the ship would remain on the island until it was time to return home, with the longest lay day being 6 months. Thus sampans, small Chinese boats, were utilized for transportation between Whampoa and Guangzhou.[92]

Daniel Nadler also describes the rules for European merchants dealing in the porcelain trade in Guangzhou in *China to Order*. Foreign merchants and seamen were strictly confined to their ships and trading areas (foreign firms in Guangzhou). They needed to clean up trading areas after their leasing periods ended and before the monsoon in January. Those who needed to stay in China over winter had to relocate to Macao. The Qing government strictly prohibited the entry of foreign women into Guangzhou. The wife of a captain was once identified in Guangzhou and was forced to repair to Macao post-haste.

Control over foreign trade in Guangzhou, while relaxed in the nineteenth century, remained very strict. Here are some rules and regulations on foreign trade in Guangzhou in the nineteenth century.

① Warships are strictly prohibited from entering the Pearl River Estuary.
② Women, guns, fishgigs and all kinds of weapons are not permitted in foreign trade houses.
③ All navigators and compradors must register in the representative offices of the Qing government in Macao and wear their permits or badges at their waist. Whenever required, the permits or badges shall be shown. Without the direct involvement of compradors, crew are prohibited from making contact with foreigners. If a comprador is involved in smuggling, he will be punished.
④ The number of employees of a foreign trade house is limited to eight people, for example, two porters, four navigators, one in charge of cargoes and one merchant.

[92] Ingrid Arensberg, *The Swedish Ship Gotheborg Sails Again*, Guangzhou Publishing House, 2006, p. 38.

⑤ Foreigners are not allowed to sail their own ships for pleasure. During holidays or festivals, foreigners are permitted to visit gardens or temples, but only in a group of no more than 10 people and accompanied by a translator. Foreigners are not permitted to stay out overnight or to party, and, if disobeyed, they will be grounded for the duration of the next holiday.

⑥ Petitioning is not permitted for foreigners. Whatever requests foreigners might like to propose, must be done by way of trade house businessmen.

⑦ Businessmen of trade houses are not allowed to be indebted to foreigners. Smuggling is strictly banned in Guangzhou.

⑧ Loaded foreign merchant ships are not permitted to loiter in waters and must head directly to Whampoa. Foreign merchants are not allowed to stroll about in the Pearl River or sell taxable goods to locals, which is deemed to be smuggling and a way of evading taxes due to the Emperor of the Great Qing Dynasty.

While with some twists and turns, this system remained in effect and reaped benefits, in terms of cargo quantity, Chinese porcelain lagged far behind Chinese tea and silk.[93]

We learn from foreign documents that initially foreigners were prohibited entry into Guangzhou, even though in 1799 Guangzhou was ostensibly opened up to tourists. This was only on paper. So, foreigners could only live within the area between the Pearl River and the outskirts of Guangzhou city, and occasionally they were allowed onto Henan Island on the Pearl River. As Dorothy Schurman Hawes writes:

> China Street and Hog Lane pass through the foreign establishments. One of the streets is crowded with shops selling silk and antiques and the other is brimming with hotels where cunning Chinese businessmen are waiting for seamen to get them drunk and take the chance to overcharge them. This street is always very noisy with foreign and Chinese merchants often colliding with the government.

> Opposite the antique street, there are many beautiful and clean buildings, properties of businessmen from the trading houses, which are used as venues to discuss trade-related business. Rich merchants or owners of the buildings often meet here to discuss old and new regulations and how to amend clauses of rights and obligations. It is also in these buildings that the occasional bankruptcy or financial difficulties are resolved.[94]

11.6.2 Foreign Trade Agencies in Guangzhou

For a very long time, Guangzhou was the Qing government's only foreign trade port. To facilitate trade with merchants from various countries, foreign trade agencies were set up in Guangzhou, and it is through these agencies that Chinese porcelain successfully made its way to countries around the world. There are few records of

[93] Daniel Nadler, *China to Order: Focusing on the XIXth Century and Surveying Polychrome Export Porcelain Produced during the Qing Dynasty (1644–1908)*. Paris, 2001, p. 49.

[94] Daniel Nadler, *China to Order: Focusing on the XIXth Century and Surveying Polychrome Export Porcelain Produced during the Qing Dynasty (1644–1908)*. Paris, 2001, p. 47.

the foreign porcelain trade agencies available in China, so the author has had to turn to foreign documents, paintings on porcelain and relevant oil paintings to discuss this topic.

Daniel Nadler once wrote that Guangzhou was under the direct governance of the Viceroy of Guangdong, representing the Qing emperors, and under the Viceroy, there was a large team of provincial-level officials. Trading agencies served as middlemen between Chinese and foreign merchants, as well as a bridge of communication between the Qing government and foreign merchants. Thus, trading agencies not only had commercial functions, but also diplomatic as well. Responsible for trade-related affairs, initially there were eight trading agencies which later expanded to 13. Merchants authorized by trading agencies were the only legal businessmen (as opposed to "barbarian" foreign traders) and were responsible for their own behavior.[95] Trading agencies managed taxation for the government and ensured that all Chinese people involved in foreign trade prospered.

Businessmen from trading agencies (for the entire eighteenth century) spent a great deal of money monopolizing the privilege of foreign trading rights, and thus made every attempt to blackmail the "barbarians" on various pretexts, such as berthing fees and unloading fees. Each Chinese who provided a service to these "barbarians" required support from the trading agencies. Compradors were responsible for introducing foreign firms and supplying shipping services. Apart from the salary earned from foreign firms, compradors were entitled to deal with any good available for supply. Translators were also very important as few Chinese mastered pidgin. Thus, translators were also in charge of arranging sampans and a workforce for loading and unloading goods. Apart from their income gained from translating, translators could also run their own business houses.[96]

Daniel Nadler reiterates that foreign merchants were "barbarians" in the eyes of Chinese back then, which also shows the arrogance of the Qing government and the backwardness of the social regime at the time.

Figure 11.158 shows many foreign-style buildings, which were trading agencies established by foreign merchants in Guangzhou. From the log of a captain of the Swedish East India Company, we learn that these trading agencies were situated next to each other along the busy Pearl River, which was the source of this bustling business. Supercargoes, their assistants, captains and crew members all lived there and the purchased products would also be placed there before loading. Classic Chinese sampans were used to transport goods and passengers from the trading agencies to ships berthed in Whampoa and vice versa. Usually, an agent would be employed to deal with any practical affairs, including loading and unloading goods, while two compradors would also be hired with one working in the trading agencies and one in Whampoa, managing goods and purchasing supplies. Additionally, a *Tongshi*, who

[95] See Footnote 94.

[96] Daniel Nadler, *China to Order: Focusing on the XIXth Century and Surveying Polychrome Export Porcelain Produced during the Qing Dynasty (1644–1908)*. Paris, 2001, pp. 45–46.

Fig. 11.158 Wallpaper
depicting Chinese scenery,
on trading scenes in
Guangzhou, in the Peabody
Essex Museum in the USA

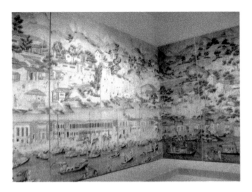

enabled negotiations and discussions with Qing officials in charge of foreign trade,
was also necessary.[97]

Samuel Shaw was the Supercargo on "Empress of China," the first American
trading ship to China. He described foreign trading agencies in Guangzhou from his
perspective:

> Trading agencies in Guangzhou are located no more than 2.5 miles away from the Pearl River.
> The wharf is equipped with guard railings. Every trading agency has its own staircases and
> gate to the river and all goods are delivered through these staircases and gates. European
> merchants have a very limited range of activity, just a few streets next to the wharf. Even
> those who have lived here for over a decade could not see more than what they have seen in
> their first month here.[98]

Carl Gustav Ekeberg (1716–1784) also described the location of trading agencies
in his report of 1773: "The suburb is situated in the southeast corner of the city and
in its west side sit trading agencies of Europeans, which are separated by a river and
a smooth street of around 10 m in width."

At the time, the Chinese people and the European merchants lacked any detailed
knowledge of each other. In the eyes of the Chinese, Europeans were "foreign ghosts"
and should be kept at a distance. Despite the fact that Dutch people (with red beards)
were respected, due to their reasonable and reliable character, they were still strictly
restricted like their counterparts from other countries. For example, no wives or
children were allowed to accompany them. No cannons, guns, or ammunition. No
riding sedans. Usually, Europeans were only allowed three walks every month in the
company of translators in places adjoining their residence and no more than 10 people
were allowed to walk together. After their ships left Guangzhou, they must also leave
and relocate to Macao. From 1776, Europeans were permitted to live in the suburbs
of Guangzhou. Initially, their trading agencies were set up in specific houses which
they rented. After 1749, European companies were allowed to offer their residence

[97] Ingrid Arensberg, *The Swedish Ship Gotheborg Sails Again*, Guangzhou Publishing House, 2006,
p. 39.

[98] D. F. Lunsingh Scheurleer, *Chinese Export Porcelain Chine de Commande*. Pitman Publishing
Corporation, 1974, p. 61.

up for lease.[99] Expanded from eight to 13 in 1822, the trading agencies were rebuilt after they were burnt down, but they suffered another major fire in 1855. Each of the buildings of the trading agencies had two floors and were built with brick walls and tile roofs. Inside the buildings, several compartments were constructed, separated by planks covered with white Chinese paper. Next to the buildings of trading agencies were warehouses. Each of the trading agencies had staircases leading to the river which were separated by fences. On top of the buildings flew the national flags of their owners, varying in color and fluttering in the wind. Each of the trading agencies had their own name. For example, the Dutch trading house was called "*Zhengyihang*" (Righteousness Trading House), and the British one "*Hepinghang*" (Peace Trading House). Heads of the trading agencies reported to the Qing emperors and were required to ensure that their merchants, local employees and shipping services were well-behaved.[100]

Relevant information regarding foreign trading houses can also be revealed through a variety of porcelain ware called trading house bowls. The earliest bowls depicting trading agencies in Guangzhou were produced in Denmark in around 1765. The idea of depicting how Europeans lived in Guangzhou as a series on bowls came into vogue in around 1780 and remained popular until the end of the eighteenth century. The Dutch East India Company recorded that it had polychrome trading house bowls "which were brought back home by individuals as treasures and given as gifts to friends." According to the manifest of the American ship "Empress of China," America had bowls with trading house patterns as early as 1785.

As for the architecture of these trading agencies, Aeneas Anderson, valet to Macartney, recorded that "Along the riverside, there was a line of trading houses which had no interaction with each other. They were distinguished by their flags or other national emblems which were put in the most distinctive places in the day." Thus, from the architectural styles, geographic features and flags on the patterns of bowls, we can tell where and when foreign businessmen lived in Guangzhou.

The earliest trading house bowls generally described the same scenes, with the most typical being Westerners looking out from their windows, walking into or out of trading houses, walking dogs on roads with Western-style architecture as a backdrop, or talking with Chinese merchants. Sampans which were used to transport goods from Whampoa to the foreign merchant ships were also depicted on such patterns, usually lining up along the wharf. We can even see ropes tied to pilings. Even though the pictures seem idealistic, such patterns would serve as a reference when foreign merchants returned home and illustrated how they spent their life in China.

Now, let us take a closer look at how these bowls depicted the Port of Guangzhou.

For example, in Fig. 11.159, the pattern of foreign trading houses in Guangzhou is placed on the sides of the bowl, with the Danish and French houses to the west (France

[99] A. M. Van Lubberhuizen-van Gelder, "De Factoryen te Canton n de 18e Eeuw", in *Oud Holland*, 1955.

[100] D. F. Lunsingch Scheurieer, *Chinese Export Porcelain Chine de Commande*. Pitman Publishing Corporation. 1974, p. 62.

had a white national flag before the Republic of France was founded) and those of
Sweden, Britain, and the Netherlands, along with some castles to the east (distances
between the trading agencies depicted here are closer than in reality). However,
the royal flag of Austria which usually appeared on similar bowls is not seen here,
indicating this bowl was made before 1779, the year that Austrian merchants first
set foot in China. In around 1780, images of trading houses begin to be depicted on
the walls around bowls. For example, sometimes, on the small blank space on such
bowls, a Chinese lady, two boys and a cow were depicted while on the other side a
couple with a child were painted. Sometimes, chrysanthemum or leaves were also
depicted inside bowls.

Figure 11.160 is a bowl with 13 continuous patterns of trading houses on its wall,
a later product produced after all 13 trading agencies had been established. From the
left to the right we have the trading houses of Austria, France, Sweden, Britain (with
long corridors extending to the riverside), and the Netherlands, each represented
by its own national flag. The Austrian trading house, known as the Royal Trading
House, had its Austrian national flag over its building only from 1779 to 1787, but the
name Royal Trading House remained in use for half a century. The double-headed
eagle in the yellow flag has MT on its breast, which might stand for Maria Theresa
(1717–1780), the name of the Queen of Austria. Among the three white sampan ships
depicted on the bowl, two carry the British flag and one the Dutch flag, berthing in
front of the British and Dutch trading houses respectively.

Fig. 11.159 A bowl with
trading house pattern,
produced in the Qianlong
period, height: 5.8 cm,
diameter: 40.5 cm, in the
Peabody Essex Museum in
the USA

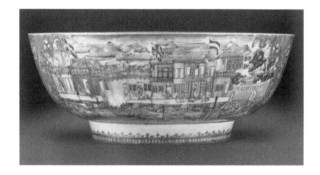

Fig. 11.160 A bowl with
trading house pattern,
produced in the Qianlong
period, height: 15.5 cm,
diameter: 36.7 cm, in the
Peabody Essex Museum in
the USA

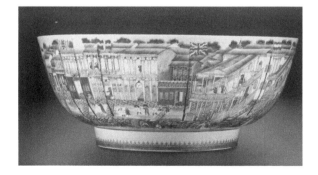

Fig. 11.161 A bowl with trading house pattern, produced in the Qianlong period, diameter: 35.5 cm, in the Peabody Essex Museum in the USA

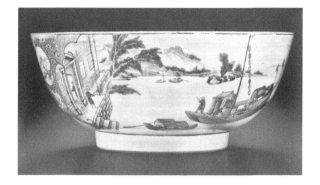

The bowl in Fig. 11.161 is painted with two similar scenes in C-shaped oval outlines, separated with a gilt leaf surface and circular panels with landscape patterns. On one side of the bowl, two Westerners seem to have just walked out of a Western-style building towards the riverside to welcome Chinese officials arriving on a sampan. On the other side, inside the door of a magnificent Western-style building, a Westerner is standing still and supervising workers unloading goods from small sampan boats onto a large sampan.[101]

However, the buildings in the pattern are not directly located on the riverbank and the background is not the typical downtown Guangzhou, so what the pattern describes might be scenes from Whampoa rather than foreign trading houses in Guangzhou. Glamorous Western-style buildings of this type have not been discovered in either of the two places to date, so the pattern might be merely a product of the imagination of bowl producers.

In Fig. 11.162, from left to right, the bowl displays the flags of Austria, Sweden, Britain and the Netherlands while Denmark and France are on the other side of the bowl. Built in 1779, there are gates in front of the fences of the trading houses, directly leading to the riverside. Such scenery can also be found on copperplate paintings. A copperplate painting from 1789 revealed some new changes. The long corridors of the trading houses of Britain and Denmark were rebuilt with heavy semicircular arches, which were probably renovated in around 1785, thus helping identify the production time of the bowl.

Another view is held regarding these bowls. Under the base of the bowls, Greek key patterns and an American flag could usually be found. On one of the bowls, a British flag was replaced by an American flag while on another, an American flag was placed between that of Britain and the Netherlands. If the latter was produced in around 1789, it means all these bowls were produced around the same period, i.e. the period after the American flag was raised in Guangzhou.[102]

[101] William R. Sargent, *Treasures of Chinese Export Ceramics: From the Peabody Essex Museum.* Distributed by Yale University Press, 2012, pp. 432–437.

[102] William R. Sargent, *Treasures of Chinese Export Ceramics: From the Peabody Essex Museum.* Distributed by Yale University Press, 2012, pp. 437–438.

Fig. 11.162 A bowl with trading house pattern, produced in the Qianlong period, height: 14.8 cm, diameter: 36.5 cm, in the Peabody Essex Museum in the USA

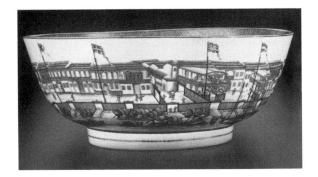

Fig. 11.163 A bowl with trading house pattern, produced in the Qianlong period, height: 16 cm, diameter: 45 cm, in the Peabody Essex Museum in the USA

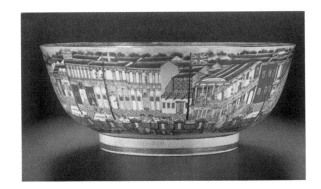

On the bowl in Fig. 11.163 we can also see the American flag, which shows that it must have been produced after 1784, after the Treaty of Paris (1783) had been signed. We can see on this bowl that the national flags of Denmark, Spain, France, America, Sweden, Britain and the Netherlands hung before their trading houses. The white flag of France indicates that the bowl was produced before 1794 when the tricolor flag was first adopted or during the period when the royal white flag was reused from 1814 to 1830. From 1792 to 1794, Aeneas Anderson, a British author, recorded that "Among those who had trading companies in China, countries that established trading houses in Guangzhou included Britain, the Netherlands, France, Sweden, Denmark, Portugal, Spain, and America. However, Britain virtually dominated China's foreign trade with the largest area of buildings and the largest number of ships."[103]

Through oil paintings by Western painters and bowls with trading house patterns custom-made in China, as well as relevant records, the prosperity of the Port of Guangzhou in the Qing Dynasty is demonstrated and we can also learn how Western merchants traded with Chinese merchants in Guangzhou at the time.

Apart from the bowls, a large wall painting housed in the Peabody Essex Museum in the USA also illustrates the trading scene in Guangzhou (Fig. 11.164). The Strathallan wall painting, an exquisite and magnificent piece of work, was hung

[103] William R. Sargent, *Treasures of Chinese Export Ceramics: From the Peabody Essex Museum.* Distributed by Yale University Press, 2012, pp. 437–438.

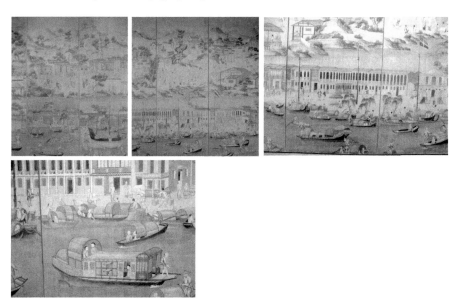

Fig. 11.164 Pictures of the Strathallan wall painting, in the Peabody Essex Museum in the USA

on the wall of Strathallan Women's Salon in Scotland for 175 years. As the only wall painting depicting trading houses and foreign factories in Guangzhou, it shows a wide-ranging view of Guangzhou at the time. Scenes of factories in Guangzhou also frequently appeared on paintings, silverware, porcelain, lacquerware, as well as fans.

In Europe and America in the eighteenth century, Chinese wallpaper was one of the most stylish and expensive means of interior decoration, far more popular than European xylographic wallpaper. Every piece of Chinese wallpaper was hand-made by artisans working in Guangzhou and at the time, Guangzhou was the only gateway for foreign trade with the outside world.

Specifically made for the West, wallpaper was usually decorated with patterns like flowers and birds, Chinese figures, or production scenes of tea, silk or porcelain. Rooms decorated with Chinese wallpaper were usually equipped with luxury goods, such as silk curtains and lacquer furniture imported from Asia, making the rooms seem exotic and comfortable. Tea, as a major import from China, was also brought back from Guangzhou and enjoyed in Chinese porcelain wares in these elegant environments.

It is highly possible that the Strathallan wall painting, a custom-made product, was made on the orders of James Drummond (1767–1851), the 8th Viscount Strathallan, an influential figure in Sino-British trade at the time. Mr. Drummond, who had intermittently worked in Guangzhou from 1787 to 1807, must have been very familiar with the scenes depicted in the wall painting. In 1818, Mr. And Mrs. Drummond put this painting to use in their new home in Strathallan.

The wall painting comprised 18 scrolls and stood 12 *chi* (a traditional Chinese unit of length, 1 m is equal to 3 *chi*) high, with each scroll measuring 4 *chi* wide, giving the whole painting a width of 72 *chi*. A smooth, thin layer of paper made of paper mulberry was placed on another layer of coarser paper made of paper mulberry and bamboo fiber to strengthen it. Before painting began, the painters outlined the motif in ink and pencil before the series of interrelated pictures of this painting were executed by Chinese painters in watercolor style. Such bright colors and plain structures gained popularity among the people. Some parts of the painting, especially the façades of trading houses, were depicted vividly. When this set of paintings was installed in the Viscount's residence in Strathallan, it was cut into several pieces to fit into spaces between its two doors and fireplace.

The scenes in the wall painting can be separated into several parts. On the bottom is the prosperous and bustling Guangzhou as a global pioneer of international trade and culture. Five of the scrolls depict the 13 foreign trading houses, complete with Western architecture where foreign merchants lived and worked during the trading seasons. In front of the buildings are the national flags of their owners. From left to right fly the flags of Denmark, Spain, France, Sweden, Britain and the Netherlands. In front of the French trading house stand two Western gentlemen, with small boats floating on the Pearl River in front of them. On the far right, we can also see a Chinese sampan which is sailing.

The upper part of the painting depicts scenes of daily life in Guangzhou. Shop owners and peddlers are peddling goods, potters are making porcelain tiles, farmers are farming, and there are even two acrobats performing. Many local landmarks can also be spotted, such as the Chinese pagoda and the busy streets.

In the eighteenth and nineteenth centuries, such wallpaper was very popular in Europe and America and was much admired, as only those who had the opportunity to visit China for trade could possibly have ordered such products. Western merchants in Guangzhou therefore capitalized on the opportunity to purchase such wallpaper from Guangzhou and transport it back home for personal use or for sale. The author has seen many goods that accompanied such wallpaper in the Peabody Essex Museum and museums in Boston, such as porcelain, silk products, furniture, lacquerware and silverware. For example, the wallpaper in Fig. 11.165 was shot by the author in the Peabody Essex Museum. It is extremely long and demonstrates many scenes and motifs, comparable even to the famous *Riverside Scene at Qingming Festival*. From this picture, we can also observe the many trading agencies from various countries in Guangzhou as well as the various workshops of foreign merchants, small shops, Qing officials on patrol, people playing ball and others loading goods, enjoying themselves, or fishing by the riverside. This wallpaper demonstrates the trading and daily-life scenes of Guangzhou as a global port city at the time and thus serves as an important reference for historical research.

Fig. 11.165 Luxury goods imported from China, in the Peabody Essex Museum in the USA

11.6.3 Islands Related to the Porcelain Trade Near Guangzhou

As mentioned above, Western merchants were only allowed into Guangzhou for the porcelain trade while other places were closed to them. Their large ships needed to berth at places like Macao, Humen, Whampoa, and Hong Kong, rather than sailing directly into Guangzhou. The author first learned about these places from paintings in museums and later made some investigations to gain a better grasp of the trade in these places. Due to limited space, we will only give a brief introduction to these places to provide the reader with another perspective to better understand the porcelain trade between China and the Western world at the time.

Figure 11.166 is an oil painting of Macao in the nineteenth century. In 1557, Portuguese merchants obtained permanent residential rights on the Macao Peninsula in the Pearl River Estuary by agreeing to pay rent every year and obeying the rules of the local Chinese government. Guangzhou could be reached from Macao via the Pearl River, and thus was used as an important springboard to enter Guangzhou. Portuguese merchants built Macao into a European-style city which was administered by a Chinese official sent from Beijing by the Qing emperors. Even after Portugal's trade with China declined, Macao remained an important city for foreign trade. By the late 18th and early nineteenth centuries, Macao had been a base for countries trading with Guangzhou. In the nineteenth century, European merchants (mainly Portuguese ones) had been in the city for over two centuries. The painting illustrated here depicts Macao in the nineteenth century. We can see that Macao by this time was a vigorous port city with luxurious buildings and Baroque-style churches. It was painted from a southern perspective. On the crescent-shaped beach and gulf on the left of the port we can see five Western ships berthed on the shore. On the left side, there is a line of white buildings on the mountain top. These are the local Catholic churches. According to records, there were many Western-style buildings, castles, churches, convents, and a senate in Macao, so foreign merchants must have felt at

Fig. 11.166 Macao in the nineteenth century, an oil painting, in the Peabody Essex Museum in the USA

home here. Outside the city lies a short fender wall, a wide beach road and Praia Grande Bay, which serves to protect the city from the sea.

The role of Macao is well documented: Guangzhou is a natural port located on the banks of the Pearl River, linking both the waterway and the inland. Many merchant ships would reach China's South Sea in October and November and sail around 8 miles to Guangzhou. Macao is around 66 miles from Guangzhou. Captains must dock at Macao first to find a navigator and, under his guidance, proceed to Humen to pay taxes. There were two categories of taxes. One was tonnage dues or berthage, and the other was "tribute" to the emperors. After this, the ships would be allowed to travel to Whampoa via the Pearl River where the ships would berth until they are fully loaded with Chinese goods. Supercargoes were allowed to alight and proceed to their trading agencies in Guangzhou for business. But all relevant negotiations had to be completed before the end of January so that their merchant ships could sail back home on the advantageous northern monsoon winds.[104]

This author has also viewed a watercolor painting of Humen in the early nineteenth century (Fig. 11.167). Humen is situated around 40 miles north of Macao, located on the only route from Macao to Guangzhou on the Pearl River. The waterway from Humen to Guangzhou is relatively narrow. Humen (or tiger's mouth) is known historically by Portuguese as the Bocca Tigris or Bogue, because bocca means mouth in Portuguese and the red cliffs of Humen on the left of the Pearl River look like the mouth of a tiger. Later, in order to defend against foreign invaders, many forts were built at Humen.

Another oil painting in Fig. 11.168 depicts a cemetery for foreigners in Whampoa, showing how many foreigners had been to China for trade and died and were buried there. This shows that many foreign merchants must have lived in Whampoa for a very long time. We have already discussed the importance of Whampoa above, but through this picture we are able to gain a better understanding of the place.

[104] D. F. Lunsingh Scheurleer, *Chinese Export Porcelain Chine de Commande*. Pitman Publishing Corporation. 1974, p. 63.

Fig. 11.167 Portrait of
Humen, a watercolor
painting, produced in the
early nineteenth century, in
the Peabody Essex Museum
in the USA

Fig. 11.168 Cemetery for
foreigners in Whampoa, an
oil painting on canvas,
produced in 1850 (under the
reign of Emperor
Daoguang), in the Peabody
Essex Museum in the USA

Situated north of Humen and south of Guangzhou, Whampoa was known as the Whampoa anchorage by foreigners. It had no deep waters, which ensured that large ships could not penetrate the mainland any further. Therefore, foreign merchant ships were forced to berth here for around three months for their goods to be sold and their ships to be reloaded with Chinese goods. In the Whampoa anchorage there were various commercial ships of different sizes and specifications. The masts on the ships seemingly composed a large floating forest.

In *China to Order: Focusing on the XIXth Century and Surveying Porlychrome Export Porcelain Produced during the Qing Dynasty*, we find a story of the author, Daniel Nadler, himself.

At eight o'clock in the evening, we reached the mainland of China. The navigator was a senior man who accompanied us on our journey. After one hour and one quarter, we arrived at our shelter in Macao. The next day, we arrived at Whampoa and berthed on the windward side of the island. It was already very crowded when we arrived. We found six British ships, six Dutch ships, one Danish ship, three Swedish ships and one French ship. Once we berthed, two Chinese ships sailed in on both sides of our ship with several customs officials on board, as all import and export goods must pay taxes... There were also some rules to follow. For example, no opium was allowed into China and no Chinese currencies were allowed out of China. Without the permission of customs officials, no goods could be taken ashore. Customs was responsible for issuing passports to foreigners. Before a provincial-level administrative official boarded our ship, we were not allowed to unload our goods. Whenever he emerged from his ship, another official would precede him and pay tribute to him by firing 12 cannons.

Fig. 11.169 Hong Kong in 1860, an oil painting, in the Peabody Essex Museum in the USA

He took measurements of the length and width of ships as a basis for charging berthage and tributes to the emperor.[105]

In the Whampoa anchorage, people were not only engaged in business. Sailors who traveled on the ships were not only busy attending to their work, but they were also busy enjoying life. Thus, on the island and places around it, there were not only European galleons, but there were also ships from the Indian sub-continent, small cargo boats from the Philippines, passenger ships, ships from the mainland, government cruisers, ferries, normal sampans, as well as ships engaged in the fortune-telling business and acrobatic performances. Some described Whampoa in the 1830s in the following manner:

...Just imagine it as living in a floating city. In this city, everything is on the move. There are various loud noises while people here lead a happy life on water.

Apart from paintings of Macao, Humen, and Whampoa, there is also an oil painting of Hong Kong in 1860. It is noted that in the nineteenth century, Hong Kong was situated at the foot of Victoria Peak while now the Peak is blocked by numerous skyscrapers (Fig. 11.169). After the Opium War, the ports of Hong Kong and Shanghai were opened to the Western world. According to the Treaty of Nanjing, Hong Kong was ceded to Britain in 1843 and did not return to the motherland until 1997. From Fig. 11.169, we can see many merchant ships in Hong Kong, including Western galleons which were not seen in Guangzhou.

The Peabody Essex Museum in the USA also houses an oil painting of the seaport of Hong Kong which was painted in 1850. Back at that time, with the opening of

[105] Daniel Nadler, *China to Order: Focusing on the XIXth Century and Surveying Polychrome Export Porcelain Produced during the Qing Dynasty (1644–1908)*. Paris, 2001, pp. 42–43.

Guangzhou and Hong Kong for foreign trade, a small number of Chinese artisans started to learn Western oil painting in order to meet the demand of foreign merchants and captains to depict typical Chinese scenes. The most popular pictures among them were images of ships and port scenes viewed from ships' decks. It is also likely that port scenes were pre-painted and that specific boats were added to the paintings later according to customer demands. Such paintings present us with a vivid picture of the port of Hong Kong at the time and are precious materials for historical research. Through relevant records and paintings such as these, we can figure out that for a very long time, foreign merchant ships were not allowed into Guangzhou. They had to stop at Macao first and pay taxes at Humen before sailing on to Whampoa to berth, unload and reload. It is still uncertain what the specific role of Hong Kong in this process was, but judging from many oil paintings, we can see that perhaps, like Macao, Hong Kong also served as a trading port and a springboard on to Guangzhou.

11.6.4 Production and Trade of Export Porcelain in the Qing Dynasty

The Qing Dynasty experienced a great boom under the reign of Emperors Kangxi, Yongzheng and Qianlong, leading to a prosperous society and flourishing trade both at home and abroad. As the porcelain production center of the world, China's porcelain exports reached a second peak in the Qing Dynasty following its earlier peak in the mid- and late-Ming Dynasty, when porcelain production peaked both in terms of quality and quantity. It is fair to say that from the Kangxi period to the time prior to the Opium War in 1840, China's export porcelain surpassed that of the mid- and late-Ming Dynasty in both quality and quantity while its market was even more focused on Europe. Additionally, from the late seventeenth century to early eighteenth century, America also began to purchase Chinese porcelain in large quantities. However, Japan, a major consumer of Chinese porcelain in the late Ming period, after learning China's porcelain-making techniques, started to produce large numbers of Chinese-style ceramics and export them to the European market as well, becoming a strong competitor for the Chinese porcelain producers. This also shows that at the time the Western world had an insatiable demand for Chinese-style porcelain.

In order to meet this demand, not only the Jingdezhen kilns, but those in Fujian and Guangdong, under the influence of Jingdezhen, also produced export porcelain in large quantities. Apart from blue and white porcelain produced in places like Dehua, kilns in Guangzhou also produced polychrome porcelain whose bisque was produced in Jingdezhen and decorated in Guangzhou. As most export porcelain was exported abroad directly, especially to Europe and America, and few pieces could be found at home, export porcelain lacked due attention in the compilation of records on Chinese porcelain in general. It is especially difficult for us to elucidate the export of Chinese porcelain from the coastal regions. But things have recently changed as more materials regarding the production of export porcelain in Jingdezhen and in

the coastal regions have been identified. We are also able to find large collections of Chinese export porcelain wares produced in the Qing and Ming periods in many museums in Europe and America, such as the Victoria and Albert Museum and the British Museum in the UK, the Musée Guimet in France, the Dresden Porcelain Collection in Germany, as well as the Museum of Fine Arts in Boston and the Peabody Essex Museum in Salem, Massachusetts.

These museums not only house large collections of Chinese porcelain produced in the Ming and Qing dynasties, but also oil paintings which reflect trade and the production of Chinese export porcelain. Most of the paintings were centered on the porcelain trade and production in the coastal regions, like Guangzhou, Macao and Hong Kong, as discussed previously.

Here, the author would like to introduce some more paintings created in the eighteenth and nineteenth century by Western painters regarding ceramic production in the coastal regions of Guangdong which are now housed in the Peabody Essex Museum in the USA. These paintings can help us gain a better knowledge of the work and life of potters in the coastal provinces.

Illustrated in Fig. 11.170 is an oil painting created in 1820 depicting porcelain firing. It was not noted where the firing took place, but the author holds that it is most probably in the coastal regions of Fujian or Guangdong, as the Jingdezhen kilns featured egg-shaped furnaces rather than dragon-shaped furnaces, which were mainly seen in coastal regions, especially in Fujian. In addition, at the time, foreign merchants were mainly active in Guangzhou and did not set foot in inland cities like Jingdezhen.

Figure 11.171 is a watercolor painting created in 1820 of a Chinese porcelain workshop, specifically for bowls. Looking at the picture as a whole, we can see that there are two parts to the workshop, one for making paste and one for fettling. Its wheels are above the ground, clearly different from the traditional wheels of Jingdezhen. In Jingdezhen, the line of business specific to producing bowls and plates was known as "*yuanqi*" (open-form ware industry), and there were specific workshops for *yuanqi*. Such workshops operated in a flowing production line, during which process various procedures like paste-making, molding, fettling, glazing, and

Fig. 11.170 A scene of firing in a coastal region, an oil painting, painted in 1820, in the Peabody Essex Museum in the USA

Fig. 11.171 A Chinese
porcelain workshop, a
watercolor painting, painted
in 1820, in the Peabody
Essex Museum in the USA

painting were completed in a flowing process in a long workshop. With every proce-
dure arranged in a specific order, time and space were saved and the rational and
scientific operation of the workshops was ensured. However, from the painting here,
this is not obvious. Paste making and fettling are even separated into two rooms.
Thus, while the specific location is not identified, the author believes that it is very
likely that it was situated around the coastal regions rather than in Jingdezhen.

Figures 11.172 and 11.173 are another two oil paintings from 1820. Figure 11.172
depicts potters using molds to make vases, flowerpots, and incense burners as well
as various sculptures. From this picture we cannot only see finished vessels made
with molds, but also some printed sculptures, and printing molds. In Fig. 11.173
workers are packing ceramics in a large warehouse. We can also see a huge set of
scales. At a distance from the workers, a merchant dressed in foreign garments is
talking to a man who looks like a manager. Close to us, workers are packing porcelain
products into delicately made wooden cases. One of them is pouring a filling like
chaff into a packed case in order to ensure the porcelain articles are not broken during
transportation. This method of packing is entirely different to that in Jingdezhen. In
Jingdezhen, it was the convention that ceramics were wrapped with straw and then
woven with thin bamboo strips, resulting in cylindrical-shaped bundles, which would
not break even if they rolled down from ships to the bank when they are unloaded
(Fig. 11.174). So we can see that not only the method of production, but even the
packing methods of different places varied.

Ranking as the largest producer of export porcelain in the Qing Dynasty,
Jingdezhen was the center of ceramic production around the globe. However, apart
from a few from the West, there are not many depictions of the landscape of

Fig. 11.172 A Chinese porcelain workshop, an oil painting, painted in 1820, in the Peabody Essex Museum in the USA

Fig. 11.173 Workers packing ceramics, an oil painting, painted in 1820, in the Peabody Essex Museum in the USA

Fig. 11.174 A conventionally packed Jingdezhen ware, in the Peabody Essex Museum in the USA

Jingdezhen or its production. Even those available could have come from *The Exploitation of the Works of Nature* from the Ming Dynasty or *Twenty Illustrations of the Manufacture of Porcelain* written by Tang Ying. Instead, there are quite a lot of paintings of ports in Guangzhou, Hong Kong and Macao as well as scenes of porcelain production in coastal regions that can be seen today. This indicates that Western merchants at the time were not trading directly with the Jingdezhen kilns. Instead, some intermediate agencies were enabling this. According to records of business groups in the old Fuliang County in 1936, before the Anti-Japanese War there were over 130 porcelain trading houses there who took charge of dealing with the porcelain trade with a commission rate of 3%. Serving as middlemen with official authorization, they were capable of handling the affairs of the whole trading process from picking up goods to taking care of delivery. Each of the trading houses had close connections with those engaged in "supervising temperatures in firing," "grading porcelain" and "hay packing." In 1928, there were 145 households in the business of "supervising temperatures in firing," engaging over 2,000 workers, 140 households in "grading porcelain," involving over 1,000 workers, and 140 households in the "hay packing" business, employing over 2,000 workers in Jingdezhen. Apart from trading houses (*cihang*), there were also trading offices (*cizhuang*) in Jingdezhen, which were set up by merchants from outside Jingdezhen in places rented or purchased for the porcelain trade with a view to sparing the costs of commission for middlemen. According to this record, the author believes Jingdezhen trade and trading agencies during the Republic of China era must have been similar to that during the Qing Dynasty in many respects. In essence, foreign merchants did not need to visit Jingdezhen personally. With porcelain dealers as go-betweens, it was easy and convenient to obtain the goods they desired in Guangzhou.

How, then, did porcelain dealers transport Jingdezhen porcelain out of there? At the time, waterway transportation should have been the major mode of transport for Jingdezhen porcelain because Jingdezhen boasted a well-developed civil shipping industry. We do not know much about the industry in the Qing Dynasty, however, according to the investigations of the author, in 1939, there were over 20 shipping firms and 10 shipping groups divided by geographic origin in Jingdezhen, among which the Poyang and Yujiang groups played a dominant role, with over 800 ships each, followed by the Yugan and Fuliang groups, with over 400 ships each, and then the Guangchang, Fuzhou, Qimen, Wuyuan, Duchang, and Hukou groups, with over 100 ships each.[106] Thus, in total, Jingdezhen had over 3,000 ships for civilian use during the Republic of China era. Considering the wars and chaos of the late Qing and early Republican period as well as the entry of foreign ships at this time, Jingdezhen should have had more ships at its peak in the Qing period.

Sometimes history reveals the past through records, while sometimes history is deduced, based on historical facts. In the view of the author, based on the historical records of porcelain production in Jingdezhen during the Republic of China era, we can trace some facts back to the Qing period. On the one hand, the Qing and Republic of China periods were chronologically proximate and things could be assumed not to

[106] *Cultural Accounts of Jingdezhen*, Vol. 10, *On Jingdezhen Dubang*, 1994.

have changed much, if any. On the other hand, the basic social structure and production mode of porcelain probably remained the same as in the Qing Dynasty, because the agricultural culture of Jingdezhen basically remained unchanged. Due to the slow evolutionary pace of agricultural civilization, people's ways of life, especially those of the lower classes and craftsmen, changed very little over the centuries. Thus, it seems logical and important that we make deductions in our research on the Qing Dynasty based on the historical facts of the Republic of China era if necessary.

Experiencing the Kang-Qian Age of Prosperity and with thousands of years of growth across history, by the Qianlong-Jiaqing period, China was a wealthy oriental nation, accounting for one third of the world's GDP at the time. This was thanks to China's unending supplies of various exports to the world, such as porcelain, lacquerware, gold and silver ware, furniture, silk and tea. Heavy and water-resistant, porcelain wares, as a major export abroad, always served well as ballast. These exports in turn brought huge profits for China, which explained why China's GDP was almost equal to the total GDP of Europe in 1700, and for the subsequent almost one and a quarter centuries from 1700 to 1820 the annual growth of the Chinese economy was almost four times that of Europe.

11.6.5 How Europeans Ordered Chinese Porcelain

Since the Wanli period of the Ming Dynasty, European merchants had begun to come to China and order porcelain. As to how they ordered Chinese porcelain, past research on ceramic history scarcely touched the topic. However, it is very important to figure out this issue as it may enable us to understand the role of Chinese porcelain in interacting with the world and how it entered the international market.

According to records, "The place where European merchants came to purchase Chinese porcelain had over 100 porcelain shops, along with various other shops." In 1769, William Hickey, an American traveler to China, described the many shops and factories he visited. In a long hall, he saw around 200 workers painting on porcelain wares, some of which were seniors while some were children of the age of six or seven. As the number of the most delicate wares was limited, the principle of "first come, first served" was adopted. For ordinary wares, there was a constant and adequate supply.

When ordering tablewares and other large-sized wares, specific deals or contracts had to be made. Additionally, an agreement needed to be reached with Chinese counterparts such that they were obliged to supply ordered products of a certain quantity within a given time and that "each piece of product must follow the requirements of their clients regarding specifications and shapes, and should be decorated under the instruction of employees of the Dutch East India Company." To avoid faults, sometimes bisque was transported from Jingdezhen to Guangzhou for decoration.

In addition, business groups could order porcelain in Jingdezhen on behalf of foreign merchants and specify the prices. Such orders would be put on a tag and business groups would prepare the products based on specific demands and the size

of the order by the deadline for delivery. If broken, the products had to be replaced. But in reality, risks were involved when foreign merchants received their orders as the quality of their goods might be poor. But in order to return home using the winds of the monsoon season, captains usually had no choice but to accept what had been delivered, or else they would have to wait a whole year for the next monsoon, which would get them into even bigger trouble.

It was very difficult to have all the ordered goods delivered at the same time because, due to the specific division of labor in Jingdezhen, it was common that one workshop specifically worked on manufacturing cups, another on cup holders, and another on saucers. Thus, sometimes the majority of products were already on their way to Europe when some sets were just being delivered to Guangzhou. Chinese officials had on multiple occasions issued orders prohibiting transportation of such goods from Jingdezhen to Guangzhou by sampan. But clearly, such sets would not sell well in Guangzhou if they were delivered late.

Sometimes, porcelain manufacture was affected by heavy rain or floods. For example, when it was rainy or cloudy over long periods, the clay would not dry. It might not always be counterproductive to occasionally produce coarse products as porcelain wares were levied taxes based on weight. Thus, light but coarse products were taxed less than heavier quality wares.[107]

From these records, we not only learn how European merchants ordered porcelain in China, but they also enable us to see that China's commodity economy at the time was already quite advanced as government authorities had already realized how to levy tariffs on export porcelain. Taxes were not only levied for government revenue, however. They were also levied to protect the interests of porcelain producers. Meanwhile, it should be noted that tariff was not paid on the number of porcelain wares, but based on their weight, which while not seeming very reasonable, was probably the only relatively simple method of measurement.

In the seventeenth century, when the Dutch East India Company ordered products from Jingdezhen, they would send their orders to the Jingdezhen workshops, along with their wooden samples. If the finished products did not meet their specifications, they could be returned to Guangzhou as a gesture of non-acceptance. If there were dragons or other "weird" patterns among the decorations on their products, they would also be rejected, because European consumers did not necessarily accept such decorations. In addition, when the orders were completed, samples sent to China had to be sent back to the Netherlands for checking whether the delivered goods had reached the required standards of the company.[108]

Relatively speaking, potters would do their best to meet the customers' demands while sometimes they would also reject some orders. For example, in 1755, an order requiring a set of tablewares with the inside painted yellow while the outside was

[107] D. F. Lunsingh Sheurleer, *Chinese Export Porcelain Chine de Commande*. Pitman Publishing Corporation, 1974, p. 64.
[108] J. G. A. N. de Vries, *Porselein*. The Hague, 1923, p. 26.

decorated with enameled flowers and golden circles was declined because potters were afraid they could not finish the job as requested.[109]

Occasionally, there were complaints regarding the quality of custom-made products. In 1767, the Dutch East India Company noted that their suppliers were required to ensure product quality because they noticed that "red flower patterns wear off, which indicates that they were not properly dried after painting and before firing. Red patterns have no gloss if unfired but are glossy after firing. More attention must be paid to this in the future."

Apart from the Dutch East India Company, there were also many orders from individuals. Large quantities of armorial porcelain were also custom-made for individuals. In London, there were Chinese merchants who took specific orders from individuals for products with special decorations. Under normal conditions, it took two years to manufacture these before delivery.

It is recorded in *Chinese Export Porcelain Chine de Commande* that "Western merchants paid in silver, such as silver coins or silver ingots from Spain or Mexico. When foreign merchants were making the payment, Chinese producers would calculate the values of the goods and weigh the silver on scales. They usually placed their small scales into an oil-painted box and hung the box on their waist. Sometimes, payment could also be made in gold, in units of *Liang*. One *Liang* equaled 2.50–3.40 Florins. Spanish Real is also mentioned in many account books, equaling 2.35–2.60 Florins per unit." We can deduce from this record that foreign merchants usually made payment in silver and occasionally, gold, during the Qing Dynasty. Porcelain wares must have been very expensive at the time, because it cost the Dutch East India Company 250 *Liang* of silver ingots for a set of Jingdezhen tableware in 1767, although it is not certain just how many pieces there were in the set. What is more, it is recorded that for a set of blue and white tableware with a total of 29 pieces, the average value of each piece was 2.8 *Liang*, amounting to 82.2 *Liang* of silver ingots for the whole set.[110]

11.6.6 Chinese Features of Export Porcelain

There were two styles of Chinese export porcelain in the Qing Dynasty. The first were those items designed in the Western style for decorative or practical purposes while being decorated in the Chinese style. The other were those that featured both Western design and decoration, with a distinctive exotic character. Meanwhile, the Jingdezhen and other kilns in coastal areas, boasted products of unprecedented variety, quality, and workmanship. Major varieties for export at the time included blue and white porcelain, blue and white *doucai* wares, *wucai* wares, plain tricolor porcelain, famille-rose porcelain, *jincai* wares and *mocai* wares.

[109] J. G. Phillips, Op. cit., p. 36. Figure 22.

[110] D. F. Lunsingh Sheurleer, *Chinese Export Porcelain Chine de Commande*. Pitman Publishing Corporation, 1974, pp. 66, 61.

From the 16th to the mid-nineteenth century, Europe adored Chinese culture. Thus, not only wares with Chinese-style decorations, but also those with traditional Chinese designs were quite popular on the European market. With the growth of foreign trade with the West, not only did Chinese products, imbued with Chinese culture, spread to the West, but even Confucianism, the dominant philosophy in China, also made its way to the Western world and exerted an immeasurable impact on the Enlightenment Movement in Europe. Enlightenment philosophers represented by Voltaire (1694–1778), a leading figure of the French Enlightenment, praised China's Confucianism highly and believed that "Confucianism offered them an ideological weapon in denouncing the corrupt feudal hierarchy, autocratic monarchy, and rule of the church."[111] They mostly sang the praises of an "idealistic and even romantic Chinese ideological culture."[112] The dissemination of such a culture not only relied on words, but also on objects, since due to language barriers, face-to-face communication could not possibly have been as convenient as today. Blue and white porcelain and various polychrome porcelain, symbols of Chinese material and spiritual culture, naturally became a calling card for Chinese culture and through these, Chinese culture was greatly promoted to the outside world. Ceramics with Confucian-related motifs especially gained much favor among European consumers.

Traditionally, the role of art in educating and cultivating sound human relations was highlighted in China. Ceramics constituted a variety of articles for daily use, a production line technique, as well as artifacts for enjoyment. During his reign, Emperor Kangxi adopted the strategy of rule by virtue, tax reduction and exemption, rewarding farming, advocating for active social engagement, and adopting Confucianism with an emphasis on loyalty, filial piety, benevolence, and courtesy in governing the country. In order to maintain the long-term stability of his rule, Emperor Kangxi attached great importance to learning and adopting Han culture, introduced Confucianism in his governance, and stressed rule by virtue and educating people with courtesy. Literature, opera, and woodcuts at the time all served as important means of disseminating the core concepts of Confucianism, which inevitably affected the art of ceramics.

Blue and white porcelain and *wucai* wares of the day often carried various motifs with the theme of loyalty and patriotism as well as those reflecting people's outlook on love and marriage, such as patterns from *Romance of the Western Chamber*. The emergence of *wucai* wares during the Kangxi period provided a new way of illustrating such concepts. *Wucai* wares in the Kangxi period were developed on the basis of those from the Ming Dynasty, but with more varied and brighter colors. Absorbing the techniques of woodcut paintings, Kangxi *wucai* wares had a finer means of expression and figures painted on them mainly hailed from opera and folk stories. In terms of layout, the paintings either formed a complete plot as a series, or were positioned as if they were appearing on a stage with specific settings, or

[111] Zhang Kai, "On Exported Blue and White Porcelain in the Qing Dynasty," Chinese Society for Ancient Ceramics (ed.), *Studies on Ancient Chinese Ceramics* (Vol. 14), The Forbidden City Publishing House, 2008, p. 368.

[112] See Footnote 112.

were separated into several parts from top to bottom, displaying different events in different settings at the same time. There were also times when all of these methods were combined. Such motifs and structural layouts were not only exotic in the eyes of Westerners, but also carried heavy cultural connotations and national characters, thus proving very popular in the Western world.

In January 2011, the author conducted a field trip to the Dresden Porcelain Collection, the largest porcelain museum in Germany with a total collection of over 60,000 pieces of ceramics from Asia and Europe, among which a considerable amount came from China, mostly from the Qing Dynasty. When entering the museum, several large blue and white pots confront one. Decorated with paneled human figures, they carry purely Chinese-style decorative motifs and decorative styles. But it is obvious that they were earmarked for export, as blue and white wares of such a size and with such delicate decorations from the same period, were rarely seen in China (Fig. 11.175).

In the Dresden Porcelain Collection, apart from blue and white porcelain from the Qing period, there was even more polychrome porcelain, mostly *wucai* wares with human figure motifs. Among them, many adopted fighting soldiers as the major pattern, which mainly came from stories like *Romance of the Three Kingdoms* and *Heroes of the Marshes*. In terms of shape, there were plates, vases and pots, etc. Most such Chinese-style porcelain pieces were decorative porcelain, which could be categorized into two groups. The first was large-sized vases and pots, or sets of these, which were often placed in halls or other places inside a room (Fig. 11.176). The second was sets of plates, vases or pots, mainly mounted on walls as decorations. They were usually composed of a large number of wares, thus often taking up most of the wall (Fig. 11.177).

In addition, plain tricolor porcelain produced by the Jingdezhen kilns during the Kangxi period was also very popular on the European market. As *Taoya* recorded: Western consumers paid high prices for plain tricolor porcelain in yellow, aubergine and green colors produced in the Kangxi era. In the Peabody Essex Museum in the USA, the author also saw many pieces of Kangxi tricolor porcelain, including some very exquisite sculptures (Fig. 11.178). In the Dresden Porcelain Collection, there

Fig. 11.175 Large blue and white pots, produced in the late Ming and early Qing period, in the Dresden Porcelain Collection

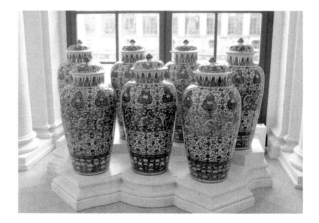

Fig. 11.176 *Wucai* decorative wares with the "fighting soldiers" pattern

Fig. 11.177 *Wucai* decorative wares with the "fighting soldiers" pattern

were also many such collections, like plates and sculptures. There were also some famille-rose porcelain with delicate paintings from Chinese opera and folk stories as well as patterns reflecting people's lives at the time (Fig. 11.179). But most famille-rose wares were from the Yongzheng period and not much could be found after the Qianlong period in the Collection. In the view of the author, this might be due to the fact that from 1710, Germany was successfully producing its own Meissen porcelain. Initially, Meissen porcelain was produced based on its Chinese counterparts, but after

1738 its own style was developed and so they rarely imported any porcelain from China (Fig. 11.180). Among the various decorative porcelain types exported abroad, there were many exquisite porcelain sculptures, including *wucai* wares, famille-rose wares, and tricolor porcelain (Fig. 11.181).

The large blue and white lidded pots with Chinese-style decorations in Fig. 11.175 are almost one meter high. They have an interesting story. It is noted that they were traded by Augustus II the Strong, King of Poland, from Frederick William I, King of Prussia, for 600 fully equipped light cavalry in 1717 and thus known as the "light cavalry porcelain." This transaction took place in the early eighteenth century, while

Fig. 11.178 Plain tricolor porcelain figurines, produced in the Qing Dynasty, in the Peabody Essex Museum in the USA

Fig. 11.179 Famille-rose plate, produced in the Qing Dynasty, in the Peabody Essex Museum in the USA

Fig. 11.180 Meissen porcelain, produced in the latter half of the eighteenth century, in the Peabody Essex Museum in the USA

Fig. 11.181 Famille-rose cow head sculpture, produced in the Qing Dynasty, in the Peabody Essex Museum in the USA

the articles exchanged were in the late Ming style, with clear crawl marks on the lids, a distinctive feature of the porcelain produced at that time. The author therefore thinks perhaps these pieces were purchased by the King of Prussia in the late Ming Dynasty and were traded to Augustus II the Strong in the early Qing period. The fact that a total of 120 of these pieces of porcelain were traded for 600 light cavalry show how expensive Chinese porcelain must have been at the time.

From the above analysis, we can see that most export porcelain in the Chinese style to the European market were for decorative purposes. As high-end decorative

wares, they were luxury goods earmarked for the royal and the privileged. Their patterns were dominated by scenes from Chinese opera, folk stories, or daily life, which reflected Chinese people's value systems and ways of life, which happened to be what European people were curious about. So Chinese export porcelain were actually works of art and luxury goods on the one hand and carriers of Chinese culture on the other.

11.6.7 Japanese Features of Export Porcelain

From the Kangxi to the Qianlong periods of the Qing Dynasty, China also exported porcelain in the Japanese Imari style to Europe. Imari wares were originally manufactured in the area of Arita, in the former "Hizen Province" (now in the area of Saga and Nagasaki prefectures) from 1610, based on the large amounts of Chinese porcelain and production techniques exported to Japan via the Korean Peninsula. Since the porcelain wares made in Arita were shipped from the Port of Imari, gradually these wares became known as "Imari wares." From the late 1640s to the early 1650s, apart from utilizing Chinese technologies, Imari wares also accomplished various technological innovations, such as colored painting. From 1659, while domestic chaos and regime change were occupying China in the late Ming and early Qing period, Japan enjoyed a boom era for Imari ware exports to Europe through the Dutch East India Company.

In the early days, Arita mainly produced blue and white porcelain modeled after Chinese "Kraak wares," known as "Kosometsuke" in Japan. For example, the Arita plate in Fig. 11.182 closely resembles Chinese products. Arita also produced *wucai* wares, known as red and green porcelain in China and "Nanjing polychrome" in Japan. As shown in Figs. 11.183 and 11.184, Imari wares achieved new technological innovations on the basis of the introduced Chinese porcelain-making techniques. In addition, under the strict quality standards of the Dutch East India Company, Arita's technologies were greatly promoted, producing not only products equal in quality to those from Jingdezhen, but also creating Imari *wucai* wares in its own style. For instance, in Fig. 11.185, on the well of the plate is a flowerpot pattern with flowers like peony and chrysanthemum, and on the lip, Japanese folk paintings are applied as decoration. Such blue and white and *wucai* wares were custom-made for export on the orders of the Dutch East India Company and captivated the hearts of the Kings and nobles of Europe.

By the Kangxi period of the Qing Dynasty, Japan's Imari wares had already developed a market in Europe. However, once the Jingdezhen kilns resumed production, the European merchants placed orders for Imari wares with Jingdezhen. China's Imari wares included blue and white porcelain, blue and white *doucai* wares, and *wucai* wares. As China's Imari wares were not only less expensive than their Japanese equivalents, but thanks to its time-honored technological basis, its products were arguably more exquisite and of higher quality than the Japanese ones, Imari wares produced in Jingdezhen were even more popular among European consumers. So, when did

Fig. 11.182 "Kosometsuke" plate with flowerpot pattern, produced in Arita, Japan, 1670–1690 (Kangxi period of the Qing Dynasty)

Fig. 11.183 *Wucai* vase with twining flower patterns, produced in Arita, Japan, 1660–1680 (Shunzhi to Kangxi periods of the Qing Dynasty)

Jingdezhen start to produce Imari wares? According to *Chinese Export Porcelain Chine de Commande*, China initiated production of Imari wares from the early eighteenth century, which can be proven with armorial tablewares. John Somers, 1st Baron Somers, who died in 1716, was owner of a piece of armorial ware. This ware must then have been produced prior to 1716. James Craggs, an English statesman, who passed away in 1721, also took possession of a piece of armorial tableware. There is also a piece of porcelain ware with the arms of Thomas Pitt, the President of Madras, who was involved in trade with India. He left India in around 1706 to 1708, and this piece of ware is believed to have been produced before his departure. This indicates that the first Imari ware made in China might have been around 1700. In addition, among the collections of Augustus II the Strong, there were also some Chinese Imari wares which were listed in an inventory list from 1721.

Fig. 11.184 *Wucai*
octagonal ewer with peony
and Ailanthus altissima
patterns, produced in Arita,
Japan, 1690–1710 (Kangxi
period of the Qing Dynasty)

Fig. 11.185 *Wucai* plate
with a flowerpot pattern,
produced in Arita, Japan,
1720–1740 (Kangxi to
Qianlong periods of the Qing
Dynasty)

China's Imari wares featured a color mix of blue, iron red and gold, and thinner, crispier and whiter bodies than their Japanese counterparts. Their bottom rings were usually unglazed or in a brown color. Different to the Japanese ones, they had no marks on the bottom that were caused by supports during firing. However, occasionally, it is very difficult to distinguish between Chinese Imari wares and Japanese ones, especially when the wares were decorated with chrysanthemum patterns in the traditional Japanese style or Chinese Imari wares featuring typical Japanese decorative patterns. Despite this, generally speaking, Japanese Imari ware featured more muscular decorations while the Chinese product carried more artistic and detailed

Fig. 11.186 Jingdezhen
blue and white *doucai* plate
with crab and peony pattern,
produced during the
Yongzheng to Qianlong
periods, diameter: 23 cm, in
the Peabody Essex Museum
in the USA

patterns. On closer inspection, you may also find some more miniscule differences between Chinese and Japanese Imari wares in terms of shape.

The plate in Fig. 11.186 was made by Chinese potters based on a Japanese design. Though its symmetrical design and colors fully reflected Japanese aesthetic tastes, its decorative patterns were typically Chinese. One of the plate's patterns, the crabs, or *xie* in Chinese, is a homophone for "harmony." It is also a pun on "*jieyuan*," the scholar who won first place in the provincial imperial examinations, symbolizing good luck in the imperial examinations. Peony is a traditional floral symbol of China, known as "flower of riches and honor" or "king of the flowers" and standing for a high post with matching salary or a high social status. The pattern of two crabs and a peony on the plate composes a rebus, symbolizing wealth in harmony. One of the crabs is holding a coin, indicating great wealth. The peony pattern further enhances the auspicious meaning of crabs and the coin, indicating that having passed the imperial examinations, one would enjoy abundant wealth and a high position.[113]

The two plates in Fig. 11.187 have chrysanthemum patterns in the well, a typical Japanese design and color mix that was copied by China and known as China's Imari style. The bottom of both plates are marked with "N:i46/+", showing that they were among the "Inventarium über das Palais zu Alt-Dresden Anno 1721" or Dresden inventory of 1721. The inventory listed around 24,000 pieces of porcelain and to this day, more than 10,000 of them are housed in the Porzellansammlung. Such marks, while not necessarily completely accurate, are very commonly seen and are known as Johanneum marks.[114]

The plum blossom, bamboo and bird pattern on the plate in Fig. 11.188 appears to have been painted on a scroll. Such designs were quite popular in Japan and

[113] William R. Sargent, *Treasures of Chinese Export Ceramics from the Peabody Essex Museum.* Distributed by Yale University Press, 2012, p. 184.

[114] William R. Sargent, *Treasures of Chinese Export Ceramics: From the Peabody Essex Museum.* Distributed by Yale University Press, 2012, p. 186.

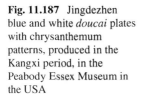

Fig. 11.187 Jingdezhen
blue and white *doucai* plates
with chrysanthemum
patterns, produced in the
Kangxi period, in the
Peabody Essex Museum in
the USA

at the dawn of the eighteenth century, Chinese potters introduced this design into their manufacturing to stabilize the European market into which they had recently launched. Augustus II the Strong, Elector of Saxony and King of Poland, also owned collections like these. In 1760, the Meissen Porcelain Manufactory copied from these plates. The underside of the plate rim is painted with blue and white twigs and two iron-red flowers. The bird on the plate does not appear to be a magpie, judging from its color, but it does resemble a magpie in terms of shape, which might have been deliberate, indicating that it is different from the traditional magpie. In China, the magpie is a symbol of good luck and good fortune, so the cryptic meaning of the picture would appear to be "Happiness appears on the brow" (plum blossom is homophonous with eyebrow in Chinese). Plum blossoms and bamboo could also stand for a bride and groom; along with a magpie, this would symbolize that they make a happy couple.[115]

The Imari ware produced in China mentioned above is all housed in the Peabody Essex Museum in the USA. *Chinese Export Porcelain Chine de Commande* holds that they were manufactured in Jingdezhen. However, no similar piece of ware has been identified in Jingdezhen to date. Perhaps they were all produced for export, hence none were kept in Jingdezhen.

11.6.8 East Asian Features of Export Porcelain (Red and Green Porcelain)

China's export porcelain produced in the Qing Dynasty not only made its way to Europe, but also to Southeast Asia and Japan as well as Africa, all traditional markets

[115] William R. Sargent, *Treasures of Chinese Export Ceramics: From the Peabody Essex Museum.* Distributed by Yale University Press, 2012, p. 188.

Fig. 11.188 Jingdezhen
blue and white *doucai* plate
with plum blossom pattern,
produced in the Yongzheng
period of the Qing Dynasty,
diameter: 31.5 cm, in the
Peabody Essex Museum in
the USA

for Chinese porcelain. With different target markets came different styles of export wares. As mentioned when we discussed the porcelain exports of the Ming Dynasty, European consumers barely knew of China's polychrome porcelain while they mainly imported blue and white porcelain or a small amount of blue and white *wucai* ware. Red and green porcelain produced in the Ming Dynasty would mainly have been exported to Southeast Asia and Japan. By the Qing Dynasty, with the boom of the Jingdezhen kilns, numerous varieties were developed and the technological level of production was boosted tremendously. Many old clients of the Zhangzhou kilns even turned to Jingdezhen at this time. Under the influence of the Cizhou kilns, Jingdezhen began to manufacture red and green wares from the Yuan Dynasty and carried it forward to the Ming and Qing dynasties. Complete pieces of Yuan red and green wares are rarely found in Jingdezhen but in Hong Kong, Jining, Chifeng, Beijing and Nanjing around the country and some places in the Philllipines. The Jingdezhen Art Institute of Private Kilns, founded by the author, houses some shards of Yuan red and green wares painted with lotus and chrysanthemum patterns and resembling the painting style of Yuan blue and white porcelain. This style shares some similarities with red and green porcelain produced by the Zhangzhou kilns in the Ming Dynasty, which might have been a result of mutual learning. Like the Zhangzhou kilns, the Jingdezhen kilns also sold some red and green wares to Japan and Southeast Asian nations during the late Ming Dynasty. But similarly, extant Ming red and green wares are rarely found in Jingdezhen, except for a single item housed in the Jingdezhen Art Institute of Private Kilns. When exported to Japan, such red and green wares produced by the Zhangzhou kilns were called "Gosu polychrome" and Jingdezhen red and green wares were called "Nanjing polychrome." In the Qing

Dynasty, Jingdezhen continued supplying red and green wares to Southeast Asia and Japan. In contrast, not many red and green wares in the Zhangzhou style produced since the Qing Dynasty have been identified abroad, which might have been a result of their losing consumers to the Jingdezhen kilns.

Red and green wares produced both in the Qing and Ming dynasties are rare at home, perhaps because they were earmarked for export. By the Qing Dynasty, after European merchants became interested in Chinese polychrome porcelain and purchased or ordered large amounts of *wucai* wares, *sancai* wares and famille-rose wares among others, not many orders for red and green wares were placed. In 2011, the Groninger Museum in the Netherlands hosted an exhibition called "Famille Verte," which is a range of Chinese porcelain wares characterized by decorations painted in a color range that includes yellow, blue, red, purple, and green, with the latter often used as a base. Since the color green dominated the exhibition of *wucai* wares and red and green wares, hence the name "Green Family." Among the collections on display were some exported red and green wares from Jingdezhen to Southeast Asian nations in the Qing period. Some scholars hold that "In the 1650s and 1660s, Emperors Shunzhi and Kangxi relentlessly ordered the removal of residents in the coastal areas, including Fujian, and strictly banned all ports or exits. The family of Zheng Chenggong, which resisted the Qing dynasty and fought to rebuild the Ming dynasty, took control of the southern coast and monopolized maritime trade. After being defeated by the Qing army, he retreated to Taiwan in 1663. In the 1650s and 1660s, probably due to the political turmoil, production of Swatow wares was halted. Thus, the Jingdezhen producers might have taken over some consumers of Swatow ware. But this continues to be questioned."[116] Such red and green wares, though bright in color and offering sharp contrast, appear tender and feature exquisite and dignified paintings while avoiding the showy and cunning features of Swatow wares.

Here are some examples of products specially made for the southeastern market by the Jingdezhen kilns to take the place of Swatow wares. In Fig. 11.189, the ewer has a round mouth and a round handle on the lid. On the rim, there are two flared horizontal knobs decorated with flower twigs. The long dark-red handle in the shape of a *ruyi* scepter appears solid and durable. The short, straight spout is located on the shoulder of the ewer. The main motif of the ewer is a traditional twining lotus pattern, and the lid is decorated with a lozenge-shaped pattern and many flowers. Ewers of this shape were usually used for holding rice wine or tea in the countryside in China. But this design was not Chinese; it was specifically for export. The red and green kundikā in Fig. 11.190 is a water vessel used by wandering monks and Moslems for washing hands. China started to produce kundikā from the Tang Dynasty, mainly for export as it was widely used in Southeast Asia. During the Ming and Qing dynasties, the Jingdezhen kilns and kilns in coastal regions all supplied this variety of porcelain to the market. But since this kind of ware was mainly earmarked for export, it was rarely seen at home. The kundikā illustrated in Fig. 11.190 is mainly decorated with

[116] Christiaan J. A. Jörg, Famille Verte: *Chinese Porcelain in Green Enamels.* Groninger Museum, 2011, p. 31.

Fig. 11.189 1900.0018:
Ewer, China, eighteenth
century, D. rim 21 cm, D.
footring 13 cm, H. 21.5 cm,
Groninger Museum, bequest
T. Arkema, photo: Marten de
Leeuw

Fig. 11.190 Jingdezhen red
and green kundikā, produced
in the Kangxi period, height:
19 cm, diameter of the upper
part: 6.5 cm, diameter of the
lower part: 7.3 cm, in the
Princessehof National
Museum of Ceramics in
Leeuwarden, the Netherlands

floral scrolls and flowers, including two large peonies. Besides, it is also exquisitely
painted with flowers and twigs on the shoulder, neck, mouth and spout. The large
tureen in Fig. 11.191 has a round bottom and a dome-shaped lid with a round handle.
It is decorated with typical red and green patterns, including various green scrolls,
four large red peonies, four small red peonies, and four small yellow peonies. Wares
of this shape came into vogue from the Kangxi period and remained in production
throughout the eighteenth and nineteenth centuries. They were very practical for
holding food and other things, and hence widely popular. Such tureens could have
been a major variety produced for the southeastern market, but not for the European
market which favored partitioned geometric-shaped patterns in the Kraak style.[117]

Most of the articles introduced above originated in Indonesia and were brought
back to the Netherlands by retirees after their service with the Dutch East India
Company ended, or were retained as collections in Indonesia. Especially famous are
the Princessehof National Museum of Ceramics in Leeuwarden and the Groninger
Museum, both of which house large quantities of such wares. These export wares to

[117] Christiaan J. A. Jörg, *Famille Verte: Chinese Porcelain in Green Enamels*. Groninger Museum,
2011, p. 33.

Fig. 11.191 1945.0181:
Covered pot, China, early
eighteenth century or later,
D. rim 11.5 cm, D. footring
7 cm, H. with cover 14 cm,
Groninger Museum, photo:
Marten de Leeuw

Southeast Asia reveal no detailed record of their place of production, and it is difficult to ascertain whether they were produced by the Jingdezhen kilns. But according to the analysis of the author, it is highly likely that they were produced in Jingdezhen, as the peony patterns in Figs. 11.189 and 11.190 exhibit typical features seen on Jingdezhen *wucai* wares and the decorative style of the wares is clearly elegant and fine, which sets them apart from the products of the Zhangzhou kilns.

11.6.9 European Features of Export Porcelain

Among Qing export porcelain to Europe, decorative porcelain and porcelain for daily use mainly featured Chinese decorative motifs while wares for daily use were designed in the European style in order to meet the aesthetic tastes of European consumers. But how did European merchants order products with European features? As early as 1635, when the Dutch East India Company placed orders with Chinese kilns for porcelain wares of European design, they attached wooden models or Dutch glass or pottery wares as samples, including articles like beer mugs, candle holders, and saltshakers, as well as mustard pots. This practice was inherited by European merchants of later generations such that they would provide pottery, porcelain, glass, silver, tin, and wooden wares as samples, along with drafts of especially-designed patterns with their orders (Fig. 11.192). It is estimated that there were thousands of such drafts provided to Chinese merchants in Guangzhou. But it is a pity that only a small number of the drafts have been preserved because old ones were usually discarded after new designs were delivered.[118]

In the mid-seventeenth century, European merchants purchased smuggled Chinese porcelain from regions like Batavia, Pattani and Surat. But before long, they were

[118] Cited from captions of *Chinese Exported Porcelain: Exhibition of Collections of Royal Museums of Art and History, Brussels*, organized by the Royal Museums of Art and History, Brussels, p. 40.

Fig. 11.192 A draft of a
coffee pot sent to China for
tailor-made production by
the Dutch East India
Company in 1786, a pencil
sketch, 12 × 17 cm, in the
Royal Museums of Art and
History, Brussels

granted access to Guangzhou for direct purchase of Chinese wares. Trading compa-
nies from countries such as the UK, France, and the Netherlands all focused on daily
use articles, including various plates, saucers, bowls, tewares, coffee pots, cups and
vases. Some sets of tablewares which consisted of various pieces that could be used
in various combinations were especially popular and had a far-reaching influence in
Europe. In the early eighteenth century, an ordinary set of tablewares could comprise
as many as 80 pieces, and even more than 600 pieces for large sets, which were all
painted in the same pattern.[119] Illustrated in Fig. 11.193 is a set of daily-use wares
produced in Jingdezhen and exported to the USA in the nineteenth century. It is now
housed in the Peabody Essex Museum in the USA.

Apart from tablewares, tewares and coffee vessels also occupied a significant
proportion of the export porcelain. In the late seventeenth century, tea and coffee
were very popular in Europe and people loved to enjoy them with Chinese porcelain.
Therefore, in the eighteenth century, foreign merchants largely imported Chinese
porcelain and won handsome profits for their companies. For example, in 1751
the Dutch East India Company alone imported around 495,000 pieces of Chinese
porcelain for the Dutch market, including around 200,000 pieces for holding tea,
coffee and chocolate. Europeans were used to traditional Chinese handle-less cups
with saucers and it was not until the late eighteenth century that the modern teacups
with handles appeared. Normally, such cups had a diameter of 6–7.5 cm, and a
height of 3.3–3.5 cm while coffee cups without handles were larger, with a diameter

[119] Cited from captions of *Chinese Exported Porcelain: Exhibition of Collections of Royal Museums
of Art and History, Brussels*, organized by the Royal Museums of Art and History, Brussels, p. 46.

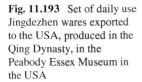

Fig. 11.193 Set of daily use
Jingdezhen wares exported
to the USA, produced in the
Qing Dynasty, in the
Peabody Essex Museum in
the USA

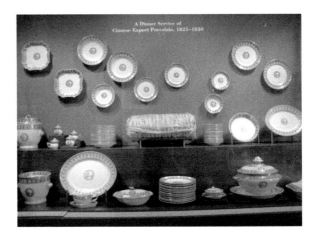

of around 8.5 cm and a height of 4.5 cm, which were sometimes enameled in brown.
From 1735 to 1740, long, deep cylindrical coffee cups mimicking the German design
came into vogue. Goblets modeled on European designs were much larger than coffee
cups and usually had two handles. Apart from cups and saucers, from 1725 consumers
also started to order various vessels in fixed amounts, which were decorated with
matching patterns and coupled with accessories for holding tea, coffee and chocolate.

Figure 11.194 features a coffee pot produced in around 1740–1750. Decorated
with overglazed patterns, it reveals a courtyard scene with flowers, plants, and a stone
(symbolizing longevity) with a perching golden pheasant around the handrail and
a peacock standing on a twig. Opposite the spout, there is a beak at the end of the
handle. The arch-shaped lid is attached with a silver chain. This pot belongs to a set
of tableware housed in the Royal Museums of Art and History, Brussels which were
decorated in the same pattern and included several other coffee pots of different sizes
as well as teapots, tureens, plates, saucers, saucer holders and butter dishes, apart
from this one.[120]

Apart from coffee pots and tablewares, there were also many other daily use
articles that were made based on Western designs and gradually modified to suit the
fashion taste of Europe in the eighteenth century, including beer mugs, butter dishes,
chamber pots, cream dishes, fruit bowls and cuspidors. Such wares were regularly
produced and shipped overseas to European nations. For example, Fig. 11.195 is a
shaving bowl exported to Europe in the early eighteenth century. Decorated with
blue and white and *wucai* patterns, it features a Chinese lady with a fan in her hand
on the left side of the well while on the right side there is a seated European figure
dressed like a clown with a top hat. On the lip, there are two dancing ladies in each
panel. The exterior wall is decorated with blue and white, iron red and green-painted
flower and twig patterns. On the bottom there is a blue and white Artemisia argyi
pattern. For *wucai* wares of the late 17th and early eighteenth century, whether of

[120] Cited from captions of *Chinese Exported Porcelain: Exhibition of Collections of Royal Museums
of Art and History, Brussels*, organized by the Royal Museums of Art and History, Brussels, p. 84.

Fig. 11.194 A coffee pot, produced in the Qianlong period, height: 27 cm, in the Royal Museums of Art and History, Brussels

Fig. 11.195 Shaving bowl, produced in the Kangxi period, 26.3 × 22.4 cm, height: 5.1 cm, in the Royal Museums of Art and History, Brussels

Chinese design or European, most of them are decorated with flowers, birds, and strange animals in the Chinese style.[121]

In the late Ming and early Qing period, custom-made wares for Europe, while European in design, their decorative motifs remained Chinese. Gradually, European merchants began to order products with specific motifs. For instance, in 1680, some merchants from Batavia placed an order for many sets of plates and dishes, with a few painted with coats of arms. This trial turned out to be an unprecedented success and armorial porcelain became an immediate hit in Europe. After that, merchants attempted to try other European-style motifs and succeeded. Entering the eighteenth

[121] Cited from captions of *Chinese Exported Porcelain: Exhibition of Collections of Royal Museums of Art and History, Brussels*, organized by the Royal Museums of Art and History, Brussels, p. 56.

Fig. 11.196 Jingdezhen
soup bowl, produced in the
Qianlong period, height:
10.2 cm, diameter: 19.5 cm,
length between two handles:
27.7 cm, in the Peabody
Essex Museum in the USA

century, porcelain wares with various Western-style motifs began to appear, a typical example of cultural exchange between East and West. For example, Fig. 11.196 is a soup bowl with two handles (similar bowls but only one handle were used for porridge). Such bowls were introduced from France and called "écuelle" (drinking bowls). French ladies usually used such bowls for drinking soup while freshening up, and French men also used them for drinking. Philippe II, Duke of Orléans also possessed one silver soup bowl of similar shape, which was made in around 1690–1692 and remains intact today.[122]

Such "custom-made" porcelain was largely decorated according to artwork and samples provided by the clients. Coins, coats of arms and patterns on European porcelain could also serve as models for imitation. Generally, Chinese porcelain painters were capable of accurately copying paintings and motifs from wood blocks and other objects. They would first pierce small holes along lines of the patterns, put the sample on the surface of a piece of ware, rub the sample with powdered carbon, leaving a rough outline of the motif on the surface of the ware through the small holes before the picture was completed. In the first half of the eighteenth century, almost all "custom-made" porcelain was blue and white porcelain produced in Jingdezhen, followed by overglazed porcelain, *wucai* wares and famille-rose wares. For example, the plate in Fig. 11.197 depicts a baptismal scene of Jesus in blue pigments. While biblical-themed porcelain had been tailor-made for Portuguese merchants as early as the Ming Dynasty, this plate was actually one of the earliest wares depicting scenes from the Bible. It is painted in Western copperplate etching style, which might be a result of imitation by Chinese potters based on illustrations from the Bible or popular presswork or copperplate etchings. Unsuited to the Chinese market, such wares must have been custom-made for the West.[123] What is interesting is that blue and white

[122] William R. Sargent, *Treasures of Chinese Export Ceramics: From the Peabody Essex Museum.* Distributed by Yale University Press, 2012, p. 136.

[123] Lv Zhangshen (ed.), *The Beauty of Porcelain* (one of a series of books for promoting international exchange by the National Museum of China), Zhonghua Book Company, 2012, pp. 110–111.

Fig. 11.197 Jingdezhen
blue and white plate with
baptism of Jesus pattern,
produced during the Kangxi
to Yongzheng periods,
diameter: 50.8 cm, in the
Victoria and Albert Museum

porcelain was no longer the mainstream product of Jingdezhen by the Qing Dynasty,
so it was rarely gilded. There was a saying in Jingdezhen that "Poor blue and white
bowls don't deserve gilt on the rim." Indeed, since the emergence of polychrome
porcelain, blue and white porcelain was not as valuable as before, so people no longer
gilded it. However, for Western consumers, blue and white porcelain that came from
the Far East was precious and deserved to be gilded, hence the existence of many
gilded blue and white porcelain collections in Europe. This plate in Fig. 11.197 is one
of them. The decoration of this plate is in the heavy Western style, with many layers
of blue patterns, demonstrating a sense of perspective and distance, quite different
from the traditional Chinese paintings on porcelain.

By the 1820s, the Yongzheng period of the Qing Dynasty, painters started to
copy the West's line carving and wood block techniques to create thin black lines.
For example, the pattern in Fig. 11.198 diligently copies Edmé Jeaurat's imitations
of Nicolas Vieughels' original woodcuts. In the picture, the newly-born Achilles, a
Greek hero-to-be, is about to be immersed in the Styx upside down by his mother,
Themis, and her two maids. The coat of arms on the bottom of the plate has been
confirmed to belong to a French family in Thornidykes and Frenchlands, Berwick-
shire, Scotland. This plate could have been ordered by Robert French (1704–1758),
a rich merchant and the last lord of Frenchlands.[124]

These two plates display the remarkable skills and amazing imitation capabilities
of Jingdezhen painters.

Initially, such porcelain was only manufactured in Jingdezhen. However, due to the
demanding requirements for accuracy of replication and coloring, as well as the pres-
sure brought by increasing production volumes and limited communication between
clients and potters, auxiliary decorations were gradually shifted to Guangzhou for

[124] Lv Zhangshen (ed.), *The Beauty of Porcelain* (one of a series of books for promoting international
exchange by the National Museum of China), Zhonghua Book Company, 2012, pp. 112–113.

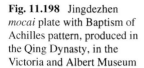

Fig. 11.198 Jingdezhen
mocai plate with Baptism of
Achilles pattern, produced in
the Qing Dynasty, in the
Victoria and Albert Museum

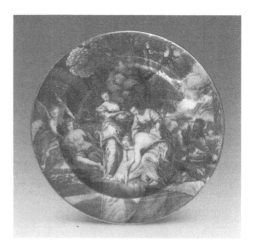

manufacturing. In Guangzhou, under the direct supervision of the purchasers, profi-
cient painters accurately painted on bisque imported from Jingdezhen, based on the
demands of European consumers, which not only reduced the risks of transporta-
tion, but also shortened the time for delivery. From 1740 to 1745, such an arrange-
ment became the standard procedure for making custom-made porcelain. However,
Guangzhou only mastered low-temperature firing, thus was only capable of painting
enamel wares while blue and white wares were still finished in Jingdezhen. For this
reason, from 1740, polychrome porcelain gradually dominated the custom-made
porcelain market, and blue and white porcelain only played a small part.

Because custom-made porcelain took more time, labor and money, large compa-
nies generally did not see it as a major commodity for them. When purchasing porce-
lain, companies usually did not have the time or opportunity to check the motifs on
every piece of ware, so it is understandable that the Chinese porcelain they dealt with,
including those with a European design, was mainly decorated with Chinese motifs,
such as flowers, birds, human figures, or landscapes, which happened to coincide with
Westerners' impression of oriental porcelain. Most custom-made porcelain was for
private use. Some were taken as souvenirs or gifts by merchants and crew members,
while some were purchased in batches to sell for profit at home. Thus, placing orders
for custom-made wares was not a principal business for foreign trading companies,
apart from a handful of companies who did this in order to improve their business,
such as the Dutch East India Company. For example, "Pronk" porcelain was made
for this purpose. In order to meet the demand for expensive porcelain at home, the
Dutch East India Company hired Cornelis Pronk (1691–1759), a famous Amsterdam
painter and designer, in 1734 to design some tablewares, teawares, decorative objects
for the fireplace and vase bases, among others. The records of the company show that
Pronk made four different designs with Chinese features and each acted as motifs for
various vessels. Artifacts displaying the four designs can be found in the Museum of
the Netherlands in Amsterdam today. These are ① Parasol Ladies; ② Doctors Visit;
③ Unknown, maybe "Handwashing"; ④ Human Figures in a Pavilion. Figure 11.199

Fig. 11.199 *Wucai* soup bowl with Parasol Ladies pattern, produced in the Qianlong period of the Qing Dynasty, height: 22 cm, diameter: 35 cm, in the Peabody Essex Museum in the USA

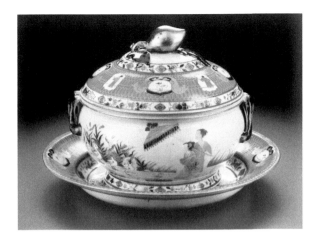

demonstrates the motif of "Parasol Ladies" which originated from Plonk's water-color painting of 1734, which is now housed in the Museum of the Netherlands. The Dutch East India Company received this painting in 1736 in Batavia, and it was later shared with China and Japan. According to documents, this design was first applied on blue and white porcelain, then on Imari wares, and then famille-rose porcelain. The motifs of this design were various and popular for about three to four decades in China and Japan.[125] However, porcelain carrying such motifs has never been identified in China, perhaps due to the fact that such wares were earmarked for export.

The plate in Fig. 11.200 was produced in around 1740, decorated with blue and white and *jincai* patterns, a design of Pronk's "Human Figures in a Pavilion," the fourth and the final Pronk design for the Dutch East India Company which was completed in 1737 and arrived in China in 1739. The pavilion on this plate has a garden door with well-trimmed flowers and grass. It can be confirmed that this is a Western-style pavilion. This design was based on a park near Haar Lem, which was close to Bosch en Hove. The motifs of human figures on the plate, a lady, her attendant, and children (usually boys) were very popular and frequently used in China, as they represented the easy life of scholars and wishes for more offspring and more blessings. As one of a set of tableware, this plate is remarkably large, which is very rare. Decorated in blue and white and overglazed patterns, it was shipped to the Netherlands in 1740. However, since it was too costly and inconvenient to produce and ship such custom-made products designed by celebrities, the Dutch East India Company ended similar deals in 1741.[126]

Of all the custom-made porcelain, "armorial porcelain" comprised a major part. In the early days, Jingdezhen only produced armorial blue and white porcelain, but

[125] William R. Sargent, *Treasures of Chinese Export Ceramics: From the Peabody Essex Museum.* Distributed by Yale University Press, 2012, pp. 226–268.

[126] William R. Sargent, *Treasures of Chinese Export Ceramics: From the Peabody Essex Museum.* Distributed by Yale University Press, 2012, p. 282.

Fig. 11.200 Pavilion pattern
plate, produced in the
Qianlong period of the Qing
Dynasty, diameter: 50.5 cm,
in the Royal Museums of Art
and History, Brussels

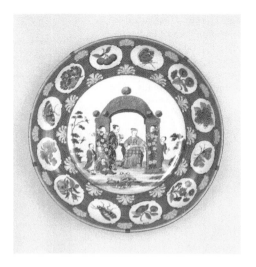

by the first half of the eighteenth century, famille-rose porcelain with coat of arms
patterns appeared. Striking as they were, *mocai* wares and famille-rose porcelain
with coats of arms gradually prevailed over blue and white porcelain. This fashion
swept across Europe and remained in vogue until the late eighteenth century.

Fine and smooth, "armorial porcelain" custom-made for foreign royal families
had the distinct foreign figures or coats of arms of their families, and was even gilded
occasionally, thus it was a typical representation of high-end porcelain. The Dresden
Porcelain Collection houses such works from the early eighteenth century, made by
Guangzhou painters. They were especially commissioned by Augustus II the Strong
in Guangzhou with the coat of arms of the noble family. The arms were painted in
the center of the plate, with traditional Chinese motifs surrounding them around the
lip, including butterflies, lotus and peony, which were varied in content and arranged
intermittently without repetition.[127]

Armorial porcelain varied, including blue and white porcelain, *wucai* wares,
famille-rose porcelain and *mocai* wares. The blue and white *wucai* plate in Fig. 11.201
is painted with the coat of arms of a Dutch city, Utrecht, marked with its ancient name
on the ribbon and decorated with lotus petals, landscapes and human figures in the
Chinese style as well as flowers on the lip.

The overglazed famille-rose plate in Fig. 11.202 is painted with the coats of arms
of two families, each of which is flanked by a dog.

[127] Huang Xiuchun, "Analysis of the Artistic Value of Porcelain Exports in the Ming and Qing
Dynasties," Chinese Society for Ancient Ceramics (ed.), *Studies on Ancient Chinese Ceramics*
(Vol. 14), The Forbidden City Publishing House, 2008, p. 303.

Fig. 11.201 Blue and white *wucai* plate, produced in the Kangxi period, diameter: 25 cm, in the Royal Museums of Art and History, Brussels

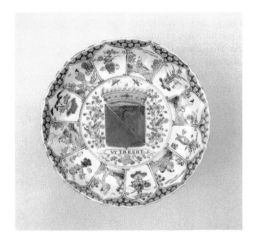

Fig. 11.202 Famille-rose armorial plate, produced in the Qianlong period, diameter: 23 cm, in the Royal Museums of Art and History, Brussels

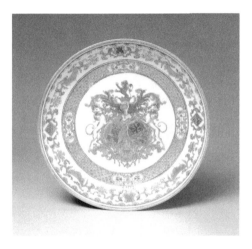

The overglazed famille-rose plate in Fig. 11.203 is painted with floral scrolls in *mocai* on a white glazed background and decorated with two indistinguishable coats of arms. The lip is decorated with patterns in the Du Paquier style.[128]

Among all armorial porcelain, famille-rose porcelain played a dominant role. In fact, the emergence of famille-rose porcelain could not have been possible without the influence of European enamel wares. During the Yongzheng period, driven by high profits, and influenced by the official kilns, Jingdezhen introduced enamel ware from Europe and adopted it into famille-rose porcelain which was more suitable for painters to paint. Meanwhile, Western painting techniques were also introduced into

[128] Cited from captions of *Chinese Exported Porcelain: Exhibition of Collections of Royal Museums of Art and History, Brussels*, organized by the Royal Museums of Art and History, Brussels, pp. 250–251.

Fig. 11.203 Famille-rose
armorial plate, produced in
the Yongzheng period,
diameter: 22.8 cm, in the
Royal Museums of Art and
History, Brussels

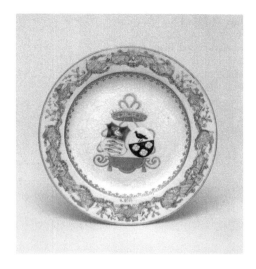

Fig. 11.204 *Mocai* plate,
produced in the Yongzheng
period, diameter: 22 cm, in
the Royal Museums of Art
and History, Brussels

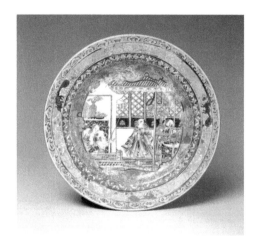

China and new varieties such as *mocai* wares and iron-red wares came into being
thanks to such techniques.

For example, the plate in Fig. 11.204 is painted with *mocai*, *jincai* and iron-red
motifs featuring a European couple with their son and attendant. The lip is decorated
with squirrel and leaf patterns.[129] Probably due to the influence of the Western clients,
since its adoption by China in 1725, the *mocai* porcelain technique featured thin gray
black outlines, which served to vividly imitate European etched and copperplate
paintings.

[129] Cited from captions of *Chinese Exported Porcelain: Exhibition of Collections of Royal Museums
of Art and History, Brussels*, organized by the Royal Museums of Art and History, Brussels, pp. 114–
115.

Fig. 11.205 *Wucai* plate, produced during the Kangxi to Yongzheng periods, diameter: 21.6 cm, in the Royal Museums of Art and History, Brussels

The *wucai* plate in Fig. 11.205 is painted with iron-red, *jincai*, *mocai*, green, purple, and yellow overglazed patterns.

Of the custom-made porcelain, apart from armorial porcelain, there was also various biblical porcelain which utilized a wide range of motifs, most of which hailed from the New Testament.

Decorated with iron-red and *jincai* patterns, the plate in Fig. 11.206 depicts the baptism of Jesus in the Jordan River. The lip is decorated with small angels and eagles holding garlands, with two of the angels on the bottom holding ribbons marked "Mat. 3·16". Originating from the Bible or other Christian classics, this picture was adapted to include stones and flowers on the upper left section by Chinese painters. Early blue and white wares usually painted a tree in this position. Of the extant objects, only plates carry such motifs. They have a diameter of around 22 cm, while this piece of work is a little larger at 27.5 cm, which is quite rare. According to the records of the Dutch East India Company in the eighteenth century, such plates were known as "duplex plates."[130]

Decorated in *mocai* and *jincai* patterns, the plate in Fig. 11.207 depicts the crucifixion of Jesus. At the front, four soldiers are playing with dice while at the rear stand Mary and St. John and various bystanders. The motif on the lip is similar to that of Du Paquier porcelain. Such wares were often produced in sets. Each set usually consisted of four pieces, decorated with patterns of the Birth, Crucifixion, Resurrection and Ascension of Jesus. There was also a fifth, with the pattern of rescuing Jesus from the cross. Some auxiliary wares also adopted similar patterns as their major motifs while different motifs were applied to the edges. Such wares were usually painted in *mocai* and some in enamel.

[130] Cited from captions of *Chinese Exported Porcelain: Exhibition of Collections of Royal Museums of Art and History, Brussels*, organized by the Royal Museums of Art and History, Brussels, p. 163.

Fig. 11.206 *Jincai* plate, produced in the Yongzheng period, diameter: 27.5 cm, in the Royal Museums of Art and History, Brussels

Fig. 11.207 Biblical plate, produced in the Qianlong period in Belgium, diameter: 22.5 cm, in the Royal Museums of Art and History, Brussels

Apart from plates, teawares also carried similar motifs. These patterns remained popular for quite a long time. In 1778, the Dutch East India Company sent a plate with the crucifixion of Jesus pattern to China as a sample for their orders. In 1779, Dutch merchants brought back 22 sets of teawares to the mother country, specifying that they be sent to the south of the country which was a Catholic region. They also mentioned that other merchants also purchased similar porcelain for their own countries, such as Austria.[131]

[131] Cited from captions of *Chinese Exported Porcelain: Exhibition of Collections of Royal Museums of Art and History, Brussels*, organized by the Royal Museums of Art and History, Brussels, pp. 164–165.

Fig. 11.208 Romance-themed plate, produced in the Yongzheng period, diameter: 22.7 cm, in the Royal Museums of Art and History, Brussels

In addition, there were also custom-made products themed on romance which were manufactured for weddings or wedding anniversaries.[132] (Fig. 11.208).

These custom-made wares were not only characterized by exotic motifs and patterns but were also in a clearly Western style in terms of decorative method, as they were mainly overglazed, and *jincai*, *mocai* and iron-red patterns were popular. But of course, famille-rose porcelain was the dominant variety at the time. Though such decorative techniques originated in China, it is obvious that in their application, they were affected by Western paintings. They depicted the life and religions of Europeans rather than Chinese, which shows that they were earmarked for export and, once finished they were soon delivered to Europe and would not remain in China for long. Thus, the production and sales of such wares have been easily ignored by past research on China's ceramic history.

In the mid- and late-Qing Dynasty, with huge and urgent demands from merchants from Denmark, Sweden, the Netherlands, Britain, and France, Jingdezhen shipped many bisque wares to Guangzhou for decoration, which reduced waste in the event of damage during transportation and also cut the time for delivery (Figs. 11.209 and 11.210).

Meanwhile, specific workshops for colored decoration emerged one after another. With foreign merchants flocking to Jingdezhen for enamel wares and famille-rose porcelain decorated with Western-style paintings, China's ceramic art was further Westernized. As Zhu Yan pointed out in *Taoshuo*: "Among porcelain patterns now, *yangcai* (foreign color) paintings take up 40%, life paintings 30%, antique-style paintings 20%, and brocade patterns 10%." The demand for *yangcai*, over-glazed paintings with transparent enamels earmarked for export, spiked at this time, which

[132] Cited from captions of *Chinese Exported Porcelain: Exhibition of Collections of Royal Museums of Art and History, Brussels*, organized by the Royal Museums of Art and History, Brussels, p. 205.

Fig. 11.209 Canton mug
with a Happy Family pattern,
produced in the Qianlong
period

Fig. 11.210 Canton soup
bowl with human figure
pattern, produced in the
Daoguang period

demonstrates how large a proportion color-painted porcelain comprised of the export
wares, as well as how foreignized the Chinese export porcelain had become. The
increase in the number of representatives and companies who supplied Western
paintings to Chinese potters and then returned with porcelain carrying Western-style
patterns marked them as important spreaders and receivers of culture who facilitated
the two-way communication between Western art and Chinese porcelain.[133]

For the Chinese potters at the time, it was not easy to imitate European motifs,
as they represented an utterly alien culture to their own. No matter how vivid their

[133] Huang Xiuchun, "Analysis of the Artistic Value of Porcelain Exports in the Ming and Qing
Dynasties," Chinese Society for Ancient Ceramics (ed.), *Studies on Ancient Chinese Ceramics*
(Vol. 14), The Forbidden City Publishing House, 2008, p. 296.

copied works were, it is still possible to identify some elements that were not Western. If a Western painting was imitated by a poor painter, then he/she tended to put more Chinese elements into the work. People at the time understood this. Pere du Halde, a French Jesuit scholar, pointed out that the Cantonese were very clever and were capable of copying Western paintings vividly. Samuel Shaw, Supercargo of the Empress of China, an American merchant ship in 1748, and consul at Canton from 1785 to 1790, remarked that many Chinese painters were very good at imitating European paintings, but lacked their own creativity and originality. When comparing the folk paintings of European artists with those of the Chinese, you will find astonishing differences. The former knew how to demonstrate the charm of scenes in the eighteenth century in attractive ways while generally, Chinese imitation works lost this feature. Similarly, Chinese painters knew nothing about European coats of arms. So sometimes there were spelling mistakes as they had no concept of what they were copying. Even so, Chinese-made European-style porcelain was a great hit in Europe.

11.6.10 Qing Porcelain's Influence on Western Culture

From the above we can see how the beautiful decorations on Chinese ceramics not only presented the beauty of the ceramic arts through wares like blue and white porcelain, *wucai* wares, tricolor porcelain and famille-rose porcelain, but also opened a window for outsiders to inform themselves of the Chinese way of life and natural environment, and to enjoy it. Before the first half of the nineteenth century, China was a highly civilized nation in the eyes of Europeans and an ideal land to which they aspired. From the early eighteenth century, European missionaries had visited China and gained the attention of emperors, especially Emperor Kangxi, who appreciated Western science and technology and hoped to maintain long-term close contacts with western Europe and enhance the bonds between China and Europe. Meanwhile, as the Enlightenment Movement swept Europe and reached its climax in the eighteenth century, it entered into an era of widely learning and absorbing foreign culture and arts, while China, a distant oriental nation, with its economic strength and cultural accumulation across thousands of years, was regarded as the only comparable civilization to the West, and its culture fascinated Europe. Many European literary and artistic works spared no effort in describing this "ideal land" through the imagination of their authors or creators, even though they had never set foot in China. At the same time, the Chinese tradition of drinking tea also spread to Europe, which opened the way for the export of Chinese teawares with various designs and decorations, leading to a fever for Chinese porcelain in Europe. In this wave of interest, what arrived from the distant China was not only exquisite porcelain, but also the extensive and profound culture and art of an ancient civilization, all of which exuded an air of natural grace and elegance. Many kings and noblemen were loyal fans and collectors of Chinese porcelain. For example, Louis XIV once built a Diana (God of the moon) room in the Grand Trianon with porcelain. Louis XV even unveiled a revolution in articles of daily use and replaced traditional silver and gold ware with

Chinese porcelain. As the most stylish luxury goods for European noble families, porcelain was the highlight of the rising Chinese fever in Europe and reshaped the tastes of aristocrats for decades to follow. The exotic and novel culture from the East also opened up new horizons for European consumers.

Becoming integrated into the lives of Europeans, China's blue and white porcelain could be seen in many oil paintings as decorations, indicating how deeply it affected the way of life in Europe. For instance, the author has viewed several paintings in the Museum of Fine Arts, Boston. One of these, entitled "Blue and White Cup," was painted with a young maid cleaning some blue and white wares for her master. On glimpsing a blue and white teacup which was as thin as paper, its beauty and novelty intoxicated her, and she stopped her work and just appreciated its beauty under the light. Another depicted two ladies chatting, with a piece of Chinese blue and white porcelain on the table next to them. Another shows a girl reading a book with a cabinet in front with a piece of blue and white porcelain and a blue and white jar. There was also one with several girls playing and a pair of large blue and white vases with landscape scenery behind them. One of the girls was leaning on one of the vases which was even higher than herself. In the museum, the real objects in the paintings were also on display alongside the works. This museum collection comprised Chinese articles from the sixteenth and nineteenth centuries which had influenced Western countries, including oil paintings, porcelain and furniture. From here, we can see that Chinese culture had affected the West on many fronts, such as values, tastes, and philosophies of life, through porcelain, tea, silk, furniture, gold ware and silverware, etc. (Figs. 11.211, 11.212, 11.213 and 11.214).

Just as the way of life and culture of China served as an inspiration for artisans at the time, so too did life scenes from China appear on the works of European artists. Among those Western artists who were ardent admirers of China, François

Fig. 11.211 "Blue and white cup", an oil painting, in the Museum of Fine Arts, Boston

Fig. 11.212 A household
with a blue and white pot, an
oil painting, in the Museum
of Fine Arts, Boston

Fig. 11.213 A blue and
white pot and a blue and
white jar on the cabinet in
front of a girl reading, an oil
painting, in the Museum of
Fine Arts, Boston

Boucher was the most representative. In his art show in 1742, many of the French painter's oil paintings were on display, including *Audience with the Emperor of China, Chinese Fair, Chinese Dance, Chinese Garden* and *Chinese Fishing Party*. Exotic as his works were, he tended to paint Asian figures in strange clothes and weird poses, leaving one bemused, such as Chinese officials with long beards and even longer braids, bald soldiers equipped with daggers, as well as Mongol warriors with bizarre pyramid-shaped fur bonnets on their heads. As a matter of fact, the

Fig. 11.214 Oil painting of girls and vases together with the real vases from the painting on display (the pair of vases was exported to Europe from Japan and modeled on the Chinese style), in the Museum of Fine Arts, Boston

figures created by the Western artists were merely products of their imagination. With their skillful craftsmanship, they transformed Western scenes and endowed them with Asian features.[134]

Europe's yearning for and depiction of Chinese culture were also manifested on ceramics. In January 2011, the author paid a visit to the Dresden Porcelain Collection in Germany and saw not only a large amount of Chinese porcelain, but also many pieces of Meissen porcelain from various historical eras. Founded in 1710, the Meissen Porcelain Manufactory cracked the secret of overglazing in 1720. From 1720 to 1750, it produced porcelain that imitated the Chinese product in terms of both decorative style and motif. Life scenes of the Chinese people often appeared on Meissen porcelain produced at this time because Europeans at the time thought Chinese people were living in a paradise and so, their imagination was reflected in the "happy Chinese people" depicted on their products. In their paintings, Chinese people were wearing beautiful silk garments, living an easy life in magnificent buildings with beautiful gardens where flowers blossomed and birds flew, just like in a wonderland. To highlight the joyous atmosphere, bright colors, such as red, gold, yellow and blue were often applied (Figs. 11.215, 11.216 and 11.217).

The Chinese life described by European artists was not necessarily true. In an age of limited means of transport and communication, European people were only depicting what they imagined and projected regarding China, and such imagination and projections propelled their social revolution, enhanced their enthusiasm for the Chinese arts, and further fueled their longing for the Chinese spiritual and material life.

Under the influence of Chinese culture and the arts, European arts turned away from the empty "magnificence" of classicism to emphasizing more exquisite and gentle lines. Affected by the traditional Chinese philosophy of the "unity of heaven and man," a natural style took form and natural beings, such as shells, swirls, water plants, garlands and bouquets were increasingly applied as decorative motifs.

[134] Jacques Marseille (ed.), *Les Grands Eve-nements De L'Histoire De L'Alt*, Shanghai Literature & Art Publishing House, 1999, p. 206.

Fig. 11.215 Porcelain with happy life scene of Chinese people, produced by Meissen Porcelain Manufactory, in the Museum of Fine Arts, Boston

Fig. 11.216 Porcelain with happy life scene of Chinese people, produced by Meissen Porcelain Manufactory, in the Museum of Fine Arts, Boston

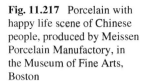

Fig. 11.217 Porcelain with happy life scene of Chinese people, produced by Meissen Porcelain Manufactory, in the Museum of Fine Arts, Boston

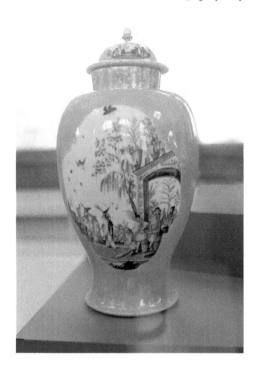

In garden design, the balanced and symmetrical landscape of the classicism was replaced by relatively asymmetrical designs as people gradually realized that gardens should be natural, with a familial atmosphere, while the custom of the geometric trimming of plants remained as part of garden design in Europe.

The Chinese fever which began in the late sixteenth century reached its peak in the eighteenth century and remained in Europe until the early nineteenth century. During this time, Chinese culture influenced Europe considerably, among which process the porcelain trade played a significant role. Meanwhile, the artistic tastes of Europe also influenced China via such trade. From the Qing Dynasty, the decorative art of Chinese porcelain became even more intricate and dazzling than before, a result of the influence of the European arts. We can thus see that cultures and the arts of different countries interact with each other and affect each other in the course of development.

However, not all national features could be totally understood and absorbed. For example, at the time, while Europeans admired Chinese culture and arts and learned about them, including the ceramic arts, due to differences in cultural traditions and aesthetic tastes, they could not necessarily grasp the essence of the beauty of Chinese civilization. Their collecting of Chinese porcelain stemmed merely out of their interest, based on the beauty that they could see and feel while it was virtually impossible for them to understand the beauty of how the porcelain feels, what it symbolizes and what it is made of. Even so, European artists absorbed some nutrition from Chinese culture and cultivated a new artistic style of its own, the Rococo style.

11.6.11 The Spread of Chinese Porcelain Making Techniques in Europe

From the moment European merchants began to purchase Chinese porcelain in large amounts in the sixteenth century, porcelain was one of the major trading commodities between China and Europe. However, the porcelain trade featured long distances and high costs on the one hand and on the other, in the late Ming and early Qing period, as China suffered from domestic turmoil, foreign trade halted, hindering the export of porcelain. In order to meet the demands of the market, from the mid-seventeenth century, the Netherlands started to attempt to produce porcelain on its own with an attempt to break the monopoly of Chinese porcelain on the European market. The Delft kilns were the first to imitate Chinese blue and white porcelain in the Netherlands. A small city close to Rotterdam, Delft's blue and white ware was in fact not porcelain at all, but a kind of low-temperature glazed pottery.

The production of Delftware boomed from 1660 to 1730. Inspired by Chinese blue and white porcelain imported by the Netherlands in the early seventeenth century, Delft potters clearly drew many features from their Chinese counterparts while also adding their own ingenuity to wares such as ewers, which demonstrated the skillful application of cobalt blue decoration techniques. Some of the best Delftware was produced between 1650 and 1710, decorated with blue and white patterns popular in the late Ming period, mostly paneled patterns, such as running deer in a forest, pavilions and buildings, and fairies in natural settings. The Dutch East India Company imported large quantities of such wares at the time. Delft blue and white porcelain was achieved by applying two layers of tin glaze, thus achieving a similar effect to that of Chinese porcelain. Additionally, under the influence of the Delft kilns, other kilns in the country also started to produce ceramics based on Chinese blue and white porcelain. Later, the Delft kilns also produced *wucai* wares, mainly in the style of Swatow wares, while adding their own cultural features in order to suit the customs and tastes of Europeans.[135]

Strictly speaking, Delftware was pottery, not porcelain, which fell short of the demands of upper-class Europeans for Chinese porcelain. Especially under the influence of the "China fever" of the eighteenth century, the European import of Chinese porcelain peaked and astonishingly priced Chinese porcelain siphoned off a lot of money from Europe. In order to find substitutes for Chinese imported porcelain and meet consumer demands, porcelain factories were founded in Europe. They tried to search for methods and techniques of porcelain making from China by various means, and in the process, missionaries who travelled to China played a significant role.

As mentioned earlier, François Xavier d'Entrecolles (Yin Hongxu), a French Jesuit priest, had direct observations of the whole process of porcelain manufacturing and recorded what he saw in his correspondence. He once wrote about the complete

[135] Cheng Yong, "Overview of Chinese Porcelain's Influence on Europe in the 17th and 18th Centuries," Chinese Society for Ancient Ceramics (ed.), *Studies on Ancient Chinese Ceramics* (Vol. 14), The Forbidden City Publishing House, 2008, pp. 525–526.

process of the manufacturing of a piece of porcelain, which passed through the hands of seventy workmen. He also sent home material specimens, including petuntse and kaolin for analysis by the French physicist René-Antoine Ferchault de Réaumur. As the priest of the Jingdezhen region, with the help of his converts, he managed to lay his hands on first-hand information regarding porcelain manufacturing. Against this background, he wrote down what he saw from Sept 1, 1712 to Jan 25, 1722. In 1750, the then Duke of Orleans also shipped home a significant number of samples of petuntse and kaolin and ordered Jean-Étienne Guettard, a French naturalist and mineralogist, to search for equivalent materials in France.

Although France was the first to engage in industrial espionage in Jingdezhen, it was Germany who set up the first porcelain factory in Europe. As mentioned earlier, Augustus II the Strong was an enthusiastic collector of Chinese porcelain, so he invested much money and effort in the enterprise. For him, collections alone were not sufficient. He wanted to produce porcelain of his own, so he demanded that Johann Friedrich Böttger, a German alchemist, copy Chinese porcelain. After many trials, the 26-year-old alchemist successfully produced white and translucent porcelain with mixtures of seven minerals on Jan 15th, 1709, which made him the father of porcelain in Europe and made this day the birthdate of European porcelain. However, it was not long before the King placed Böttger under house arrest for fear of leaking the porcelain-making secrets. Then in 1710, the King founded the Meissen Porcelain Manufactory in Meissen, which operated at a high level of secrecy. For a very long time thereafter, the entire European ceramics industry was heavily influenced by Meissen-style porcelain.

The Meissen Porcelain Manufactory successfully developed the overglazing technique. From 1720 to 1750, it was basically copying the Chinese style and Chinese motifs. For example, in Fig. 11.218, the famille-rose teapot is framed with iron-red, pink and gilt patterns, a typical design of Meissen porcelain in the early 1820s to the 1840s. An early product of the Meissen Porcelain Manufactory, the teapot features Chinese figure patterns with special designs and is fully decorated, an innovation made by Johann Gregorius Höroldt, an artist designer at the factory at this time who once worked in the Du Paquier porcelain factory in Vienna. Before Höroldt was appointed to this post in 1720, the Meissen Porcelain Manufactory had tried to decorate porcelain with color glaze. In the 1820s, Höroldt developed new varieties of glaze, techniques and decorations, including Chinese portraits. On Western articles that depicted China, China was described as an exotic fairyland with people dressed in luxurious garments and leading an easy life, known as the "Happy Chinese." This is one of these objects that depicts the happy life of Chinese people as imagined by the Europeans. A representative work of the time, this pot shifted from depicting the Chinese painting style to describing Chinese people's way of life. After 1750, Meissen porcelain gradually broke from the Chinese style and developed its own features (Fig. 11.219).

In order to retain the monopoly over the production of the "white gold," the material formula was jointly held by three people, Böttger, the private doctor of Augustus II the Strong, and his first Prime Minister and Member of Cabinet. Each part of the production process was kept secret from the other. Even so, relevant secrets

Fig. 11.218 A famille-rose teapot of the Meissen Porcelain Manufactory, produced in around 1723–1725 (the Yongzheng period), height: 10.8 cm, width: 16.8 cm, in the Victoria and Albert Museum

Fig. 11.219 Meissen porcelain entirely free of Chinese features, in the Museum of Fine Arts, Boston

were released by a potter, first to Vienna, and then to Venice. By the early nineteenth century, porcelain factories emerged in Europe one after another. With the success of Meissen porcelain, France followed and became a major porcelain producer. In 1765, under the rule of King Louis XV, with the discovery of local supplies of kaolin at Saint-Yrieix-la-Perche near Limoges, factories were established in and around the area to imitate Chinese blue and white porcelain while developing wares in the French style.

Manufacture nationale de Sèvres was the most famous porcelain manufactory for French-style porcelain. Initially, its decorative style originated from Chinese wares and the Rococo style was gradually added. Established in 1738 with the support of Madame de Pompadour, the manufactory was purchased by the King in 1759 and began trials of making ivory-colored soft-paste porcelain. By 1767 it began to develop hard-paste porcelain. While it had already put aside the Chinese styles by 1777, the shapes and designs, including decorative patterns such as blue outlines, still exhibited Chinese features. For example, its gilt color-painted teapot was clearly very Chinese with its gilding, large blank spaces, and cherry-shaped knob.[136] Apart from

[136] Cheng Yong, "Overview of Chinese Porcelain's Influence on Europe in the 17th and 18th Centuries," Chinese Society for Ancient Ceramics (ed.), *Studies on Ancient Chinese Ceramics* (Vol. 14), The Forbidden City Publishing House, 2008, p. 524.

Fig. 11.220 An openwork
coffee pot produced by
Manufacture nationale de
Sèvres, designed by Renier
from 1831 to 1832, produced
in 1873 (the Tongzhi period
of the Qing Dynasty), in the
Victoria and Albert Museum

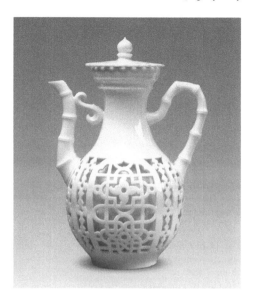

the influence of the Jingdezhen kilns, it also learned from other kilns in China. For instance, the openwork coffee pot in Fig. 11.220 was produced under the influence of the Dehua kilns.

In the late seventeenth century, under the influence of Delft's imitation Chinese porcelain, the UK began its own trial of porcelain making in regions around Bristol. The glazed pottery wares produced in Redcliffe Backs and Brislington in particular were largely decorated with Chinese patterns.

The reason the UK tried to produce blue and white pottery like Delft was mainly to meet the demands of the middle class, as Chinese porcelain, being a luxury good, was exclusive for the upper class. Thanks to Dutch immigrants in Bristol, the Delftware production techniques made their way into Britain. In 1640, the Bristol Porcelain Manufactory introduced the techniques of Delftware and set up manufactories in Liverpool, Glasgow, and Dublin for daily use articles, until 1770 when creamware was created by Josiah Wedgwood.

Delftware was very popular in Europe and its imitations flowed to China for copying, which might have been a private venture. The plate in Fig. 11.221 has a circular mark of worn-off gilt on the rim while the well is painted with figures in Western garments walking on grass against the backdrop of a church and cross. The design was misunderstood by the Chinese potters as they placed the background in the foreground and displayed the flying bird patterns in an awkward manner. Even so, it still manages to convey the Delftware style to some extent. The bottom is marked with "N = 499", a sign of the Dresden warehouse, indicating that it belonged to the most enthusiastic collector in Europe, Augustus II the Strong, Elector of Saxony, King of Poland and Grand Duke of Lithuania.[137]

[137] Rose Kerr & Luisa E. Mengoni, *Chinese Export Ceramics*. V&A Publishing, 2011.

Fig. 11.221 Jingdezhen
blue and white plate in
imitation of Delftware

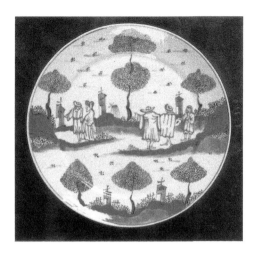

British Delft-style ceramics were coarser and more cumbersome than Dutch Delftware. With blue and pink flaws on the glazed surface, they were a far cry from Delftware in terms of quality. In the late eighteenth century, as Wedgwood creamware came into vogue, the production of British Delftware gradually declined.

At the outset, Wedgwood adopted machine production and its creamware won the favor of the royal court and was known as "Queen's Ware." In 1769, the founder, Josiah Wedgwood (1730–1795) established the first production line for porcelain in Europe in Staffordshire in England, which was actually inspired by the letters of François Xavier d'Entrecolles regarding the production of Chinese porcelain. In its operation, he also creatively introduced a comprehensive division of labor system, demanding that workers in every part of the production process must be the master of their line of work, a very revolutionary idea at the time.

In 1751, the Vauxhall porcelain factory was established on the southern bank of the Thames River in London. Influenced by silverware, Delftware and Chinese porcelain, it manufactured many daily use articles such as tea vessels and candlesticks.

Chelsea Porcelain, which was established in 1744 and operated until 1784, the Royal Crown Derby Porcelain Company which was founded in 1750, and Liverpool porcelain which was set up in 1756 in the northwest port city, were all famous British porcelain companies that produced large amounts of product in imitation of Chinese porcelain. In 1768, Plymouth porcelain, the first English hard-paste porcelain mass producer was built, and many of its products were decorated with Chinese patterns, clearly displaying features of Kangxi *wucai* wares.

Royal Worcester in Britain was also one of the major imitators of Chinese porcelain. For example, the soft-paste vases in Fig. 11.222 are modeled on "*gu*," a kind of bronze drinking vessel in ancient China. The lady patterns on the pair of vases are products of the imagination of European artists while the motifs on the rim are wholly European. Such vases were usually produced in sets and the three piece lidded cylindrical vase sets were often placed as decorations over the fireplace.

Fig. 11.222 Blue and white vases with Chinese lady patterns produced by Royal Worcester in around 1700 (the Qianlong period), marked with the blue and white crescent sign of the manufactory, height: 20.1 cm, in the British Museum

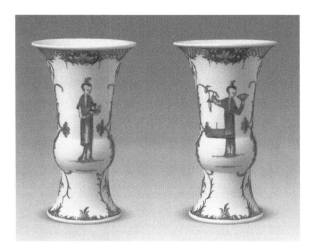

In the mid-eighteenth century, transfer printing was invented by European factories and enabled the mass production of blue and white porcelain. Many porcelain manufactories in Staffordshire, being early imitators of Chinese porcelain, also strove to produce products with their own features. However, while the paste and underglazed oxidation tint of the kilns in Staffordshire were quite special, generally, the originality of their early products was quite poor and most products continued to be modeled on Chinese porcelain.

Most of the polychrome porcelain produced in Staffordshire was blue and white porcelain with motifs in the Chinese style, such as willow patterns. Rose Kerr, former Keeper of the Far Eastern Department at the Victoria & Albert Museum, is an English art historian specializing in Chinese art, and especially Chinese ceramics. In *Chinese Export Ceramics* she describes such "willow patterns." In her view, such patterns, like a figure standing on a bridge, had a romantic story to tell. The implication, serving as a smart marketing tool, was capitalized on and exaggerated by speculators who claimed it to be a legendary story brought back by reformers from the East, a tale which had circulated for thousands of years in China.[138]

The origins of willow patterns have been further illustrated in the research of Qiu Xinqian. According to Qiu, willow patterns mainly included motifs like pavilions and buildings, gardens and fences, poplar and willow in the early spring, pedestrians on small bridges, a small boat on a river, a thatched cottage on an isolated island, as well as a pair of birds. There are usually two layers of motifs on the rim, thin and tight grids and coin patterns on the internal one and even more complicated patterns on the external one, including exaggerated peonies, frets, and coin patterns as well as thin, tight grids and dots. The structure of the motifs is usually as follows: the lower right corner takes a relatively large proportion, with two or three traditional Chinese pavilions and buildings (which could be understood as gatehouses). Behind the houses, there is a huge orange tree bearing bountiful fruit. Next to the houses are

[138] Rose Kerr & Luisa E. Mengoni, *Chinese Export Ceramics*. V&A Publishing, 2011., p. 28.

some unknown trees (including peach trees). In front of the houses is a road leading to the upper part of the plate, with a garden and fences in the middle of the road. On the left side of the plate there is a weeping willow on a bank, with a small bridge with three openings standing next to it and horizontally extending to a post house on the other side of the bank. On the bridge stands three pedestrians with rod-like objects in their hands. On the upper left side of the plate is an isolated island in the distance, with a thatched cottage and some trees. The blank space represents a river with one or two small boats on it and helmsmen are rowing energetically. On the top, two birds fly with their eyes on each other, signifying inseparable love.

To impress consumers, Spode even created a touching story about this image. Once a wealthy Mandarin built a luxurious house on the right side of the river, next to the orange tree with fences and willows all around. He had a beautiful daughter called Koong-See, who fell in love with her father's humble accounting assistant, Chang, angering her father. He dismissed the young man and built a high fence around his house to keep the lovers apart. The Mandarin was planning for his daughter to marry a powerful Duke. On the eve of the daughter's wedding to the Duke, the young accountant slipped into the house unnoticed and eloped with Koong-See. They eventually escaped to a secluded island, where they led a happy life. But one day, the Duke learned of their refuge. Hungry for revenge, he sent soldiers, captured the lovers, and put Chang to death and planned a new wedding with Koong-See. Heartbroken as she was, Koong-See set herself on fire. The gods, moved by their plight, transformed the lovers into a pair of birds, and they remained free and inseparable ever after.

This beautiful but sad romance not only depicts a loving couple breaking free from family disapproval and steadfastly pursuing love, but like Liang Shanbo and Zhu Yingtai, a pair of traditional legendary Chinese lovers, they transcended worldly prejudice and ended up together ever after. Once introduced, this story was widely disseminated across Britain and even today, after more than two hundred years, the romance of the "willow pattern" is still a Chinese legend known to every household in Britain. Thus, porcelain with a "Willow Pattern" is the most legendary ware in Britain and fascinates numerous people.

Spode's "Willow Pattern" wares brought huge commercial returns and positive social feedback. Many large porcelain producers in the UK, including Wedgwood, Royal Worcester, Bristol Porcelain Manufactory, Royal Crown Derby and Caughley Porcelain all manufactured large volumes of porcelain in the Chinese style, decorated with willows, pavilions, and landscapes, which were intimately related to the "Willow Pattern."[139]

The author has viewed several real articles with such patterns in the Peabody Essex Museum in the USA and in the houses of friends in Britain and the USA. At the home of one British friend, the author saw a set of tea vessels which were clearly mechanically produced British products. While at the home of an American friend, there were several blue and white hand-painted plates of various shapes, products of

[139] Qiu Xinqian, *Research on Willow Patterns on Jingdezhen Exported Porcelain in the Qing Dynasty*, a Master's thesis, Jingdezhen Ceramic Institute, 2009, p. 25.

Fig. 11.223 Blue and white
plate with "Willow Pattern",
produced in the nineteenth
century, in the Peabody
Essex Museum in the USA

Fig. 11.224 Blue and white
plate with "Willow Pattern",
produced in the nineteenth
century, in a private
collection

the late nineteenth century, which were probably not manufactured in Europe, but in Jingdezhen (Figs. 11.223, 11.224, and 11.225).

All this shows that Chinese porcelain with willow patterns has deeply impressed the Western market. Apart from this variety of porcelain, China also in fact designed and created a series of blue and white porcelain with motifs like pavilions and landscapes. For example, when Rose Kerr discusses porcelain with the willow patterns in her book, she gives an example of a piece of ware with a blue Chinese parasol motif which also belongs to the category of porcelain with pavilion and natural scenery patterns. Such wares were not only exported to Europe, but also had a large market at home. They were in fact one of the most competitive products from Jingdezhen until the late 1980s. Frequently seen in Europe, such wares with blue Chinese parasol motifs were also salvaged from the sunken ship, Gotheborg (Figs. 11.226 and 11.227).

Rose Kerr wrote that "Since the mid-eighteenth century, British porcelain manufactories always imitated Chinese import porcelain and some consumers could not even tell the difference between the genuine ones and the imitated ones."[140]

[140] Rose Kerr & Luisa E. Mengoni, *Chinese Export Ceramics*. V&A Publishing, 2011., p. 29.

Fig. 11.225 Blue and white plate with "Willow Pattern", produced in the nineteenth century, in a private collection

Fig. 11.226 Blue and white lotus-shaped soup basin with pavilion and landscape patterns, produced in the Qianlong period

Fig. 11.227 Blue and white teapot with pavilion and landscape patterns, produced in the Qianlong period

But imitation was just a means to the end of producing British porcelain and even building itself into a competitor for China in porcelain manufacturing. The industrial revolution which originated in Europe, stimulated the emergence of many technological inventions and enabled the mass production of porcelain which had originally been hand-made. By the early nineteenth century, the mechanized manu-factories such as Wedgwood and Royal Worcester were already capable of producing porcelain of high quality.[141]

From the above, we can see how Chinese porcelain-making technology was trans-ferred to Europe. The porcelain technology of China, the inventor of porcelain, had spread to neighboring countries from the Tang and Song dynasties and even beyond to Europe by the eighteenth and nineteenth centuries, so in essence, China's ceramic history is also a history of how Chinese porcelain technology made its way to the whole world.

11.6.12 Porcelain Trade Since the Second Half of the 18th Century

From the late Ming period, the major export market for Chinese porcelain was Europe. However, from the late eighteenth century, things started to change because at this time, propelled by the industrial revolution, European manufactories such as the Meissen Porcelain Manufactory, Manufacture nationale de Sèvres, and others in Britain were involved in porcelain manufacturing, thus breaking the Chinese monopoly in porcelain production that had stood for thousands of years. In order to protect this infant industry, European nations started to impose protective tariffs to minimize competition from China. In this way, Britain levied a 150% tariff on imported porcelain in 1800. While still ongoing, Chinese exports of porcelain were greatly diminished and from 1791, the British East India Company ceased importing Chinese porcelain.

However, in 1784, the USA entered the Guangzhou market, which lent new impetus to the shrinking export market for Chinese porcelain. As the nation was still in its infancy, in order to break from the rule and arrogance of Britain, the US was reluctant to purchase anything from Britain, so Guangzhou became their source of porcelain products as the young nation was yet to master the technology of porce-lain production. The fact that the European nations were locked in the Napoleonic Wars and had no time to spare for trade in Guangzhou provided a great opportunity for the US to engage in the trade.

It is recorded that from 1790 to 1791, 14 American merchant ships berthed at Whampoa. In 1795 and 1796, there was never less than 10 American ships in Guangzhou during the trading seasons. In fact, the figure was estimated to be around

[141] Cheng Yong, "Overview of Chinese Porcelain's Influence on Europe in the 17th and 18th Centuries," Chinese Society for Ancient Ceramics (ed.), *Studies on Ancient Chinese Ceramics* (Vol. 14), The Forbidden City Publishing House, 2008, p. 531.

15–20 each year until 1808–1809 when about 42 arrived in Guangzhou. There is no doubt that President Jefferson's Embargo Act of 1807 and the ensuing difficulties in maritime transportation largely contributed to the diminishing numbers of American ships. However, from 1790 to 1812, the ships journeying to Guangzhou every year were, on average, on the increase, with a total of over 400 arriving during this time span.

In the trading year 1815–1816, there was an aggregate of 30 American merchant ships in Guangzhou. After only three trading seasons, 1818–1819 saw the number of American ships in Guangzhou peak at 42. In fact, from 1815 to 1839, more than 30 or even 40 such ships arrived in Guangzhou annually. From the trading seasons of 1836–1838, it was recorded that 43 American commercial ships reached Guangzhou. In the late 1830s, this number started to drop and in 1840–1841 it stood at 28. During these five decades, a large amount of cargo was traded between the east coast of the USA and Guangzhou and around 1,260 American merchant ships unloaded at Whampoa, Guangzhou, which ranked only second to that of Britain in terms of number and tonnage.[142]

After the War of Independence, apart from China, the US also established trade relations with other nations and regions such as Mumbai, Calcutta and Batavia in the East Indies and many other places in Southeast Asia.

At the time, the porcelain China supplied to the international market mainly included ① wares with American inscriptions; ② wares with Siamese dancer patterns in traditional Siamese garments for the Siam market; ③ special wares made for Chinese migrants to Singapore, Malaysia and Indonesia; ④ at least two varieties of wares favored by the Persian market; ⑤ ceramics custom-made for the Turkish and Middle Eastern market (prior to the Medieval period, because Chinese potters were poor at copying Arabic characters, they hired Muslim potters and allowed them to settle in Guangzhou); ⑥ enameled wares which intoxicated Indian consumers with bright colors; ⑦ wares popular among Portuguese consumers which were purchased through Macao; ⑧ wares supplied to the Portuguese and Brazilian markets which were the most attractive of all, as well as being large in number.[143] However, it is yet to be determined whether the USA was involved in trading Chinese porcelain in its exchange with Southeast Asia and whether it was through American ships that Chinese porcelain was transported to Southeast and West Asia.

The decorative style of Chinese porcelain experienced fundamental changes at this time as the Taiping forces overtook Jingdezhen in 1853. Even though the Qing armies reclaimed Jingdezhen in 1856, reconstruction of the Jingdezhen kilns, mainly the imperial kilns, was slow.

There was also another factor that contributed to the change in decorative style of Chinese export porcelain after the Opium War and Taiping Rebellion. Looting of the Old Summer Palace by Anglo-French forces opened the Westerners' eyes

[142] Jean Mcclure Mudge, *Chinese Export Porcelain for the American Trade 1785–1835*. University of Delaware Press, 1962, p. 18.

[143] Daniel Nadler, *China to Order: Focusing on the XIXth Century and Surveying Polychrome Export Porcelain Produced during the Qing Dynasty (1644–1908)*. Paris, 2001, p. 100.

to classical Chinese porcelain, including exquisite official wares, thus creating new demands for similar products. Such demands not only prompted imitation of high-quality Chinese ceramics which had been produced over generations, but it also induced the emergence of new ceramics to compete with the classical ones. Thus, apart from large amounts of *wucai* wares and blue and white porcelain modeled after the Kangxi style, numerous magnificent wares in new styles came into being. Chinese merchants also came to realize that traditional blue and white porcelain was no longer an accomplished competitor for the new varieties produced in Europe, so they chose to turn to a more complex and glamorous decorative style.

Like their predecessors, such wares were also mainly produced in Jingdezhen and Guangzhou. Most blue and white *doucai* wares were custom-made in Jingdezhen, including some with colored motifs, such as tobacco leaf patterns and Fitzhugh patterns, which were early formalized as four paneled decorations on Chinese export porcelain. Named after a director of the British East India Company who is thought to have been one of the most famous figures in his family engaged in trade with China, the Fitzhugh pattern, while unclear as to its origin, was one of the major decorative motifs in the early nineteenth century, and porcelain with this motif was mainly exported to the USA with some to Britain and Portugal.

For example, the blue and white *doucai* plate in Fig. 11.228 was produced 1800–1801 and decorated with overglazed blue and Fitzhugh patterns. It was capable of rivaling the classic export porcelain that had been produced over a century earlier, during the Kangxi and Yongzheng periods, in terms of production technique and quality.

The *wucai* plate illustrated in Fig. 11.229 can be dated back to 1802–1850. The beautiful tobacco leaf pattern on the plate was attractive to Portuguese, British and American consumers. With high-fired glaze and gilded rim, this pattern became one of the most popular motifs on Chinese export porcelain. It utilized cobalt blue, turquoise, yellow, brown, yellowish green, orange, dark rose, black and golden colors

Fig. 11.228 Jingdezhen blue and white *doucai* plate, produced in the Jiaqing period, diameter: 24.3 cm

in decoration. On the exterior rim, it was decorated with blue twigs and gilded flowers. As the European market shrank, Jingdezhen and Guangzhou not only welcomed American merchants, but also those from Arabian nations and India. For example, the plate in Fig. 11.230 was especially made for the Turkish or Arabian market. The well is painted with roses in rose and green colors while diamond and star patterns are placed on the rim. In Fig. 11.231, the blue and white colored plate is inscribed with an Arabic blessing, meaning "Allah is watching you. 1249 (in the Islamic calendar)." This plate was evidently produced for the Arabian market. The plate in Fig. 11.232 is painted with an overglazed rose pattern in blue, green, rose, and some black and golden colors, known as "flower and nightingale" in Iran, the most popular motif in West Asia at the time.

These were all products tailor-made in Jingdezhen. They were not entirely overglazed porcelain and some of them were painted blue, which had to be produced there. Apart from such wares with special features, Jingdezhen also produced overglazed polychrome porcelain painted with complex patterns, such as hundreds of butterflies, hundreds of children, Chinese cabbage (symbolizing wealth), and hundreds of flowers. These patterns were once very popular at home and were also applied to export porcelain in the 19th and early twentieth centuries.

The dessert plate in Fig. 11.233 is fully painted with butterflies, known as the "hundreds of butterflies" pattern in Jingdezhen. In fact, such patterns were open to improvisation and a gold color was frequently applied, leading to a very delicate appearance. The Chinese cabbage soup plate in Fig. 11.234 is covered all over with a cabbage pattern. In the center lies a "*Shou*" (Longevity) character surrounded by bright-green leaves and several beautiful butterflies. This beautiful pattern remained in vogue until the twentieth century.

The famille-rose breakfast plate in Fig. 11.235 is painted with various flowers on a black background, featuring exquisite workmanship and glamorous coloring. On the bottom is painted three flowers and the reign name of Emperor Qianlong.

Fig. 11.229 Jingdezhen *wucai* plate with tobacco leaf pattern, produced during the Jiaqing to Daoguang periods, diameter: 19.6 cm

Fig. 11.230 Jingdezhen
large shallow plate, produced
during the Qianlong to
Daoguang periods, diameter:
32.4 cm

Fig. 11.231 Blue and white
polychrome plate, produced
in the Daoguang period,
diameter: 24 cm

However, this piece was actually manufactured in the late nineteenth century. This
decorative style originated from the Qianlong period and was once a hit on the
domestic market. In the nineteenth century, it was revived and was widely applied to
export porcelain.[144]

The overglazed polychrome wares mentioned above were mainly produced in
Jingdezhen and decorated with traditional Jingdezhen motifs while earmarked for
the American market. We can find signs of "CHINA" or "MADE IN CHINA" on
such wares, indicating its status as export porcelain.

[144] Daniel Nadler, *China to Order: Focusing on the XIXth Century and Surveying Polychrome
Export Porcelain Produced during the Qing Dynasty (1644–1908)*. Paris, 2001, p. 181.

Fig. 11.232 Overglazed polychrome plate, produced during the Daoguang to Xianfeng periods, diameter: 27.4 cm

Fig. 11.233 Jingdezhen dessert plate with hundreds of butterflies pattern, produced during the Tongzhi and Guangxu periods

Fig. 11.234 Jingdezhen soup plate with Chinese cabbage pattern, produced during the Tongzhi and Guangxu periods

Fig. 11.235 Jingdezhen
breakfast plate with
hundreds of flowers pattern,
produced during the Jiaqing
to Guangxu periods,
diameter: 24.3 cm

Meanwhile, Guangzhou was also producing overglazed porcelain. At the turn of the eighteenth century to the nineteenth century, Guangzhou developed a new decorative pattern on overglazed porcelain, known as the "Manchu pattern." As Daniel Nadler wrote, "In a countryside setting, there are a group of people in gorgeous garments, which are imaginary, or a scene in a Peking opera. Though nobody has done a thorough study on it, it can be certain that these figures were actually of the Han ethnicity, not Manchu."[145] The human figures and decorations on the rim were usually integrated. The famille-rose plate in Fig. 11.236 was produced during 1820–1840. The green painting on the rim is particularly eye-catching and attractive. In the well, an old man is beating a gong to call those inside the house to welcome a bowing attendant; it seems like a happy occasion. In Fig. 11.237, the Canton washbasin, produced in the mid-nineteenth century, has a flat rim while in the center a gorgeous lady sits in front of a window, draped with two garlands. All these patterns feature roses because Chinese potters knew consumers in the Middle East and the West loved roses. Rose patterns were first seen in the 1840s. Creative as potters were, they added human figures, scenes from tales, and other motifs in the right places and placed flowers and twigs around them, thus creating varied rose patterns. For example, in Fig. 11.238, the lozenge-shaped bowl produced in Guangzhou in 1840 is painted with a royal palace scene of the Qing court, surrounded by rose patterns.

From the above, we can see that during the time around the Opium War, China's ceramics industry was on the one hand faced with the decline in national power, and the rise of the ceramic industries in Europe and Japan on the other. Thus, its export was greatly reduced, though it managed to survive in the markets of the US, Southeast Asia and the Middle East. In addition, in order to increase its presence on the international market, both Jingdezhen and Guangzhou adopted new market

[145] Daniel Nadler, *China to Order: Focusing on the XIXth Century and Surveying Polychrome Export Porcelain Produced during the Qing Dynasty (1644–1908)*. Paris, 2001, p. 118.

Fig. 11.236 Canton plate
with human figure patterns,
produced in the Daoguang
period, diameter: 15.8 cm

Fig. 11.237 Canton
washbasin with a human
figure pattern, produced in
the Jiaqing period, diameter:
37.5 cm, height: 11.5 cm

Fig. 11.238 Canton bowl
with human figure patterns,
produced in the Daoguang
period, diameter: 37.8 cm,
height: 9.5 cm

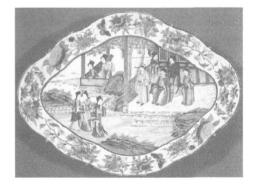

strategies and produced decorative porcelain with Chinese features while also innovating through exquisite craftsmanship and glamorous decoration, hence a series of decorative patterns representative of the time emerged.

11.6.13 Western Research on the Chinese Porcelain Trade

China's foreign porcelain trade is a topic especially worthy of attention and investigation. However, it has yet to receive enough attention among academics in China, while in the West it has always been a hot issue for both academics and collectors. In the eighteenth century, Europe had a large interest in Chinese porcelain, especially during the Rococo period when porcelain fever peaked. However, in the late eighteenth century and the early half of the nineteenth century, it cooled down. Later, in 1861, after the Old Summer Palace had been looted and destroyed by the French and British troops, many exquisite artworks housed there were dispersed. Some entered the market and reached Europe and the USA, leading to a new wave of interest in Chinese porcelain. But what is worth noting is that such interest was no longer in export porcelain to Europe, but in the domestic porcelain produced in China, and especially porcelain for imperial use.

Almost at the same time, research on Chinese porcelain started to spring up in Europe and the USA and some works regarding Chinese porcelain were translated into English. For example, Stanislas Julien took charge of part of the translation of *Jingdezhen Taolu* and it was published in 1856 in Paris. *Taoshuo*, written by Zhu Yan, was also well-known in Europe as Stephen W. Bushell, an English physician and amateur Orientalist, translated it into English and renamed it *Description of Chinese Pottery and Porcelain and the Ching-te Chen T'ao-Lu*.[146] Translation and publication of these books were crucial to European research on Chinese porcelain.

Due to the interest in Chinese porcelain, Europeans collected such wares on the one hand and also engaged in research on the other. The first European treatise on porcelain was co-authored by two collectors, A. Jacquemart and E. Le Blant. A. Jacquemart was the one who coined terms such as Famille Verte and Famille Rose, which continue to be in wide use today. At the time, Europe knew little about Chinese and Japanese porcelain and had no knowledge at all regarding how to distinguish them, but things started to change gradually. Now, various books regarding collections of Chinese porcelain have been published, such as those written by Sir Augustus Wollaston Franks on the many porcelain collections in the British Museum.[147] Ernest Grandidier also took account of the many collections in the Guimet Museum among many others.[148] Such works, though varied in terms of importance, were all conducive to research on Chinese porcelain.

[146] Translated with notes and introduction by G. R. Sayer.

[147] A. W. Franks, *Catalogue of a Collection of Oriental Porcelain*. London, 1879.

[148] E. Grandidier, *La Cerramique Chinoise*, Paris, 1894.

Nanne Ottema, an art collector, was the first to try to gather together all Chinese porcelain in the Netherlands in the first half of the twentieth century. Through systematic collection, he obtained large amounts of Chinese porcelain, which were able to reflect the development of Chinese porcelain from ancient times to the present. His collections are now housed in the Princessehof National Museum of Ceramics in Leeuwarden, the Netherlands, where Ottema was the founder and first head. His *Chineesch Ceramiek* was published in 1943, a handbook on the collections of the museum.[149]

Meanwhile, there were various exhibitions of Chinese ceramics. The most important and instructive for academia and collectors must be one held in Berlin in 1929,[150] one unveiled in London from 1935 to 1936[151] as well as one which took place in New York in 1941.[152] Other interesting exhibitions, organized by the Oriental Ceramics Society, displayed some of the items mentioned in *Chinese Export Porcelain Chine de Commande,* such as "Enamelled Polychrome Porcelain of the Manchu Dynasty (1951)," "Chinese Blue and White Porcelain 14th to 19th Centuries (1953–1954)," "The Arts of the Ming Dynasty (1957)," "The Arts of the Ch'ing Dynasty (1964)," and "The Animal in Chinese Art (1968)."

"Chinese Art under the Mongols, the Yuan Dynasty (1279–1368)" was an important exhibition held in the USA in 1968. "Ming Blue and White" held in the Philadelphia Museum of Art in 1949 served as an important showcase for research on Chinese blue and white porcelain. "Precious Chinese Porcelain" which took place in the Museum Für Ostasiatische Kunst in Cologne, Germany, in 1965 was also an important milestone.

In 1968, De Chinese Porseleinkast organized by the Dutch museum authorities displayed many Chinese ceramics. This exhibition had also traveled to Germany, Sweden, Denmark, and France.

As various exhibitions of Chinese porcelain were held, many research projects and works relating to it also emerged. Among early authors of Chinese porcelain in Europe, some categorized Chinese porcelain into two groups, porcelain custommade for the West and porcelain for domestic use in China. For example, this is true of *Histoire Artistique, Industrielle et Commerciale de La Por-celaine* which was coauthored by A. Jacquemart and E. Le Blant and published in 1862. In many works, it took at least one chapter to cover Chinese export porcelain or porcelain custommade for the West. Published in 1887, *Illustrations of Armorial China* by William Griggs especially discussed coats of arms on Chinese porcelain. Besides, *Armorial China* by Frederick Arthur Crisp which was published in 1907, *Oriental Ceramic Art* and *Chinese Art* by Stephen Wootton Bushell, which were published in 1899 and 1904 respectively, as well as Bushell's works in 1910, were all landmarks of

[149] D. F. Lunsingh Scheurleer, *Chinese Export Porcelain Chine de Commande.* Pitman Publishing Corporation, 1974.

[150] O. Kiimmel, Chinesische Kunst, *Ausstellung Chinesischer Kunst.* Berlin, 1929.

[151] Exhibition of Chinese Art—A Commemorative Catalogue. London, 1936.

[152] Joseph Downs, "The China Trade and its Influences," Bulletin of the Metropolitan Museum of Art. New York, 1941, p. 84.

their time. In addition, published in 1915, *Chinese Pottery and Porcelain* by Robert Lockhart Hobson is still a valuable masterpiece, even today.

Many English writers also wrote books on Chinese porcelain and enriched the studies in this field, including W. B. Honey, E. E. Bluett, A. D. Brankston and Soame Jenyns. *Chinesisches Porzellan* written by Ernst Zimmermann, of lasting reference value, published a second edition in 1923.[153] From the late nineteenth century to the early twentieth century, the publication of these works increased knowledge and understanding of the Western nations of Chinese ceramic arts and Chinese culture and also left valuable accounts of the foreign trade in Chinese porcelain in the past. This book could not have been possible without these works which have provided the author with a global perspective on the historical development of Chinese ceramics.

11.7 Conclusion

11.7.1 Overview

If we say that the Yuan Dynasty was the beginning of the transition from high-brow to low-brow art, then it was during the Ming and Qing dynasties that folk culture started to dominate the aesthetic tastes of the time and even affect the royal and privileged. Especially after the Qing Dynasty, folk culture evolved on the basis of that of the Ming Dynasty and with the further development of the urban economy, culture and the means of entertainment further varied and prospered, such as opera, literature, and woodcuts, which accelerated the maturity of the folk arts in terms of form and content. Meanwhile, culture and arts from the West also made their way to Southeast and Southern China along with foreign trade, bringing the highly ornamental and glamorous Rococo style to China. At the same time, some literati passionately pursued antique styles and flaunted "orthodox" philosophy while some other scholars turned their eyes to civil society to make their works more down-to-earth by largely utilizing primary colors to form sharp contrasts and a more vivid atmosphere. To conclude, during the entire Qing Dynasty, as folk culture and popular culture formed the mainstream, porcelain art mainly featured bright and cheerful colors and complex and magnificent decorations to reflect life, thus education became the primary purpose that Qing ceramic art pursued.

[153] D. F. Lunsingh Scheurleer, *Chinese Export Porcelain China de Commande*. Pitman Publishing Corporation, 1974.

11.7.2 Masculine Beauty and the Educational Function of Ceramic Art in the Early Qing Period

In the early Qing Dynasty, especially the Kangxi era, China's feudal society was still rising steadily. With a large territory, Chinese people lived in peace and the era exuded confidence. When this confidence was reflected in ceramic art, it displayed a masculine beauty. Of course, the manifestation of an art is not only affected by the aesthetic tastes of a single era, but reform in raw materials also played a significant role. In the early Qing period, the most remarkable progress in Chinese ceramic art lay in blue and white porcelain and *wucai* ware, which although already having reached maturity in the Ming Dynasty, formed a unique style in the Kangxi period. The polishing technique, which created a multi-layered effect, was also influenced by Western painting techniques as well as traditional Chinese water and brush paintings. Thus, compared with that of the Ming Dynasty, the blue and white porcelain of the Qing period was distinctively different in terms of style and means of expression.

Wucai porcelain reached a peak among polychrome wares produced in China during the Kangxi period, so *wucai* ware during this time was also known as "Kangxicai" (Kangxi polychrome ware). The reason it was able to reach such a height can be very much attributed to the reform of raw materials at the time. During the Kangxi period, the proportion of kaolin was increased in clay. Meanwhile, the reform of furnaces further lifted firing temperatures, which made possible the unprecedented hardness and uprightness of bodies. Thanks to this, wares produced in the Kangxi period, large or small, round or square, all featured exquisite workmanship. At the same time, new trials and innovations were also made in pigment mixes and their use. For example, in painting lines, glue was used as an auxiliary tool on Ming *wucai* wares while olibanum oil was applied for the same purpose on Kangxi polychrome wares. With different properties, these actions led to different effects. Glue is a water-like pigment which requires rapid and accurate application on water-resistant smooth surfaces, otherwise inks would remain and it would be difficult to draw neat and intricate lines, thus it was very suitable for free and bold styled works. In contrast, olibanum oil is an oil-like pigment with a certain level of viscosity and tenacity, which could be mixed with a cobalt blue material called *zhumingliao*, which was used for painting *wucai* wares. When painting, a little camphorated oil was applied to the pigment to enable it to dissolve into liquid and to penetrate the brushes which were specially made in Jingdezhen. Once potters grasped the properties of olibanum oil, they were free to draw lines quickly or slowly, thick or thin, and it enabled them to execute neat and fine patterns. In addition, Ming *wucai* ware was generally outlined in blue pigments while black *zhumingliao* was yet to appear, let alone purple and green colors, thus they were not as varied or bright as Kangxi *wucai* ware in terms of color. With new techniques and new colors, painters in the Qing period modeled their work after woodcut paintings, woodcut New Year pictures as well as various illustrations, embroidery works and paintings, adding their own creativity, and producing the highly prestigious Kangxi *wucai* ware famed in the history of art (Fig. 11.239).

Fig. 11.239 Blue and white *wucai zun* with peony and pheasant patterns, produced in the Kangxi period, height: 46 cm, in the Palace Museum

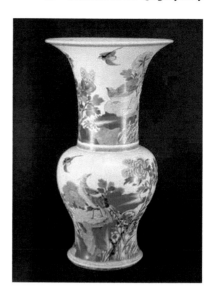

Porcelain produced in the early Qing period not only made innovations in technique, shaping, and painting, but also featured unprecedentedly varied motifs. The rulers of every regime had to choose an orthodox academic philosophy for the longevity and stability of their reign. In the late Ming and early Qing periods, the thought of "studying in order to apply knowledge" gained popularity. However, this thought was a little radical for the Qing rulers as it implied an opposition to dictatorship and a distinction between the Han ethnicity and others. The School of the Mind (*Xinxue*) upheld by scholars in the late Ming period was largely more empty talk than concrete action, which readily endangered the country, a lesson well-learned by the Qing rulers in their battles against the Ming regime. After repeated reviews, Emperor Kangxi decided to endorse the Cheng-Zhu school, one of the major philosophical schools of Neo-Confucianism, based on the ideas of the Neo-Confucian philosophers Cheng Yi, Cheng Hao, and Zhu Xi, as the orthodox philosophy of his rule. Traditionally, Confucianism highlights virtues practiced in daily life, ethical rule and educating people through ritual norms and propriety. Traditionally, the role of art in educating and cultivating sound human relations was highlighted in China and it was believed that "*Dao* is something with no specific form while *Qi* is something with specific form. Without *Qi*, *Dao* would have no place to be cultivated...".[154] Thus, the porcelain produced at the time was equipped with an educating role. For example, there were large Confucian motifs advocating loyalty to rulers often seen on *wucai* and blue and white wares, such as scenes from *the Three Kingdoms*, *Heroes of the Marshes*, *The Legend Of Yue Fei* and *Zhao Jun Ventures Abroad*. These pictures also displayed scenes of warfare, thus appearing magnificent with marvelous and exaggerated moves, known as "fighting soldiers" patterns. Such patterns were not

[154] Gu Yanwu, *Rizhilu*, Vol. 1, *Xingerxiazheweizhiqi*.

only popular on the domestic market, but also in the foreign market and were much favored by Western painters. Many modern Western painters also highly appreciated the masculine beauty of the patterns, such as Picasso, Gauguin and Gustav Klimt.

The plate in Fig. 11.240 is illustrated with the story of Guo Ziyi fighting his enemies. Guo Ziyi, a famous general of the mid-Tang Dynasty, recovered the two capital cities, Luoyang and Chang'an, after the outbreak of the Anshi Rebellion, and he even persuaded Uyghur chieftains to join the Tang forces in his fight against the Tibetans. Guo who spent his lifetime on the battlefields, had repeatedly established wonderful merit and enjoyed great fame and prestige. Thanks to him, the Tang regime remained at peace for over two decades. The plate illustrated here shows how he fought his enemies. The *wucai* vase in Fig. 11.241 is painted with a war scene which hails from the legend of Liu Bei, Guan Yu and Zhang Fei from Luo Guanzhong's *Three Kingdoms*. Depicting the scene of Zhang Fei and Ma Chao fighting on horseback in the Jiameng Pass, Zhang Fei was battling Ma Chao who was wearing silver armor while Liu Bei was ordering Zhang Fei to leave for their campsite. Such patterns on porcelain were modeled on woodcut paintings. Emperor Kangxi was very smart in adopting this as a means of political propaganda, an attempt to persuade anti-Qing forces in Southern China to come to terms with the Qing court and accept the Qing regime as the legitimate ruler of the nation.

Additionally, Confucianism advocated scholarly learning, so there were many paintings reflecting the interests of scholars on *wucai* ware and blue and white porcelain during the Kangxi period, such as Wang Xizhi observing geese, Su Dongpo and the inkstone, Tao Yuanming admiring the beauty of a chrysanthemum, Zhou Maoshu and lotus, the Seven Sages of the Bamboo Grove, the three durable winter plants, namely pine, bamboo and plum blossom, *Qiushengfutu*, and Mifu worshiping a strange stone, and more.

From 1691, the 30th year of the reign of Kangxi, the emperor frequently held imperial examinations and honored the Han culture. Large amounts of porcelain were inscribed with poems and essays. In addition, images like the top scholar of an

Fig. 11.240 *Wucai* plate with Guo Ziyi fighting pattern, produced in the Kangxi period, diameter: 35.5 cm, bottom diameter: 20.1 cm, height: 6.1 cm, in the Rijksmuseum, Amsterdam

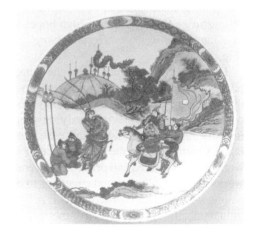

Fig. 11.241 *Wucai* vase
with *Three Kingdoms* scene,
produced in the Kangxi
period, height: 45 cm, mouth
rim diameter: 12 cm, bottom
rim diameter: 14 cm, in the
Rijksmuseum, Amsterdam

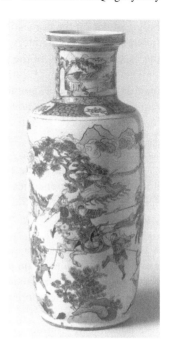

imperial examination gracing the street, the top scholar of an imperial examination presenting himself before the emperor with an *ao*-head-shaped (a huge legendary turtle) relief above, five sons passing civil examinations, and *lianzhongsanyuan* (coming first in the civil examinations in the provincial capital, the national capital and the palace), also reflected this social milieu. Confucian tradition also meant that Chinese people attached great importance to family continuity and wished for more offspring. Reflected on porcelain, there were various auspicious motifs such as pomegranate seeds (symbolizing more children), peach, fingered citron and pomegranate patterns (wishing for more children, blessings, and longevity), "*Wangzichenglong*" (Holding high hopes for one's child), kylin delivering children to a family, as well as "*Zisunmantang*" (Sons and grandsons pervading the hall) (Fig. 11.242).

Dominated by Confucianism, the Qing rulers attached great importance to the propaganda and "educating" role of the arts. Qing rulers therefore restricted the development of the civil woodblock industry which had boomed in the late Ming Dynasty on the one hand, and vigorously developed and supported the royal publishing industry regardless of labor and cost, producing large quantities of books on the other. Capitalizing on the convenience of woodblock printing, many "royal edition" works were produced and printed. The ceramics industry drew inspiration from these works and applied some of the patterns to blue and white porcelain and *wucai* wares, among which Jiao Bingzhen, a court painter's *Gengzhitu* was the most utilized and influential among the decorative motifs on porcelain.

Fig. 11.242 Famille-rose pot with children at play pattern, produced in the Qianlong period, height: 15.3 cm, mouth rim diameter: 8.2 cm, foot rim diameter: 7.8 cm, in the Palace Museum

Gengzhitu was reproduced and distributed in the form of wood engravings in 1696 under the sponsorship of Emperor Kangxi who even wrote a foreword and painted some illustrations for it. The Emperor intended to emphasize among his officials that agriculture was the major pillar of wealth and prosperity of the Great Qing Dynasty. Various cheap versions of *Gengzhitu* were widely available and some of the illustrations came to serve as models for many forms of decorative arts, especially for porcelain produced for the domestic market. At times such illustrations were copied entirely and faithfully, but more often they were modified to suit a limited space or recreated as interesting motifs to attract potential consumers. For example, the *wucai* plate in Fig. 11.243 depicts a farming scene of paddy. In front, four farmers are planting while at the back, another two are taking a break under two trees. This pattern originated from a *Gengzhitu* woodcut painting. But in the original painting, there were only farmers in the front planting paddy, without the two resting behind, which must have been added by the porcelain painters.

Fig. 11.243 1986.0396: Dish, China, c. 1700, D. rim 20 cm, D. footring 14 cm, H. 3.2 cm, Groninger Museum, photo: John Stoel—The Groninger Museum receives two copies of the publication free of charge

The *wucai* plate in Fig. 11.244 depicts a mulberry leaf picking scene. Inside a garden fenced with rails there is an artificial hill with two trees next to it. Under the tree there are a grown-up, a boy and a large pot. On the tree there is another boy with his shoes lying on the ground. This scene also comes from *Gengzhitu* and was later adopted by porcelain painters while the major motifs remained unchanged. A small gold seal mark was even adopted as part of the scene.

The brush tube in Fig. 11.245 is depicted with scenery and a hut with its door open. Inside, there are several people raising silkworms. This was also inspired by the *Gengzhitu*.

From these patterns, we can see that the Qing government played a dominant role in popular culture.

Fig. 11.244 Jingdezhen *wucai* plate with mulberry leaf picking scene, produced in the Kangxi period, diameter: 27 cm, foot rim diameter: 15.7 cm, height: 4.4 cm, in the Rijksmuseum, Amsterdam

Fig. 11.245 Jingdezhen *wucai* brush tube with *Gengzhitu* pattern, produced in the Kangxi period, height: 11.5 cm, mouth rim diameter: 18 cm, foot rim diameter: 17.7 cm, in the Princessehof National Museum of Ceramics in Leeuwarden, the Netherlands

11.7.3 The Mid-Qing Period—An Aggregating Era for Ceramic Art

The Qing Dynasty was a wide-learning and aggregating era for ceramic art. In the mid-Qing period, as textual research and antique collecting gained popularity in society, Jingdezhen, the ceramic production center of the nation from the Yongzheng to the Qianlong periods, indulged in producing ancient-style wares, both official and private kilns alike, which was a result of the influence of the retro trend in society as a whole. Some critiques therefore note that the ceramic art of the Qing Dynasty features an antique beauty from the perspective of aesthetics.[155] But the author does not agree. Indeed, the antique style was a fashion in the Qing period, and not only on porcelain. Other artifact forms were also reproduced. From the porcelain produced since the Tang and Song periods, we can see that traditional Chinese ceramic art pursued a plain, reserved, natural, antique and ethereal beauty. Among wares based on antique styles produced in Jingdezhen in the mid-Qing period, there were articles carrying such features. But it should be noted that such wares were not of the mainstream. Instead, in the eyes of the public, mainstream wares remained the bright and cheerful *wucai* ware and the complex and glamorous famille-rose porcelain. The development of *wucai* ware and famille-rose porcelain were inevitably affected by traditional Chinese ceramic values, but what they reflected was a kind of man-made, ornamental and magnificent beauty, a worldly beauty quite different from the traditional one, and gave full expression to popular culture in the ceramic arts. Jingdezhen in the mid-Qing period was not only affected by the retro fashion of the entire society, but also influenced by Western culture and the flourishing civil culture. Thus, Qing porcelain was not simply a result of copying the ancient styles, but also a mixing with foreign features drawn from Western enamel wares, silverware, gold ware, glassware, and pottery. In the course of imitation, it also embarked on a learning process and innovation. In this way, ceramic art boomed further in the mid-Qing period to reach an unprecedented level, and produced many new varieties.

What is especially worth noting here is that by learning from Western culture, Qing ceramic art was greatly enriched. From the mid- and late-Ming period, porcelain merchants from the West had flocked to Jingdezhen and placed orders. Due to differences in culture and way of life, porcelain merchants not only purchased existing varieties of products from Jingdezhen, but also customized products based on the demands of the Western market and consumers, thus making possible various new designs and motifs suitable to the aesthetic tastes and lifestyles of Westerners. Some porcelain merchants were artists themselves who were capable of various designs which were delivered to Jingdezhen via the East India Company branches. The Swiss East India Company had its own special designers who took charge of designs for custom-made porcelain in China. Other nations simply sent samples of gold ware, silverware, glassware, and pottery that they liked to China for potters to

[155] Wang Xiaoshu, *History of Chinese Aesthetic Culture, On the Yuan, Ming and Qing Dynasties*, Shandong Pictorial Publishing House, in 2000, p. 311.

model from.[156] The designs of these samples significantly affected the formation of a new Jingdezhen ceramic style and new varieties. Some of the designs were even directly adopted by potters with no modification at all, such as coffee vessels, tea vessels, sets of tableware, flat plates with wide rims, thin lantern porcelain, as well as *cibanhua* (porcelain plaques) which were exported abroad from the Qing Dynasty onwards. The influence of foreign culture was not only displayed in design, but also in color and decorative motifs. As people from different nations held different aesthetic values, in ordering products, some demanded wares with dimensional and free-style paintings of motifs such as flowers, human figures, scenery and architecture, some Rococo-style patterns, and some with coats of arms. Such paintings and decorative motifs in the Western style gradually influenced the traditional Jingdezhen decorative arts and changed the decoration style of Jingdezhen wares. According to *Jingdezhen Taolu*, private kilns in Jingdezhen "copied from Western enamel wares and painted on *yangcai* wares motifs such as landscapes, human figures, flowers and feathers exquisitely and vividly." "Red, green, … *wujin* (mirror black) wares in the Western style are all new varieties."[157] Not only were private kilns imitating and producing wares carrying Western styles and features for domestic and foreign markets, but this was also true of the official kilns. Tang Ying recorded in *Taochengjishibei* (*Memorial on Ceramic Production*) that "The five sacrificial wares (including one incense burner, one pair of candle holders and one pair of flower *zun*), plates, saucers, vases and boxes, etc. are all modeled after Western sculptures, enamel wares or real objects, and even the polishing of paintings was in the Western style." "There are yellow and purple wares produced, based on the Western style" and "The painting features of Western enamel wares are copied."[158] (Figs. 11.246 and 11.247) Apart from new overglazed varieties, as introduced when discussing export porcelain of the Qing Dynasty above, Western style red wares were iron-red porcelain while *wujin* wares were *mocai* and *jincai* wares. Exotic style porcelain, while produced in Jingdezhen or decorated in Guangdong, was painted with pigments from Europe, known as *yangliao* (foreign pigments), *yangcai* (foreign colors) or *xincai* (new colors). Illustrations from European classical works or popular literature also lent new inspiration to porcelain decoration as sample illustrations or even whole books were brought to China. For example, the pattern on the plate in Fig. 11.248 was in fact drawn from *Don Quixote* by the famous Spanish writer, Miguel de Cervantes. At the time, porcelain wares with such a decorative style burgeoned in the workshops of Jingdezhen and Guangzhou. Thus, the records of Lan Pu and Tang Ying were absolutely true. However, such overglazed wares were rarely seen in Jingdezhen and Guangzhou because they were almost all shipped to Europe. So this variety has been easily neglected in the *History of Chinese Ceramics*, which was edited by the Chinese Ceramic Society and published by the Cultural Relics Press in 1982, the most authoritative work on China's ceramic history ever published, let alone other research or works.

[156] Luo Xuezheng, "On the Influence of European and American Culture on Jingdezhen's Ceramic Arts," *Jingdezhen Porcelain*, Issue 2, 1991.

[157] Tang Ying, *Taochengjishibei*, from the *Gazetteer of Fuliang County* from the Qianlong period.

[158] Lan Pu, *Jingdezhen Taolu*, Vol. 3.

Fig. 11.246 Enamel cup with paneled peony patterns on a red background, produced in the Kangxi period, height: 4.2 cm, mouth rim diameter: 6.3 cm, foot rim diameter: 2.3 cm, in the Palace Museum

Fig. 11.247 Enamel vase with flower and butterfly pattern on a blue background, produced in the Qianlong period, height: 21.8 cm, mouth rim diameter: 5.3 cm, foot rim diameter: 6.3 cm, in the Palace Museum

While Chinese ceramic art affected Europe, the European Rococo style also influenced China, especially the Qing royal court. Emperor Kangxi greatly valued Western art. He not only invited European artists to work in the royal palace and participate in the design of the Old Summer Palace, but also specially set up the "Enamel Workshop" in the "*Zaobanchu*" (Office of Manufacture) in the palace and allowed these artists to work together with Chinese painters and artisans. Meanwhile, the imperial kilns in Jingdezhen often produced articles based on drafts and designs supplied by painters from the "*Zaobanchu*," "*Ruyiguan*" (Institute of Indulgence, an agency that investigated Western scientific achievements), and "*Qintianjian*" (the Imperial Board of Astronomy), while all European artists serving in the court worked together

Fig. 11.248 Jingdezhen *wucai* plate with Don Quixote and his attendant pattern, produced in the Qianlong period, diameter: 22.3 cm, in the Victoria and Albert Museum

with their Chinese counterparts to pool wisdom and talents. Due to the influence of European arts, from the mid-Qing period, Chinese ceramic art, which was dominated by Jingdezhen, shifted from the refreshing, elegant and vigorous style that prevailed prior to the Kangxi period, to a magnificent, delicate and complex fashion, thus giving rise to the typical royal style. This new fashion remained in vogue from the mid-Qing period and directly shaped the formation and growth of the ceramic style in that era. The plain, natural beauty worshiped in the past was replaced by a glamorous, colorful and man-made beauty, and remained so until the late Qing and even the Republican era.

The mid-Qing period was an aggregating era for Chinese ceramic arts which not only learned in retrospect from the past and produced considerable quantities of wares in the antique style and many varieties of high-fired color glaze which had heretofore remained unseen, but it also absorbed inspiration from nature and produced wares modeled after real objects which enriched the shape designs of porcelain. Meanwhile, it drew upon other forms of art and created porcelain that resembled wares with other textures, while also learning from the West and producing exquisite famille-rose wares, including enamel ware, *mocai*, *jincai*, and iron-red porcelain. In addition, folk culture also served as an important reference and many auspicious motifs made their way into porcelain decoration. By imitating and absorbing nourishment from various sources, the ceramic art of the mid-Qing period reached a new level in design, variety, decoration and color mix.

Through aggregation, beauty is also created. Ceramic art in this period was extremely inclusive, with elements of China and the West, ancient and modern, magnificent and plain, antique and popular, complex and ethereal coexisting. Meanwhile, for ceramic production in the official and private kilns, unprecedented prosperity and impending crisis also went hand in hand.

11.7.4 The Popularization of Auspicious Motifs in the Mid-Qing Period

Auspicious motifs and patterns were popular in decorating porcelain in the mid-Qing Dynasty. This originated from folk culture and life in civil society as well in religion. Emperor Kangxi endorsed Confucianism and highly respected Zhu Xi. However, his son, Emperor Yongzheng who ascended the throne after ferocious fights with his own brothers, adopted a new policy of equal emphasis on Confucianism, Buddhism and Taoism, in order to dispel the doubt over the legitimacy of his reign and to strengthen the imperial rule. During his time, the court especially highlighted interaction between heaven and mankind and paid much attention to auspicious and calamitous signs. This ethos endured for the rest of the Qing Dynasty and prompted the popularity of auspicious symbols of Taoism and Buddhism.

Auspicious motifs in Chinese civil society are widely seen and an important cultural symbol. Traditionally, culture was divided into refined and popular, official and folk, orthodox and unorthodox. Generally, auspicious motifs belonged to popular culture, folk culture and unorthodox culture, and they formed two functions. The first was survival and reproduction which are eternal themes of auspicious symbols which point directly to people's aspirations for good luck and fortune. The second was beliefs and customs, which are the core and the carriers of auspicious art. Springing from folk culture, auspicious art is a product of beliefs and customs while beliefs are the leading contributors to the formation of customs.

Auspicious signs are normally used as symbolic or metaphorical markers. For example, "fish swimming among lotus," "lions playing with balls," and "butterflies flying around melons" were not an attempt to display natural phenomena but were symbols of the intercourse of *yin* and *yang* (male and female) and thus the source of all living things. Additionally, *mianmianguadie* (bountiful melons), "*shiliuduozi*" (pomegranate seeds), and "*zaoshengguizi*" (date, peanut, longan and lotus seeds) patterns all stood for a surfeit of offspring. What is more, homophonous words were also used to express best wishes. For instance, sheep (*yang*) patterns included *sanyangkaitai* (symbolizing an auspicious beginning to a new year), monkey (*hou*) and horse (*ma*) patterns including "*mashangfenghou*" (monkey riding a horse, signifying scholarly honor or official rank just around the corner), deer (*lu*) and crane (*he*) patterns including "*liuhetongchun*" (spring is sweeping all over the world), deer patterns signifying higher incomes subsequent to a promotion (*lu* in Chinese is homophonous with the character meaning income), and fish (*yu*) patterns standing for surplus for the whole year (*yu* in Chinese is homophonous with the character meaning surplus). Such patterns were mainly modeled after woodblocks and woodcut New Year paintings, as well as other forms of artifact from civil society.

Due to the Chinese people's quest for completeness and animation, most of the patterns were bright and complicated and some were even completely covered with motifs without revealing a background color, for example the famous hundred-flowers patterns. But more often than not, contrasts of emptiness and fullness, sparseness and compactness were formed. Motifs were also usually paneled at

this time, such as in petal-shaped panels or in various geometric shapes, popularly known as "*kaitangzi*" in Jingdezhen. Popular Chinese motifs were usually painted in these window-like panels. As "*kaitangzi*" closely resembled the paneling techniques applied to Kraak wares exported to Europe in the late Ming and early Qing periods, it was also known as "*kaiguang*." This technique was in fact first adopted in the Islamic regions and was popular on the European market. Gradually, it became a traditional means of decoration in Chinese ceramic arts.

11.7.5 The Popularization of Ancient-style Porcelain in the Late Qing Period

The British East India Company's development of tea plantations in India and the production of silk in France significantly cut European imports of tea and silk from China. Meanwhile, as various porcelain manufactories were founded in Europe and much effort was made in publicizing the merits of their own products, Western demand for Chinese porcelain gradually declined.

However, in the late nineteenth century, eyes were once again turned to Chinese arts, thanks to the West's new cause in China, namely the construction of railways, hence a new door was opened to discover various Chinese arts, such as traditional Chinese porcelain and bronzeware. This triggered the interest of collectors from Europe and the USA. Meanwhile, China opened trading ports to the West, which further enabled Westerners to learn about Chinese arts and paintings, especially imperial decorative arts. During this time, Western consumers preferred Chinese porcelain aimed at the domestic market rather than its export porcelain custom-made for the foreign market, especially imperial wares manufactured by official kilns. Therefore, despite the downfall of the Jingdezhen ceramics industry from the late Qing period, its antique-style porcelain remained competitive on the international market.

The retro style of the late Qing period was different from that in the mid-Qing which was a little experimental and aimed at aggregating various styles together, such as the antique style, foreign styles, the styles of various kilns, and other forms of art, thus creating a new fashion to win over the Western market. In the late Qing period, with the rise of the European ceramics industry, the shrinking international market and the decline of the domestic economy, China barely saw any innovation in porcelain production and scholars and men of refinement all adored the wares of previous dynasties. In *Taoya*, Chen Liu wrote that "China's ceramics industry has declined. The reason Chinese porcelain manages to maintain its good name in the world is thanks to products produced previously. Chinese people, unable to dominate the sea with hard boats and cannons, incapable of producing competitive industrial goods for the market, can only brag about porcelain wares produced a long time

ago, which has led people around the world to call our country China."[159] At the time, discussions of ceramics were heated, and numerous "accounts" and "logs" were produced in the late Qing period. Meanwhile, due to the invasion of foreign powers, lots of antique porcelain wares were lost and for those remaining, some were on sale in the market at high prices. To seek profit in this fashion, antique dealers engaged in producing copycat products and launched them into the market, which to some extent stimulated the growth of the retro fashion. Numerous varieties were imitated, including blue and white porcelain, *wucai* ware, *jilan* ware, peacock green ware, tricolor ware and aubergine glazed porcelain of the Kangxi period as well as blue and white porcelain, famille-rose porcelain, *doucai* vases, *zun*, and plates of the Qianlong period which were large in size, clumsy in shape and coarse in decoration. After the Boxer Uprising in 1900, production of antique-style porcelain, which was popularly used as decorations or dowry, peaked.

Rich western merchants loved Chinese antique-style porcelain. "They preferred those in the antique style among the blue and white porcelain and those with fighting soldier patterns among the *wucai* wares."[160] For colors, they favored "plum green and azure, and those without patterns are of especially great value." Meanwhile, "Japan is fond of plain porcelain, such as pea green ware, Jian-style products, Canton wares and tea-flake glazed ware. French consumers, however, prefer *wucai* wares and even those with dazzling patterns. British merchants favor blue and white porcelain which has dropped in price recently while quality items remain high in value. In contrast, the US market adores red wares, azure wares, and official wares with marks, known as monochrome glazed porcelain, especially vases and pots. For German businessmen, *zhanbao qing* (purplish green) vases and pots are the best."[161]

The active antique-style porcelain market stimulated production of antique-style artifacts. According to *Yinliuzhaishuoci*, "As the Western market largely increased the purchase of porcelain, competition in this industry was very fierce, hence painting techniques were further improved." Thus, during the Guangxu period, antique-style porcelain achieved remarkable progress and polychrome porcelain modeled after the Ming and Qing dynasties was very popular, among which "*Yanzhihong* (carmine) wares were comparable to that produced in the Jiaqing and Daoguang periods while light painted azure glazed porcelain was almost as good as the genuine items."[162] Additionally, many precious products with exquisite paintings and blue and white patterns modeled on those of the Kangxi and Qianlong periods were manufactured. However, products produced in this fashion were tailored to the antique market rather than for the daily use of the common public and most gains went into the pockets of merchants, so little contribution was actually made towards the progress of the ceramics industry and the economic growth of society at large. Moreover, in order

[159] Chen Liu, Preface to *Taoya*, Shanghai Scientific & Technological Education Publishing House, 1993, p. 381.

[160] *China Porcelain*, Ceramic Science Research Institute (ed.), China Light Industry Press, 1983.

[161] See Footnote 160.

[162] Chen Liu, *Taoya*, the second volume.

to cater to the antique market, more emphasis was placed on imitation and little innovation was made.

Since the late Qing Guangxu period, porcelain making was transformed from workshop production to semi-mechanized manufacturing. This shift endowed Xuantong porcelain with features of the modern era. Through mechanical production, shapes were more standardized, the paste was harder, glaze was glassier, and so wares were smooth and glossy. Some seal marks took the place of hand-drawn paintings. However, due to the low level of mechanization, daily use porcelain was still not on a par with its foreign counterparts and thus was trapped in the low-end market, which further drove the poor production process and poor quality of ceramics. Meanwhile, due to the popularization of the retro style and the production of decorative porcelain, fine and exquisite wares produced by kilns centered around Jingdezhen maintained a certain share of the market. More importantly, the production of decorative wares used to be dominated by the official kilns while private kilns were strictly restricted by rules such as those from business organizations, restraining some special techniques from being fully utilized. In the late Qing and early Republican era, "With the collapse of official kilns, master potters flowed all over the country. The lifting of the bans on them made possible the production of wares in imitation of imperial wares." With the stimulus from the antique-style porcelain market, the strict boundary between ordinary daily-use wares and high-end quality wares was dismantled, which further aided the dissemination of porcelain-making techniques and facilitated the emergence of Jingdezhen decorative wares in the Republic of China era. The Eight Friends of Zhushan ("Pearl Hill"), a group of porcelain painters mostly active from the nineteenth century to the twentieth century, were representatives of those who contributed to the growth of decorative porcelain at this time. However, decorative wares, which were outstanding mainly for their paintings, were still not enough to turn around the falling trajectory of the industry.

11.7.6 Downfall of the Chinese Ceramics Industry in the Late Qing and Republic of China Eras

After surviving through the late Qing period, by the Republican period, large amounts of foreign mechanized industrial goods flowed into China and the traditional Chinese handicraft industries became sluggish. The traditional ceramics industry which once commanded a large share of the international market was no exception. Apart from antique-style porcelain as mentioned previously and some artistic porcelain produced by famous artisans, most workshops ceased operation under the pressure from machine production.

Far removed from Jingdezhen, the coastal Guangdong Province also shared the same fate. Historically famous kilns in Guangdong, such as those in Shiwan, Raoping, Dapu and Chaoan, while boasting advantages in porcelain production, embarked on a downward path before the Anti-Japanese War erupted. For the Shiwan kilns alone,

numerous potters were forced to leave their hometown to seek a livelihood due to long-term unemployment there. The once internationally famous Canton porcelain lost its charm. Even the Yixing kilns in Jiangsu, the renowned "capital of pottery," also turned to other businesses and were trapped in the plight of losing both labor resources and techniques. Southern porcelain producers, such as the Longquan kilns in Zhejiang, the Dehua kilns in Fujian, the Liling kilns in Hunan and the Rongchang kilns in Sichuan, also saw their past glory disappear and were in sluggish production or had closed down. This was also true of the northern kilns. While these kilns had maintained production of some traditional varieties for over a century, they were not able to survive these hard times. For example, Henan Province, a glorious porcelain producer with thousands of years of history and home to the famous "Yangshao culture" and the Ru, Guan, Jun and other famous kilns were largely unable to survive. Only certain large workshops in Mianchi, Linru, Yuxian County, and Xin'an continued to produce some coarse wares. The Cizhou kilns in Hebei Province, producers of the time-honored pottery wares of the "Cishan culture," celadon wares of the Northern Dynasties, and initiators of the traditions of Cizhou-style porcelain, were not spared this doomed destiny. With poor and shoddy workmanship and a sluggish market, its techniques were almost lost.[163] Like various kilns around China, Jingdezhen, the international porcelain capital, also hit rock bottom. Reasons contributing to this included the following:

① By the late Qing and Republican period, Chinese commerce and industry, including the ceramics industry, still ran in an agriculture-based mode. Not only the method of production, but the whole society was organized on the basis of agricultural relations. In the heavily agricultural society, blood, geographic, and industrial relations defined the basic social relations of the ceramic potters. Meanwhile, as laissez-faire capitalism was booming in the West, it was led to believe that "now that things have gone so far, the new machines invented by Britain will replace millions of Chinese workers and take their jobs away."[164] At this time, Europe had already grasped the porcelain-making techniques and enabled mechanized and modern production. What is more, while Western capitalist countries had already realized large-scale mechanized and modernized production, China still produced in small-scale workshops; while Western machines were powered with heat and electricity, China still relied on manual power or natural forces; while the West had already equipped itself with railways and steam boats, China was stuck with horses and sampans…[165] Against such an historical and social backdrop, it seemed reasonable that the Chinese ceramics industry, reeling from the shock of its Western competitors, should fall from its peak of the mid-Qing period.

[163] Ye Zhemin, *History of Chinese Ceramics*, SDX Joint Publishing Company, 2006.

[164] *Selections from the Works of K. Marx and F. Engels*, Vol. 1, People's Publishing House, 1972, p. 214.

[165] Hao Xiajun (ed.), et al., *Comparisons Between East and West across 500 Years*, China Worker Publishing House, 1996, p. 357.

② Dumping of foreign wares. In the late Qing period, Emperor Tongzhi took the throne at a young age while his mother, Empress Dowager Cixi, was effectively in control of the country. The vigorous Taiping Movement following the Xianfeng period was finally suppressed during this time with the joint efforts of the Qing government and foreign forces. Invading forces led by Britain directly controlled the Qing regime, reducing China to a semi-colonial society, which not only accelerated the demise of national industries, but turned China into a dumping ground for foreign industrial goods.

Against this background, the imperialist forces sped up the dumping of foreign goods and delivered huge blows to China's national industries based on their overwhelming strength and the unequal treaties that they signed with China. Apart from import duties of 5% paid at customs and a further 2.5% tax, all imported goods were free to move within China. In this way, foreign goods found no difficulty in flowing into every corner of the country without any extra costs or taxes. The foreign imperialist powers even forced China to acknowledge the foreign merchants' right to trade freely without paying any further taxes. With the free flow of foreign goods throughout China, the role of China's customs in protecting its national industries disappeared. This parlous situation was a heavy blow to the Jingdezhen ceramics industry, but not as heavy as it was to other handicraft industries, as Jingdezhen was endowed with abundant natural raw materials and low labor costs, thus appearing resistant. Before the Sino-Japanese War of 1894–1895, Jingdezhen was yet to hit rock bottom. However, after the war, and based on the Treaty of Shimonoseki signed as a consequence of the war, the imperialist powers were permitted to set up factories in China and to run capitalist industries with China's raw materials and cheap labor, which deprived China's porcelain industry of its final advantages. Machine-made porcelain produced by factories run by foreign powers was low in cost and free from local taxes, thus they soon seized a large market share. The national ceramics industry was indeed faced with daunting challenges. Porcelain factories run by foreign merchants and produced by machine were low in cost and high in terms of efficiency. By capitalizing on China's raw materials and cheap labor, the foreign owned factories were so competitive against the domestic porcelain industry that they were a major contributor to the difficulties the Jingdezhen ceramics industry was facing.

③ Unfair taxes. Another important factor leading to the downfall of China's ceramics industry was the heavy burden and exploitation of government taxes. As the foreign capitalist forces dumped goods and capitalized on their investment, they also supported Chinese feudal forces politically and economically with a view to transforming the Qing government into a bureaucratic, feudal, comprador-dominant capitalist regime. Such a mutated mechanism endowed foreign goods and foreign-funded factories with various privileges such that they ran rampant across the country and squeezed the domestic products out of the market. Meanwhile, the unified Chinese market was dismantled such that even domestically produced goods had taxes levied at customs passes. Under such a scenario, the decline of the ceramics industry was inevitable. High costs,

heavy taxes and strong competition from foreign porcelain ensured the collapse of China's ceramics industry in the late Qing period.

11.7.7 Final Thoughts

Though focusing on ceramic history, this book has actually outlined the ups and downs of China over the historical course of thousands of years. We experienced glorious times, but also suffered great failures and humiliations. Ceramic history is not all of Chinese history, but it accounts for an important part of it. During the course of China's development, it encompassed various aspects, such as technological, political, economic and cultural progress, the evolution of aesthetic tastes and artistic prosperity, as well as exchange and dialogue with other civilizations, which was an aggregate manifestation of the hard and soft power of the country. By the late Qing and Republican period, the downfall of China's ceramics industry was also attributable to the weakening national strength and the lagging of the national industries.

Naturally, China's ceramic culture recovered. Since the founding of the People's Republic of China in 1949, the ceramics industry has enjoyed new growth while the traditional backward porcelain-making techniques that had been applied in workshops were phased out gradually. Jingdezhen, the renowned porcelain capital, abolished various workshops and established ten national porcelain manufactories. Apart from Jingdezhen, many other porcelain producers had similar experiences. For example, the town of Chenlu, the largest traditional porcelain producer in the northwest, was home to hundreds of porcelain workshops across its eleven villages prior to 1949, while since the 1950s, they have been consolidated into a large national porcelain factory. Such manufactories, by adopting streamlined production techniques, produce daily-use wares which are high in quality and low in price, for consumers nationwide. The ceramics industry which lasted for thousands of years in China, after hitting rock bottom, has recovered. In order to earn foreign exchange, some ceramic-producing regions still retained some techniques for making decorative wares, mainly antique-style porcelain.

By the 1980s, thanks to the reform and opening policy, the Chinese economy took off and the traditional ceramic sector again captured people's attention. Initially catering to the overseas demand and then thanks to urban development and the improvement in people's living standards, new artistic hand-made decorative wares and daily-use wares were called for. These new demands urged many traditional porcelain-producing regions which had ceased operation for a while, to resume production, even including the famous kilns of the Song Dynasty, such as the Ru, Ding, Yaozhou, and Jun kilns. It should be noted that they no longer just produced for the daily use of consumers, but more importantly, they were producing decorative wares for the sake of art.

Jingdezhen especially, once the production center of daily-use wares in the world, has now become the center of artistic porcelain production. Ceramic artists nationwide and worldwide all gather here, including some painters and sculptors, who come to create innovative works based on local materials and exquisite techniques. So, Jingdezhen not only boasts abundant raw materials and a coordinated production service, but also numerous excellent craftsmen who through cooperating with artisans from other areas and sectors, drive forward new growth in ceramic art.

Meanwhile, some ceramic artisans from traditional porcelain-making regions such as Jingdezhen, Yixing, Longquan and Shiwan have distinguished themselves with their work and gained much popularity in the market. Some Chinese who were first to become rich, had a penchant for collecting modern artistic works. Ceramic art, a representative of the essence of Chinese culture, is naturally a focus for collectors. At the same time, China's urban construction and infrastructure all create new demands for decorative wares. All of these new opportunities bring new vigor and vitality to the growth of ceramic art in the modern era.

Traditional porcelain production, rather than serving people's daily needs, has been transformed into an artistic activity. Potters are now artisans, masters or assistants to them. How to perceive and interpret this cultural phenomenon, including how to record it, is beyond the scope of this book, as that is the history of modern ceramic art. Perhaps this could be the next adventure for the current author?

Within the limits of time, space and personal capacity, the author has attempted to make a small contribution to the fascinating research on the lengthy and complicated ceramic history of China. It is my sincere hope that this work might serve in some small way to induce more experts to come forward with their valuable contributions. And of course, any appropriate criticism is warmly welcomed!

Afterword

Since 1997, the author has spent 16 years in writing this book in fits and starts. Now that it is completed, when I recall the journey, it really was not easy. In the first three years, I focused on it wholeheartedly and completed the first draft. In the ensuing eight years, I was busy with research on the protection of cultural resources in western China under a key national project. During these eight years, I undertook field visits to the central Shaanxi plain area and the Northern Shaanxi region to study local civilian culture and arts, including the Chenlu region. Later, I traveled to Northwest Guizhou to investigate the local *Miao* culture and arts. These field investigations enhanced my knowledge and understanding of traditional Chinese culture, folk culture and the cultures of ethnic minority groups. When this project was completed, a series of relevant reports and a thesis were produced, which offered me new ideas and understandings of the methodology and theory of the anthropology of art. Such field investigations and theoretical summaries, while seeming irrelevant to studies on Chinas ceramic history, have in fact been highly relevant. They not only helped expand my horizons and enriched me with knowledge of Chinese art and cultural history, but also helped me cultivate a holistic sense in writing so that I could equally view cultural interactions among different classes, nationalities, and races. Without this knowledge and awareness, this work would have been completely different to what it now is. I therefore believe that any work is the ideological result of a given author at a certain stage in his/her development.

When the project on western China was completed in 2008, I resumed my work on this book for another six years. During this time, I visited countries and regions around the Indian Ocean, the Persian Gulf, the Red Sea, and the Mediterranean Sea, which were all on the routes of the ancient Ceramic Road, and grasped a basic sense of the geography of China's ancient ceramictrade. Meanwhile, I also visited many famous museums in the USA, Europe, Africa, Japan and other Asian countries and saw a considerable amount of Chinese porcelain displayed in eminent venues. In these museums, I felt so proud to be a Chinese, seeing people in these countries bestowing respect and laudations on Chinese artifacts, including but not limited to porcelain wares, produced from the sixteenth century to the nineteenth century. In the Museum of Fine Arts in Boston, I attended an exhibition especially showcasing

© Foreign Language Teaching and Research Publishing Co., Ltd 2023

L. Fang, *The History of Chinese Ceramics*, China Academic Library,

https://doi.org/10.1007/978-981-19-9094-6

how Chinese culture in the 17th, 18th and early nineteenth centuries affected Europe and the USA. Porcelain wares formed a significant part of this exhibition. At the time, China not only exported real articles like porcelain to Western countries, but also Chinese cultural philosophies and ways of life. During my one-year stay in the USA as a visiting scholar, I purchased and researched many English language books regarding Western research on Chinese export porcelain. By reading these books, I was impressed by how profoundly Chinese porcelain culture has influenced the world.

All these experiences spurred me to complete the book I was working on. During the course of writing, I realized when talking about traditional Chinese culture, the four great inventions of ancient China are usually the first to come to mind. Proud as we are when talking about it, we tend to forget that porcelain is also a great invention and contribution that China has made to the world. Its exquisite technology has been imported by many countries around the globe and it has profoundly changed the culture and way of life there. Historically, the ceramictrade was one of the largest foreign trade endeavors and many countries started to learn about China through porcelain. I have personally also obtained a better understanding of traditional Chinese culture and arts through ceramic culture. All the efforts expended on this book have aimed to serve the readership well and to provide them with a perspective to understand Chinese culture, the Chinese artistic way of life and philosophy by observing the history of ceramic development. How to grasp the pulse of China's cultural development and evolution through studying porcelain production and its international trade is vital.

I am not sure whether I have managed to achieve this goal or not. Everyone has their own aspirations and ambitions to pursue, from their own personal and professional perspective and vision. All this is closely related to one's living and educational background. People's ideas are not all created by themselves alone, but sometimes inherited from predecessors, extracted from the times and influenced by peers. We are simply individuals who integrate all the ideas to which we have been exposed and manifest them from our own perspective. Thus, every achievement must be attributed to those who have lent a helping hand.

I would first of all like to thank Professor Tian Zibing, my doctoral advisor who assigned me this writing mission in the first place. Without him and his constant guidance and encouragement, this book would not have been possible. So, this book is also an assignment which I hand to Professor Tian (although it has taken 16 long years and is indeed overdue). Many thanks to my postdoctoral supervisor, Professor Fei Xiaotong. His view of "cultural self-consciousnesshas always spurred me to actively consider and investigate Chinese cultural traditions. Under his guidance, I have come to realize that looking back at the past is in order to look better at the future, as the past serves as the foundation of future development. Without Professor Fei, this book would have followed a different path without an anthropological methodology or perspective. Now, Professor Tian is in his old age, Professor Fei has passed away and I have been tutoring my own doctoral students, some of which have already entered the workforce. But my gratitude to my teachers will last forever. They are

the lighthouse in my academic career and will always guide me in every forward step.

I also thank many of my predecessors and peer scholars who have contributed to the research on China's ceramic history and Chinese culture. Their archaeological reports, theses and papers provide valuable research materials and references for my writing. Meanwhile, I have also received support from many scholars from ceramics academic circles, including Mr. Geng Baochang, one of China's top porcelain experts from the Palace Museum. Already in his 90s, when I solicited his advice regarding this book at the end of 2012, he spent the entire Spring Festival holiday reading it through, proofreading and revising all captions, kindly inscribing it, including its title. As a younger scholar, I was deeply moved and would like to offer my sincere appreciation to him. After reading through the whole manuscript, Cao Jianwen, Professor of the JingdezhenCeramic Institute, and Feng Xiaoqi, Researcher in the Palace Museum, meticulously proofread it and checked all the references. Zhou Sizhong, Professor of the JingdezhenCeramic Institute, also helped proofread part of the manuscript from the primitive era to the Yuan Dynasty. During the course of writing, my postgraduate student, Ye Rufei helped proofread all references, sort out part of the illustrations and collected some information. On several occasions, she traveled with me from Beijing to Qilu Press in Shandong for proofreading. Wang Danwei, another student of mine was also involved in proofreading some of the illustrations. Thank you all for your hard work!

I am also grateful to my family: my father, my husband and my son who have been so supportive of my career and who have shared all the family chores that I was supposed to undertake so that I could focus on my research. Special thanks to my beloved husband, Mr. Zhu Legeng, who is the strongest supporter of my career and research funding. Zhu Yang, my son and the first reader of this work, made many valuable suggestions from the point of view of a young overseas returnee.

Meanwhile, many thanks to Mr. Zhao Faguo, Deputy Editor-in-Chief, and Song Ti, Director General, of Qilu Press. In 2007, when they personally came to Beijing to sign a contract with me, the first draft had already been completed and we all believed it would only take a little time for polishing and revision. However, when I started to revise the manuscript, I came to realize that completed years ago, this draft was outdated as many new archaeological discoveries had been revealed. Besides, as the years have gone by, I myself had also changed a lot in my ways of thinking. All these brought great challenges to my revision. Determined as I was, I decided to put in an all-out effort to revise it, eventually taking five to six years to complete. The publication date was inevitably delayed significantly. As it dragged on, Zhao and Song were extremely patient. They constantly kept in contact with me and asked about the progress of the revision. When the book was finally ready for editing, they spared no effort at editing, type setting, and cover design. So publication of this book would not have been possible without their patience, tolerance and hard work. In addition, Mr. Liu Qiang also went to great pains in editing, proofreading and examining the work to ensure its quality.

In closing, it should be noted that, complicated as the ceramic history of China is, in order to make sense to the readers and to make clear the points discussed in

the book, the author has inserted many illustrations. Some were shot by the author herself and some are cited from other sources, such as painting albums and treatises. In utilizing these illustrations, the author has attempted to get in touch with their original proprietors to gain their consent before the publication of this book. Wide as the sources were, it was not possible for the author to contact all proprietors. I would hereby like to express my sincere apology, therefore, and plead for their kind authorization and understanding. As a way of showing respect to proprietors, I have listed all the sources available in the ensuing Photo Credits. Once again, I am grateful to all the creators of the painting albums, treatises and relevant publishing houses referred to in this work. In addition, there are some photos which were shot by the author during visits to museums such as the Metropolitan Museum of Art, the Peabody Essex Museum, the Museum of Fine Arts, Boston, and the Berkeley Art Museum in the USA; the British Museum and the Victoria and Albert Museum in the UK; Musée Guimet in France; the Royal Museums of Art and History, Brussels in Belgium; the Dresden State Art Collections in Germany; and Museum Boijmans Van Beuningen in Rotterdam, the Groninger Museum, the Princessehof National Museum of Ceramics in Leeuwarden, the Netherlands. Due to limited energy and access in getting in touch with all relevant museums, the author has taken the liberty of adopting these pictures without the permission of these museums. To pay tribute to these museums, the author has identified the sources and names of the collections in all these illustrations and offers her sincere gratitude to the museums!

<div align="right">

Fang Lili

July 10, 2013

Final draft completed in the Wanwanshu Apartments, Beijing

</div>

Index

A

Abbasid Dynasty, 332
Abbasid Empire, 327
Abdication system, 66
Above-glaze painted porcelain, 486
Abstract geometric patterns, 51
Accounts of Ceramics at Jingdezhen, 402
Acheng District, 458
A Comprehensive History of Zhejiang, 418
Acrobats, 158, 159, 360, 988
Additional stacking pattern, 15, 17, 25, 27,
 29, 35, 57, 60, 69, 74, 77, 81, 87, 96,
 111
Aestheticism, 49, 51
Aesthetic preferences, 102, 131, 197, 347,
 350, 364, 483, 508, 511, 512, 515
Aesthetics, 10, 14, 28, 39, 59, 62, 88, 102,
 103, 113, 120, 122–124, 136, 176,
 186, 200, 204, 222–225, 232, 265,
 327, 339, 340, 345, 352, 363, 372,
 389, 391, 394, 398, 399, 422, 464,
 506–516, 581, 626, 627, 632, 634,
 672, 673, 724, 734, 735, 796, 800,
 804, 805, 808, 811, 857, 860, 865,
 868, 1009, 1014, 1034, 1054, 1055,
 1061, 1062, 1071
Africa, 320, 324, 329, 336, 364, 490, 501,
 547, 595, 667, 689, 734, 743, 750,
 796, 829, 1010, 1073
Agate, 394
Agricultural ancestor, 397
Agricultural civilization, 3, 4, 128, 348,
 673, 895, 963, 998
Agricultural era, 90
Agriculture, 2, 3, 28, 34, 52, 66, 71, 129,
 409, 490, 523, 646, 664, 816, 886,
 908, 927, 928, 955, 964, 1059, 1069

A History of Sino-Japanese Cultural
 Exchanges, 321
Aichi Prefecture, 336, 750
Aikou, 472, 475, 480, 610
Aleppo, 330
Alfred Gell, ix
Alkali lime glaze, 581
Al Qusayr, 321
Altar blue porcelain, 535
Altar ware, xxiii
Alumina oxide, 145, 201, 244
Aluminum, 196, 206, 252, 367, 606
Aluminum oxide (Al2O3), 244, 252, 278,
 287, 534, 544, 590
Amami Islands, 320
America, 644, 648, 717, 755, 806, 829,
 892, 973, 983, 986–988, 993, 994
Amphora, 36, 350, 840
Ampule, 147
An'nan (Vietnam), 229, 337
Ancestors, 2, 21, 30, 39–41, 47, 48, 50, 54,
 62, 78, 92, 101, 179, 180, 218, 219,
 356, 457, 511, 551, 555, 570, 603,
 652, 656, 660, 731
Ancestral temple, 93, 230, 232, 398
Ancestral tombs, 169
Ancient aristocratic society, 128
Ancient China, 13, 88, 92, 128, 217, 222,
 229, 364, 553, 573, 584, 591, 656,
 673, 684, 956, 1039, 1074
Ancient Chinese, 33, 40, 51, 80, 81, 101,
 156, 160, 185–187, 193, 194, 200,
 202–204, 211, 214–222, 227, 236,
 261, 268, 296, 297, 310–312, 315,
 317–325, 330, 335, 336, 352, 355,
 366, 367, 370, 371, 373, 374, 381,
 385–387, 390, 391, 394, 395, 398,

© Foreign Language Teaching and Research Publishing Co., Ltd 2023 1077
L. Fang, *The History of Chinese Ceramics*, China Academic Library,
https://doi.org/10.1007/978-981-19-9094-6